GREEK ALPHABET

alpha	α	eta	η	nu	ν	tau	τ
beta	β	theta	θ, Θ	xi	ξ, Ξ	upsilon	υ
gamma	γ, Γ	iota	ι	omicron	o	phi	ϕ, Φ
delta	δ, Δ	kappa	κ	pi	π, Π	chi	χ
epsilon	ϵ	lambda	λ, Λ	rho	ρ	psi	ψ, Ψ
zeta	ζ	mu	μ	sigma	σ, Σ	omega	ω, Ω

Acclaim for Dave Eberly's *3D Game Engine Design*

I have been baffled by the lackluster quality of past publications targeted specifically at the interactive, real-time engineer and developer, and I am confident that Dr. Eberly's magnum opus will raise the bar for everyone who follows in his footsteps. I expect his work to become to game developers what Foley, Van Dam, et al., was to the graphics community in the late 80s and early 90s: the de facto mirror of the state of art in research and development in the field.

—Andrea Pessino
Blizzard Entertainment

This is a great book for someone who is writing his or her first 3D engine and has a reasonable background in math. Even for people who have written game engines before, there is plenty of value in the alternative techniques that Eberly presents for various parts of the 3D pipeline, which makes for a great reference text. I particularly like the presentation of various alternatives and their pros and cons. He clearly covers performance issues and includes all the important elements of a graphics game engine. He even includes a good introduction to animation techniques and collision detection. The book is not ashamed to delve deep into the technical details and the mathematics behind 3D graphics; I think this is good. *3D Game Engine Design* would certainly find a prime place on my bookshelf.

—Dominic Mallinson
Director of Technology, Research, and Development
Sony Computer Entertainment America

Virtually all the books on building 3D game engines cover the basics: here's a polygon, here's a transformation matrix, here's a perspective projection, and so on. The problem is that you can't make a professional quality game with just the basics. This leaves a large gap between you and your goal of creating a great game engine. With this book, Dave is launching a huge boulder into the gap, helping you scamper to your destination. Managing a generalized 3D environment in real-time is difficult, the book covers a complete set of high-end techniques to do the job. I think most game companies would be lucky to come anywhere close to this level of sophistication. I loved Appendix A, "Object-Oriented Infrastructure." It covers many of the software-engineering issues we have had to solve over the years: things like objects with multiple references being managed by a reference count semaphore.

—Eric Yiskis
Lead Programmer, Oddworld Inhabitants

[3D Game Engine Design] presents an incredible amount of difficult and complex information in a clear and understandable manner.

—Ian Ashdown
University of British Columbia

Well done . . . definitely a must-have reference for the budding 3D engine developer.

—Steven Woodcock
Raytheon

I don't know of anything that approaches this subject in such a comprehensive and analytically complete way. This book combines all the concepts underlying 3D engine algorithms in a thorough and rigorous fashion, and is a wonderful addition to the technical literature of 3D.

—Peter Lipson
Mindscape

Before reading the chapters, [the table of contents] engaged me and I said to myself, "I am going to learn a lot from this book." I'm inclined to recommend this to my undergraduates who want to have a reference for 3D graphics programming.

—John Laird
University of Michigan

This book will serve as a welcome resource for game programmers who wish to work at the cutting edge of their trade. It is a remarkably comprehensive and elegant guide to the construction of interactive 3D environments at a professional level. Drawing on the latest advances in real-time rendering and software engineering, Eberly astutely brings game engine development into the 21st century.

—Sherry McKenna
CEO, Oddworld Inhabitants

Dave Eberly has written the definitive book on real-time 3D game engine design. It's a must-have for anyone who writes real-time 3D code.

—Franz Lanzinger
Actual Entertainment

In an industry where quality information is extremely difficult to come by, Dave Eberly has managed to compile a desperately needed perspective for those programming the most critical link in the game production process: the game engine. This book should be mandatory reading for all aspiring game engine designers.

—Lorne Lanning
Cofounder and President, Oddworld Inhabitants

3D GAME ENGINE DESIGN

A Practical Approach to
Real-Time Computer Graphics

3D GAME ENGINE DESIGN

A Practical Approach to Real-Time Computer Graphics

DAVID H. EBERLY
Magic Software, Inc.

MORGAN KAUFMANN PUBLISHERS

AN IMPRINT OF ACADEMIC PRESS

A Harcourt Science and Technology Company

SAN FRANCISCO SAN DIEGO NEW YORK BOSTON
LONDON SYDNEY TOKYO

Acquisitions Editor Tim Cox
Production Editors Elisabeth Beller and Sarah Burgundy
Editorial Assistants Brenda Modliszewski and Stacie Pierce
Cover Design Ross Carron Design
Text Design Rebecca Evans
Color Insert Preparation Side By Side Studios/Mark Ong
Composition/Illustration Windfall Software, using ZzTEX
Copyeditor Ken DellaPenta
Proofreader Jennifer McClain
Indexer Steve Rath
Printer Courier Corporation

Trademarks are listed on page 561.

Cover images: Top image courtesy Random Games. Bottom three Prince of Persia images Copyright © 1999, 2000 Mattel Interactive and Jordan Mechner. All Rights Reserved. Prince of Persia is a registered trademark of Mattel Interactive.

ACADEMIC PRESS
A Harcourt Science and Technology Company
525 B Street, Suite 1900, San Diego, CA 92101-4495, USA
http://www.academicpress.com

Academic Press
Harcourt Place, 32 Jamestown Road, London, NW1 7BY, United Kingdom
http://www.academicpress.com

Morgan Kaufmann Publishers
340 Pine Street, Sixth Floor, San Francisco, CA 94104-3205, USA
http://www.mkp.com

© 2001 by Academic Press
All rights reserved
Printed in the United States of America

05 04 03 02 01 5 4 3

Library of Congress Cataloging-in-Publication Data

Eberly, David H.
 3D game engine design : a practical approach to real-time computer graphics / David H. Eberly.
 p. cm.
 Includes bibliographical references and index.
 ISBN 1-55860-593-2
 1. Computer graphics. 2. Three-dimensional display systems. 3. Real-time programming. I. Title.
T385 .E373 2001
006.6'93—dc21 00-055019

This book is printed on acid-free paper.

*This book is dedicated to all those folks
who participate in comp.graphics.algorithms
and have made my online life quite interesting and meaningful.
Enjoy!*

CONTENTS

vii

CHAPTER 3

THE GRAPHICS PIPELINE 79

CHAPTER

4

HIERARCHICAL SCENE REPRESENTATIONS 141

CHAPTER

5

CHAPTER

6

CHAPTER
7

CURVES 257

CHAPTER
8

SURFACES 287

CHAPTER
12

SPATIAL SORTING 411

APPENDIX

B

FIGURES

TABLES

PREFACE

This book is the culmination of many years of reading and participating in the Internet newsgroups on computer graphics and computer games, most notably *comp.graphics.algorithms* and the hierarchy of groups *comp.games.development*. The focus of my participation has been to provide free source code that solves common problems that arise in computer graphics, image analysis, and numerical methods, available through Magic Software at *www.magic-software.com*. The book is also a technical summary of my experiences in helping to produce a commercial game engine, NetImmerse, developed by Numerical Design Limited (NDL), *www.ndl.com*.

The focus of this book is on understanding that a game engine, or more generally a real-time computer graphics engine, is a complex entity that consists of more than simply a rendering layer that draws triangles. It is also more than just a collection of unorganized techniques. A game engine must deal with issues of scene graph management as a front end that efficiently provides the input to the back end renderer, whether it be a software- or hardware-based renderer. The engine must also provide the ability to process complex and moving objects in a physically realistic way. The engine must support collision detection, curved surfaces as well as polygonal models, animation of characters, geometric level of detail, terrain management, and spatial sorting. Moreover, the engine is large enough that the principles of object-oriented design must be practiced with great care.

The chapters of this book tend to be fairly mathematical and geometrical. The intended audience includes anyone who is interested in becoming involved in the development of a real-time computer graphics engine. It is assumed that the reader's background includes a basic understanding of vector and matrix algebra, linear algebra, multivariate calculus, and data structures.

Many people have directly or indirectly contributed to the book. Most notable are the engineers at NDL: Lars Bishop, Jon McAllister, Chad Robertson, Rob Phillips, Tim Preston, Scott Sherman, Ed Holzworth, and Andy Jones. Lars and I are the primary architects for NetImmerse. He is the renderer expert, especially with regards to Direct3D, and has been instrumental in helping me to understand many of the issues for rendering. We also have had many productive design sessions about how best to incorporate the ideas for scene graph management to properly feed the renderers and to properly manage renderer state. Chad and Rob are the animation experts. They did a lot of legwork on understanding how various modeling packages animate characters and deciding how NetImmerse can best support the animation. Chad also contributed many good ideas on how to structure the collision detection system to work well with the hierarchical scene graph system. Jon is the expert on continuous level of detail and has implemented some of the algorithms mentioned in this book for NetImmerse. The implementations go well beyond what is discussed here and

addressed practical concerns that some of the research papers did not cover. Jon also worked with Chad and Rob on the integration of continuous level of detail with the skin-and-bones system, a nontrivial task. Tim was helpful in reading Chapter 8 and attempting to implement the top-down algorithm as I originally wrote it. He pointed out what I had overlooked, leading to some fine discussions about how to properly tessellate the surfaces without paying for a large memory overhead. The algorithm as described in this book reflects these discussions. Finally, Bill Baxter was a summer intern from the University of North Carolina, but in his time at NDL was able to investigate the topic of inverse kinematics and implement that system in NetImmerse. Discussions with him led to my understanding of how inverse kinematics should work in the game engine and is reflected in how I wrote the section on that topic.

I want to thank the reviewers for the book: Ian Ashdown (byHeart Consultants Limited), John Laird (University of Michigan), Jeff Lander (Darwin 3D), Franz Lanzinger (Actual Entertainment), Ming Lin (University of North Carolina), Peter Lipson (Mindscape), Tomas Möller (Chalmers), Andrea Pessino (Blizzard Entertainment), and Steve Woodcock (Raytheon). They spent a quite large amount of time reading over the two drafts of the book and provided many helpful comments and criticisms. I also want to thank my editor, Tim Cox, and his assistants, Brenda Modliszewski and Stacie Pierce, for the time they have put into helping the book come to completion.

INTRODUCTION

I have no fault to find with those who teach geometry. That science is the only one which has not produced sects; it is founded on analysis and on synthesis and on the calculus; it does not occupy itself with probable truth; moreover it has the same method in every country.

— Frederick the Great

1.1 A BRIEF MOTIVATION

Computer graphics has been a popular area of computer science for the last few decades. Much of the research has been focused on obtaining physical realism in rendered images, but generating realistic images comes at a price. The algorithms tend to be computationally expensive and must be implemented on high-end, special-purpose graphics hardware affordable only by universities through research funding or by companies whose focus is computer graphics. Although computer games have also been popular for decades, for most of that time the personal computers available to the general public have not been powerful enough to produce realistic images. The game designers and programmers have had to be creative to produce immersive environments that draw the attention of the player to the details of game play and yet do not detract from the game by the low-quality graphics required for running on a low-end machine.

Times are changing. As computer technology has improved, the demand for more realistic computer games that support real-time interaction has increased. Moreover, the group of computer gamers itself has evolved from a small number of, shall we say, computer geeks to a very large segment of the population. One of the most popular, successful, and best-selling games was *Myst*, created and produced by Cyan Productions and published through Broderbund. This game and others like it showed that an entirely new market was possible—a market that included the general consumer, not just computer-savvy people. The increased demand for games and the potential size of the market has created an impetus for increased improvement in the computer technology—a not-so-vicious circle.

One result of the increased demand has been the advent of hardware-accelerated graphics cards that off-load a lot of the work a CPU normally does for software rendering. The initial cards were add-ons that handled only the 3D acceleration and ran only in full-screen mode. The 2D graphics cards were still used for the standard graphics display interface (GDI) calls. Later-generation accelerators have been designed to handle both 2D GDI and 3D acceleration within a window that is not full screen. Since triangle rasterization has been the major bottleneck in software rendering, the hardware-accelerated cards have acted as fast triangle rasterizers. As of the time of this writing, the next-generation hardware cards are being designed to off-load even more work. In particular, the cards will perform point transformations and lighting calculations in hardware.

Another result of the increased demand for games has been the evolution of the CPUs themselves to include support for operations that typically arise in game applications: fast division, fast inverse square roots (for normalizing vectors), and parallelism to help with transforming points and computing dot products. The possibilities for the evolutionary paths are endless. Many companies are now exploring new ways to use the 3D technology in applications other than games, for example, in Web commerce and in plug-ins for business applications.

And yet one more result of the increased demand is that a lot of people now want to write computer games. The Internet newsgroups related to computer graphics, computer games, and rendering application programmer interfaces (APIs) are filled with questions from eager people wanting to know how to program for games. At its highest level, developing a computer game consists of a number of factors. First and foremost (at least in my opinion) is having a good story line and good game play— without this, everything else is irrelevant. Creation of the story line and deciding what the game play should be can be categorized as *game design*. Once mapped out, artists must build the *game content,* typically through modeling packages. Interaction with the content during run time is controlled through *game artificial intelligence*, more commonly called *game AI*. Finally, programmers must create the application to load content when needed, integrate the AI to support the story line and game play, and build the *game engine* that manages the data in the world and renders it on the computer screen. The last topic is what this book is about—building a sophisticated real-time game engine. Although games certainly benefit from real-time computer

graphics, the ideas in this book are equally applicable to any other area with three-dimensional data, such as scientific visualization, computer-aided design, and medical image analysis.

1.2 A SUMMARY OF THE CHAPTERS

The classical view of what a computer graphics engine does is the *rendering* of triangles (or polygons). Certainly this is a necessary component, but it is only half the story. Viewed as a black box, a renderer is a consumer-producer. It consumes triangles and produces output on a graphics raster display. As a consumer it can be fed too much data, too quickly, or it can be starved and sit idly while waiting for something to do. A front-end system is required to control the input data to the renderer; this process is called *scene graph management*. The main function of the scene graph management is to provide triangles to the renderer, but how those triangles are obtained in the first place is a key aspect of the front end. The more realistic the objects in the scene, the more complex the process of deciding which triangles are sent to the renderer. Scene graph management consists of various modules, each designed to handle a particular type of object in the world or to handle a particular type of process. The common theme in most of the modules is *geometry*.

Chapter 2 covers basic background material on geometrical methods, including matrix transformations, coordinate systems, quaternions, Euler angles, the standard three-dimensional objects that occur most frequently when dealing with bounding volumes, and a collection of distance calculation methods.

The graphics pipeline, the subject of Chapter 3, is discussed in textbooks on computer graphics to varying degrees. Some people would argue against the inclusion of some parts of this chapter, most notably the sections on rasterization, contending that hardware-accelerated graphics cards handle the rasterization for you, so why bother expounding on the topic. My argument for including these sections is twofold. First, the computer games industry has been evolving in a way that makes it difficult for the "garage shop" companies to succeed. Companies that used to focus on creating games in-house are now becoming publishers and distributors for other companies. If you have enough programmers and resources, there is a chance you can convince a publisher to support your effort. However, publishers tend to think about reaching the largest possible market and often insist that games produced by their clients run on low-end machines without accelerated graphics cards. And so the clients, interested in purchasing a third-party game engine, request that software renderers and rasterizers be included in the package. I hope this trend goes the other way, but the commercial reality is that it will not, at least in the near future. Second, hardware-accelerated cards do perform rasterization, but hardware requires drivers that implement the high-level graphics algorithms on the hardware. The cards are evolving rapidly, and the quality of the drivers is devolving at the same rate—no one wants to fix bugs in the drivers

for a card that will soon be obsolete. But another reason for poor driver quality is that programming 3D hardware is a much more difficult task than programming 2D hardware. The driver writers need to understand the hardware and the graphics pipeline. This chapter may be quite useful to that group of programmers.

Chapter 4 introduces scene graph management and provides the foundation for a hierarchical organization designed to feed the renderer efficiently, whether a software or hardware renderer. The basic concepts of local and world transforms, bounding volumes for culling, render state management, and animation support are covered.

Chapters 5 and 6 discuss aspects of the intersection of objects in the world. Picking is the process of computing the intersection of a line, ray, or line segment with objects. Collision detection refers to computing intersections between planar or volumetric objects. Some people include picking as part of the definition of collision detection, but the complexity of collision systems for nonlinear objects greatly exceeds that for picking, so I have chosen to separate the two systems.

Chapters 7 through 12 cover various systems that are supported by the scene graph management system. Chapters 7 and 8, on curves and surfaces, are somewhat general, but the emphasis is on tessellation. The next-generation game consoles have powerful processors but are limited in memory and bandwidth between processors. The dynamic tessellation of surfaces is desirable since the surfaces can be modeled with a small number of control points (reducing memory usage and bandwidth requirements) and tessellated to as fine a level as the processors have cycles to spare. The emphasis will start to shift from building polygonal models to building curved surface models to support the trend in new hardware on game consoles. Chapter 9 discusses the animation of geometric data, and in particular, key frame animation, inverse kinematics, and skin-and-bones systems. Level of detail is the subject of Chapter 10, with a special focus on continuous level of detail, which supports dynamic change in the number of triangles to render based on view frustum parameters.

Chapter 11 presents an algorithm for handling terrain. Although there are other algorithms that are equally viable, I chose to focus on one in detail rather than briefly talk about many algorithms. The key ideas in implementing this terrain algorithm are applicable to implementing other algorithms. High-level sorting algorithms, including portals and binary space partitioning trees, are the topic of Chapter 12.

Chapter 13 provides a brief survey of special effects that can be used in a game engine. The list is not exhaustive, but it does give an idea of what effects are possible with not much effort.

Building a commercial game engine certainly requires understanding a lot about computer graphics, geometry, mathematics, and data structures. Just as important is properly architecting the modules so that they all integrate in an efficient manner. A game engine is a large library to which the principles of object-oriented design apply. Appendix A provides a brief review of those principles and includes a discussion on an object-oriented infrastructure that makes maintenance of the library easier down the road. These aspects of building an engine are often ignored because it is faster and easier to try to get the basic engine up and running right away. However, short-

term satisfaction will inevitably come at the price of long-term pain in maintenance. Appendix B is a summary of various numerical methods that, in my experience, are necessary to implement the modules described in Chapters 7 through 12.

1.3 TEXT IS NOT ENOUGH

This book is not like the academic textbooks you would find in the school bookstore or the popular computer game programming books that you see at your favorite bookseller. Academic texts on computer graphics tend to be tomes covering a large number of general topics and are designed for learning the basic concepts, not for implementing a full-blown system. Algorithmic details are modest in some books and lacking in others. The popular programming books present the basic mathematics and concepts, but in no way indicate how complex a process it is to build a good engine. The technical level in those books is simply insufficient.

A good collection of books that address more of the algorithmic issues for computer graphics is the *Graphics Gems* series (Glassner 1990; Aarvo 1991; Kirk 1992; Heckbert 1994; Paeth 1995). Although providing a decent set of algorithms, the collection consists of contributions from various people with no guidance as to how to incorporate these into a larger integrated package such as a game engine. The first real attempt at providing a comprehensive coverage of the topics required for real-time rendering is Möller and Haines (1999), which provides much more in-depth coverage about the computer graphics topics relevant to a real-time graphics engine. The excellent references provided in that book are a way to investigate the roots of many of the concepts that current-generation game engines incorporate.

But there is one last gap to fill. Textual descriptions of graphics algorithms, no matter how detailed, are difficult to translate into real working code, even for experienced programmers. Just try to implement some of the algorithms described in the ACM SIGGRAPH proceedings! Many of those articles were written after the authors had already worked out the details of the algorithms and implemented them. That process is not linear. Ideas are formulated, algorithms are designed, then implemented. When the results of the coding point out a problem with the algorithmic formulation, the ideas and algorithms are reformulated. This natural process iterates until the final results are acceptable. Written and published descriptions of the algorithms are the final summary of the final algorithm. However, taken out of context of the idea-to-code environment, they sometimes are just not enough. Because having an actual implementation to look at while attempting to learn the ideas can only accelerate the learning process, a CD-ROM containing an implementation of a game engine accompanies this book. While neither as feature complete nor as optimized as a commercial engine, the code should help in understanding the ideas and how they are implemented. Pointers to the relevant source code files that implement the ideas are given in the text.

GEOMETRICAL METHODS

This chapter provides some basic mathematics, geometry, and algorithms that will be used throughout the book. I am assuming that you are familiar with the concepts of elementary vector and matrix algebra: vectors, matrices, dot product, cross product, and length. I am also assuming that you are familiar with the basic concepts in calculus: continuity, derivatives, and integrals. The set of real numbers is denoted \mathbb{R}, and the set of vectors with n components is \mathbb{R}^n. In almost all cases in this book, $n \leq 3$. Numerical methods that are referred to in the book are described in Appendix B.

Transformations (Section 2.1) and coordinate systems (Section 2.2) are pervasive throughout a game engine. In particular, the graphics pipeline (Chapter 3) and scene graph management (Chapter 4) require a thorough understanding of these topics. Section 2.3 covers the topic of quaternions and describes what these entities are and how they relate to rotations, which are fundamental in orienting objects. For key frame animation, sequences of rotations must be interpolated in a way that produces reasonable in-between orientations. Quaternions are quite useful for interpolation. Section 2.4 covers the topic of Euler angles and shows how to work with rotations viewed in this way. In particular, there is a discussion of how to factor rotations into ones that represent rotation about coordinate axes, which many applications require.

Certain types of 3D objects are useful in a game engine, especially spheres and oriented boxes. Other types that are less frequently seen but are nevertheless quite useful are cylinders, ellipsoids, capsules, and lozenges. These objects are defined and their properties listed in Section 2.5. Finally, Section 2.6 discusses computing distance between various geometric entities. Computing distance accurately and efficiently is absolutely essential for collision detection.

2.1 TRANSFORMATIONS

SOURCE CODE

LIBRARY

Core

FILENAME

Vector3

Matrix3

A matrix $M : \mathbb{R}^3 \to \mathbb{R}^3$ is called a *linear transformation* and maps vectors to vectors by $\vec{Y} = M\vec{X}$. The linearity refers to the property that $M(c\vec{U} + \vec{V}) = cM\vec{U} + M\vec{V}$ for any scalar c and any vectors \vec{U} and \vec{V}. The *zero matrix* is a matrix with all zero entries. The *identity matrix* is the matrix I with 1 on the diagonal entries and 0 for the other entries. A matrix is said to be *invertible* if there exists a matrix, denoted M^{-1}, such that $MM^{-1} = M^{-1}M = I$. The *transpose* of a matrix $M = [m_{ij}]$ is the matrix $M^{\mathrm{T}} = [m_{ji}]$. That is, the rows of M become the columns of M^{T}. A matrix is *symmetric* if $M^{\mathrm{T}} = M$ or *skew-symmetric* if $M^{\mathrm{T}} = -M$. *Diagonal matrices* $D = [d_{ij}]$ have the property $d_{ij} = 0$ for $i \neq j$ and are typically denoted $D = \mathrm{diag}\{a, b, c\}$. Some special 3×3 matrices that appear regularly in computer graphics are described below.

2.1.1 SCALING

If a diagonal matrix $D = \mathrm{diag}\{d_0, d_1, d_2\}$ has all positive entries, it is a *scaling matrix*. Each diagonal term represents how much stretching ($d_i > 1$) or shrinking ($d_i < 1$) occurs for the corresponding coordinate direction. *Uniform scaling* is $D = sI = \mathrm{diag}\{s, s, s\}$ for $s > 0$.

2.1.2 ROTATION

A matrix R is a *rotation matrix* if its transpose and inverse are the same matrix; that is, $R^{-1} = R^{\mathrm{T}}$, in which case $RR^{\mathrm{T}} = R^{\mathrm{T}}R = I$. The matrix has a corresponding unit-length axis of rotation \vec{U} and angle of rotation θ. The choice is not unique since $-\vec{U}$ is also an axis of rotation and $\theta + 2\pi k$ for any integer k is an angle of rotation. If $\vec{U} = (u_0, u_1, u_2)$, define the skew-symmetric matrix S by

$$S = \begin{bmatrix} 0 & u_2 & -u_1 \\ -u_2 & 0 & u_0 \\ u_1 & -u_0 & 0 \end{bmatrix}.$$

The rotation corresponding to axis \vec{U} and angle θ is

$$R = I + (\sin\theta)S + (1 - \cos\theta)S^2.$$

2.1.3 TRANSLATION

Translation of vectors by a fixed vector $\vec{T} \in \mathbb{R}^3$ is represented by the function $\vec{Y} = \vec{X} + \vec{T}$ for $\vec{X}, \vec{Y} \in \mathbb{R}^3$. It is not possible to represent this as a linear transformation of the form $\vec{Y} = M\vec{X}$ for some constant matrix M. However, if the problem is embedded in a four-dimensional setting, it is possible to represent translation with a linear transformation. The next section describes how to do this.

2.1.4 HOMOGENEOUS TRANSFORMATIONS

A vector $(x, y, z) \in \mathbb{R}^3$ can be mapped uniquely onto a vector $(x, y, z, 1) \in \mathbb{R}^4$. Other vectors $(x, y, z, w) \in \mathbb{R}^4$ can be projected onto the hyperplane $w = 1$ by $(x, y, z, w) \to (x/w, y/w, z/w, 1)$. An entire line of points (with origin $(0, 0, 0, 0)$) is projected onto the single point $(x, y, z, 1)$. All of $\mathbb{R}^4 \setminus \{\vec{0}\}$ is partitioned into equivalence classes, each class having representative projection $(x, y, z, 1)$. A 4-tuple in this setting is called a *homogeneous coordinate*. Two homogeneous coordinates that are equivalent are indicated to be so by $(x_0, y_0, z_0, w_0) \sim (x_1, y_1, z_1, w_1)$.

Transformations can be applied to homogeneous coordinates to obtain other homogeneous coordinates. Such a 4×4 matrix $H = [h_{ij}]$, $0 \leq i \leq 3$ and $0 \leq j \leq 3$, is called a *homogeneous transformation* as long as $h_{33} = 1$. Usually, homogeneous matrices are written as a 2×2 block matrix,

$$H = \left[\begin{array}{c|c} M & \vec{T} \\ \hline \vec{S}^T & 1 \end{array}\right],$$

where the M is 3×3, \vec{T} is 3×1, \vec{S}^T is 1×3, and the lower-right entry is just the scalar 1. The product of a homogenous coordinate and homogeneous transformation in block format is

$$H = \left[\begin{array}{c|c} M & \vec{T} \\ \hline \vec{S}^T & 1 \end{array}\right]\left[\begin{array}{c} \vec{V} \\ \hline w \end{array}\right] = \left[\begin{array}{c} M\vec{V} + w\vec{T} \\ \hline \vec{S}^T\vec{V} + w \end{array}\right] \sim \left[\begin{array}{c} \frac{M\vec{V}+w\vec{T}}{\vec{S}^T\vec{V}+w} \\ \hline 1 \end{array}\right].$$

Any 3×3 linear transformation M can be represented by the homogeneous matrix

$$\left[\begin{array}{c|c} M & \vec{0} \\ \hline \vec{0}^T & 1 \end{array}\right].$$

Moreover, translation by vector \vec{T} can also be represented by a homogeneous transformation,

$$\left[\begin{array}{c|c} I & \vec{T} \\ \hline \vec{0}^{\mathrm{T}} & 1 \end{array}\right].$$

The two can be composed to represent $\vec{Y} = M\vec{X} + \vec{T}$ as

$$\left[\begin{array}{c} \vec{Y} \\ \hline 1 \end{array}\right] = \left[\begin{array}{c|c} M & \vec{T} \\ \hline \vec{0}^{\mathrm{T}} & 1 \end{array}\right]\left[\begin{array}{c} \vec{X} \\ \hline 1 \end{array}\right].$$

Assuming M is invertible, the equation can be solved for $\vec{X} = M^{-1}(\vec{Y} - \vec{T})$. Thus, the inverse of a homogeneous matrix is

$$\left[\begin{array}{c|c} M & \vec{T} \\ \hline \vec{0}^{\mathrm{T}} & 1 \end{array}\right]^{-1} = \left[\begin{array}{c|c} M^{-1} & -M^{-1}\vec{T} \\ \hline \vec{0}^{\mathrm{T}} & 1 \end{array}\right].$$

Perspective projection is discussed in Chapter 3. It too can be represented by a homogenous matrix where the lower-left entry \vec{S}^{T} is not the zero vector. Most graphics textbooks discuss the geometric pipeline in terms of products of homogeneous transformations. That notation is a convenience and is not particularly useful in an implementation unless the underlying hardware has native support for vector and matrix operations in four dimensions.

2.2 COORDINATE SYSTEMS

A *3D coordinate system* consists of an *origin* \vec{P} and three *coordinate axes* \vec{U}_0, \vec{U}_1, and \vec{U}_2 that are each unit length and mutually perpendicular. The axes can be written as the columns of a matrix, $R = [\vec{U}_0 \mid \vec{U}_1 \mid \vec{U}_2]$. This matrix is orthonormal; that is, $R^{-1} = R^{\mathrm{T}}$ and $\mid \det(R) \mid = 1$. The coordinate system is said to be *right-handed* if $\det(R) = 1$ or *left-handed* if $\det(R) = -1$. The axes in a right-handed coordinate system satisfy $\vec{U}_0 = \vec{U}_1 \times \vec{U}_2, \vec{U}_1 = \vec{U}_2 \times \vec{U}_0$, and $\vec{U}_2 = \vec{U}_0 \times \vec{U}_1$. In a left-handed coordinate system, $\vec{U}_0 = \vec{U}_2 \times \vec{U}_1, \vec{U}_1 = \vec{U}_0 \times \vec{U}_2$, and $\vec{U}_2 = \vec{U}_1 \times \vec{U}_0$. The standard Euclidean coordinate system is right-handed and has origin $\vec{P} = (0, 0, 0), \vec{U}_0 = (1, 0, 0), \vec{U}_1 = (0, 1, 0)$, and $\vec{U}_2 = (0, 0, 1)$.

Given a coordinate system, any vector \vec{X} can be written in terms of that system as $\vec{X} = \vec{P} + y_0\vec{U}_0 + y_1\vec{U}_1 + y_2\vec{U}_2 = \vec{P} + R\vec{Y}$. It is simple to solve this system to obtain $\vec{Y} = R^{\mathrm{T}}(\vec{X} - \vec{P})$. Specifically, $y_i = \vec{U}_i \cdot (\vec{X} - \vec{P})$ for $0 \leq i \leq 2$.

2.3 QUATERNIONS

This section provides a mathematical summary of quaternion algebra and calculus and explains how they relate to rotations and interpolation of rotations. The ideas are based on Shoemake (1987).

2.3.1 QUATERNION ALGEBRA

SOURCE CODE

LIBRARY

Core

FILENAME

Quaternion

A *quaternion* is given by $q = w + xi + yj + zk$, where w, x, y, and z are real numbers. Define $q_n = w_n + x_n i + y_n j + z_n k$ $(n = 0, 1)$. *Addition* and *subtraction* of quaternions is defined by

$$q_0 \pm q_1 = (w_0 + x_0 i + y_0 j + z_0 k) \pm (w_1 + x_1 i + y_1 j + z_1 k)$$
$$= (w_0 \pm w_1) + (x_0 \pm x_1)i + (y_0 \pm y_1)j + (z_0 \pm z_1)k. \tag{2.1}$$

Multiplication for the primitive elements i, j, and k is defined by $i^2 = j^2 = k^2 = -1$, $ij = -ji = k$, $jk = -kj = i$, and $ki = -ik = j$. *Multiplication* of quaternions is defined by

$$q_0 q_1 = (w_0 + x_0 i + y_0 j + z_0 k)(w_1 + x_1 i + y_1 j + z_1 k)$$
$$= (w_0 w_1 - x_0 x_1 - y_0 y_1 - z_0 z_1) + (w_0 x_1 + x_0 w_1 + y_0 z_1 - z_0 y_1)i +$$
$$(w_0 y_1 - x_0 z_1 + y_0 w_1 + z_0 x_1)j + (w_0 z_1 + x_0 y_1 - y_0 x_1 + z_0 w_1)k. \tag{2.2}$$

Multiplication is not commutative; that is, the products $q_0 q_1$ and $q_1 q_0$ are not necessarily equal. This is clearly evident for primitive elements since $k = ij \neq ji = -k$.

The *conjugate* of a quaternion is defined by

$$q^* = (w + xi + yj + zk)^* = w - xi - yj - zk. \tag{2.3}$$

The conjugate of a product of quaternions satisfies the properties $(p^*)^* = p$ and $(pq)^* = q^* p^*$.

The *norm* of a quaternion is defined by

$$N(q) = N(w + xi + yj + zk) = w^2 + x^2 + y^2 + z^2. \tag{2.4}$$

The norm is a real-valued function, and the norm of a product of quaternions satisfies the properties $N(q^*) = N(q)$ and $N(pq) = N(p)N(q)$.

The *multiplicative inverse* of a quaternion q is denoted q^{-1} and has the property $qq^{-1} = q^{-1}q = 1$. It is constructed as

$$q^{-1} = q^*/N(q), \tag{2.5}$$

where the division of a quaternion by a real-valued scalar is just componentwise division. The inverse operation satisfies the properties $(p^{-1})^{-1} = p$ and $(pq)^{-1} = q^{-1}p^{-1}$.

A simple but useful function is the *selection* function

$$W(q) = W(w + xi + yj + zk) = w, \tag{2.6}$$

which selects the *real part* of the quaternion. This function satisfies the property $W(q) = (q + q^*)/2$.

The quaternion $q = w + xi + yj + zk$ may also be viewed as $q = w + \hat{v}$, where $\hat{v} = xi + yj + zk$. If \hat{v} is identified with the 3D vector (x, y, z), then quaternion multiplication can be written using vector dot product (\cdot) and cross product (\times) as

$$(w_0 + \hat{v}_0)(w_1 + \hat{v}_1) = (w_0 w_1 - \hat{v}_0 \cdot \hat{v}_1) + w_0 \hat{v}_1 + w_1 \hat{v}_0 + \hat{v}_0 \times \hat{v}_1. \tag{2.7}$$

In this form it is clear that $q_0 q_1 = q_1 q_0$ if and only if $\hat{v}_0 \times \hat{v}_1 = 0$ (these two vectors are parallel).

A quaternion q may also be viewed as a 4D vector (w, x, y, z). The *dot product* of two quaternions is

$$q_0 \cdot q_1 = w_0 w_1 + x_0 x_1 + y_0 y_1 + z_0 z_1 = W(q_0 q_1^*). \tag{2.8}$$

A *unit quaternion* is a quaternion q for which $N(q) = 1$. The inverse of a unit quaternion and the product of unit quaternions are themselves unit quaternions. A unit quaternion can be represented by

$$q = \cos\theta + \hat{u}\sin\theta, \tag{2.9}$$

where $\hat{u} = u_0 i + u_1 j + u_2 k$ and vector (u_0, u_1, u_2) has length 1. However, observe that the quaternion product $\hat{u}\hat{u} = -1$. Note the similarity to unit-length complex numbers $\cos\theta + i\sin\theta$. In fact, Euler's identity for complex numbers generalizes to quaternions,

$$\exp(\hat{u}\theta) = \cos\theta + \hat{u}\sin\theta, \tag{2.10}$$

where the exponential on the left-hand side is evaluated by symbolically substituting $\hat{u}\theta$ into the power series representation for $\exp(x)$ and replacing products $\hat{u}\hat{u}$ by -1. From this identity it is possible to define the *power* of a unit quaternion,

$$q^t = (\cos\theta + \hat{u}\sin\theta)^t = \exp(\hat{u}t\theta) = \cos(t\theta) + \hat{u}\sin(t\theta). \tag{2.11}$$

It is also possible to define the *logarithm* of a unit quaternion,

$$\log(q) = \log(\cos\theta + \hat{u}\sin\theta) = \log(\exp(\hat{u}\theta)) = \hat{u}\theta. \tag{2.12}$$

Note that the noncommutativity of quaternion multiplication disallows the standard identities for exponential and logarithm functions. The quaternions $\exp(p)\exp(q)$ and $\exp(p+q)$ are not necessarily equal. The quaternions $\log(pq)$ and $\log(p) + \log(q)$ are not necessarily equal.

2.3.2 RELATIONSHIP OF QUATERNIONS TO ROTATIONS

A unit quaternion $q = \cos\theta + \hat{u}\sin\theta$ represents the rotation of the 3D vector \hat{v} by an angle 2θ about the 3D axis \hat{u}. The rotated vector, represented as a quaternion, is $R(\hat{v}) = q\hat{v}q^*$. The proof requires showing that $R(\hat{v})$ satisfies four conditions: it is a 3D vector, it is a length-preserving function of \hat{v}, it is a linear transformation, and it does not have a reflection component.

To see that $R(\hat{v})$ is a 3D vector:

$$
\begin{aligned}
W(R(\hat{v})) &= W(q\hat{v}q^*)\\
&= [(q\hat{v}q^*) + (q\hat{v}q^*)^*]/2\\
&= [q\hat{v}q^* + q\hat{v}^*q^*]/2\\
&= q[(\hat{v} + \hat{v}^*)/2]q^*\\
&= qW(\hat{v})q^*\\
&= W(\hat{v})\\
&= 0.
\end{aligned}
$$

To see that $R(\hat{v})$ is length preserving:

$$
\begin{aligned}
N(R(\hat{v})) &= N(q\hat{v}q^*)\\
&= N(q)N(\hat{v})N(q^*)\\
&= N(q)N(\hat{v})N(q)\\
&= N(\hat{v}).
\end{aligned}
$$

To see that $R(\hat{v})$ is a linear transformation, let a be a real-valued scalar and let \hat{v} and \hat{w} be 3D vectors; then

$$
\begin{aligned}
R(a\hat{v} + \hat{w}) &= q(a\hat{v} + \hat{w})q^*\\
&= (qa\hat{v}q^*) + (q\hat{w}q^*)\\
&= a(q\hat{v}q^*) + (q\hat{w}q^*)\\
&= aR(\hat{v}) + R(\hat{w}),
\end{aligned}
$$

thereby showing that the transform of a linear combination of vectors is the linear combination of the transforms.

The previous three properties show that $R(\hat{v})$ is an orthonormal transformation, a class that includes rotations *and* reflections. We need to show that reflections cannot occur. For unit-length vector \vec{v}, define the function M by $\hat{v} = M(\vec{v})$, a function from the unit sphere in \mathbb{R}^3 to the unit quaternions with zero real part. Its inverse is $\vec{v} = M^{-1}(\hat{v})$. If $\hat{w} = M(\vec{w})$ and $\hat{w} = R(\hat{v}) = q\hat{v}q^*$, then the composition

$$\vec{w} = M^{-1}(\hat{w}) = M^{-1}(R(\hat{v})) = M^{-1}(R(M(\vec{v})))$$

defines a matrix transformation $\vec{w} = P\vec{v}$, where P is an orthonormal matrix since $R(\hat{v})$ is an orthonormal transformation. Thus, $|\det(P)| = 1$, which implies that the determinant can be only $+1$ or -1. P is determined by the choice of unit quaternion q, so it is a function of q, written as $P(q)$ to show the functional dependence. Moreover, $P(q)$ is a continuous function, which in turn implies that $\delta(q) = \det(P(q))$ is a continuous function of q. By the definition of continuity, $\lim_{q \to 1} P(q) = P(1) = I$, the identity matrix, and $\lim_{q \to 1} \delta(q) = \delta(1) = 1$. Since $\delta(q)$ can only be $+1$ or -1 and since the limiting value is $+1$, $\delta(q) = 1$ is true for all unit quaternions. Consequently, P cannot contain reflections.

We now prove that the unit rotation axis is the 3D vector \hat{u} and the rotation angle is 2θ. To see that \hat{u} is a unit rotation axis, we need only show that \hat{u} is unchanged by the rotation. Recall that $\hat{u}^2 = \hat{u}\hat{u} = -1$. This implies that $\hat{u}^3 = -\hat{u}$. Now

$$R(\hat{u}) = q\hat{u}q^*$$
$$= (\cos\theta + \hat{u}\sin\theta)\hat{u}(\cos\theta - \hat{u}\sin\theta)$$
$$= (\cos\theta)^2\hat{u} - (\sin\theta)^2\hat{u}^3$$
$$= (\cos\theta)^2\hat{u} - (\sin\theta)^2(-\hat{u})$$
$$= \hat{u}.$$

To see that the rotation angle is 2θ, let \hat{u}, \hat{v}, and \hat{w} be a right-handed set of orthonormal vectors. That is, the vectors are all unit length; $\hat{u} \cdot \hat{v} = \hat{u} \cdot \hat{w} = \hat{v} \cdot \hat{w} = 0$, and $\hat{u} \times \hat{v} = \hat{w}$, $\hat{v} \times \hat{w} = \hat{u}$, and $\hat{w} \times \hat{u} = \hat{v}$. The vector \hat{v} is rotated by an angle ϕ to the vector $q\hat{v}q^*$, so $\hat{v} \cdot (q\hat{v}q^*) = \cos(\phi)$. Using Equation (2.8) and $\hat{v}^* = -\hat{v}$, and $\hat{p}^2 = -1$ for unit quaternions with zero real part,

$$\cos(\phi) = \hat{v} \cdot (q\hat{v}q^*)$$
$$= W(\hat{v}^*q\hat{v}q^*)$$
$$= W[-\hat{v}(\cos\theta + \hat{u}\sin\theta)\hat{v}(\cos\theta - \hat{u}\sin\theta)]$$

$$= W[(-\hat{v}\cos\theta - \hat{v}\hat{u}\sin\theta)(\hat{v}\cos\theta - \hat{v}\hat{u}\sin\theta)]$$

$$= W[-\hat{v}^2(\cos\theta)^2 + \hat{v}^2\hat{u}\sin\theta\cos\theta - \hat{v}\hat{u}\hat{v}\sin\theta\cos\theta + (\hat{v}\hat{u})^2(\sin\theta)^2]$$

$$= W[(\cos\theta)^2 - (\sin\theta)^2 - (\hat{u} + \hat{v}\hat{u}\hat{v})\sin\theta\cos\theta].$$

Now $\hat{v}\hat{u} = -\hat{v}\cdot\hat{u} + \hat{v}\times\hat{u} = \hat{v}\times\hat{u} = -\hat{w}$ and $\hat{v}\hat{u}\hat{v} = -\hat{w}\hat{v} = \hat{w}\cdot\hat{v} - \hat{w}\times\hat{v} = \hat{u}$. Consequently,

$$\cos(\phi) = W[(\cos\theta)^2 - (\sin\theta)^2 - (\hat{u} + \hat{v}\hat{u}\hat{v})\sin\theta\cos\theta]$$

$$= W[(\cos\theta)^2 - (\sin\theta)^2 - \hat{u}(2\sin\theta\cos\theta)]$$

$$= (\cos\theta)^2 - (\sin\theta)^2$$

$$= \cos(2\theta),$$

and the rotation angle is $\phi = 2\theta$.

Note that the quaternions q and $-q$ represent the same rotation since $(-q)\hat{v}(-q)^* = q\hat{v}q^*$. While either quaternion will do, the interpolation methods require choosing one over the other.

2.3.3 CONVERSION BETWEEN ANGLE-AXIS AND ROTATION MATRIX

Applications represent rotations using either an angle-axis pair or a rotation matrix. Sometimes it is necessary to convert from one representation to the other. The conversions are discussed here.

Angle-Axis to Rotation Matrix

Any standard computer graphics text discusses the relationship between an angle and axis of rotation and the rotation matrix, although the constructions can be varied. A useful one is given here. If θ is the angle of rotation and \vec{U} is the unit-length axis of rotation, then the corresponding rotation matrix is

$$R = I + (\sin\theta)S + (1 - \cos\theta)S^2,$$

where I is the identity matrix and

$$S = \begin{bmatrix} 0 & -u_2 & u_1 \\ u_2 & 0 & -u_0 \\ -u_1 & u_0 & 0 \end{bmatrix},$$

a skew-symmetric matrix. For $\theta > 0$, the rotation represents a counterclockwise rotation about the axis. The sense of clockwise or counterclockwise is based on looking at

the plane with normal \vec{U} from the side of the plane to which the normal points. Note that $S\vec{V} = \vec{U} \times \vec{V}$ and

$$R\vec{V} = \vec{V} + (\sin\theta)\vec{U} \times \vec{V} + (1 - \cos\theta)\vec{U} \times (\vec{U} \times \vec{V}).$$

Rotation Matrix to Angle-Axis

The inverse problem is to start with the rotation matrix and extract an angle and unit-length axis. There are multiple solutions since $-\vec{U}$ is a valid axis whenever \vec{U} is and $\theta + 2\pi k$ is a valid solution whenever θ is. First, the *trace* of a matrix is defined to be the sum of the diagonal terms. Some algebra will show that $\cos\theta = (\mathrm{trace}(R) - 1)/2$ and $R - R^{\mathrm{T}} = (2\sin\theta)S$. The first formula can be solved for the angle, $\theta = \cos^{-1}((\mathrm{trace}(R) - 1)/2) \in [0, \pi]$. If $\theta = 0$, then any axis is valid since there is no rotation. If $\theta \in (0, \pi)$, the second formula allows direct extraction of the axis, $\vec{V} = (r_{21} - r_{12}, r_{02} - r_{20}, r_{10} - r_{01})$ and $\vec{U} = \vec{V}/|\vec{V}|$. If $\theta = \pi$, the second formula does not help with the axis since $R - R^{\mathrm{T}} = 0$. In this case note that

$$R = I + 2S^2 = \begin{bmatrix} 1 - 2(u_1^2 + u_2^2) & 2u_0 u_1 & 2u_0 u_2 \\ 2u_0 u_1 & 1 - 2(u_0^2 + u_2^2) & 2u_1 u_2 \\ 2u_0 u_2 & 2u_1 u_2 & 1 - 2(u_0^2 + u_1^2) \end{bmatrix}.$$

The idea now is to extract the maximum component of the axis from the diagonal entries of the rotation matrix. If r_{00} is maximum, then u_0 must be the largest component in magnitude. Compute $4u_0^2 = r_{00} - r_{11} - r_{22} + 1$ and select $u_0 = \sqrt{r_{00} - r_{11} - r_{22} + 1}/2$. Consequently, $u_1 = r_{01}/(2u_0)$ and $u_2 = r_{02}/(2u_0)$. If r_{11} is maximum, then compute $4u_1^2 = r_{11} - r_{00} - r_{22} + 1$ and select $u_1 = \sqrt{r_{11} - r_{00} - r_{22} + 1}/2$. Consequently, $u_0 = r_{01}/(2u_1)$ and $u_2 = r_{12}/(2u_1)$. Finally, if r_{22} is maximum, then compute $4u_2^2 = r_{22} - r_{00} - r_{11} + 1$ and select $u_2 = \sqrt{r_{22} - r_{00} - r_{11} + 1}/2$. Consequently, $u_0 = r_{02}/(2u_2)$ and $u_1 = r_{12}/(2u_2)$.

2.3.4 CONVERSION BETWEEN QUATERNION AND ANGLE-AXIS

Applications also can represent rotations by quaternions in addition to angle-axis pairs and rotation matrices. The conversions between quaternions and angle-axis pairs are discussed here.

Angle-Axis to Quaternion

Recall from earlier in this section that the quaternion $q = w + xi + yj + zk = \cos(\theta/2) + \sin(\theta/2)(u_0 i + u_1 j + u_2 k)$ represents the rotation by θ radians about

the axis $\vec{U} = (u_0, u_1, u_2)$. Given the angle and axis, the components of the quaternion are $w = \cos(\theta/2)$, $x = u_0 \sin(\theta/2)$, $y = u_1 \sin(\theta/2)$, and $z = u_2 \sin(\theta/2)$.

Quaternion to Angle-Axis

The inverse problem is also straightforward. If $|w| = 1$, then the angle is $\theta = 0$ and any axis will do. If $|w| < 1$, the angle is obtained as $\theta = 2 \cos^{-1}(w)$ and the axis is computed as $\vec{U} = (x, y, z)/\sqrt{1 - w^2}$.

2.3.5 CONVERSION BETWEEN QUATERNION AND ROTATION MATRIX

To complete the set of conversions between representations of rotations, this section describes the conversions between quaternions and rotation matrices.

Quaternion to Rotation Matrix

The problem is to compute θ and \vec{U} given w, x, y, and z. Using the identities $2 \sin^2(\theta/2) = 1 - \cos(\theta)$ and $\sin(\theta) = 2 \sin(\theta/2) \cos(\theta/2)$, it is easily shown that $2wx = (\sin \theta)u_0$, $2wy = (\sin \theta)u_1$, $2wz = (\sin \theta)u_2$, $2x^2 = (1 - \cos \theta)u_0^2$, $2xy = (1 - \cos \theta)u_0 u_1$, $2xz = (1 - \cos \theta)u_0 u_2$, $2y^2 = (1 - \cos \theta)u_1^2$, $2yz = (1 - \cos \theta)u_1 u_2$, and $2z^2 = (1 - \cos \theta)u_2^2$. The right-hand sides of all these equations are terms in the expression $R = I + (\sin \theta)S + (1 - \cos \theta)S^2$. Replacing them yields

$$R = \begin{bmatrix} 1 - 2y^2 - 2z^2 & 2xy - 2wz & 2xz + 2wy \\ 2xy + 2wz & 1 - 2x^2 - 2z^2 & 2yz - 2wx \\ 2xz - 2wy & 2yz + 2wx & 1 - 2x^2 - 2y^2 \end{bmatrix}. \tag{2.13}$$

Rotation Matrix to Quaternion

Earlier it was mentioned that $\cos \theta = (\text{trace}(R) - 1)/2$. Using the identity $2 \cos^2(\theta/2) = 1 + \cos \theta$ yields $w^2 = \cos^2(\theta/2) = (\text{trace}(R) + 1)/4$ or $|w| = \sqrt{\text{trace}(R) + 1}/2$. If $\text{trace}(R) > 0$, then $|w| > 1/2$, so without loss of generality choose w to be the positive square root, $w = \sqrt{\text{trace}(R) + 1}/2$. The identity $R - R^T = (2 \sin \theta)S$ also yielded $(r_{12} - r_{21}, r_{20} - r_{02}, r_{01} - r_{10}) = 2 \sin \theta (u_0, u_1, u_2)$. Finally, identities derived earlier were $2xw = u_0 \sin \theta$, $2yw = u_1 \sin \theta$, and $2zw = u_2 \sin \theta$. Combining these leads to $x = (r_{12} - r_{21})/(4w)$, $y = (r_{20} - r_{02})/(4w)$, and $z = (r_{01} - r_{10})/(4w)$.

If $\text{trace}(R) \leq 0$, then $|w| \leq 1/2$. The idea is to first extract the largest one of x, y, or z from the diagonal terms of the rotation R in Equation (2.13). If r_{00} is the maximum diagonal term, then x is larger in magnitude than y or z. Some algebra shows

that $4x^2 = r_{00} - r_{11} - r_{22} + 1$, from which is chosen $x = \sqrt{r_{00} - r_{11} - r_{22} + 1}/2$. Consequently, $w = (r_{12} - r_{21})/(4x)$, $y = (r_{01} + r_{10})/(4x)$, and $z = (r_{02} + r_{20})/(4x)$. If r_{11} is the maximum diagonal term, then compute $4y^2 = r_{11} - r_{00} - r_{22} + 1$ and choose $y = \sqrt{r_{11} - r_{00} - r_{22} + 1}/2$. Consequently, $w = (r_{20} - r_{02})/(4y)$, $x = (r_{01} + r_{10})/(4y)$, and $z = (r_{12} + r_{21})/(4y)$. Finally, if r_{22} is the maximum diagonal term, then compute $4z^2 = r_{22} - r_{00} - r_{11} + 1$ and choose $z = \sqrt{r_{22} - r_{00} - r_{11} + 1}/2$. Consequently, $w = (r_{01} - r_{10})/(4z)$, $x = (r_{02} + r_{20})/(4z)$, and $y = (r_{12} + r_{21})/(4z)$.

2.4 EULER ANGLES

Rotations about the coordinate axes are easy to define and work with. Rotation about the x-axis by angle θ is

SOURCE CODE

LIBRARY

Core

$$R_x(\theta) = \begin{bmatrix} 1 & 0 & 0 \\ 0 & \cos\theta & -\sin\theta \\ 0 & \sin\theta & \cos\theta \end{bmatrix},$$

FILENAME

Matrix3

where $\theta > 0$ indicates a counterclockwise rotation in the plane $x = 0$. The observer is assumed to be positioned on the side of the plane with $x > 0$ and looking at the origin. Rotation about the y-axis by angle θ is

$$R_y(\theta) = \begin{bmatrix} \cos\theta & 0 & \sin\theta \\ 0 & 1 & 0 \\ -\sin\theta & 0 & \cos\theta \end{bmatrix},$$

where $\theta > 0$ indicates a counterclockwise rotation in the plane $y = 0$. The observer is assumed to be positioned on the side of the plane with $y > 0$ and looking at the origin. Rotation about the z-axis by angle θ is

$$R_z(\theta) = \begin{bmatrix} \cos\theta & -\sin\theta & 0 \\ \sin\theta & \cos\theta & 0 \\ 0 & 0 & 1 \end{bmatrix},$$

where $\theta > 0$ indicates a counterclockwise rotation in the plane $z = 0$. The observer is assumed to be positioned on the side of the plane with $z > 0$ and looking at the origin. Rotation by an angle θ about an arbitrary axis containing the origin and having unit-length direction $\vec{U} = (U_x, U_y, U_z)$ is given by

$$R_{\vec{U}}(\theta) = I + (\sin\theta)S + (1 - \cos\theta)S^2,$$

where I is the identity matrix,

$$S = \begin{bmatrix} 0 & -U_z & U_y \\ U_z & 0 & -U_x \\ -U_y & U_x & 0 \end{bmatrix},$$

and $\theta > 0$ indicates a counterclockwise rotation in the plane $\vec{U} \cdot (x, y, z) = 0$. The observer is assumed to be positioned on the side of the plane to which \vec{U} points and is looking at the origin.

2.4.1 FACTORING ROTATION MATRICES

A common problem is to factor a rotation matrix as a product of rotations about the coordinate axes. The form of the factorization depends on the needs of the application and what ordering is specified. For example, we might want to factor a rotation as $R = R_x(\theta_x) R_y(\theta_y) R_z(\theta_z)$ for some angles θ_x, θ_y, and θ_z. The ordering is xyz. Five other possibilities are xzy, yxz, yzx, zxy, and zyx. We might also envision factorizations such as xyx—these are not discussed here. In the following discussion, we use the notation $c_a = \cos(\theta_a)$ and $s_a = \sin(\theta_a)$ for $a = x, y, z$.

Factor as $R_x R_y R_z$

Setting $R = [r_{ij}]$ for $0 \le i \le 2$ and $0 \le j \le 2$, formally multiplying $R_x(\theta_x) R_y(\theta_y) R_z(\theta_z)$, and equating yields

$$\begin{bmatrix} r_{00} & r_{01} & r_{02} \\ r_{10} & r_{11} & r_{12} \\ r_{20} & r_{21} & r_{22} \end{bmatrix} = \begin{bmatrix} c_y c_z & -c_y s_z & s_y \\ c_z s_x s_y + c_x s_z & c_x c_z - s_x s_y s_z & -c_y s_x \\ -c_x c_z s_y + s_x s_z & c_z s_x + c_x s_y s_z & c_x c_y \end{bmatrix}.$$

From this we have $s_y = r_{02}$, so $\theta_y = \text{Sin}^{-1}(r_{02})$. If $\theta_y \in (-\pi/2, \pi/2)$, then $c_y \ne 0$ and $c_y(s_x, c_x) = (-r_{12}, r_{22})$, in which case $\theta_x = \text{Tan}^{-1}(-r_{12}, r_{22})$. Similarly, $c_y(s_z, c_z) = (-r_{01}, r_{00})$, in which case $\theta_z = \text{Tan}^{-1}(-r_{01}, r_{00})$.

If $\theta_y = \pi/2$, then $s_y = 1$ and $c_y = 0$. In this case

$$\begin{bmatrix} r_{10} & r_{11} \\ r_{20} & r_{21} \end{bmatrix} = \begin{bmatrix} c_z s_x + c_x s_z & c_x c_z - s_x s_z \\ -c_x c_z + s_x s_z & c_z s_x + c_x s_z \end{bmatrix} = \begin{bmatrix} \sin(\theta_z + \theta_x) & \cos(\theta_z + \theta_x) \\ -\cos(\theta_z + \theta_x) & \sin(\theta_z + \theta_x) \end{bmatrix}.$$

Therefore, $\theta_z + \theta_x = \text{Tan}^{-1}(r_{10}, r_{11})$. There is one degree of freedom, so the factorization is not unique. One choice is $\theta_z = 0$ and $\theta_x = \text{Tan}^{-1}(r_{10}, r_{11})$. If $\theta_y = -\pi/2$, then $s_y = -1$ and $c_y = 0$. In this case

$$\begin{bmatrix} r_{10} & r_{11} \\ r_{20} & r_{21} \end{bmatrix} = \begin{bmatrix} -c_z s_x + c_x s_z & c_x c_z + s_x s_z \\ c_x c_z + s_x s_z & c_z s_x - c_x s_z \end{bmatrix} = \begin{bmatrix} \sin(\theta_z - \theta_x) & \cos(\theta_z - \theta_x) \\ \cos(\theta_z - \theta_x) & -\sin(\theta_z - \theta_x) \end{bmatrix}.$$

Therefore, $\theta_z - \theta_x = \text{Tan}^{-1} 2(r_{10}, r_{11})$. There is one degree of freedom, so the factorization is not unique. One choice is $\theta_z = 0$ and $\theta_x = -\text{Tan}^{-1} 2(r_{10}, r_{11})$.

Pseudocode for the factorization is

```
thetaY = asin(r02);
if ( thetaY < PI/2 )
{
    if ( thetaY > -PI/2 )
    {
        thetaX = atan2(-r12,r22);
        thetaZ = atan2(-r01,r00);
    }
    else
    {
        // not a unique solution
        thetaX = -atan2(r10,r11);
        thetaZ = 0;
    }
}
else
{
    // not a unique solution
    thetaX = atan2(r10,r11);
    thetaZ = 0;
}
```

Factor as $R_x R_z R_y$

Setting $R = [r_{ij}]$ for $0 \le i \le 2$ and $0 \le j \le 2$, formally multiplying $R_x(\theta_x) R_z(\theta_z) R_y(\theta_y)$, and equating yields

$$
\begin{bmatrix} r_{00} & r_{01} & r_{02} \\ r_{10} & r_{11} & r_{12} \\ r_{20} & r_{21} & r_{22} \end{bmatrix} = \begin{bmatrix} c_y c_z & -s_z & c_z s_y \\ s_x s_y + c_x c_y s_z & c_x c_z & -c_y s_x + c_x s_y s_z \\ -c_x s_y + c_y s_x s_z & c_z s_x & c_x c_y + s_x s_y s_z \end{bmatrix}.
$$

Analysis similar to the xyz case leads to the pseudocode

```
thetaZ = asin(-r01);
if ( thetaZ < PI/2 )
{
    if ( thetaZ > -PI/2 )
    {
        thetaX = atan2(r21,r11);
```

```
        thetaY = atan2(r02,r00);
    }
    else
    {
        // not a unique solution
        thetaX = -atan2(-r20,r22);
        thetaY = 0;
    }
}
else
{
    // not a unique solution
    thetaX = atan2(-r20,r22);
    thetaY = 0;
}
```

Factor as $R_y R_x R_z$

Setting $R = [r_{ij}]$ for $0 \leq i \leq 2$ and $0 \leq j \leq 2$, formally multiplying $R_y(\theta_y) R_x(\theta_x) R_z(\theta_z)$, and equating yields

$$\begin{bmatrix} r_{00} & r_{01} & r_{02} \\ r_{10} & r_{11} & r_{12} \\ r_{20} & r_{21} & r_{22} \end{bmatrix} = \begin{bmatrix} c_y c_z + s_x s_y s_z & c_z s_x s_y - c_y s_z & c_x s_y \\ c_x s_z & c_x c_z & -s_x \\ -c_z s_y + c_y s_x s_z & c_y c_z s_x + s_y s_z & c_x c_y \end{bmatrix}.$$

Analysis similar to the xyz case leads to the pseudocode

```
thetaX = asin(-r12);
if ( thetaX < PI/2 )
{
    if ( thetaX > -PI/2 )
    {
        thetaY = atan2(r02,r22);
        thetaZ = atan2(r10,r11);
    }
    else
    {
        // not a unique solution
        thetaY = -atan2(-r01,r00);
        thetaZ = 0;
    }
}
```

```
else
{
    // not a unique solution
    thetaY = atan2(-r01,r00);
    thetaZ = 0;
}
```

Factor as $R_y R_z R_x$

Setting $R = [r_{ij}]$ for $0 \leq i \leq 2$ and $0 \leq j \leq 2$, formally multiplying $R_y(\theta_y) R_z(\theta_z) R_x(\theta_x)$, and equating yields

$$
\begin{bmatrix} r_{00} & r_{01} & r_{02} \\ r_{10} & r_{11} & r_{12} \\ r_{20} & r_{21} & r_{22} \end{bmatrix} = \begin{bmatrix} c_y c_z & s_x s_y - c_x c_y s_z & c_x s_y + c_y s_x s_z \\ s_z & c_x c_z & -c_z s_x \\ -c_z s_y & c_y s_x + c_x s_y s_z & c_x c_y - s_x s_y s_z \end{bmatrix}.
$$

Analysis similar to the xyz case leads to the pseudocode

```
thetaZ = asin(r10);
if ( thetaZ < PI/2 )
{
    if ( thetaZ > -PI/2 )
    {
        thetaY = atan2(-r20,r00);
        thetaX = atan2(-r12,r11);
    }
    else
    {
        // not a unique solution
        thetaY = -atan2(r21,r22);
        thetaX = 0;
    }
}
else
{
    // not a unique solution
    thetaY = atan2(r21,r22);
    thetaX = 0;
}
```

Factor as $R_z R_x R_y$

Setting $R = [r_{ij}]$ for $0 \le i \le 2$ and $0 \le j \le 2$, formally multiplying $R_z(\theta_z) R_x(\theta_x) R_y(\theta_y)$, and equating yields

$$
\begin{bmatrix} r_{00} & r_{01} & r_{02} \\ r_{10} & r_{11} & r_{12} \\ r_{20} & r_{21} & r_{22} \end{bmatrix} = \begin{bmatrix} c_y c_z - s_x s_y s_z & -c_x s_z & c_z s_y + c_y s_x s_z \\ c_z s_x s_y + c_y s_z & c_x c_z & -c_y c_z s_x + s_y s_z \\ -c_x s_y & s_x & c_x c_y \end{bmatrix}.
$$

Analysis similar to the xyz case leads to the pseudocode

```
thetaX = asin(r21);
if ( thetaX < PI/2 )
{
    if ( thetaX > -PI/2 )
    {
        thetaZ = atan2(-r01,r11);
        thetaY = atan2(-r20,r22);
    }
    else
    {
        // not a unique solution
        thetaZ = -atan2(r02,r00);
        thetaY = 0;
    }
}
else
{
    // not a unique solution
    thetaZ = atan2(r02,r00);
    thetaY = 0;
}
```

Factor as $R_z R_y R_x$

Setting $R = [r_{ij}]$ for $0 \le i \le 2$ and $0 \le j \le 2$, formally multiplying $R_z(\theta_z) R_y(\theta_y) R_x(\theta_x)$, and equating yields

$$
\begin{bmatrix} r_{00} & r_{01} & r_{02} \\ r_{10} & r_{11} & r_{12} \\ r_{20} & r_{21} & r_{22} \end{bmatrix} = \begin{bmatrix} c_y c_z & c_z s_x s_y - c_x s_z & c_x c_z s_y + s_x s_z \\ c_y s_z & c_x c_z + s_x s_y s_z & -c_z s_x + c_x s_y s_z \\ -s_y & c_y s_x & c_x c_y \end{bmatrix}.
$$

Analysis similar to the xyz case leads to the pseudocode

```
thetaY = asin(-r20);
if ( thetaY < PI/2 )
{
    if ( thetaY > -PI/2 )
    {
        thetaZ = atan2(r10,r00);
        thetaX = atan2(r21,r22);
    }
    else
    {
        // not a unique solution
        thetaZ = -atan2(-r01,r02);
        thetaX = 0;
    }
}
else
{
    // not a unique solution
    thetaZ = atan2(-r01,r02);
    thetaX = 0;
}
```

2.4.2 FACTOR PRODUCT OF TWO

Given a rotation R that is a product of two coordinate axis rotations, the problem is to factor it into three coordinate axis rotations using the ordering xyz. Derivations for the other orderings are similar. In the subsections the matrices are $P_x = R_x(\phi_x)$, $P_y = R_y(\phi_y)$, and $P_z = R_z(\phi_z)$. Define $s_a = \sin(\phi_x)$, $s_b = \sin(\phi_y)$, $s_c = \sin(\phi_z)$, $c_a = \cos(\phi_x)$, $c_b = \cos(\phi_y)$, and $c_c = \cos(\phi_z)$.

Factor $P_x P_y$

Trivial. The factorization is $R = R_x(\phi_x)R_y(\phi_y) = R_x(\theta_x)R_y(\theta_y)R_z(\theta_z)$. Therefore, $\theta_x = \phi_x$, $\theta_y = \phi_y$, and $\theta_z = 0$.

Factor $P_y P_x$

The factorization is $R = R_y(\phi_y)R_x(\phi_x) = R_x(\theta_x)R_y(\theta_y)R_z(\theta_z)$. Formal multiplication of the various terms leads to the equation

$$\begin{bmatrix} c_b & s_a s_b & c_a s_b \\ 0 & c_a & -s_a \\ -s_b & c_b s_a & c_a c_b \end{bmatrix} = \begin{bmatrix} c_y c_z & -c_y s_z & s_y \\ c_z s_x s_y + c_x s_z & c_x c_z - s_x s_y s_z & -c_y s_x \\ -c_x c_z s_y + s_x s_z & c_z s_x + c_x s_y s_z & c_x c_y \end{bmatrix}.$$

It is easy to see that $s_y = c_a s_b$, in which case $\theta_y = \text{Sin}^{-1}(\cos\theta_y \sin\theta_x)$. Adding the 10 and 21 terms yields

$$0 + c_b s_a = (c_z s_x s_y + c_x s_z) + (c_z s_x + c_x s_y s_z) = (1 + s_y)(c_z s_x + c_x s_z),$$

which leads to $\sin(\theta_x + \theta_z) = c_b s_a/(1 + c_a s_b)$. In the event that $c_a s_b = -1$, this leads to a special case in the coding that is easy to solve. Subtracting the 10 term from the 21 term yields

$$c_b s_a - 0 = (c_z s_x s_y + c_x s_z) - (c_z s_x + c_x s_y s_z) = (1 - s_y)(c_z s_x - c_x s_z),$$

which leads to $\sin(\theta_x - \theta_z) = c_b s_a/(1 - c_a s_b)$. In the event that $c_a s_b = 1$, this also leads to a special case in the coding that is easy to solve. The sine functions can be inverted and the two resulting equations for θ_x and θ_z can be solved. For the case $|c_a s_b| < 1$,

$$\theta_x = \frac{1}{2}\left[\text{Sin}^{-1}\left(\frac{c_b s_a}{1 + c_b s_a}\right) + \text{Sin}^{-1}\left(\frac{c_b s_a}{1 - c_b s_a}\right)\right]$$

$$\theta_y = \text{Sin}^{-1}(c_a s_b)$$

$$\theta_z = \frac{1}{2}\left[\text{Sin}^{-1}\left(\frac{c_b s_a}{1 + c_b s_a}\right) - \text{Sin}^{-1}\left(\frac{c_b s_a}{1 - c_b s_a}\right)\right].$$

Factor $P_x P_z$

Trivial. The factorization is $R = R_x(\phi_x) R_z(\phi_z) = R_x(\theta_x) R_y(\theta_y) R_z(\theta_z)$. Therefore, $\theta_x = \phi_x$, $\theta_y = 0$, and $\theta_z = \phi_z$.

Factor $P_z P_x$

A construction similar to the case $P_y P_x$ leads to

$$\theta_x = \frac{1}{2}\left[\text{Sin}^{-1}\left(\frac{c_a c_c}{1 + s_a s_c}\right) + \text{Sin}^{-1}\left(\frac{c_a c_c}{1 - s_a s_c}\right)\right]$$

$$\theta_y = \text{Sin}^{-1}(s_a s_c)$$

$$\theta_z = \frac{1}{2}\left[\text{Sin}^{-1}\left(\frac{c_a c_c}{1 + s_a s_c}\right) - \text{Sin}^{-1}\left(\frac{c_a c_c}{1 - s_a s_c}\right)\right].$$

Factor $P_y P_z$

Trivial. The factorization is $R = R_y(\phi_y)R_z(\phi_z) = R_x(\theta_x)R_y(\theta_y)R_z(\theta_z)$. Therefore, $\theta_x = 0, \theta_y = \phi_y$, and $\theta_z = \phi_z$.

Factor $P_z P_y$

A construction similar to the case $P_y P_x$ leads to

$$\theta_x = \frac{1}{2}\left[\text{Sin}^{-1}\left(\frac{c_b s_c}{1 + s_b c_c}\right) - \text{Sin}^{-1}\left(\frac{c_b s_c}{1 - s_b c_c}\right)\right]$$

$$\theta_y = \text{Sin}^{-1}(s_b c_c)$$

$$\theta_z = \frac{1}{2}\left[\text{Sin}^{-1}\left(\frac{c_b s_c}{1 + s_b c_c}\right) + \text{Sin}^{-1}\left(\frac{c_b s_c}{1 - s_b c_c}\right)\right].$$

2.5 STANDARD 3D OBJECTS

The objects described here are useful as bounding regions for two purposes: rapid culling in the rendering process and rapid determination that two objects are not intersecting during the collision detection process.

2.5.1 SPHERES

A *sphere* is defined by the set of all points \vec{X} equidistant from a center point \vec{C} with distance $r > 0$. The quadratic equation defining the set is $|\vec{X} - \vec{C}|^2 = r^2$.

For a geometric object that consists of a collection of points $\{\vec{V}_i\}_{i=0}^n$, a bounding sphere can be computed in a number of ways.

Sphere Containing Axis-Aligned Box

SOURCE CODE

LIBRARY

Containment

FILENAME

ContSphere

A simple approach is to compute the minimum-volume axis-aligned bounding box of the points, then select the smallest enclosing sphere of the box with sphere centered at the box center. The algorithm is

```
Point min = V[0], max = min;
for (i = 1; i <= n; i++)
{
```

```
    if ( V[i].x < min.x )
        min.x = V[i].x;
    else if ( V[i].x > max.x )
        max.x = V[i].x;

    if ( V[i].y < min.y )
        min.y = V[i].y;
    else if ( V[i].y > max.y )
        max.y = V[i].y;

    if ( V[i].z < min.z )
        min.z = V[i].z;
    else if ( V[i].z > max.z )
        max.z = V[i].z;
}
Point center = (min+max)/2;
Point diagonal = (max-min)/2;
float radiusSqr = diagonal.SquaredLength();
```

An advantage of this algorithm is the speed with which it is executed. The drawback to this algorithm is that the bounding sphere is not as good a fit as it could be.

Sphere Centered at Average of Points

SOURCE CODE

LIBRARY

Containment

FILENAME

ContSphere

An alternative that takes longer to compute but provides a somewhat better fit is to select the sphere center to be the average of the points and the sphere radius to be the smallest value for which the sphere of the given center and that radius encloses the points. The algorithm is

```
Point sum = V[0];
for (i = 1; i <= n; i++)
    sum += V[i];

Point center = sum/n;
float radiusSqr = 0;
for (i = 0; i <= n; i++)
{
    Point diff = V[i] - center;
    float temp = diff.SquaredLength();
    if ( temp > radiusSqr )
        radiusSqr = temp;
}
```

Minimum-Volume Sphere

SOURCE CODE

LIBRARY

Containment

FILENAME

MinSphere

Computing the minimum-volume sphere that encloses the points requires a more complicated algorithm based on work by Emo Welzl (1991). The problem uses a randomized linear algorithm, so the order is *expected* to be linear. The worst case is polynomial in the number of inputs, but the input data is randomly permuted so that the probability of the worst case occurring is negligible.

The pseudocode for the algorithm given below computes the minimum-volume sphere containing N points $P[0]$ through $P[N-1]$. The idea is to maintain a set of supporting points for the sphere while processing the input point set one point at a time. The supporting points lie on the sphere and no other points are necessary to form the sphere.

```
Sphere ComputeMinimumSphere (int N, Point P[])
{
    randomly permute the points P[0]..P[N-1];
    Sphere sphere = ExactSphere1(P[0]);
    PointSet support = { P[0] };
    i = 1;
    while ( i < N )
    {
        if ( P[i] not in support )
        {
            if ( P[i] not in sphere )
            {
                add P[i] to support and (possibly) remove
                    unnecessary points;
                compute sphere from current support;
                i = 0;  // need to start over when support
                        // changes
                continue;
            }
        }
        i++;
    }
}
```

Internally, the algorithm requires computing spheres that contain exactly two points, exactly three points, or exactly four points. Updating the support can be modularized into a collection of update functions, each depending on the current number of points in the support.

2.5.2 ORIENTED BOXES

Oriented boxes generally provide a better fit of the object than spheres. An oriented box is defined by a center \vec{C}, three orthonormal axes \vec{U}_i that form a right-handed coordinate system, and three extents $e_i > 0$ for $i = 0, 1, 2$. Let $R = [\vec{U}_0\ \vec{U}_1\ \vec{U}_2]$, an orthonormal matrix with determinant one. Any point $\vec{X} = (x_0, x_1, x_2)$ inside or on the box can be represented as $\vec{X} = \vec{C} + R\vec{Y}$, where $\vec{Y} = (y_0, y_1, y_2)$ with $|y_i| \leq e_i$ for all i.

Axis-Aligned Boxes

SOURCE CODE

LIBRARY

Containment

FILENAME

ContBox

There are various methods for generating bounding boxes that contain a set of points $\{\vec{V}_i\}_{i=0}^n$. The simplest is to fit with an axis-aligned box. This type of box is simpler to represent as two points, $\vec{p}_{\min} = (x_{\min}, y_{\min}, z_{\min})$ and $\vec{p}_{\max} = (x_{\max}, y_{\max}, z_{\max})$. The pseudocode is

```
Point min = V[0], max = min;
for (i = 1; i <= n; i++)
{
    if ( V[i].x < min.x ) min.x = V[i].x;
    if ( V[i].x > max.x ) max.x = V[i].x;
    if ( V[i].y < min.y ) min.y = V[i].y;
    if ( V[i].y > max.y ) max.y = V[i].y;
    if ( V[i].z < min.z ) min.z = V[i].z;
    if ( V[i].z > max.z ) max.z = V[i].z;
}
```

Fitting Points with a Gaussian Distribution

SOURCE CODE

LIBRARY

Containment

FILENAME

ContBox

A *Gaussian distribution* is a probability distribution of the form $A\exp((\vec{X} - \vec{C})M^{-1}(\vec{X} - \vec{C}))$, where A is an appropriate scaling factor, \vec{C} is the mean of the distribution, and M is the covariance matrix of the distribution. The distribution is said to be anisotropic if the eigenvalues of M are not all the same value.

A more sophisticated method for building an oriented box that usually fits the points better than an axis-aligned box is based on fitting the points with an anisotropic Gaussian distribution. The center of the box is the mean of the points,

$$\vec{C} = \frac{1}{n}\sum_{j=0}^n \vec{V}_j.$$

The axes of the box are selected as unit-length eigenvectors of the covariance matrix

$$M = \frac{1}{n}\sum_{j=0}^{n-1}(\vec{V}_j - \vec{C})(\vec{V}_j - \vec{C})^{\mathrm{T}}.$$

If \vec{U}_i are unit-length eigenvectors, the extents along those axes are the extreme values of the projections of the points onto those axes, $e_i = \max_j |\vec{U}_i \cdot (\vec{V}_j - \vec{C})|$. The pseudocode is

```
// Box has center, axis[3], extent[3]
Box box;

// compute mean of points
Point3 sum = V[0];
for (i = 1; i < n; i++)
    sum += V[i];
box.center = sum/n;

// compute covariances of points
Matrix3 mat = 0;
for (i = 0; i < n; i++)
{
    Point3 delta = V[i] - box.center;
    mat += Tensor(delta,delta);
}
Matrix3 covariance = mat/n;

// eigenvectors for covariance matrix are the box axes
ExtractEigenvectors(covariance,box.axis[3]);

// compute extents as extreme values of projections onto axes
box.extent = 0;
for (i = 0; i < n; i++)
{
    Point3 delta = V[i] - box.center;
    for (j = 0; j < 3; j++)
    {
        Real adot = |Dot(box.axis[j],delta)|
        if ( adot > box.extent[j] )
            box.extent[j] = adot;
    }
}
```

For a vector \vec{W}, $\text{Tensor}(\vec{W}, \vec{W})$ is the matrix $\vec{W}\vec{W}^{\mathrm{T}}$. The code does require an eigensolver for a 3×3 matrix. The eigenvectors can be computed using a closed-form solution rather than an iterative scheme.

One variation of the algorithm is to compute the convex hull of the data points first, then build an oriented box containing the hull. Another variation is to compute the eigenvectors of the covariance matrix, project the points onto the lines $\vec{C} + t\vec{U}_i$ in the direction of the eigenvectors \vec{U}_i, then compute the intervals of projection $[\min_i, \max_i]$. The point \vec{C} is not the center of the box and must be replaced with the correct center of the box implied by the projected intervals,

$$\vec{C}' = \vec{C} + \sum_{i=0}^{2} \frac{\min_i + \max_i}{2} \vec{U}_i.$$

Minimum-Volume Box

The best-fitting box may be considered to be the box of minimum volume that contains the points. Constructing this box requires an iterative scheme to solve a minimization problem, so it is recommended that minimum-volume boxes be computed off-line or during program initialization and not during program run time. The algorithm is as follows. For any choice of coordinate axes \vec{A}_i, $i = 0, 1, 2$, the points are projected onto the axes $\vec{V}_0 + s\vec{A}_i$, the values being $\rho_{ij} = \vec{A}_i \cdot (\vec{V}_j - \vec{V}_0)$ for all j. Define $\alpha_i = \min_j(\rho_{ij})$, $\beta_i = \max_j(\rho_{ij})$, and $\gamma_i = (\alpha_i + \beta_i)/2$. The center of the smallest-volume oriented box with specified axes is

$$\vec{C} = \vec{V}_0 + \sum_{i=0}^{2} \gamma_i \vec{A}_i.$$

The extents of the oriented box are $a_i = (\beta_i - \alpha_i)/2$.

Each set of coordinate axes can be represented as the columns of rotation matrices. Each rotation matrix is generated by a unit-length vector \vec{U} and an angle $\theta \in [0, 2\pi]$. The mapping from rotation matrices to coordinate axes is of course not one-to-one. However, the volume of the oriented boxes can be viewed as a function $v : S^2 \times [0, 2\pi] \rightarrow [0, \infty)$, where S^2 is the unit sphere. The volume is $v(\vec{U}, \theta) = \prod_{i=0}^{2}(\beta_i - \alpha_i)$. This function is continuous on its compact domain, so from calculus it must attain its minimum on that domain. Therefore, there exists an axis \vec{U}_0 and an angle θ_0 for which $v(\vec{U}_0, \theta_0) \leq v(\vec{U}, \theta)$ for all axes \vec{U} and all angles θ. The construction of \vec{U}_0 and θ_0 can be implemented as a numerical minimization using techniques that do not require derivatives. A good choice is Powell's direction set method (Press et al. 1988). The rate of convergence to the minimum depends on the initial guesses for axis and angle.

Fitting Triangles with a Gaussian Distribution

This method was presented in Gottschalk, Lin, and Manocha (1996). If the data points are the vertices of a triangle mesh, the triangles themselves may be used to generate an oriented box containing the vertices. The fit of an oriented bounding box to the convex hull of the vertices given previously has problems with sampling. The vertices on the convex hull may be irregularly distributed so that a small, dense collection of points can unfairly affect the orientation of the bounding box. This effect can be minimized by using a continuous formulation of the covariance matrix.

Suppose there are ℓ triangles. If the ith triangle has vertices $\vec{V}_{0,i}$, $\vec{V}_{1,i}$, and $\vec{V}_{2,i}$, then the triangle and its interior are represented by $\vec{X}_i(s, t) = \vec{V}_{0,i} + s(\vec{V}_{1,i} - \vec{V}_{0,i}) + t(\vec{V}_{2,i} - \vec{V}_{0,i})$ for $0 \leq s \leq 1, 0 \leq t \leq 1$, and $s + t \leq 1$. Let $m_i = |(\vec{V}_{1,i} - \vec{V}_{0,i}) \times (\vec{V}_{2,i} - \vec{V}_{0,i})|/2$ be the area of the triangle. Define the weights $w_i = m_i / \sum_{i=0}^{\ell-1} m_i$. The mean point of the convex hull is

$$\vec{C} = \frac{2}{\ell} \sum_{i=0}^{\ell-1} w_i \int_0^1 \int_0^{1-t} \vec{X}_i(s, t) \, ds \, dt$$

$$= \frac{1}{3\ell} \sum_{i=0}^{\ell-1} w_i \left(\sum_{j=0}^{2} \vec{V}_{j,i} \right)$$

and the covariance matrix of the convex hull is

$$M = \frac{2}{\ell} \sum_{i=0}^{\ell-1} w_i \int_0^1 \int_0^{1-t} (\vec{X}_i(s, t) - \vec{C})(\vec{X}_i(s, t) - \vec{C})^{\mathrm{T}} \, ds \, dt$$

$$= \frac{1}{12\ell} \sum_{i=0}^{\ell-1} w_i \left(\sum_{j=0}^{2} \sum_{k=0}^{2} (\vec{V}_{j,i} - \vec{C})(\vec{V}_{k,i} - \vec{C})^{\mathrm{T}} \right).$$

If \vec{A}_i are unit-length eigenvectors, the extents along those axes are $a_i = \max_j |\vec{A}_i \cdot (\vec{X}_j - \vec{C})|$, where the \vec{X}_j are the vertices. As in the subsection on fitting points with a Gaussian distribution, a variation allows adjustment of \vec{C} once the axes \vec{A}_i are known.

2.5.3 CAPSULES

A *capsule* is a natural extension of a sphere based on equidistance. It is defined as the set of all points that are distance $r > 0$ from a line segment with end point \vec{P} and direction \vec{D}. The other end point is $\vec{P} + \vec{D}$. A capsule is a cylinder that has two hemispherical caps attached at the end points.

In this section, we present two algorithms to bound the points $\{\vec{X}_i\}_{i=0}^n$, one involving least-squares fitting and one based on a minimization that is solved using an iterative algorithm.

Least-Squares Fit

Fit the points by a line using the least-squares algorithm described in Appendix B. Let the line be $\vec{A} + t\vec{W}$, where \vec{W} is unit length and \vec{A} is the average of the data points. The line will contain the capsule line segment. Compute r to be the maximum distance from the data points to the line. Select unit vectors \vec{U} and \vec{V} so that the matrix $R = [\vec{U}\ \vec{V}\ \vec{W}]$ is orthonormal and has determinant one. The data points can be represented as $\vec{X}_i = \vec{A} + R\vec{Y}_i$, where $\vec{Y}_i = (u_i, v_i, w_i)$. In the (u, v, w) coordinate system, the capsule axis is contained by the line $t(0, 0, 1)$. We need to compute the largest ξ_0 so that all points lie above the hemisphere $u^2 + v^2 + (w - \xi_0)^2 = r^2$ with $w \leq \xi_0$. The value is computed as

$$\xi_0 = \min_i\{w_i + \sqrt{r^2 - (u_i^2 + v_i^2)}\},$$

where $0 \leq i \leq n$. Similarly, there is a smallest value ξ_1 so that all points lie below the hemisphere $u^2 + v^2 + (w - \xi_1)^2 = r^2$ with $w \geq \xi_1$. The value is computed as

$$\xi_1 = \max_i\{w_i - \sqrt{r^2 - (u_i^2 + v_i^2)}\}.$$

The end points of the capsule line segment are $\vec{P}_j = \vec{A} + \xi_j\vec{W}$ for $j = 0, 1$. If instead the data points are fit by a least-squares plane $\vec{W} \cdot (\vec{X} - \vec{A}) = 0$, the result is the same since the unit-length plane normal \vec{W} is exactly the line direction.

Minimum of Minimum-Area Projected Circles

For each unit-length direction \vec{W} such that $\vec{W} \cdot (0, 0, 1) \geq 0$ (\vec{W} lies on the upper unit hemisphere), select unit vectors \vec{U} and \vec{V} so that the matrix $R = [\vec{U}\ \vec{V}\ \vec{W}]$ is orthonormal and has determinant one. The data points can be represented as $\vec{X}_i = \vec{A} + R\vec{Y}_i$, where $\vec{Y}_i = (u_i, v_i, w_i)$. The projections of the points onto the plane $\vec{W} \cdot \vec{X} = 0$ are (u_i, v_i). The minimum-area circle containing these points can be computed, say, the radius is $r = r(\vec{W})$ and the center is $\vec{C} = \vec{C}(\vec{W})$. Compute the vector \vec{W}' that minimizes $r(\vec{W})$. The capsule radius is $r(\vec{W}')$ and let w_{\min} and w_{\max} be the extreme values for the w_i. The capsule line segment has end points $\vec{P}_0 = \vec{C}(\vec{W}') + w_{\min}\vec{W}'$ and $\vec{P}_0 = \vec{C}(\vec{W}') + w_{\max}\vec{W}'$.

2.5.4 LOZENGES

A *lozenge* is also a natural extension of a sphere based on equidistance. It is defined as the set of all points that are distance $r > 0$ from a rectangle with origin \vec{P} and edge directions \vec{E}_0 and \vec{E}_1, where $\vec{E}_0 \cdot \vec{E}_1 = 0$. The four vertices of the rectangle are \vec{P}, $\vec{P} + \vec{E}_0$, $\vec{P} + \vec{E}_1$, and $\vec{P} + \vec{E}_0 + \vec{E}_1$. A lozenge is an oriented rectangle that has attached four half-cylinder sides and four quarter-spherical corners.

In this section, we present two algorithms to bound the points $\{\vec{X}_i\}_{i=0}^n$, one involving fitting with a Gaussian distribution and one based on a minimization that is solved using an iterative algorithm.

Fit with a Gaussian Distribution

Compute the mean \vec{A} of the points and compute the covariance matrix, just as in the algorithm for fitting with an oriented box. Let unit-length eigenvectors of the matrix be \vec{U}, \vec{V}, and \vec{W}. Assume these are labeled so that \vec{U} corresponds to the largest eigenvalue and \vec{W} corresponds to the smallest eigenvalue. The data points are represented as $\vec{X}_i = \vec{A} + u_i \vec{U}_i + v_i \vec{V}_i + w_i \vec{W}_i$. Let w_{\min} and w_{\max} be the extreme values for the w_i. The data points are bounded by the two planes $\vec{W} \cdot (\vec{X} - \vec{A}) = w_{\min}$ and $\vec{W} \cdot (\vec{X} - \vec{A}) = w_{\max}$. Set the lozenge radius to $r = (w_{\max} - w_{\min})/2$ and adjust the mean to $\vec{A} \leftarrow \vec{A} + ((w_{\max} + w_{\min})/2)\vec{W}$.

Analogous to the fitting of data by a three-dimensional capsule, construct a two-dimensional capsule containing the pairs (v_i, w_i). We need to compute the largest β_0 so that all points lie above the hemicircle $w^2 + (v - \beta_0)^2 = r^2$ with $v \le \alpha_0$. The value is computed as

$$\beta_0 = \min_i \left\{ v_i + \sqrt{r^2 - w_i^2} \right\},$$

where $0 \le i \le n$. Similarly, there is a smallest value β_1 so that all points lie below the hemicircle $w^2 + (v - \beta_0)^2 = r^2$ with $v \ge \beta_1$. The value is computed as

$$\beta_1 = \max_i \left\{ v_i - \sqrt{r^2 - w_i^2} \right\}.$$

The end points of the projected capsule line segment determine an edge of the lozenge, $\vec{E}_1 = (\beta_1 - \beta_0)\vec{V}$.

Repeat this process for the pairs (u_i, w_i) to obtain values

$$\alpha_0 = \min_i \left\{ u_i + \sqrt{r^2 - w_i^2} \right\}$$

and

$$\alpha_1 = \max_i \left\{ u_i - \sqrt{r^2 - w_i^2} \right\}.$$

Although it appears that the other lozenge edge should be $\vec{E}_0 = (\alpha_1 - \alpha_0)\vec{U}$, it might not be. The hemicylinder ends that are attached by the above process form mitered corners that enclose more space than the quarter spheres. It is possible for some data points to be inside the hemicylinder overlap, but outside the quarter sphere. The candidate edge \vec{E}_0 may need to be increased to enclose the outliers.

Let $\vec{K}_0 = \vec{A} + \alpha_0\vec{U} + \beta_0\vec{V}$ be one of the corner points of the current lozenge rectangle. Suppose that $\vec{P} = \vec{A} + \alpha_p\vec{U} + \beta_p\vec{V} + \gamma_p\vec{W}$ is a point outside the quarter sphere centered at \vec{K}. For this to be true, $|\vec{P} - \vec{K}_0| > r$. The corner must be adjusted to $\vec{K}_1 = \vec{A} + \alpha_1\vec{U} + \beta_1\vec{V}$ so that $|\vec{P} - \vec{K}_1| = r$. There are two degrees of freedom for the adjustment. One degree is eliminated by requiring $(\alpha_1, \beta_1) = t(\alpha_0, \beta_0) + (1 - t)(\alpha_p, \beta_p)$. Replacing in the previous distance equation yields a quadratic in t that can be solved for

$$t = \frac{r^2 - \gamma_p^2}{(\alpha_p - \alpha_0)^2 + (\beta_p - \beta_0)^2}.$$

The adjustment on the corner point does not affect previous containment relationships. Thus, the list of input points can be iterated and the corners adjusted as needed.

After the adjustment, the lozenge rectangle parameters are $[\alpha_0, \alpha_1] \times [\beta_0, \beta_1]$. The lozenge origin is chosen to be $\vec{A} + \alpha_0\vec{U} + \beta_0\vec{V}$, and the lozenge edges are $\vec{E}_0 = (\alpha_1 - \alpha_0)\vec{U}$ and $\vec{E}_1 = (\beta_1 - \beta_0)\vec{V}$.

Minimization Method

The construction of a lozenge in the last subsection used eigenvectors from the covariance matrix. The same construction can be applied for any choice of orthonormal vectors that form a right-handed system. The corresponding rotation matrices whose columns are the selected vectors form a three-parameter family (the unit quaternions form a three-dimensional manifold in 4-space). Let the parameters be labeled as the 3-tuple $\vec{\rho}$. The volume for a given set of parameters, $v(\vec{\rho})$, can be computed by adding the volumes of the pieces forming the lozenge: the rectangular box, the four hemicylinder sides, and the four quarter-sphere corners. A minimization algorithm can be applied to v to obtain parameters $\vec{\rho}'$ so that $v(\vec{\rho}')$ is a global minimum.

2.5.5 CYLINDERS

An *infinite cylinder* is the set of all points a distance r from a line $\vec{P} + t\vec{D}$, where $t \in \mathbb{R}$ and \vec{D} is unit length. A *finite cylinder* is a subset of an infinite cylinder, where $|t| \leq h/2$

for a specified height h. We will refer to finite cylinders simply as "cylinders." If we need to talk about infinite cylinders, we will refer to them explicitly as "infinite cylinders."

Two algorithms to bound the points $\{\vec{X}_i\}_{i=0}^n$ are as follows. Fit the points by a line using the least-squares algorithm described in Appendix B. Let the line be $\vec{A} + t\vec{W}$, where \vec{W} is unit length and \vec{A} is the average of the data points. Select unit vectors \vec{U} and \vec{V} so that the matrix $R = [\vec{U}\ \vec{V}\ \vec{W}]$ is orthonormal and has determinant one. The data points can be represented as $\vec{X}_i = \vec{A} + R\vec{Y}_i$, where $\vec{Y}_i = (u_i, v_i, w_i)$.

Least-Squares Line Contains Axis

SOURCE CODE

LIBRARY
Containment

FILENAME
ContCylinder

The cylinder radius is $r = \max_i\{\sqrt{u_i^2 + v_i^2}\}$. The cylinder height is $h = w_{max} - w_{min}$, where w_{min} and w_{max} are the extreme values of the w_i. To conform to the finite cylinder definition, the line must have its translation vector adjusted. The new translation is

$$\vec{A}' = \vec{A} + \frac{w_{min} + w_{max}}{2}\vec{W}.$$

The line is $\vec{A}' + t\vec{W}$ and the cylinder is constrained by $|t| \leq h/2$.

Least-Squares Line Moved to Minimum-Area Center

The minimum-area circle containing the (u_i, v_i) values is computed and has center (u', v') and radius r. The least-squares line is shifted to contain the circle center,

$$\vec{A}' = \vec{A} + u'\vec{U} + v'\vec{V}.$$

The cylinder radius is r and the algorithm in the last subsection is applied to compute h. That algorithm also shifts the line in the direction of \vec{W} to $\vec{A}'' + t\vec{W}$, where

$$\vec{A}'' = \vec{A}' + \frac{w_{min} + w_{max}}{2}\vec{W}.$$

2.5.6 ELLIPSOIDS

An *ellipsoid* in standard axis-aligned form is

$$\frac{x^2}{a^2} + \frac{y^2}{b^2} + \frac{z^2}{c^2} = 1$$

with center $(0, 0, 0)$ and semiaxis lengths $a > 0$, $b > 0$, and $c > 0$. The axis directions of the ellipse are $(1, 0, 0)$, $(0, 1, 0)$, and $(0, 0, 1)$.

Given a coordinate system with center \vec{C} and orthonormal axis directions \vec{U}_i for $0 \le i \le 2$, the ellipsoid with that center and axes is

$$(\vec{X} - \vec{C})^{\mathrm{T}} R^{\mathrm{T}} D R (\vec{X} - \vec{C}) = 1,$$

where $R = [\vec{U}_0 \, \vec{U}_1 \, \vec{U}_2]$ is a rotation matrix, $D = \mathrm{diag}\{1/d_0^2, 1/d_1^2, 1/d_2^2\}$ has positive diagonal entries that are the squared semiaxis lengths, and \vec{X} is the algebraic variable for the equation. An equation $(\vec{X} - \vec{C})^{\mathrm{T}} M (\vec{X} - \vec{C}) = 1$, where M is a positive definite matrix, also represents an ellipsoid. The axes and semiaxis lengths are obtained by an eigendecomposition $M = R^{\mathrm{T}} D R$ (see Section B.2 in Appendix B).

The most general form for the ellipsoid is $\vec{X}^{\mathrm{T}} A \vec{X} + \vec{b}^{\mathrm{T}} \vec{X} + c = 0$, where A is positive definite. It is possible to algebraically manipulate this, analogous to completing the square for a quadratic polynomial of one variable, and obtain the other form. The center is $\vec{C} = -A^{-1}\vec{b}/2$, and the matrix is $M = A/(\vec{b}^{\mathrm{T}} A^{-1} \vec{b}/4 - c)$.

Axis-Aligned Ellipsoid

Given a set of points $\{\vec{V}_i\}_{i=0}^n$, a simple way to bound with an ellipsoid is to first generate the axis-aligned box containing the points and establish the ratios of semiaxis lengths. Let \vec{p}_{min} and \vec{p}_{max} be the vectors storing the minimum and maximum component values. The center of the ellipsoid is $\vec{C} = (\vec{p}_{\mathrm{max}} + \vec{p}_{\mathrm{min}})/2$. The semiaxis lengths are components of $\lambda(\vec{p}_{\mathrm{max}} - \vec{p}_{\mathrm{min}})/2 = \lambda(\delta_0, \delta_1, \delta_2)$, where $\lambda > 0$ is to be determined. Let $D = \mathrm{diag}\{1/(\lambda\delta_0)^2, 1/(\lambda\delta_1)^2, 1/(\lambda\delta_2)^2\}$. The ellipsoid is $(\vec{X} - \vec{C})^{\mathrm{T}} E (\vec{X} - \vec{C}) = 1$, where $E = D/\max_i\{(\vec{V}_i - \vec{C})^{\mathrm{T}} D (\vec{V}_i - \vec{C})\}$.

Fitting Points with a Gaussian Distribution

SOURCE CODE

LIBRARY

Containment

FILENAME

ContEllipsoid

This method is similar to the one used for fitting points with an oriented box. The mean of the points is used for the center of the ellipsoid, and the eigenvectors of the covariance matrix are used for the axes. The eigenvalues are used in the same way as the vector $(\delta_0, \delta_1, \delta_2)$ in the fit with an axis-aligned ellipsoid. The ellipsoid is $(\vec{X} - \vec{C})^{\mathrm{T}} E (\vec{X} - \vec{C}) = 1$, where $E = (R^{\mathrm{T}} D R)/\max_i\{(\vec{V}_i - \vec{C})^{\mathrm{T}} R^{\mathrm{T}} D R (\vec{V}_i - \vec{C})\}$.

Minimum-Volume Ellipsoid

While the theory of such a fit has been worked out using randomized linear techniques (Welzl 1991), an implementation is extremely difficult because it requires special-case handlers for bounding point sets with up to nine points (the minimum-volume sphere algorithm requires special-case handlers with up to four points). An alternative is to use a constrained numerical minimization, something that is challenging but

not impossible to implement. In either case, rapidly computing minimum-volume ellipsoids is not possible at the moment for real-time applications.

2.6 DISTANCE METHODS

Calculating distances between points, linear components (line, ray, or line segment), triangles, and rectangles is based on minimizing a quadratic function on a compact set. The solution can be computed using methods of calculus. Generally, if two objects are parameterized as $\vec{X}(\vec{s})$ and $\vec{Y}(\vec{t})$ for $\vec{s} \in A \subset \mathbb{R}^n$ and $\vec{t} \in B \subset \mathbb{R}^m$, then the squared distance between two points, one from each set, is $Q(\vec{s}, \vec{t}) = |\vec{X}(\vec{s}) - \vec{Y}(\vec{t})|^2$ for $(\vec{s}, \vec{t}) \in A \times B \subset \mathbb{R}^n \times \mathbb{R}^m$. This is a continuously differentiable function whose minimum occurs either at an interior point of $A \times B$, in which case $\vec{\nabla}(Q) = \vec{0}$, or at a boundary point of $A \times B$, in which case the problem is reduced to minimizing a quadratic function in spaces with dimension smaller than $n + m$. Thus, the algorithm is recursive in dimension.

2.6.1 POINT TO LINEAR COMPONENT

SOURCE CODE

LIBRARY

Distance

FILENAME

DistVec3Lin3

The following construction applies in any dimension, not just in three dimensions. Let the point be \vec{P}. A line is parameterized as $\vec{L}(t) = \vec{B} + t\vec{M}$, where \vec{B} is a point on the line, \vec{M} is the line direction, and $t \in \mathbb{R}$. A ray is of the same form but with restriction $t \geq 0$. A line segment is restricted even further with $t \in [0, 1]$.

The closest point on the line to \vec{P} is the projection of \vec{P} onto the line, $\vec{Q} = \vec{B} + t_0\vec{M}$, where

$$t_0 = \frac{\vec{M} \cdot (\vec{P} - \vec{B})}{\vec{M} \cdot \vec{M}}.$$

The distance from \vec{P} to the line is

$$D = |\vec{P} - (\vec{B} + t_0\vec{M})|. \tag{2.14}$$

If $t_0 \leq 0$, then the closest point on the ray to \vec{P} is \vec{B}. For $t_0 > 0$, the projection $\vec{B} + t_0\vec{M}$ is the closest point. The distance from \vec{P} to the ray is

$$D = \begin{cases} |\vec{P} - \vec{B}|, & t_0 \leq 0 \\ |\vec{P} - (\vec{B} + t_0\vec{M})|, & t_0 > 0 \end{cases}. \tag{2.15}$$

Finally, if $t_0 > 1$, then the closest point on the line segment to \vec{P} is $\vec{B} + \vec{M}$. The distance from \vec{P} to the line segment is

$$D = \begin{cases} |\vec{P} - \vec{B}|, & t_0 \leq 0 \\ |\vec{P} - (\vec{B} + t_0\vec{M})|, & 0 < t_0 < 1 \\ |\vec{P} - (\vec{B} + \vec{M})|, & t_0 \geq 1 \end{cases} \quad\quad (2.16)$$

The division by $\vec{M} \cdot \vec{M}$ is the most expensive algebraic operation. The implementation should defer the division as late as possible. The pseudocode is given below. The returned quantity is squared distance and the segment parameter of the closest point is also made available.

```
float SquaredDistancePointSegment (Point P, Segment segment,
  float& t)
{
    diff = P - segment.B;
    t = Dot(segment.M,diff);

    if ( t > 0 )
    {
        dotMM = Dot(segment.m,segment.m);
        if ( t < dotMM )
        {
            t = t/dotMM;
            diff = diff - t*segment.M;
        }
        else
        {
            t = 1;
            diff = diff - segment.M;
        }
    }
    else
    {
        t = 0;
    }

    return Dot(diff,diff);
}
```

It is also possible to implement a point-to-segment distance algorithm without divisions, but it requires storing more information with the linear component. The line segment can be represented in the style of oriented boxes, $\vec{C} + t\vec{U}$, where \vec{U} is a unit-length vector and $t \in [-r, r]$. The line segment data structure still stores two vector quantities, but must additionally store r. Given two end points initially,

preprocessing time includes computing \vec{U}, an operation that requires an inverse square root. The pseudocode is

```
float SquaredDistancePointSegment (Point P, Segment segment,
  float& t)
{
    diff = P - segment.C;
    t = Dot(segment.U,diff);

    if ( t < -segment.r )
        t = -segment.r;
    else if ( t > segment.r )
        t = segment.r;

    diff = diff - t*segment.U;
    return Dot(diff,diff);
}
```

A further small speedup (on average) is possible by allowing the line segment to store $r\vec{U}$ in addition to r and \vec{U}. The pseudocode is

```
float SquaredDistancePointSegment (Point P, Segment segment,
  float& t)
{
    diff = P - segment.C;
    t = Dot(segment.U,diff);

    if ( t < -segment.r )
    {
        t = -segment.r;
        diff = diff + segment.rU;
    }
    else if ( t > segment.r )
    {
        t = segment.r;
        diff = diff - segment.rU;
    }
    else
    {
        diff = diff - t*segment.U;
    }
    return Dot(diff,diff);
}
```

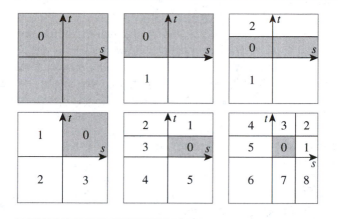

Figure 2.1 The six possibilities for $I \times J$.

2.6.2 LINEAR COMPONENT TO LINEAR COMPONENT

SOURCE CODE

LIBRARY

Distance

FILENAME

DistLin3Lin3

The two linear components are $\vec{L}_0(s) = \vec{B}_0 + s\vec{M}_0$ for $s \in I \subset \mathbb{R}$ and $\vec{L}_1(t) = \vec{B}_1 + t\vec{M}_1$ for $t \in J \subset \mathbb{R}$. The first component is a line if $I = \mathbb{R}$, a ray if $I = [0, \infty)$, or a segment if $I = [0, 1]$. The second component is similarly classified.

The squared-distance function for any two points on the linear components is $Q(s, t) = |\vec{L}_0(s) - \vec{L}_1(t)|^2$ for $(s, t) \in I \times J$. The function is quadratic in s and t,

$$Q(s, t) = as^2 + 2bst + ct^2 + 2ds + 2et + f,$$

where $a = \vec{M}_0 \cdot \vec{M}_0$, $b = -\vec{M}_0 \cdot \vec{M}_1$, $c = \vec{M}_1 \cdot \vec{M}_1$, $d = \vec{M}_0 \cdot (\vec{B}_0 - \vec{B}_1)$, $e = -\vec{M}_1 \cdot (\vec{B}_0 - \vec{B}_1)$, and $f = (\vec{B}_0 - \vec{B}_1) \cdot (\vec{B}_0 - \vec{B}_1)$. Quadratics are classified by the sign of $ac - b^2$. For function Q,

$$ac - b^2 = (\vec{M}_0 \cdot \vec{M}_0)(\vec{M}_1 \cdot \vec{M}_1) - (\vec{M}_0 \cdot \vec{M}_1)^2 = |\vec{M}_0 \times \vec{M}_1|^2 \geq 0.$$

If $ac - b^2 > 0$, then the two linear components are not parallel and the graph of Q is a paraboloid. If $ac - b^2 = 0$, then the two line segments are parallel and the graph of Q is a parabolic cylinder.

The goal is to minimize $Q(s, t)$ over the domain $I \times J$. Since Q is a continuously differentiable function, the minimum occurs either at an interior point of the domain where the gradient $\vec{\nabla} Q = 2(as + bt + d, bs + ct + e) = (0, 0)$ or at a point on the boundary of the domain. Figure 2.1 shows the six possibilities for $I \times J$. The plane is partitioned into regions in which \vec{P} can live. Each region is handled differently in the distance calculations.

Line to Line

If the lines are not parallel ($ac - b^2 > 0$), then the minimum distance must occur when $\vec{\nabla} Q = (0, 0)$. The two equations in two unknowns can be solved for $s = (be - cd)/(ac - b^2)$ and $t = (bd - ae)/(ac - b^2)$. If the lines are parallel, only one equation from $\vec{\nabla} Q = (0, 0)$ is independent. Any choice of s and t satisfying this equation will produce a pair of closest points on the lines. The simplest choice is $s = -d/a$ and $t = 0$. The pseudocode is

```
float SquaredDistanceLineLine (Line line0, Line line1, float& s,
  float& t)
{
    diff = line0.B - line1.B;
    a = Dot(line0.M,line0.M);
    b = -Dot(line0.M,line1.M);
    c = Dot(line1.M,line1.M);
    d = Dot(line0.M,diff);
    f = Dot(diff,diff);
    det = |a*c-b*b|;  // = |Cross(line0.M,line1.M)|^2 >= 0

    if ( Positive(det) )
    {
        // lines are not parallel
        e = -Dot(line1.M,diff);
        invDet = 1/det;
        s = (b*e-c*d)*invDet;
        t = (b*d-a*e)*invDet;
        return s*(a*s+b*t+2*d)+t*(b*s+c*t+2*e)+f;
    }
    else
    {
        // lines are parallel, select any closest pair of points
        s = -d/a;
        t = 0;
        return d*s+f;
    }
}
```

The code `Positive(det)` is a tolerance test for parallelism. If $\delta = |ac - b^2| = |\vec{M}_0 \times \vec{M}_1|$, a simple absolute error test such as $\delta \geq \epsilon$ is possible, but assumes the error tolerance is based on knowing the lengths of the direction vectors. It would be better to use a relative error that takes into account the lengths of the line directions, $\delta \geq \epsilon |\vec{M}_0||\vec{M}_1|$. The lengths of the line directions can be stored with the lines to be used for this test. If that is not desired, the squared lengths should be used and the test becomes $\delta^2 \geq \epsilon^2 |ab|$.

Line to Ray or Segment

Similar algorithms can be written for line to ray and line to segment. The source code on the CD-ROM contains implementations for them.

Ray to Ray or Segment, and Segment to Segment

These cases are slightly more complicated because of the presence of the corner points in the st-domain. The description here is for segment-to-segment calculations. Similar algorithms can be written for the other cases, and the source code on the CD-ROM contains implementations for them.

When $ac - b^2 > 0$, the line segments are not parallel. The gradient of Q is zero only when $\bar{s} = (be - cd)/(ac - b^2)$ and $\bar{t} = (bd - ae)/(ac - b^2)$. If $(\bar{s}, \bar{t}) \in [0, 1]^2$, then the minimum of Q is found. Otherwise, the minimum must occur on the boundary of the square. The eight regions referred to in the remaining discussion are those shown in Figure 2.1.

Suppose (\bar{s}, \bar{t}) is in region 1. The level curves of Q are those curves in the st-plane for which Q is a constant. Since the graph of Q is a paraboloid, the level curves are ellipses. At the point where $\vec{\nabla} Q = (0, 0)$, the level curve degenerates to a single point (\bar{s}, \bar{t}). The global minimum of Q occurs there, call it V_{\min}. As the level values V increase from V_{\min}, the corresponding ellipses are increasingly further away from (\bar{s}, \bar{t}). There is a smallest level value V_0 for which the corresponding ellipse (implicitly defined by $Q = V_0$) just touches the unit square edge $s = 1$ at a value $t = t_0 \in [0, 1]$. For level values $V < V_0$, the corresponding ellipses do not intersect the unit square. For level values $V > V_0$, portions of the unit square lie inside the corresponding ellipses. In particular, any points of intersection of such an ellipse with the edge must have a level value $V > V_0$. Therefore, $Q(1, t) > Q(1, t_0)$ for $t \in [0, 1]$ and $t \neq t_0$. The point $(1, t_0)$ provides the minimum squared distance between two points on the 3D line segments. The point on the first line segment is an end point, and the point on the second line segment is interior to that segment. Figure 2.2 illustrates the idea by showing various level curves.

An alternate way of visualizing where the minimum distance point occurs on the boundary is to intersect the graph of Q with the plane $s = 1$. The curve of intersection is a parabola and is the graph of $F(t) = Q(1, t)$ for $t \in [0, 1]$. Now the problem has been reduced by one dimension to minimizing a function $F(t)$ for $t \in [0, 1]$. The minimum of $F(t)$ occurs either at an interior point of $[0, 1]$, in which case $F'(t) = 0$ at that point, or at an end point $t = 0$ or $t = 1$. Figure (2.2) shows the case when the minimum occurs at an interior point. At that point the ellipse is tangent to the line $s = 1$. In the end point cases, the ellipse may just touch one of the corners of the unit square but not necessarily tangentially.

To distinguish between the interior point and end point cases, the same partitioning idea applies in the one-dimensional case. The interval $[0, 1]$ partitions the real line into three intervals, $t < 0$, $t \in [0, 1]$, and $t > 1$. Let $F'(\hat{t}) = 0$. If $\hat{t} < 0$, then $F(t)$ is an increasing function for $t \in [0, 1]$. The minimum restricted to $[0, 1]$ must occur

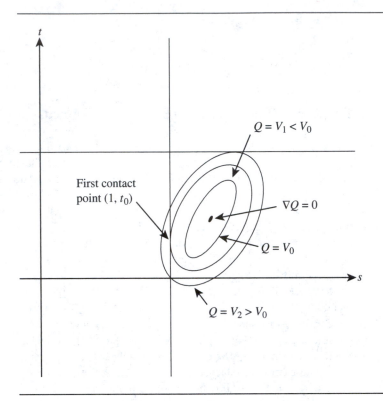

Figure 2.2 Various level curves $Q(s, t) = V$.

at $t = 0$, in which case Q attains its minimum at $(s, t) = (1, 0)$. If $\hat{t} > 1$, then $F(t)$ is a decreasing function for $t \in [0, 1]$. The minimum for F occurs at $t = 1$, and the minimum for Q occurs at $(s, t) = (1, 1)$. Otherwise, $\hat{t} \in [0, 1]$, F attains its minimum at \hat{t}, and Q attains its minimum at $(s, t) = (1, \hat{t})$.

The occurrence of (\bar{s}, \bar{t}) in region 3, 5, or 7 is handled in the same way as when the global minimum is in region 0. If (\bar{s}, \bar{t}) is in region 3, then the minimum occurs at $(s_0, 1)$ for some $s_0 \in [0, 1]$. If (\bar{s}, \bar{t}) is in region 5, then the minimum occurs at $(0, t_0)$ for some $t \in [0, 1]$. Finally, if (\bar{s}, \bar{t}) is in region 7, then the minimum occurs at $(s_0, 0)$ for some $s_0 \in [0, 1]$. Determining if the first contact point is at an interior or end point of the appropriate interval is handled the same as discussed earlier.

If (\bar{s}, \bar{t}) is in region 2, it is possible the level curve of Q that provides first contact with the unit square touches either edge $s = 1$ or edge $t = 1$. Because the global minimum occurs in region 2, the gradient at the corner $(1, 1)$ cannot point inside the unit square. If $\vec{\nabla} Q = (Q_s, Q_t)$, where Q_s and Q_t are the partial derivatives of Q, it must be that the partial derivatives cannot both be negative. The choice of edge $s = 1$ or $t = 1$ can be made based on the signs of $Q_s(1, 1)$ and $Q_t(1, 1)$. If $Q_s(1, 1) > 0$, then the minimum must occur on edge $t = 1$ since $Q(s, 1) < Q(1, 1)$ for $s < 1$ but close to 1.

Similarly, if $Q_t(1, 1) > 0$, then the minimum must occur on edge $s = 1$. Determining whether the minimum is interior to the edge or at an end point is handled as in the case of region 1. The occurrence of (\bar{s}, \bar{t}) in regions 4, 6, and 8 is handled similarly.

When $ac - b^2 = 0$, the gradient of Q is zero on an entire st-line, $s = -(bt + d)/a$ for all $t \in \mathbb{R}$. If any pair (s, t) satisfying this equation is in $[0, 1]$, then that pair leads to two points on the 3D lines that are closest. Otherwise, the minimum must occur on the boundary of the square. Rather than solving the problem using minimization, we take advantage of the fact that the line segments lie on parallel lines.

The origin of the first line is assumed to be \vec{B}_0 and the line direction is \vec{M}_0. The first line segment is parameterized as $\vec{B}_0 + s\vec{M}_0$ for $s \in [0, 1]$. The second line segment can be projected onto the first line. The end point \vec{B}_1 can be represented as

$$\vec{B}_1 = \vec{B}_0 + \sigma_0 \vec{M}_0 + \vec{U}_0,$$

where \vec{U}_0 is a vector orthogonal to \vec{M}_0. The coefficient of \vec{M}_0 is

$$\sigma_0 = \frac{\vec{M}_0 \cdot (\vec{B}_1 - \vec{B}_0)}{\vec{M}_0 \cdot \vec{M}_0} = -\frac{d}{a},$$

where a and d are some coefficients of $Q(s, t)$ defined earlier. The other end point $\vec{B}_1 + \vec{M}_1$ can be represented as

$$\vec{B}_1 + \vec{M}_1 = \vec{B}_0 + \sigma_1 \vec{M}_0 + \vec{U}_1,$$

where \vec{U}_1 is a vector orthogonal to \vec{M}_0. The coefficient of \vec{M}_0 is

$$\sigma_1 = \frac{\vec{M}_0 \cdot (\vec{M}_1 + \vec{B}_1 - \vec{B}_0)}{\vec{M}_0 \cdot \vec{M}_0} = -\frac{b + d}{a},$$

where b is also a coefficient of $Q(s, t)$. The problem now reduces to determining the relative position of $[\min(\sigma_0, \sigma_1), \max(\sigma_0, \sigma_1)]$ with respect to $[0, 1]$. If the two intervals are disjoint, then the minimum distance occurs at end points of the two 3D line segments. If the two intervals overlap, then there are many pairs of points at which the minimum distance is attained. In this case the implementation returns a pair of points, an end point of one line and an interior point of the other line.

The implementation of the algorithm is designed so that at most one floating-point division is used when computing the minimum distance and corresponding closest points. Moreover, the division is deferred until it is needed. In some cases no division is needed.

Quantities that are used throughout the code are computed first. In particular, the values computed are $\vec{D} = \vec{B}_0 - \vec{B}_1$, $a = \vec{M}_0 \cdot \vec{M}_0$, $b = -\vec{M}_0 \cdot \vec{M}_1$, $c = \vec{M}_1 \cdot \vec{M}_1$, $d = \vec{M}_0 \cdot \vec{D}$, $e = -\vec{M}_1 \cdot \vec{D}$, and $f = \vec{D} \cdot \vec{D}$. It must be determined immediately whether or not the two line segments are parallel. The quadratic classifier is $\delta = ac - b^2$ and is also computed initially. The code actually computes $\delta = |ac - b^2|$ since it is possible for

nearly parallel lines that some floating-point round-off errors lead to a small negative quantity. Finally, δ is compared to a floating-point tolerance value. If larger, the two line segments are nonparallel and the code for that case is processed. If smaller, the two line segments are assumed to be parallel and the code for that case is processed.

In the theoretical development, $\bar{s} = (be - cd)/\delta$ and $(bd - ae)/\delta$ were computed so that $\vec{\nabla}Q(\bar{s}, \bar{t}) = (0, 0)$. The location of the global minimum is then tested to see if it is in the unit square $[0, 1]$. If so, then all the information to compute the minimum distance is known. If not, then the boundary of the unit square must be tested. To defer the division by δ, the code instead computes $\bar{s} = be - cd$ and $\bar{t} = bd - ae$ and tests for containment in $[0, \delta]^2$. If in that set, then the divisions are performed. If not, then the boundary of the unit square is tested. The general outline of the conditionals for determining which region contains (\bar{s}, \bar{t}) is

```
det = a*c-b*b;   s = b*e-c*d;   t = b*d-a*e;
if ( s >= 0 )
{
    if ( s <= det )
    {
        if ( t >= 0 ) { if ( t <= det ) { region 0 } else {
            region 3 } }
        else { region 7 }
    }
    else
    {
        if ( t >= 0 ) { if ( t <= det ) { region 1 } else {
            region 2 } }
        else { region 8 }
    }
}
else
{
    if ( t >= 0 ) { if ( t <= det ) { region 5 } else {
        region 4 } }
    else { region 6 }
}
```

The block of code for handling region 0 is

```
invDet = 1/det;
s *= invDet;
t *= invDet;
```

and requires a single division. The block of code for handling region 1 is

```
// F(t) = Q(1,t) = (a+2*d+f)+2*(b+e)*t+(c)*t^2
```

```
// F'(t) = 2*((b+e)+c*t)
// F'(T) = 0 when T = -(b+e)/c
s = 1;
tmp = b+e;
if ( tmp > 0 )  // T < 0, so minimum at t = 0
    t = 0;
else if ( -tmp > c )  // T > 1, so minimum at t = 1
    t = 1;
else  // 0 <= T <= 1, so minimum at t = T
    t = -tmp/c;
```

Notice that at most one division occurs in this block during run time. Code blocks for regions 3, 5, and 7 are similar.

The block of code for handling region 2 is

```
// Q_s(1,1)/2 = a+b+d,   Q_t(1,1)/2 = b+c+e
tmp = b+d;
if ( -tmp < a )  // Q_s(1,1) > 0
{
    // F(s) = Q(s,1) = (c+2*e+f)+2*(b+d)*s+(a)*s^2
    // F'(s) = 2*((b+d)+a*s), F'(S) = 0 when S = -(b+d)/a < 1
    t = 1;
    if ( tmp > 0 )  // S < 0, so minimum at s = 0
        s = 0;
    else  // 0 <= S < 1, so minimum at s = S
        s = -tmp/a;
}
else  // Q_s(1,1) <= 0
{
    s = 1;
    tmp = b+e;
    if ( -tmp < c )  // Q_t(1,1) > 0
    {
        // F(t) = Q(1,t) = (a+2*d+f)+2*(b+e)*t+(c)*t^2
        // F'(t) = 2*((b+e)+c*t), F'(T) = 0 when T =
        // -(b+e)/c < 1
        if ( tmp > 0 )  // T < 0, so minimum at t = 0
            t = 0
        else  // 0 <= T < 1, so minimum at t = T
            t = -tmp/c;
    }
    else  // Q_t(1,1) <= 0, gradient points to region 2, so
        // minimum at t = 1
        t = 1;
}
```

Notice that at most one division occurs in this block during run time. Code blocks for regions 4, 6, and 8 are similar.

For parallel line segments, the first information to be computed is the ordering of $\sigma_0 = -d/a$ and $-(b+d)/a$. Once the ordering is known, the two s-intervals can be compared to determine minimum distance. Note that $-d/a$ corresponds to $t = 0$ and $-(b+d)/a$ corresponds to $t = 1$.

```
if ( b > 0 )
{
    // compare intervals [-(b+d)/a,-d/a] to [0,1]
    if ( d >= 0 )
        // -d/a <= 0, so minimum is at s = 0, t = 0
    else if ( -d <= a )
        // 0 < -d/a <= 1, so minimum is at s = -d/a, t = 0
    else
        // minimum occurs at s = 1, need to determine t (see
        // below)
}
else
{
    // compare intervals [-d/a,-(b+d)/a] to [0,1]
    if ( -d >= a )
        // 1 <= -d/a, so minimum is at s = 1, t = 0
    else if ( d <= 0 )
        // 0 <= -d/a < 1, so minimum is at s = -d/a, t = 0
    else
        // minimum occurs at s = 0, need to determine t (see
        // below)
}
```

When $b > 0$, the remaining problem is to determine on which side of $s = 1$ is the quantity $-(b+d)/a$. This is done by first finding that value of t for which $-(bt+d)/a \in [-(b+d)/a, -d/a]$ corresponds to $s = 1$. Simply set $-(bt+d)/a = 1$ and solve for $t = -(a+d)/b$. By the time this case is reached at run time, it is known that $a + d < 0$, so $t > 0$. If $t \le 1$, then the quantity can be used as is. But if $t > 1$, then clip to $t = 1$. The block of code is

```
tmp = a+d;
if ( -tmp >= b ) t = 1; else t = -tmp/b;
```

Again note that the division is deferred until actually needed.

When $b < 0$, the remaining problem is to determine on which side of $s = 0$ is the quantity $-(b+d)/a$. Set $-(bt+d)/a = 0$ and solve for $t = -d/b$. By the time this

case is reached at run time, it is known that $d > 0$, so $t > 0$. If $t \leq 1$, then the quantity can be used as is. But if $t > 1$, then clip to $t = 1$. The block of code is

```
if ( d >= -b ) t = 1; else t = -d/b;
```

Just as in the algorithm for distance from point to line segment, the algorithm for distance from line segment to line segment can be implemented without divisions as long as the line segments are represented as $\vec{C} + t\vec{U}$ for unit-length \vec{U} and $t \in [-r, r]$.

2.6.3 POINT TO TRIANGLE

SOURCE CODE

LIBRARY

Distance

FILENAME

DistVec3Tri3

The problem is to compute the minimum distance between a point \vec{P} and a triangle $\vec{T}(s, t) = \vec{B} + s\vec{E}_0 + t\vec{E}_1$ for $(s, t) \in D = \{(s, t) : s \in [0, 1], t \in [0, 1], s + t \leq 1\}$. The minimum distance is computed by locating the values $(\bar{s}, \bar{t}) \in D$ corresponding to the point on the triangle closest to \vec{P}. The squared-distance function for any point on the triangle to \vec{P} is $Q(s, t) = |\vec{T}(s, t) - \vec{P}|^2$ for $(s, t) \in D$. The function is quadratic in s and t,

$$Q(s, t) = as^2 + 2bst + ct^2 + 2ds + 2et + f,$$

where $a = \vec{E}_0 \cdot \vec{E}_0$, $b = \vec{E}_0 \cdot \vec{E}_1$, $c = \vec{E}_1 \cdot \vec{E}_1$, $d = \vec{E}_0 \cdot (\vec{B} - \vec{P})$, $e = -\vec{E}_1 \cdot (\vec{B} - \vec{P})$, and $f = (\vec{B} - \vec{P}) \cdot (\vec{B} - \vec{P})$.

Quadratics are classified by the sign of $ac - b^2$. For function Q,

$$ac - b^2 = (\vec{E}_0 \cdot \vec{E}_0)(\vec{E}_1 \cdot \vec{E}_1) - (\vec{E}_0 \cdot \vec{E}_1)^2 = |\vec{E}_0 \times \vec{E}_1|^2 > 0.$$

The positivity is based on the assumption that the two edges \vec{E}_0 and \vec{E}_1 of the triangle are linearly independent, so their cross product is a nonzero vector. The goal is to minimize $Q(s, t)$ over D. Since Q is a continuously differentiable function, the minimum occurs either at an interior point of D where the gradient $\vec{\nabla}Q = 2(as + bt + d, bs + ct + e) = (0, 0)$ or at a point on the boundary of D.

The gradient of Q is zero only when $\bar{s} = (be - cd)/(ac - b^2)$ and $\bar{t} = (bd - ae)/(ac - b^2)$. If $(\bar{s}, \bar{t}) \in D$, then the minimum of Q is found. Otherwise, the minimum must occur on the boundary of the triangle. To find the correct boundary, consider Figure 2.3, which shows a partitioning of the plane analogous to that shown in Figure 2.1. The central triangle labeled region 0 is the domain of Q, $(s, t) \in D$. If (\bar{s}, \bar{t}) is in region 0, then the point on the triangle closest to \vec{P} is interior to the triangle.

Suppose (\bar{s}, \bar{t}) is in region 1. The level curves of Q are those curves in the st-plane for which Q is a constant. Since the graph of Q is a paraboloid, the level curves are ellipses. At the point where $\vec{\nabla}Q = (0, 0)$, the level curve degenerates to a single point (\bar{s}, \bar{t}). The global minimum of Q occurs there, call it V_{\min}. As the level values V increase from V_{\min}, the corresponding ellipses are increasingly further away from (\bar{s}, \bar{t}). There is a smallest level value V_0 for which the corresponding ellipse

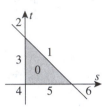

Figure 2.3 Partitioning of the st-plane by triangle domain D.

(implicitly defined by $Q = V_0$) just touches the triangle domain edge $s + t = 1$ at a value $s = s_0 \in [0, 1]$, $t_0 = 1 - s_0$. For level values $V < V_0$, the corresponding ellipses do not intersect D. For level values $V > V_0$, portions of D lie inside the corresponding ellipses. In particular, any points of intersection of such an ellipse with the edge must have a level value $V > V_0$. Therefore, $Q(s, 1 - s) > Q(s_0, t_0)$ for $s \in [0, 1]$ and $s \neq s_0$. The point (s_0, t_0) provides the minimum squared distance between \vec{P} and the triangle. The triangle point is an edge point. Figure 2.4 illustrates the idea by showing various level curves.

An alternate way of visualizing where the minimum distance point occurs on the boundary is to intersect the graph of Q with the plane $s = 1$. The curve of intersection is a parabola and is the graph of $F(s) = Q(s, 1 - s)$ for $s \in [0, 1]$. Now the problem has been reduced by one dimension to minimizing a function $F(s)$ for $s \in [0, 1]$. The minimum of $F(s)$ occurs either at an interior point of $[0, 1]$, in which case $F'(s) = 0$ at that point, or at an end point $s = 0$ or $s = 1$. Figure 2.4 shows the case when the minimum occurs at an interior point of the edge. At that point the ellipse is tangent to the line $s + t = 1$. In the end point cases, the ellipse may just touch one of the vertices of D, but not necessarily tangentially.

To distinguish between the interior point and end point cases, the same partitioning idea applies in the one-dimensional case. The interval $[0, 1]$ partitions the real line into three intervals, $s < 0$, $s \in [0, 1]$, and $s > 1$. Let $F'(\hat{s}) = 0$. If $\hat{s} < 0$, then $F(s)$ is an increasing function for $s \in [0, 1]$. The minimum restricted to $[0, 1]$ must occur at $s = 0$, in which case Q attains its minimum at $(s, t) = (0, 1)$. If $\hat{s} > 1$, then $F(s)$ is a decreasing function for $s \in [0, 1]$. The minimum for F occurs at $s = 1$ and the minimum for Q occurs at $(s, t) = (1, 0)$. Otherwise, $\hat{s} \in [0, 1]$, F attains its minimum at \hat{s}, and Q attains its minimum at $(s, t) = (\hat{s}, 1 - \hat{s})$.

The occurrence of (\bar{s}, \bar{t}) in region 3 or 5 is handled in the same way as when the global minimum is in region 0. If (\bar{s}, \bar{t}) is in region 3, then the minimum occurs at $(0, t_0)$ for some $t_0 \in [0, 1]$. If (\bar{s}, \bar{t}) is in region 5, then the minimum occurs at $(s_0, 0)$ for some $s_0 \in [0, 1]$. Determining if the first contact point is at an interior or end point of the appropriate interval is handled the same as discussed earlier.

If (\bar{s}, \bar{t}) is in region 2, it is possible the level curve of Q that provides first contact with the unit square touches either edge $s + t = 1$ or edge $s = 0$. Because the global minimum occurs in region 2, the negative of the gradient at the corner $(0, 1)$ cannot

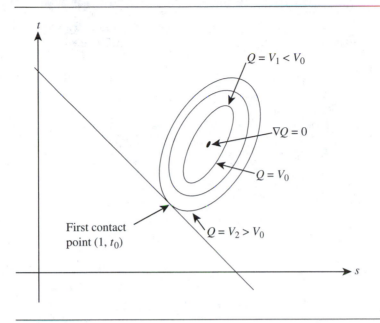

Figure 2.4 Various level curves $Q(s, t) = V$.

point inside D. If $\vec{\nabla} Q = (Q_s, Q_t)$, where Q_s and Q_t are the partial derivatives of Q, it must be that $(0, -1) \cdot \vec{\nabla} Q(0, 1)$ and $(1, -1) \cdot \vec{\nabla} Q(0, 1)$ cannot both be negative. The two vectors $(0, -1)$ and $(1, -1)$ are directions for the edges $s = 0$ and $s + t = 1$, respectively. The choice of edge $s + t = 1$ or $s = 0$ can be made based on the signs of $(0, -1) \cdot \vec{\nabla} Q(0, 1)$ and $(1, -1) \cdot \vec{\nabla} Q(0, 1)$. The same type of argument applies in region 6. In region 4, the two quantities whose signs determine which edge contains the minimum are $(1, 0) \cdot \vec{\nabla} Q(0, 0)$ and $(0, 1) \cdot \vec{\nabla}(0, 0)$.

The implementation of the algorithm is designed so that at most one floating-point division is used when computing the minimum distance and corresponding closest points. Moreover, the division is deferred until it is needed, and in some cases no division is needed.

Quantities that are used throughout the code are computed first. In particular, the values computed are $\vec{D} = \vec{B} - \vec{P}$, $a = \vec{E}_0 \cdot \vec{E}_0$, $b = \vec{E}_0 \cdot \vec{E}_1$, $c = \vec{E}_1 \cdot \vec{E}_1$, $d = \vec{E}_0 \cdot \vec{D}$, $e = \vec{E}_1 \cdot \vec{D}$, and $f = \vec{D} \cdot \vec{D}$. The code actually computes $\delta = |ac - b^2|$ since it is possible for small edge lengths that some floating-point round-off errors lead to a small negative quantity.

In the theoretical development, $\bar{s} = (be - cd)/\delta$ and $(bd - ae)/\delta$ were computed so that $\vec{\nabla} Q(\bar{s}, \bar{t}) = (0, 0)$. The location of the global minimum is then tested to see if it is in the triangle domain D. If so, then the information to compute the minimum distance is known. If not, then the boundary of D must be tested. To defer the division by δ, the code instead computes $\bar{s} = be - cd$ and $\bar{t} = bd - ae$ and tests for

containment in a scaled domain, $s \in [0, \delta], t \in [0, \delta]$, and $s + t \leq \delta$. If in that set, then the divisions are performed. If not, then the boundary of the unit square is tested. The general outline of the conditionals for determining which region contains (\bar{s}, \bar{t}) is

```
det = a*c-b*b;  s = b*e-c*d;  t = b*d-a*e;
if ( s+t <= det )
{
    if ( s < 0 ) { if ( t < 0 ) { region 4 } else { region 3 } }
    else if ( t < 0 ) { region 5 }
    else { region 0 }
}
else
{
    if ( s < 0 ) { region 2 }
    else if ( t < 0 ) { region 6 }
    else { region 1 }
}
```

The block of code for handling region 0 is

```
invDet = 1/det;
s *= invDet;
t *= invDet;
```

and requires a single division.

The block of code for region 1 is

```
// F(s) = Q(s,1-s) = (a-2b+c)s^2 + 2(b-c+d-e)s + (c+2e+f)
// F'(s)/2 = (a-2b+c)s + (b-c+d-e)
// F'(S) = 0 when S = (c+e-b-d)/(a-2b+c)
// a-2b+c = |E0-E1|^2 > 0, so only sign of c+e-b-d need be
// considered

if ( numer <= 0 )
{
    s = 0;
}
else
{
    denom = a-2*b+c;  // positive quantity
    s = ( numer >= denom ? 1 : numer/denom );
}
t = 1-s;
```

The block of code for region 3 is given below. The block of code for region 5 is similar.

```
// F(t) = Q(0,t) = ct^2 + et + f
// F'(t)/2 = ct+e
// F'(T) = 0 when T = -e/c
s = 0;
t = ( e >= 0 ? 0 : ( -e >= c ? 1 : -e/c ) );
```

The block of code for region 2 is given below. The blocks of code for regions 4 and 6 are similar.

```
// Grad(Q) = 2(as+bt+d,bs+ct+e)
// (0,-1)*Grad(Q(0,1)) = (0,-1)*(b+d,c+e) = -(c+e)
// (1,-1)*Grad(Q(0,1)) = (1,-1)*(b+d,c+e) = (b+d)-(c+e)
// min on edge s+t=1 if (1,-1)*Grad(Q(0,1)) > 0 )
// min on edge s=0 otherwise

tmp0 = B+D;
tmp1 = C+E;
if ( tmp1 > tmp0 )  // minimum on edge s+t=1
{
    numer = tmp1 - tmp0;
    denom = A-2*B+C;
    s = ( numer >= denom ? 1 : numer/denom );
    t = 1-s;
}
else   // minimum on edge s=0
{
    s = 0;
    t = ( tmp1 <= 0 ? 1 : ( E >= 0 ? 0 : -E/C ) );
}
```

2.6.4 LINEAR COMPONENT TO TRIANGLE

SOURCE CODE

LIBRARY

Distance

FILENAME

DistLin3Tri3

The problem is to compute the minimum distance between a linear component $\vec{L}(r) = \vec{B} + r\vec{M}$ for $r \in I$ and a triangle $\vec{T}(s,t) = \vec{A} + s\vec{E}_0 + t\vec{E}_1$ for $(s,t) \in D = \{(s,t) : s \in [0,1], t \in [0,1], s+t \leq 1\}$. The squared-distance function between a point on the line and point on the triangle is $Q(s,t,r) = |\vec{T}(s,t) - \vec{L}(r)|^2$ for $(s,t,r) \in D \times I$, so

$$Q(s,t,r) = a_{00}s^2 + a_{11}t^2 + a_{22}r^2 + 2a_{01}st + 2a_{02}sr + 2a_{12}tr + 2b_0 s + 2b_1 t$$
$$+ 2b_2 r + c,$$

where $a_{00} = \vec{E}_0 \cdot \vec{E}_0$, $a_{11} = \vec{E}_1 \cdot \vec{E}_1$, $a_{22} = \vec{M} \cdot \vec{M}$, $a_{01} = \vec{E}_0 \cdot \vec{E}_1$, $a_{02} = -\vec{E}_0 \cdot \vec{M}$, $a_{12} = -\vec{E}_1 \cdot \vec{M}$, $b_0 = \vec{E}_0 \cdot (\vec{A} - \vec{B})$, $b_1 = \vec{E}_1 \cdot (\vec{A} - \vec{B})$, $b_2 = -\vec{M} \cdot (\vec{A} - \vec{B})$, and $c = (\vec{A} - \vec{B}) \cdot (\vec{A} - \vec{B})$.

The partitioning of \mathbb{R}^3 into regions is similar to that shown in Figure 2.3, except that the regions are extruded along the r-axis and split based on whether I is \mathbb{R}, $[0, \infty)$, or $[0, 1]$. For example, region 0 is an infinite prism (line case), semi-infinite prism (ray case), or finite prism (segment case). As in the other distance calculation algorithms, if the solution $(\bar{s}, \bar{t}, \bar{r})$ to $\vec{\nabla} Q = (0, 0, 0)$ lies in region 0, then the minimum occurs at an interior point that is determined by the solution. Otherwise, the minimum occurs on a face separating regions. The region that contains the zero gradient solution must be determined and the correct faces between the regions must be analyzed to see which one contains the global minimum. Also analogous to the other algorithms, it is possible that the determinant of the system for $\vec{\nabla} Q = (0, 0, 0)$ is zero. In this case the linear component is parallel to the triangle and must be handled separately.

Line to Triangle

The partitioning of \mathbb{R}^3 yields eight regions. The system of equations from $\vec{\nabla} Q = (0, 0, 0)$ is $A\vec{p} = -\vec{b}$, where $A = [a_{ij}]$, $\vec{b} = [b_j]$, and $\vec{p} = [s \ t \ r]^\mathrm{T}$. The skeleton of the pseudocode to handle the various regions is

```
bool SquaredDistanceLineTriangle (Line line, Triangle triangle)
{
    a00 = Dot(triangle.E0,triangle.E0);
    a01 = Dot(triangle.E0,triangle.E1);
    a02 = -Dot(triangle.E0,line.M);
    a11 = Dot(triangle.E1,triangle.E1);
    a12 = -Dot(triangle.E1,line.M);
    a22 = Dot(line.M,line.M);
    diff = triangle.A - line.B;
    b0 = Dot(triangle.E0,diff);
    b1 = Dot(triangle.E1,diff);
    b2 = -Dot(line.M,diff);
    c = Dot(diff,diff);

    // cofactors to be used for determinant and inversion of
    // matrix A
    cof00 = a11*a22 - a12*a12;
    cof01 = a02*a12 - a01*a22;
    cof02 = a01*a12 - a02*a11;
    det = a00*cof00 + a01*cof01 + a02*cof02;
    if ( det < 0 )
    {
        // avoids having to do dual cases for each region
```

```
            det = -det;
            b0 = -b0;
            b1 = -b1;
            b2 = -b2;
        }

    if ( Positive(det) )
    {
        cof11 = a00*a22 - a02*a02;
        cof12 = a02*a01 - a00*a12;
        s = -(cof00*b0 + cof01*b1 + cof02*b2);
        t = -(cof01*b0 + cof11*b1 + cof12*b2);

        if ( s+t <= det )
        {
            if ( s < 0 ) { if ( t < 0 ) { region 4 } else {
                region 3 } }
            else if ( t < 0 ) { region 5 }
            else { region 0 }
        }
        else
        {
            if ( s < 0 ) { region 2 }
            else if ( t < 0 ) { region 6 }
            else { region 1 }
        }
    }
    else
    {
        // Line is parallel to triangle.  A closest pair of
        // points can be found by computing distance from line
        // to triangle edges (at most three line-to-segment
        // tests).
    }
```

The code `Positive(det)` should be a relative error test on the determinant with an application-specified tolerance. The code for the case when the minimum occurs at an interior point (region 0) is

```
invDet = 1/det;
s = s*invDet;
t = t*invDet;

cof22 = a00*a11 - a01*a01;
r = -(cof02*b0 + cof12*b1 + cof22*b2)*invdet;
```

The other regions involve the recursion in dimension. For example, in the case of region 3, the minimum must occur when $s = 0$. The quadratic function to minimize is $Q_1(t, r) = a_{11}t^2 + a_{22}r^2 + 2a_{12}tr + 2b_1t + 2b_2r + c$ for $(t, r) \in [0, 1] \times \mathbb{R}$. The tr-plane is partitioned into three pieces, an infinite strip and two half planes. The solution (\bar{t}, \bar{r}) to $\vec{\nabla} Q_1 = (0, 0)$ is computed. If it lies in the infinite strip, then the minimum of Q_1 (and hence Q) is found. Otherwise it lies in one of the half planes and the minimum must occur on the corresponding line boundary between the half plane and the infinite strip. This is yet one more recursion in dimension. Suppose that $\bar{t} < 0$. The minimum must occur when $t = 0$. The quadratic function to minimize is $Q_2(r) = a_{22}r^2 + 2b_2r + c$ for $r \in \mathbb{R}$. The solution occurs when $dQ_2/dr = 0$, so $r = -b_2/a_{22}$. Similarly, if $\bar{t} > 1$, the quadratic function to minimize is $a_{22}r^2 + 2(a_{12} + b_2)r + (a_{11} + 2b_1 + c)$, so $r = -(a_{12} + b_2)/a_{22}$. The pseudocode for region 3 is

```
s = 0;
t = a12*b2 - a22*b1;
if ( t >= 0 )
{
    // det = a11*a22-a12*a12 = cof00 =
    // |Cross(triangle.E1,line.M)| > 0
    if ( t <= det )
    {
        invDet = 1/cof00;
        t *= invDet;
        r = (a12*b1 - a22*b2)*invDet;
    }
    else
    {
        t = 1;
        r = -(b2+a12)/a22;
    }
}
else
{
    t = 0;
    r = -b2/a22;
}
```

The determinant is positive since it was already determined by this time that the line is not parallel to the triangle, so it cannot be parallel to an edge of the triangle. The code for the other regions is structured in a similar fashion.

Ray to Triangle and Segment to Triangle

These are straightforward modifications of the line-to-triangle algorithm where the domain of $Q(s, t, r)$ is $D \times [0, \infty)$ or $D \times [0, 1]$. The partitioning of \mathbb{R}^3 for a ray now has 16 components, 8 for $r > 0$ and 8 for $r < 0$. The partitioning for a segment has 24 components, 8 for $r < 0$, 8 for $r \in [0, 1]$, and 8 for $r > 1$. The source code on the CD-ROM contains an implementation of this algorithm.

2.6.5 POINT TO RECTANGLE

SOURCE CODE

LIBRARY

Distance

FILENAME

DistVec3Rct3

The distance algorithm for point to rectangle appears to be nearly the same as the distance algorithm for point to triangle except that the parameter domain is $(s, t) \in [0, 1]^2$. The parameter plane is partitioned into nine regions by the lines $s = 0$, $s = 1$, $t = 0$, and $t = 1$. This partition is shown in Figure 2.1, the lower-right diagram. There is, however, one main difference. If the zero of the gradient of Q occurred in regions 2, 4, or 6 in the partition of the plane by the triangle parameters, then the minimum of Q could occur on one of two edges. For rectangles, this is not the case. If the zero of the gradient of the quadratic is in region 2, then the minimum must occur at the vertex. The same argument is made for regions 4, 6, and 8. Because the edges of the rectangle meet at a right angle, the level sets of the squared-distance function are in fact circles, not ellipses. The closest point on the rectangle to the specified point \vec{P} is obtained by projecting \vec{P} onto the plane of the rectangle; call this point \vec{P}_0. If \vec{P}_0 is inside the rectangle, then it is the closest point. If it is in regions 1, 3, 5, or 7, then the closest point is obtained by projecting \vec{P} onto the rectangle edge for that region. Otherwise, \vec{P}_0 is in one of region 2, 4, 6, or 8, and the closest point is the rectangle vertex of that region.

Let the rectangle be $\vec{B} + s\vec{E}_0 + t\vec{E}_1$ for $(s, t) \in [0, 1]^2$. Define $\vec{D} = \vec{P} - \vec{B}$. The projection onto the plane of the rectangle is $\vec{P}_0 = \vec{P} + s\vec{E}_0 + t\vec{E}_1$, where $s = \vec{D} \cdot \vec{E}_0$ and $t = \vec{D} \cdot \vec{E}_1$. Determination of the correct region and closest point requires a simple analysis of s and t. The pseudocode is

```
float SquaredDistancePointRectangle (Rectangle rectangle,
  Point P)
{
    D = P - rectangle.B;

    s = Dot(rectangle.E0,D);
    if ( s > 0 )
    {
        dot0 = Dot(rectangle.E0,rectangle.E0);
        if ( s < dot0 )
            D = D - (s/dot0)*rectangle.E0;
```

```
            else
                D = D - rectangle.E0;
    }

    t = Dot(rectangle.E1,D);
    if ( t > 0 )
    {
        dot1 = Dot(rectangle.E1,rectangle.E1);
        if ( t < dot1 )
            D = D - (t/dot1)*rectangle.E1;
        else
            D = D - rectangle.E1;
    }

    return Dot(D,D);
}
```

2.6.6 LINEAR COMPONENT TO RECTANGLE

SOURCE CODE

LIBRARY

Distance

FILENAME

DistLin3Rct3

The problem is to compute the minimum distance between a linear component $\vec{L}(r)$ $= \vec{B} + r\vec{M}$ for $r \in I$ and a rectangle $\vec{R}(s,t) = \vec{A} + s\vec{E}_0 + t\vec{E}_1$ for $(s,t) \in D = \{(s,t) : s \in [0,1], t \in [0,1], s+t \le 1\}$. The squared-distance function between a point on the line and a point on the rectangle is $Q(s,t,r) = |\vec{R}(s,t) - \vec{L}(r)|^2$ for $(s,t,r) \in D \times I$, so

$$Q(s,t,r) = a_{00}s^2 + a_{11}t^2 + a_{22}r^2 + 2a_{01}st + 2a_{02}sr + 2a_{12}tr + 2b_0s + 2b_1t$$
$$+ 2b_2r + c,$$

where $a_{00} = \vec{E}_0 \cdot \vec{E}_0$, $a_{11} = \vec{E}_1 \cdot \vec{E}_1$, $a_{22} = \vec{M} \cdot \vec{M}$, $a_{01} = \vec{E}_0 \cdot \vec{E}_1$, $a_{02} = -\vec{E}_0 \cdot \vec{M}$, $a_{12} = -\vec{E}_1 \cdot \vec{M}$, $b_0 = \vec{E}_0 \cdot (\vec{A} - \vec{B})$, $b_1 = \vec{E}_1 \cdot (\vec{A} - \vec{B})$, $b_2 = -\vec{M} \cdot (\vec{A} - \vec{B})$, and $c = (\vec{A} - \vec{B}) \cdot (\vec{A} - \vec{B})$.

The partitioning of \mathbb{R}^3 into regions is similar to that shown in Figure 2.1, the lower-right diagram, except that the regions are extruded along the r-axis and split based on whether I is \mathbb{R}, $[0, \infty)$, or $[0, 1]$. For example, region 0 is an infinite square column (line case), semi-infinite square column (ray case), or cube (segment case). As in the other distance calculation algorithms, if the solution $(\bar{s}, \bar{t}, \bar{r})$ to $\vec{\nabla}Q = (0, 0, 0)$ lies in region 0, then the minimum occurs at an interior point that is determined by the solution. Otherwise, the minimum occurs on a face separating regions. The region that contains the zero gradient solution must be determined and the correct faces between the regions must be analyzed to see which one contains the global minimum. Also analogous to the other algorithms, it is possible that the determinant of the system for

$\vec{\nabla}Q = (0, 0, 0)$ is zero. In this case the linear component is parallel to the rectangle and must be handled separately.

The partitioning of \mathbb{R}^3 yields nine regions. The system of equations from $\vec{\nabla}Q = (0, 0, 0)$ is $A\vec{p} = -\vec{b}$, where $A = [a_{ij}]$, $\vec{b} = [b_j]$, and $\vec{p} = [s\ t\ r]^{\mathrm{T}}$. The skeleton of the pseudocode to handle the various regions is

```
bool SquaredDistanceLineRectangle (Line line, Rectangle
  rectangle)
{
    a00 = Dot(rectangle.E0,rectangle.E0);
    a01 = Dot(rectangle.E0,rectangle.E1);
    a02 = -Dot(rectangle.E0,line.M);
    a11 = Dot(rectangle.E1,rectangle.E1);
    a12 = -Dot(rectangle.E1,line.M);
    a22 = Dot(line.M,line.M);
    diff = rectangle.A - line.B;
    b0 = Dot(rectangle.E0,diff);
    b1 = Dot(rectangle.E1,diff);
    b2 = -Dot(line.M,diff);
    c = Dot(diff,diff);

    // cofactors to be used for determinant and inversion of
    // matrix A
    cof00 = a11*a22 - a12*a12;
    cof01 = a02*a12 - a01*a22;
    cof02 = a01*a12 - a02*a11;
    det = a00*cof00 + a01*cof01 + a02*cof02;
    if ( det < 0 )
    {
        // avoids having to do dual cases for each region
        det = -det;
        b0 = -b0;
        b1 = -b1;
        b2 = -b2;
    }

    if ( Positive(det) )
    {
        cof11 = a00*a22 - a02*a02;
        cof12 = a02*a01 - a00*a12;
        s = -(cof00*b0 + cof01*b1 + cof02*b2);
        t = -(cof01*b0 + cof11*b1 + cof12*b2);
```

```
            if ( s < 0 )
            {
                if ( t < 0 ) { region 6 }
                else if ( t <= det ) { region 5 }
                else { region 4 }
            }
            else if ( s <= det )
            {
                if ( t < 0 ) { region 7 }
                else if ( t <= det ) { region 0 }
                else { region 3 }
            }
            else
            {
                if ( t < 0 ) { region 8 }
                else if ( t <= det ) { region 1 }
                else { region 2 }
            }
        }
        else
        {
            // Line is parallel to rectangle.  A closest pair of
            // points can be found by computing distance from line
            // to rectangle edges (at most four line-to-segment
            // tests).
        }
```

The code Positive(det) should be a relative error test on the determinant with an application-specified tolerance. Code for the various regions is implemented in exactly the way that the line-to-triangle code is built. That code is based on the same recursive descent on dimension that was discussed earlier.

Ray to Rectangle and Segment to Rectangle

These are straightforward modifications of the line-to-rectangle algorithm where the domain of $Q(s, t, r)$ is $D \times [0, \infty)$ or $D \times [0, 1]$. The partitioning of \mathbb{R}^3 for a ray now has 18 components, 9 for $r > 0$ and 9 for $r < 0$. The partitioning for a segment has 27 components, 9 for $r < 0$, 9 for $r \in [0, 1]$, and 9 for $r > 1$. The source code on the CD-ROM contains an implementation of this algorithm.

2.6.7 TRIANGLE TO TRIANGLE

The quadratic function for squared distance between two triangles is $Q(s_0, t_0, s_1, t_1) = |\vec{T}_0(s_0, t_0) - \vec{T}_1(s_1, t_1)|^2$, where $(s_i, t_i) \in D$ for $0 \leq i \leq 1$, the triangular domain defined earlier. The domain of Q is the Cartesian product $D \times D \subset \mathbb{R}^4$. The code structure is straightforward, but there are a lot of cases. Since D partitions \mathbb{R}^2 into 7 regions, $D \times D$ partitions \mathbb{R}^4 into 49 regions. That is the number of cases within the code. The pseudocode is not presented here because it is quite lengthy. The implementation is given in the source code on the CD-ROM.

2.6.8 TRIANGLE TO RECTANGLE

The quadratic function for squared distance between a triangle and a rectangle is $Q(s_0, t_0, s_1, t_1) = |\vec{T}(s_0, t_0) - \vec{R}(s_1, t_1)|^2$, where $(s_0, t_0) \in D$, the triangular domain defined earlier, and $(s_1, t_1) \in [0, 1]^2$. The domain of Q is the Cartesian product $D \times [0, 1]^2 \subset \mathbb{R}^4$. As in the triangle-to-triangle case, the code structure is straightforward, but there are a lot of cases. Since D partitions \mathbb{R}^2 into 7 regions and $[0, 1]^2$ partitions \mathbb{R}^2 into 9 cases, $D \times [0, 1]^2$ partitions \mathbb{R}^4 into 63 regions, again the number of cases within the code. The pseudocode is not presented here, but the implementation is given in the source code on the CD-ROM.

2.6.9 RECTANGLE TO RECTANGLE

The largest chunk of code occurs for this case. The quadratic function for squared distance between two rectangles is $Q(s_0, t_0, s_1, t_1) = |\vec{R}_0(s_0, t_0) - \vec{R}_1(s_1, t_1)|^2$, where $(s_i, t_i) \in [0, 1]^2$ for $0 \leq i \leq 1$. The domain of Q is $[0, 1]^4 \subset \mathbb{R}^4$. Since $[0, 1]$ partitions \mathbb{R}^2 into 9 regions, $[0, 1]^4$ partitions \mathbb{R}^2 into 81 cases, the number of cases within the code. The pseudocode is not presented here as it is quite lengthy. The implementation is given in the source code on the CD-ROM.

2.6.10 POINT TO ORIENTED BOX

The first algorithm treats the box as a solid. Any point inside the box has distance zero from the box. Let the box have center \vec{C}, orthonormal axes \vec{U}_i, and extents e_i. Let the point be written as $\vec{P} = \vec{C} + s_0\vec{U}_0 + s_1\vec{U}_1 + s_2\vec{U}_2$. Solving for the coefficients yields $s_i = \vec{U}_i \cdot (\vec{P} - \vec{C})$ for all i. Depending on the values of (s_0, s_1, s_2) relative to parameter domain $[-e_0, e_0] \times [-e_1, e_1] \times [-e_2, e_2]$, the closest point is either \vec{P} itself, a face point, an edge point, or a vertex. The pseudocode is

```
float SquaredDistancePointSolidBox (Box box, Point P)
{
    D = P - box.C;
    s0 = Dot(box.U0,D);
    s1 = Dot(box.U1,D);
    s2 = Dot(box.U2,D);

    if ( s0 <= -box.e0 )
        D = D + box.e0*box.U0;
    else if ( s0 < box.e0 )
        D = D - s0*box.U0;
    else
        D = D - box.e0*box.U0;

    if ( s1 <= -box.e1 )
        D = D + box.e1*box.U1;
    else if ( s1 < box.e1 )
        D = D - s1*box.U1;
    else
        D = D - box.e1*box.U1;

    if ( s2 <= -box.e2 )
        D = D + box.e2*box.U2;
    else if ( s2 < box.e2 )
        D = D - s2*box.U2;
    else
        D = D - box.e2*box.U2;

    return Dot(D,D);
}
```

For computing the distance from a point to a box treated just as a shell, the algorithm is different for points inside the box. Points outside the box will have the same distance whether we use the previous code or we use the code about to be discussed. For a point \vec{P} inside the box, it must be determined for each pair of parallel faces which of the two faces the point is closest to. This determines to which face the point must be projected in order to find the closest point on the shell. The pseudocode is

```
float SquaredDistancePointHollowBox (Box box, Point P)
{
    D = P - box.C;
    s0 = Dot(box.U0,D);
```

```
s1 = Dot(box.U1,D);
s2 = Dot(box.U2,D);

if ( s0 <= -box.e0 )
{
    D = D + box.e0*box.U0;

    if ( s1 <= -box.e1 )
        D = D + box.e1*box.U1;
    else if ( s1 < box.e1 )
        D = D - s1*box.U1;
    else
        D = D - box.e1*box.U1;

    if ( s2 <= -box.e2 )
        D = D + box.e2*box.U2;
    else if ( s2 < box.e2 )
        D = D - s2*box.U2;
    else
        D = D - box.e2*box.U2;
}
else if ( s0 < box.e0 )
{
    D = D - s0*box.U0;

    if ( s1 <= -box.e1 )
    {
        D = D + box.e1*box.U1;

        if ( s2 <= -box.e2 )
            D = D + box.e2*box.U2;
        else if ( s2 < box.e2 )
            D = D - s2*box.U2;
        else
            D = D - box.e2*box.U2;
    }
    else if ( s1 < box.e1 )
    {
        D = D - s1*box.U1;

        if ( s2 <= -box.e2 )
        {
            D = D + box.e2*box.U2;
        }
```

```
                else if ( s2 < box.e2 )
                {
                    // P is inside the box
                    dist = min(box.e0-|s0|,box.e1-|s1|,box.e2-|s2|);
                    return dist*dist;
                }
                else
                {
                    D = D - box.e2*box.U2;
                }
            }
            else
            {
                D = D - box.e1*box.U1;

                if ( s2 <= -box.e2 )
                    D = D + box.e2*box.U2;
                else if ( s2 < box.e2 )
                    D = D - s2*box.U2;
                else
                    D = D - box.e2*box.U2;
            }
        }
        else
        {
            D = D - box.e0*box.U0;

            if ( s1 <= -box.e1 )
                D = D + box.e1*box.U1;
            else if ( s1 < box.e1 )
                D = D - s1*box.U1;
            else
                D = D - box.e1*box.U1;

            if ( s2 <= -box.e2 )
                D = D + box.e2*box.U2;
            else if ( s2 < box.e2 )
                D = D - s2*box.U2;
            else
                D = D - box.e2*box.U2;
        }

        return Dot(D,D);
    }
```

2.6.11 MISCELLANEOUS

A library of distance calculation methods can be arbitrarily complex. There are many other cases that can arise in an application. Chapter 6 discusses intersections of moving spheres, capsules, or lozenges. Those routines require distance calculations not specifically derived here: parallelogram to point, segment, rectangle, or parallelogram; and parallelepiped to point, segment, rectangle, parallelogram, or parallelepiped. All of these follow the pattern for setting up a quadratic function on a compact set and analyzing the regions obtained by partitioning the parameter space appropriately. Other cases might involve distance from point to quadric surface, distance from point to circle (in 3D) or disk, point to cylinder, line segment to these same quadratic-style objects, ad infinitum. At any rate, such a library is never complete and will continually evolve.

Point to Ellipse

SOURCE CODE

LIBRARY

Distance

FILENAME

DistVec2Elp2

We only need to solve this problem when the ellipse is axis-aligned. Oriented ellipses can be rotated and translated to an axis-aligned ellipse centered at the origin and the distance can be measured in that system. The basic idea can be found in an article by John Hart (on computing distance, but between point and ellipsoid) in *Graphic Gems IV* (Heckbert 1994).

Let (u, v) be the point in question. Let the ellipse be $(x/a)^2 + (y/b)^2 = 1$. The closest point (x, y) on the ellipse to (u, v) must occur so that $(x - u, y - v)$ is normal to the ellipse. Since an ellipse normal is $\vec{\nabla}((x/a)^2 + (y/b)^2) = (x/a^2, y/b^2)$, the orthogonality condition implies that $u - x = t * x/a^2$ and $v - y = t * y/b^2$ for some t. Solving yields $x = a^2 u/(t + a^2)$ and $y = b^2 v/(t + b^2)$. Replacing in the ellipse equation yields

$$\left(\frac{au}{t + a^2}\right)^2 + \left(\frac{bv}{t + b^2}\right)^2 = 1.$$

Multiplying through by the denominators yields the quartic polynomial

$$F(t) = (t + a^2)^2(t + b^2)^2 - a^2 u^2(t + b^2)^2 - b^2 v^2(t + a^2)^2 = 0.$$

The largest root \bar{t} of the polynomial corresponds to the closest point on the ellipse.

A closed-form solution for the roots of a quartic polynomial exists and can be used to compute the largest root. This root also can be found by a Newton's iteration scheme. If (u, v) is inside the ellipse, then $t_0 = 0$ is a good initial guess for the iteration. If (u, v) is outside the ellipse, then $t_0 = \max\{a, b\}\sqrt{u^2 + v^2}$ is a good initial guess. The iteration itself is

$$t_{i+1} = t_i - F(t_i)/F'(t_i), \quad i \geq 0.$$

Some numerical issues need to be addressed. For (u, v) near the coordinate axes, the algorithm is ill-conditioned because of the divisions of values near zero in the equations relating (x, y) to (u, v). Those cases need to be handled separately. Also, if a and b are large, then $F(t_i)$ can be quite large. In these cases consider uniformly scaling the data to $O(1)$ as floating-point numbers first, computing the distance, then rescaling to get the distance in the original coordinates.

Point to Ellipsoid

SOURCE CODE

LIBRARY

Distance

FILENAME

DistVec3Elp3

The method of measuring distance is a straightforward generalization of that for an ellipse. Let (u, v, w) be the point in question. Let the ellipse be $(x/a)^2 + (y/b)^2 + (z/c)^2 = 1$. The closest point (x, y, z) on the ellipsoid to (u, v, w) must occur so that $(x - u, y - v, z - w)$ is normal to the ellipsoid. Since an ellipsoid normal is $\nabla((x/a)^2 + (y/b)^2 + (z/c)^2) = (x/a^2, y/b^2, z/c^2)$, the orthogonality condition implies that $u - x = t * x/a^2$, $v - y = t * y/b^2$, and $w - z = t * z/c^2$ for some t. Solving yields $x = a^2 u/(t + a^2)$, $y = b^2 v/(t + b^2)$, and $z = c^2 w/(t + c^2)$. Replacing in the ellipsoid equation yields

$$\left(\frac{au}{t + a^2}\right)^2 + \left(\frac{bv}{t + b^2}\right)^2 + \left(\frac{cw}{t + c^2}\right)^2 = 1.$$

Multiplying through by the denominators yields the sixth-degree polynomial

$$F(t) = (t + a^2)^2(t + b^2)^2(t + c^2)^2 - a^2 u^2(t + b^2)^2(t + c^2)^2$$
$$- b^2 v^2(t + a^2)^2(t + c^2)^2 - c^2 w^2(t + a^2)^2(t + b^2)^2 = 0.$$

The largest root \bar{t} of the polynomial corresponds to the closest point on the ellipse.

The largest root can be found by a Newton's iteration scheme. If (u, v, w) is inside the ellipse, then $t_0 = 0$ is a good initial guess for the iteration. If (u, v, w) is outside the ellipse, then $t_0 = \max\{a, b, c\}\sqrt{u^2 + v^2 + w^2}$ is a good initial guess. The iteration method is the same as before, $t_{i+1} = t_i - F(t_i)/F'(t_i)$ for $i \geq 0$. The same numerical issues that occur in the ellipse problem need to be addressed for ellipsoids. For (u, v, w) near the coordinate planes, the algorithm is ill-conditioned because of the divisions of values near zero in the equations relating (x, y, z) to (u, v, w). These cases can be handled separately. Also, if a, b, and c are large, $F(t_i)$ can be quite large. In these cases consider uniformly scaling the data to $O(1)$ as floating-point numbers first, computing the distance, then rescaling to get the distance in the original coordinates.

Point to Quadratic Curve or Quadric Surface

SOURCE CODE

LIBRARY

Distance

FILENAME

DistVec2Elp2

DistVec3Elp3

This subsection describes an algorithm for computing the distance from a point in 2D to a general quadratic curve defined implicitly by a second-degree quadratic equation in two variables or from a point in 3D to a general quadric surface defined implicitly by a second-degree quadratic equation in three variables.

The general quadratic equation is

$$Q(\vec{X}) = \vec{X}^T A \vec{X} + \vec{b}^T \vec{X} + c = 0,$$

where A is a symmetric $N \times N$ matrix ($N = 2$ or $N = 3$ not necessarily invertible, for example, in the case of a cylinder or paraboloid), \vec{b} is an $N \times 1$ vector, and c is a scalar. The parameter is \vec{X}, an $N \times 1$ vector. Given the surface $Q(\vec{X}) = 0$ and a point \vec{Y}, find the distance from \vec{Y} to the surface and compute a closest point \vec{X}.

Geometrically, the closest point \vec{X} on the surface to \vec{Y} must satisfy the condition that $\vec{Y} - \vec{X}$ is normal to the surface. Since the surface gradient $\nabla Q(\vec{X})$ is normal to the surface, the algebraic condition for the closest point is

$$\vec{Y} - \vec{X} = t \nabla Q(\vec{X}) = t(2A\vec{X} + \vec{b})$$

for some scalar t. Therefore,

$$\vec{X} = (I + 2tA)^{-1}(\vec{Y} - t\vec{b}),$$

where I is the identity matrix. You could replace this equation for \vec{X} into the general quadratic equation to obtain a polynomial in t of at most sixth degree.

Instead of immediately replacing \vec{X} in the quadratic equation, the problem can be reduced to something simpler to code. Factor A using an eigendecomposition to obtain $A = RDR^T$, where R is an orthonormal matrix whose columns are eigenvectors of A and where D is a diagonal matrix whose diagonal entries are the eigenvalues of A. Then

$$\vec{X} = (I + 2tA)^{-1}(\vec{Y} - t\vec{b})$$

$$= (RR^T + 2t\,RDR^T)^{-1}(\vec{Y} - t\vec{b})$$

$$= [R(I + 2tD)R^T]^{-1}(\vec{Y} - t\vec{b})$$

$$= R(I + 2tD)^{-1}R^T(\vec{Y} - t\vec{b})$$

$$= R(I + 2tD)^{-1}(\vec{\alpha} - t\vec{\beta}),$$

where the last equation defines $\vec{\alpha}$ and $\vec{\beta}$. Replacing in the quadratic equation and simplifying yields

$$0 = (\vec{\alpha} - t\vec{\beta})^{\mathrm{T}}(I + 2tD)^{-1}D(I + 2tD)^{-1}(\vec{\alpha} - t\vec{\beta}) + \vec{\beta}^{\mathrm{T}}(I + 2tD)^{-1}(\vec{\alpha} - t\vec{\beta}) + c.$$

The inverse diagonal matrix is

$$(I + 2tD)^{-1} = \mathrm{diag}\{1/(1 + 2td_0), 1/(1 + 2td_1)\}$$

for 2D or

$$(I + 2tD)^{-1} = \mathrm{diag}\{1/(1 + 2td_0), 1/(1 + 2td_1), 1/(1 + 2td_2)\}$$

for 3D. Multiplying through by $((1 + 2td_0)(1 + 2td_1))^2$ in 2D leads to a polynomial of at most fourth degree. Multiplying through by $((1 + 2td_0)(1 + 2td_1)(1 + 2td_2))^2$ in 3D leads to a polynomial equation of at most sixth degree.

The roots of the polynomial are computed and $\tilde{X} = (I + 2tA)^{-1}(\vec{Y} - t\vec{b})$ is computed for each root t. The distances between \tilde{X} and \vec{Y} are computed and the minimum distance is selected from them.

Point to Circle in 3D

A circle in 3D is represented by a center \vec{C}, a radius R, and a plane containing the circle, $\vec{N} \cdot (\vec{X} - \vec{C}) = 0$, where \vec{N} is a unit length normal to the plane. If \vec{U} and \vec{V} are also unit-length vectors so that \vec{U}, \vec{V}, and \vec{N} form a right-handed orthonormal coordinate system, then the circle is parameterized as

$$\vec{X} = \vec{C} + R(\cos(\theta)\vec{U} + \sin(\theta)\vec{V}) =: \vec{C} + R\vec{W}(\theta)$$

for angles $\theta \in [0, 2\pi)$. Note that $|\vec{X} - \vec{C}| = R$, so the \vec{X} values are all equidistant from \vec{C}. Moreover, $\vec{N} \cdot (\vec{X} - \vec{C}) = 0$ since \vec{U} and \vec{V} are perpendicular to \vec{N}, so the \vec{X} lie in the plane.

For each angle $\theta \in [0, 2\pi)$, the squared distance from a specified point \vec{P} to the corresponding circle point is

$$F(\theta) = |\vec{C} + R\vec{W}(\theta) - \vec{P}|^2 = R^2 + |\vec{C} - \vec{P}|^2 + 2R(\vec{C} - \vec{P}) \cdot \vec{W}.$$

The problem is to minimize $F(\theta)$ by finding θ_0 such that $F(\theta_0) \leq F(\theta)$ for all $\theta \in [0, 2\pi)$. Since F is a periodic and differentiable function, the minimum must occur when $F'(\theta) = 0$. Also, note that $(\vec{C} - \vec{P}) \cdot \vec{W}$ should be negative and as large in magnitude as possible to reduce the right-hand side in the definition of F. The derivative is

$$F'(\theta) = 2R(\vec{C} - \vec{P}) \cdot \vec{W}'(\theta),$$

where $\vec{W} \cdot \vec{W}' = 0$ since $\vec{W} \cdot \vec{W} = 1$ for all θ. The vector \vec{W}' is unit length since $\vec{W}'' = -\vec{W}$ and $0 = \vec{W} \cdot \vec{W}'$ implies $0 = \vec{W} \cdot \vec{W}'' + \vec{W}' \cdot \vec{W}' = -1 + \vec{W}' \cdot \vec{W}'$. Finally, \vec{W}' is perpendicular to \vec{N} since $\vec{N} \cdot \vec{W} = 0$ implies $0 = \vec{N} \cdot \vec{W}'$. All conditions imply that \vec{W} is parallel to the projection of $\vec{P} - \vec{C}$ onto the plane and points in the same direction.

Let \vec{Q} be the projection of \vec{P} onto the plane. Then

$$\vec{Q} - \vec{C} = \vec{P} - \vec{C} - \left(\vec{N} \cdot (\vec{P} - \vec{C}) \right) \vec{N}.$$

The vector $\vec{W}(\theta)$ must be the normalized projection $(\vec{Q} - \vec{C})/|\vec{Q} - \vec{C}|$. The closest point on the circle to \vec{P} is

$$\vec{X} = \vec{C} + R \frac{\vec{Q} - \vec{C}}{|\vec{Q} - \vec{C}|}$$

assuming that $\vec{Q} \neq \vec{C}$. The distance from point to circle is then $|\vec{P} - \vec{X}|$.

If the projection of \vec{P} is exactly the circle center \vec{C}, then all points on the circle are equidistant from \vec{C}. The distance from point to circle is the length of the hypotenuse of any right triangle whose vertices are \vec{C}, \vec{P}, and any circle point. The lengths of the adjacent and opposite triangle sides are R and $|\vec{P} - \vec{C}|$, so the distance from point to circle is $\sqrt{R^2 + |\vec{P} - \vec{C}|^2}$.

Circle to Circle in 3D

SOURCE CODE

LIBRARY

Distance

FILENAME

DistCir3Cir3

The previous subsection described the formulation for a circle in three dimensions. Using this formulation, let the two circles be $\vec{C}_0 + R_0 \vec{W}_0(\theta)$ for $\theta \in [0, 2\pi)$ and $\vec{C}_1 + R_1 \vec{W}_1(\phi)$ for $\phi \in [0, 2\pi)$. The squared distance between any two points on the circles is

$$F(\theta, \phi) = |\vec{C}_1 - \vec{C}_0 + R_1 \vec{W}_1 - R_0 \vec{W}_0|^2$$

$$= |\vec{D}|^2 + R_0^2 + R_1^2 + 2R_1 \vec{D} \cdot \vec{W}_1 - 2R_0 R_1 \vec{W}_0 \cdot \vec{W}_1 - 2R_0 \vec{D} \cdot \vec{W}_0,$$

where $\vec{D} = \vec{C}_1 - \vec{C}_0$. Since F is doubly periodic and continuously differentiable, its global minimum must occur when $\nabla F = (0, 0)$. The partial derivatives are

$$\frac{\partial F}{\partial \theta} = -2R_0 \vec{D} \cdot \vec{W}_0' - 2R_0 R_1 \vec{W}_0' \cdot \vec{W}_1$$

and

$$\frac{\partial F}{\partial \phi} = 2R_1\vec{D} \cdot \vec{W}_1' - 2R_0R_1\vec{W}_0 \cdot \vec{W}_1'.$$

Define $c_0 = \cos(\theta)$, $s_0 = \sin(\theta)$, $c_1 = \cos(\phi)$, and $s_1 = \sin(\phi)$. Then $\vec{W}_0 = c_0\vec{U}_0 + s_0\vec{V}_0$, $\vec{W}_1 = c_1\vec{U}_1 + s_1\vec{V}_1$, $\vec{W}_0' = -s_0\vec{U}_0 + c_0\vec{V}_0$, and $\vec{W}_1' = -s_1\vec{U}_1 + c_1\vec{V}_1$. Setting the partial derivatives equal to zero leads to

$$0 = s_0(a_0 + a_1c_1 + a_2s_1) + c_0(a_3 + a_4c_1 + a_5s_1)$$

$$0 = s_1(b_0 + b_1c_0 + b_2s_0) + c_1(b_3 + b_4c_0 + b_5s_0),$$

where

$$a_0 = -\vec{D} \cdot \vec{U}_0, a_1 = -R_1\vec{U}_0 \cdot \vec{U}_1, a_2 = -R_1\vec{U}_0 \cdot \vec{V}_1, a_3 = \vec{D} \cdot \vec{V}_0, a_4 = R_1\vec{U}_1 \cdot \vec{V}_0,$$

$$a_5 = R_1\vec{V}_0 \cdot \vec{V}_1,$$

$$b_0 = -\vec{D} \cdot \vec{U}_1, b_1 = R_0\vec{U}_0 \cdot \vec{U}_1, b_2 = R_0\vec{U}_1 \cdot \vec{V}_0, b_3 = \vec{D} \cdot \vec{V}_1, b_4 = -R_0\vec{U}_0 \cdot \vec{V}_1,$$

$$b_5 = -R_0\vec{V}_0 \cdot \vec{V}_1.$$

In matrix form,

$$\begin{bmatrix} m_{00} & m_{01} \\ m_{10} & m_{11} \end{bmatrix}\begin{bmatrix} s_0 \\ c_0 \end{bmatrix} = \begin{bmatrix} a_0 + a_1c_1 + a_2s_1 & a_3 + a_4c_1 + a_5s_1 \\ b_2s_1 + b_5c_1 & b_1s_1 + b_4c_1 \end{bmatrix}\begin{bmatrix} s_0 \\ c_0 \end{bmatrix}$$

$$= \begin{bmatrix} 0 \\ -(b_0s_1 + b_3c_1) \end{bmatrix} = \begin{bmatrix} 0 \\ \lambda \end{bmatrix}.$$

Let M denote the 2×2 matrix on the left-hand side of the equation. Multiplying by the adjoint of M yields

$$\det(M)\begin{bmatrix} s_0 \\ c_0 \end{bmatrix} = \begin{bmatrix} m_{11} & -m_{01} \\ -m_{10} & m_{00} \end{bmatrix}\begin{bmatrix} 0 \\ \lambda \end{bmatrix} = \begin{bmatrix} -m_{01}\lambda \\ m_{00}\lambda \end{bmatrix}. \tag{2.17}$$

Summing the squares of the vector components and using $s_0^2 + c_0^2 = 1$ yields

$$(m_{00}m_{11} - m_{01}m_{10})^2 = \lambda^2\left(m_{00}^2 + m_{01}^2\right).$$

The above equation can be reduced to a polynomial of degree 8 whose roots $c_1 \in [-1, 1]$ are the candidates to provide the global minimum of F. Formally computing the determinant and using $s_1^2 = 1 - c_1^2$ leads to

$$m_{00}m_{11} - m_{01}m_{10} = p_0(c_1) + s_1p_1(c_1),$$

where $p_0(z) = \sum_{i=0}^{2} p_{0i}z^i$ and $p_1(z) = \sum_{i=0}^{1} p_{1i}z$. The coefficients are

$p_{00} = a_2b_1 - a_5b_2$

$p_{01} = a_0b_4 - a_3b_5$

$p_{02} = a_5b_2 - a_2b_1 + a_1b_4 - a_4b_5$

$p_{10} = a_0b_1 - a_3b_2$

$p_{11} = a_1b_1 - a_5b_5 + a_2b_4 - a_4b_2.$

Similarly,

$$m_{00}^2 + m_{01}^2 = q_0(c_1) + s_1q_1(c_1),$$

where $q_0(z) = \sum_{i=0}^{2} q_{0i}z^i$ and $q_1(z) = \sum_{i=0}^{1} q_{1i}z$. The coefficients are

$q_{00} = a_0^2 + a_2^2 + a_3^2 + a_5^2$

$q_{01} = 2(a_0a_1 + a_3a_4)$

$q_{02} = a_1^2 - a_2^2 + a_4^2 - a_5^2$

$q_{10} = 2(a_0a_2 + a_3a_5)$

$q_{11} = 2(a_1a_2 + a_4a_5).$

Finally,

$$\lambda^2 = r_0(c_1) + s_1r_1(c_1),$$

where $r_0(z) = \sum_{i=0}^{2} r_{0i}z^i$ and $r_1(z) = \sum_{i=0}^{1} r_{1i}z$. The coefficients are

$r_{00} = b_0^2$

$r_{01} = 0$

$r_{02} = b_3^2 - b_0^2$

$r_{10} = 0$

$r_{11} = 2b_0b_3.$

Combining these yields

$$0 = \left[(p_0^2 - r_0q_0) + (1 - c_1^2)(p_1^2 - r_1q_1) \right] + s_1 \left[2p_0p_1 - r_0q_1 - r_1q_0 \right]$$

$$= g_0(c_1) + s_1g_1(c_1), \tag{2.18}$$

where $g_0(z) = \sum_{i=0}^{4} g_{0i} z^i$ and $g_1(z) = \sum_{i=0}^{3} g_{1i} z^i$. The coefficients are

$$g_{00} = p_{00}^2 + p_{10}^2 - q_{00} r_{00}$$

$$g_{01} = 2(p_{00} p_{01} + p_{10} p_{11}) - q_{01} r_{00} - q_{10} r_{11}$$

$$g_{02} = p_{01}^2 + 2 p_{00} p_{02} + p_{11}^2 - p_{10}^2 - q_{02} r_{00} - q_{00} r_{02} - q_{11} r_{11}$$

$$g_{03} = 2(p_{01} p_{02} - p_{10} p_{11}) - q_{01} r_{02} + q_{10} r_{11}$$

$$g_{04} = p_{02}^2 - p_{11}^2 - q_{02} r_{02} + q_{11} r_{11}$$

$$g_{10} = 2 p_{00} p_{10} - q_{10} r_{00}$$

$$g_{11} = 2(p_{01} p_{10} + p_{00} p_{11}) - q_{11} r_{00} - q_{00} r_{11}$$

$$g_{12} = 2(p_{02} p_{10} + p_{01} p_{11}) - q_{10} r_{02} - q_{01} r_{11}$$

$$g_{13} = 2 p_{02} p_{11} - q_{11} r_{02} - q_{02} r_{11}.$$

The s_1 term can be eliminated by solving $g_0 = -s_1 g_1$ and squaring to obtain

$$0 = g_0^2 - (1 - c_1^2) g_1^2 = h(c_1),$$

where $h(z) = \sum_{i=0}^{8} h_i z^i$. The coefficients are

$$h_0 = g_{00}^2 - g_{10}^2$$

$$h_1 = 2(g_{00} g_{01} - g_{10} g_{11})$$

$$h_2 = g_{01}^2 + g_{10}^2 - g_{11}^2 + 2(g_{00} g_{02} - g_{10} g_{12})$$

$$h_3 = 2(g_{01} g_{02} + g_{00} g_{03} + g_{10} g_{11} - g_{11} g_{12} - g_{10} g_{13})$$

$$h_4 = g_{02}^2 + g_{11}^2 - g_{12}^2 + 2(g_{01} g_{03} + g_{00} g_{04} + g_{10} g_{12} - g_{11} g_{13})$$

$$h_5 = 2(g_{02} g_{03} + g_{01} g_{04} + g_{11} g_{12} + g_{10} g_{13} - g_{12} g_{13})$$

$$h_6 = g_{03}^2 + g_{12}^2 - g_{13}^2 + 2(g_{02} g_{04} + g_{11} g_{13})$$

$$h_7 = 2(g_{03} g_{04} + g_{12} g_{13})$$

$$h_8 = g_{04}^2 + g_{13}^2.$$

To find the minimum squared distance, all the real-valued roots of $h(c_1) = 0$ are computed. For each c_1, compute $s_1 = \pm\sqrt{1 - c_1^2}$ and choose either (or both)

of these that satisfies Equation (2.18). For each pair (c_1, s_1), solve for (c_0, s_0) in Equation (2.17). The main numerical issue to deal with is how close to zero is $\det(M)$.

Ellipse to Ellipse in 3D

An ellipse in 3D is represented by a center \vec{C}, unit-length axes \vec{U} and \vec{V} with corresponding axis lengths a and b, and a plane containing the ellipse, $\vec{N} \cdot (\vec{X} - \vec{C}) = 0$, where \vec{N} is a unit length normal to the plane. The vectors \vec{U}, \vec{V}, and \vec{N} form a right-handed orthonormal coordinate system. The ellipse is parameterized as

$$\vec{X} = \vec{C} + a\,\cos(\theta)\vec{U} + b\,\sin(\theta)\vec{V}$$

for angles $\theta \in [0, 2\pi)$. The ellipse is also defined by the two polynomial equations

$$\vec{N} \cdot (\vec{X} - \vec{C}) = 0$$

$$(\vec{X} - \vec{C})^{\mathrm{T}} \left(\frac{\vec{U}\vec{U}^{\mathrm{T}}}{a^2} + \frac{\vec{V}\vec{V}^{\mathrm{T}}}{b^2} \right) (\vec{X} - \vec{C}) = 1,$$

where the last equation is written as a quadratic form. The first equation defines a plane, and the second equation defines an ellipsoid. The intersection of plane and ellipsoid is an ellipse.

Solution as Polynomial System

The two ellipses are $\vec{N}_0 \cdot (\vec{X} - \vec{C}_0) = 0$ and $(\vec{X} - \vec{C}_0)^{\mathrm{T}} A_0 (\vec{X} - \vec{C}_0) = 1$, where $A_0 = \vec{U}_0\vec{U}_0^{\mathrm{T}}/a_0^2 + \vec{V}_0\vec{V}_0^{\mathrm{T}}/b_0^2$, and $\vec{N}_1 \cdot (\vec{Y} - \vec{C}_1) = 0$ and $(\vec{Y} - \vec{C}_1)^{\mathrm{T}} A_1 (\vec{Y} - \vec{C}_1) = 1$, where $A_1 = \vec{U}_1\vec{U}_1^{\mathrm{T}}/a_1^2 + \vec{V}_1\vec{V}_1^{\mathrm{T}}/b_1^2$.

The problem is to minimize the squared distance $|\vec{X} - \vec{Y}|^2$ subject to the four constraints mentioned above. The problem can be solved with the method of Lagrange multipliers (Thomas and Finney 1988). Introduce four new parameters, α, β, γ, and δ, and minimize

$$F(\vec{X}, \vec{Y}; \alpha, \beta, \gamma, \delta) = |\vec{X} - \vec{Y}|^2 + \alpha((\vec{X} - \vec{C}_0)^{\mathrm{T}} A_0 (\vec{X} - \vec{C}_0) - 1)$$

$$+ \beta(\vec{N}_0 \cdot (\vec{X} - \vec{C}_0) - 0) + \gamma((\vec{Y} - \vec{C}_1)^{\mathrm{T}} A_1 (\vec{Y} - \vec{C}_1) - 1)$$

$$+ \delta(\vec{N}_1 \cdot (\vec{Y} - \vec{C}_1) - 0).$$

Taking derivatives yields

$$F_{\vec{X}} = 2(\vec{X} - \vec{Y}) + 2\alpha A_0(\vec{X} - \vec{C}_0) + \beta \vec{N}_0$$

$$F_{\vec{Y}} = -2(\vec{X} - \vec{Y}) + 2\gamma A_1(\vec{Y} - \vec{C}_1) + \delta \vec{N}_1$$

$$F_{\alpha} = (\vec{X} - \vec{C}_0)^{\mathrm{T}} A_0(\vec{X} - \vec{C}_0) - 1$$

$$F_{\beta} = \vec{N}_0 \cdot (\vec{X} - \vec{C}_0)$$

$$F_{\gamma} = (\vec{Y} - \vec{C}_1)^{\mathrm{T}} A_1(\vec{Y} - \vec{C}_1) - 1$$

$$F_{\delta} = \vec{N}_1 \cdot (\vec{Y} - \vec{C}_1).$$

Setting the last four equations to zero yields the four original constraints. Setting the first equation to the zero vector and multiplying by $(\vec{X} - \vec{C}_0)^{\mathrm{T}}$ yields

$$\alpha = -2(\vec{X} - \vec{C}_0)^{\mathrm{T}}(\vec{X} - \vec{Y}).$$

Setting the first equation to the zero vector and multiplying by \vec{N}_0^{T} yields

$$\beta = -2\vec{N}_0^{\mathrm{T}}(\vec{X} - \vec{Y}).$$

Similar manipulations of the second equation yield

$$\gamma = 2(\vec{Y} - \vec{C}_1)^{\mathrm{T}}(\vec{X} - \vec{Y})$$

and

$$\delta = 2\vec{N}_1^{\mathrm{T}}(\vec{X} - \vec{Y}).$$

The first two derivative equations become

$$M_0(\vec{X} - \vec{Y}) = \left(\vec{N}_0 \vec{N}_0^{\mathrm{T}} + A_0(\vec{X} - \vec{C}_0)(\vec{X} - \vec{C}_0)^{\mathrm{T}} - I \right) (\vec{X} - \vec{Y}) = \vec{0}$$

$$M_1(\vec{X} - \vec{Y}) = \left(\vec{N}_1 \vec{N}_1^{\mathrm{T}} + A_1(\vec{Y} - \vec{C}_1)(\vec{Y} - \vec{C}_1)^{\mathrm{T}} - I \right) (\vec{X} - \vec{Y}) = \vec{0}.$$

Observe that $M_0 \vec{N}_0 = \vec{0}$, $M_0 A_0(\vec{X} - \vec{C}_0) = \vec{0}$, and $M_0(\vec{N}_0 \times (\vec{X} - \vec{C}_0)) = -\vec{N}_0 \times (\vec{X} - \vec{C}_0)$. Therefore, $M_0 = -\vec{W}_0 \vec{W}_0^{\mathrm{T}}/|\vec{W}_0|^2$, where $\vec{W}_0 = \vec{N}_0 \times (\vec{X} - \vec{C}_0)$. Similarly, $M_1 = -\vec{W}_1 \vec{W}_1^{\mathrm{T}}/|\vec{W}_1|^2$, where $\vec{W}_1 = \vec{N}_1 \times (\vec{Y} - \vec{C}_1)$. The previous displayed equations are equivalent to $\vec{W}_0^{\mathrm{T}}(\vec{X} - \vec{Y}) = 0$ and $\vec{W}_1^{\mathrm{T}}(\vec{X} - \vec{Y}) = 0$.

The points $\vec{X} = (x_0, x_1, x_2)$ and $\vec{Y} = (y_0, y_1, y_2)$ that attain minimum distance between the two ellipses are solutions to six quadratic equations in six unknowns:

$$p_0(x_0, x_1, x_2) = \vec{N}_0 \cdot (\vec{X} - \vec{C}_0) = 0$$

$$p_1(x_0, x_1, x_2) = (\vec{X} - \vec{C}_0)^{\mathrm{T}} A_0 (\vec{X} - \vec{C}_0) = 1$$

$$p_2(x_0, x_1, x_2, y_0, y_1, y_2) = (\vec{X} - \vec{Y}) \cdot \vec{N}_0 \times (\vec{X} - \vec{C}_0) = 0$$

$$q_0(y_0, y_1, y_2) = \vec{N}_1 \cdot (\vec{Y} - \vec{C}_1) = 0$$

$$q_1(y_0, y_1, y_2) = (\vec{Y} - \vec{C}_1)^{\mathrm{T}} A_1 (\vec{Y} - \vec{C}_1) = 1$$

$$q_2(x_0, x_1, x_2, y_0, y_1, y_2) = (\vec{X} - \vec{Y}) \cdot \vec{N}_1 \times (\vec{Y} - \vec{C}_1) = 0.$$

On a computer algebra system that supports the resultant operation for eliminating polynomial variables, the following set of operations leads to a polynomial in one variable. Let resultant$[P, Q, z]$ denote the resultant of polynomials P and Q where the variable z is eliminated (for information on resultants, see Wee and Goldman 1995a, 1995b):

$$r_0(x_0, x_1, y_0, y_1, y_2) = \text{resultant}[p_0, p_2, x_2]$$

$$r_1(x_0, x_1) = \text{resultant}[p_1, p_2, x_2]$$

$$r_2(x_0, x_1, y_0, y_1) = \text{resultant}[r_0, q_2, y_2]$$

$$s_0(x_0, x_1, x_2, y_0, y_1) = \text{resultant}[q_0, q_2, y_2]$$

$$s_1(y_0, y_1) = \text{resultant}[q_1, q_2, y_2]$$

$$s_2(x_0, x_1, y_0, y_1) = \text{resultant}[s_0, p_2, x_2]$$

$$r_3(x_0, y_0, x_1) = \text{resultant}[r_2, r_1, x_1]$$

$$r_4(x_0, y_0) = \text{resultant}[r_3, s_1, y_1]$$

$$s_3(x_0, x_1, y_0) = \text{resultant}[s_2, s_1, y_1]$$

$$s_4(x_0, y_0) = \text{resultant}[s_3, r_1, x_1]$$

$$\phi(x_0) = \text{resultant}[r_4, s_4, y_0].$$

For two circles, the degree of ϕ is 8. For a circle and an ellipse, the degree of ϕ is 12. For two ellipses, the degree of ϕ is 16.

Trigonometric Solution

Let the two ellipses be

$$\vec{X} = \vec{C}_0 + a_0 \cos(\theta) \vec{U}_0 + b_0 \sin(\theta) \vec{V}_0$$

$$\vec{Y} = \vec{C}_1 + a_1 \cos(\phi) \vec{U}_1 + b_1 \sin(\phi) \vec{V}_1$$

for $\theta \in [0, 2\pi)$ and $\phi \in [0, 2\pi)$. The squared distance between any two points on the ellipses is $F(\theta, \phi) = |\vec{X}(\theta) - \vec{Y}(\phi)|^2$. The problem is to minimize $F(\theta, \phi)$.

Define $c_0 = \cos(\theta)$, $s_0 = \sin(\theta)$, $c_1 = \cos(\phi)$, and $s_1 = \sin(\phi)$. Compute derivatives $F_\theta = (\vec{X}(\theta) - \vec{Y}(\phi)) \cdot \vec{X}'(\theta)$ and $F_\phi = -(\vec{X}(\theta) - \vec{Y}(\phi)) \cdot \vec{Y}'(\phi)$. Setting these equal to zero leads to the two polynomial equations in c_0, s_0, c_1, and s_1. The two polynomial constraints for the sines and cosines are also listed:

$$p_0 = (a_0^2 - b_0^2)s_0c_0 + a_0(\alpha_{00} + \alpha_{01}s_1 + \alpha_{02}c_1)s_0 + b_0(\beta_{00} + \beta_{01}s_1 + \beta_{02}c_1)c_0 = 0$$

$$p_1 = (a_1^2 - b_1^2)s_1c_1 + a_1(\alpha_{10} + \alpha_{11}s_0 + \alpha_{12}c_0)s_1 + b_1(\beta_{10} + \beta_{11}s_0 + \beta_{12}c_0)c_1 = 0$$

$$q_0 = s_0^2 + c_0^2 - 1 = 0$$

$$q_1 = s_1^2 + c_1^2 - 1 = 0.$$

This is a system of four quadratic polynomial equations in four unknowns and can be solved with resultants:

$$r_0(s_0, s_1, c_1) = \text{resultant}[p_0, q_0, c_0]$$

$$r_1(s_0, s_1, c_0) = \text{resultant}[p_1, q_1, c_1]$$

$$r_2(s_0, s_1) = \text{resultant}[r_0, q_1, c_1]$$

$$r_3(s_0, s_1) = \text{resultant}[r_1, q_0, c_0]$$

$$\phi(s_0) = \text{resultant}[r_2, r_3, s_1].$$

Alternatively, we can use the simple nature of q_0 and q_1 to do some of the elimination. Let $p_0 = \alpha_0 s_0 + \beta_0 c_0 + \gamma_0 s_0 c_0$, where α_0 and β_0 are linear polynomials in s_1 and c_1. Similarly, $p_1 = \alpha_1 s_1 + \beta_1 c_1 + \gamma_1 s_1 c_1$, where α_1 and β_1 are linear polynomials in s_0 and c_0. Solving for c_0 in $p_0 = 0$ and c_1 in $p_1 = 0$, squaring, and using the q_i constraints leads to

$$r_0 = (1 - s_0^2)(\gamma_0 s_0 + \beta_0)^2 - \alpha_0^2 s_0^2 = 0$$

$$r_1 = (1 - s_1^2)(\gamma_1 s_1 + \beta_1)^2 - \alpha_1^2 s_1^2 = 0.$$

Using the q_i constraints, write $r_i = r_{i0} + r_{i1}c_{1-i}$, $i = 0, 1$, where the r_{ij} are polynomials in s_0 and s_1. The terms r_{i0} are degree 4 and the terms r_{i1} are degree 3. Solving for c_0 in $r_1 = 0$ and c_1 in $r_0 = 0$, squaring, and using the q_i constraints leads to

$$w_0 = (1 - s_1^2)r_{01}^2 - r_{00}^2 = \sum_{j=0}^{8} w_{0j}s_0^j = 0$$

$$w_1 = (1 - s_0^2)r_{11}^2 - r_{10}^2 = \sum_{j=0}^{4} w_{1j}s_0^j = 0.$$

The coefficients w_{ij} are polynomials in s_1. The degrees of w_{00} through w_{08}, respectively, are 4, 3, 4, 3, 4, 3, 2, 1, and 0. The degree of w_{1j} is $8 - j$. The total degree for each of w_i is 8.

The final elimination can be computed using a Bézout determinant, $\phi(s_1) = \det[e_{ij}]$, where the underlying matrix is 8×8 and the entry is

$$e_{ij} = \sum_{k=\max(9-i,9-j)}^{\min(8,17-i-j)} v_{k,17-i-j-k},$$

where $v_{i,j} = w_{0i}w_{1j} - w_{0j}w_{1i}$. If the i or j index is out of range in the w terms, then the term is assumed to be zero. The solutions to $\phi = 0$ are the candidate points for s_1. For each s_1, two c_1 values are computed using $s_1^2 + c_1^2 = 1$. For each s_1, the roots of the polynomial $w_1(s_0)$ are computed. For each s_0, two c_0 values are computed using $s_0^2 + c_0^2 = 1$. Out of all such candidates, $|\vec{X} - \vec{Y}|^2$ can be computed and the minimum value is selected.

Numerical Solution

Neither algebraic method above seems reasonable. Each looks very slow to compute, and the usual numerical problems with polynomials of large degree must be handled. An iterative alternative is to implement a distance calculator for point to ellipse in three dimensions. This involves a function of a single parameter, say, $F(\theta)$ for $\theta \in [0, 2\pi]$. Use a numerical minimizer that does not require derivative calculation (Powell's method, for example) and minimize F on the interval $[0, 2\pi]$. The scheme is iterative and should converge rapidly to the solution.

THE GRAPHICS PIPELINE

In a nutshell, a game engine is responsible for managing the data and artistic content of the game and deciding *what* to draw on the computer screen and *how* to draw it. The decisions are made at both a high and a low level. The high-level decisions are handled by the game AI and by a scene graph management system. Game AI is specific to the game itself and is not discussed in this book. Scene graph management is a general topic that applies to most games and is discussed in this book. Chapter 4 provides the foundations for scene graphs and their manipulation. Chapters 5 through 12 cover specific types of objects and algorithms that are part of the scene graph system.

The low-level decisions on what and how to draw are the topic of this chapter. Aspiring game programmers invariably want to implement a *renderer* whose job it is to draw objects in the 3D world on a 2D computer screen. At first glance, building a renderer appears to be an easy task, but the frequency of questions occurring in the graphics newsgroups about how to build a renderer is evidence that the task can be quite formidable. The main goal of this chapter is to describe the three responsibilities of a renderer; examining each responsibility in turn should make it easier to understand how to implement a renderer.

The first responsibility of a renderer is to transform the 3D data in world space into 3D data in view space, the latter specified by a *camera model*. View space provides

a convenient coordinate system that supports the decision on what to draw. A second transformation converts the data in view space to 2D data in screen space, a process called *projection*. In this form the data can be drawn as pixels on the computer screen. Sections 3.1, 3.2, and 3.3 describe the various spaces and the transformations between them.

The second responsibility of a renderer is to eliminate portions of the data that are not visible to the observer whose location is specified as part of the camera model. This involves the concepts of *culling* (a process that determines if an object is completely out of view) and *clipping* (a process that splits an object into smaller pieces, some of them visible; the invisible pieces are discarded by the renderer, and the visible pieces are further processed). Section 3.4 describes culling and clipping in general terms. Section 3.7 contains a specific algorithm for clipping that is quite efficient.

The third responsibility of a renderer is to draw the 2D data that has been transformed to screen space. This process is called rasterization and the component of the renderer that does the work is called a rasterizer. The majority of time for rendering is spent in the rasterizer. Current-generation graphics cards are designed to accelerate the rasterization, but it is possible to implement one that uses only the CPU. Sections 3.5 and 3.6 describe the ideas of rasterization, including how to compute the final colors of the pixels based on various effects such as lighting, materials, textures, transparency, and fogging. A discussion of higher-level special effects is found in Chapter 13, but the application of these effects is usually the responsibility of the scene graph management system.

3.1 MODEL AND WORLD COORDINATES

Artists develop most game content in coordinate systems specific to each model, called the *model coordinate system*. In a typical game, many objects are built. Each must be placed relative to the other objects by applying transformations (translation, scaling, orientation). Moreover, the transformations that position and orient an object might be relative to another object, not to the final *world coordinate system* of the game. A hierarchical organization of data, a topic described in Chapter 4, becomes essential at this point. For each object to be drawn, the hierarchical organization provides a single transformation that converts the model coordinate system of the object into the world coordinate system. Once in world coordinates, the data can be further transformed into view space coordinates and projected onto the viewing plane. Section 3.2 defines and discusses perspective projection. View space and viewing planes are considered in Section 3.3.

3.2 PERSPECTIVE PROJECTION

Consider a point \vec{E}, called the *eye point*, and a plane $\vec{N} \cdot \vec{X} = d$, called the *view plane*, not containing the point. Without loss of generality, assume that \vec{E} is on the positive

side of the plane; that is, $\vec{N} \cdot \vec{E} > d$. The *perspective projection* of a point $\overset{\cdot}{X}$ onto the view plane is the intersection of the ray starting at \vec{E} that also contains $\overset{\cdot}{X}$. The projection exists as long as $\vec{N} \cdot \vec{E} > \vec{N} \cdot \overset{\cdot}{X}$. If $\vec{Y} = (1 - t)\vec{E} + t\vec{X}$ is the projection, then, since it lies on the plane, it must be that $\vec{N} \cdot \vec{Y} = d$. This equation can be solved for t to obtain

$$t = \frac{\vec{N} \cdot \vec{E} - d}{\vec{N} \cdot \vec{E} - \vec{N} \cdot \vec{X}}. \tag{3.1}$$

Both the numerator and denominator are positive, so $t > 0$ is necessary. A canonical model for perspective projection makes it somewhat easier to express the concepts. Let the eye point be the origin $\vec{E} = (0, 0, 0)$, and let the view plane be $z = n > 0$. The plane normal is $\vec{N} = (0, 0, -1)$, and the plane constant is $d = -n$. Equation (3.1) yields $t = n/z$. The perspective projection of (x, y, z) onto the view plane is $(nx/z, ny/z, n)$. Because the view plane remains fixed at $z = n$, the projected points can be written as 2-tuples, $(nx/z, ny/z)$. A convenient variable to define is $w = z/n$. The view plane is $w = 1$, and the projected point is $(x/w, y/w)$.

3.2.1 LINES PROJECT TO LINES

In perspective projections, line segments are projected to line segments. Consider a line segment with end points $\vec{Q}_i = (x_i, y_i, z_i)$ for $i = 0, 1$. Let the corresponding projected points be $\vec{P}_i = (x_i/w_i, y_i/w_i)$ with $w_i = z_i/n$ for $i = 0, 1$. The 3D line segment is $\vec{Q}(s) = \vec{Q}_0 + s(\vec{Q}_1 - \vec{Q}_0)$ for $s \in [0, 1]$. For each s, let $\vec{P}(s)$ be the projection of $\vec{Q}(s)$. Thus,

$$\vec{Q}(s) = (x_0 + s(x_1 - x_0), y_0 + s(y_1 - y_0), z_0 + s(z_1 - z_0))$$

and

$$\vec{P}(s) = \left(\frac{x_0 + s(x_1 - x_0)}{w_0 + s(w_1 - w_0)}, \frac{y_0 + s(y_1 - y_0)}{w_0 + s(w_1 - w_0)} \right)$$

$$= \left(\frac{x_0}{w_0} + \frac{w_1 s}{w_0 + (w_1 - w_0)s} \left(\frac{x_1}{w_1} - \frac{x_0}{w_0} \right), \frac{y_0}{w_0} \right.$$

$$\left. + \frac{w_1 s}{w_0 + (w_1 - w_0)s} \left(\frac{y_1}{w_1} - \frac{y_0}{w_0} \right) \right)$$

$$= \vec{P}_0 + \frac{w_1 s}{w_0 + (w_1 - w_0)s} (\vec{P}_1 - \vec{P}_0).$$

$$= \vec{P}_0 + \bar{s}(\vec{P}_1 - \vec{P}_0),$$

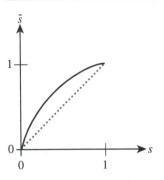

Figure 3.1 Relationship between s and \bar{s}.

where the last equality defines

$$\bar{s} = \frac{w_1 s}{w_0 + (w_1 - w_0)s},$$

(3.2)

a quantity that is also in the interval $[0, 1]$. We have obtained a parametric equation for a 2D line segment with end points \vec{P}_0 and \vec{P}_1, so in fact line segments are projected to line segments. It is possible that the projected segment is a single point, a degenerate case. The inverse mapping $s(\bar{s})$ is actually important for perspectively correct rasterization, as we will see later:

$$s = \frac{w_0 \bar{s}}{w_1 + (w_0 - w_1)\bar{s}}.$$

(3.3)

Equation (3.2) has more to say about perspective projection. Assuming $w_1 > w_0$, a uniform change in s does not result in a uniform change in \bar{s}. The graph of $\bar{s} = F(s)$ is shown in Figure 3.1. The first derivative is $F'(s) = w_0 w_1 / [w_0 + s(w_1 - w_0)]^2 > 0$, and the second derivative is $F''(s) = -2w_0 w_1 / [w_0 + s(w_1 - w_0)]^3 < 0$. The slopes of the graph at the end points are $F'(0) = w_1 / w_0 > 1$ and $F'(1) = w_0 / w_1 < 1$. Since the second derivative is always negative, the graph is concave. An intuitive interpretation is to select a set of uniformly spaced points on the 3D line segment. The projections of these points are not uniformly spaced. More specifically, the spacing between the projected points decreases as \bar{s} increases from 0 to 1. The relationship between s and \bar{s} and limited floating-point precision are what contribute to depth buffering artifacts, to be discussed later.

3.2.2 TRIANGLES PROJECT TO TRIANGLES

Because line segments project to line segments, we can immediately assume that triangles project to triangles, although possibly degenerating to a line segment. However, let's derive the parametric relationships that are analogous to those of Equations (3.2) and (3.3) anyway.

Let $\vec{Q}_i = (x_i, y_i, z_i)$ for $i = 0, 1, 2$ be the vertices of a triangle. The triangle is specified parametrically as $\vec{Q}(s, t) = \vec{Q}_0 + s(\vec{Q}_1 - \vec{Q}_0) + t(\vec{Q}_2 - \vec{Q}_0)$ for $0 \le s \le 1$, $0 \le t \le 1$, and $s + t \le 1$. Let the projected points for the \vec{Q}_i be $\vec{P}_i = (x_i/w_i, y_i/w_i)$ for $i = 0, 1, 2$. For each s and t, let $\vec{P}(s, t)$ be the projection of $\vec{Q}(s, t)$. Some algebra will show that

$$\vec{P}(s, t) = \left(\frac{x_0 + s(x_1 - x_0) + t(x_2 - x_0)}{w_0 + s(w_1 - w_0) + t(w_2 - w_0)}, \frac{y_0 + s(y_1 - y_0) + t(y_2 - y_0)}{w_0 + s(w_1 - w_0) + t(w_2 - w_0)} \right)$$

$$= \left(\frac{x_0}{w_0} + \frac{w_1 s}{w_0 + (w_1 - w_0)s + (w_2 - w_0)t} \left(\frac{x_1}{w_1} - \frac{x_0}{w_0} \right), \frac{y_0}{w_0} \right.$$

$$\left. + \frac{w_1 s}{w_0 + (w_1 - w_0)s + (w_2 - w_0)t} \left(\frac{y_1}{w_1} - \frac{y_0}{w_0} \right) \right)$$

$$= \vec{P}_0 + \frac{w_1 s}{w_0 + (w_1 - w_0)s + (w_2 - w_0)t} (\vec{P}_1 - \vec{P}_0)$$

$$+ \frac{w_2 t}{w_0 + (w_1 - w_0)s + (w_2 - w_0)t} (\vec{P}_2 - \vec{P}_0).$$

Define

$$\left(\bar{s}(s, t), \bar{t}(s, t) \right) = \frac{(w_1 s, w_2 t)}{w_0 + (w_1 - w_0)s + (w_2 - w_0)t}. \tag{3.4}$$

The inverse mapping can be used by the rasterizers for perspectively correct triangle rasterization. The inverse is

$$\left(s(\bar{s}, \bar{t}), t(\bar{s}, \bar{t}) \right) = \frac{(w_0 w_2 \bar{s}, w_0 w_1 \bar{t})}{w_1 w_2 + w_2 (w_0 - w_1) \bar{s} + w_1 (w_0 - w_2) \bar{t}}. \tag{3.5}$$

3.2.3 CONICS PROJECT TO CONICS

Showing that the projection of a conic section is itself a conic section requires a bit more algebra. Let $\vec{Q}_i = (x_i, y_i, z_i)$ for $i = 0, 1, 2$ be points such that $\vec{Q}_1 - \vec{Q}_0$ and $\vec{Q}_2 - \vec{Q}_0$ are unit length and orthogonal. The points in the plane containing the \vec{Q}_i are represented by $\vec{Q}(s, t) = \vec{Q}_0 + s(\vec{Q}_1 - \vec{Q}_0) + t(\vec{Q}_2 - \vec{Q}_0)$ for $s \in \mathbb{R}$ and $t \in \mathbb{R}$.

Within that plane a conic section is defined by

$$As^2 + Bst + Ct^2 + Ds + Et + F = 0. \tag{3.6}$$

To show that the projection is also a conic, substitute the formulas in Equation (3.5) into Equation (3.6) to obtain

$$\bar{A}\bar{s}^2 + \bar{B}\bar{s}\bar{t} + \bar{C}\bar{t}^2 + \bar{D}\bar{s} + \bar{E}\bar{t} + \bar{F} = 0, \tag{3.7}$$

where

$$\bar{A} = w_2^2 \left(w_0^2 A + w_0(w_0 - w_1)D + (w_0 - w_1)^2 F \right)$$

$$\bar{B} = w_1 w_2 \left(w_0^2 B + w_0(w_0 - w_2)D + w_0(w_0 - w_1)E + 2(w_0 - w_1)(w_0 - w_2)F \right)$$

$$\bar{C} = w_1^2 \left(w_0^2 C + w_0(w_0 - w_2)E + (w_0 - w_2)^2 F \right)$$

$$\bar{D} = w_1 w_2^2 \left(w_0 D + 2(w_0 - w_1)F \right)$$

$$\bar{E} = w_1^2 w_2 \left(w_0 E + 2(w_0 - w_2)F \right)$$

$$\bar{F} = w_1^2 w_2^2 F.$$

A special case is $D = E = F = 0$, in which case the conic is centered at \vec{Q}_0 and has axes $\vec{Q}_1 - \vec{Q}_0$ and $\vec{Q}_2 - \vec{Q}_0$. Consequently, $\bar{A} = w_2^2 w_0^2 A$, $\bar{B} = w_1 w_2 w_0^2 B$, $\bar{C} = w_1^2 w_0^2 C$, and $\bar{B}^2 - 4\bar{A}\bar{C} = B^2 - 4AC$. The sign of $B^2 - 4AC$ is preserved, so ellipses are mapped to ellipses, hyperbolas are mapped to hyperbolas, and parabolas are mapped to parabolas.

3.3 CAMERA MODELS

The world is a very big place. And not all of it can be completely processed in a reasonable amount of time to be displayed on a computer screen. We can make things easier by limiting the processing to those objects in a region of space called the *view volume*. All objects that are completely outside the view volume are not processed. Such objects are said to be *culled*. All objects totally inside the view volume are processed for display on the computer screen. Objects that intersect the boundary of the view volume must be *clipped* against the boundary, then processed for display on the computer screen.

The display process includes *projection* onto a *view plane*. Moreover, only a portion of the view plane can be displayed on a computer screen at one time. A rectangular region of interest, called a *viewport*, is selected for display. Although parallel projection

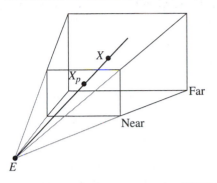

Figure 3.2 The standard camera model.

is possible, most 3D game engines use perspective projection, so we will restrict further discussion to this case. An infinite pyramid is formed by the eye point as vertex and four planar sides, each side containing the eye point and an edge of the viewport. If additionally the pyramid is limited by two planes, both parallel to the view plane, the resulting view volume is called the *view frustum*. The parallel plane closest to the eye point is called the *near plane* and the plane farthest from the eye point is called the *far plane*. The combination of an eye point, a view plane, a viewport, and view frustum is called a *camera model*. In this book we will assume that the view plane is the same as the near plane.

3.3.1 STANDARD CAMERA MODEL

The simplest camera model for perspective projection occurs when the eye point is the origin $(0, 0, 0)$, the near plane is $z = n > 0$, the far plane is $z = f > n$, and the viewport is the rectangle defined by $l \leq x \leq r$ and $b \leq y \leq t$. The view frustum is limited on the sides by the left plane $x = lz/n$, the right plane $x = rz/n$, the top plane $y = tz/n$, and the bottom plane $y = bz/n$. In nearly all applications, the viewport is chosen with $l = -r$ and $b = -t$ so that the frustum is part of an orthogonal pyramid. The camera is assumed to be located at the eye point and has a set of coordinate axes associated with it, the *left direction* $\vec{L} = (1, 0, 0)$, the *up direction* $\vec{U} = (0, 1, 0)$, and the *view direction* $\vec{D} = (0, 0, 1)$. Figure 3.2 illustrates the camera model. A typical point (x, y, z) inside the view frustum is shown together with its projection $(nx/z, ny/z, n) = (x/w, y/w, n)$ onto the view plane.

The axis of the view frustum is the ray that contains both the origin and the center point of the viewport. This ray is parameterized as $((r + l)z/(2n), (t + b)z/(2n), z)$ for $z \in [n, f]$. It is convenient to transform the (possibly) skewed view frustum into

an orthogonal frustum with viewport $[-1, 1]^2$. We accomplish this by removing the skew, then scaling the result:

$$x' = \frac{2}{r-l}\left(x - \frac{(r+l)z}{2n}\right)$$

$$y' = \frac{2}{t-b}\left(y - \frac{(t+b)z}{2n}\right). \tag{3.8}$$

The view frustum is now delimited by $x' \in [-1, 1]$, $y' \in [-1, 1]$, and $z \in [n, f]$. The projection is $(x'/w, y'/w)$ with $w = z/n$.

It is also convenient to transform the z values in $[n, f]$ so that the new range is $[0, 1]$. This is somewhat tricky because the transformation should be consistent with the perspective projection. The linear transformation $z' = (z - n)/(f - n)$ is not the correct one to use. Equation (3.2) saves the day. The z values in $[n, f]$ can be written as $z = (1 - s)n + sf$ for $s \in [0, 1]$. We can use $z' = \bar{s}(s)$ to rescale so that $z' \in [0, 1]$. Solving for $s = (z - n)/(f - n)$, using $w_0 = 1$ and $w_1 = f/n$, and replacing in Equation (3.2) yields

$$z' = \frac{f}{f-n}\left(1 - \frac{n}{z}\right). \tag{3.9}$$

The point (x', y', z') is specified in a right-handed coordinate system. However, the computer screen is treated as a left-handed system. The x-axis points to the right, the y-axis points up, and the z-axis points into the screen. A simple way to change handedness is to change sign on one of the coordinates. For an engine that includes its own geometric pipeline (e.g., one built on top of Glide), any coordinate is as good as another. For an engine that is built on top of an API (e.g., OpenGL or Direct3D), the choice is determined since those APIs have a predetermined format for the transformation specified as a 4×4 homogeneous matrix H. Typically, the entries of the z-column of the matrix have their signs changed. The matrix specification of the projection may lead to some confusion because of the properties of homogeneous matrices and vectors.

Let \vec{V} be a 4×1 homogeneous vector. The projected values obtained from $H\vec{V}$ and $cH\vec{V}$ for any $c \neq 0$ are the same because of the division by the w-term. Even more confusing is that OpenGL maps the z values into $[-1, 1]$, but the above derivation and Direct3D map the z values into $[0, 1]$. Homogeneous matrices representing the projection are

$$P_{[0,1]} = \left[\begin{array}{ccc|c} \frac{2n}{r-l} & 0 & \frac{r+l}{r-l} & 0 \\ 0 & \frac{2n}{t-b} & \frac{t+b}{t-b} & 0 \\ 0 & 0 & -\frac{f}{f-n} & -\frac{fn}{f-n} \\ \hline 0 & 0 & -1 & 0 \end{array}\right] \tag{3.10}$$

and

$$
P_{[-1,1]} = \left[
\begin{array}{ccc|c}
\frac{2n}{r-l} & 0 & \frac{r+l}{r-l} & 0 \\
0 & \frac{2n}{t-b} & \frac{t+b}{t-b} & 0 \\
0 & 0 & -\frac{f+n}{f-n} & -\frac{2fn}{f-n} \\
\hline
0 & 0 & -1 & 0
\end{array}
\right].
$$
(3.11)

In either case, let H_{proj} denote the homogeneous projection matrix.

3.3.2 GENERAL CAMERA MODEL

In the standard camera model, we assume that the eye point is at the origin and that the camera looks in the direction of the z-axis. In general, the eye point can occur anywhere in space and the camera can be arbitrarily oriented. Specifically, let \vec{E} be the eye point and let the camera have left direction \vec{L}, up vector \vec{U}, and view direction \vec{D} so that \vec{L}, \vec{U}, and \vec{D} form a right-handed coordinate system. Consequently, the matrix $R = [\vec{L} \mid \vec{U} \mid \vec{D}]$ whose columns are the specified vectors is orthonormal and has determinant one. The view plane origin is $\vec{P} = \vec{E} + n\vec{D}$, a point that is n units of distance from the eye point. Let the viewport be defined by the rectangle in the view plane whose corners are $\vec{P} + r\vec{L} + t\vec{U}, \vec{P} + r\vec{L} + b\vec{U}, \vec{P} + l\vec{L} + t\vec{U}$, and $\vec{P} + l\vec{L} + b\vec{U}$.

We can write any world point \vec{X} in terms of the camera's coordinate system as $\vec{X} = \vec{E} + R\vec{Y}$ and then solve to obtain $\vec{Y} = R^{\mathrm{T}}(\vec{X} - \vec{E})$. This transformation is called the *view transformation*. The camera model in the \vec{Y} coordinate system is in standard form. The homogeneous transformation representing the view transformation is

$$
H_{\text{view}} = \left[
\begin{array}{c|c}
R^{\mathrm{T}} & -R^{\mathrm{T}}\vec{E} \\
\hline
\vec{0}^{\mathrm{T}} & 1
\end{array}
\right].
$$
(3.12)

The matrix that maps the view frustum into normalized projection coordinates is $H_{\text{proj}}H_{\text{view}}$, where H_{proj} is either Equation (3.10) or (3.11). In the implementation of a camera, the two matrices are stored separately and applied in sequence. The matrix H_{proj} is typically constructed at the initialization of the application and remains static. The matrix H_{view} is a dynamic quantity that changes every time the camera moves to a new location or changes orientation.

3.3.3 MODEL-TO-VIEW TRANSFORMATION

The total transformation from the model space coordinates to the view space coordinates of the object to be drawn is

$$
H_{\text{total}} = H_{\text{proj}}H_{\text{view}}H_{\text{world}},
$$

where H_{proj} is given in Equation (3.10) or (3.11), H_{view} is given in Equation (3.12), and H_{world} is the transformation from the object's model coordinates to its world coordinates,

$$H_{world} = \left[\begin{array}{c|c} M_w & \vec{T}_w \\ \hline \vec{0}^T & 1 \end{array} \right].$$

Because the matrix H_{proj} is based solely on the intrinsic properties of the camera, and the matrix H_{view} changes whenever the camera changes position or orientation, an implementation of a camera model should maintain these two matrices separately. The matrix H_{world} is dependent on each rendered object and can change any time the application desires.

From the point of view of efficiency, and assuming there is no hardware support for geometric transformations, the actual matrix product should be computed as follows. (We will use the projection of Equation (3.10) for the following discussion, but a similar one can be made for the other projection matrix.)

The goal is to compute H_{total} so that it can be used in transforming a collection of homogeneous points of the form $(x, y, z, 1)$ to a collection of preprojected triples of the form (x', y', w'). The third component really is the homogeneous term w' and not z'. As we shall see, depth information is not necessarily required for rasterization depending on what the application knows about the objects it is rendering. The depth values can be computed later in the pipeline when they are needed. This observation allows us to use a slightly different projection matrix than H_{proj},

$$H_{proj'} = \left[\begin{array}{ccc|c} \frac{2}{r-l} & 0 & -\frac{r+l}{n(r-l)} & 0 \\ 0 & \frac{2}{t-b} & -\frac{t+b}{n(t-b)} & 0 \\ 0 & 0 & 0 & 0 \\ \hline 0 & 0 & \frac{1}{n} & 0 \end{array} \right].$$

The difference is that the z-value of the point to be transformed need not be carried along since the term $w = z/n$ already contains the information about z. The total transformation is

$$H_{total'} = H_{proj'} H_{view} H_{world}.$$

The presence of a row of zeros in the matrix allows us to skip formal calculations that might otherwise be performed in a general routine to multiply matrices. The order of calculation for $H_{total'}$ that minimizes the number of operations is $H_{total'} = (H_{proj'} H_{view}) H_{world}$. The camera implementation maintains the product $H_{proj'} H_{view}$ as the camera model, position, or orientation changes. During a rendering pass, the renderer need only take the current camera's matrix product and multiply it times the object's model-to-world transform to produce a single matrix that is used to

transform vertices. In this last product, the zero row in $H_{\text{proj}'}H_{\text{view}}$ need not participate in the actual computations. Effectively, the renderer has a 3×4 matrix, $[M|\vec{T}]$, for transforming points rather than a full 4×4 homogeneous matrix. The matrix M is 3×3 and the vector \vec{T} is 3×1. The 3×4 matrix is obtained by removing the row of zeros from the product $H_{\text{total}'}$. The total transform applied to input points is

$$M \begin{bmatrix} x \\ y \\ z \end{bmatrix} + \vec{T} = \begin{bmatrix} x' \\ y' \\ w' \end{bmatrix}. \tag{3.13}$$

More precisely, the matrix M and vector \vec{T} can be generated by swapping the row of zeros with the last row of $H_{\text{proj}'}$ and computing products of 4×4 matrices. That is,

$$H_{\text{proj}'} = \left[\begin{array}{c|c} C & \vec{0} \\ \hline \vec{0}^{\mathrm{T}} & 0 \end{array} \right] = \left[\begin{array}{ccc|c} \frac{2}{r-l} & 0 & -\frac{r+l}{n(r-l)} & 0 \\ 0 & \frac{2}{t-b} & -\frac{t+b}{n(t-b)} & 0 \\ 0 & 0 & \frac{1}{n} & 0 \\ \hline 0 & 0 & 0 & 0 \end{array} \right]$$

and

$$
\begin{aligned}
H_{\text{total}'} &= \left[\begin{array}{c|c} M & \vec{T} \\ \hline \vec{0}^{\mathrm{T}} & 0 \end{array} \right] \\
&= \left[\begin{array}{c|c} C & \vec{0} \\ \hline \vec{0}^{\mathrm{T}} & 0 \end{array} \right] \left[\begin{array}{c|c} R^{\mathrm{T}} & -R^{\mathrm{T}}\vec{E} \\ \hline \vec{0}^{\mathrm{T}} & 1 \end{array} \right] \left[\begin{array}{c|c} M_w & \vec{T}_w \\ \hline \vec{0}^{\mathrm{T}} & 1 \end{array} \right] \\
&= \left[\begin{array}{c|c} C R^{\mathrm{T}} M_w & C R^{\mathrm{T}} \left(\vec{T}_w - \vec{E} \right) \\ \hline \vec{0}^{\mathrm{T}} & 0 \end{array} \right].
\end{aligned}
\tag{3.14}
$$

The quantity $C R^{\mathrm{T}}$ is maintained by the camera implementation. The difference $\vec{T}_w - \vec{E}$ is computed once the model-to-world transform for the object is known.

3.3.4 MAPPING TO SCREEN COORDINATES

The raster display has its own (\bar{x}, \bar{y}) coordinates called *screen coordinates*. This coordinate system is right-handed with its origin in the lower-left corner of the display. The \bar{x} values increase from left to right and the \bar{y} values increase from bottom to top. The full screen has dimensions (S_x, S_y) such that $0 \le \bar{x} < S_x$ and $0 \le \bar{y} < S_y$. The

mapping from normalized projection coordinates $(x, y) \in [-1, 1]^2$ to screen coordinates (\bar{x}, \bar{y}) is a straightforward transformation,

$$\bar{x} = \frac{(S_x - 1)(x + 1)}{2}, \qquad \bar{y} = \frac{(S_y - 1)(y + 1)}{2}.$$

The subtractions by 1 from the screen dimensions are necessary since $\bar{x} \le S_x - 1$ and $\bar{y} \le S_y - 1$ are required for the final integer-based screen coordinates.

The transformation to screen coordinates can be applied before or after clipping. In this chapter, clipping is implemented in view space using the viewport $[-1, 1]^2$. If the transformation to screen coordinates is performed first, then clipping must be implemented against the viewport $[0, S_x - 1] \times [0, S_y - 1]$.

Another issue for screen coordinates is the *aspect ratio*, $\rho = S_x/S_y$. Typical display hardware has square pixels and an aspect ratio of $4/3$, although high-definition television has an aspect ratio of $16/9$. In order for the world to be rendered properly, the view frustum should be constructed to maintain the aspect ratio of the screen. In this case $(r - l)/(t - b) = \rho$ should be enforced in the camera model.

3.3.5 SCREEN SPACE DISTANCE MEASUREMENTS

Consider a camera model with $l = -r$ and $b = -t$. The upper-left matrix of the homogeneous matrix is $C = \text{diag}(n/r, n/t, -1)$. Given a line segment with midpoint \vec{V}, unit direction \vec{A}, and length L_w, we want to measure the length L_s of the screen space projection of the line segment. The model-to-world transform is assumed to be the identity. The world end points are $\vec{V}_0 = \vec{V} - (L_w/2)\vec{A} = (x_0, y_0, z_0)$ and $\vec{V}_1 = \vec{V} + (L_w/2)\vec{A} = (x_1, y_1, z_1)$. From Equation (3.14), the normalized projection coordinates of the end points are $\vec{T}_0 = C\Theta^{\text{T}}(\vec{V} - \vec{E}) - (L_w/2)CR^{\text{T}}\vec{A}$ and $\vec{T}_1 = CR^{\text{T}}(\vec{V} - \vec{E}) + (L_w/2)CR^{\text{T}}\vec{A}$. Define $\vec{P} = CR^{\text{T}}(\vec{V} - \vec{E}) = (P_0, P_1, P_2)$ and $\vec{B} = CR^{\text{T}}\vec{A} = (B_0, B_1, B_2)$. The screen space transformation of \vec{T}_0 and \vec{T}_1 yields $Q_0 = (\sigma_x(1 + x_0/w_0), \sigma_y(1 + y_0/w_0)) = (\bar{x}_0, \bar{y}_0)$ and $Q_1 = (\sigma_x(1 + x_1/w_1), \sigma_y(1 + y_1/w_1)) = (\bar{x}_1, \bar{y}_1)$ for some $\sigma_x > 0$ and $\sigma_y > 0$. The screen space coordinates are measured in pixels, so σ_x measures the number of pixels per unit of distance along the \bar{x}-axis on the view plane at $w = 1$ and σ_y measures the number of pixels per unit of distance along the \bar{y}-axis on the view plane.

The squared length of the screen space segment is

$$L_s^2 = (\bar{x}_1 - \bar{x}_0)^2 + (\bar{y}_1 - \bar{y}_0)^2 = \sigma_x^2 \left(\frac{x_1}{w_1} - \frac{x_0}{w_0} \right)^2 + \sigma_y^2 \left(\frac{y_1}{w_1} - \frac{y_0}{w_0} \right)^2,$$

where

$$\frac{x_1}{w_1} - \frac{x_0}{w_0} = \frac{x_1 w_0 - x_0 w_1}{w_1 w_0} = \frac{L_w(P_2 B_0 - P_0 B_2)}{P_2^2 - L_w^2 B_2^2/4}$$

and

$$\frac{y_1}{w_1} - \frac{y_0}{w_0} = \frac{y_1 w_0 - y_0 w_1}{w_1 w_0} = \frac{L_w(P_2 B_1 - P_1 B_2)}{P_2^2 - L_w^2 B_2^2/4}.$$

Using the definitions of \vec{P}, \vec{B}, defining $\vec{\Delta} = \vec{V} - \vec{E}$, and assuming that the view frustum maintains the screen aspect ratio $\sigma_x/r = \sigma_y/t$, some algebra leads to

$$L_s^2 = \frac{\lambda^2 n^2 L_w^2 \, \vec{\Delta}^{\mathrm{T}} \left(\vec{\Phi}\vec{\Phi}^{\mathrm{T}} + \vec{\Psi}\vec{\Psi}^{\mathrm{T}} \right) \vec{\Delta}}{[(\vec{D} \cdot \vec{\Delta})^2 - L_w^2 (\vec{D} \cdot \vec{A})^2/4]^2}, \tag{3.15}$$

where $\lambda = \sigma_x/r$, $\vec{\Phi} = (\vec{L} \cdot \vec{A})\vec{D} - (\vec{D} \cdot \vec{A})\vec{L}$, and $\vec{\Psi} = (\vec{U} \cdot \vec{A})\vec{D} - (\vec{D} \cdot \vec{A})\vec{U}$. The vectors \vec{L}, \vec{U}, and \vec{D} are the coordinate frame for the camera. The numerator of the right-hand side of Equation (3.15) is a quadratic function and the denominator is a quartic function in $\vec{\Delta}$.

In the special case of $\vec{A} = (0, 0, 1)$, we can reduce Equation (3.15) to a more amenable form. Since $R = [\vec{L} \mid \vec{U} \mid \vec{D}]$ is orthonormal and has determinant one, it must be that $\vec{L} \times \vec{U} = \vec{D}$, $\vec{U} \times \vec{D} = \vec{L}$, and $\vec{D} \times \vec{L} = \vec{U}$. If $\vec{L} = (L_x, L_y, L_z)$, $\vec{U} = (U_x, U_y, U_z)$, and $\vec{D} = (D_x, D_y, D_z)$, then $\vec{\Phi} = (L_z D_x - L_x D_z, L_z D_y - L_y D_z, 0) = (-U_y, U_x, 0)$ and $\vec{\Psi} = (U_z D_x - U_x D_z, U_z D_y - U_y D_z, 0) = (L_x, -L_y, 0)$. Consequently, $\vec{\Phi} \cdot \vec{\Delta} = -U_y \Delta_x + U_x \Delta_y$ and $\vec{\Psi} \cdot \vec{\Delta} = L_y \Delta_x - L_x \Delta_y$ and $(\vec{\Phi} \cdot \vec{\Delta})^2 + (\vec{\Psi} \cdot \vec{\Delta})^2 = (L_y^2 + L_y^2)\Delta_x^2 - 2(L_x L_y + U_x U_y)\Delta_x \Delta_y + (L_x^2 + U_x^2)\Delta_y^2$. Because R is orthonormal, its rows are unit length and mutually perpendicular. This provides the relationships $L_x^2 + U_x^2 = 1 - D_x^2 = D_y^2 + D_z^2$, $L_y^2 + U_y^2 = 1 - D_y^2 = D_x^2 + D_z^2$, and $L_x L_y + U_x U_y = -D_x D_y$. Thus, $(\vec{\Phi} \cdot \vec{\Delta})^2 + (\vec{\Psi} \cdot \vec{\Delta})^2 = D_z^2(\Delta_x^2 + \Delta_y^2) + (D_x \Delta_x + D_y \Delta_y)^2$, and the relationship between world height and screen space distance is

$$L_s^2 = \frac{\lambda^2 n^2 L_w^2 [D_z^2(\Delta_x^2 + \Delta_y^2) + (D_x \Delta_x + D_y \Delta_y)^2]}{[(D_x \Delta_x + D_y \Delta_y + D_z \Delta_z)^2 - L_w^2 D_z^2/4]^2}. \tag{3.16}$$

3.4 CULLING AND CLIPPING

Culling and clipping of objects reduces the amount of data sent to the rasterizer for drawing. Culling refers to eliminating portions of an object, possibly the entire object, that are not visible to the eye point. For an object represented by a triangle mesh, the typical culling operations amount to determining which triangles are outside the view frustum and which triangles are facing away from the eye point. Clipping refers to computing the intersection of an object with the view frustum, and with additional planes provided by the application such as in a portal system (see Section 12.2), so that only the visible portion of the object is sent to the rasterizer. For an object represented

by a triangle mesh, the typical clipping operations amount to splitting triangles by the various view frustum planes and retaining only those triangles inside the frustum.

3.4.1 OBJECT CULLING

Object culling involves deciding whether or not an object as a whole is contained in the view frustum. If an object is not in the frustum, there is no point in consuming CPU cycles to process the object for the rasterizer. Typically, the application maintains a bounding volume for each object. The idea is to have an inexpensive test for nonintersection between bounding volume and view frustum that can lead to quick rejection of an object for further processing. If the bounding volume of an object does intersect the view frustum, then the entire object is processed further even if that object does not lie entirely inside the frustum. It is also possible that the bounding volume and view frustum intersect, but the object is completely outside the frustum. Chapter 4 discusses a variety of bounding volumes that can be used for object culling.

Regardless of choice of bounding volume, culling attempted on a plane-by-plane basis has the problem that the bounding volume is not necessarily culled even though it is outside the view frustum. This feature could be viewed as a flaw in a plane-by-plane culling system, but it is in fact beneficial to use this system as an aid in reducing clipping time. If a bounding volume for an object is tested against a frustum plane and is found to be on the frustum side of the plane, that plane need not be processed by the clipping system if indeed the object is not culled and must be clipped against the view frustum. Before handing the renderer the object to be processed, the application can specify which frustum planes need to be clipped against. Moreover, in a portal system where additional clipping planes are present, the application can likewise attempt to cull against those planes and inform the renderer which ones need to be used when clipping. In an implementation, the camera can maintain an array of clipping planes and an array of Boolean flags that indicate whether or not each clipping plane is enabled (renderer uses in clipping) or disabled (renderer ignores in clipping).

3.4.2 BACK FACE CULLING

Object culling is an attempt to eliminate the entire object from being processed by the renderer. If an object is not culled based on its bounding volume, then the renderer has the opportunity to reduce the amount of data it must draw. The next level of culling is called *back face culling*. The triangles are oriented so that their normal vectors point outside the object whose surface they comprise. If the triangle is oriented away from the eye point, then that triangle is not visible and need not be drawn by the renderer. For a perspective projection, the test for a back facing triangle is to determine if the eye point is on the negative side of the plane of the triangle (the triangle is a "back face" of the object to be rendered). If \vec{E} is the world eye point and if the plane of the triangle is $\vec{N} \cdot \vec{X} = d$, then the triangle is back facing if $\vec{N} \cdot \vec{E} < d$. Figure 3.3 shows the

Figure 3.3 Object with front facing and back facing triangles indicated.

front view of an object. The front facing triangles are drawn with solid lines. The back facing triangles are indicated with dotted lines (although they would not be drawn at all by the renderer).

If the application stores a triangle as an array of three vertices, the renderer would need to compute the normal vector for back face culling. This cost can be eliminated if the application also stores a triangle normal vector, called a *facet normal*, in addition to the vertices. Moreover, if the triangle is stored as model coordinates and the facet normal is in model coordinates, the renderer still needs to know the vertices and normal in world coordinates. Rather than transforming all vertices and normal, it is cheaper to inverse-transform the camera to the model space coordinates of the triangle, especially if this is done for a triangle mesh that contains many triangles in the same model coordinate system. Let \vec{E} be the world coordinates of the eye point for the camera. If the model-to-world transform involves only translation \vec{T}, rotation R, and uniform scale s, then the coordinates of the eye point in the model space coordinates for the triangle are

$$\vec{E}_m = \frac{1}{s} R^{\mathrm{T}} (\vec{E} - \vec{T}).$$

If the model space facet plane is $\vec{N}_m \cdot \vec{X} = d_m$, then the triangle is back facing if

$$\vec{N}_m \cdot \vec{E}_m < d_m.$$

3.4.3 CLIPPING

Clipping is the process by which the front facing triangles of an object in the world are intersected with the view frustum planes. A triangle either is completely inside the frustum (no clipping necessary), is completely outside the frustum (triangle is culled), or intersects at least one frustum plane. In the last case the portion of the triangle that lies on the frustum side of the clipping plane must be calculated. That portion is either a triangle itself or a quadrilateral that is partitioned into two triangles. The triangles in the intersection are then clipped against the remaining clipping planes. After all

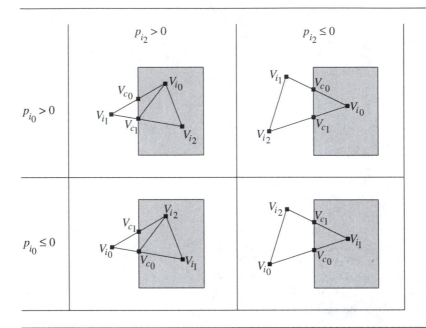

Figure 3.4 Four configurations for triangle splitting. Only the triangles in the shaded region are important, so the quadrilaterals outside are not split.

clipping planes are processed, the renderer has a list of triangles that are completely inside the view frustum.

The splitting of a triangle by a frustum plane is accomplished by computing the intersection of the triangle edges with the plane. The three vertices of the triangle are tested for inclusion in the frustum. If the frustum plane is $\vec{N} \cdot \vec{X} = d$ and if the vertices of the triangle are \vec{V}_i for $i = 0, 1, 2$, then the edge with end points \vec{V}_{i_0} and \vec{V}_{i_1} intersects the plane if $p_{i_0} p_{i_1} < 0$, where $p_i = \vec{N} \cdot \vec{V}_i - d$ for $i = 0, 1, 2$. This simply states that one vertex is on the positive side of the plane and one vertex is on the negative side of the plane. The point of intersection, called a *clip vertex*, is

$$\vec{V}_{\text{clip}} = \vec{V}_{i_0} + \frac{p_{i_0}}{p_{i_0} - p_{i_1}} \left(\vec{V}_{i_1} - \vec{V}_{i_0} \right). \tag{3.17}$$

Figure 3.4 illustrates the possible configurations for the triangle. The vertices \vec{V}_{i_0}, \vec{V}_{i_1}, and \vec{V}_{i_2} are assumed to be in counterclockwise order. The pseudocode for clipping a single triangle against a plane is given below. After splitting, the new triangles have vertices that are in counterclockwise order.

```
ClipConfiguration (pi0,pi1,pi2,Vi0,Vi1,Vi2)
{
    // assert: pi0*pi1 < 0
    Vc0 = Vi0+(pi0/(pi0-pi1))*(Vi1-Vi0);
    if ( pi0 > 0 )
    {
        if ( pi2 > 0 )  // figure, top left
        {
            Vc1 = Vi1+(pi1/(pi1-pi2))*(Vi2-Vi1);
            add triangle <Vc0,Vc1,Vi0> to triangle list;
            add triangle <Vc1,Vi2,Vi0> to triangle list;
        }
        else            // figure, top right
        {
            Vc1 = Vi0+(pi0/(pi0-pi2))*(Vi2-Vi0);
            add triangle <Vc0,Vc1,Vi0> to triangle list;
        }
    }
    else
    {
        if ( pi2 > 0 )  // figure, bottom left
        {
            Vc1 = Vi0+(pi0/(pi0-pi2))*(Vi2-Vi0);
            add triangle <Vc0,Vi1,Vi2> to triangle list;
            add triangle <Vc0,Vi2,Vc1> to triangle list;
        }
        else            // figure, bottom right
        {
            Vc1 = Vi1+(pi1/(pi1-pi2))*(Vi2-Vi1);
            add triangle <Vc0,Vi1,Vc1> to triangle list;
        }
    }
}

ClipTriangle ()
{
    remove triangle <V0,V1,V2> from triangle list;

    p0 = Dot(N,V0)-d;
    p1 = Dot(N,V1)-d;
    p2 = Dot(N,V2)-d;

    if ( p0*p1 < 0 )
    {
```

```
            // triangle needs splitting along edge <V0,V1>
            ClipConfiguration(p0,p1,p2,V0,V1,V2);
    }
    else if ( p0*p2 < 0 )
    {
            // triangle needs splitting along edge <V0,V2>
            ClipConfiguration(p2,p0,p1,V2,V0,V1);
    }
    else if ( p1*p2 < 0 )
    {
            // triangle needs splitting along edge <V1,V2>
            ClipConfiguration(p1,p2,p0,V1,V2,V0);
    }
    else if ( p0 > 0 || p1 > 0 || p2 > 0 )
    {
            // triangle is completely inside frustum
            add triangle <V0,V1,V2> to triangle list;
    }
}
```

To avoid copying vertices, the triangle representation can store pointers to vertices in a vertex pool. However, the above pseudocode has a drawback in that information about shared edges is not maintained. A shared edge will be clipped as many times as there are triangles sharing the edge. For manifold geometry, the shared edge is typically clipped twice when the edge has two triangles sharing it. Clipping pipelines also typically interpolate vertex attributes at the same time the clip vertices are computed. Multiple processing of shared edges and premature calculation of vertex attributes is extremely inefficient. A better approach is to use a triangle mesh data structure that supports single clipping of an edge. The same structure supports deferred vertex attribute calculation and interpolation so that a minimal set of initial vertices need to be lit and only visible clip vertices are interpolated. Details of how to do this are discussed in Section 3.7.

Regardless of data structures used for triangle representation in the clipping pipeline, a choice must be made about the order of clipping and transformation to view space coordinates. The costs associated with each order vary. Let N_{ov} be the number of vertices of the object. Let N_0 be the number of vertices remaining after back face culling. Of course, $N_0 \leq N_{ov}$. Let N_i be the number of vertices after clipping against the ith frustum plane, $1 \leq i \leq 6$. The N_i may be larger or smaller than N_0 depending on the object and how it is positioned with respect to each frustum plane. Various per-vertex costs are associated with the stages of clipping:

- C_{tr}, the cost of transforming as $M\vec{V} + \vec{T}$. The cost includes nine multiplications and nine additions.

- C_{wp}, the cost of computing the world plane equation, $\vec{N} \cdot \vec{V}$. The cost includes three multiplications, two additions, and one comparision to the plane constant d.

- C_{vp}, the cost of computing the view plane equation. The view planes are $x \le w$, $x \ge -w$, $y \le w$, $y \ge -w$, $w \ge 1$, and $w \le K$ for a fixed constant K. For each plane the cost is one comparison. The cost of the sign changes is considered to be negligible.

The cost of back-face culling is the same regardless of choice of clipping pipeline, so it is not included in the comparative costs of the pipelines.

Clip World, Transform World to View

The first choice is to clip in world space and transform the postclip vertices from world space to view space. The sequence of operations is

1. If world coordinates of object vertices require updating, then transform the model coordinates to world coordinates.

2. Back-face cull in world space.

3. Inverse transform the frustum planes from view space to world space (or let the camera maintain world space frustum planes).

4. Clip against the world space frustum planes.

5. Transform the postclip vertices from world space to view space.

This style of clipping is possibly of use if the object maintains world coordinates in addition to model coordinates for purposes other than rendering. For example, the application might use a collision detection system that requires knowledge of world coordinates of an object even if that object is not currently visible.

The cost of transforming from model coordinates to world coordinates for such an application may be considered a necessity, so it is not necessarily included in the cost of rendering. For the record, the cost of the transform is $C_{tr} N_{ov}$. The inverse transform of the frustum planes is negligible as long as the object has a significant number of vertices. The rendering costs are incurred mainly from the clipping and transforming from world space to view space:

$$C_1 = C_{wp} \sum_{i=0}^{5} N_i + C_{tr} N_6.$$

The first part of the cost comes from computing on which side of the frustum planes the vertices lie. The second part is from the world space to view space transformation.

Clip Model, Transform Model to View

The second choice is to clip in the model space of the object and transform the postclip vertices from model space to view space. The sequence of operations is

1. Inverse transform the camera from world space to the model space of the object.
2. Back-face cull in the model space of the object.
3. Inverse transform the frustum planes from view space to model space.
4. Clip against the model space frustum planes.
5. Transform the postclip vertices from model space to view space.

As in the first choice, the main rendering costs are incurred from the clipping and transforming from model space to view space. The cost is effectively the same as before:

$$C_2 = C_{wp} \sum_{i=0}^{5} N_i + C_{tr} N_6.$$

Transform Model to View, Clip View

The third choice is to transform the vertices to view space and clip. The sequence of operations is

1. Inverse transform the camera from world space to the model space of the object.
2. Back-face cull in the model space of the object.
3. Transform the vertices from model space to view space.
4. Clip against the view space frustum planes.

The main rendering costs are incurred from transforming from model space to view space and clipping. The cost is

$$C_3 = C_{tr} N_0 + C_{vp} \sum_{i=0}^{5} N_i.$$

The third choice is faster than the second whenever $C_3 \leq C_2$, in which case

$$N_0 \leq \frac{C_{wp} - C_{vp}}{C_{tr}} \sum_{i=0}^{5} N_i + N_6.$$

On an Intel Pentium processor, floating-point multiplications and additions each take 3 cycles. A floating-point comparison takes 4 cycles. Thus, C_{tr} is 54 cycles, C_{wp} is 19 cycles, and C_{vp} is 4 cycles. The third choice is faster than the second whenever

$$N_0 \le \frac{13}{41} \sum_{i=1}^{5} N_i + \frac{54}{41} N_6.$$

If the number of clip vertices increases with each frustum plane, then $N_i \ge N_0$ for $i \ge 1$. In this case the inequality is clearly satisfied (replace N_i by N_0). If the number of clip vertices is reduced by a fraction for each frustum plane, say, $N_{i+1} = r N_i$ for $i \ge 0$ and for some $r \in [0, 1]$, then the inequality reduces to a sixth-degree polynomial inequality in r that is true for $r \ge 0.76$. Therefore, if there is a 3/4 (or greater) reduction of vertices from each frustum plane, the third method is slower. This situation does not typically happen because reasonable scenes tend to have the majority of the vertices well inside the frustum. The values N_i should be about equal to N_0 or larger. Note that the performance comparisons here are theoretical; in practice the costs are also affected by availability of data in memory cache.

3.5 SURFACE AND VERTEX ATTRIBUTES

Triangles are drawn by the renderer as colored entities, the color of each pixel determined by *vertex attributes* assigned to the vertices of the triangle. The pixels at nonvertex locations are computed via interpolation by the rasterizer, the final values in total called *surface attributes*. In screen space the projected vertices have locations (x', y'), derived in Equation (3.8), that are used to control the interpolation process. Each vertex is endowed with a list of attributes depending on how the application wants the triangle to be drawn.

3.5.1 DEPTH

The first vertex attribute that always exists is the depth value z or, equivalently, the value $w = z/n$ where $z \in [n, f]$ and $w \in [1, f/n]$. The projected values were derived earlier in Equation (3.9), $z' = f(1 - 1/w)/(f - n) \in [0, 1]$. These quantities are perspectively interpolated by the rasterizer to compute the depth values (more appropriately, pseudodepth values) on a per-pixel basis that are used for sorting at the pixel level.

3.5.2 COLORS

Each vertex can be assigned a *vertex color* $\vec{c} = (r, g, b)$, where r is the red channel, g is the green channel, and b is the blue channel. Channels from other color models

could be used instead, but standard renderers and graphics hardware support the RGB model. A rasterized triangle whose vertices are assigned only colors is not that visually appealing since interpolation of three color values over a triangle does not produce a wide variation in color. However, using only vertex colors may be necessary either on systems with a limited amount of memory, which prevents having a large number of textures at hand, or on systems with slow processors that take many cycles to combine multiple colors. Vertex colors are typically used in conjunction with textures to add more realism to the rendering. Moreover, the vertex colors can be used in conjunction with lights in the scene to generate dynamic effects, such as a flaming fireball traveling down a corridor and lighting portions of the walls near its path. This is termed *dynamic lighting* and is described in the next section.

3.5.3 LIGHTING AND MATERIALS

Dynamic lighting effects can be achieved by using light sources to illuminate portions of the scene and by assigning material properties to various objects in the scene.

Lights

The standard light sources in a real-time engine are

- Directional lights. The light source is assumed to be infinitely far away so that the directions of the light rays are all parallel. The sun is the classic example of a directional light.

- Point lights. The light source has a location in space and emits light in all directions.

- Spot lights. The light source has a location in space, but emits light only within a cone.

Figure 3.5 illustrates the three possible sources. Real light sources emit light from an area or volume source. Point light sources are a reasonable approximation in a real-time setting but do not always produce visually correct information. For example, shadows generated by a point source have hard edges, but shadows generated by a real light source have soft edges.

Light sources have various attributes in addition to position and direction. Each light can be monochrome or can have an RGB color associated with it. Instead of a single color for the light, multiple colors can be used to represent the contribution to ambient, diffuse, and specular lighting. The light can also maintain an intensity parameter that applies to the various colors, and a Boolean parameter can be used to indicate whether the light is on or off, a quick way to enable or disable lights in the rendering system. Other attributes assigned to lights depend on type. Point lights and

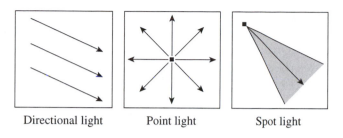

Directional light Point light Spot light

Figure 3.5 Various light sources.

spot lights can have their light attenuated with distance from the light source, with the parameter usually specified as an inverse quadratic:

$$d_{\text{dist}} = \frac{1}{a + b|\vec{P} - \vec{V}| + c|\vec{P} - \vec{V}|^2},$$

where \vec{P} is the light position and \vec{V} is a point to be illuminated. The physically correct model is $a = b = 0$ and produces the inverse square relationship that we expect. However, the a and b parameters give an application more control over how the attenuation is to occur. Moreover, choosing $a > 0$ guards against floating-point overflow when $|\vec{P} - \vec{V}|$ is nearly zero.

Materials

Associating a material with an object is an attempt to give the object surface character-istics based on the material parameters and the light sources. The material parameters include emissive, ambient, diffuse, and specular color components and can include scalar parameters for shininess and alpha blending. The emissive color represents the fact that a material itself can emit light rather than simply reflect it. The ambient, dif-fuse, and specular colors are intended to be terms that interact with the light sources. Shininess is used to control how sharp or diffuse a specular highlight is. The alpha value is used to support transparent materials as an alternative to applying texture images with an alpha channel.

Lighting and Shading

The term *lighting* refers to the process of computing colors based on light sources and materials. The term *shading* refers to the process of computing pixel colors after any

lighting has been calculated. The three standard shading models are *flat*, *Gouraud*, and *Phong*. Flat shading uses the same color for all pixels in a rendered triangle. Thus, a color is assigned to the entire triangle rather than separate colors assigned to the three vertices. Gouraud shading calculates the vertex colors of the triangle based on light sources and materials, then interpolates those colors to fill out the remaining pixels in the triangle. Phong shading takes the three vertex normals and interpolates them to compute a normal vector per pixel. Each pixel is then lit according to the light sources and materials that affect the triangle. Flat shading and Gouraud shading are supported in hardware graphics cards, but Phong shading is more expensive and is not supported on consumer machines. This is actually surprising because the discrete methods that are used in line and circle drawing algorithms can be applied to interpolating normal vectors. Specifically, if the three vertex normals are plotted on a unit sphere, the normal at any triangle interior point corresponds to a point on the unit sphere contained in the spherical triangle formed by the original three normals. A discretization of the spherical triangle is quite possible and not expensive (Andres 1994; Andres and Jacob 1997), so it is conceivable that consumer graphics hardware could support normal interpolation in this way.

The colors at the triangle vertices are computed via a *lighting model*. The models used in real-time graphics involve decomposition into ambient, diffuse, and specular components. The model described here assumes that each light has an ambient color \vec{L}_{ambi}, a diffuse color \vec{L}_{diff}, a specular color \vec{L}_{spec}, and an intensity L_{intn} that is applied equally to all three colors. Point and spot lights also have an attenuation value L_{attn}. Each material has an emissive color \vec{M}_{emis}, an ambient color \vec{M}_{ambi}, a diffuse color \vec{M}_{diff}, a specular color \vec{M}_{spec}, a shininess parameter M_{shine}, and an alpha component M_{alpha}.

Ambient Light

A light ray in the real world follows a path that has it reflecting off many surfaces and decreasing in intensity along the way. The global effect from all the rays is termed *ambient lighting*. The light model incorporates this effect by combining the light's ambient color with the material's ambient color,

$$\vec{C}_{\text{ambi}} = \vec{M}_{\text{ambi}} \circ (L_{\text{intn}} \vec{L}_{\text{ambi}}).$$

The operator ∘ can represent componentwise multiplication (modulated color model) or componentwise addition (additive color model). To support operations between colors, it is necessary to represent the colors in a normalized way. The standard way is to store all color channels (including alpha) as floating-point numbers in $[0, 1]$. If ∘ represents multiplication, then the product of two normalized colors is a normalized color. However, multiplication produces a darkening effect since the product of $c_0 < 1$ and $c_1 < 1$ yields a product $c_0 c_1 < \min\{c_0, c_1\} < 1$. One way to counteract the darkening is to adjust the light intensity parameter. Another way to avoid darkening is to choose ∘ to represent addition. The pitfall here is that the sum of two colors can

result in channel values being larger than 1. Clamping the sum per channel to 1 can be used but might possibly change the perceived color value since the ratios between pairs of red, green, and blue are not preserved. Instead, the maximum channel value is determined and, if larger than 1, is used to scale all three channels to be within $[0, 1]$. Rescaling comes at a price since two divisions are required per color, whereas clamping does not require any divisions. Either clamping or rescaling is necessary even when \circ represents multiplication since the final lighting equation will involve sums of various color components in the lighting model.

For spot lights with a unit-length cone axis \vec{U} and angle θ, the light direction is $\vec{D} = (\vec{V} - \vec{P})/|\vec{V} - \vec{P}|$. The ambient color is attenuated depending on the angle formed by \vec{D} and \vec{U}. If $\vec{D} = \vec{U}$, the attenuation coefficient is 1. If $\vec{D} \cdot \vec{U} = \cos(\theta)$, then \vec{D} is on the cone boundary and the attenuation coefficient is 0. The drop-off from cone axis to cone boundary is generally chosen as $(\vec{D} \cdot \vec{U})^\epsilon$, where $\epsilon > 0$ is called the *spot exponent*. The attenuation coefficient is therefore

$$d_{\text{spot}} = \begin{cases} \left(\frac{\vec{D} \cdot \vec{U} - |\vec{D}| \cos \theta}{(\vec{D} \cdot \vec{U}) \sin \theta} \right)^\epsilon, & \vec{D} \cdot \vec{U} \geq |\vec{D}| \cos \theta \\ 0, \vec{D} \cdot \vec{U} < |\vec{D}| \cos \theta \end{cases}$$

and the ambient component is written as

$$\vec{C}_{\text{ambi}} = d_{\text{spot}} \vec{M}_{\text{ambi}} \circ (L_{\text{intn}} \vec{L}_{\text{ambi}}).$$

For directional lights and point lights the value of d_{spot} is simply set to 1, indicating it has no effect on the final color.

Diffuse Light

Diffuse lighting is based on Lambert's law, which says for a matte surface, the intensity of the reflected light is determined by the cosine of the angle between the surface normal \vec{N} and the light direction vector \vec{D}. Moreover, the intensity drops to zero when the angle between \vec{N} and \vec{D} is $\pi/2$ radians or larger. The light model incorporates diffuse lighting by

$$\vec{C}_{\text{diff}} = d_{\text{spot}} \max\{\vec{N} \cdot \vec{D}, 0\} \vec{M}_{\text{diff}} \circ (L_{\text{intn}} \vec{L}_{\text{diff}}),$$

where d_{spot} is the spot angle attenuation factor described in the previous subsection.

The light direction depends on light type. Moreover, spot lights have an attenuation based on the angle between light direction and cone axis. For directional lights, the light direction \vec{D} is already known. For point lights, the light direction is $\vec{D} = (\vec{V} - \vec{P})/|\vec{V} - \vec{P}|$ for light source location \vec{P} and for each point \vec{V} to be illuminated. For spot lights with a unit-length cone axis \vec{U} and angle θ, the light direction is $\vec{D} = (\vec{V} - \vec{P})/|\vec{V} - \vec{P}|$.

Specular Light

Diffuse lighting represents reflection of light on matte surfaces. Specular lighting represents reflection of light on shiny surfaces. In particular, specular highlights can show up on highly reflective surfaces. These are places where the surface normal and light direction are parallel. The tightness of the region of brightness is something that can be controlled by the material's shininess parameter. Let \vec{E} be the eye point. Let $\vec{U} = (\vec{E} - \vec{V})/|\vec{E} - \vec{V}|$ be the view direction for a point \vec{V} that is to be illuminated. Let \vec{D} be the light direction, specified for directional lights but computed to be $\vec{D} = (\vec{V} - \vec{P})/|\vec{V} - \vec{P}|$ for point and spot lights. The reflection vector of the light direction through the vertex normal \vec{N} is $\vec{R} = 2(\vec{N} \cdot \vec{D})\vec{N} - \vec{D}$. The specular coefficient is $(\vec{R} \cdot \vec{D})^{M_{shine}}$, assuming that the dot product is nonnegative. The light model incorporates specular lighting by

$$\vec{C}_{spec} = d_{spot} \left(\max\{\vec{R} \cdot \vec{D}, 0\} \right)^{M_{shine}} \vec{M}_{spec} \circ (L_{intn}\vec{L}_{spec}).$$

The attenuation coefficient d_{spot} is the same one discussed in the subsection on ambient lights.

The Light Equation

The final equation for lighting a vertex with a single material and using multiple light sources, given below, includes the attenuation factors for distance as well as for spot angles. The superscripts are indices for the array of active lights.

$$\vec{C}_{final} = \vec{M}_{emis} +$$

$$\vec{M}_{ambi} \circ \sum_{i=1}^{n} d^i_{spot}L^i_{intn}\vec{L}^i_{ambi} +$$

$$\vec{M}_{diff} \circ \sum_{i=1}^{n} d^i_{spot}d^i_{dist} \max\{\vec{N} \cdot \vec{D}^i, 0\}L^i_{intn}\vec{L}^i_{diff} +$$

$$\vec{M}_{spec} \circ \sum_{i=1}^{n} d^i_{spot}d^i_{dist} \max\{\vec{R} \cdot \vec{D}^i, 0\}^{M_{shine}}L^i_{intn}\vec{L}^i_{spec}.$$

Note that if no lights are present and the material emits light, the final vertex color is not black. It is also possible to include a global ambient light term $\vec{M}_{ambi} \circ \vec{G}_{ambi}$, where the global ambient color is specified by the application.

3.5.4 TEXTURES

Textured images, or simply *textures*, provide the most realism in a model and can be used effectively to hide the model's polygonal aspects. A triangle is assigned a textured image $\vec{c}(u, v) = (r(u, v), g(u, v), b(u, v)$, where $(u, v) \in [0, 1]^2$. The tuple $(u, v, \vec{c}(u, v))$ is called a *texture element,* or *texel* for short. Each triangle vertex is assigned a *texture coordinate* $\vec{t} = (u, v)$ so that a color lookup can be done in the image. The texture coordinates at the vertices are perspectively interpolated by the rasterizer to obtain texture coordinates at other pixels in the triangle. Each interpolated coordinate is also used to do a color lookup in the image.

Coordinate Modes

It is not necessary that a texture coordinate at a vertex be in $[0, 1]^2$. This allows for efficient use of textures and for interesting effects. The two standard texture coordinate modes are *clamping* and *wrapping*. A coordinate (u, v) is *clamped* by setting

$$(u', v') = (\min(\max(0, u), 1), \min(\max(0, v), 1).$$

One special effect obtained by clamping is to place a small detail in the interior of a triangle. For example, a triangle that represents part of a glass window can have a texture applied to make it appear as if the window has a bullet hole in it. The texture image for the bullet hole can be quite small (to minimize memory usage), and the texture coordinates for the vertices can be set to quantities well outside the range of $[0, 1]^2$ to control the size and placement of the bullet hole.

A coordinate (u, v) is *wrapped* by setting

$$(u', v') = (u - \lfloor u \rfloor, v - \lfloor v \rfloor),$$

where $\lfloor w \rfloor$ is the largest integer smaller or equal to w. The typical special effect obtained by wrapping is to allow a texture to repeat, thereby producing a doubly periodic effect. The texture in this case is said to be *toroidal,* and great care must be taken so that the left/right edges and top/bottom edges of the texture match (otherwise the texture boundaries are noticeable) in the replication. For example, a brick wall can be built from a small number of triangles with a small texture representing a few bricks.

The coordinates can be *mixed* in a texture, one coordinate being clamped and the other being wrapped. The texture in this case is said to be *cylindrical,* and the edges corresponding to the wrapped coordinate must match to hide the texture boundaries. Some hardware drivers might not support mixed coordinate modes.

Filtering Modes

The texture image is defined on a discrete lattice of points, so it is not a continuous quantity. A texture coordinate (u, v) computed at a pixel via interpolation usually is not in the lattice. The method of computing a lattice point for the coordinate is called *texture filtering*. There are two standard ways to select a lattice point. The first method selects the *nearest* lattice point,

$$(u', v') = (\lfloor u + 1/2 \rfloor, \lfloor v + 1/2 \rfloor).$$

This gives the textured triangles a blocky appearance, especially when the texture image is high frequency in its data.

The second method uses *bilinear interpolation* as a way of smoothing the results and avoiding the aliasing problem from selection of the nearest lattice point. Let the texture image be $N \times M$, and let the image lattice coordinates (i, j) correspond to texture coordinates $(u, v) = (\delta_u i, \delta_v j)$, where $\delta_u = 1/(N-1)$ and $\delta_v = 1/(M-1)$. The lattice coordinates satisfy $0 \le i < N$ and $0 \le j < M$. For a specified texture coordinate $(u, v) \in [0, 1]^2$, the base lattice coordinate is $(i, j) = (\lfloor (N-1)u \rfloor, \lfloor (M-1)v \rfloor)$. The corresponding base texture coordinate is $(u', v') = (\delta_u i, \delta_v j)$. Setting $s = u - u'$ and $t = v - v'$, the texture value \vec{c}' to be used at the pixel is

$$\vec{c}' = (1-s)(1-t)\vec{c}(i, j) + (1-s)t\vec{c}(i, j+1) + s(1-t)\vec{c}(i+1, j)$$

$$+ st\vec{c}(i+1, j+1).$$

Mipmapping

Even bilinear filtering can have aliasing problems when a textured triangle is in the distance. As the distance from the eye point increases, the perceived frequency in the texture increases because the same range of texture coordinates is applied over the smaller set of pixels covered by the triangle. This produces a temporal aliasing of the textures on objects close to the far plane. A method for reducing the aliasing is *mipmapping* (Williams 1983). The prefix *mip* is an acronym for the Latin *multum in parvo*, which means "many things in a small place." The idea is that a pyramid of textures is built from the original by downsampling via averaging or blurring. If the original texture is a square of size $2^n \times 2^n$, there are n downsampled textures of sizes $2^i \times 2^i$ for $0 \le i \le n, i = n$ representing the original texture. For a nonsquare texture, the recursive downsampling is applied until one of the dimensions is 1.

The selection of texture to use from the pyramid is based on determining the number of texels that cover a pixel. As the number of texels per pixel increases, the amount of averaging will increase. The relationship between screen space point (x, y) and the texture coordinates (u, v) at that point is constructed as follows. Let the triangle have vertices (x_i, y_i) and corresponding texture coordinates (u_i, v_i) for $0 \le i \le 2$. As a function of world space triangle parameters (s, t),

$$(u, v) = (u_0, v_0) + s(u_1 - u_0, v_1 - v_0) + t(u_2 - u_0, v_2 - v_0).$$

Recall from the section on perspective projection that

$$(x, y) = (x_0, y_0) + \bar{s}(x_1 - x_0, y_1 - y_0) + \bar{t}(x_2 - x_0, y_2 - y_0),$$

where (\bar{s}, \bar{t}) and (s, t) are related by Equations (3.4) and (3.5). The previous equation can be inverted to obtain

$$\begin{bmatrix} \bar{s} \\ \bar{t} \end{bmatrix} = \frac{1}{(x_1 - x_0)(y_2 - y_0) - (x_2 - x_0)(y_1 - y_0)} \begin{bmatrix} y_2 - y_0 & -(x_2 - x_0) \\ -(y_1 - y_0) & x_1 - x_0 \end{bmatrix}$$
$$\times \begin{bmatrix} x - x_0 \\ y - y_0 \end{bmatrix}.$$

Replacing this in Equation (3.5) produces (s, t) as a function of (x, y). Finally, replacing this in the equation for (u, v) produces

$$u(x, y) = \frac{a_0 x + b_0 y + c_0}{dx + ey + f}$$

$$v(x, y) = \frac{a_1 x + b_1 y + c_1}{dx + ey + f},$$

where the various coefficients depend on the (x_i, y_i) and (u_i, v_i) quantities. This function is a mapping from \mathbb{R}^2 to \mathbb{R}^2. From standard multivariate calculus it is known that the absolute value of the determinant of the first derivative matrix is a measure of how the infinitesimal area at (x, y) is magnified to an infinitesimal area at (u, v). The magnification factor is

$$d = \left| \frac{\partial u}{\partial x} \frac{\partial v}{\partial y} - \frac{\partial u}{\partial y} \frac{\partial v}{\partial x} \right|$$

and is an approximate measure of how many texels are required to cover the pixel (x, y). A mapping from d to the mipmap index $i \in \{0, \ldots, n\}$ must be selected. If $d \leq 1$, then $i = n$ (the original texture) is the obvious choice. As d increases, i decreases to 0.

The final problem is to select a texel value given (x, y, d). The choices are many, but the standard ones are the following:

- Select the nearest mipmap to d and select the nearest texel to (x, y).

- Select the nearest mipmap to d and bilinearly interpolate using the appropriate four pixels for (x, y).

- Select the two bounding mipmaps for d, select the nearest texels to (x, y) on the two mipmaps, then linearly interpolate using the relationship of d to the mipmap d values.

- Select the two bounding mipmaps for d, bilinearly interpolate using the appropriate four pixels for (x, y) on each mipmap, then linearly interpolate using the relationship of d to the mipmap d values. This choice is called *trilinear interpolation* and is supported by most hardware cards.

The value d measures a change in infinitesimal area in an isotropic way. It does not contain information about magnification in individual directions. The pixel covers a square area, but the region of the texture image corresponding to it is a quadrilateral that can be quite narrow. The end result in using d for mipmapping is that overblurring occurs in the direction of the narrow width of the quadrilateral. An attempt to reduce this effect is to use *ripmaps* (McReynolds et al. 1998). The averaging process to obtain a sequence of blurred images is applied independently in each dimension. The lookup process now involves two parameters, one related to the length of the gradient of u and one related to the length of the gradient of v.

Multitexture

The number of texture images associated with a triangle does not always have to be one. Multiple textures, or *multitextures*, allow for a lot of special effects that enhance the realism of the rendered scene. For example, multitextures can add variations in lighting to textures on the walls in a room. This is a form of *static multitexture*—the secondary texture corresponding to the lighting is combined with the primary texture corresponding to the walls in a view-independent manner. Combining such textures is a way to add visual variation in a scene without an exponential growth in texture memory usage. N primary textures and M secondary textures can be combined in NM ways, but only $N + M$ textures are required in memory rather than storing NM textures. Moreover, an artist can generate the smaller number of textures in less time.

Here's another example: A character moves along a textured floor in a scene with a light and casts a shadow on the floor. The shadow can be dynamically computed as a texture and is applied to the floor triangles. This is a form of *dynamic multitexture*—the secondary texture is generated on the fly. The triangles on which the shadow is cast must be selected by the application, and the corresponding texture coordinates must also be computed on the fly.

In either case, the natural question is, How should the various texels be combined to produce the final colors on the triangles? Combining colors and texels is discussed in Section 3.5.7.

3.5.5 TRANSPARENCY AND OPACITY

A texture image can have an additional channel, called the *alpha channel,* used to control transparency or opacity of the applied texture. The image is $\bar{c}(u, v) =$

$(r(u, v), g(u, v), b(u, v), \alpha(u, v))$. A value of $\alpha = 1$ indicates the texel is completely opaque. That is, any previous color drawn at a pixel is overwritten by the texture RGB color. A value of $\alpha = 0$ indicates the texel is completely transparent. That is, any previous color drawn at a pixel is unaffected by the texture RGB color. For $0 < \alpha < 1$, the texture RGB color \vec{c}_{texture} is combined with the current pixel color \vec{c}_{pixel} to obtain the final color,

$$\vec{c}_{\text{final}} = (1 - \alpha)\vec{c}_{\text{pixel}} + \alpha\vec{c}_{\text{texture}}.$$

3.5.6 FOG

The addition of fog to an image adds to the realism of the image and also helps to hide clipping artifacts at the far plane. Without fog, as the eye point moves away from an object, the object approaches the far plane and is noticeably clipped when the far plane intersects it. With fog, if the fog density increases with distance from the eye point, the effect is to provide a depth cue for objects in the distance. And if the fog density increases to full opacity at the far plane, clipping is substantially hidden and the objects disappear in a more natural fashion. If \vec{c}_{fog} is the designated fog color, \vec{c}_{pixel} is the current pixel color, and $\phi \in [0, 1]$ is the fog factor and is proportional to distance from the eye point, then the final color \vec{c}_{final} is

$$\vec{c}_{\text{final}} = (1 - \phi)\vec{c}_{\text{pixel}} + \phi\vec{c}_{\text{fog}}.$$

There are a variety of ways to generate the fog factor. The standard way, called *linear fog*, is based on the z value (or w value) of the pixel to be fogged. Moreover, the fog can be applied to a subset $[z_0, z_1] \subseteq [n, f]$ of the view frustum. The linear fog factor is

$$\phi = \begin{cases} 0, & z < z_0 \\ \frac{z - z_0}{z_1 - z_0}, & z \in [z_0, z_1] \\ 1, & z > z_1 \end{cases}.$$

Since the z values or w values are computed by the renderer for other purposes, linear fog is relatively inexpensive to compute compared to other fog methods.

Exponential fog is obtained by allowing the fog to increase exponentially with the z value of the pixel to be fogged,

$$\phi = \exp(\lambda z),$$

where $\lambda > 0$ is a parameter that controls the rate of increase with respect to z.

Range-based fog assigns the fog factor based on the distance r from eye point to pixel. A subset of radial values $[r_0, r_1]$ can be used, just as in linear fogging,

$$\phi = \begin{cases} 0, & r < r_0 \\ \frac{r-r_0}{r_1-r_0}, & r \in [r_0, r_1] \\ 1, & r > r_1 \end{cases} .$$

This type of fog is more expensive to compute than linear fog since the distance must be calculated for each rendered pixel.

Another possibility for fog is to assign a factor per triangle vertex and let the rasterizer interpolate the factors over the entire triangle. This effect is used in volumetric fogging (see Section 13.4). If the number of triangles to be fogged is small, noticeable artifacts can occur with this type of fogging. Rather than interpolation, renderers can allow fog tables to be used with lookup per pixel based either on z value or on depth. The table lookup can be done with a nearest-neighbor selection or with linear interpolation between two bounding table values. Moreover, the table can be constructed with values that do not necessarily increase with z or depth, which allows for some interesting visual effects.

3.5.7 COMBINING ATTRIBUTES

The various attributes described in this section all contribute to the final pixel color. An important observation to make is that the final color depends on the order of combination. Unfortunately, not all graphics hardware cards perform the combination in the same order. For a single texture rendering, the two possible orders are vertex colors first and texture colors second or texture colors first and vertex colors second. The last combination appears to be the the right choice since vertex colors tend to be used for dynamic lighting and modulation, so they should be applied after the texture colors are set up. The pixel color pipeline described here uses the vertex-colors-last scheme. The order of application is

1. Texture 1
2. Texture 2 through texture n (multitextures, if any)
3. Vertex colors
4. Fog
5. Alpha blending

For a single texture and vertex colors, the colors are denoted \vec{C} and the alpha channel is denoted α. A subscript V corresponds to the vertex attributes, a subscript T corresponds to the texture attributes, and a subscript F corresponds to the final combined color. If a texture does not have an alpha channel, then the alpha values are assumed to be 1 in the combinations. Table 3.1 shows the standard combinations.

Let \vec{C}_{fog} denote the RGB fog color and let ϕ be the fog factor for the given vertex. The output of the texture-vertex blending is updated by the fog color using

Table 3.1 Combining a single texture and vertex colors.

Mode	Equations	Uses
Replace	$\vec{C}_F = \vec{C}_T$ $\alpha_F = \alpha_T$	Texture colors only, no lighting.
Decal	$\vec{C}_F = (1 - \alpha_T)\vec{C}_V + \alpha_T\vec{C}_T$ $\alpha_F = \alpha_V$	Decal application such as bullet-hole texture on vertex-colored surface.
Multiply	$\vec{C}_F = \vec{C}_T * \vec{C}_V$ $\alpha_F = \begin{cases} \alpha_T, & \text{if texture has alpha} \\ \alpha_V, & \text{otherwise} \end{cases}$	Modulate the texture by vertex colors to support dynamic lighting effects.
Multiply Alpha	$\vec{C}_F = \vec{C}_T * \vec{C}_V$ $\alpha_F = \alpha_T * \alpha_V$	Modulate the texture by vertex colors to support dynamic lighting effects. The vertex alpha values allow more control over transparency and can be adjusted over time.
Inverse Multiply Alpha	$\vec{C}_F = \vec{C}_T * (\vec{1} - \vec{C}_V)$ $\alpha_F = \alpha_T * \alpha_V$	Same as Multiply Alpha, but the normalized vertex colors are inverted $(\vec{1} = (1, 1, 1))$.

$$\vec{C}_F = (1 - \phi)\vec{C}_F + \phi\vec{C}_{\text{fog}}.$$

The source alpha values are not modified. The semantics of using both fog and transparency is dependent on context. If an observer is looking through a partially transparent window at a fogged landscape, the alpha blending should occur after the fogging. However, if the landscape contains a lake with partially transparent ice, then the alpha blending for the ice should occur before fogging. Moreover, if the observer is looking through the window at the lake, the sorting of triangles for purposes of transparency becomes an issue.

For multitextures, the textures are combined first before blending with vertex colors. A subscript 0 indicates the first texture of the pair to be combined and in a two-texture system is the primary texture. A subscript 1 indicates the second texture of the pair and in a two-texture system is the secondary texture. A subscript F corresponds to the final combined color of the pair. Table 3.2 shows some standard combinations.

Table 3.2 Combining multitextures.

Mode	Equation	Uses
Multiply	$\vec{C}_F = \vec{C}_0 * \vec{C}_1$	RGB light maps. Texture 0 is the base texture, texture 1 is the light map.
Multiply Inverse	$\vec{C}_F = \vec{C}_0 * (\vec{1} - \vec{C}_1)$	RGB dark maps.
Add	$\vec{C}_F = \vec{C}_0 + \vec{C}_1$	Specular light maps. Texture 1 is used to whiten portions of texture 0.
Primary Alpha Blend	$\vec{C}_F = \alpha_0 \vec{C}_0 + (1 - \alpha_0) \vec{C}_1$	Advanced environment maps. Texture 0 represents the surface RGB colors; the alpha channel represents the shininess of the surface. Texture 1 represents the environment colors that are reflected by the object.
Secondary Alpha Blend	$\vec{C}_F = \alpha_1 \vec{C}_1 + (1 - \alpha_1) \vec{C}_0$	Decal maps. Texture 0 is the base texture. Texture 1 contains the decal.
Multiply Alpha	$\vec{C}_F = \alpha_1 \vec{C}_0$	Monochrome light maps. The alpha channel of texture 1 is used as an intensity on the colors of texture 0.
Multiply Alpha Add Color	$\vec{C}_F = \alpha_1 \vec{C}_0 + \vec{C}_1$	Advanced light maps. The RGB channels of texture 1 are used for color specular highlights. The alpha channel of texture 1 is used for intensity adjustment of texture 0.
Multiply Color Add Alpha	$\vec{C}_F = \vec{C}_0 \vec{C}_1 + \alpha_1 \vec{1}$	Advanced light maps. The RGB channels of texture 1 are used for modulating texture 0. The alpha channel of texture 1 is used for adding specular highlights.

3.6 RASTERIZING

Rasterization is the process of taking a geometric entity in screen space and selecting those pixels to be drawn that correspond to the entity. The standard objects that most engines rasterize are line segments and triangles, but rasterization of circles and ellipses is also discussed here. The constructions contained in this section all assume integer arithmetic since the main goal is to rasterize as fast as possible—floating-point arithmetic tends to be more expensive than integer arithmetic.

3.6.1 LINES

Given two screen points (x_0, y_0) and (x_1, y_1), a line segment must be drawn that connects them. Since the pixels form a discrete set, decisions must be made about which pixels to draw in order to obtain the "best" line segment. Figure 3.6 illustrates this. If $x_1 = x_0$ (vertical segment) or $y_1 = y_0$ (horizontal segment), it is clear which pixels to draw. And if $|x_1 - x_0| = |y_1 - y_0|$, the segment is diagonal and it is clear which pixels to draw. But for the other cases it is not immediately apparent which pixels to draw. The algorithm should depend on the magnitude of the slope. If the magnitude is larger than 1, each row that the segment intersects should have a pixel drawn. If the magnitude is smaller than 1, each column that the segment intersects should have a pixel drawn. Figure 3.7 illustrates the cases. The two blocks of pixels on the left illustrate the possibilities for drawing pixels for a line with slope whose magnitude is larger than 1. The left case draws one pixel per column. The right case draws one pixel per row, the correct decision. The two blocks of pixels on the right illustrate the possibilities for drawing pixels for a line with slope whose magnitude is less than 1. The top case draws one pixel per row. The bottom case draws one pixel per column, the correct decision.

The process of pixel selection, called Bresenham's algorithm (Bresenham 1965), uses an integer decision variable that is updated for each increment in the appropriate

Figure 3.6 Pixels that form the best line segment between two points.

Figure 3.7 Pixel selection based on slope.

input variable. The sign of the decision variable is used to select the correct pixel to draw at each step. Define $dx = x_1 - x_0$ and $dy = y_1 - y_0$. For the sake of argument, assume that $dx > 0$ and $dy \neq 0$. The decision variable is d_i, and its value is determined by the pixel (x_i, y_i) that was drawn at the previous step. Figure 3.8 shows two values s_i and t_i, the fractional lengths of the line segment connecting two vertical pixels. The value of s_i is determined by $s_i = y_0 + (dy/dx)(x_i + 1 - x_0)$ and $s_i + t_i = 1$. The decision variable is $d_i = dx(s_i - t_i)$. From the figure it can be seen that

- If $d_i \geq 0$, then the line is closer to the pixel at $(x_i + 1, y_i + 1)$, so draw that pixel.
- If $d_i < 0$, then the line is closer to the pixel at $(x_i + 1, y_i)$, so draw that pixel.

Now consider

$$d_{i+1} - d_i = dx(s_{i+1} - t_{i+1}) - dx(s_i - t_i)$$
$$= 2dx(s_{i+1} - s_i)$$
$$= 2dy(x_{i+1} - x_i) - 2dx(y_{i+1} - y_i).$$

The initial decision value is $d_0 = 2dy - dx$. The figure indicates that the slope has magnitude less than 1, so x is incremented in the drawing, $x_{i+1} = x_i + 1$. The decision equation is therefore

$$d_{i+1} = d_i + 2dy - 2dx(y_{i+1} - y_i)$$

and the rules for setting the next pixel are

- If $d_i \geq 0$, then $y_{i+1} = y_i + 1$ and the next decision value is $d_{i+1} = d_i + 2(dy - dx)$.
- If $d_i < 0$, then $y_{i+1} - y_i$ and the next decision value is $d_{i+1} = d_i + 2dy$.

A concise implementation is given below. The special cases of horizontal, vertical, and diagonal lines can be factored out if desired.

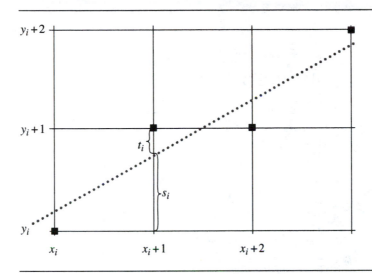

Figure 3.8 Deciding which line pixel to draw next.

```
void DrawLine (int x0, int y0, int x1, int y1)
{
    // starting point of line
    int x = x0, y = y0;

    // direction of line
    int dx = x1 - x0, dy = y1 - y0;

    // increment or decrement depending on direction of line
    int sx, sy;
    if ( dx > 0 )
    {
        sx = 1;
    }
    else if ( dx < 0 )
    {
        sx = -1;
        dx = -dx;
    }
    else
    {
        sx = 0;
    }
```

```
if ( dy > 0 )
{
    sy = 1;
}
else if ( dy < 0 )
{
    sy = -1;
    dy = -dy;
}
else
{
    sy = 0;
}

int ax = 2*dx, ay = 2*dy;

if ( dy <= dx )
{
    // single-step in x-direction
    for (int decy = ay-dx; /**/; x += sx, decy += ay)
    {
        DrawPixel(x,y);

        // take Bresenham step
        if ( x == x1 )
            break;
        if ( decy >= 0 )
        {
            decy -= ax;
            y += sy;
        }
    }
}
else
{
    // single-step in y-direction
    for (int decx = ax-dy; /**/; y += sy, decx += ax)
    {
        DrawPixel(x,y);

        // take Bresenham step
        if ( y == y1 )
            break;
```

```
                    if ( decx >= 0 )
                    {
                        decx -= ay;
                        x += sx;
                    }
                }
            }
        }
```

In the line drawing algorithm, the calls `DrawLine(x0,y0,x1,y1)` and `Draw-Line(x1,y1,x0,y0)` can produce different sets of drawn pixels. It is possible to avoid this by using a variation called the *midpoint line algorithm*; the midpoint $(x_m, y_m) = ((x_0 + x_1)/2, (y_0 + y_1)/2)$ is computed, then two line segments are drawn, `Draw-Line(xm,ym,x0,y0)` and `DrawLine(xm,ym, x1,y1)`. This is particularly useful if a line segment is drawn twice, something that happens when rasterizing triangles that share an edge. If the original line drawer is used for the shared edge, but the line is drawn the second time with the end points swapped, gaps (undrawn pixels) can occur because the two sets of drawn pixels cause an effect called *cracking*. Another way to avoid cracking is to always draw the line starting with the vertex of the minimum y-value. This guarantees that the shared edge is drawn in the same order each time.

3.6.2 CIRCLES

The Bresenham line drawing algorithm has a counterpart for drawing circles using only integer arithmetic. Let the circle be $x^2 + y^2 = r^2$, where r is a positive integer. The algorithm will draw one-eighth of the circle for $y \geq x \geq 0$. The remaining parts are drawn by symmetry.

Let (x_0, y_0) be the last drawn pixel. Let $\vec{A} = (x_0 + 1, y_0)$ and $\vec{B} = (x_0 + 1, y_0 - 1)$. A decision must be made about which of the two points should be drawn next. Figure 3.9 illustrates the various possibilities. The selected pixel will be the one closest to the circle measured in terms of radial distance from the origin. The squared distance will be calculated to avoid square roots.

Define $D(x, y) = x^2 + y^2$; then $D(\vec{A}) = (x_0 + 1)^2 + y_0^2$ and $D(\vec{B}) = (x_0 + 1)^2 + (y_0 - 1)^2$. Define $f(x, y) = D(x, y) - r^2$. If $f(\vec{P}) > 0$, then \vec{P} is outside the circle. If $f(\vec{P}) < 0$, then \vec{P} is inside the circle. Finally, if $f(\vec{P}) = 0$, then \vec{P} is on the circle. The rules for setting pixels are

- If $|f(\vec{A})| > |f(\vec{B})|$, then \vec{B} is closer to the circle, so draw that pixel.

- If $|f(\vec{A})| < |f(\vec{B})|$, then \vec{A} is closer to the circle, so draw that pixel.

- If $|f(\vec{A})| = |f(\vec{B})|$, the pixels are equidistant from the circle, so either one can be drawn.

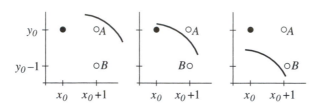

Figure 3.9 Deciding which circle pixel to draw next.

The decision variable is $d = f(\vec{A}) + f(\vec{B})$. In the left part of Figure 3.9, $f(\vec{A})$ and $f(\vec{B})$ are both negative, so $d < 0$. In the right part of the figure, $f(\vec{A})$ and $f(\vec{B})$ are both positive, so $d > 0$. In the middle part of the figure, $f(\vec{A})$ is positive and $f(\vec{B})$ is negative. If \vec{A} is closer to the circle than \vec{B}, then $|f(\vec{A})| < |f(\vec{B})|$ and so $d < 0$. If \vec{B} is closer, then $|f(\vec{A})| > |f(\vec{B})|$ and $d > 0$. In all cases,

- If $d > 0$, draw pixel \vec{B}.

- If $d < 0$, draw pixel \vec{A}.

- If $d = 0$, the pixels are equidistant from the circle, so draw pixel \vec{A}.

The current decision variable is constructed based on its previous value. Let $d_i = (x_i + 1)^2 + y_i^2 - r^2 + (x_i + 1)^2 + (y_i - 1)^2 - r^2 = 2(x_i + 1)^2 + y_i^2 + (y_i - 1)^2 - r^2$. Then

$$d_{i+1} - d_i = \begin{cases} 4x_i + 6, & y_{i+1} = y_i \\ 4x_i + 6 - 4y_i + 4, & y_{i+1} = y_i - 1 \end{cases}.$$

The circle is centered at the origin. For a circle centered elsewhere, a simple translation of each pixel will suffice before drawing. Concise code is

```
void DrawCircle (int xcenter, int ycenter, int radius)
{
    for (int x = 0, y = radius, dec = 3-2*radius; x <= y; x++)
    {
        DrawPixel(xcenter+x,ycenter+y);
        DrawPixel(xcenter+x,ycenter-y);
        DrawPixel(xcenter-x,ycenter+y);
        DrawPixel(xcenter-x,ycenter-y);
        DrawPixel(xcenter+y,ycenter+x);
        DrawPixel(xcenter+y,ycenter-x);
```

```
    DrawPixel(xcenter-y,ycenter+x);
    DrawPixel(xcenter-y,ycenter-x);

    if ( dec >= 0 )
        dec += -4*(y--)+4;
    dec += 4*x+6;
}
}
```

3.6.3 ELLIPSES

Rasterizing an ellipse is conceptually like rasterizing a circle, but the anisotropy of ellipses makes an implementation more challenging. The following material discusses how to conveniently specify the ellipse, how to draw an axis-aligned ellipse, and how to draw general ellipses.

Specifying the Ellipse

The algorithm described here draws ellipses of any orientation on a 2D raster. The simplest way for an application to specify the ellipse is by choosing an oriented bounding box with center (x_c, y_c) and axes (x_a, y_a) and (x_b, y_b), where all components are integers. The axes must be perpendicular, so $x_a x_b + y_a y_b = 0$. It is assumed that (x_a, y_a) is in the first quadrant (not including the y-axis), so $x_a > 0$ and $y_a \geq 0$ are required. It is also required that the other axis is in the second quadrant, so $x_b \leq 0$ and $y_b > 0$. There must be integers n_a and n_b such that $n_b(x_b, y_b) = n_a(-y_a, x_a)$, but the algorithm does not require knowledge of these. The ellipse axes are the box axes and have the same orientation as the box.

All pixel computations are based on the ellipse with center $(0, 0)$. These pixels are translated by (x_c, y_c) to obtain the ones for the original ellipse. A quadratic equation for the ellipse centered at the origin is

$$\frac{(x_a x + y_a y)^2}{(x_a^2 + y_a^2)^2} + \frac{(x_b x + y_b y)^2}{(x_b^2 + y_b^2)^2} = 1.$$

In this form it is easy to see that (x_a, y_a) and (x_b, y_b) are on the ellipse. Multiplying the matrices and multiplying through by denominators yields the quadratic equation

$$Ax^2 + 2Bxy + Cy^2 = D,$$

where the integer coefficients are

$$A = x_a^2(x_b^2 + y_b^2)^2 + x_b^2(x_a^2 + y_a^2)^2$$

$$B = x_a y_a(x_b^2 + y_b^2)^2 + x_b y_b(x_a^2 + y_a^2)^2$$

$$C = y_a^2(x_b^2 + y_b^2)^2 + y_b^2(x_a^2 + y_a^2)^2$$

$$D = (x_a^2 + y_a^2)^2(x_b^2 + y_b^2)^2.$$

For standard-size rasters, since these integers can be quite large, an implementation should use 64-bit integers.

Axis-Aligned Ellipses

The algorithm for an axis-aligned ellipse draws the arc of the ellipse in the first quadrant and uses reflections about the coordinate axes to draw the other arcs. The ellipse centered at the origin is $b^2 x^2 + a^2 y^2 = a^2 b^2$. Starting at $(0, b)$, the arc is drawn in clockwise order. The initial slope of the arc is 0. As long as the arc has a slope smaller than 1 in absolute magnitude, the x value is incremented. The corresponding y value is selected based on a decision variable, just as in Bresenham's circle drawing algorithm. The remaining part of the arc in the first quadrant has a slope larger than 1 in absolute magnitude. That arc is drawn by starting at $(a, 0)$ and incrementing y at each step. The corresponding x value is selected based on a decision variable.

While drawing the arc starting at $(0, b)$, let (x, y) be the current pixel that has been drawn. A decision must be made to select the next pixel $(x + 1, y + \delta)$ to be drawn, where δ is either 0 or -1. The ellipse is defined implicitly as $Q(x, y) = 0$, where $Q(x, y) = b^2 x^2 + a^2 y^2 - a^2 b^2$. Each choice for the next pixel lies on its own ellipse defined implicitly by $Q(x, y) = \lambda$ for some constant λ that is not necessarily zero. The idea is to choose δ so that the corresponding level curve has λ as close to zero as possible. This is the same idea that is used for Bresenham's circle algorithm. For the circle algorithm, the choice is based on selecting the pixel that is closest to the true circle. For ellipses, the choice is based on level set value and not on the distance between two ellipses (a much harder problem).

Given current pixel (x, y), for the next step the ellipse must do one of three things:

1. Pass below $(x + 1, y)$ and $(x + 1, y - 1)$, in which case $Q(x + 1, y) \geq 0$ and $Q(x + 1, y - 1) \geq 0$.

2. Pass between $(x + 1, y)$ and $(x + 1, y - 1)$, in which case $Q(x + 1, y) \geq 0$ and $Q(x + 1, y - 1) \leq 0$.

3. Pass above $(x + 1, y)$ and $(x + 1, y - 1)$, in which case $Q(x + 1, y) \leq 0$ and $Q(x + 1, y - 1) \leq 0$.

In the first case the next pixel to draw is $(x + 1, y)$. In the second case the pixel with Q value closest to zero is chosen. In the third case the next pixel to draw is $Q(x + 1, y - 1)$. The decision in all three cases can be made by using the sign of $\sigma = Q(x + 1, y) + Q(x + 1, y - 1)$. If $\sigma < 0$, then the next pixel is $(x + 1, y - 1)$. If $\sigma > 0$, then the next pixel is $(x + 1, y)$. For $\sigma = 0$, either choice is allowed, so $(x + 1, y)$ will be the one selected.

The decision variable σ can be updated incrementally. The initial value is $\sigma_0 = Q(1, b) + Q(1, b - 1) = 2b^2 + a^2(1 - 2b)$. Given current pixel (x, y) and decision variable σ_i, the next decision is

$$\sigma_{i+1} = \begin{cases} Q(x + 2, y) + Q(x + 2, y - 1), & \sigma_i \geq 0 \\ Q(x + 2, y - 1) + Q(x + 2, y - 2), & \sigma_i < 0 \end{cases}.$$

The choice is based on whether or not the chosen pixel after (x, y) is $(x + 1, y)$ [when $\sigma_i > 0$] or $(x + 1, y - 1)$ [when $\sigma_i \leq 0$]. Some algebra leads to

$$\sigma_{i+1} = \sigma_i + \begin{cases} 2b^2(2x + 3), & \sigma_i \geq 0 \\ 2b^2(2x + 3) + 4a^2(1 - y), & \sigma_i < 0 \end{cases}.$$

On this arc x is always incremented at each step. The processing stops when the slope becomes 1 in absolute magnitude. The slope dy/dx of the ellipse can be computed implicitly from $Q(x, y) = 0$ as $Q_x + Q_y dy/dx = 0$, where Q_x and Q_y are the partial derivatives of Q with respect to x and y. Therefore, $dy/dx = -Q_x/Q_y = -(2b^2x)/(2a^2y) = -(b^2x)/(a^2y)$. The iteration on x continues as long as $-(b^2x)/(a^2y) \geq -1$. The termination condition of the iteration using only integer arithmetic is $b^2x \leq a^2y$.

The code for the iteration is

```
int a2 = a*a, b2 = b*b, fa2 = 4*a2;
int x, y, sigma;

for (x = 0, y = b, sigma = 2*b2+a2*(1-2*b); b2*x <= a2*y; x++)
{
    DrawPixel(xc+x,yc+y);
    DrawPixel(xc-x,yc+y);
    DrawPixel(xc+x,yc-y);
    DrawPixel(xc-x,yc-y);

    if ( sigma >= 0 )
    {
        sigma += fa2*(1-y);
        y--;
    }
    sigma += b2*(4*x+6);
}
```

The code for the other half of the arc in the first quadrant is symmetric in x and y and in a and b:

```
int a2 = a*a, b2 = b*b, fb2 = 4*b2;
int x, y, sigma;

for (x = a, y = 0, sigma = 2*a2+b2*(1-2*a); a2*y <= b2*x; y++)
{
    DrawPixel(xc+x,yc+y);
    DrawPixel(xc-x,yc+y);
    DrawPixel(xc+x,yc-y);
    DrawPixel(xc-x,yc-y);

    if ( sigma >= 0 )
    {
        sigma += fb2*(1-x);
        x--;
    }
    sigma += a2*(4*y+6);
}
```

General Ellipses

An attempt could be made to mimic the case of axis-aligned ellipses by drawing the arc from (x_b, y_b) to (x_a, y_a) and reflecting each pixel (x, y) through the appropriate lines. For example, given pixel $\vec{u} = (x, y)$, the pixel reflected through $\vec{v} = (x_b, y_b)$ given by

$$(x', y') = \vec{u} - 2 \left(\frac{\vec{u} \cdot \vec{v}}{\vec{v} \cdot \vec{v}} \right) \vec{v} = (x, y) - 2 \left(\frac{x_b x + y_b y}{x_b^2 + y_b^2} \right) (x_b, y_b)$$

would also be drawn. The right-hand side requires a division. Moreover, even if the division is performed (whether as float or integer), the resulting pixels are not always contiguous and noticeable gaps occur. The general orientation of the ellipse requires a better method for selecting the pixels. Instead, the arc is generated from $(-x_a, -y_a)$ to (x_a, y_a), and pixels $(x_c + x, y_c + y)$ and their reflections through the origin $(x_c - x, y_c - y)$ are plotted.

The algorithm is divided into two cases:

1. Slope at $(-x_a, -y_a)$ is larger than 1 in absolute magnitude. Five subarcs are drawn.

 (a) Arc from $(-x_a, y_a)$ to a point (x_0, y_0) whose slope is infinite. For all points between, the ellipse has a slope larger than 1 in absolute magnitude, so y is always incremented at each step.

(b) Arc from (x_0, y_0) to a point (x_1, y_1) whose slope is 1. For all points between, the ellipse has a slope larger than 1 in absolute magnitude, so y is always incremented at each step.

(c) Arc from (x_1, y_1) to a point (x_2, y_2) whose slope is 0. For all points between, the ellipse has a slope less than 1 in absolute magnitude, so x is always incremented at each step.

(d) Arc from (x_2, y_2) to a point (x_3, y_3) whose slope is -1. For all points between, the ellipse has a slope less than 1 in absolute magnitude, so x is always incremented at each step.

(e) Arc from (x_3, y_3) to (x_a, y_a). For all points between, the ellipse has a slope larger than 1 in absolute magnitude, so y is always decremented at each step.

2. Slope at $(-x_a, -y_a)$ is smaller than 1 in absolute magnitude. Five subarcs are drawn.

(a) Arc from $(-x_a, -y_a)$ to a point (x_0, y_0) whose slope is -1. For all points between, the ellipse has a slope less than 1 in absolute magnitude, so x is always decremented.

(b) Arc from (x_0, y_0) to a point (x_1, y_1) whose slope is infinite. For all points between, the ellipse has a slope larger than 1, so y is always incremented.

(c) Arc from (x_1, y_1) to a point (x_2, y_2) whose slope is 1. For all points between, the ellipse has a slope larger than 1 in absolute magnitude, so y is always incremented at each step.

(d) Arc from (x_2, y_2) to a point (x_3, y_3) whose slope is 0. For all points between, the ellipse has a slope less than 1 in absolute magnitude, so x is always incremented at each step.

(e) Arc from (x_3, y_3) to (x_a, y_a). For all points between, the ellipse has a slope less than 1 in absolute magnitude, so x is always incremented at each step.

Each subarc is computed using a decision variable as in the case of an axis-aligned ellipse. The decision to switch between the three subarcs is based on the slope of the ellipse. The ellipse is implicitly defined by $Q(x, y) = 0$, where $Q(x, y) = Ax^2 + 2Bxy + Cy^2 - D = 0$. The derivative $dy/dx = -(Ax + By)/(Bx + Cy)$ is obtained by implicit differentiation. The numerator and denominator of the derivative can be maintained incrementally. Initially, the current pixel $(x, y) = (-x_a, -y_a)$ and the numerator and denominator of the slope are $dy = Ax_a + By_a$ and $dx = -(Bx_a + Cy_a)$.

The decision variable σ is handled slightly differently than in the case of an axis-aligned ellipse. In the latter case, the decision was made to use the pixel whose own level curve is closest to the zero level curve. In the current case, a general ellipse handled in the same way can lead to gaps at the end points of the arc and the reflected arc. To avoid the gaps, the decision is made to always select the ellipse with the *smallest positive*

level curve value rather than the smallest magnitude level curve value. The selected pixels are always outside the true ellipse. The decision variable is not incrementally maintained because it is not expensive to compute, although it is possible to maintain it so.

Each of the algorithms for the 10 subarcs are similar in structure. Case 1(a) is described here. The initial values are $x = -x_a$, $y = -y_a$, $dx = Bx_a + Cy_a$, and $dy = -(Ax_a + By_a)$. As y is incremented, eventually the leftmost point in the x-direction is encountered where the slope of the ellipse is infinite. At each step the two pixels to test are $(x, y + 1)$ and $(x - 1, y + 1)$. It is enough to test $\sigma = Ax^2 + 2Bx(y + 1) + C(y + 1)^2 - D < 0$ to see if $(x, y + 1)$ is inside the true ellipse. If it is, then $(x - 1, y + 1)$ is the next pixel to draw. If $\sigma \geq 0$, then $(x, y + 1)$ is outside the true ellipse and closer to it than $(x - 1, y + 1)$, so the next pixel is $(x, y + 1)$. The code is

```
while ( dx <= 0 ) // loop until point with infinite slope occurs
{
    DrawPixel(xc+x,yc+y);
    DrawPixel(xc-x,yc-y);
    y++;
    sigma = a*x*x+2*b*x*y+c*y*y-d;
    if ( sigma < 0 )
    {
        dx -= b;
        dy += a;
        x--;
    }
    dx += c;
    dy -= b;
}
```

The other nine cases are structured similarly.

3.6.4 TRIANGLES

Drawing a triangle as a white object on a black background is a simple process that determines the pixels with minimum and maximum x values on each scan line intersected by the triangle, then draws the pixels between. This is accomplished by keeping two buffers for the minimum and maximum, with each buffer having a number of elements equal to the height of the screen, and using the Bresenham line drawing algorithm to draw the three edges of the triangle. The line drawer updates the buffers when necessary. It is useful to sort the vertices on y so that the line drawer can update only one of the buffers at a time. This also helps to trap degenerate triangles that are passed to the rasterizer; the degeneracy is caused by triangles seen nearly edge on by the eye point, with numerical round-off errors leading to the projection being

a line segment. Pseudocode is given for a triangle with integer-valued vertices (x_i, y_i) for $0 \leq i \leq 2$ that are listed in counterclockwise order. There are 13 cases, 6 of the form $y_{i_0} < y_{i_1} < y_{i_2}$, 3 of the form $y_{i_0} = y_{i_1} < y_{i_2}$, 3 of the form $y_{i_0} < y_{i_1} = y_{i_2}$, and 1 of the form $y_{i_0} = y_{i_1} = y_{i_2}$. Only a couple of the cases are listed in the pseudocode. It is assumed that there are two update routines, one that updates the minimum buffer (UpdateMin) and one that updates the maximum buffer (UpdateMax). The return value of false indicates a degenerate triangle, true otherwise.

```
// global quantities
xmin[0..H-1] = minimum x-values for scan lines 0 <= y <= H-1;
xmax[0..H-1] = maximum x-values for scan lines 0 <= y <= H-1;
ymin = last minimum y-value for scan lines;
ymax = last maximum y-value for scan lines;
pixel[0..H-1][0..W-1] = frame buffer;

bool ComputeEdgeBuffers ()
{
    //*** case: y0 < y1 < y2
    dx0 = x1-x0; dy0 = y1-y0; dx1 = x2-x0; dy1 = y2-y0;
    det = dx0*dy1-dx1*dy0;
    // assert: det <= 0 since vertices are counterclockwise and
    // screen space has left-handed coordinates
    if ( det < 0 )
    {
        UpdateMin(x0,y0,x1,y1);
        UpdateMin(x1,y1,x2,y2);
        UpdateMax(x0,y0,x2,y2);
        return true;
    }
    else
    {
        // degenerate triangle
        return false;
    }

    //*** case: y0 < y1 = y2
    // assert:  x1 <= x2 since vertices are counterclockwise and
    // screen space has left-handed coordinates
    if ( x1 < x2 )
    {
        UpdateMax(x0,y0,x2,y2);
        UpdateMin(x0,y0,x1,y1);
        return true;
    }
```

```
        else
        {
            // degenerate triangle
            return false;
        }
    }
```

Lines are always drawn starting from the vertex with the smaller *y*-value. This avoids the cracking between triangles that was mentioned in Section 3.6.1. The triangle rasterizer is

```
void DrawWhiteTriangle ()
{
    clear xmin[ymin..ymax];
    clear xmax[ymin..ymax];

    if ( ComputeEdgeBuffers() )
    {
        for (y = ymin; y <= ymax; y++)
        {
            for (x = xmin[y]; x <= xmax[y]; x++)
                pixel[y][x] = WHITE;
        }
    }
}
```

3.6.5 INTERPOLATION DURING RASTERIZATION

Obviously, we don't usually draw solid colored triangles in rendering. The vertex attributes must be interpolated to obtain the final colors of the pixels. In the context of perspective projection, all the vertex attributes should be interpolated in a perspective way. This is an expensive operation for a software renderer, so usually only the texture coordinates are perspectively interpolated. Vertex colors and other attributes are linearly interpolated, under the assumption that the visual differences between the two types of interpolation are not significant. In the discussion, let (x_0, y_0, α_0) and (x_1, y_1, α_1) be end points of a line that are endowed with vertex attribute α. The edge buffers that stored the extreme *x* values per scan line are extended to store the interpolated attributes at those extremes.

Linear Interpolation

The edge buffer updates can be set up to iterate over the *y*-value of the triangle edges. Floating-point operations are used to compute the *x*-values and α-values, so the

Bresenham line drawing method is not used here. The idea is to avoid interpolation over long horizontal runs of pixels that are generated by edges with a slope of nearly zero.

The x-value of the line can be viewed as an interpolated value,

$$x = x_0 + \frac{x_1 - x_0}{y_1 - y_0}(y - y_0) = \frac{(x_0 y_1 - x_1 y_0) + (x_1 - x_0)y}{y_1 - y_0},$$

and applies to the minimum or maximum buffer calculations. The pseudocode for computing this is

```
dx = x1 - x0;
dy = y1 - y0;  // dy > 0 is guaranteed by sorting in
               // ComputeEdgeBuffers
inv = 1.0/dy;  // floating-point division
det = x0*y1 - x1*y0;
c0 = det*inv;
c1 = dx*inv;
for (y = y0+1; y < y1; y++)
    x[y] = c0 + c1*y;
```

The attribute α is linearly interpolated in the same way,

$$\alpha = \frac{(\alpha_0 y_1 - \alpha_1 y_0) + (\alpha_1 - \alpha_0)y}{y_1 - y_0},$$

and the pseudocode is

```
da = a1 - a0;
dy = y1 - y0;  // dy > 0 is guaranteed by sorting in
               // ComputeEdgeBuffers
inv = 1.0/dy;  // floating-point division
det = a0*y1 - a1*y0;
c0 = det*inv;
c1 = dx*inv;
for (y = y0+1; y < y1; y++)
    a[y] = c0 + c1*y;
```

Although division is usually an expensive operation, there are only $n + 1$ divisions per triangle edge, one for the x-value and n for the list of attributes to be interpolated, so the cost is acceptable. The computations also involve conversions from floating-point numbers to integers. The conversions can come at some expense if left to a compiler to decide which method to use, but there may be methods using hand-coded assembly that provide for a faster conversion.

When all three edges of the triangle are processed, the edge buffers contain the extreme x-values and the corresponding interpolated attributes. An iteration over the relevant scan lines is performed, and the attributes for the vertical run of pixels between the extreme x-values are themselves computed by linear interpolation of the edge buffer attributes. In order to make the inner loop as fast as possible, integer arithmetic is possible (in the style of Bresenham's line drawing algorithm) as long as the attributes are mapped to an appropriate range of integer values. The pseudocode for rasterizing a triangle with a single vertex attribute is

```
<packing of vertex attributes for the edge buffer algorithm
  goes here>;
ComputeEdgeBuffers();
for (y = ymin; y <= ymax; y++)
{
    x0 = xmin[y];
    x1 = xmax[y];
    a0 = amin[y];
    a1 = amax[y];

    <map a0 and a1 to integer range, use the same names a0
      and a1>;

    dx = x1 - x0;
    if ( dx > 1 )
    {
        if ( a1 > a0 )
        {
            sx = 1;
            tx = 2*(a1 - a0);
        }
        else if ( a1 < a0 )
        {
            sx = -1;
            tx = 2*(a0 - a1);
        }
        else
        {
            sx = 0;
            tx = 0;
        }

        dec = tx - dx;
```

```
        for (x = x0, ax = 2*dx; x <= x1; x++)
        {
            pixel[y][x] = a0;

            if ( dec >= 0 )
            {
                dec -= ax;
                a0 += sx;
            }
            dec += tx;
        }
    }
    else if ( dx == 1 )
    {
        pixel[y][x0] = a0;
        pixel[y][x1] = a1;
    }
    else
    {
        pixel[y][x0] = a0;
    }
}
```

Perspective Interpolation

As before, the x-values of the triangle edges are computed using linear interpolation. A vertex attribute α is computed using perspective interpolation. Let (x_0, y_0, α_0) and (x_1, y_1, α_1) be end points of a line that are endowed with vertex attribute α. The edge buffers that stored the extreme x-values per scan line are extended to store the interpolated attributes at those extremes.

Equation (3.3) provides the relationship between the parameter $s \in [0, 1]$ of a line segment in the world and the parameter $\bar{s} \in [0, 1]$ of the perspective projection of the line segment on the screen. The attribute α is linearly interpolated in world space, so

$$s = \frac{\alpha - \alpha_0}{\alpha_1 - \alpha_0}.$$

The value y is linearly interpolated in screen space, so

$$\bar{s} = \frac{y - y_0}{y_1 - y_0}.$$

Replacing this in Equation (3.3) and performing some algebra manipulation yield the perspective interpolation

$$\alpha = \frac{(\alpha_0 w_1 y_1 - \alpha_1 w_0 y_0) + (\alpha_1 w_0 - \alpha_0 w_1)y}{(w_1 y_1 - w_0 y_0) + (w_0 - w_1)y}.$$

The perspective aspect is clear since the right-hand side is a ratio of two linear functions of y. The vertex attribute that is always perspectively interpolated is the depth value z or, equivalently, $w = z/n$. Replacing α by z or w in the interpolation equation yields

$$z = \frac{z_0 z_1 (y_1 - y_0)}{(z_1 y_1 - z_0 y_0) + (z_0 - z_1)y}$$

or

$$w = \frac{w_0 w_1 (y_1 - y_0)}{(w_1 y_1 - w_0 y_0) + (w_0 - w_1)y}.$$

This interpolator is used to compute the depth values per pixel that are used for depth buffer sorting. The calculated value at each pixel is compared to the corresponding value in the depth buffer to control whether or not the pixel is written.

The pseudocode for the edge buffer setup is

```
b0 = w1*y1 - w0*y0;
b1 = w0 - w1;
t0 = w0*a1;
t1 = w1*a0;
c0 = t1*y1 - t0*y0;
c1 = t0 - t1;
for (y = y0+1; y < y1; y++)
    a[y] = (c0+c1*y)/(b0+b1*y);
```

Linear interpolation involves one division per edge per attribute. Perspective interpolation involves one division per pixel per attribute, so a greater cost is incurred.

When all three edges of the triangle are processed, the edge buffers contain the extreme x-values and the corresponding interpolated attributes. An iteration over the relevant scan lines is performed, and the attributes for the vertical run of pixels between the extreme x-values are themselves computed by perspective interpolation of the edge buffer attributes. The pseudocode for rasterizing a triangle with a single vertex attribute is

```
for (int y = ymin; y <= ymax; y++)
{
    x0 = xmin[y];
    x1 = xmax[y];
    a0 = amin[y];
    a1 = amax[y];

    dx = x1 - x0;
    if ( dx > 1 )
    {
        b1 = w0 - w1;
        b0 = w1*x1 - w0*x0;
        t0 = w0*a1;
        t1 = w1*a0;
        c1 = t0 - t1;
        c0 = t0*x1 - t0*x0;

        pixel[y][x0] = a0;

        for (x = x0+1; x < x1; x++)
            pixel[y][x] = (c0+c1*x)/(b0+b1*x);

        pixel[y][x1] = a1;
    }
    else if ( dx == 1 )
    {
        pixel[y][x0] = a0;
        pixel[y][x1] = a1;
    }
    else
    {
        pixel[y][x0] = a0;
    }
}
```

As implemented, rasterization of a triangle with an attribute that must be perspectively interpolated requires a division per pixel—an expense clearly noticed in software renderers. But there are a couple of ways to avoid this expense. One way is to replace the floating-point division by an algorithm that approximates division but uses less cycles. Current-generation CPUs have division-approximation instructions that typically require just a few cycles more than a multiplication or addition. A second way has been the standard approach for CPUs that allow the floating-point unit

and integer unit to work in parallel. The division is performed at every Nth pixel (typically, $N = 4$ or 8 or 16), and the other pixels are linearly interpolated using integer arithmetic. The first pixel and last pixel in a run have their divisions calculated. The last pixel of the current run becomes the first pixel of the next run. The last pixel of the next run is started. While the floating-point unit stalls to complete the division, the intermediate pixels of the current run are linearly interpolated from the known values of the first and last pixels of that run. This is done using integer arithmetic, so the integer unit and floating-point unit are executing in parallel.

There is a very nicely written set of articles on the topic of perspective interpolation that includes source code for a PC (Hecker 1995a, 1995b, 1995c, 1995d, 1996).

3.7 AN EFFICIENT CLIPPING AND LIGHTING PIPELINE

The graphics pipeline illustrated here is built with the goal of saving as much information as possible to minimize execution time. The object is represented as a triangle mesh with manifold geometry. Object culling can be performed as indicated earlier, whether with bounding spheres, oriented bounding boxes, or any other preferred bounding volume. The clipping pipeline used is the one that transforms vertices to view space, then clips in view space. The workhorse of the pipeline is the clipping of the triangle mesh, a process described here in detail. Only clipping of vertices is performed. Lighting of vertices and interpolation of vertex attributes is deferred until after the completion of clipping. The triangle mesh retains enough information to allow us to light the minimum number of vertices and to interpolate the minimum number of clip vertices. Projection into screen space is straightforward.

3.7.1 TRIANGLE MESHES

An object representation that is well suited for efficient clipping is a *triangle mesh*. The meshes considered here have manifold geometry; that is, each edge is shared by at most two triangles and there are no degenerate vertex junctions. Triangle fans, triangle strips, and triangle soups fall into this category.

The triangle mesh stores an array of vertices that are contained in the mesh. Other quantities are stored but not shown here, for example, facet plane normals (for back face culling) and vertex attributes (color, alpha, texture coordinates, fog). The minimum connectivity structure for supporting the geometric clipping is

```
Vertex : point in 3-space

Edge Record :
  indices for vertex end points of edge (V0, V1)
  indices for triangles sharing the edge (T0, T1)
```

```
Triangle Record :
  indices for vertices of triangle (V0, V1, V2)
  indices for edges of triangle (E0 = <V0,V1>, E1 = <V1,V2>,
    E2 = <V2,V0>)

Triangle Mesh :
  number of Vertices, NV
  number of Edges, NE
  number of Triangles, NT
  array[0..NV-1] of Vertex
  array[0..NE-1] of Edge Record
  array[0..NT-1] of Triangle Record
```

The renderer appends to this data structure additional information that supports minimum execution time for clipping and deferred lighting calculations:

```
Per Vertex:
  visibility flags
  pseudodistance to current clip plane
  old edge index for clip vertex
  new edge index for clip vertex
  clip parameters

Per Edge:
  visibility flags
  index of clip vertex on edge (if any)

Per Triangle:
  visibility flags
```

The reasons for the design of `Edge Record` and `Triangle Record` and for the additional information in the renderer will become clear shortly.

The renderer maintains a single extended triangle mesh that can contain any application triangle mesh to be rendered. Initially, the extended mesh dynamically resizes itself as the scene graph is rendered piece by piece. Eventually, a steady state is reached, at which time the resizing is no longer necessary.

3.7.2 Clipping a Triangle Mesh

Each frustum plane in view space is of the form $Ax + By + Cw + D = 0$. A point (x, y, w) is said to be on the *frustum side of the plane* when $Ax + By + Cw +$

$D \geq 0$. The quantity $Ax + By + Cw + D$ is referred to as a *pseudodistance*. The actual distance of point to plane is $|Ax + By + Cw + D|/\sqrt{A^2 + B^2 + C^2}$. The only important thing to determine is on which side of a plane the point lives. The distance to plane is not needed, so the expensive square root evaluation is avoided. The near plane is $w = 1$, the far plane is $-w + f/n$, the left plane is $x + w = 0$, the right plane is $-x + w = 0$, the bottom plane is $y + w = 0$, and the top plane is $-y + w = 0$. The frustum side conditions use \geq instead of $=$ in the plane equations.

The vertex visibility flags are used to determine which vertices need to be processed by the clipper. If a vertex is tagged as visible and is outside the currently processed frustum plane, it is tagged as not visible and the next frustum plane test ignores the vertex. A pass is made over the visible vertices, and the pseudodistances are computed and saved.

The edge visibility flags are used to determine which edges need to be tested for clipping. If both pseudodistances are nonpositive, then the edge is culled and is tagged as invisible. If both pseudodistances are nonnegative, then the edge is on the frustum side of the plane and remains visible for the next plane test. If an edge is currently visible and the product of the pseudodistances is negative, then the edge is split by the frustum plane. The clip vertex is computed according to Equation (3.17). To support deferred lighting calculations, the parameter $p_{i0}/(p_{i0} - p_{i1})$ is saved in an array of clip parameters that is stored by the renderer. The new vertex is appended to the vertex array of the mesh and is tagged as visible. The old vertex that is outside the frustum is tagged as invisible. The new edge is the portion of the old edge that is on the frustum side of the plane. It is appended to the edge array of the mesh and tagged as visible. The old edge is tagged as invisible so that it will not be tested against the next frustum plane.

The technical challenge is in updating the triangle and edge connectivity information. The edges themselves were clipped against the frustum plane. If two edges in a single triangle are clipped, the corresponding clip vertices must be connected by adding a new edge to the mesh. The old triangle must also be subdivided into one or two triangles. The old triangle is then tagged as invisible and the new triangles are tagged as visible. Figure 3.10 shows the three possible configurations. The original triangle T_0 consists of vertices $\{V_0, V_1, V_2\}$ and edges $\{E_0, E_1, E_2\}$, where $E_0 = \{V_0, V_1; T_0, \infty\}$, $E_1 = \{V_1, V_2; T_0, \infty\}$, and $E_2 = \{V_2, V_0; T_0, \infty\}$. The edge format contains the two vertices that form its end points (stored in the actual data structure as indices into the vertex array) and the two triangles that share the edge (stored in the actual data structure as indices into the triangle array, an ∞ indicating no adjacent triangle). The triangle format is $T_0 = \{V_0, V_1, V_2; E_0, E_1, E_2\}$ (stored in the actual data structure as indices into the appropriate arrays).

In case 1, the vertex array is expanded to $\{\bar{V}_0, V_1, \bar{V}_2, V_3, V_4\}$, the edge array is expanded to $\{\bar{E}_0, \bar{E}_1, \bar{E}_2, E_3, E_4, E_5\}$, and the triangle array is expanded to $\{\bar{T}_0, T_1\}$. The bars over the vertices, edges, and triangles indicate that those objects have been tagged as invisible. The new edges are $E_3 = \{V_3, V_1; T_1, \infty\}$, $E_4 = \{V_4, V_1; T_1, \infty\}$, and $E_5 = \{V_3, V_4; T_1, \infty\}$. The new triangle is $T_1 = \{V_3, V_4, V_1; E_5, E_4, E_3\}$.

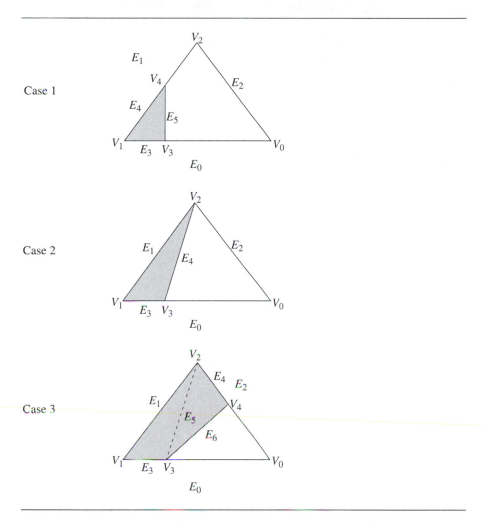

Figure 3.10 Three configurations for clipped triangle.

In case 2, the vertex array is expanded to $\{\bar{V}_0, V_1, V_2, V_3\}$, the edge array is expanded to $\{\bar{E}_0, E_1, \bar{E}_2, E_3, E_4\}$, and the triangle array is expanded to $\{\bar{T}_0, T_1\}$. The new edges are $E_3 = \{V_3, V_1; T_1, \infty\}$ and $E_4 = \{V_3, V_2; T_1, \infty\}$. The new triangle is $T_1 = \{V_3, V_2, V_1; E_4, E_1, E_3\}$.

In case 3, the vertex array is expanded to $\{\bar{V}_0, V_1, V_2, V_3, V_4\}$, the edge array is expanded to $\{\bar{E}_0, E_1, \bar{E}_2, E_3, E_4, E_5, E_6\}$, and the triangle array is expanded to $\{\bar{T}_0, T_1, T_2\}$. The new edges are $E_3 = \{V_3, V_1; T_1, \infty\}$, $E_4 = \{V_4, V_2; T_2, \infty\}$, $E_5 = \{V_3, V_2;$

T_1, T_2}, and $E_6 = \{V_3, V_4; T_2, \infty\}$. The new triangles are $T_1 = \{V_3, V_2, V_1; E_5, E_1, E_3\}$ and $T_2 = \{V_3, V_4, V_2; E_6, E_4, E_5\}$.

Figure 3.10 is slightly misleading about the complexity of the algorithm. First, T_0 consists of vertices $\{U_{i_0}, U_{i_1}, U_{i_2}\}$ and edges $\{F_{j_0}, F_{j_1}, F_{j_2}\}$. These must be mapped onto the V and E terms so that the ordering of the U and F values is consistent with what is shown in the figure. The old edge indices that are stored by the renderer are used to assist in calculating the ordering. Second, if T_0 happened to share edge E_0 with another triangle S_0, then both T_0 and S_0 must be subdivided. The new edge is $E_3 = \{V_3, V_1; T_1, S_1\}$, where T_1 and S_1 are the appropriate subtriangles. The problem is that T_0 is the first of the two triangles to be processed. S_0 has not yet been subdivided, and S_1 does not exist in the triangle array at the time that E_3 is constructed. In this situation the algorithm sets $E_3 = \{V_3, V_1; T_1, S_0\}$. S_0 is immediately processed after T_0 because when E_0 is processed, both of its adjacent triangles are analyzed for splitting. Once S_0 is processed, the triangle index for S_0 in the edge record for E_3 is updated to S_1.

3.7.3 COMPUTING VERTEX ATTRIBUTES

Vertex lighting and interpolation is performed in four steps. The first step is to make a pass over the visible original vertices and mark them as needing to be lit. The second step is to make a pass over the visible clip vertices and determine which of the original vertices (at most three) contributed to it. The edge clipping algorithm and data structures implicitly contain a directed acyclic graph of related vertices. The algorithm amounts to a traversal of the graph and tagging the appropriate original vertices. Note that an invisible original vertex can contribute to a visible clip vertex, so this pass may tag additional vertices as needing to be lit, even though those vertices are invisible. In particular, this is the case when an edge just straddles the frustum. One vertex is inside and one vertex is outside. The outside vertex is invisible, but its attributes need to be computed so that the clip vertex attributes can also be computed. The third step is to make a pass over the original vertices that need to be lit and actually do the lighting calculations. The process of lighting was described earlier. The fourth step is to make a pass over the visible clipped vertices and interpolate their attributes. This pass also uses the directed acyclic graph of vertices and uses the clip parameters that have been stored by the renderer.

The directed acyclic graphs of vertices corresponding to the three cases in Figure 3.10 are shown in Figure 3.11. The graphs consisting solely of vertices are weighted. The arcs connecting vertices contain the appropriate clip parameter values that produced the clip vertex. The graphs can become more complicated if a triangle is split by more than one frustum plane.

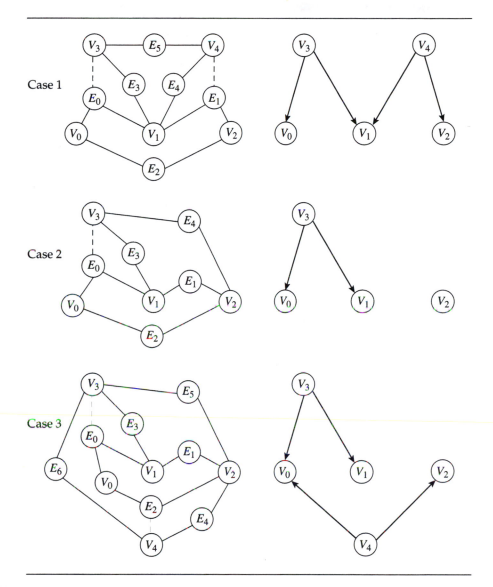

Figure 3.11 Three configurations for clipped triangle.

3.8 ISSUES OF SOFTWARE, HARDWARE, AND APIs

In summary, this chapter describes the relevant issues in building a renderer without regard to whether the work is done by a general-purpose CPU, in part by a hardware-accelerated graphics card, or totally by specialized graphics hardware. Independent of software or hardware, the rendering pipeline was also described without regard to integration with existing software that provides an application programmer interface (API). The reality of building a real-time computer graphics engine requires an understanding of what platforms are to be supported and what other existing systems can be used rather than implemented from scratch.

APIs such as Direct3D, OpenGL, or Glide for consumer graphics accelerators can be viewed as providing a boundary between the scene graph management and the rendering system. Direct3D and OpenGL are fairly high-level rendering APIs, and both attempt to hide the underlying hardware to allow an application to be portable across multiple hardware cards. Glide is a low-level rasterizing API specifically for 3dfx cards. Writing to this API clearly makes the application nonportable, but if the only intended platform is one that uses a 3dfx card (an arcade machine, for example), then there is a lot to be gained by using the specific features of the low-level API.

Heated debates arise in the computer graphics and games newsgroups about whether Direct3D or OpenGL is the "best" system to build on. This is an unanswerable question—and in fact is not the question to ask. Each system has its advantages and disadvantages. As with most of computer science, the issue is more about understanding the trade-offs between using one system or another. OpenGL is clearly superior with respect to portability simply by its design. An application can be written to run on a high-end SGI machine or on a consumer machine such as a PC or Macintosh. Direct3D was intended only to provide portability among cards in a PC. On the other hand, OpenGL insists on handling many details that an application might like to control but cannot. Direct3D provides much more fine-grained control over the rendering process. Both APIs are constantly evolving based on what the end programmers want, but evolution takes time. Moreover, the consumer hardware cards are evolving at a fast enough rate that the drivers that ship with them are buggy but are not always corrected because the next-generation card is almost ready to ship. This requires patching the layer on top of the APIs with work-arounds for specific cards. Evolution is good, but fast evolution is painful, especially for a company producing a commercial product that runs on top of those cards and drivers.

As hardware evolves and begins doing the higher-level work that the scene graph management system has been doing, the APIs should become easier to work with. However, there will always be work necessary on the scene graph side to feed data through the API. The next-generation cards that are shipping as of the time of this writing will be providing support for hardware transforming and lighting. The model data is expected to be in some compacted format and may require conversion from the natural format for the application to the required format of the graphics card. If two hardware cards require different formats and the APIs do not hide this difference

from the application, then portability among cards becomes a difficult issue again. Repackaging of data does incur some cost.

Another part of the evolution of graphics on a consumer machine involves the CPUs themselves. Both Intel's Pentium III and AMD's K6 chipsets have new instructions to support a small amount of parallelism (SIMD: single instruction, multiple data) and to provide for faster operations such as inverse square roots (for normalizing vectors). To make the most of the new instructions, the registers of the CPUs must be loaded quickly. For the Pentium III, the natural format for storing an array of points to support fast register loading is to have three arrays, one for x-values, one for y-values, and one for z-values. However, most applications have tended to store points as an array of structures, not as a structure of arrays. Repackaging points to feed the registers quickly invariably offsets most of the speedup for using SIMD. Again, portability between platforms becomes a significant issue simply because of data formats. The new CPUs also tend to have data alignment requirements that are not necessarily guaranteed by current-generation compilers, so either a memory manager must be written to handle the alignment or the chip companies must supply a compiler. In fact, current compilers have to catch up and provide support for the new machine instructions, so it is essential to have additional compiler support from the chip companies.

Finally, one of the most important low-level aspects of building a renderer is cache coherence. Experience has shown that even with the best-designed high-level algorithms, the performance can be significantly reduced if the data is organized in such a way as to cause many cache misses. Unless those implementing the system are experts for the particular CPU's instruction set, the most reliable way to determine cache problems or floating-point unit stalls is to use performance tools. Intel provides a profiler, called VTune, that does give a lot of information, showing if cache misses or floating-point stalls have occurred. At a high level, a rearrangement of statements can help eliminate some of these problems; the necessity of rearranging is the result of the optimizing compiler not being powerful enough to recognize the problems and rearrange transparently. But in many cases, a low-level solution is required, namely, writing parts of the code in assembly language. And once again portability becomes a problem.

All of these issues must be weighed and the trade-offs made when building a renderer. This is where the art of renderer construction really kicks in. Someone who does not understand all the issues will be unlikely to succeed in building a good renderer.

HIERARCHICAL SCENE REPRESENTATIONS

The graphics pipeline discussed in Chapter 3 requires that each drawable object be tested for culling against the view frustum and, if not culled, be passed to the renderer for clipping, lighting, and rasterizing. Given a 3D world with a large number of objects, the simplest method for processing the objects is to group them into a list and iterate over the items in the list for culling and rendering. Although this approach may be simple, it is not efficient since each drawable object in the world must be tested for culling.

A better method for processing the objects is to group them hierarchically according to spatial location. The grouping structure discussed in this chapter is a *tree*. The tree has leaf nodes that contain geometric data and internal nodes that provide a grouping mechanism. Each node has one parent (except for the root node, which has none) and any number of child nodes. It is possible to use a directed acyclic graph as an attempt to support high-level sharing of objects. Each node in the graph can have multiple parents, each parent sharing the object represented by the subgraph rooted at the node. However, the memory costs and code complexity to maintain such a graph do not justify using it. Sharing should occur at a lower level so that leaf nodes can

141

share vertices, texture images, and other data that tends to use a lot of memory. The implied links from sharing are not part of the parent-child relationships in the hierarchy. Regardless of whether trees or directed acyclic graphs are used, the resulting set of grouped objects is called a *scene graph*.

The organization of content in a scene graph is quite important for games in many ways, of which four are listed here. First, the amount of content to manage is typically large and is built in small pieces by the artists. The level editor can assemble the content for a single level as a hierarchy by concentrating on the local items of interest. The global ramifications are effectively the responsibility of the hierarchy itself. For example, a light in the world can be chosen to illuminate only a subtree of the graph. The level editor's responsibility is to assign that light to a node in the graph. The effect of the light on the subtree rooted at that node is automatically handled by the scene graph management system. Second, hierarchical organization provides a form of locality of reference, a common concept in memory management by a computer system. Objects that are of current interest in the game tend to occur in the same spatial region. The scene graph allows the game program to quickly eliminate other regions from consideration for further processing. Although minimizing the data sent to the renderer is an obvious goal to keep the game running fast, focusing on a small amount of data is particularly important in the context of collision detection. The collision system can become quite slow when the number of potentially colliding objects is large. A hierarchical scene graph supports grouping only a small number of potentially colliding objects, those objects occurring only in the local region of interest in the game. Third, many objects are naturally modeled with a hierarchy, most notably humanoid characters. The location and orientation of the hand of a character is naturally dependent on the locations and orientations of the wrist, elbow, and shoulder. Fourth, invariably the game must deal with persistence issues. A player wants to save the current game, and the game is to be continued at a later time. Hierarchical organization makes it quite simple to save the state of the world by asking the root node of the scene graph to save itself, the descendants saving themselves in a naturally recursive fashion.

Section 4.1 provides the basic concepts for management of a tree-based representation of a scene, including specification and composition of local and world transforms, construction of bounding volumes for use both in rapid view frustum culling and fast determination of nonintersection of objects managed by a collision system, selection and scope of renderer state at internal or leaf nodes, and control of animated quantities.

Changes in the world environment of the game are handled by changing various attributes at the nodes of the tree. A change at a single node affects the subtree for which that node is the root. Therefore, all nodes in the subtree must be notified of the change so that appropriate action can be taken. One typical action that requires an update of the scene graph is moving an object by changing its local transform. The world transforms of the object's descendants in the tree must be recalculated. Additionally, the object's bounding volume has changed, in turn affecting all the bounding volumes of its ancestors in the tree. The new bounding volume at a node

involves computing a single bounding volume that contains all the bounding volumes of its children, a process called *merging*. Another typical action that requires an update of the scene graph is changing renderer state at a node. The renderer state at all the leaf nodes in the affected tree must be updated. The update process is the topic of Section 4.2.

After a scene graph is updated, it is ready for processing by the renderer. The drawing pass uses the bounding volumes to cull entire subtrees at once, thereby reducing the amount of time the renderer has to spend on low-level processing of objects that ultimately will not appear on the computer screen. Section 4.3 presents culling algorithms for various bounding volumes compared to a plane at a time in the view frustum. The general drawing algorithm for a hierarchy is also discussed.

4.1 TREE-BASED REPRESENTATION

A simple grouping structure for objects in the world is a tree. Each node in the tree has exactly one parent, except for the root node, which has none. The root is the first node to be processed when attempting to render objects in the tree. The simplest example of a tree is illustrated in Figure 4.1. The top-level node is a *grouping node* (bicycle) and acts as a *parent* for the two *child nodes* (wheels). The children are grouped because they are part of the same object both spatially and semantically.

To take advantage of this structure, the nodes must maintain spatial and semantic information about the objects they represent. The main categories of information are *transforms, bounding volumes, render state,* and *animation state*. Transforms are used to position, orient, and size the objects in the hierarchy. Bounding volumes are used for hierarchical culling purposes and intersection testing. Render state is used to set up the renderer to properly draw the objects. Animation state is used to represent any time-varying node data.

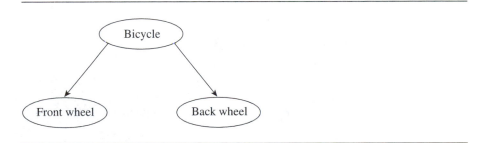

Figure 4.1 A simple tree with one grouping node.

4.1.1 TRANSFORMS

In Figure 4.1, it is not enough to know the semantic information that the two wheels are part of the bicycle. The spatial information, the location of the wheels, must also be specified. Moreover, it is necessary to know a coordinate system in which to specify that information. The parent node has its own coordinate system, and the location of a child is given relative to its parent's coordinates.

Local Transforms

The location of a node relative to its parent is represented abstractly as a homogeneous matrix with no perspective component. The matrix, called a *local transform,* represents any translation, rotation, scaling, and shearing of the node within the parent's coordinate system. While an implementation of scene graph nodes could directly store the homogeneous matrix as a 4×4 array, it is not recommended. The last row of the matrix is always [0 0 0 1]. Less memory is used if the homogeneous matrix is stored as a 3×3 matrix representing the upper-left block and a 3×1 vector representing the translation component of the matrix. This also avoids the inefficient general multiplication of homogeneous matrices and vectors since in that multiplication, there would be three multiplies by 0 and one multiply by 1. Given a homogeneous matrix with no perspective component, the matrix is denoted by

$$\left\langle M \mid \vec{T} \right\rangle := \left[\begin{array}{c|c} M & \vec{T} \\ \hline \vec{0}^{\mathrm{T}} & 1 \end{array} \right]. \tag{4.1}$$

Using this compressed notation, the product of two homogeneous matrices is

$$\left\langle M_1 \mid \vec{T}_1 \right\rangle \left\langle M_2 \mid \vec{T}_2 \right\rangle = \left\langle M_1 M_2 \mid M_1 \vec{T}_2 + \vec{T}_1 \right\rangle \tag{4.2}$$

and the product of a homogeneous matrix with a homogeneous vector $[\vec{V}|1]^{\mathrm{T}}$ is

$$\left\langle M \mid \vec{T} \right\rangle \vec{V} = M\vec{V} + \vec{T}. \tag{4.3}$$

To keep the update time to a minimum and to avoid using numerical inversion of matrices in various settings, it is better to require that the local transform have only translation, rotation, and uniform scaling components. The general form of such a matrix is

$$\left\langle sR \mid \vec{T} \right\rangle \tag{4.4}$$

and is called an *SRT-transform*. The uniform scaling factor is $s > 0$, the rotational component is the orthogonal matrix R whose determinant is one, and the translational component is \vec{T}. The product of two *SRT*-transforms is

$$\left\langle s_1 R_1 \mid \vec{T}_1 \right\rangle \left\langle s_2 R_2 \mid \vec{T}_2 \right\rangle = \left\langle s_1 s_2 R_1 R_2 \mid s_1 R_1 \vec{T}_2 + \vec{T}_1 \right\rangle, \tag{4.5}$$

the product of an *SRT*-transform and a vector \vec{V} is

$$\left\langle s R \mid \vec{T} \right\rangle \vec{V} = s R \vec{V} + \vec{T}, \tag{4.6}$$

and the inverse of an *SRT*-transform is

$$\left\langle s R \mid \vec{T} \right\rangle^{-1} = \left\langle \frac{1}{s} R^{\mathrm{T}} \mid -\frac{1}{s} R^{\mathrm{T}} \vec{T} \right\rangle. \tag{4.7}$$

World Transforms

The local transform at a node specifies how the node is positioned with respect to its parent. The entire scene graph represents the world itself. The world location of the node depends on all the local transforms of the node and its predecessors in the scene graph. Given a parent node P with child node C, the *world transform* of C is the product of P's world transform with C's local transform,

$$\left\langle M_{\mathrm{world}}^{(C)} \mid \vec{T}_{\mathrm{world}}^{(C)} \right\rangle = \left\langle M_{\mathrm{world}}^{(P)} \mid \vec{T}_{\mathrm{world}}^{(P)} \right\rangle \left\langle M_{\mathrm{local}}^{(C)} \mid \vec{T}_{\mathrm{local}}^{(C)} \right\rangle$$
$$= \left\langle M_{\mathrm{world}}^{(P)} M_{\mathrm{local}}^{(C)} \mid M_{\mathrm{world}}^{(P)} \vec{T}_{\mathrm{local}}^{(C)} + \vec{T}_{\mathrm{world}}^{(P)} \right\rangle.$$

The world transform of the root node in the scene graph is just its local transform. The world position of a node N_k in a path $N_0 \cdots N_k$, where N_0 is the root node, is generated recursively by the above definition as

$$\left\langle M_{\mathrm{world}}^{(N_k)} \mid \vec{T}_{\mathrm{world}}^{(N_k)} \right\rangle = \left\langle M_{\mathrm{local}}^{(N_0)} \mid \vec{T}_{\mathrm{local}}^{(N_0)} \right\rangle \cdots \left\langle M_{\mathrm{local}}^{(N_k)} \mid \vec{T}_{\mathrm{local}}^{(N_k)} \right\rangle.$$

4.1.2 BOUNDING VOLUMES

Object-based culling within a scene graph is very efficient whenever the bounding volumes of the nodes are properly nested. If the bounding volume of the parent node encloses the bounding volumes of the child nodes, culling of entire subtrees is supported. If the bounding volume of the parent node is outside the view frustum, then

the child nodes must be outside the view frustum and no culling tests need be done on the children. Hierarchical culling provides a fast way for eliminating large portions of the world from being processed by the renderer. The same nested bounding volumes support collision detection. If the bounding volume of the parent node does not intersect an object of interest, then neither do the child nodes. Hierarchical collision detection provides a fast way for determining that two objects do not intersect. The bounding volumes that are discussed in this chapter include spheres, oriented boxes, capsules, lozenges, cylinders, and ellipsoids.

A leaf node containing geometric data will also contain a bounding volume based on the model space coordinates of the data. However, the leaf node has a world space representation based on the product of local transforms from scene graph root to that leaf. That means the leaf node must also contain a world bounding volume, obtained by applying the world transform to the model bounding volume.

To support the efficiencies of a hierarchical organization of the world, an internal node requires a world bounding volume that contains the world bounding volumes of all its children. It is not necessary to maintain a model bounding volume at an internal node since such a node does not contain its own geometric data. While transforms are propagated from the root of the scene graph toward the leaf nodes, the bounding sphere calculations must occur from leaf node to root. A parent bounding volume cannot be known until its child bounding volumes are known. A recursive traversal downward allows computation of the world transforms. The upward return from the traversal allows computation of the world bounding volumes.

4.1.3 RENDERER STATE

Renderer state can also be maintained in a hierarchical fashion. For example, if a subtree rooted at a node has all leaf nodes that want their textures to be alpha blended, the node can be tagged with state information that indicates alpha blending should be enabled for the entire subtree. Alternatively, tagging all the leaf nodes with the same renderer state information is an efficient use of memory. A traversal along a single path in the tree from root to leaf node accumulates the renderer state necessary to draw the geometry of the leaf node. Just before a leaf node is about to be drawn, the renderer processes the state information at that node and decides whether or not it needs to change its own internal state. As changes in rendering state can be expensive, the number of changes should be minimal. A typical expensive change involves using different textures. If a texture is in system memory but not in video memory, the texture must be copied to video memory, and that takes time. For sorting purposes, it is convenient to allow each leaf node to store a copy of the renderer state. A sorter can select a renderer state for which it wants to minimize changes, then sort the leaf nodes accordingly.

4.1.4 ANIMATION

Animation in the classic sense is the motion of articulated characters and objects in the scene. If a character is represented hierarchically, each node might represent a joint (neck, shoulder, elbow, wrist, knee, etc.) whose local transformations change over time. Moreover, the values of the transformations are usually controlled by procedural means (see Chapter 9) as compared to the application manually adjusting the transforms. This can be accomplished by allowing each node to store *controllers*, with each controller managing some quantity that changes over time. In the case of classic animation, a controller might represent the local transform as a matrix function of time. For each specified time in the application, the matrix is computed by the controller and the world transform is computed using this matrix.

It is possible to allow any quantity at a node to change over time. For example, a node might be tagged to indicate that fogging is to be used in its subtree. The fog depth can be made to vary with time. A controller can be used to procedurally compute the depth based on current time. In this way animation is controlling any time-varying quantity in a scene graph.

4.2 UPDATING A SCENE GRAPH

The scene graph represents the state of the world at a given time. If the state changes for whatever reason, the scene graph must be updated to represent the new state. Typical state changes include model data changing at a node, local transforms changing at a node, the topological structure of the tree changing, renderer state changing, or some animated quantity changing. Updating the scene graph is only necessary in those subtrees affected by the changes. For example, if a local transform is changed at a single node, then only the subtree rooted at that node is affected. The world transforms of descendants must be recalculated to reflect the new position and orientation of the subtree's root node. It is possible that more than one change has been made at different locations in the scene graph. An implementation of a scene graph manager can attempt to maintain the minimum number of subtree root nodes that need to be updated. For example, if the local transforms are changed at nodes A and B, and if B is a descendant of A, the update of the subtree rooted at node A will automatically update the subtree rooted at B. It would be inefficient to first update the subtree at B, then update the subtree at A.

The updating is done in a recursive pass. Transforms are updated on the downward pass; bounding volumes are updated on the upward pass that is initiated as a return from the recursive calls. Note that the upward pass should not terminate at the node at which the initial update call was made. If the bounding volume of this node has changed as a result of changes in bounding volumes of the descendants, then the parent's bounding volume might also change. Thus, the upward pass must proceed

all the way to the root of the scene graph. If transforms are animated, the update pass is responsible for asking the controllers to make the necessary adjustments to the quantities they manage before the world transform is computed. Finally, if renderer state has changed, that information must be propagated to the leaf nodes (to support sorting as mentioned earlier). A single update call can be implemented to handle all changes in the scene graph, but since renderer state tends to change independently of geometry and transform changes, it might be desirable to have separate update passes.

The computation of model bounding volumes for geometric data was already discussed in Chapter 2. The main focus in the remainder of this section is on computing the parent's bounding volume from the child bounding volumes. The expense and algorithmic complexity depends on the type of volume used. It is possible to consider all child bounds simultaneously, but practice has shown that it is easier and faster to incrementally bound the children. For a node with three or more children, a bound is found for the first two children. That bound is increased in size to include the third child bound, and so on.

4.2.1 MERGING TWO SPHERES

SOURCE CODE

LIBRARY

Containment

FILENAME

ContSphere

The algorithm described here computes the smallest sphere containing two spheres. Let the spheres S_i be $|\vec{X} - \vec{C}_i|^2 = r_i^2$ for $i = 0, 1$. Define $L = |\vec{C}_1 - \vec{C}_0|$ and unit-length vector $\vec{U} = (\vec{C}_1 - \vec{C}_0)/L$. The problem can be reduced to one dimension by projecting the spheres onto the line $\vec{C}_0 + t\vec{U}$. The projected intervals in terms of parameter t are $[-r_0, r_0]$ for S_0 and $[L - r_1, L + r_1]$ for S_1.

If $[-r_0, r_0] \subseteq [L - r_1, L + r_1]$, then $S_0 \subseteq S_1$ and the two spheres merge into S_1. The test for this case is $r_0 \leq L + r_1$ and $L - r_1 \leq -r_0$. A single test covers both conditions, $r_1 - r_0 \geq L$. To avoid the square root in computing L, compare instead $r_1 \geq r_0$ and $(r_1 - r_0)^2 \geq L^2$.

If $[L - r_1, L + r_1] \subseteq [-r_0, r_0]$, then $S_1 \subseteq S_0$ and the two spheres merge into S_0. The test for this case is $L + r_1 \leq r_0$ and $-r_0 \leq L - r_1$. A single test covers both conditions, $r_1 - r_0 \leq -L$. Again to avoid the square root, compare instead $r_1 \leq r_0$ and $(r_1 - r_0)^2 \geq L^2$.

Otherwise, the intervals either have partial overlap or are disjoint. The interval containing the two projected intervals is $[-r_0, L + r_1]$. The corresponding merged sphere whose projection is the containing interval has radius

$$r = \frac{L + r_1 + r_0}{2}.$$

The center t-value is $(L + r_1 - r_0)/2$ and corresponds to the point

$$\vec{C} = \vec{C}_0 + \frac{L + r_1 - r_0}{2}\vec{U} = \vec{C}_0 + \frac{L + r_1 - r_0}{2L}\left(\vec{C}_1 - \vec{C}_0\right).$$

The pseudocode is

```
Input:  Sphere(C0,r0) and Sphere(C1,r1)
centerDiff = C1 - C0;
radiusDiff = r1 - r0;
radiusDiffSqr = radiusDiff*radiusDiff;
Lsqr = centerDiff.SquaredLength();
if ( radiusDiffSqr >= LSqr )
{
    if ( radiusDiff >= 0.0f )
        return Sphere(C1,r1);
    else
        return Sphere(C0,r0);
}
else
{
    L = sqrt(Lsqr);
    t = (L+r1-r0)/(2*L);
    return Sphere(C0+t*centerDiff,(L+r1+r0)/2);
}
```

4.2.2 Merging Two Oriented Boxes

SOURCE CODE

LIBRARY

Containment

FILENAME

ContBox

If two oriented boxes were built to contain two separate sets of data points, it is possible to build a single oriented bounding box that contains the union of the sets. That box might not contain the two original oriented boxes—something that is not desired in a hierarchical decomposition of an object. Moreover, the time it takes to build the single oriented box could be expensive.

An alternative approach is to construct an oriented box from only the original boxes and that contains the original boxes. This can be done by interpolation of the box centers and axes, then growing the box to contain the originals. Let the original two boxes have centers \vec{C}_i for $i = 0, 1$. Let the box axes be stored as columns of a rotation matrix R_i. Now represent the rotation matrices by unit quaternions q_i such that the dot product of the quaternions is nonnegative, $q_0 \cdot q_1 \geq 0$. The final box is assigned center $\vec{C} = (\vec{C}_0 + \vec{C}_1)/2$. The axes are obtained by interpolating the quaternions. The unit quaternion representing the final box is $q = (q_0 + q_1)/|q_0 + q_1|$, where the absolute value signs indicate length of the quaternion as a four-dimensional vector. The final box axes can be extracted from the quaternion using the methods described in Section 2.3. The extents of the final box are computed by projecting the vertices of the two original boxes onto the final box axes and computing the extreme values.

The pseudocode is

```
// Box has center, axis[3], extent[3]
Input:  Box box0, Box box1
Output:  Box box

// compute center
box.center = (box0.center + box1.center)/2;

// compute axes
Quaternion q0 = ConvertAxesToQuaternion(box0.axis);
Quaternion q1 = ConvertAxesToQuaternion(box1.axis);
Quaternion q = q0+q1;
Real length = Length(q);
q /= Length(q);
box.axis = ConvertQuaternionToAxes(q);

// compute extents
box.extent[0] = box.extent[1] = box.extent[2] = 0;
for each vertex V of box0 do
{
    Point3 delta = V - box.center;
    for (j = 0; j < 3; j++)
    {
        Real adot = |Dot(box0.axis[j],delta)|
        if ( adot > box.extent[j] )
            box.extent[j] = adot;
    }
}
for each vertex V of box1 do
{
    Point3 delta = V - box.center;
    for (j = 0; j < 3; j++)
    {
        Real adot = |Dot(box1.axis[j],delta)|
        if ( adot > box.extent[j] )
            box.extent[j] = adot;
    }
}
```

The function ConvertAxesToQuaternion stores the axes as columns of a rotation matrix, then uses the algorithm to convert a rotation matrix to a quaternion. The function ConvertQuaternionToAxes converts the quaternion to a rotation matrix, then extracts the axes as columns of the matrix.

4.2.3 MERGING TWO CAPSULES

Two capsules may be merged into a single capsule with the following algorithm. If one capsule contains the other, just use the containing capsule. Otherwise, let the capsules have radii $r_i > 0$, end points \vec{P}_i, and directions \vec{D}_i for $i = 0, 1$. The center points of the line segments are $\vec{C}_i = \vec{P}_i + \vec{D}_i/2$. Unit-length directions are $\vec{U}_i = \vec{D}/|\vec{D}|$.

The line L containing the final capsule axis is computed below. The origin of the line is the average of the centers of the original capsules, $\vec{C} = (\vec{C}_0 + \vec{C}_1)/2$. The direction vector of the line is obtained by averaging the unit direction vectors of the input capsules. Before doing so, the condition $\vec{U}_0 \cdot \vec{U}_1 \geq 0$ should be satisfied. If it is not, replace \vec{U}_1 by $-\vec{U}_1$. The direction vector for the line is $\vec{U} = (\vec{U}_0 + \vec{U}_1)/|\vec{U}_0 + \vec{U}_1|$.

The final capsule radius r must be chosen sufficiently large so that the final capsule contains the original capsules. It is enough to consider the spherical ends of the original capsules. The final radius is

$$r = \max\{\text{dist}(\vec{P}_0, L) + r_0, \text{dist}(\vec{P}_0 + \vec{D}_0) + r_0, \text{dist}(\vec{P}_1, L) + r_1, \text{dist}(\vec{P}_1 + \vec{D}_1, L) + r_1\}.$$

Observe that $r \geq r_i$ for $i = 0, 1$.

The final capsule direction \vec{D} will be a scalar multiple of line direction \vec{U}. Let \vec{E}_0 and \vec{E}_1 be the end points for the final capsule, so $\vec{P} = \vec{E}_0$ and $\vec{D} = \vec{E}_1 - \vec{E}_0$. The end points must be chosen so that the final capsule contains the end spheres of the original capsules. Let the projections of \vec{P}_0, $\vec{P}_0 + \vec{D}_0$, \vec{P}_1, and $\vec{P}_1 + \vec{D}_1$ onto $\vec{C} + t\vec{U}$ have parameters τ_0, τ_1, τ_2, and τ_3, respectively. Let the corresponding capsule radii be denoted ρ_i for $0 \leq i \leq 3$. Let $\vec{E}_j = \vec{C} + T_j \vec{D}$ for $j = 0, 1$. The T_j are determined by "supporting" spheres that are selected from the end point spheres of the original capsules. If \vec{Q} is the center of such a supporting sphere of radius ρ for end point \vec{E}_1, then T_1 is the smallest root of the equation $|\vec{C} + T\vec{U} - \vec{Q}| + \rho = r$. Since $r \geq \rho$, the equation can be written as a quadratic

$$T^2 + 2\vec{U} \cdot (\vec{C} - \vec{Q})T + |\vec{C} - \vec{Q}|^2 - (r - \rho)^2 = 0.$$

This equation must have only real-valued solutions. Similarly, if the \vec{Q} is the center of the supporting sphere corresponding to end point \vec{E}_0, then T_0 is the largest root of the quadratic. The quadratics are solved for all four end points of the original capsules, and the appropriate minimum and maximum roots are chosen for the final T_0 and T_1.

4.2.4 MERGING TWO LOZENGES

Two lozenges may be merged into a single lozenge that contains them with the following algorithm. Let the lozenges have radii $r_i > 0$, origins \vec{P}_i, and edges \vec{E}_{ji} for $i = 0, 1$ and $j = 0, 1$. The center points of the rectangles of the lozenge are $\vec{C}_i = \vec{P}_i + (\vec{E}_{0i} + \vec{E}_{1i})/2$. Unit-length edge vectors are $\vec{U}_{ji} = \vec{E}_{ji}/|\vec{E}_{ji}|$. Unit-length normal vectors are $\vec{N}_i = \vec{U}_{0i} \times \vec{U}_{1i}$.

The center point of the final lozenge is the average of the centers of the original lozenges, $\vec{C} = (\vec{C}_0 + \vec{C}_1)/2$.

The edge vectors are obtained by averaging the coordinate frames of the original lozenges using a quaternion representation. Let q_i be the unit quaternion that represents the rotation matrix $[\vec{U}_{0i}\ \vec{U}_{1i}\ \vec{N}_i]$. If $q_0 \cdot q_1 < 0$, replace q_1 by $-q_1$. The final lozenge coordinate frame is extracted from the rotation matrix $[\vec{U}_0\ \vec{U}_1\ \vec{N}]$ corresponding to the unit quaternion $q = (q_0 + q_1)/|q_0 + q_1|$.

The problem now is to compute r sufficiently large so that the final lozenge contains the original lozenges. Project the original lozenges onto the line containing \vec{P} and having direction \vec{N}. Each projection has extreme points determined by the corners of the projected rectangle and the radius of the original lozenge. The radius r of the final lozenge is selected to be the length of the smallest interval that contains all the extreme points of projection. Observe that $r \geq r_i$ is necessary.

Project the rectangle vertices of original lozenges onto the plane containing \vec{P} and having normal \vec{N}. Compute the oriented bounding rectangle in that plane where the axes correspond to \vec{U}_i. This rectangle is associated with the final lozenge and produces the edges $\vec{E}_i = L_i \vec{U}_i$ for some scalars $L_i > 0$. The origin point for the final lozenge is $\vec{P} = \vec{C} - \vec{E}_0/2 - \vec{E}_1/2$.

4.2.5 MERGING TWO CYLINDERS

To keep the merging algorithm simple, the original two cylinders are treated as capsules: their representations are converted to those for capsules, end points are \vec{P}_i, directions are \vec{D}_i, and radii are r_i. The capsule merging algorithm is applied to obtain the cylinder radius r. Rather than fitting a capsule to the points $\vec{P}_i \pm r_i \vec{U}$ and $\vec{P}_i + \vec{D}_i \pm r_i \vec{U}$, the points are projected onto the line $\vec{P} + t\vec{D}$, where \vec{P} is suitably chosen from one of the fitting algorithms. The smallest interval containing the projected points determines cylinder height h.

4.2.6 MERGING TWO ELLIPSOIDS

Computing a bounding ellipsoid for two other ellipsoids is done in a way similar to that of oriented boxes. The ellipsoid centers are averaged, and the quaternions representing the ellipsoid axes are averaged and then the average is normalized. The original ellipsoids are projected onto the newly constructed axes. On each axis, the smallest interval of the form $[-\sigma, \sigma]$ is computed to contain the intervals of projection. The σ-values determine the minor axis lengths for the final ellipsoid.

4.2.7 ALGORITHM FOR SCENE GRAPH UPDATING

The pseudocode for updating the spatial information in a scene graph is given below. Three abstract classifications are used: Spatial, Geometry, and Node. In an object-

oriented implementation, the last two classes are both derived from `Spatial`. The `Spatial` class manages a link to a parent, local transforms, and a world transform. It represents leaf nodes in a tree. The `Node` class manages links to children. It represents internal nodes in the tree. The `Geometry` class represents leaf nodes that contain geometric data. It manages a model bounding volume.

The entry point into the update system for geometric state (GS) is

```
void Spatial::UpdateGS (float time, bool initiator)
{
    UpdateWorldData(time);
    UpdateWorldBound();
    if ( initiator )
        PropagateBoundToRoot();
}
```

The input parameter to the call is set to `true` by the node at which the update is initiated. This allows the calling node to propagate the world bounding volume update to the root of the scene graph.

The function `UpdateWorldData` is virtual and controls the downward pass that computes world transforms and updates time-varying quantities:

```
virtual void Spatial::UpdateWorldData (float time)
{
    // update dynamically changing render state
    for each render state controller rcontroller do
        rcontroller.Update(time);

    // update local transforms if managed by controllers
    for each transform controller tcontroller do
        tcontroller.Update(time);

    // Compute product of parent's world transform with this object's
    // local transform.  If no parent exists, the child's world
    // transform is just its local transform.

    if ( world transform not computed by a transform controller )
    {
        if ( parent exists )
        {
            worldScale = parent.worldScale*localScale;
            worldRotate = parent.worldRotate*localRotate;
            worldTranslate = parent.worldTranslate +
                parent.worldScale*(parent.worldRotate*localTranslate);
        }
```

```
    else
    {
        // node is the root of the scene graph
        worldScale = localScale;
        worldRotate = localRotate;
        worldTranslate = localTranslate;
    }
}
}
```

The function UpdateWorldBound is also virtual and controls the upward pass and allows each node object to update its world bounding volume. Base class Spatial has no knowledge of geometric data and in particular does not manage a model bounding sphere, so the function is pure virtual and must be implemented both by Geometry, which knows how to transform a model bounding volume to a world bounding volume, and by Node, which knows how to merge world bounding volumes of its children.

Finally, the propagation of world bounding volumes is not virtual and is a simple recursive call:

```
void Spatial::PropagateBoundToRoot ()
{
    if ( parent exists )
    {
        parent.UpdateWorldBound();
        parent.PropagateBoundToRoot();
    }
}
```

The derived classes override the virtual functions. Class Geometry has nothing more to say about updating world data, but it must update the world bound,

```
virtual void Geometry::UpdateWorldBound ()
{
    worldBound = modelBound.TransformBy(worldRotate,
        worldTranslate,worldScale);
}
```

The model bound is assumed to be correct. If model data is changed, the application is required to update the model bound.

Class Node updates are as shown:

```
virtual void Node::UpdateWorldData (float time)
{
    Spatial::UpdateWorldData(time);
```

```
        for each child do
            child.UpdateGS(false); // child not initiator of
                                   // original UpdateGS call
}

virtual void Node::UpdateWorldBound ()
{
    worldBound = firstChild.GetWorldBound();
    for each additional child do
        worldBound = Merge(worldBound,child.worldBound);
}
```

The downward pass is controlled by UpdateWorldData. The node first updates its world transforms by a call to the base class update of world transforms. The children of the node are each given a chance to update themselves, thus yielding a recursive chain of calls involving UpdateGS and UpdateWorldData. The update of world bounds is done incrementally. The world bound is set to the first child's world bound. As each remaining child is visited, the current world bound and the child world bound are merged into a single bound that contains both. Although this approach usually does not produce the tightest bound, it is much faster than methods that do attempt the tightest bound. For example, if bounding spheres are used, it is possible to compute the parent world bound as the minimum volume sphere containing any geometric data of the descendants. Such a computation is expensive and will severely affect the frame rate of the application. The trade-off is to obtain a reasonable world bounding volume for the parent that is inexpensive to compute.

Updating the set of current renderer states at the leaf nodes is also a recursive system just as UpdateGS is. Class Geometry maintains a set of such states; call that member stateSet. Each state can be attached to or detached from an object of this class. A state object itself has information that can be modified at run time. If the information is changed, then an update must occur starting at that node. The global renderer state set is maintained by the renderer, so any changes to renderer state by the objects must be communicated to the renderer. Class Spatial provides the virtual function foundation for the renderer state (RS) update:

```
void Spatial::UpdateRS (RenderState parentState)
{
    // update render states
    if ( parentState exists )
    {
        // parentState must remain intact to restore state after
        // recursion
        currentState = parentState;
        modify currentState with thisState;
    }
```

```
else
{
    // this object is initiator of UpdateRS, use default
    // renderer states
    currentState = defaultRenderState;
    PropagateStateFromRoot(currentState);
}

UpdateRenderState(currentState);
}
```

The initial call to UpdateRS is typically applied to a node in the tree that is not the root node. Any renderer state from predecessors of the initiating node must be accumulated before the downward recursive pass. The function PropagateState-FromRoot does this work:

```
void Spatial::PropagateStateFromRoot (RenderState
                                               currentState)
{
    // traverse to root to allow downward state propagation
    if ( parent exists )
        parent.PropagateStateFromRoot(currentState);

    // update parent state by current state
    modify currentState with thisState;
}
```

The call UpdateRenderState is pure virtual. Class Geometry implements this to update its renderer state at leaf nodes. Class Node implements this to perform the recursive traversal of the call on its children.

```
void Geometry::UpdateRenderState (RenderState currentState)
{
    modify thisState with currentState;
}

void Node::UpdateRenderState (RenderState currentState)
{
    for each child do
        child.UpdateRS(currentState);
}
}
```

Notice that UpdateRS and UpdateRenderState form a recursive chain just as UpdateGS and UpdateWorldData form a recursive chain.

4.3 RENDERING A SCENE GRAPH

The renderer manages a camera whose job it is to define the *view frustum,* the portion of the world to be viewed. The process of rendering the scene graph in the frustum at a given instant is typically referred to as the *camera click*. This process involves a traversal of the scene graph, and the graph is assumed to be current (as established by the necessary `UpdateGS()` and `UpdateRS()` calls at the relevant nodes).

Scene graph traversal includes object level culling as described earlier. If the world bounding volume for a node is outside the view frustum, then the subtree rooted at that node need not be traversed. If a subtree is not culled, then the traversal is recursive. The renderer states are collected during traversal until a leaf node of the scene graph is reached. At this point the renderer has all the state information it requires to be able to properly draw the geometry represented by the leaf node. The leaf node has the responsibility of providing the renderer with its geometric data such as vertices, triangle connectivity information, triangle normals (for back face culling), and surface attributes including vertex normals, colors, and texture coordinates.

Before the actual rendering of the leaf node object, it is useful to allow the object to perform any preparations that are necessary for proper display. For example, culling is based on world bounding volumes. The classes derived from `Geometry` have the liberty of keeping current the world bounding sphere via the `UpdateWorldBound` call. If an object is to be culled, then computing any expensive world data in the call to `UpdateWorldData` is wasteful. Instead, the `Geometry` classes could provide a Boolean flag indicating whether or not the world data is current. The call to `UpdateWorldData` updates world transforms, but additionally sets only the Boolean flag indicating the world data is not current. A prerendering function called *after* it is determined that an object is not to be culled can test the Boolean flag, find out the world data is not current, make the data current, then set the flag to indicate the data is current.

Another use of a prerendering function involves dynamic tessellation of an object. Chapter 10 discusses objects represented by a triangular mesh whose triangles are increased or reduced based on a continuous level-of-detail algorithm involving a preprocessed set of incremental mesh changes. The prerendering function can select the appropriate level of detail based on the current camera and view frustum. Chapter 8 discusses objects represented by curved surfaces. The prerendering function can dynamically tessellate the surfaces to the appropriate level of detail.

The complement of a prerendering function is a postrendering function that gives the object a chance to do any cleanup associated with prerendering and actual rendering.

4.3.1 CULLING BY SPHERES

The test for intersection of bounding volume with view frustum is performed in world space since the world bounding information is kept current by the object and the world view frustum information is kept current by the camera. Let the world

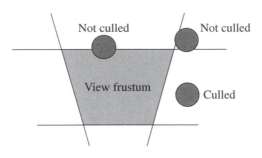

Figure 4.2 Examples of culled and unculled objects.

bounding sphere have center \vec{C} and radius r. Let a view frustum plane be specified by $\vec{N} \cdot \vec{X} = d$, where \vec{N} is a unit-length vector that points to the interior of the frustum. The bounding sphere does not intersect the frustum when the distance from \vec{C} to the plane is larger than the sphere radius. An object is completely culled if its bounding sphere satisfies

$$\vec{N} \cdot \vec{C} - d < -r \tag{4.8}$$

for one of the frustum planes. The left-hand side of the inequality is the signed distance from \vec{C} to the plane. The right-hand side is negative and indicates that to be culled, \vec{C} must be on the outside of the frustum plane and must be at least the sphere radius units away from the plane. The test requires 3 multiplications and 3 additions. The pseudocode is

```
bool CullSpherePlane (Sphere sphere, Plane plane)
{
    return Dot(plane.N,sphere.C) - plane.d < -sphere.r;
}
```

It is possible for a bounding sphere to be outside the frustum even if all six culling tests fail. Figure 4.2 shows examples of an object that is culled by the tests. It also shows examples of objects that are not culled, one object whose bounding sphere intersects the frustum and one object whose bounding sphere does not intersect the frustum. In either case, the object must be further processed in the clipping pipeline. Alternatively, the exact distance from bounding sphere to frustum can be computed at greater expense than the distances from sphere to planes.

Better-fitting bounding volumes can lead to rejection of an object when the bounding sphere does not, thereby leading to savings in CPU cycles. However, the

application must keep the bounding volume current as the object moves about the world. For each change in a rigid object's orientation, the bounding volume must be rotated accordingly. This leads to a trade-off between more time to update bounding volume and less time to process objects because they are more accurately culled.

The following sections describe the culling algorithms for oriented boxes, capsules, lozenges, cylinders, and ellipsoids. In each section the frustum plane is $\vec{N} \cdot \vec{X} = d$ with unit-length normal pointing to frustum interior.

4.3.2 CULLING BY ORIENTED BOXES

SOURCE CODE

LIBRARY

Intersection

FILENAME

IntrPlnBox3

An oriented bounding box is outside the frustum plane if all its vertices are outside the plane. The obvious algorithm of testing if all eight vertices are on the "negative side" of the plane requires eight comparisons of the form $\vec{N} \cdot \vec{V} < d$. The vertices are of the form

$$\vec{V} = \vec{C} + \sigma_0 a_0 \vec{A}_0 + \sigma_1 a_1 \vec{A}_1 + \sigma_2 a_2 \vec{A}_2,$$

where $|\sigma_i| = 1$ for all i (eight possible choices, two for each σ_i). Each test requires computing signed distances

$$\vec{N} \cdot \vec{V} - d = (\vec{N} \cdot \vec{C} - d) + \sigma_0 a_0 \vec{N} \cdot \vec{A}_0 + \sigma_1 a_1 \vec{N} \cdot \vec{A}_1 + \sigma_2 a_2 \vec{N} \cdot \vec{A}_2.$$

The 4 dot products are computed once, each dot product using 3 multiplications and 2 additions. Each test requires an additional 3 multiplications and 4 additions (the multiplications by σ_i are not counted). The eight tests therefore require 36 multiplications and 40 additions.

A faster test is to project the box and plane onto the line $\vec{C} + s\vec{N}$. The symmetry provided by the box definition yields an interval of projection $[\vec{C} - r\vec{N}, \vec{C} + r\vec{N}]$. The interval is centered at \vec{C} and has radius

$$r = a_0 |\vec{N} \cdot \vec{A}_0| + a_1 |\vec{N} \cdot \vec{A}_1| + a_2 |\vec{N} \cdot \vec{A}_2|.$$

The frustum plane projects to a single point

$$\vec{P} = \vec{C} + (d - \vec{N} \cdot \vec{C})\vec{N}.$$

The box is outside the plane as long as the projected interval is outside, in which case $\vec{N} \cdot \vec{C} - d < -r$. The test is identical to that of sphere-versus-plane, except that r is known for the sphere but must be calculated for each test of an oriented bounding box. The test requires 4 dot products, 3 multiplications, and 3 additions for a total operation count of 15 multiplications and 11 additions. The pseudocode is

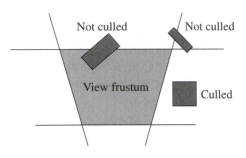

Figure 4.3 Examples of culled and unculled objects.

```
bool CullBoxPlane (Box box, Plane plane)
{
    r = box.a0*|Dot(plane.N,box.A0)| +
        box.a1*|Dot(plane.N,box.A1)| +
        box.a2*|Dot(plane.N,box.A2)|;

    return Dot(plane.N,box.C) - plane.d < -r;
}
```

As with the sphere, it is possible for an oriented bounding box not to be culled when tested against each frustum plane one at a time, even though the box is outside the view frustum. Figure 4.3 illustrates such a situation.

4.3.3 CULLING BY CAPSULES

SOURCE CODE

LIBRARY

Intersection

FILENAME

IntrPlnCap

A capsule consists of a radius $r > 0$ and a parameterized line segment $\vec{P} + t\vec{D}$, where $\vec{D} \neq \vec{0}$ and $t \in [0, 1]$. The signed distances from plane to end points are $\delta_0 = \vec{N} \cdot \vec{P} - d$ and $\delta_1 = \vec{N} \cdot (\vec{P} + \vec{D}) - d$. If either $\delta_0 \geq 0$ or $\delta_1 \geq 0$, then the capsule is not culled since it is either intersecting the frustum plane or on the frustum side of the plane. Otherwise, both signed distances are negative. If $\vec{N} \cdot \vec{D} \leq 0$, then end point \vec{P} is closer in signed distance to the frustum plane than is the other end point $\vec{P} + \vec{D}$. The distance between \vec{P} and the plane is computed and compared to the capsule radius. If $\vec{N} \cdot \vec{P} - d \leq -r$, then the capsule is outside the frustum plane and it is culled; otherwise it is not culled. If $\vec{N} \cdot \vec{D} > 0$, then $\vec{P} + \vec{D}$ is closer in signed distance to the frustum plane than is \vec{P}. If $\vec{N} \cdot (\vec{P} + \vec{D}) - d \leq -r$, then the capsule is culled; otherwise it is not culled. The pseudocode for the culling algorithm is given below. The Boolean result is `true` if and only if the capsule is culled.

```
bool CullCapsulePlane (Capsule capsule, Plane plane)
{
    sd0 = Dot(plane.N,capsule.P) - plane.d;
    if ( sd0 < 0 )
    {
        sd1 = sd0 + Dot(plane.N,capsule.D);
        if ( sd1 < 0 )
        {
            if ( sd0 <= sd1 )
            {
                // P0 closest to plane
                return sd0 <= -capsule.r;
            }
            else
            {
                // P1 closest to plane
                return sd1 <= -capsule.r;
            }
        }
    }

    return false;
}
```

4.3.4 CULLING BY LOZENGES

A lozenge consists of a radius $r > 0$ and a parameterized rectangle $\vec{P} + s\vec{E}_0 + t\vec{E}_1$, where $\vec{E}_0 \neq \vec{0}$, $\vec{E}_1 \neq \vec{0}$, $\vec{E}_0 \cdot \vec{E}_1 = 0$, and $(s, t) \in [0, 1]^2$. The four rectangle corners are $\vec{P}_{00} = \vec{P}$, $\vec{P}_{10} = \vec{P} + \vec{E}_0$, $\vec{P}_{01} = \vec{P} + \vec{E}_1$, and $\vec{P}_{11} = \vec{P} + \vec{E}_0 + \vec{E}_1$. The signed distances are $\delta_{ij} = \vec{N} \cdot \vec{P}_{ij} - d$. If any of the signed distances are nonnegative, then the lozenge either intersects the plane or is on the frustum side of the plane and it is not culled. Otherwise, all four signed distances are negative. The rectangle corner closest to the frustum plane is determined, and its distance to the plane is compared to the lozenge radius to determine if there is an intersection. The pseudocode for the culling algorithm is

SOURCE CODE

LIBRARY

Intersection

FILENAME

IntrPlnLoz

```
bool CullLozengePlane (Lozenge lozenge, Plane P)
{
    sd00 = Dot(plane.N,lozenge.P) - plane.d;
    if ( sd00 < 0 )
    {
        dotNE0 = Dot(plane.N,lozenge.E0);
        sd10 = sd00 + dotNE0;
```

```
                    if ( sd10 < 0 )
                    {
                        dotNE1 = Dot(plane.N,lozenge.E1);
                        sd01 = sd00 + dotNE1;
                        if ( sd01 < 0 )
                        {
                            sd11 = sd10 + dotNE1;
                            if ( sd11 < 0 )
                            {
                                // all rectangle corners on negative side
                                // of plane
                                if ( sd00 <= sd10 )
                                {
                                    if ( sd00 <= sd01 )
                                    {
                                        // P00 closest to plane
                                        return sd00 <= -lozenge.r;
                                    }
                                    else
                                    {
                                        // P01 closest to plane
                                        return sd01 <= -lozenge.r;
                                    }
                                }
                                else
                                {
                                    if ( sd10 <= sd11 )
                                    {
                                        // P10 closest to plane
                                        return sd10 <= -lozenge.r;
                                    }
                                    else
                                    {
                                        // P11 closest to plane
                                        return sd11 <= -lozenge.r;
                                    }
                                }
                            }
                        }
                    }

                    return false;
    }
```

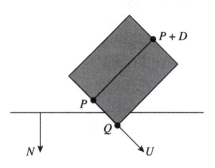

Figure 4.4 Projection of cylinder and frustum plane, no-cull case.

4.3.5 CULLING BY CYLINDERS

SOURCE CODE

LIBRARY

Intersection

FILENAME

IntrPlnCyln

A cylinder consists of a radius $r > 0$, a height $h \in [0, \infty]$, and a parameterized line segment $\vec{C} + t\vec{W}$, where $|\vec{W}| = 1$ and $t \in [-h/2, h/2]$. Figure 4.4 shows a typical no-cull situation. Let the plane be $\vec{N} \cdot \vec{X} = d$, where $|\vec{N}| = 1$. Let \vec{U}, \vec{V}, and \vec{W} form an orthonormal set of vectors. Any cylinder point \vec{X} can be written as $\vec{X} = \vec{C} + y_0\vec{U} + y_1\vec{V} + y_2\vec{W}$, where $y_0^2 + y_1^2 = r^2$ and $|y_2| <= h/2$. Let $y_0 = r\cos(A)$ and $y_1 = r\sin(A)$. Substitute \vec{X} in the plane equation to get

$$-(\vec{N} \cdot \vec{W})y_2 = (\vec{N} \cdot \vec{C} - d) + (\vec{N} \cdot \vec{U})r\cos(A) + (\vec{N} \cdot \vec{V})r\sin(A).$$

If $\vec{N} \cdot \vec{W} = 0$, then the plane is parallel to the axis of the cylinder. The two intersect if and only if the distance from \vec{C} to the plane satisfies

$$|\vec{N} \cdot \vec{C} - d| \le r.$$

In this situation the cylinder is culled when $\vec{N} \cdot \vec{C} - d \le -r$.

If $\vec{N} \cdot \vec{W} \ne 0$, then y_2 is a function of A. The minimum and maximum values can be found by the methods of calculus. The extreme values are

$$\frac{d - \vec{N} \cdot \vec{C} \pm \sqrt{1 - (\vec{N} \cdot \vec{W})^2}}{\vec{N} \cdot \vec{W}}.$$

The plane and cylinder intersect if and only if

$$\min(y_2) \le h/2 \quad \text{and} \quad \max(y_2) \ge -h/2.$$

In this situation the cylinder is culled when the previous tests show no intersection and $\vec{N} \cdot \vec{C} - d \leq -r$. The pseudocode is

```
bool CullCylinderPlane (Cylinder cylinder, Plane plane)
{
    sd0 = Dot(plane.N,cylinder.P) - plane.d;
    if ( sd0 < 0 )
    {
        dotND = Dot(plane.N,cylinder.D)
        sd1 = sd0 + dotND;
        if ( sd1 < 0 )
        {
            dotDD = Dot(cylinder.D,cylinder.D);
            r2 = cylinder.r*cylinder.r;
            if ( sd0 <= sd1 )
            {
                // P0 closest to plane
                return dotDD*sd0*sd0 >= r2*(dotDD-dotND*dotND);
            }
            else
            {
                // P1 closest to plane
                return dotDD*sd1*sd1 >= r2*(dotDD-dotND*dotND);
            }
        }
    }

    return false;
}
```

The quantities $\vec{D} \cdot \vec{D}$ and r^2 can be precomputed and stored by the cylinder as a way of reducing execution time for the intersection test.

4.3.6 CULLING BY ELLIPSOIDS

An ellipsoid is represented by the quadratic equation $Q(\vec{X}) = (\vec{X} - \vec{C})^{\mathrm{T}} M (\vec{X} - \vec{C}) = 1$, where \vec{C} is the center of the ellipsoid, where M is a positive definite matrix, and where \vec{X} is any point on the ellipsoid. An ellipsoid is outside a frustum plane whenever the projection of the ellipsoid onto the line $\vec{C} + s\vec{N}$ is outside the frustum plane. The projected interval is $[-r, r]$. Figure 4.5 shows a typical no-cull situation. The ellipsoid is culled whenever

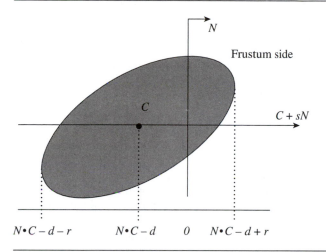

Figure 4.5 Projection of ellipsoid and frustum plane, no-cull case.

$$\vec{N} \cdot \vec{C} - d \leq -r.$$

The construction of r is as follows. The points \vec{X} that project to the end points of the interval must occur where the normals to the ellipsoid are parallel to \vec{N}. The gradient of $Q(\vec{X})$ is a normal direction for the point, $\vec{\nabla} Q = 2M(\vec{X} - \vec{C})$. Thus, \vec{X} must be a solution to $M(\vec{X} - \vec{C}) = \lambda \vec{N}$ for some scalar λ. Inverting M and multiplying yields $\vec{X} - \vec{C} = \lambda M^{-1}\vec{N}$. Replacing this in the quadratic equation yields $1 = \lambda^2 (M^{-1}\vec{N})^{\mathrm{T}} M(M^{-1}\vec{N}) = \lambda^2 \vec{N}^{\mathrm{T}} M^{-1}\vec{N}$. Finally, $r = \vec{N} \cdot (\vec{X} - \vec{C}) = \lambda \vec{N}^{\mathrm{T}} M^{-1}\vec{N}$, so $r = \sqrt{\vec{N}^{\mathrm{T}} M^{-1}\vec{N}}$. The pseudocode is

```
bool CullEllipsoidPlane (Ellipsoid ellipsoid, Plane plane)
{
    sd0 = Dot(plane.N,ellipsoid.C) - plane.d;
    if ( sd0 < 0 )
    {
        r2 = Dot(plane.N,ellipsoid.Minverse*plane.N);
        return sd0*sd0 >= r2;
    }

    return false;
}
```

4.3.7 ALGORITHM FOR SCENE GRAPH RENDERING

An abstract class `Renderer` has a method that is the entry point for drawing a scene graph:

```
void Renderer::Draw (Spatial scene)
{
    scene.OnDraw(thisRenderer);
}
```

Its sole job is to start the scene graph traversal and pass the renderer for camera access and for accumulating render state. The method is virtual so that any derived class renderer can perform any setup before, and any cleanup after, the scene graph is drawn.

The class `Spatial` implements

```
void Spatial::OnDraw (Renderer renderer)
{
    if ( forceCulling )
        return;

    savePlaneState = renderer.planeState;

    if ( !renderer.Cull(worldBound) )
        Draw(renderer);

    renderer.planeState = savePlaneState;
}
```

The class `Spatial` provides a Boolean flag to allow the application to force culling of an object. If the object is not forced to be culled, then comparison of the world bounding volume to the camera frustum planes is done next. As mentioned in Section 3.4, if the bounding volumes are properly nested, once a bounding volume is inside a frustum plane there is no need to test bounding volumes of descendants against that plane. In this case the plane is said to be *inactive*. The renderer keeps track of which planes are active and inactive (the plane state). The current object must save the current plane state since the state might change during the recursive pass and the old state must be restored.

The member function `Draw` of class `Spatial` is also a pure virtual function. Class `Geometry` manages the leaf node renderer state and uses the `Draw` function to tell the renderer about the state it should use for drawing that leaf node. Class `Node` again provides for the recursive propagation to its children.

```
void Geometry::Draw (Renderer renderer)
{
    renderer.SetState(thisState);
}

void Node::Draw (Renderer renderer)
{
    for each child do
        child.OnDraw(renderer);
}
```

Notice the pattern of recursive chains provided by classes Spatial and Node. In this case Draw and OnDraw form the recursive chain.

Finally, for a specific class derived from Geometry that has actual data, the renderer must implement how to draw that data. For example, if TriMesh is derived from Geometry and manages a triangle mesh with vertices, normals, colors, and texture coordinates, the class must implement the virtual function as

```
void TriMesh::Draw (Renderer renderer)
{
    Geometry::Draw(renderer);
    renderer.Draw(this);
}
```

The call to the base class Draw tells the renderer to use the current rendering state at the leaf node. The next call allows the renderer to do its specific work with the triangle mesh. The Draw call in the renderer is a pure virtual function. If class SoftRender is derived from Renderer and represents software rendering, then the entire geometric pipeline of transformation, clipping, projection, and rasterizing is encapsulated in Draw for SoftRender. On the other hand, if class HardRender is derived from Renderer and represents a hardware-accelerated renderer, then Draw probably does very little work and can feed the hardware card directly.

CHAPTER

PICKING

The term *picking* typically refers to the process of selecting a 3D object from its 2D projection on the screen by pointing and clicking with a mouse. For a perspective camera model, the idea is to build a ray whose origin is the eye point and whose direction is from the eye point to a world point that projects onto the screen at the selected location. The ray is converted to world coordinates and a search is made to find those objects that are intersected by the ray. This chapter considers a more general picking process where the ray can have any origin, not just the eye point. The general picking operation supports collision detection where linear probing is used to determine if the camera or an object can move unimpeded in various directions. It also supports various special effects—for example, determining if a projectile or laser beam fired from a character's gun hits an intended target. Other uses for general picking include determining height of objects above a terrain, establishing visibility of objects from current eye point, and avoiding collisions with obstacles while an object attempts to follow a desired path. In these examples the common theme is estimation of distance from objects to obstacles.

Support for picking in a hierarchical scene graph amounts to recursively traversing the graph until each leaf node is reached. The triangles represented by a leaf node are tested one by one to see if the ray intersects them. All sorts of information can be

169

reported about an intersection, including the point of intersection, normal vector at the intersection, surface attributes at the point such as color or texture coordinate, or other information that an object might have been tagged with by the application. Given a list of triangles intersected by the ray, additional processing might be required such as sorting the list or computing the closest triangle to the ray's origin.

An exhaustive test of intersection by ray with triangles can be expensive, especially if the ray does not intersect any of the triangles at a leaf node. To avoid this, the hierarchical structure of the graph can be exploited. The picking operation at a node is propagated to the children of the node only if the ray intersects a bounding volume associated with the original node. A test for intersection of ray with bounding volume is usually inexpensive. If the ray does not intersect the volume, then a small amount of time is required to show this, and time is not wasted on searching that portion of the scene graph contained in the bounding volume. The pseudocode for the process is

```
void DoPick (Node node, Ray ray, PickResults results)
{
    if ray intersects node.boundingVolume
    {
        if node is a leaf
        {
            for each triangle of node do
            {
                if (ray intersects triangle)
                    add intersection information to results;
            }
        }
        else
        {
            for each child of node do
                DoPick(child,ray,results);
        }
    }
}

// application code
Node root = <root of scene graph to be tested>;
Ray ray = <origin and direction of ray to be tested>;
PickResults results;
DoPick(root,ray,results);
```

The key tests here involve the intersection of a ray with bounding volumes or with triangles. It is possible that an application requires information about the intersection of objects with lines or with line segments. Although the intersection tests are algorithmically similar, the implementations might take advantage of the knowledge

that a line, ray, or line segment is involved and avoid some unnecessary calculations. The remainder of the chapter deals with the mathematical algorithms and their implementations for intersection of *linear components* (lines, rays, or line segments) with bounding volumes and triangles. In all sections, the line is parameterized as $\vec{L}(t) = \vec{P} + t\vec{D}$, where \vec{P} is the line origin and \vec{D} is a unit-length direction vector. For a line, there is no restriction on t. For a ray, $t \geq 0$ is required. For a line segment, $t \in [0, T]$ is required for some specified value $T > 0$.

5.1 INTERSECTION OF A LINEAR COMPONENT AND A SPHERE

SOURCE CODE

LIBRARY

Intersection

FILENAME

IntrLin3Sphr

A sphere with center \vec{C} and radius R is specified by $|\vec{X} - \vec{C}|^2 - R^2 = 0$. Replacing \vec{X} by $\vec{L}(t)$ leads to the quadratic equation

$$0 = |t\vec{D} + \vec{P} - \vec{C}|^2 - R^2 = t^2 + 2t\vec{D} \cdot (\vec{P} - \vec{C}) + |\vec{P} - \vec{C}|^2 - R^2.$$

The quadratic formula may be used to solve the equation. The discriminant is

$$\Delta = 4\left(\vec{D} \cdot (\vec{P} - \vec{C})\right)^2 - 4\left(|\vec{P} - \vec{C}|^2 - R^2\right)$$

$$= 4\left(R^2 - (\vec{P} - \vec{C})^{\mathrm{T}}(I - \vec{D}\vec{D}^{\mathrm{T}})(\vec{P} - \vec{C})\right).$$

The projection matrix $I - \vec{D}\vec{D}^{\mathrm{T}}$ is nonnegative definite, so the discriminant is possibly negative. If $\Delta < 0$, then the line does not intersect the sphere. If $\Delta = 0$, the line is tangential to the sphere. The parameter at the point of intersection is $t = -\vec{D} \cdot (\vec{P} - \vec{C})$. If $t < 0$, then the line is tangent to the sphere but neither the ray nor line segment intersect the sphere. If $t > T$, then the line and ray are tangent to the sphere but the line segment does not intersect the sphere. If $\Delta \geq 0$, then the line intersects the sphere in two locations. The parameters at the points of intersection are

$$t = -\vec{D} \cdot (\vec{P} - \vec{C}) \pm \sqrt{R^2 - (\vec{P} - \vec{C})^{\mathrm{T}}(I - \vec{D}\vec{D}^{\mathrm{T}})(\vec{P} - \vec{C})}.$$

Analysis of the t-values (comparison to 0 and T) determines whether or not the ray or the line segment intersect the sphere.

In the recursive traversal of the hierarchical scene graph, it may not be necessary to determine where a linear component intersects a bounding volume, only *if* the linear component intersects the bounding volume. Existence of an intersection may be determined more cheaply for some situations. For example, the quadratic equation for a ray intersecting a sphere has constant term $|\vec{P} - \vec{C}|^2 - R^2$. If this term is negative, then \vec{P} is inside the sphere and the ray must necessarily intersect the sphere. This leads to a quick return from the intersection routine, and the propagation of the test to node

children commences. The pseudocode for determining the existence of an intersection of a ray with a sphere is

```
bool TestIntersection (Ray ray, Sphere sphere)
{
    // quadratic is t^2 + 2*a1*t + a0 = 0

    Q = ray.P - sphere.C;
    a0 = Q.Dot(Q) - sphere.R*sphere.R;
    if ( a0 <= 0 )
    {
        // ray.P is inside the sphere
        return true;
    }
    // else ray.P is outside the sphere

    a1 = ray.D.Dot(Q);
    if ( a1 >= 0 )
    {
        // acute angle between P-C and D, C is "behind" ray
        return false;
    }

    // quadratic has a real root if discriminant is nonnegative
    return ( a1*a1 >= a0 );
}
```

Similarly structured code can be written for comparison of a line or a line segment to a sphere. Actual points of intersection may also be computed by solving the quadratic equation for its roots.

5.2 INTERSECTION OF A LINEAR COMPONENT AND A BOX

SOURCE CODE

LIBRARY

Intersection

FILENAME

IntrLin3Box3

Finding the points of intersection between a linear component and a box is the classic clipping problem. For parametric lines, an effective method is Liang-Barsky clipping (Liang and Barsky 1984; Foley et al. 1990). We first describe the algorithm for an axis-aligned box. The adaptation to an oriented box requires a change in coordinate system. Although we describe the method for line segments, it can easily be extended to rays and lines.

Consider the axis-aligned box centered at the origin with extents e_i for $0 \leq i \leq 2$. The region of space filled by the box is $[-e_0, e_0] \times [-e_1, e_1] \times [-e_2, e_2]$. The idea is to clip the line segment $(p_0, p_1, p_2) + t(d_0, d_1, d_2)$ for $t \in [0, 1]$ against the three

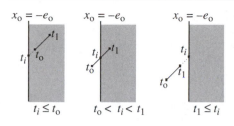

Figure 5.1 The three cases for clipping when $d_0 > 0$.

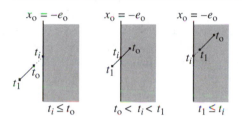

Figure 5.2 The three cases for clipping when $d_0 < 0$.

sets of parallel faces, one pair at a time. The initial interval for the line segment is $[t_0, t_1] = [0, 1]$, and the values of t_0 and t_1 are updated appropriately for the clipping against the faces.

The intersection of a line with the face $x_0 = -e_0$ is determined by $p_0 + t d_0 = -e_0$. If $d_0 \neq 0$, then the line is not parallel to the face and the point of intersection occurs when $t_i = -(e_0 + p_0)/d_0$. Moreover, if $d_0 > 0$, then the line parameter t increases as x_0 increases. If $t_i > t_1$, then the line segment is outside the face and is completely clipped. If $t_i \leq t_0$, then the line segment is inside the face and no adjustments are needed on t_0. Otherwise, $t_i \in (t_0, t_1]$ and the minimum parameter value is updated to $t_0 = t_i$. In the event that $t_i = t_1$, the line segment intersects the face in a single point. For geometric intersection testing, this point may be of interest. For clipping against a view frustum, this point may be ignored by using the test $t_i \geq t_1$ instead. Figure 5.1 illustrates the three cases when $d_0 > 0$. If $d_0 < 0$, the line parameter t decreases as x_0 increases. If $t_i \leq t_0$, then the line segment is outside the face and is completely clipped. If $t_i \geq t_1$, then the line segment is inside the face and no adjustments are needed on t_1. Otherwise, $t_i \in (t_0, t_1)$ and the maximum parameter value is updated to $t_1 = t_i$. Figure 5.2 illustrates the three cases when $d_0 < 0$. Finally, if $d_0 = 0$, the line is parallel to the face. A sign test must be made on $-e_0 - p_0$ to determine if the line segment is inside

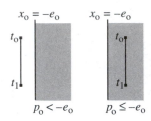

Figure 5.3 The two cases for clipping when $d_0 = 0$.

the face $(-e_0 - p_0 > 0)$ or outside the face $(-e_0 - p_0 \le 0)$. In the latter case the line segment is completely clipped. Figure 5.3 illustrates the two cases when $d_0 = 0$.

Similar tests can be made for all six faces. A single clipping function can be derived that handles the tests. The pseudocode as shown in most graphics texts is given below. A return value of `false` means the line segment is completely clipped (culled). A return value of `true` means the line segment was clipped or needed no adjustments.

```
bool Clip (float denom, float numer, float& t0, float& t1)
{
    if ( denom > 0 )
    {
        ti = numer/denom;
        if ( ti > t1 )
            return false;
        if ( ti > t0 )
            t0 = ti;
        return true;
    }
    else if ( denom < 0 )
    {
        ti = numer/denom;
        if ( ti < t0 )
            return false;
        if ( ti < t1 )
            t1 = ti;
        return true;
    }
    else
    {
        return numer > 0;
    }
}
```

For hardware with fast multiplication and slow division, a version that defers the divisions until absolutely needed will have on average a smaller execution time. The worst case for a single call is the use of two additional multiplications. The pseudocode is

```
bool Clip (float denom, float numer, float& t0, float& t1)
{
    if ( denom > 0 )
    {
        if ( numer > denom*t1 )
            return false;
        if ( numer > denom*t0 )
            t0 = numer/denom;
        return true;
    }
    else if ( denom < 0 )
    {
        ti = numer/denom;
        if ( numer > denom*t0 )
            return false;
        if ( numer > denom*t1 )
            t1 = numer/denom;
        return true;
    }
    else
    {
        return numer > 0;
    }
}
```

The clipper itself is given by the following pseudocode. A return value of `false` indicates the line segment is outside the box. A return value of `true` indicates the line segment has been clipped or is completely inside the box. On return, the end points of the clipped segment are $\vec{P} + t_0\vec{D}$ and $\vec{P} + t_1\vec{D}$. To maintain the format for line segments, the new segment is $\vec{P}' + s\vec{D}'$ for $s \in [0, 1]$, where $\vec{P}' = \vec{P} + t_0\vec{D}$ and $\vec{D}' = (t_1 - t_0)\vec{D}$.

```
bool Clip3D (Point E, Point P, Point D, float& t0, float& t1)
{
    // extents E = (e0,e1,e2), all positive components
    // line point P = (p0,p1,p2)
    // line direction D = (d0,d1,d2)

    t0 = 0;
    t1 = 1;
```

Figure 5.4 Typical separating axis for a line segment and a box.

```
            return Clip(+d0,-p0-e0,t0,t1) and Clip(-d0,+p0-e0,t0,t1) and
                   Clip(+d1,-p1-e1,t0,t1) and Clip(-d1,+p1-e1,t0,t1) and
                   Clip(+d2,-p2-e2,t0,t1) and Clip(-d2,+p2-e2,t0,t1);
    }
```

Clipping against an oriented box requires some transformations. Let the box have center \vec{C}, axes \vec{U}_i, and extents e_i for $0 \leq i \leq 2$. The line point \vec{P} and direction vector \vec{D} must be represented in terms of the coordinate system of the box. The p_i and d_i used in the axis-aligned case are now defined by $\vec{P} = \vec{C} + \sum_{i=0}^{2} p_i \vec{U}_i$ and $\vec{D} = \sum_{i=0}^{2} d_i \vec{U}_i$. Thus, $p_i = \vec{U}_i \cdot (\vec{P} - \vec{C})$ and $d_i = \vec{U}_i \cdot \vec{D}$.

Testing whether or not a line, ray, or line segment intersects a box can be done more cheaply than with a clipping algorithm by separating axes. It can be determined if the linear component does not intersect the box by analyzing the projections of the linear component and the box onto a small number of lines and testing if the projections are disjoint. This approach for comparing line segment and box is used in Gregory et al. (1998). In the following sections, the oriented box has center \vec{C}, axes \vec{U}_i, and corresponding extents e_i for $i = 0, 1, 2$. Although they are not necessary to compute in the algorithm, the vertices of the box are $\vec{C} + \sum_{i=0}^{2} \sigma_i e_i \vec{U}_i$, where $|\sigma_i| = 1$ (eight possible choices, two per i).

5.2.1 LINE SEGMENT

Let the line segment have midpoint \vec{M} and end points $\vec{M} \pm \vec{V}$. The six potential separating axes have directions \vec{U}_i and $\vec{V} \times \vec{U}_i$ for $i = 0, 1, 2$. Figure 5.4 shows the general situation of projecting onto an axis with direction \vec{W}, with the direction not necessarily unit length. Let $\vec{D} = \vec{M} - \vec{C}$. The radius of the interval corresponding to the projected line segment is

$$R_s = \left| \vec{M} \cdot \frac{\vec{W}}{|\vec{W}|} \right|.$$

Table 5.1 Separating axis tests for a line segment and a box.

\vec{W}	R_b	R_s	R_d										
\vec{U}_0	e_0	$	\vec{W} \cdot \vec{U}_0	$	$	\vec{D} \cdot \vec{U}_0	$						
\vec{U}_1	e_1	$	\vec{W} \cdot \vec{U}_1	$	$	\vec{D} \cdot \vec{U}_1	$						
\vec{U}_2	e_2	$	\vec{W} \cdot \vec{U}_2	$	$	\vec{D} \cdot \vec{U}_2	$						
$\vec{V} \times \vec{U}_0$	$\left(e_1	\vec{V} \cdot \vec{U}_2	+ e_2	\vec{V} \cdot \vec{U}_1	\right)/	\vec{V}	$	0	$	\vec{U}_0 \cdot \vec{V} \times \vec{D}	/	\vec{V}	$
$\vec{V} \times \vec{U}_1$	$\left(e_0	\vec{V} \cdot \vec{U}_2	+ e_2	\vec{V} \cdot \vec{U}_0	\right)/	\vec{V}	$	0	$	\vec{U}_1 \cdot \vec{V} \times \vec{D}	/	\vec{V}	$
$\vec{V} \times \vec{U}_2$	$\left(e_0	\vec{V} \cdot \vec{U}_1	+ e_1	\vec{V} \cdot \vec{U}_0	\right)/	\vec{V}	$	0	$	\vec{U}_2 \cdot \vec{V} \times \vec{D}	/	\vec{V}	$

The radius of the interval corresponding to the projected box is

$$R_b = \sum_{i=0}^{2} e_i \left| \vec{U}_i \cdot \frac{\vec{W}}{|\vec{W}|} \right|.$$

The distance between the projected centers is the length of the projection of \vec{D},

$$R_d = \left| \vec{D} \cdot \frac{\vec{W}}{|\vec{W}|} \right|.$$

The axis separates the line segment and box if

$$R_d > R_b + R_s.$$

Table 5.1 shows the potential separating axes and the corresponding quantities required for showing the projected intervals are disjoint. The divisions in the last three cases can be avoided by multiplying the test inequality by $|\vec{W}|$.

5.2.2 RAY

Let the ray have origin \vec{P} and direction \vec{V}. The six potential separating axes are the same as for a line compared to a box. Figure 5.5 shows two typical situations for projection of a ray and a box onto a potential separating axis with direction \vec{W}. Let $\vec{D} = \vec{P} - \vec{C}$. The radius of the interval corresponding to the projected box is

$$R_b = \sum_{i=0}^{2} e_i \left| \vec{U}_i \cdot \frac{\vec{W}}{|\vec{W}|} \right|.$$

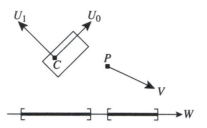

Figure 5.5 Typical situations for a ray and a box.

The distance between the projected box center and projected ray origin is the length of the projection of \vec{D},

$$R_d = \left| \vec{D} \cdot \frac{\vec{W}}{|\vec{W}|} \right|.$$

The axis separates the line segment and box if the projection of the ray origin is outside the projection of the box and if the ray direction forces the projected ray to point away from the box. The tests are

$$R_d > R_b \quad \text{and} \quad (\vec{W} \cdot \vec{V})(\vec{W} \cdot \vec{D}) \geq 0.$$

For the first three potential separating axes, the tests are

$$|\vec{U}_0 \cdot \vec{D}| > e_0, \quad (\vec{U}_0 \cdot \vec{D})(\vec{U}_0 \cdot \vec{V}) \geq 0$$
$$|\vec{U}_1 \cdot \vec{D}| > e_1, \quad (\vec{U}_1 \cdot \vec{D})(\vec{U}_1 \cdot \vec{V}) \geq 0$$
$$|\vec{U}_2 \cdot \vec{D}| > e_2, \quad (\vec{U}_2 \cdot \vec{D})(\vec{U}_2 \cdot \vec{V}) \geq 0.$$

For the last three potential separating axis tests the secondary test is always true. The tests are

$$|\vec{U}_0 \cdot \vec{V} \times \vec{D}| > e_1|\vec{V} \cdot \vec{U}_2| + e_2|\vec{V} \cdot \vec{U}_1|$$
$$|\vec{U}_1 \cdot \vec{V} \times \vec{D}| > e_0|\vec{V} \cdot \vec{U}_2| + e_2|\vec{V} \cdot \vec{U}_0|$$
$$|\vec{U}_2 \cdot \vec{V} \times \vec{D}| > e_0|\vec{V} \cdot \vec{U}_1| + e_1|\vec{V} \cdot \vec{U}_0|.$$

5.2.3 LINE

Let the line have origin \vec{P} and direction \vec{V}. The projection of the line onto at least one of the axes with direction \vec{U}_i will intersect the projection of the box. The only potential separating axes are $\vec{V} \times \vec{U}_i$ for $i = 0, 1, 2$. The tests are

$$|\vec{U}_0 \cdot \vec{V} \times \vec{D}| > e_1|\vec{V} \cdot \vec{U}_2| + e_2|\vec{V} \cdot \vec{U}_1|$$

$$|\vec{U}_1 \cdot \vec{V} \times \vec{D}| > e_0|\vec{V} \cdot \vec{U}_2| + e_2|\vec{V} \cdot \vec{U}_0|$$

$$|\vec{U}_2 \cdot \vec{V} \times \vec{D}| > e_0|\vec{V} \cdot \vec{U}_1| + e_1|\vec{V} \cdot \vec{U}_0|.$$

5.3 INTERSECTION OF A LINEAR COMPONENT AND A CAPSULE

SOURCE CODE

LIBRARY

Intersection

FILENAME

IntrLin3Cap

Testing for the existence of an intersection between a linear component and a capsule is relatively inexpensive compared to finding the actual points of intersection. The test involves computing the distance between the capsule line segment and the linear component and comparing it to the capsule radius. Section 2.6.2 gives algorithms for computing the distance between linear components.

Finding the points of intersection is more expensive. Let the capsule line segment be $\vec{P}_0 + s\vec{D}_0$ for $s \in [0, 1]$ and let the capsule radius be R. Let the line be $\vec{P}_1 + t\vec{D}_1$. If $\vec{D}_0 \cdot \vec{D}_1 \neq 0$, then the line must intersect the planes on which the capsule hemispheres connect to the cylindrical body. The planes are $\vec{D}_0 \cdot (\vec{X} - \vec{P}_0) = 0$ and $\vec{D}_0 \cdot (\vec{X} - \vec{P}_0 - \vec{D}_0) = 0$. The intersections of the line with the planes occur at $t_0 = \vec{D}_0 \cdot (\vec{P}_0 - \vec{P}_1)/\vec{D}_0 \cdot \vec{D}_1$ and $t_1 = t_0 + \vec{D}_0 \cdot \vec{D}_0/\vec{D}_0 \cdot \vec{D}_1$. For the sake of argument, let $\vec{D}_0 \cdot \vec{D}_1 > 0$ so that $t_1 > t_0$. Similar arguments can be made when the dot product is negative and $t_1 < t_0$. The points of intersection (if any) are computed

- between the ray with $t \leq t_0$ and the capsule hemisphere with origin \vec{P}_0,
- between the ray with $t \geq t_1$ and the capsule hemisphere with origin $\vec{P}_0 + \vec{D}_0$, and
- between the line segment with $t \in [t_0, t_1]$ and the capsule cylindrical wall.

Each of these requires finding the roots of a quadratic equation. In the first case, the points of intersection are at a distance R from \vec{P}_0. The squared distance between the ray and end point is $|t\vec{D}_1 + \vec{P}_1 - \vec{P}_0|^2$ for $t \leq t_0$, a quadratic polynomial in t. In the second case, the squared distance between the ray and end point is $|t\vec{D}_1 + \vec{P}_1 - \vec{P}_0 - \vec{D}_0|^2$ for $t \geq t_1$. In the third case, the distance between any point \vec{Q} (lying between the two planes) and the capsule line segment is $|\vec{D}_0 \times (\vec{Q} - \vec{P}_0)|/|\vec{D}_0|$. The squared distance between the line segment with $t \in [t_0, t_1]$ and the capsule line segment is $|\vec{D}_0 \times (t\vec{D}_1 + \vec{P}_1 - \vec{P}_0)|^2/|\vec{D}_0|^2$. Each of the squared-distance quadratic polynomials

Figure 5.6 Partitioning of a line by a capsule.

is set to r^2, and the real roots (if any) of the polynomial are computed. Once two roots are found, other cases do not have to be processed because there are at most two points of intersection between the linear component and the capsule.

If $\vec{D}_0 \cdot \vec{D}_1 = 0$, then the line is contained between the two planes mentioned earlier. In this case only a single quadratic equation must be processed (the third case in the previous paragraph but with no restriction on t).

Figure 5.6 illustrates in two dimensions the partitioning of the line by the capsule, including points of intersection.

5.4 INTERSECTION OF A LINEAR COMPONENT AND A LOZENGE

Testing for the existence of an intersection between a linear component and a lozenge is similar to that for capsules. The test involves computing the distance between the lozenge rectangle and the linear component and comparing it to the lozenge radius. Section 2.6.6 gives algorithms for computing the distance between linear components and rectangles.

Finding points of intersection is also similar to that of capsules. The algorithm uses partitions of the line and analyzes each partition separately. The lozenge is $\vec{P}_0 + u\vec{E}_0 + v\vec{E}_1$, where $\vec{E}_0 \cdot \vec{E}_1 = 0$, $(u, v) \in [0, 1]$, and has radius r. The line is $\vec{P}_1 + t\vec{D}$.

If $\vec{D} \cdot \vec{E}_0 \times \vec{E}_1 \neq 0$, the line is partitioned by the planes $\vec{E}_0 \cdot (\vec{X} - \vec{P}_0) = 0$, $\vec{E}_0 \cdot (\vec{X} - \vec{P}_0 - \vec{E}_0) = 0$, $\vec{E}_1 \cdot (\vec{X} - \vec{P}_0) = 0$, and $\vec{E}_1 \cdot (\vec{X} - \vec{P}_0 - \vec{E}_1) = 0$. Two of the clipped components are rays. There are at most three clipped components that are line segments. In the plane of the lozenge rectangle, the partition planes split that plane into nine pieces: the lozenge rectangle itself, four edge regions, and four corner regions. Figure 5.7 illustrates in two dimensions the partitioning of a line by the lozenge. The number of clipped components in this example is five, as shown by the projection of the line onto the horizontal axis with tick marks at the points of intersection with the partition lines. If a clipped component corresponds to a corner region, a squared-distance function is computed between the component and the corner point for that region. If a component corresponds to an edge region, the squared distance between that component and the edge line segment is computed.

Figure 5.7 Partitioning of a line by a lozenge.

This process is exactly the one that occurs in the case of intersections between lines and capsules. If a component corresponds to the lozenge rectangle region, then the squared-distance function is computed. The squared distance between any point \vec{Q} in the rectangle region and the lozenge rectangle is

$$|\vec{Q} - \vec{P}_0|^2 - \frac{[\vec{E}_0 \cdot (\vec{Q} - \vec{P}_0)]^2}{|\vec{E}_0|^2} - \frac{[\vec{E}_1 \cdot (\vec{Q} - \vec{P}_0)]^2}{|\vec{E}_1|^2}.$$

Point \vec{Q} is replaced by $\vec{P}_1 + t\vec{D}$ to obtain the quadratic polynomial. Any of the computed polynomials is set to r^2 and solved. The corresponding values of t provide the points of intersection between the line and the lozenge.

If $\vec{D} \cdot \vec{E}_0 \times \vec{E}_1 = 0$, the line is perpendicular to the lozenge rectangle. The appropriate region of the nine possible ones is determined, and the squared-distance polynomial is computed between the line and the corresponding lozenge component (quarter sphere, half cylinder, or rectangle slab).

5.5 INTERSECTION OF A LINEAR COMPONENT AND A CYLINDER

SOURCE CODE

LIBRARY

Intersection

FILENAME

IntrLin3Cyln

In the case of capsules, testing for intersections involves measuring the distance between the linear component and the capsule line segment. For cylinders the test is more complicated since there are no hemispherical caps. The portion of the linear component between the two planes of the cylinder ends must be computed. The distance between the clipped linear component and the cylinder line segment is measured and compared to the cylinder radius.

Finding the intersections with the cylinder is similar to that with capsules, but again the clipped linear component is used. The same quadratic equation arises when measuring the distance between the clipped linear component and the cylinder line segment. However, the linear component might also intersect the circular disks at the ends of the cylinder. If the clipped component has an end point on a plane containing

a circular disk, there must be a test to see if that end point is inside the circle. If so, the end point is a point of intersection.

5.6 INTERSECTION OF A LINEAR COMPONENT AND AN ELLIPSOID

SOURCE CODE

LIBRARY

Intersection

FILENAME

IntrLin3Elp3

An ellipsoid is represented by the quadratic equation $(\vec{X} - \vec{C})^{\mathrm{T}} M (\vec{X} - \vec{C}) = 1$, where \vec{C} is the center of the ellipsoid and where M is a positive definite matrix. The matrix can be factored as $M = R^{\mathrm{T}} D R$, where R is a rotation matrix and D is a diagonal matrix whose diagonal entries are positive. The rows of R are the axes of the ellipsoid, and the diagonal entries of D are the axis lengths. If the line is $\vec{P} + t\vec{V}$, then substitution into the ellipsoid equation produces a quadratic equation

$$(\vec{V}^{\mathrm{T}} M \vec{V}) \, t^2 + (2\vec{V}^{\mathrm{T}} M (\vec{P} - \vec{C})) \, t + (\vec{P} - \vec{C})^{\mathrm{T}} M (\vec{P} - \vec{C}) - 1 = 0.$$

The points of intersection are determined by the real roots of this equation. If there are no real roots, the line does not intersect the ellipsoid. If there is one real root, the line is tangent to the ellipsoid. If there are two real roots, then the line penetrates the ellipsoid at two distinct locations.

5.7 INTERSECTION OF A LINEAR COMPONENT AND A TRIANGLE

SOURCE CODE

LIBRARY

Intersection

FILENAME

IntrLin3Tri3

An excellent article for computing ray-triangle intersections is Möller and Trumbore (1997). The general strategy for lines, rays, or segments is described below.

Let the triangle have vertices \vec{V}_0, $\vec{V}_1 = \vec{V}_0 + \vec{E}_0$, and $\vec{V}_2 = \vec{V}_0 + \vec{E}_1$. The plane of the triangle is given by $\vec{N} \cdot (\vec{X} - \vec{V}_0) = 0$, where $\vec{N} = \vec{E}_0 \times \vec{E}_1$. Let the line be $\vec{L}(t) = \vec{P} + t\vec{D}$, where the direction vector is not necessarily unit length. The ray satisfies $t \geq 0$, and the line segment satisfies $t \in [0, 1]$.

The first problem is to determine if the linear component intersects the plane of the triangle. If \vec{D} is not perpendicular to \vec{N}, then the line must intersect the plane. The corresponding t value is computed by substitution of $\vec{L}(t)$ into the plane equation,

$$T = \frac{\vec{N} \cdot (\vec{V}_0 - \vec{P})}{\vec{N} \cdot \vec{D}}.$$

The point of intersection is $\vec{L}(T)$. If the linear component is a ray, then the point of intersection is valid if $T \geq 0$. If the linear component is a line segment, then the point of intersection is valid if $T \in [0, 1]$.

For a valid point of intersection, the second problem is to determine if the point is inside the triangle. Writing $\vec{L}(T) = \vec{V}_0 + s_0 \vec{E}_0 + s_1 \vec{E}_1$, the coefficients are determined

by the linear system shown below, where $\vec{Q} = \vec{L}(T) - \vec{V}_0$:

$$\begin{bmatrix} \vec{E}_0 \cdot \vec{E}_0 & \vec{E}_0 \cdot \vec{E}_1 \\ \vec{E}_0 \cdot \vec{E}_1 & \vec{E}_1 \cdot \vec{E}_1 \end{bmatrix} \begin{bmatrix} s_0 \\ s_1 \end{bmatrix} = \begin{bmatrix} \vec{E}_0 \cdot \vec{Q} \\ \vec{E}_1 \cdot \vec{Q} \end{bmatrix}.$$

Define $e_{ij} = \vec{E}_i \cdot \vec{E}_j$, $q_i = \vec{E}_i \cdot \vec{Q}$, and $\Delta = e_{00}e_{11} - e_{01}^2 = |\vec{E}_0 \times \vec{E}_1|^2 = |\vec{N}|^2$; then $s_0 = (e_{11}q_0 - e_{01}q_1)/\Delta$ and $s_1 = (e_{00}q_1 - e_{01}q_0)/\Delta$. The point is inside the triangle if $s_0 \geq 0$, $s_1 \geq 0$, and $s_0 + s_1 \leq 1$. The division can be avoided by setting $\sigma_0 = e_{11}q_0 - e_{01}q_1$, $\sigma_1 = e_{00}q_1 - e_{01}q_0$, and testing $\sigma_0 \geq 0$, $\sigma_1 \geq 0$, and $\sigma_0 + \sigma_1 \leq \Delta$.

If the line is parallel to, but not contained in the plane, then the linear component does not intersect the triangle. This condition occurs when $\vec{N} \cdot \vec{D} = 0$ and $\vec{N} \cdot (\vec{V}_0 - \vec{P}) \neq 0$. Otherwise, the line is contained in the plane of the triangle. A 3D application could consider this case as not meaningful (transverse intersections are the only important cases). If not, more work must be done to decide if the linear component actually intersects the triangle.

First consider the case of a line. The line intersects the triangle if at least one of the vertices is on the line or if at least two vertices straddle the line. These conditions can be tested by projecting the vertices onto a line in the plane of the triangle that is perpendicular to the test line, $\vec{P} + s\vec{N} \times \vec{D}$. In fact, this has the same flavor as separating axes. It is enough to consider the signs of the numerators of the projection components, $\vec{V}_i \cdot \vec{N} \times \vec{D}$. Define $m_0 = \min_i\{\vec{V}_i \cdot \vec{N} \times \vec{D}\}$ and $m_1 = \max_i\{\vec{V}_i \cdot \vec{N} \times \vec{D}\}$. The line intersects the triangle if and only if $0 \in [m_0, m_1]$.

Segments and rays are handled using the method of separating axes (see Sections 5.2.1 and 5.2.2). In addition to the triangle edges already defined, set $\vec{E}_2 = \vec{V}_1 - \vec{V}_0$.

For rays the potential separating axes have directions $\vec{N} \times \vec{E}_i$ for $0 \leq i \leq 2$ and $\vec{N} \times \vec{D}$. In this case, though, let the potential separating axis contain the ray origin \vec{P}. Assuming the potential separating axis direction \vec{W} is not perpendicular to the ray direction \vec{D}, the ray projects to a semi-infinite interval $[0, +\infty)$ or $(-\infty, 0]$ depending on the sign of $\vec{W} \cdot \vec{D}$. If $\vec{W} \cdot \vec{D} = 0$, then the ray projects to the singleton point set $\{0\}$. The vertices of the triangle project to $\vec{W} \cdot (\vec{V}_i - \vec{P})$ for $0 \leq i \leq 2$. Let m_0 and m_1 be the minimum and maximum values of these projections. If $\vec{W} \cdot \vec{D} > 0$, the ray does not intersect the triangle if $[m_0, m_1] \cap [0, \infty) = \emptyset$. If $\vec{W} \cdot \vec{D} < 0$, the ray does not intersect the triangle if $[m_0, m_1] \cap (-\infty, 0] = \emptyset$. If $\vec{W} \cdot \vec{D} = 0$, the ray does not intersect the triangle if $0 \notin [m_0, m_1]$.

For line segments the potential separating axes are the same as for rays. The midpoint representation should be used, $\vec{M} = \vec{P} + 0.5\vec{D}$, and $\vec{U} = 0.5\vec{D}$, so the line segment has midpoint \vec{M} and end points $\vec{M} \pm \vec{U}$. The potential separating axis with direction \vec{W} is required to contain \vec{M}, in which case the line segment projects to an interval of the form $[-\mu, \mu]$, where $\mu = \vec{W} \cdot \vec{U}$. The triangle vertices project to an interval $[m_0, m_1]$. The line segment and triangle do not intersect when $[-\mu, \mu] \cap [m_0, m_1] = \emptyset$.

COLLISION DETECTION

ollision detection is a very broad topic, relevant to computer games and to other applications such as navigation and robotics. The classic example for collision detection in a third–person perspective, indoor game is having the main character move around in a set of rooms that contain obstacles. The character is controlled by an input device, typically a joystick, keyboard, or mouse, and must not be allowed to walk through the walls or obstacles. Moreover, if the character walks into a wall, he might be allowed to slide along the wall in a direction that is oblique to the one implied by the event from the input device. A standard technique for preventing the character from walking through a wall is to enclose the character with a tight-fitting bounding volume and testing if it intersects the plane of the wall. The collision detection system must provide support for this test even when the character (and bounding volume) are moving. Preventing the character from walking through an obstacle is as simple as enclosing the obstacle with its own bounding volume and testing for intersection between the character and obstacle bounding volumes. Other typical situations in a game that require collision detection are keeping vehicles moving over a terrain without dropping through it, monitoring racing cars on a track and detecting when two cars hit or when a car hits a wall, determining when a projectile hits an intended

target, bouncing objects off other objects, providing feedback about character control when two characters are fighting, and determining if an object can pass through an opening, such as when a character attempts to walk through a doorway that may or may not be tall enough.

Implementing a robust collision detection system is a difficult and elusive task, as many game programmers have found. The algorithms for *dynamic* (moving) objects tend to be somewhat more difficult to implement than for *static* (nonmoving) objects, particularly because of the implied increase in dimension (four dimensions, three in space and one in time).

Collision detection is determining *if, when,* and *where* two objects intersect. Determining if two objects intersect is referred to in this chapter as *testing intersection*—typically easy to implement and inexpensive in CPU time. However, testing intersection only provides a Boolean result—the objects either do or do not intersect. Determining when two moving objects intersect involves computing the *first time of contact.* This is slightly more expensive to compute than the Boolean result from testing for intersection, but conceptually still doable. Determining where two objects intersect is referred to in this chapter as *finding intersection.* This is the most difficult part of collision detection, both conceptually and in terms of the use of CPU time, and involves finding *first point(s) of contact.* For strictly convex objects such as ellipsoids that are initially separated, the first time of contact results in a single first point of contact. Finding isolated contact points is relatively easy. However, for other convex objects such as oriented boxes or capsules, the first time of contact might result in a continuum of first contact points (two boxes can collide edge-to-edge, edge-to-face, or face-to-face). A collision system must deal with these pathological cases. In a typical system, most of the code deals with the pathologies.

The types of objects that are handled in this chapter are the same ones found discussed in Chapter 2: linear components, planes, triangles, rectangles, oriented boxes, spheres, capsules, lozenges, cylinders, and ellipsoids. Complex objects can be arbitrary unions of these, but for game engine purposes, the only complex objects to consider are those that are unions of triangles. Later in the chapter is a discussion on the use of bounding volume trees to assist in collision detection between two complex objects.

The types of intersections considered fall into three categories: linear component versus object (picking), object versus plane (navigation or culling), and object versus object (general collision). For static objects, Chapter 5 already described intersection testing and finding. Chapter 4 described intersection testing between objects and planes for culling purposes. Later in this chapter, picking moving objects and moving object navigation among a collection of planes are discussed. Object-object intersections, whether static or dynamic, are discussed separately.

6.1 DESIGN ISSUES

One of the most important concepts in designing a collision system is how to organize the data. Because the world might contain a large number of interacting objects, an exhaustive comparison of the objects is too expensive. The objects should be

organized into *collision groups*. For example, in an indoor environment, rooms are natural candidates for partitioning dynamic objects into groups. Each room can act as a collision group. Only objects moving within a room are compared to each other. However, if an object moves from one room into another, then the object must switch groups, but not before possibly comparing it to objects within the group of the current room followed by comparing it to objects within the group of the adjacent room.

Given a single complex object, it is also important how the object is structured. Using a scene graph representation and bounding volumes at the nodes of the graph, quick rejection testing is supported for determining that two objects do not intersect. While the rejection testing is done at a coarse level, the geometric data at the leaf nodes of the graph can be further decomposed using bounding volume trees. Comparison of these trees can lead to further rejections or might eventually result in computing the intersections of triangles represented by the leaf nodes of those trees. The following issues come up in using a hierarchical representation of objects for collision purposes:

- Should the hierarchy be built top-down or bottom-up?
- Should the bounding volumes be built manually or automatically?
- How should intersection information be reported?
- How should the propagation of the test/find collision calls be controlled?
- How much information should be retained about the current collision state to support future test/find collision calls?

Bottom-up construction of hierarchies is natural for building the world from small models. Bounding volumes at the leaf nodes are based on geometric data. Bounding volumes at interior nodes contain child bounding volumes, as described in Section 4.3. Top-down construction is good for a decomposition of complex objects, in particular, triangle meshes. The bounding volumes can be built using recursive subdivision methods.

The automatic generation of bounding volumes is desirable to minimize the work of artists and programmers, but it does not always generate a good set of volumes. Manual generation gives better control for fitting the data and using a minimum number of bounding volumes for maximum coverage of space in which the object lives. But manual generation can be time-consuming and perhaps is not a good use of artist/programmer resources. The best approach appears to be a mixture of the two. An automatic generation algorithm can be applied, but the output is subject to manual inspection and tweaking. Tools that support this process are highly desirable.

A reasonable mechanism for reporting intersection information is to use callbacks. Each object involved in the collision test has a callback that is executed when an intersection is predicted or detected. Relevant information about the intersection (location, time, normal vectors, surface attributes, etc.) is passed to the callback. The application has the responsibility for deciding what to do with the information. The callback mechanism provides for *collision response* and maintains an abstract separation between the response and the detection. In particular, this scheme integrates nicely with

physics systems: any collision detection back end can be fit with any physics system front end.

Hierarchical organization of data allows the application to tag each node with a set of flags indicating how the collision test should propagate. The simplest choice is whether or not to recurse on the call or to terminate immediately. Other choices involve specifying what types of calculations should occur (test only, first time only, first point of contact, do only bounding volume comparisons but not triangle-triangle tests, go all the way to triangle-triangle tests, etc.).

Remembering information about a previous intersection may help in localizing the search for the next call of the collision system. The usual space-time trade-off applies: more memory is used to retain state information in exchange for a faster execution. Whether space or time is important depends on the application and its data. For example, retaining state information is a key feature in the GJK and extended GJK algorithms (Gilbert, Johnson, and Keerthi 1988; Cameron 1996; van den Bergen 1999), but bounding volume trees typically do not retain state information and are designed to localize the search by fast intersection tests between the bounding volumes (Gottschalk, Lin, and Manocha 1991; Gregory et al. 1998). Both approaches are viable, but in this chapter we will discuss only the bounding volume tree ideas.

6.2 INTERSECTION OF DYNAMIC OBJECTS AND LINES

In the following sections, the line is stationary and defined by $\vec{P} + s\vec{D}$ for $s \in \mathbb{R}$. The other objects are moving with constant linear velocity \vec{W} over a time interval $t \in [0, t_{\max}]$. If $\vec{D} \times \vec{W} = \vec{0}$, then the object is moving parallel to the line. The static test for intersection is sufficient for this case.

The algorithms presented here determine only if the line and object will intersect on the time interval. Computation of the first time of contact is typically more expensive. For the sphere, capsule, and lozenge, finding the first time of contact involves solving a quadratic equation, which requires taking a square root.

6.2.1 SPHERES

The moving sphere has center $\vec{C} + t\vec{W}$ for $t \in [0, t_{\max}]$ and radius $r > 0$. The distance between a point and a line is given by Equation 2.14. Replacing the time-varying center in this equation leads to a quadratic function in t that represents the squared distance,

SOURCE CODE

LIBRARY

Intersection

$$Q(t) = \left| \left(\vec{W} - \frac{\vec{D} \cdot \vec{W}}{\vec{D} \cdot \vec{D}} \vec{D} \right) t + \left((\vec{C} - \vec{P}) - \frac{\vec{D} \cdot (\vec{C} - \vec{P})}{\vec{D} \cdot \vec{D}} \vec{D} \right) \right|^2 =: at^2 + 2bt + c.$$

FILENAME

IntrLin3Sphr

The coefficient a is positive because of the assumption that the direction of motion is not parallel to the line. If $Q(t) \le r^2$ for some $t \in [0, t_{\max}]$, then the line intersects the sphere during the specified time interval. The problem is now one of determining the

minimum of Q on the interval. Solve $Q'(T) = 0$ for $T = -b/a$. If $T \in [0, t_{max}]$, then the minimum is $Q(T)$. If $T < 0$, the minimum is $Q(0)$. If $T > t_{max}$, the minimum is $Q(t_{max})$. The minimum value is then compared to r^2. The coefficients each simplify to a fraction whose denominator is $\vec{D} \cdot \vec{D}$. To avoid the division, Q and r^2 can be multiplied through and the minimization is performed using those quantities. The pseudocode is

```
bool TestSphereLine (Sphere sphere, Line line, Velocity W,
  float tmax)
{
    E = sphere.C - line.P;
    dotDW = Dot(line.D,W);
    dotDD = Dot(line.D,line.D);
    dotWW = Dot(W,W);
    dotWE = Dot(W,E);
    dotDE = Dot(line.D,E);
    dotEE = Dot(E,E);
    ddr2 = dotDD*sphere.r*sphere.r;
    a = dotDD*dotWW - dotDW*dotDW; // = |Cross(line.D,W)|^2 >= 0
    b = dotDD*dotWE - dotDE*dotDW;
    c = dotDD*dotEE - dotDE*dotDE; // = |Cross(line.D,E)|^2 >= 0
    if ( a > 0 )
    {
        t = -b/a;
        if ( t < 0 )
        {
            // minimum occurs at t = 0
            return c <= ddr2;
        }
        else if ( t > tmax )
        {
            // minimum occurs at t = tmax
            return tmax*(a*tmax+2*b)+c <= ddr2;
        }
        else
        {
            // minimum occurs at t
            return t*(a*t+2*b)+c <= ddr2;
        }
    }
    else
    {
        // a = 0, sphere moving parallel to line, just need to
        // test t = 0
        return c <= ddr2;
    }
}
```

6.2.2 ORIENTED BOXES

SOURCE CODE

LIBRARY

Intersection

FILENAME

IntrLin3Box3

In Section 5.2 it was shown that the three separating axis tests for a line versus a static oriented box are

$$|\vec{U}_0 \cdot \vec{D} \times (\vec{C} - \vec{P})| > e_1|\vec{D} \cdot \vec{U}_2| + e_2|\vec{D} \cdot \vec{U}_1|$$

$$|\vec{U}_1 \cdot \vec{D} \times (\vec{C} - \vec{P})| > e_0|\vec{D} \cdot \vec{U}_2| + e_2|\vec{D} \cdot \vec{U}_0|$$

$$|\vec{U}_2 \cdot \vec{D} \times (\vec{C} - \vec{P})| > e_0|\vec{D} \cdot \vec{U}_1| + e_1|\vec{D} \cdot \vec{U}_0|.$$

If any of these tests are true, then the line and box do not intersect. For the motion case, \vec{C} is replaced by $\vec{C} + t\vec{W}$ for $t \in [0, t_{max}]$. Squaring the terms in the inequalities, the three tests are of the form $Q_i(t) := a_i t^2 + 2b_i t + c_i > d_i$ for $0 \le i \le 2$. The line and box intersect on the given interval if all three tests fail. That is, if there is a time $T \in [0, t_{max}]$ for which $Q_i(T) \le d_i$ for all i, then an intersection must occur. If I_i is the interval (possibly empty) for which $Q_i(t) \le c_i$, then the line and box must intersect if $I_0 \cap I_1 \cap I_2 \cap [0, t_{max}] \ne \emptyset$.

6.2.3 CAPSULES

The moving capsule is $\vec{C} + u\vec{E} + t\vec{W}$, where the capsule origin is \vec{C} and the capsule axis has direction \vec{E}. The parameter domain is $(u, t) \in [0, 1] \times [0, t_{max}]$. Replacing this in Equation 2.14 leads to a quadratic equation in u and t that represents the squared distance,

SOURCE CODE

LIBRARY

Intersection

FILENAME

IntrLin3Cap

$$Q(u, t) = |\vec{\alpha}u + \vec{\beta}t + \vec{\gamma}|^2,$$

where

$$\vec{\alpha} = \vec{E} - \frac{\vec{D} \cdot \vec{E}}{\vec{D} \cdot \vec{D}}\vec{D}$$

$$\vec{\beta} = \vec{W} - \frac{\vec{D} \cdot \vec{W}}{\vec{D} \cdot \vec{D}}\vec{D}$$

$$\vec{\gamma} = (\vec{C} - \vec{P}) - \frac{\vec{D} \cdot (\vec{C} - \vec{E})}{\vec{D} \cdot \vec{D}}\vec{D}.$$

If $Q(u, t) \le r^2$ for some $(u, t) \in [0, 1] \times [0, t_{max}]$, then the line and capsule must intersect during the given time interval. Just as for the line-sphere test, the division can be avoided by multiplying through by $\vec{D} \cdot \vec{D}$ and comparing the minimum of the modified quadratic to $r^2 \vec{D} \cdot \vec{D}$. The minimization problem is solved in the same way as for measuring the distance from a point to a rectangle.

6.2.4 LOZENGES

The moving lozenge is $\vec{C} + u\vec{E}_0 + v\vec{E}_1 + t\vec{W}$, where the lozenge origin is \vec{C} and the lozenge edge directions are \vec{E}_0 and \vec{E}_1. The parameter domain is $(u, v, t) \in [0, 1]^2 \times [0, t_{max}]$. Replacing this in Equation 2.14 leads to a quadratic equation in u, v, and t that represents the squared distance,

SOURCE CODE

LIBRARY

Intersection

$$Q(u, v, t) = |\vec{\alpha}u + \vec{\beta}v + \vec{\gamma}t + \vec{\delta}|^2,$$

where

FILENAME

IntrLin3Loz

$$\vec{\alpha} = \vec{E}_0 - \frac{\vec{D} \cdot \vec{E}_0}{\vec{D} \cdot \vec{D}} \vec{D}$$

$$\vec{\beta} = \vec{E}_1 - \frac{\vec{D} \cdot \vec{E}_1}{\vec{D} \cdot \vec{D}} \vec{D}$$

$$\vec{\gamma} = \vec{W} - \frac{\vec{D} \cdot \vec{W}}{\vec{D} \cdot \vec{D}} \vec{D}$$

$$\vec{\delta} = (\vec{C} - \vec{P}) - \frac{\vec{D} \cdot (\vec{C} - \vec{E})}{\vec{D} \cdot \vec{D}} \vec{D}.$$

If $Q(u, v, t) \leq r^2$ for some $(u, v, t) \in [0, 1]^2 \times [0, t_{max}]$, then the line and lozenge must intersect during the given time interval. Just as for the line-sphere test, the division can be avoided by multiplying through by $\vec{D} \cdot \vec{D}$ and comparing the minimum of the modified quadratic to $r^2 \vec{D} \cdot \vec{D}$. The minimization problem is solved in the same way as for measuring the distance from a point to an oriented box.

6.2.5 CYLINDERS

SOURCE CODE

LIBRARY

Intersection

Testing for the intersection of a line with a moving cylinder is an extremely complicated and somewhat expensive process. For that reason, cylinders are not recommended for use as bounding volumes. Capsules are a better choice. The algorithm for picking a moving cylinder is not presented here.

FILENAME

IntrLin3Cyln

6.2.6 ELLIPSOIDS

Given the line $\vec{P} + s\vec{D}$ and static ellipsoid $(\vec{X} - \vec{C})^T M (\vec{X} - \vec{C}) = 1$, the line intersects the ellipsoid whenever the quadratic equation $as^2 - 2bs + c = 0$ has a real-valued

root; the coefficients are $a = (\vec{D}^T M \vec{D})$, $b = 2\vec{D}^T M \vec{\Delta}$ with $\vec{\Delta} = \vec{C} - \vec{P}$, and $c = \vec{\Delta}^T M \vec{\Delta} - 1$. The condition for having a real-valued root is $b^2 - ac \geq 0$.

For a moving ellipsoid, the center is $\vec{C} + t\vec{W}$ for $t \in [0, t_{\max}]$. The b and c coefficients of the quadratic in s now become functions of t, $b = b_1 t + b_0$ and $c = c_2 t^2 + 2c_1 t + c_0$, where $b_0 = \vec{D}^T M \vec{\Delta}$, $b_1 = \vec{D}^T M \vec{W}$, $c_0 = \vec{\Delta}^T M \vec{\Delta} - 1$, $c_1 = \vec{\Delta}^T M \vec{W}$, and $c_2 = \vec{W}^T M \vec{W}$. The condition for having a real-valued root is

$$Q(t) = (b_1 t + b_0)^2 - a(c_2 t^2 + 2c_1 t + c_0) \geq 0.$$

The minimum of $Q(t)$ can be computed on $[0, t_{\max}]$ and compared to zero.

SOURCE CODE

LIBRARY

Intersection

FILENAME

IntrLin3Elp3

6.2.7 TRIANGLES

The moving triangle has vertices $\vec{V}_0 + t\vec{W}$, $\vec{V}_1 = \vec{V}_0 + \vec{E}_0$, and $\vec{V}_0 + \vec{E}_2$. The plane of the triangle at time t is $\vec{N} \cdot (\vec{X} - \vec{V}_0) = t\vec{N} \cdot \vec{W}$, where $\vec{N} = \vec{E}_0 \times \vec{E}_1$. Let the line be $\vec{P} + s\vec{D}$ for $s \in \mathbb{R}$. If $\vec{N} \cdot \vec{D}$, then the line must intersect each plane regardless of t. In this case the point of intersection occurs when

SOURCE CODE

LIBRARY

Intersection

$$s = \frac{t\vec{N} \cdot \vec{W} + \vec{N} \cdot (\vec{V}_0 - \vec{P})}{\vec{N} \cdot \vec{D}}.$$

FILENAME

IntrLin3Tri3

The intersection point can be represented as $\vec{L}(s) = \vec{V}_0 + t\vec{W} + u_0\vec{E}_0 + u_1\vec{E}_1$ for some choice of u_0 and u_1. Defining $\vec{Q} = \vec{L}(s) - \vec{V}_0$ and using the same notation as in the intersection test for a line and a static triangle, the coefficients are computed as $u_0 = (e_{11}q_0 - e_{01}q_1)/\Delta$ and $u_1 = (e_{00}q_1 - e_{01}q_0)/\Delta$. The point is inside the triangle if $u_0 \geq 0$, $u_1 \geq 0$, and $u_0 + u_1 \leq 1$.

However, for the moving case, $u_i = u_i(t) = (a_i t + b_i)/\Delta$ for some coefficients a_i and b_i. The test for a point inside a triangle is $a_0 t + b_0 \geq 0$, $a_1 t + b_1 \geq 0$, and $(a_0 + a_1)t + (b_0 + b_1) \leq \Delta$. To show an intersection of a line and a moving triangle, it is enough to show that there is a $t \in [0, t_{\max}]$ for which these three inequalities are all true. If I_0 is the set of t for which $a_0 t + b_0 \geq 0$, I_1 is the set of t for which $a_1 t + b_1 \geq 0$, and I_2 is the set of t for which $(a_0 + a_1)t + (b_0 + b_1) \leq \Delta$, then the line and moving triangle intersect whenever $I_0 \cap I_1 \cap I_2 \cap [0, t_{\max}] \neq \emptyset$.

For the case of $\vec{N} \cdot \vec{D}$, if there is no $t \in [0, t_{\max}]$ for which the corresponding plane of the triangle contains the line, then there is no intersection. If there is such a t, it is computed and the problem reduces to determining if the line intersects the triangle within that plane, a two-dimensional problem. However, note that the triangle may very well be moving in that plane. The two-dimensional problem itself has a time component, and the algorithm shown earlier for the static case needs to be slightly modified to handle time.

6.3 INTERSECTION OF DYNAMIC OBJECTS AND PLANES

In the following sections, the plane is stationary and defined by $\vec{N} \cdot \vec{X} = d$. The other objects are moving with constant linear velocity \vec{W} over a time interval $t \in [0, t_{max}]$. The problem is to determine if the moving object intersects the plane within the specified interval of time. Typically, in a game environment, the objects start out in nonintersecting positions. The algorithms presented here only report an intersection time of $t = 0$ when the object and plane are initially intersecting. The intersection set is usually a continuum of points, and the time necessary to calculate the full set is sometimes expensive.

The following sections use notations that were introduced, and formulas that were derived, in Section 4.3. They are not redefined or rederived here.

6.3.1 SPHERES

SOURCE CODE

LIBRARY

Intersection

FILENAME

IntrPlnSphr

Consider a sphere of radius r with moving center $\vec{C}(t) = \vec{C}_0 + t\vec{W}$. The distance between center and plane is $|\vec{N} \cdot \vec{C}(t) - d|$. If $|\vec{N} \cdot \vec{C}_0 - d| \leq r$, then the sphere is already intersecting the plane. The first time of contact is $t = 0$, and the intersection set is a point (distance is exactly r) or a circle. If not initially intersecting, then the intersection testing depends on the motion of the sphere relative to the plane. That is, the sign of $\vec{N} \cdot \vec{W}$ is important. The first time of contact T of the sphere with the plane is a solution to $|\vec{N} \cdot \vec{C}(T) - d| = r$,

$$T = \frac{d - \vec{N} \cdot \vec{C}_0 - \text{sign}(\vec{N} \cdot \vec{C}_0)r}{\vec{N} \cdot \vec{W}}. \tag{6.1}$$

If $T > 0$, then the sphere will intersect the plane. If $T < 0$, the sphere is moving away from the plane.

In an implementation, the division does not have to be performed first. The numerator and denominator are computed, and if they have different signs, then there is no intersection. If the signs are the same, then there is an intersection and the division is performed to obtain T. The first point of contact, if required by the application, is computed by evaluating $\vec{C}(T)$. The pseudocode for test intersection is given below. A return value of `true` indicates the intersection will occur. In this case the T value is set to the first time of contact. If no intersection occurs, the return value is `false` and the T parameter is invalid.

```
bool TestSpherePlane (Sphere sphere, Plane plane, Velocity W,
    float& T)
{
    sdist = Dot(plane.N,sphere.C) - plane.d;
```

```
if ( sdist > sphere.r )
{
    dotNW = Dot(plane.N,W);
    if ( dotNW < 0 )
    {
        T = (sphere.r - sdist)/dotNW;
        return true;
    }
    else
    {
        return false;
    }
}
else if ( sdist < -sphere.r )
{
    dotNW = Dot(plane.N,W);
    if ( dotNW > 0 )
    {
        T = -(sphere.r + sdist)/dotNW;
        return true;
    }
    else
    {
        return false;
    }
}
else
{
    T = 0;
    return true;
}
}
```

An implementation can also provide the maximum time allowed, t_{max}, with the obvious changes to the code to compare T to that time. An implementation for `FindSpherePlane` will have additional code to compute the first point of contact.

6.3.2 ORIENTED BOXES

Consider an oriented box with center \vec{C}_0 and fixed coordinate axes \vec{A}_i and extents a_i for $0 \le i \le 2$. The quantity $r = \sum_{i=0}^{2} a_i |\vec{N} \cdot \vec{A}_i|$ is the radius of the interval of the projected box onto a normal line to the plane. Computation of the first time of contact T (if any) is identical to that of a sphere versus a plane; see Equation (6.1). The pseudocode is

```
bool TestBoxPlane (Box box, Plane plane, Velocity W, float& T)
{
    r = box.a0*|Dot(plane.N,box.A0)| +
        box.a1*|Dot(plane.N,box.A1)| +
        box.a2*|Dot(plane.N,box.A2)|;

    sdist = Dot(plane.N,box.C) - plane.d;
    if ( sdist > r )
    {
        dotNW = Dot(plane.N,W);
        if ( dotNW < 0 )
        {
            T = (r - sdist)/dotNW;
            return true;
        }
        else
        {
            return false;
        }
    }
    else if ( sdist < -r )
    {
        dotNW = Dot(plane.N,W);
        if ( dotNW > 0 )
        {
            T = -(r + sdist)/dotNW;
            return true;
        }
        else
        {
            return false;
        }
    }
    else
    {
        T = 0;
        return true;
    }
}
```

Determining the first point of contact is more difficult for boxes. If there is a first time of contact, then the intersection set depends on the orientation of \vec{N} to the box axes. If \vec{N} is aligned with a box axis (it is perpendicular to two box axes), then the intersection set is an entire face of the box. If \vec{N} is not aligned with a single

axis, but is perpendicular to one axis, then the intersection set is an entire edge of the box. Otherwise, the intersection set is a vertex of the box. How you implement `FindBoxPlane` depends on the application's requirements. Choices on what to return from the function include (1) the entire set of intersection; (2) a representative point in the intersection; or (3) a flag indicating that there are multiple contact points, probably with information about type such as vertex, edge, or face.

6.3.3 CAPSULES

SOURCE CODE

LIBRARY

Intersection

FILENAME

IntrPlnCap

Consider a capsule whose axis is the line segment $\vec{P}(t) + s\vec{D}$ for $s \in [0, 1]$ and where $\vec{P}(t) = \vec{P}_0 + t\vec{W}$. Define the signed distances $\delta_0 = \vec{N} \cdot \vec{P}_0 - d$ and $\delta_1 = \vec{N} \cdot \vec{P}_1 - d$, where $\vec{P}_1 = \vec{P}_0 + \vec{D}$. If $\delta_0 \delta_1 \le 0$, then the capsule is already intersecting the plane. Otherwise, the sign of $\vec{N} \cdot \vec{D}$ is analyzed to decide which of \vec{P}_0 and \vec{P}_1 is closer to the plane. Once that is known, it is enough to apply the intersection testing algorithm between a sphere and a plane. The pseudocode is

```
bool TestCapsulePlane (Capsule capsule, Plane plane, Velocity W,
    float& T)
{
    sd0 = Dot(plane.N,capsule.P) - plane.d;
    sd1 = sd0 + Dot(plane.N,capsule.D);
    if ( sd0*sd1 > capsule.r*capsule.r )
    {
        // Both end points of capsule on same side of plane and
        // the capsule is not initially intersecting the plane.
        if ( |sd0| <= |sd1| )
        {
            // P is closer to plane than P+D
            Sphere sphere(capsule.P,capsule.r);
            return TestSpherePlane(sphere,plane,W,T);
        }
        else
        {
            // P+D is closer to plane than P
            Sphere sphere(capsule.P+capsule.D,capsule.r);
            return TestSpherePlane(sphere,plane,W,T);
        }
    }

    // capsule already intersecting plane
    T = 0;
    return true;
}
```

An implementation should inline the sphere-plane tests since the signed distances to \vec{P}_0 and \vec{P}_1 have already been computed, yet `TestSpherePlane` computes them again. An implementation for `FindCapsulePlane` must deal with the fact that the intersection set at first contact time is either a point or, if $\vec{N} \cdot \vec{D} = 0$, a line segment.

6.3.4 LOZENGES

Consider a lozenge $\vec{P} + u\vec{E}_0 + v\vec{E}_1$, where $\vec{E}_0 \neq \vec{0}$, $\vec{E}_1 \neq \vec{0}$, $\vec{E}_0 \cdot \vec{E}_1$, and $(u, v) \in [0, 1]$. The four corners of the lozenge rectangle are $\vec{P}_{00} = \vec{P}$, $\vec{P}_{10} = \vec{P} + \vec{E}_0$, $\vec{P}_{01} = \vec{P} + \vec{E}_1$, and $\vec{P}_{11} = \vec{P} + \vec{E}_0 + \vec{E}_1$. The signed distances to the plane are $\delta_{ij} = \vec{N} \cdot \vec{P}_{ij} - d$. If the signed distances are not all positive or not all negative, then the lozenge is already intersecting the plane. Otherwise, the corner closest to the plane is determined and the test intersection algorithm is applied to the sphere corresponding to that corner. The pseudocode is

```
bool TestLozengePlane (Lozenge lozenge, Plane plane, Velocity W,
    float& T)
{
    r2 = lozenge.r*lozenge.r;
    sd00 = Dot(plane.N,lozenge.P) - plane.d;
    sd10 = sd00 + Dot(plane.N,lozenge.E0);
    if ( sd00*sd10 > r2 )
    {
        // P00 and P10 on same side of plane and the capsule
        // connecting them is not intersecting the plane.
        dotNE1 = Dot(plane.N,lozenge.E1);
        sd01 = sd00 + dotNE1;
        if ( sd00*sd01 > r2 )
        {
            // P00 and P01 on same side of plane and the capsule
            // connecting them is not intersecting the plane.
            sd11 = sd10 + dotNE1;
            if ( sd11*sd10 > r2 )
            {
                // All rectangle corners on same side of plane and the
                // lozenge containing them is not intersecting the plane.
                if ( |sd00| <= |sd10| )
                {
                    if ( |sd00| <= |sd01| )
                    {
                        // P00 closest to plane
                        Sphere sphere(lozenge.P,lozenge.r);
```

```
            return TestSpherePlane(sphere,plane,W,T);
        }
        else
        {
            // P01 closest to plane
            Sphere sphere(lozenge.P+lozenge.E1,lozenge.r);
            return TestSpherePlane(sphere,plane,W,T);
        }
    }
    else
    {
        if ( |sd10| <= |sd11| )
        {
            // P10 closest to plane
            Sphere sphere(lozenge.P+lozenge.E0,lozenge.r);
            return TestSpherePlane(sphere,plane,W,T);
        }
        else
        {
            // P11 closest to plane
            Sphere sphere(lozenge.P+lozenge.E0+lozenge.E1,lozenge.r);
            return TestSpherePlane(sphere,plane,W,T);
        }
    }
    }
    }
}

// lozenge already intersecting plane
T = 0;
return true;
}
```

An implementation should inline the sphere-plane tests since the signed distances to \vec{P}_{ij} have already been computed, yet TestSpherePlane computes them again. An implementation for FindLozengePlane must deal with the fact that the intersection set at first contact time is either a point, a line segment, or a rectangle.

6.3.5 CYLINDERS

This algorithm is similar to the one discussed for the culling of cylinders. If δ_0 and δ_1 are the signed distances for the end points, then the four important cases are where

both are positive (two cases based on order of the distances) or both are negative (again two cases). The pseudocode is

```
bool TestCylinderPlane (Cylinder cylinder, Plane plane,
    Velocity W, float& T)
{
    dotND = Dot(plane.N,capsule.D);
    sd0 = Dot(plane.N,capsule.P) - plane.d;
    sd1 = sd0 + dotND;
    if ( sd0*sd1 > 0 )
    {
        // both end points of cylinder on same side of plane
        lenD = Length(cylinder.D);
        lenNxD = Length(Cross(plane.N,cylinder.D));
        ratio = lenNxD/lenD;
        if ( sd0 > 0 )
        {
            if ( sd0 <= sd1 )
            {
                // P is closest to plane
                sdq = sd0 - cylinder.r*ratio;
            }
            else
            {
                // P+D is closest to plane
                sdq = sd1 - cylinder.r*ratio;
            }

            if ( sdq > 0 )
            {
                // cylinder not initially intersecting plane
                dotNW = Dot(plane.N,W);
                if ( dotNW < 0 )
                {
                    // cylinder moving towards plane
                    T = -sdq/dotNW;
                    return true;
                }
                else
                {
                    // cylinder moving away from plane
                    return false;
                }
```

```
                }
            }
            else
            {
                if ( sd1 <= sd0 )
                {
                    // P is closest to plane
                    sdq = sd0 + cylinder.r*ratio;
                }
                else
                {
                    // P+D is closest to plane
                    sdq = sd1 + cylinder.r*ratio;
                }

                if ( sdq < 0 )
                {
                    // cylinder not initially intersecting plane
                    dotNW = Dot(plane.N,W);
                    if ( dotNW > 0 )
                    {
                        // cylinder moving toward plane
                        T = -sdq/dotNW;
                        return true;
                    }
                    else
                    {
                        // cylinder moving away from plane
                        return false;
                    }
                }
            }
        }

        // cylinder already intersecting plane
        T = 0;
        return true;
    }
```

Here is where the first snag with cylinders shows up. In order to find the first time of contact, a square root must be taken, an expensive operation. Even if the length of \vec{D} is precomputed and stored with the cylinder, the length of $\vec{N} \times \vec{D}$ must be computed at run time. For this reason, capsules are better bounding volumes to use than cylinders.

6.3.6 ELLIPSOIDS

The algorithm for ellipsoids is similar to that for spheres and oriented boxes. One difference is in the computation of the radius of the interval of projection; here the square root is avoided. The pseudocode is

SOURCE CODE

LIBRARY

Intersection

FILENAME

IntrPlnElp3

```
bool TestEllipsoidPlane (Ellipsoid ellipsoid, Plane plane,
  Velocity W, float& T)
{
    sdist = Dot(plane.N,sphere.C) - plane.d;

    if ( sdist > 0 )
    {
        r2 = Dot(plane.N,ellipsoid.Minverse*plane.N);
        if ( sdist*sdist > r2 )
        {
            dotNW = Dot(plane.N,W);
            if ( dotNW < 0 )
            {
                // ellipsoid moving toward plane
                r = sqrt(r2);
                T = (r - sdist)/dotNW;
                return true;
            }
            else
            {
                // ellipsoid moving away from plane
                return false;
            }
        }
    }
    else if ( sdist < 0 )
    {
        r2 = Dot(plane.N,ellipsoid.Minverse*plane.N);
        if ( sdist*sdist > r2 )
        {
            dotNW = Dot(plane.N,W);
            if ( dotNW > 0 )
            {
                // ellipsoid moving toward plane
                r = sqrt(r2);
                T = -(r + sdist)/dotNW;
                return true;
            }
        }
```

```
            else
            {
                // ellipsoid moving away from plane
                return false;
            }
        }
    }

    T = 0;
    return true;
}
```

6.3.7 TRIANGLES

SOURCE CODE

LIBRARY

Intersection

FILENAME

IntrPlnTri3

Let the three vertices be \vec{V}_i and three signed distances be $\delta_i = \vec{N} \cdot \vec{V}_i - d$ for $0 \le i \le 2$. If the signed distances are not all positive or not all negative, the triangle is already intersecting the plane. Otherwise, the closest vertex to the plane is determined and an intersection test is applied to it. The pseudocode is

```
bool TestTrianglePlane (Triangle triangle, Plane plane,
    Velocity W, float& T)
{
    sd0 = Dot(plane.N,triangle.V0);
    if ( sd0 > 0 )
    {
        sd1 = Dot(plane.N,triangle.V1);
        if ( sd1 > 0 )
        {
            sd2 = Dot(plane.N,triangle.V2);
            if ( sd2 > 0 )
            {
                // vertices all on same side of plane
                GetMinimumDistanceAndVertex(sdMin,VMin);
                dotNW = Dot(plane.N,W);
                if ( dotNW < 0 )
                {
                    // triangle moving toward plane
                    T = -sdMin/dotNW;
                    return true;
                }
                else
                {
                    // triangle moving away from plane
```

```
                        return false;
                    }
                }
            }
        }
        else if ( sd0 < 0 )
        {
            sd1 = Dot(plane.N,triangle.V1);
            if ( sd1 < 0 )
            {
                sd2 = Dot(plane.N,triangle.V2);
                if ( sd2 < 0 )
                {
                    // vertices all on same side of plane
                    GetMinimumDistanceAndVertex(sdMin,VMin);
                    dotNW = Dot(plane.N,W);
                    if ( dotNW < 0 )
                    {
                        // triangle moving toward plane
                        T = -sdMin/dotNW;
                        return true;
                    }
                    else
                    {
                        // triangle moving away from plane
                        return false;
                    }
                }
            }
        }

        // triangle already intersecting plane
        T = 0;
        return true;
    }
```

The function `GetMinimumDistanceAndVertex` finds the minimum value of $\{\delta_0, \delta_1, \delta_2\}$ and the corresponding vertex.

6.4 STATIC OBJECT-OBJECT INTERSECTION

The algorithms in this section determine if two of the same type or stationary objects intersect, but it is also possible to develop intersection testing algorithms for mixed

Table 6.1 Relationship between sphere-swept volumes and distance calculators (*pnt*, point; *seg*, line segment; *rct*, rectangle).

	Sphere	Capsule	Lozenge
Sphere	dist(pnt,pnt)	dist(pnt,seg)	dist(pnt,rct)
Capsule	dist(seg,pnt)	dist(seg,seg)	dist(seg,rct)
Lozenge	dist(rct,pnt)	dist(rct,seg)	dist(rct,rct)

types. In the case of spheres, capsules, and lozenges, this is not a difficult process, and the details are presented here. For a case such as an oriented box and an ellipsoid, the details are sufficiently complex and beyond what was intended for the scope of this book. When analyzing intersections between objects there is a difference between treating the objects as three-dimensional solids and treating them as two-dimensional shells. The testing here assumes that the objects are solids since that is the natural setting for bounding volumes. Finally, the return value of any "test" pseudocode functions is `true` if there is an intersection, `false` otherwise.

The objects for which intersection testing is relatively inexpensive are considered here and include spheres, capsules, lozenges, oriented boxes, and triangles. Testing for the intersection of two ellipsoids can be solved by a constrained minimization that leads to three polynomial equations in three unknowns. The methods in Wee and Goldman (1995a, 1995b) can be used to solve the system, but they are too expensive for a real-time application on current hardware. Testing for the intersection of two cylinders requires a lot of special-case handling based on how the cylinders are oriented with respect to each other and is also too expensive for real time.

6.4.1 SPHERES, CAPSULES, AND LOZENGES

SOURCE CODE

LIBRARY
Intersection

FILENAME
IntrSphrSphr
IntrSphrCap
IntrSphrLoz
IntrCapCap
IntrCapLoz
IntrLozLoz

Spheres, capsules, and lozenges are examples of *sphere-swept volumes*. Intersection testing between pairs of objects is equivalent to measuring distances between the medial structures and comparing to the sum of the radii. Table 6.1 shows the relationship between the volumes and the corresponding distance calculators.

The pseudocode for the six distinct cases is

```
bool TestSphereSphere (Sphere sphere0, Sphere sphere1)
{
    diff = sphere0.C - sphere1.C;
    rsum = sphere0.r + sphere1.r;
    return Dot(diff,diff) <= rsum*rsum;
}
```

```
bool TestSphereCapsule (Sphere sphere, Capsule capsule)
{
    rsum = sphere.r + capsule.r;
    Segment seg(capsule.P,capsule.D);
    return SquaredDistancePointSegment(sphere.C,seg) <= rsum*rsum;
}

bool TestSphereLozenge (Sphere sphere, Lozenge lozenge)
{
    rsum = sphere.r + lozenge.r;
    Rectangle rct(lozenge.P,lozenge.E0,lozenge.E1);
    return SquaredDistancePointRectangle(sphere.C,rct) <= rsum*rsum;
}

bool TestCapsuleCapsule (Capsule capsule0, Capsule capsule1)
{
    rsum = capsule0.r + capsule1.r;
    Segment seg0(capsule0.P,capsule0.D);
    Segment seg1(capsule1.P,capsule1.D);
    return SquaredDistanceSegmentSegment(seg0,seg1) <= rsum*rsum;
}

bool TestCapsuleLozenge (Capsule capsule, Lozenge lozenge)
{
    rsum = capsule.r + lozenge.r;
    Segment seg(capsule.P,capsule.D);
    Rectangle rct(lozenge.P,lozenge.E0,lozenge.E1);
    return SquaredDistanceSegmentRectangle(seg,rct) <= rsum*rsum;
}

bool TestLozengeLozenge (Lozenge lozenge0, Lozenge lozenge1)
{
    rsum = lozenge0.r + lozenge1.r;
    Rectangle rect0(lozenge0.P,lozenge0.E0,lozenge0.E1);
    Rectangle rect1(lozenge1.P,lozenge1.E0,lozenge1.E1);
    return SquaredDistanceRectangleRectangle(rect0,rect1) <= rsum*rsum;
}
```

The functions for computing the various distances can be found in Chapter 2.

6.4.2 ORIENTED BOXES

The method of separating axes is used to determine whether or not two boxes intersect. Let the first box have center \vec{C}_0, axes \vec{A}_0, \vec{A}_1, \vec{A}_2, and extents a_0, a_1, a_2. Let the second

box have center \vec{C}_1, axes \vec{B}_0, \vec{B}_1, \vec{B}_2, and extents b_0, b_1, b_2. The potential separating axes are of the form $\vec{C}_0 + s\vec{L}$, where \vec{L} is one of \vec{A}_i, \vec{B}_j, or $\vec{A}_i \times \vec{B}_j$ for $0 \le i \le 2$ and $0 \le j \le 2$.

The projections of the vertices of the first box onto the line $\vec{C}_0 + s\vec{L}$ relative to origin \vec{C}_0 are

$$\sum_{i=0}^{2} \sigma_i a_i \frac{\vec{L} \cdot \vec{A}_i}{\vec{L} \cdot \vec{L}}.$$

The interval of projection is $[-r_0, r_0]$ and contains all the vertex projections. The radius is obtained by making the summation as large as possible by choosing σ_i to be the sign of $\vec{L} \cdot \vec{A}_i$. Thus,

$$r_0 = \sum_{i=0}^{2} a_i \frac{|\vec{L} \cdot \vec{A}_i|}{\vec{L} \cdot \vec{L}}.$$

The projections of the vertices of the second box onto the same line are

$$\frac{\vec{L} \cdot \vec{D}}{\vec{L} \cdot \vec{L}} + \sum_{i=0}^{2} \sigma_i b_i \frac{\vec{L} \cdot \vec{B}_i}{\vec{L} \cdot \vec{L}},$$

where $\vec{D} = \vec{C}_1 - \vec{C}_0$. The interval of projection is $[r - r_1, r + r_1]$, where

$$r_1 = \sum_{i=0}^{2} b_i \frac{|\vec{L} \cdot \vec{B}_i|}{\vec{L} \cdot \vec{L}}$$

and

$$r = \frac{\vec{L} \cdot \vec{D}}{\vec{L} \cdot \vec{L}}.$$

The two projected intervals do not intersect whenever the distance between interval centers is larger than the sum of the radii of the intervals: $|r| > r_0 + r_1$. Each of the quantities involved has in its denominator $\vec{L} \cdot \vec{L}$. The division is therefore not necessary. Define $R = |r|\vec{L} \cdot \vec{L}$, $R_0 = r_0\vec{L} \cdot \vec{L}$, and $R_1 = r_1\vec{L} \cdot \vec{L}$. The nonintersection test is

$$|\vec{L} \cdot \vec{D}| = R > R_0 + R_1 = \sum_{i=0}^{2} a_i|\vec{L} \cdot \vec{A}_i| + \sum_{i=0}^{2} b_i|\vec{L} \cdot \vec{B}_i|.$$

That is, the line with direction \vec{L} is a separating axis if $R > R_0 + R_1$.

The axes of the second box can be written as combinations of axes of the first,

$$\vec{B}_i = c_{0i}\vec{A}_0 + c_{1i}\vec{A}_1 + c_{2i}\vec{A}_2$$

for $0 \le i \le 2$. Let A be the matrix whose columns are the \vec{A}_i, let B be the matrix whose columns are the \vec{B}_i, and let C be the matrix whose entries are c_{ij}; then $B = AC$, in which case $C = A^{\mathrm{T}}B$. The components of C are just $c_{ij} = \vec{A}_i \cdot \vec{B}_j$. Similarly, the axes of the first box can be written as linear combinations of axes of the second box,

$$\vec{A}_i = c_{i0}\vec{B}_0 + c_{i1}\vec{B}_1 + c_{i2}\vec{B}_2$$

for $0 \le i \le 2$. These relationships allow computation of the various dot products between the separating axis directions and the box axes in terms of the c_{ij} and extents. In particular, the nonintersection tests involve various triple scalar products involving the box axes:

$$\vec{A}_{i_0} \cdot \vec{A}_{i_1} \times \vec{B}_j = \text{sign}(i_0, i_1)c_{i_2 j} \quad \text{and} \quad \vec{B}_{j_0} \cdot \vec{A}_i \times \vec{B}_{j_1} = \text{sign}(j_1, j_0)c_{i j_2}, \qquad (6.2)$$

where $\text{sign}(0, 1) = \text{sign}(1, 2) = \text{sign}(2, 0) = +1$ and $\text{sign}(1, 0) = \text{sign}(2, 1) = \text{sign}(0, 2) = -1$. For two boxes there are 15 potential separating axes, which include 6 box axes (3 per box) and 9 axes obtained as cross products of box axes, one chosen from each box. Table 6.2 summarizes the quantities that must be computed for the separating axes tests.

Testing for intersection amounts to processing each axis of the 15 potential separating axes. If a separating axis is found, the remaining ones of course are not processed. The various entries c_{ij} and $|c_{ij}|$ are computed only when needed, avoiding unnecessary calculations in the event that a separating axis is found quickly and some of the c_{ij} do not need to be computed. The basic separating axis test involves computing R_0, R_1, and R and then testing for nonintersection by comparing $R > R_0 + R_1$.

6.4.3 ORIENTED BOXES AND TRIANGLES

SOURCE CODE

LIBRARY

Intersection

FILENAME

IntrBox3Tri3

Let the triangle have vertices \vec{U}_i for $0 \le i \le 2$. The edges of the triangle are $\vec{E}_0 = \vec{U}_1 - \vec{U}_0$, $\vec{E}_1 = \vec{U}_2 - \vec{U}_0$, and $\vec{E}_2 = \vec{E}_1 - \vec{E}_0$. A normal for the triangle is $\vec{N} = \vec{E}_0 \times \vec{E}_1$ and is not necessarily unit length. The triangle and its interior are given by

$$\left\{ \vec{U}_0 + s\vec{E}_0 + t\vec{E}_1 : 0 \le s \le 1, \ 0 \le t \le 1, \ s + t \le 1 \right\}.$$

Let the box have center \vec{C}, axes \vec{A}_i, and extents a_i for $0 \le i \le 2$. Define $\vec{D} = \vec{U}_0 - \vec{C}$. The potential separating axes are of the form $\vec{C} + s\vec{L}$, where \vec{L} is one of \vec{N}, \vec{A}_i, or $\vec{A}_i \times \vec{E}_j$ for $0 \le i \le 2$ and $0 \le j \le 2$.

Table 6.2 Values for R, R_0, and R_1 for the separating axis tests.

\vec{L}	R_0	R_1	R										
\vec{A}_0	a_0	$b_0	c_{00}	+ b_1	c_{01}	+ b_2	c_{02}	$	$	\vec{A}_0 \cdot \vec{D}	$		
\vec{A}_1	a_1	$b_0	c_{10}	+ b_1	c_{11}	+ b_2	c_{12}	$	$	\vec{A}_1 \cdot \vec{D}	$		
\vec{A}_2	a_2	$b_0	c_{20}	+ b_1	c_{21}	+ b_2	c_{22}	$	$	\vec{A}_2 \cdot \vec{D}	$		
\vec{B}_0	$a_0	c_{00}	+ a_1	c_{10}	+ a_2	c_{20}	$	b_0	$	\vec{B}_0 \cdot \vec{D}	$		
\vec{B}_1	$a_0	c_{01}	+ a_1	c_{11}	+ a_2	c_{21}	$	b_1	$	\vec{B}_1 \cdot \vec{D}	$		
\vec{B}_2	$a_0	c_{02}	+ a_1	c_{12}	+ a_2	c_{22}	$	b_2	$	\vec{B}_2 \cdot \vec{D}	$		
$\vec{A}_0 \times \vec{B}_0$	$a_1	c_{20}	+ a_2	c_{10}	$	$b_1	c_{02}	+ b_2	c_{01}	$	$	c_{10}\vec{A}_2 \cdot \vec{D} - c_{20}\vec{A}_1 \cdot \vec{D}	$
$\vec{A}_0 \times \vec{B}_1$	$a_1	c_{21}	+ a_2	c_{11}	$	$b_0	c_{02}	+ b_2	c_{00}	$	$	c_{11}\vec{A}_2 \cdot \vec{D} - c_{21}\vec{A}_1 \cdot \vec{D}	$
$\vec{A}_0 \times \vec{B}_2$	$a_1	c_{22}	+ a_2	c_{12}	$	$b_0	c_{01}	+ b_1	c_{00}	$	$	c_{12}\vec{A}_2 \cdot \vec{D} - c_{22}\vec{A}_1 \cdot \vec{D}	$
$\vec{A}_1 \times \vec{B}_0$	$a_0	c_{20}	+ a_2	c_{00}	$	$b_1	c_{12}	+ b_2	c_{11}	$	$	c_{20}\vec{A}_0 \cdot \vec{D} - c_{00}\vec{A}_2 \cdot \vec{D}	$
$\vec{A}_1 \times \vec{B}_1$	$a_0	c_{21}	+ a_2	c_{01}	$	$b_0	c_{12}	+ b_2	c_{10}	$	$	c_{21}\vec{A}_0 \cdot \vec{D} - c_{01}\vec{A}_2 \cdot \vec{D}	$
$\vec{A}_1 \times \vec{B}_2$	$a_0	c_{22}	+ a_2	c_{02}	$	$b_0	c_{11}	+ b_1	c_{10}	$	$	c_{22}\vec{A}_0 \cdot \vec{D} - c_{02}\vec{A}_2 \cdot \vec{D}	$
$\vec{A}_2 \times \vec{B}_0$	$a_0	c_{10}	+ a_1	c_{00}	$	$b_1	c_{22}	+ b_2	c_{21}	$	$	c_{00}\vec{A}_1 \cdot \vec{D} - c_{10}\vec{A}_0 \cdot \vec{D}	$
$\vec{A}_2 \times \vec{B}_1$	$a_0	c_{11}	+ a_1	c_{01}	$	$b_0	c_{22}	+ b_2	c_{20}	$	$	c_{01}\vec{A}_1 \cdot \vec{D} - c_{11}\vec{A}_0 \cdot \vec{D}	$
$\vec{A}_2 \times \vec{B}_2$	$a_0	c_{12}	+ a_1	c_{02}	$	$b_0	c_{21}	+ b_1	c_{20}	$	$	c_{02}\vec{A}_1 \cdot \vec{D} - c_{12}\vec{A}_0 \cdot \vec{D}	$

The interval of projection for the box is $[-r, r]$, where

$$r = \sum_{i=0}^{2} a_i \frac{|\vec{L} \cdot \vec{A}_i|}{\vec{L} \cdot \vec{L}}.$$

The projections of the triangle's vertices relative to the line origin are

$$\frac{\vec{L} \cdot (\vec{U}_i - \vec{C})}{\vec{L} \cdot \vec{L}}$$

for $0 \leq i \leq 2$. The projection of the triangle does not have a natural center or radius as does the box. Nonintersection now amounts to showing that the minimal interval containing the three projected triangle vertices is separated from the projected box interval. As before, the division by $\vec{L} \cdot \vec{L}$ is not necessary. Define $R = r\vec{L} \cdot \vec{L}$ and $p_i = \vec{L} \cdot (\vec{U}_i - \vec{C})$ for $0 \leq i \leq 2$. Note that $p_0 = \vec{L} \cdot (\vec{U}_0 - \vec{C}) = \vec{L} \cdot \vec{D}$, $p_1 = \vec{L} \cdot (\vec{U}_1 - \vec{C}) = \vec{L} \cdot (\vec{D} + \vec{E}_0) = p_0 + \vec{L} \cdot \vec{E}_0$, and $p_2 = \vec{L} \cdot (\vec{U}_2 - \vec{C}) = \vec{L} \cdot (\vec{D} + \vec{E}_1) = p_0 + \vec{L} \cdot \vec{E}_1$. Table 6.3 summarizes the quantities that must be computed for the separating axis tests.

Table 6.3 Values for R, p_0, p_1, and p_2 for the separating axis tests.

\vec{L}	p_0	p_1	p_2	R						
\vec{N}	$\vec{N}\cdot\vec{D}$	p_0	p_0	$a_0	\vec{N}\cdot\vec{A}_0	+a_1	\vec{N}\cdot\vec{A}_1	+a_2	\vec{N}\cdot\vec{A}_2	$
\vec{A}_0	$\vec{A}_0\cdot\vec{D}$	$p_0+\vec{A}_0\cdot\vec{E}_0$	$p_0+\vec{A}_0\cdot\vec{E}_1$	a_0						
\vec{A}_1	$\vec{A}_1\cdot\vec{D}$	$p_0+\vec{A}_1\cdot\vec{E}_0$	$p_0+\vec{A}_1\cdot\vec{E}_1$	a_1						
\vec{A}_2	$\vec{A}_2\cdot\vec{D}$	$p_0+\vec{A}_2\cdot\vec{E}_0$	$p_0+\vec{A}_2\cdot\vec{E}_1$	a_2						
$\vec{A}_0\times\vec{E}_0$	$\vec{A}_0\times\vec{E}_0\cdot\vec{D}$	p_0	$p_0+\vec{A}_0\cdot\vec{N}$	$a_1	\vec{A}_2\cdot\vec{E}_0	+a_2	\vec{A}_1\cdot\vec{E}_0	$		
$\vec{A}_0\times\vec{E}_1$	$\vec{A}_0\times\vec{E}_1\cdot\vec{D}$	$p_0-\vec{A}_0\cdot\vec{N}$	p_0	$a_1	\vec{A}_2\cdot\vec{E}_1	+a_2	\vec{A}_1\cdot\vec{E}_1	$		
$\vec{A}_0\times\vec{E}_2$	$\vec{A}_0\times\vec{E}_2\cdot\vec{D}$	$p_0-\vec{A}_0\cdot\vec{N}$	$p_0-\vec{A}_0\cdot\vec{N}$	$a_1	\vec{A}_2\cdot\vec{E}_2	+a_2	\vec{A}_1\cdot\vec{E}_2	$		
$\vec{A}_1\times\vec{E}_0$	$\vec{A}_1\times\vec{E}_0\cdot\vec{D}$	p_0	$p_0+\vec{A}_1\cdot\vec{N}$	$a_0	\vec{A}_2\cdot\vec{E}_0	+a_2	\vec{A}_0\cdot\vec{E}_0	$		
$\vec{A}_1\times\vec{E}_1$	$\vec{A}_1\times\vec{E}_1\cdot\vec{D}$	$p_0-\vec{A}_1\cdot\vec{N}$	p_0	$a_0	\vec{A}_2\cdot\vec{E}_1	+a_2	\vec{A}_0\cdot\vec{E}_1	$		
$\vec{A}_1\times\vec{E}_2$	$\vec{A}_1\times\vec{E}_2\cdot\vec{D}$	$p_0-\vec{A}_1\cdot\vec{N}$	$p_0-\vec{A}_1\cdot\vec{N}$	$a_0	\vec{A}_2\cdot\vec{E}_2	+a_2	\vec{A}_0\cdot\vec{E}_2	$		
$\vec{A}_2\times\vec{E}_0$	$\vec{A}_2\times\vec{E}_0\cdot\vec{D}$	p_0	$p_0+\vec{A}_2\cdot\vec{N}$	$a_0	\vec{A}_1\cdot\vec{E}_0	+a_1	\vec{A}_0\cdot\vec{E}_0	$		
$\vec{A}_2\times\vec{E}_1$	$\vec{A}_2\times\vec{E}_1\cdot\vec{D}$	$p_0-\vec{A}_2\cdot\vec{N}$	p_0	$a_0	\vec{A}_1\cdot\vec{E}_1	+a_1	\vec{A}_0\cdot\vec{E}_1	$		
$\vec{A}_2\times\vec{E}_2$	$\vec{A}_2\times\vec{E}_2\cdot\vec{D}$	$p_0-\vec{A}_2\cdot\vec{N}$	$p_0-\vec{A}_2\cdot\vec{N}$	$a_0	\vec{A}_1\cdot\vec{E}_2	+a_1	\vec{A}_0\cdot\vec{E}_2	$		

For axis direction \vec{N}, the projected triangle vertices are identical, so the nonintersection test amounts to showing $\vec{N}\cdot\vec{D}$ is not in the interval $[-R, R]$. For axis directions \vec{A}_i, the projected triangle vertices may all be distinct. For axis directions $\vec{A}_i\times\vec{E}_j$, at most two of the projected vertices are distinct. If the triangle interval is $[\min(p_0, p_1, p_2), \max(p_0, p_1, p_2)]$ and the box interval is $[-R, R]$, then the triangle and box do not intersect whenever $\min(p_0, p_1, p_2) > R$ or $\max(p_0, p_1, p_2) < -R$.

Testing for intersection amounts to processing each axis of the 13 potential separating axes. If a separating axis is found, the remaining ones are not processed. Any quantities that are needed multiple times are calculated only once and only when needed. Pseudocode that shows how to minimize the calculations is given below for each type of axis test.

Axis \vec{N}

The nonintersection test is $|\vec{N}\cdot\vec{D}| > R$. The pseudocode for testing if p is not in $[-R, R]$ is

```
if ( |p| > R )
    return no_intersection;
```

Axes \vec{A}_k

The nonintersection test is $\min(p_0, p_1, p_2) > R$ or $\max(p_0, p_1, p_2) < -R$. The pseudocode is

```
if ( p0 > R )
{
    if ( p1 > R and p2 > R )
        return no_intersection;
    }
}
else if ( p0 < -R )
{
    if ( p1 < -R and p2 < -R )
        return no_intersection;
}
```

Axes $\vec{A}_i \times \vec{E}_j$

The triangle projects to at most two values u_0 and u_1. The nonintersection test is $\min(u_0, u_1) > R$ or $\max(u_0, u_1) < -R$. The pseudocode is

```
if ( (u0 > R and u1 > R) or (u0 < -R and u1 < -R) )
    return no_intersection;
```

6.4.4 TRIANGLES

SOURCE CODE

LIBRARY

Intersection

FILENAME

IntrTri3Tri3

Two fast tests for the intersection of triangles are the *interval overlap test* (Möller 1997) and an algorithm in the ERIT package (Held 1997). The underlying idea is effectively the same for both methods. If the two triangles intersect, the set of intersection must occur on the line of intersection of the two planes containing the triangles, and it must be an interval. Each method attempts to find that interval in its own way. Both methods are discussed in detail in Möller and Haines (1999). The method presented here uses separating axes. This approach easily extends to the case of moving triangles; the interval overlap test and the ERIT algorithm do not have a simple extension.

Let the first triangle have vertices $\vec{A}_0, \vec{A}_1, \vec{A}_2$, edges $\vec{E}_0 = \vec{A}_1 - \vec{A}_0, \vec{E}_1 = \vec{A}_2 - \vec{A}_0$, $\vec{E}_2 = \vec{E}_1 - \vec{E}_0$, and normal $\vec{N} = \vec{E}_0 \times \vec{E}_1$ (not necessarily unit length). Let the second triangle have vertices $\vec{B}_0, \vec{B}_1, \vec{B}_2$, edges $\vec{F}_0 = \vec{B}_1 - \vec{B}_0, \vec{F}_1 = \vec{B}_2 - \vec{B}_0, \vec{F}_2 = \vec{F}_1 - \vec{F}_0$, and normal $\vec{M} = \vec{F}_0 \times \vec{F}_1$ (not necessarily unit length). Define $\vec{D} = \vec{B}_0 - \vec{A}_0$.

Triangles in three dimensions present an interesting problem for nonintersection by the separating axis approach. The set of potential separating axes depends on whether or not the triangles are parallel. If the two triangles are parallel but not

coplanar, then the triangle normals will provide separating axes. However, if the triangles are coplanar, then neither normal provides a separating axis. Moreover, cross products of pairs of edges from the triangles are all normal vectors, so they do not yield separating axes. It turns out that for the coplanar case, cross products of a triangle normal with the edges of the other triangle provide the potential separating axes. As a two-dimensional problem, the potential separating axis directions are just normal vectors to the edges.

For nonparallel triangles, the potential separating axes are of the form $\vec{A}_0 + s\vec{L}$, where \vec{L} is one of \vec{N}, \vec{M}, or $\vec{E}_i \times \vec{F}_j$ for $0 \le i \le 2$ and $0 \le j \le 2$. For parallel or coplanar triangles, \vec{L} is one of \vec{N}, $\vec{N} \times \vec{E}_i$, or $\vec{N} \times \vec{F}_i$ for $i = 0, 1, 2$.

The projection distances of the triangle vertices scaled by $\vec{L} \cdot \vec{L}$ are

$$p_0 = \vec{L} \cdot (\vec{A}_0 - \vec{A}_0) = 0$$

$$p_1 = \vec{L} \cdot (\vec{A}_1 - \vec{A}_0) = \vec{L} \cdot \vec{E}_0$$

$$p_2 = \vec{L} \cdot (\vec{A}_2 - \vec{A}_0) = \vec{L} \cdot \vec{E}_1$$

and

$$q_0 = \vec{L} \cdot (\vec{B}_0 - \vec{A}_0) = \vec{L} \cdot \vec{D}$$

$$q_1 = \vec{L} \cdot (\vec{B}_1 - \vec{A}_0) = \vec{L} \cdot (\vec{D} + \vec{F}_0) = q_0 + \vec{L} \cdot \vec{F}_0$$

$$q_2 = \vec{L} \cdot (\vec{B}_2 - \vec{A}_0) = \vec{L} \cdot (\vec{D} + \vec{F}_1) = q_0 + \vec{L} \cdot \vec{F}_1.$$

The tests for separation are $\min_i(p_i) > \max_j(q_j)$ or $\max_i(p_i) < \min_j(q_j)$. Table 6.4 summarizes the quantities that must be computed for the separating axis tests for noncoplanar triangles.

Table 6.5 summarizes the quantities that must be computed for the separating axis tests for coplanar triangles. The quantites in that table are $\ell = |\vec{N}|$; $\vec{E}_i \times \vec{F}_j = \lambda_{ij}\vec{N}$ for $i = 0, 1$ and $j = 0, 1$; and $\vec{F}_0 \times \vec{F}_1 = \mu\vec{N}$.

Testing for intersection amounts to processing the various potential separating axes. Any quantities that are needed multiple times are calculated only once and only when needed. The basic separating axis test involves computing the triangle intervals $[\min_i(p_i), \max_i(p_i)]$ and $[\min_j(q_j), \max_j(q_j)]$ and then testing for nonintersection by comparing the two intervals. The pseudocode for the outer-level structure is

```
bool TestTriangleTriangle (Triangle tri0, Triangle tri1)
{
    if ( tri0.N is separating ) return false;
    if ( tri1.N is separating ) return false;

    cross01 = Cross(tri0.N,tri1.N);
```

Table 6.4 Values for p_i and q_j for the separating axis tests for noncoplanar triangles.

\vec{L}	p_0	p_1	p_2	q_0	q_1	q_2
\vec{N}	0	0	0	$\vec{N}\cdot\vec{D}$	$q_0+\vec{N}\cdot\vec{F}_0$	$q_0+\vec{N}\cdot\vec{F}_1$
\vec{M}	0	$\vec{M}\cdot\vec{E}_0$	$\vec{M}\cdot\vec{E}_1$	$\vec{M}\cdot\vec{D}$	q_0	q_0
$\vec{E}_0\times\vec{F}_0$	0	0	$-\vec{N}\cdot\vec{F}_0$	$\vec{E}_0\times\vec{F}_0\cdot\vec{D}$	q_0	$q_0+\vec{M}\cdot\vec{E}_0$
$\vec{E}_0\times\vec{F}_1$	0	0	$-\vec{N}\cdot\vec{F}_1$	$\vec{E}_0\times\vec{F}_1\cdot\vec{D}$	$q_0-\vec{M}\cdot\vec{E}_0$	q_0
$\vec{E}_0\times\vec{F}_2$	0	0	$-\vec{N}\cdot\vec{F}_2$	$\vec{E}_0\times\vec{F}_2\cdot\vec{D}$	$q_0-\vec{M}\cdot\vec{E}_0$	$q_0-\vec{M}\cdot\vec{E}_0$
$\vec{E}_1\times\vec{F}_0$	0	$\vec{N}\cdot\vec{F}_0$	0	$\vec{E}_1\times\vec{F}_0\cdot\vec{D}$	q_0	$q_0+\vec{M}\cdot\vec{E}_1$
$\vec{E}_1\times\vec{F}_1$	0	$\vec{N}\cdot\vec{F}_1$	0	$\vec{E}_1\times\vec{F}_1\cdot\vec{D}$	$q_0-\vec{M}\cdot\vec{E}_1$	q_0
$\vec{E}_1\times\vec{F}_2$	0	$\vec{N}\cdot\vec{F}_2$	0	$\vec{E}_1\times\vec{F}_2\cdot\vec{D}$	$q_0-\vec{M}\cdot\vec{E}_1$	$q_0-\vec{M}\cdot\vec{E}_1$
$\vec{E}_2\times\vec{F}_0$	0	$\vec{N}\cdot\vec{F}_0$	$\vec{N}\cdot\vec{F}_0$	$\vec{E}_2\times\vec{F}_0\cdot\vec{D}$	q_0	$q_0+\vec{M}\cdot\vec{E}_2$
$\vec{E}_2\times\vec{F}_1$	0	$\vec{N}\cdot\vec{F}_1$	$\vec{N}\cdot\vec{F}_1$	$\vec{E}_2\times\vec{F}_1\cdot\vec{D}$	$q_0-\vec{M}\cdot\vec{E}_2$	q_0
$\vec{E}_2\times\vec{F}_2$	0	$\vec{N}\cdot\vec{F}_2$	$\vec{N}\cdot\vec{F}_2$	$\vec{E}_2\times\vec{F}_2\cdot\vec{D}$	$q_0-\vec{M}\cdot\vec{E}_2$	$q_0-\vec{M}\cdot\vec{E}_2$

Table 6.5 Values for p_i and q_j for the separating axis tests for coplanar triangles.

\vec{L}	p_0	p_1	p_2	q_0	q_1	q_2
\vec{N}	0	0	0	$\vec{N}\cdot\vec{D}$	q_0	q_0
$\vec{N}\times\vec{E}_0$	0	0	ℓ^2	$\vec{N}\times\vec{E}_0\cdot\vec{D}$	$q_0+\lambda_{00}\ell^2$	$q_0+\lambda_{01}\ell^2$
$\vec{N}\times\vec{E}_1$	0	$-\ell^2$	0	$\vec{N}\times\vec{E}_1\cdot\vec{D}$	$q_0+\lambda_{10}\ell^2$	$q_0+\lambda_{11}\ell^2$
$\vec{N}\times\vec{E}_2$	0	$-\ell^2$	$-\ell^2$	$\vec{N}\times\vec{E}_2\cdot\vec{D}$	$q_0+(\lambda_{10}-\lambda_{00})\ell^2$	$q_0+(\lambda_{11}-\lambda_{01})\ell^2$
$\vec{N}\times\vec{F}_0$	0	$-\lambda_{00}\ell^2$	$-\lambda_{10}\ell^2$	$\vec{N}\times\vec{F}_0\cdot\vec{D}$	q_0	$q_0+\mu\ell^2$
$\vec{N}\times\vec{F}_1$	0	$-\lambda_{01}\ell^2$	$-\lambda_{11}\ell^2$	$\vec{N}\times\vec{F}_1\cdot\vec{D}$	$q_0-\mu\ell^2$	q_0
$\vec{N}\times\vec{F}_2$	0	$(\lambda_{00}-\lambda_{01})\ell^2$	$(\lambda_{10}-\lambda_{11})\ell^2$	$\vec{N}\times\vec{F}_2\cdot\vec{D}$	$q_0-\mu\ell^2$	$q_0-\mu\ell^2$

```
if ( Dot(cross01,cross01) > 0 )
{
    // triangles are not parallel
    if ( Cross(tri0.E0,tri1.E0) is separating ) return false;
    if ( Cross(tri0.E0,tri1.E1) is separating ) return false;
    if ( Cross(tri0.E0,tri1.E2) is separating ) return false;
    if ( Cross(tri0.E1,tri1.E0) is separating ) return false;
```

```
        if ( Cross(tri0.E1,tri1.E1) is separating ) return false;
        if ( Cross(tri0.E1,tri1.E2) is separating ) return false;
        if ( Cross(tri0.E2,tri1.E0) is separating ) return false;
        if ( Cross(tri0.E2,tri1.E1) is separating ) return false;
        if ( Cross(tri0.E2,tri1.E2) is separating ) return false;
    }
    else
    {
        // Triangles are parallel and must be coplanar since the
        // N separating axis tests did not cause an exit.
        if ( Cross(tri0.N,tri0.E0) is separating ) return false;
        if ( Cross(tri0.N,tri0.E1) is separating ) return false;
        if ( Cross(tri0.N,tri0.E2) is separating ) return false;
        if ( Cross(tri1.N,tri1.E0) is separating ) return false;
        if ( Cross(tri1.N,tri1.E1) is separating ) return false;
        if ( Cross(tri1.N,tri1.E2) is separating ) return false;
    }

    return true;
}
```

The pseudocode for the individual separating axis tests requires searching for the minima and maxima of sets. The various tests depend on how many points are in each set.

Axes \vec{N} or \vec{M}

One triangle projects to a single point u and the other projects to three points v_0, v_1, and v_2. The nonintersection test is $\min(v_0, v_1, v_2) > u$ or $\max(v_0, v_1, v_2) < u$. The pseudocode is

```
if ( v0 > u )
{
    if ( v1 > u and v2 > u )
        return no_intersection;
}
else if ( v0 < u )
{
    if ( v1 < u and v2 < u )
        return no_intersection;
}
```

Axes $\vec{E}_i \times \vec{F}_j$

The triangles each project to exactly two points, the first to u_0 and u_1 and the second to v_0 and v_1. The nonintersection test is $\min(v_0, v_1) > \max(u_0, u_1)$ or $\max(v_0, v_1) < \min(u_0, u_1)$. The pseudocode is

```
if ( u1 >= u0 )
{
    if ( (v0 < u0 and v1 < u0) or (v0 > u1 and v1 > u1) )
        return no_intersection;
}
else
{
    if ( (v0 > u0 and v1 > u0) or (v0 < u1 and v1 < u1) )
        return no_intersection;
}
```

Axes $\vec{N} \times \vec{E}_i$ or $\vec{M} \times \vec{F}_i$

One triangle projects to two points u_0 and u_1 and the other projects to three points v_0, v_1, and v_2. The nonintersection test is $\min(v_0, v_1, v_2) > \max(u_0, u_1)$ or $\max(v_0, v_1, v_2) < \min(u_0, u_1)$. The pseudocode is

```
if ( u1 >= u0 )
{
    if ( (v0 < u0 and v1 < u0 and v2 < u0) or (v0 > u1 and v1 >
u1 and v2 > u1) )
        return no_intersection;
}
else
{
    if ( (v0 > u0 and v1 > u0 and v2 > u0) or (v0 < u1 and
      v1 < u1 and v2 < u1) )
        return no_intersection;
}
```

6.5 DYNAMIC OBJECT-OBJECT INTERSECTION

The algorithms in this section determine if two of the same type of dynamic objects intersect. In some of the dynamic cases the algorithms are also presented for deter-

Table 6.6 Relationship between sphere-swept volumes and distance calculators when the second object is moving (*pnt*, point; *seg*, line segment; *rct*, rectangle; *pgm*, parallelogram; *ppd*, parallelepiped; *hex*, hexagon).

	Dynamic		
	Sphere	*Capsule*	*Lozenge*
Static			
Sphere	dist(pnt,{pnt,seg})	dist(pnt,{seg,pgm})	dist(pnt,{rct,hex,ppd})
Capsule	dist(seg,{pnt,seg})	dist(seg,{seg,pgm})	dist(seg,{rct,hex,ppd})
Lozenge	dist(rct,{pnt,seg})	dist(rct,{seg,pgm})	dist(rct,{rct,hex,ppd})

mining a first point of contact. Both objects can have nonzero velocities, but without any loss of generality one of the objects can be assumed to be stationary and the other moving by subtracting the velocity of one from the other. If a point of intersection is computed, it needs to be adjusted by adding back in the velocity of the first object. The velocity vector in all the dynamic sections is named \vec{W}, and the time interval of consideration is $[0, t_{\max}]$. The objects are treated as solids, just as in the static case. The return value of any "test" pseudocode functions is true if there is an intersection, false otherwise.

6.5.1 Spheres, Capsules, and Lozenges

SOURCE CODE

LIBRARY

Intersection

FILENAME

IntrSphrSphr

IntrSphrCap

IntrSphrLoz

IntrCapCap

IntrCapLoz

IntroLozLoz

As mentioned in Section 6.5, intersection testing on sphere-swept volumes of this type is equivalent to computing distances between the medial structures and comparing to the sum of the radii. In this case, the first object is assumed to be static and the second object is assumed to be dynamic. The medial structure of the moving object spans part of space to form yet another sphere-swept volume, so intersection testing is the same process as for the static cases. Table 6.6 shows the relationship between the volumes and the corresponding distance calculators. The left column objects are static and the top row objects are dynamic. For a single entry in the table, the choice of distance calculator depends on how the object is moving (if at all). For example, comparing static sphere to moving capsule, it is possible that the direction of motion is in the direction of the capsule axis, in which case the swept volume is another capsule. But if the direction of motion is not along the capsule axis, then the swept volume has a medial structure that is a parallelogram (not a lozenge by this book's definition since the medial structure might not be a rectangle).

An example of pseudocode for one of the table entries is

```
bool TestCapsuleCapsule (Capsule cap0, Capsule cap1, Velocity W,
  float tmax)
{
    dotWW = Dot(W,W);
    rsum = cap0.r + cap1.r;
    Segment seg0(cap0.P,cap0.D);

    if ( dotWW > 0 )
    {
        crsWD = Cross(W,D);
        dotWxD = Dot(crsWD,crsWD);
        if ( dotWxD > 0 )
        {
            // moving capsule axis spans a parallelogram (parameters [0,1]^2)
            Parallelogram pgm(cap1.P,cap1.D,tmax*W);
            sqrDist = SquaredDistanceSegmentParallelogram(seg0,pgm);
        }
        else
        {
            // moving capsule axis spans a line segment
            dotWD = Dot(W,cap1.D);
            if ( dotWD > 0 )
            {
                Segment seg1(cap1.P,cap1.D+tmax*W);
                sqrDist = SquaredDistanceSegmentSegment(seg0,seg1);
            }
            else
            {
                Segment seg1(cap1.P-tmax*W,cap1.D);
                sqrDist = SquaredDistanceSegmentSegment(seg0,seg1);
            }
        }
    }
    else
    {
        // both capsules are static
        Segment seg1(cap1.P,cap1.D);
        sqrDist = SquaredDistanceSegmentSegment(seg0,seg1);
    }

    return sqrDist <= rsum*rsum;
}
```

However, if the distance calculator for a segment to a parallelogram is already set up to handle the degenerate case when an edge vector of the parallelogram is zero, then the code simplifies to

```
bool TestCapsuleCapsule (Capsule cap0, Capsule cap1, Velocity W,
  float tmax)
{
    dotWW = Dot(W,W);
    rsum = cap0.r + cap1.r;
    Segment seg0(cap0.P,cap0.D);

    if ( dotWW > 0 )
    {
        // moving capsule axis spans a parallelogram (parameters
[0,1]^2)
        Parallelogram pgm(cap1.P,cap1.D,tmax*W);
        sqrDist = SquaredDistanceSegmentParallelogram(seg0,pgm);
    }
    else
    {
        // both capsules are static
        Segment seg1(cap1.P,cap1.D);
        sqrDist = SquaredDistanceSegmentSegment(seg0,seg1);
    }

    return sqrDist <= rsum*rsum;
}
```

Additionally, if the distance calculator is really robust and handles the degenerate case when both parallelogram edges are zero, then the code greatly simplifies to

```
bool TestCapsuleCapsule (Capsule cap0, Capsule cap1, Velocity W,
  float tmax)
{
    dotWW = Dot(W,W);
    rsum = cap0.r + cap1.r;
    Segment seg(cap0.P,cap0.D);
    Parallelogram pgm(cap1.P,cap1.D,tmax*W);
    return SquaredDistanceSegmentParallelogram(seg,pgm) <= rsum*rsum;
}
```

6.5.2 ORIENTED BOXES

The method of separating axes still applies for moving boxes. However, there are six additional axes that must be considered due to the motion of the boxes. Assuming the first box is static and the second box is dynamic with velocity \vec{W}, the two boxes

Table 6.7 Values for R, R_0, and R_1 for the separating axis test $R > R_0 + R_1$ for two boxes in the direction of motion.

\vec{L}	R_0	R_1	R
$\vec{W} \times \vec{A}_0$	$a_1\|\alpha_2\| + a_2\|\alpha_1\|$	$\sum_{i=0}^{2} b_i\|c_{1i}\alpha_2 - c_{2i}\alpha_1\|$	$\|\vec{A}_0 \cdot \vec{W} \times \vec{D}\|$
$\vec{W} \times \vec{A}_1$	$a_0\|\alpha_2\| + a_2\|\alpha_0\|$	$\sum_{i=0}^{2} b_i\|c_{0i}\alpha_2 - c_{2i}\alpha_0\|$	$\|\vec{A}_1 \cdot \vec{W} \times \vec{D}\|$
$\vec{W} \times \vec{A}_2$	$a_0\|\alpha_1\| + a_1\|\alpha_0\|$	$\sum_{i=0}^{2} b_i\|c_{0i}\alpha_1 - c_{1i}\alpha_0\|$	$\|\vec{A}_2 \cdot \vec{W} \times \vec{D}\|$
$\vec{W} \times \vec{B}_0$	$\sum_{i=0}^{2} a_i\|c_{i1}\beta_2 - c_{i2}\beta_1\|$	$b_1\|\beta_2\| + b_2\|\beta_1\|$	$\|\vec{B}_0 \cdot \vec{W} \times \vec{D}\|$
$\vec{W} \times \vec{B}_1$	$\sum_{i=0}^{2} a_i\|c_{i0}\beta_2 - c_{i2}\beta_0\|$	$b_0\|\beta_2\| + b_2\|\beta_0\|$	$\|\vec{B}_1 \cdot \vec{W} \times \vec{D}\|$
$\vec{W} \times \vec{B}_2$	$\sum_{i=0}^{2} a_i\|c_{i0}\beta_1 - c_{i1}\beta_0\|$	$b_0\|\beta_1\| + b_1\|\beta_0\|$	$\|\vec{B}_2 \cdot \vec{W} \times \vec{D}\|$

SOURCE CODE

LIBRARY

Intersection

FILENAME

IntrBox3Box3

appear to be stationary when viewed along the direction of motion. It is possible that the boxes are separated within a plane orthogonal to the motion. The additional axes to test are $\vec{W} \times \vec{A}_i$ and $\vec{W} \times \vec{B}_i$ for $0 \leq i \leq 2$. Geometrically, the projections of the boxes can be at worst hexagons but with parallel opposing edges. The separation of such hexagons in a two-dimensional setting requires six separating axis tests, one for each pair of parallel opposing edges. Define $\alpha_i = \vec{W} \cdot \vec{A}_i$ and $\beta_i = \vec{W} \cdot \vec{B}_i$ for $0 \leq i \leq 2$. Table 6.2 is extended by Table 6.7 to handle the cases with motion.

Testing for intersection is a Boolean operation. The algorithm returns `true` if there is an intersection, `false` if not. No information is provided about where an intersection occurs, and there may be many such points. In the case of two intersecting stationary objects, the region of intersection can be computed with great pain. This is the realm of computational solid geometry. For a dynamic system, the more interesting case is to have two moving objects that are initially not intersecting, but then do intersect during the specified time interval. Of interest to an application is the first time of intersection and a point (or points) of intersection at that time. The following construction provides a point of intersection. In the cases of vertex-to-vertex, vertex-to-edge, vertex-to-face, or edge-to-edge (transversely), the intersection point (at first time) is unique. In the other cases of edge-to-face or face-to-face, the intersection is not unique, but the construction provides one of the intersection points.

Finding the First Time of Intersection

Given that the two objects do not intersect at time $t = 0$, but do intersect at some later time, a simple modification of the algorithm for testing for an intersection provides the first time of intersection. The first time is computed as the *maximum* time $T > 0$ for which there is at least one separating axis for any $t \in [0, T)$, but for which no separating axis exists at time T. The idea is to test each potential separating axis from

the original 15 and keep track of the time at which the intervals of projection intersect for the first time. The additional 6 axes due to motion have no effect on determining the time of intersection. The largest such time is the first time at which the boxes intersect. Also, it is important to keep track of which side of $[-R_0, R_0]$ the other interval intersects. Finally, knowing the separating axis associated with the maximum time T allows reconstruction of a point of intersection.

The code for stationary boxes needs to be modified only slightly to handle the case of constant velocities. If the two boxes are moving with velocities \vec{V}_0 and \vec{V}_1, subtract the velocities so that only the second box is moving, $\vec{W} = \vec{V}_1 - \vec{V}_0$. The time interval is $[0, t_{max}]$. Define $\vec{D}(t) = \vec{C}_1 - \vec{C}_0 + t\vec{W}$ for $t \in [0, t_{max}]$.

Consider the separating axis $\vec{C}_0 + s\vec{L}$. The interval values R_0 and R_1 are independent of t and can be calculated as in the stationary case. The quantity R is dependent on time. The nonintersection test is to show $R(t) > R_0 + R_1$ for nonintersection for all $t \in [0, t_{max}]$. One potential problem is that the moving projected interval may start out on one side of the stationary interval, then pass through it to the other side during the time period. However, because of the linear velocity it is enough for nonintersection to show that $R(0) > R_0 + R_1$, $R(t_{max}) > R_0 + R_1$, and $\text{sign}(\vec{L} \cdot \vec{D}(0)) = \text{sign}(\vec{L} \cdot \vec{D}(1))$. Abstractly, the problem amounts to showing that $|p + tw| > r > 0$ for all $t \in [0, t_{max}]$. The pseudocode is

```
if ( p > r )
{
    if ( p + tmax*w > r )
        return no_intersection;
}
else if ( p < -r )
{
    if ( p + tmax*w < -r )
        return no_intersection;
}
```

Finding a Point of Intersection

If T is the first time of intersection, the problem is now to find a point in the intersection of the two boxes at that time. The equation to solve is

$$\sum_{i=0}^{2} x_i \vec{A}_i = \vec{D} + \sum_{j=0}^{2} y_j \vec{B}_j, \tag{6.3}$$

where $\vec{D} = (\vec{C}_1 + T\vec{V}_1) - (\vec{C}_0 + T\vec{V}_0)$, and for x_i with $|x_i| \leq a_i$, $0 \leq i \leq 2$, and for y_j with $|y_j| \leq b_j$, $0 \leq j \leq 2$.

Last Separating Axis \vec{A}_i

If the separating axis at time T is \vec{A}_i, then the intersection must occur on one of the two faces perpendicular to \vec{A}_i. Dotting Equation (6.3) with \vec{A}_i yields

$$x_i = \vec{A}_i \cdot \vec{D} + \sum_{j=0}^{2} c_{ij} y_j.$$

If $\vec{A}_i \cdot \vec{D} > 0$, then $\vec{A}_i \cdot \vec{D} = R_0 + R_1$ since the two intervals intersect at the right end point of $[-R_0, R_0]$. If $\vec{A}_i \cdot \vec{D} < 0$, then $\vec{A}_i \cdot \vec{D} = -(R_0 + R_1)$ since the two intervals intersect at the left end point of $[-R_0, R_0]$. Thus, $\vec{A}_i \cdot \vec{D} = \sigma(R_0 + R_1)$, where $|\sigma| = 1$ and

$$x_i = \sigma(R_0 + R_1) + \sum_{j=0}^{2} c_{ij} y_j$$

$$= \sigma \left(a_i + \sum_{j=0}^{2} b_j |c_{ij}| \right) + \sum_{j=0}^{2} c_{ij} y_j$$

$$0 = \sum_{j=0}^{2} |c_{ij}| (b_j + \sigma \operatorname{sign}(c_{ij}) y_j) + (a_i - \sigma x_i). \tag{6.4}$$

Since $|y_j| \le b_j$ and $|\sigma \operatorname{sign}(c_{ij})| \le 1$, it must be that $b_j + \sigma \operatorname{sign}(c_{ij}) y_j \ge 0$. Similarly, $a_i - \sigma x_i \ge 0$, in which case $x_i = \sigma a_i$. If $c_{ij} \ne 0$, then $y_j = -\sigma \operatorname{sign}(c_{ij}) b_j$ is required to make the sum in Equation (6.4) zero.

If any $c_{ij} = 0$, then the sum in Equation (6.4) places no restriction on y_j. For example, this happens when the intersection is edge-to-face or face-to-face. Instead, take the dot product of Equation (6.3) with \vec{B}_j to obtain

$$y_j = -\vec{B}_j \cdot \vec{D} + \sum_{k=0}^{2} x_k c_{kj}.$$

Using $|x_k| \le a_k$ leads to

$$\min(y_j) = -\vec{B}_j \cdot \vec{D} - \sum_{k=0}^{2} |c_{kj}| a_k \le y_j \le -\vec{B}_j \cdot \vec{D} + \sum_{k=0}^{2} |c_{kj}| a_k = \max(y_j).$$

Additionally, it is known that $|y_j| \le b_j$. A value $y_j \in [\min(y_j), \max(y_j)] \cap [-b_j, b_j]$ must be chosen. Since it is known an intersection must occur, $\min(y_j) \le b_j$ and $-b_j \le \max(y_j)$. If $b_j \le \max(y_j)$, then $y_j = b_j$ is an intersection point. If $-b_j \ge$

$\min(y_j)$, then $y_j = -b_j$ is an intersection point. Otherwise, choose $y_j = \min(y_j)$ as an intersection point.

Last Separating Axis \vec{B}_i

If the separating axis at time T is \vec{B}_i, then the intersection must occur on one of the two faces perpendicular to \vec{B}_i. Dotting Equation (6.3) with \vec{B}_i yields

$$\sum_{j=0}^{2} c_{ji} x_j = \vec{B}_i \cdot \vec{D} + y_i.$$

As in the last section it can be shown that $\vec{B}_i \cdot \vec{D} = \sigma(R_0 + R_1)$, where $|\sigma| = 1$. Moreover,

$$\sum_{j=0}^{2} c_{ji} x_j = \sigma(R_0 + R_1) + y_i$$

$$= \sigma\left(\sum_{j=0}^{2} a_j |c_{ji}| + b_i\right) + y_i$$

$$0 = \sum_{j=0}^{2} |c_{ji}|(a_j - \sigma \operatorname{sign}(c_{ji})x_j) + (b_0 + \sigma y_0). \tag{6.5}$$

Since $|x_j| \le a_j$ and $|\sigma \operatorname{sign}(c_{ji})| \le 1$, it must be that $a_j - \sigma \operatorname{sign}(c_{ji})x_j \ge 0$. Similarly, $b_i + \sigma y_i \ge 0$, in which case $y_i = -\sigma b_i$. If $c_{ji} \ne 0$, then $x_j = \sigma \operatorname{sign}(c_{ji})a_j$ is required to make the sum in Equation (6.5) zero.

If any $c_{ji} = 0$, then the sum in Equation (6.5) places no restriction on x_i. For example, this happens when the intersection is edge-to-face or face-to-face. Instead, take the dot product of Equation (6.3) with \vec{A}_j to obtain

$$x_j = \vec{A}_j \cdot \vec{D} + \sum_{k=0}^{2} y_k c_{jk}.$$

Using $|y_k| \le b_k$, we have

$$\min(x_j) = \vec{A}_j \cdot \vec{D} - \sum_{k=0}^{2} |c_{jk}|b_k \le x_j \le \vec{A}_j \cdot \vec{D} + \sum_{k=0}^{2} |c_{jk}|b_k = \max(x_j).$$

Additionally, it is known that $|x_j| \le a_j$. A value $x_j \in [\min(x_j), \max(x_j)] \cap [-a_j, a_j]$ must be chosen. Since it is known an intersection must occur, $\min(x_j) \le a_j$

and $-a_j \le \max(x_j)$. If $a_j \le \max(x_j)$, then $x_j = a_j$ is an intersection point. If $-a_j \ge \min(x_j)$, then $x_j = -a_j$ is an intersection point. Otherwise, choose $x_j = \min(x_j)$ as an intersection point.

Last Separating Axis $\vec{A}_i \times \vec{B}_j$

Let (i_0, i_1, i_2) and (j_0, j_1, j_2) be permutations of $(0, 1, 2)$ in the set $\{(0, 1, 2), (1, 0, 2), (2, 1, 0)\}$. Dot Equation (6.3) with $\vec{A}_{i_0} \times \vec{B}_{j_0}$ to obtain

$$(\vec{A}_{i_1} \cdot \vec{A}_{i_0} \times \vec{B}_{j_0})x_{i_1} + (\vec{A}_{i_2} \cdot \vec{A}_{i_0} \times \vec{B}_{j_0})x_{i_2} = \vec{A}_{i_0} \times \vec{B}_{j_0} \cdot \vec{D} + (\vec{B}_{j_1} \cdot \vec{A}_{i_0} \times \vec{B}_{j_0})y_{j_1} + (\vec{B}_{j_2} \cdot \vec{A}_{i_0} \times \vec{B}_{j_0})y_{j_2}$$

$$\text{sign}(i_1, i_0)c_{i_2 j_0}x_{i_1} + \text{sign}(i_2, i_0)c_{i_1 j_0}x_{i_1} = \sigma \left(|c_{i_2 j_0}|a_{i_1} + |c_{i_1 j_0}|a_{i_2} + |c_{i_0 j_2}|b_{j_1} + |c_{i_0 j_1}|b_{j_2} \right)$$

$$+ \text{sign}(j_0, j_1)c_{i_0 j_2}y_{j_1} + \text{sign}(j_0, j_2)c_{i_0 j_1}y_{j_2},$$

where $|\sigma| = 1$. Grouping terms and factoring yields

$$0 = |c_{i_2 j_0}|(a_{i_1} - \sigma \, \text{sign}(i_1, i_0) \, \text{sign}(c_{i_2 j_0})x_{i_1}) + |c_{i_1 j_0}|(a_{i_2} - \sigma \, \text{sign}(i_1, i_0) \, \text{sign}(c_{i_1 j_0})x_{i_2}) +$$

$$|c_{i_0 j_2}|(b_{j_1} - \sigma \, \text{sign}(j_1, j_0) \, \text{sign}(c_{i_0 j_2})y_{j_1}) + |c_{i_0 j_1}|(b_{j_2} - \sigma \, \text{sign}(j_2, j_0) \, \text{sign}(c_{i_0 j_1})y_{j_2}).$$

As in the previous subsection, the quantities multiplying the $|c_{ij}|$ terms must be zero when the c_{ij} term is not zero.

The first case to consider is $c_{i_2 j_0} \ne 0$, $c_{i_1 j_0} \ne 0$, $c_{i_0 j_2} \ne 0$, and $c_{i_0 j_1} \ne 0$. Then

$$x_{i_1} = \sigma \, \text{sign}(i_1, i_0) \, \text{sign}(c_{i_2 j_0})a_{i_1}$$

$$x_{i_2} = \sigma \, \text{sign}(i_2, i_0) \, \text{sign}(c_{i_1 j_0})a_{i_2}$$

$$y_{j_1} = \sigma \, \text{sign}(j_1, j_0) \, \text{sign}(c_{i_0 j_2})b_{j_1}$$

$$y_{j_2} = \sigma \, \text{sign}(j_2, j_0) \, \text{sign}(c_{i_0 j_1})b_{j_2}.$$

To solve for x_{i_0} and y_{j_0}, dot Equation (6.3) with \vec{A}_{i_0} and \vec{B}_{j_0} to obtain

$$x_{i_0} = \vec{A}_{i_0} \cdot \vec{D} + c_{i_0 j_0}y_{j_0} + c_{i_0 j_1}y_{j_1} + c_{i_0 j_2}y_{j_2}$$

$$c_{i_0 j_0}x_{i_0} + c_{i_1 j_0}x_{i_1} + c_{i_2 j_0}x_{i_2} = \vec{B}_{j_0} \cdot \vec{D} + y_{j_0}.$$

Replacing each equation in the other yields

$$x_{i_0} = \frac{1}{1 - c_{i_0 j_0}^2} \left[\vec{A}_{i_0} \cdot \vec{D} + c_{i_0 j_0} \left(-\vec{B}_{j_0} \cdot \vec{D} + c_{i_1 j_0}x_{i_1} + c_{i_2 j_0}x_{i_2} \right) + c_{i_0 j_1}y_{j_1} + c_{i_0 j_2}y_{j_2} \right]$$

$$y_{j_0} = \frac{1}{1 - c_{i_0 j_0}^2} \left[-\vec{B}_{j_0} \cdot \vec{D} + c_{i_0 j_0} \left(\vec{A}_{i_0} \cdot \vec{D} + c_{i_0 j_1}y_{j_1} + c_{i_0 j_2}y_{j_2} \right) + c_{i_1 j_0}x_{i_1} + c_{i_2 j_0}x_{i_2} \right].$$

The denominator of the fraction is not zero since $1 - c_{i_0 j_0}^2 = c_{i_1 j_0}^2 + c_{i_2 j_0}^2 \neq 0$ since $c_{i_1 j_0} \neq 0$ and $c_{i_2 j_0} \neq 0$.

Geometrically, the four c_{ij} numbers must be zero since this case represents either (1) an edge-to-edge collision and the intersection point must be unique or (2) an edge-to-edge collision where the edges are perfectly aligned. In the latter case, a face axis should separate the two boxes. Just in case the face axis separation does not happen due to numerical round-off errors, the code has cases to handle whenever any of the $c_{ij} = 0$. The handlers are similar to what was discussed earlier. The intersection equation is dotted with the appropriate vector to solve explicitly for the to-be-determined variable (an x_i or a y_j term). Inequalitites are obtained for that variable, and the minimum and maximum values are used as before to find a point in the intersection of two intervals for that variable.

The coefficients needed to produce the unique points of intersection are summarized in Table 6.8.

6.5.3 ORIENTED BOXES AND TRIANGLES

SOURCE CODE

LIBRARY

Intersection

FILENAME

IntrBox3Tri3

The method of separating axes still applies for moving boxes and triangles. As with moving boxes, there are (up to) six additional axes that must be considered due to the motion. Assuming the box is static and the triangle is dynamic with velocity \vec{W}, the two objects appear to be stationary when viewed along the direction of motion. It is possible that the objects are separated within a plane orthogonal to the motion. The additional axes to test are $\vec{W} \times \vec{A}_i$ (normals to the edges of the projected box) and $\vec{W} \times (\vec{N} \times \vec{E}_i)$ (normals to the edges of the projected triangle) for $0 \leq i \leq 2$. Table 6.3 can be extended to add the six new tests, the values being $R = \sum_{i=0}^{2} a_i |\vec{L} \cdot \vec{A}_i|$, $p_0 = \vec{L} \cdot \vec{D}$, $p_1 = p_0 + \vec{L} \cdot \vec{E}_0$, and $p_2 = p_0 + \vec{L} \cdot \vec{E}_1$.

Finding the First Time of Intersection

Given that the two objects do not intersect at time $t = 0$, but do intersect at some later time, a simple modification of the algorithm for testing for an intersection provides the first time of intersection. The first time is computed as the *maximum* time $T > 0$ for which there is at least one separating axis for any $t \in [0, T)$, but for which no separating axis exists at time T. The idea is to test each potential separating axis and keep track of the time at which the intervals of projection intersect for the first time. The largest such time is the first time at which the triangle and box intersect. Also, it is important to keep track of which side of $[-R, R]$ the other interval intersects. Finally, knowing the separating axis associated with the maximum time T allows us to reconstruct a point of intersection.

The code for a stationary triangle and a box needs to be modified to handle the case of constant velocities. The velocity of the box is subtracted from the velocity of the triangle so that all calculations are done relative to a stationary box. If the box velocity

Table 6.8 Coefficients for unique points of oriented bounding box-oriented bounding box intersection.

\vec{L}	Coefficients
\vec{A}_i	$y_j = -\sigma \; \text{sign}(c_{ij})b_j, \quad j = 0, 1, 2$
\vec{B}_j	$x_i = +\sigma \; \text{sign}(c_{ij})a_i, \quad i = 0, 1, 2$
$\vec{A}_0 \times \vec{B}_0$	$x_1 = -\sigma \; \text{sign}(c_{20})a_1, \quad x_2 = +\sigma \; \text{sign}(c_{10})a_2, \quad y_1 = -\sigma \; \text{sign}(c_{02})b_1, \quad y_2 = +\sigma \; \text{sign}(c_{01})b_2,$ $x_0 = \frac{1}{1-c_{00}^2}\left(\vec{A}_0 \cdot \vec{D} + c_{00}(-\vec{B}_0 \cdot \vec{D} + c_{10}x_1 + c_{20}x_2) + c_{01}y_1 + c_{02}y_2\right)$
$\vec{A}_0 \times \vec{B}_1$	$x_1 = -\sigma \; \text{sign}(c_{21})a_1, \quad x_2 = +\sigma \; \text{sign}(c_{11})a_2, \quad y_0 = +\sigma \; \text{sign}(c_{02})b_0, \quad y_2 = -\sigma \; \text{sign}(c_{00})b_2,$ $x_0 = \frac{1}{1-c_{01}^2}\left(\vec{A}_0 \cdot \vec{D} + c_{01}(-\vec{B}_1 \cdot \vec{D} + c_{11}x_1 + c_{21}x_2) + c_{00}y_0 + c_{02}y_2\right)$
$\vec{A}_0 \times \vec{B}_2$	$x_1 = -\sigma \; \text{sign}(c_{22})a_1, \quad x_2 = +\sigma \; \text{sign}(c_{12})a_2, \quad y_0 = -\sigma \; \text{sign}(c_{01})b_0, \quad y_1 = +\sigma \; \text{sign}(c_{00})b_1,$ $x_0 = \frac{1}{1-c_{02}^2}\left(\vec{A}_0 \cdot \vec{D} + c_{02}(-\vec{B}_2 \cdot \vec{D} + c_{12}x_1 + c_{22}x_2) + c_{00}y_0 + c_{01}y_1\right)$
$\vec{A}_1 \times \vec{B}_0$	$x_0 = +\sigma \; \text{sign}(c_{20})a_0, \quad x_2 = -\sigma \; \text{sign}(c_{00})a_2, \quad y_1 = -\sigma \; \text{sign}(c_{12})b_1, \quad y_2 = +\sigma \; \text{sign}(c_{11})b_2,$ $x_1 = \frac{1}{1-c_{10}^2}\left(\vec{A}_1 \cdot \vec{D} + c_{10}(-\vec{B}_0 \cdot \vec{D} + c_{00}x_0 + c_{20}x_2) + c_{11}y_1 + c_{12}y_2\right)$
$\vec{A}_1 \times \vec{B}_1$	$x_0 = +\sigma \; \text{sign}(c_{21})a_0, \quad x_2 = -\sigma \; \text{sign}(c_{01})a_2, \quad y_0 = +\sigma \; \text{sign}(c_{12})b_0, \quad y_2 = -\sigma \; \text{sign}(c_{10})b_2,$ $x_1 = \frac{1}{1-c_{11}^2}\left(\vec{A}_1 \cdot \vec{D} + c_{11}(-\vec{B}_1 \cdot \vec{D} + c_{01}x_0 + c_{21}x_2) + c_{10}y_0 + c_{12}y_2\right)$
$\vec{A}_1 \times \vec{B}_2$	$x_0 = +\sigma \; \text{sign}(c_{22})a_0, \quad x_2 = -\sigma \; \text{sign}(c_{02})a_2, \quad y_0 = -\sigma \; \text{sign}(c_{11})b_0, \quad y_1 = +\sigma \; \text{sign}(c_{10})b_1,$ $x_1 = \frac{1}{1-c_{12}^2}\left(\vec{A}_1 \cdot \vec{D} + c_{12}(-\vec{B}_2 \cdot \vec{D} + c_{02}x_0 + c_{22}x_2) + c_{10}y_0 + c_{11}y_1\right)$
$\vec{A}_2 \times \vec{B}_0$	$x_0 = -\sigma \; \text{sign}(c_{10})a_0, \quad x_1 = +\sigma \; \text{sign}(c_{00})a_1, \quad y_1 = -\sigma \; \text{sign}(c_{22})b_1, \quad y_2 = +\sigma \; \text{sign}(c_{21})b_2,$ $x_2 = \frac{1}{1-c_{20}^2}\left(\vec{A}_2 \cdot \vec{D} + c_{20}(-\vec{B}_0 \cdot \vec{D} + c_{00}x_0 + c_{10}x_1) + c_{21}y_1 + c_{22}y_2\right)$
$\vec{A}_2 \times \vec{B}_1$	$x_0 = -\sigma \; \text{sign}(c_{11})a_0, \quad x_1 = +\sigma \; \text{sign}(c_{01})a_1, \quad y_0 = +\sigma \; \text{sign}(c_{22})b_0, \quad y_2 = -\sigma \; \text{sign}(c_{20})b_2,$ $x_2 = \frac{1}{1-c_{21}^2}\left(\vec{A}_2 \cdot \vec{D} + c_{21}(-\vec{B}_1 \cdot \vec{D} + c_{01}x_0 + c_{11}x_1) + c_{20}y_0 + c_{22}y_2\right)$
$\vec{A}_2 \times \vec{B}_2$	$x_0 = -\sigma \; \text{sign}(c_{12})a_0, \quad x_1 = +\sigma \; \text{sign}(c_{02})a_1, \quad y_0 = -\sigma \; \text{sign}(c_{21})b_0, \quad y_1 = +\sigma \; \text{sign}(c_{20})b_1,$ $x_2 = \frac{1}{1-c_{22}^2}\left(\vec{A}_2 \cdot \vec{D} + c_{22}(-\vec{B}_2 \cdot \vec{D} + c_{02}x_0 + c_{12}x_1) + c_{20}y_0 + c_{21}y_1\right)$

is \vec{V}_0 and the triangle velocity is \vec{V}_1, define the relative velocity to be $\vec{W} = \vec{V}_1 - \vec{V}_0$. Let the time interval be $[0, t_{\max}]$. Define $\vec{D}_0 = \vec{U}_0 - \vec{C}$ and $\vec{D}_1 = \vec{D}_0 + t_{\max}\vec{W}$.

The projected box interval $[-R, R]$ is stationary. The projected triangle interval is dependent on time, $[\min(p)(t), \max(p)(t)]$. The test for nonintersection during the time interval $[0, t_{\max}]$ is $\min(p)(t) > R$ for all $t \in [0, t_{\max}]$ or $\max(p)(t) < -R$ for all $t \in [0, t_{\max}]$. Because the linear velocity is constant, it is enough to show nonintersection by verifying that $\min(\min(p)(0), \min(p)(T)) > R$ or $\max(\max(p)(0), \max(p)(T)) < -R$.

Axis \vec{N}

The nonintersection test amounts to showing $p + tw$ is not in $[-R, R]$ for $t \in [0, t_{max}]$. Moreover, the point $p + tw$ must not pass through $[-R, R]$ during the given time period, so the algorithm keeps track of which side of $[-R, R]$ the point starts on. The pseudocode is

```
if ( p > R )
{
    if ( p + tmax*w > R )
        return no_intersection;
}
else if ( p < -R )
{
    if ( p + tmax*w < -R )
        return no_intersection;
}
```

Axes \vec{A}_k

The problem is to make sure that the minimum interval containing $\{p_0 + t_{max}w, p_1 + t_{max}w, p_2 + t_{max}w\}$ does not intersect $[-R, R]$. The pseudocode is

```
if ( p0 > R )
{
    if ( p1 >= p0 )
    {
        if ( p2 >= p0 )
        {
            min = p0;
            if ( min + tmax*w > R )
                return no_intersection;
        }
        else
        {
            min = p2;
            if ( min > R and min + tmax*w > R )
                return no_intersection;
        }
    }
    else if ( p1 >= p2 )
    {
        min = p2;
```

```
                if ( min > R and min + tmax*w > R )
                    return no_intersection;
            }
            else
            {
                min = p1;
                if ( min > R and min + tmax*w > R )
                    return no_intersection;
            }
        }
    }
    else if ( p0 < -R )
    {
        if ( p1 <= p0 )
        {
            if ( p2 <= p0 )
            {
                max = p0;
                if ( max + tmax*w < -R )
                    return no_intersection;
            }
            else
            {
                max = p2;
                if ( max < -R and max + tmax*w < -R )
                    return no_intersection;
            }
        }
        else if ( p1 <= p2 )
        {
            max = p2;
            if ( max < -R and max + tmax*w < -R )
                return no_intersection;
        }
        else
        {
            max = p1;
            if ( max < -R and max + tmax*w < -R )
                return no_intersection;
        }
    }
```

Axes $\vec{A}_i \times \vec{E}_j$

The problem is to make sure that the minimum interval containing $\{u_0 + t_{\max}w, u_1 + t_{\max}w\}$ does not intersect $[-R, R]$. The pseudocode is

```
if ( u0 > R )
{
    if ( u1 >= u0 )
    {
        min = u0;
        if ( min + tmax*w > R )
            return no_intersection;
    }
    else
    {
        min = u1;
        if ( min > R and min + tmax*w > R )
            return no_intersection;
    }
}
else if ( u0 < -R )
{
    if ( u1 <= u0 )
    {
        max = u0;
        if ( max + tmax*w < -R )
            return no_intersection;
    }
    else
    {
        max = u1;
        if ( max < -R and max + tmax*w < -R )
            return no_intersection;
    }
}
```

Finding a Point of Intersection

If T is the first time of intersection, the problem is now to find a point in the intersection of the triangle and box at that time. The equation to be solved is

$$\sum_{i=0}^{2} x_i \vec{A}_i = \vec{D} + y_0 \vec{E}_0 + y_1 \vec{E}_1,$$ (6.6)

where $\vec{D} = (\vec{C} + T\vec{V}_1) - (\vec{U}_0 + T\vec{V}_0)$, and for x_i with $|x_i| \le a_i, i = 0, 1, 2$, and for y_j with $0 \le y_0 \le 1, 0 \le y_1 \le 1$, and $y_0 + y_1 \le 1$.

Equation (6.6) can be solved for each variable individually. The solutions are

$$x_i = \vec{A}_i \cdot \vec{D} + (\vec{A}_i \cdot \vec{E}_0) y_0 + (\vec{A}_i \cdot \vec{E}_1) y_1$$

$$y_j = \frac{1 - 2j}{|\vec{N}|^2} \left(-\vec{N} \cdot \vec{D} \times \vec{E}_{1-j} + \sum_{i=0}^{2} x_i \vec{N} \cdot \vec{A}_i \times \vec{E}_{1-j} \right) \tag{6.7}$$

for $i = 0, 1, 2$ and $j = 0, 1$. The equations define the left-hand side as a linear function of the variables in the right-hand side. The extreme x-values occur at the vertices of the triangular domain of the function: $(0, 0)$, $(1, 0)$, and $(0, 1)$. The extreme values of the equations define intervals bounding each variable, $x_i \in [\min(x_i), \max(x_i)]$. The interval end points are

$$\min(x_i) = \vec{A}_i \cdot \vec{D} + \min(0, \vec{A}_i \cdot \vec{E}_0, \vec{A}_i \cdot \vec{E}_1)$$

$$\max(x_i) = \vec{A}_i \cdot \vec{D} + \max(0, \vec{A}_i \cdot \vec{E}_0, \vec{A}_i \cdot \vec{E}_1).$$

The extreme y-values occur at the vertices of the rectoidal domain of the function (all $|x_i| = a_i$). The extreme values of the equations define intervals bounding each variable, $y_j \in [\min(y_j), \max(y_j)]$. The interval end points are

$$\min(y_j) = \frac{(2j - 1)\vec{N} \cdot \vec{D} \times \vec{E}_{1-j} - \sum_{i=0}^{2} a_i |\vec{N} \cdot \vec{A}_i \times \vec{E}_{1-j}|}{|\vec{N}|^2}$$

$$\max(y_j) = \frac{(2j - 1)\vec{N} \cdot \vec{D} \times \vec{E}_{1-j} + \sum_{i=0}^{2} a_i |\vec{N} \cdot \vec{A}_i \times \vec{E}_{1-j}|}{|\vec{N}|^2}. \tag{6.8}$$

In the following constructions of the first point of intersection, if any of the variables is not uniquely constrained by the derived equations, then such a variable can be selected from the intervals $[\min(x_i), \max(x_i)]$ or $[\min(y_j), \max(y_j)]$ and subject to the other domain constraints for that variable.

The following are a few useful functions in the constructions. Define α, β, γ, and δ by

$$\alpha(k) = \begin{cases} 0, & k = 0 \\ 1, & k = 1 \\ 1, & k = 2 \end{cases}$$

$$\beta(k) = \begin{cases} 1, & k = 0 \\ 0, & k = 1 \\ 1, & k = 2 \end{cases}$$

$$\gamma(k) = \begin{cases} -1, & k = 0 \\ 0, & k = 1 \\ 1, & k = 2 \end{cases}$$

$$\delta(k) = \begin{cases} -1, & k = 0 \\ 1, & k = 1 \\ 1, & k = 2 \end{cases}.$$

Some useful identities are $\delta \equiv 2\alpha - 1$, $\delta^2 \equiv 1$, $\alpha\delta \equiv \alpha$, and $\gamma\delta \equiv \beta$.

Last Separating Axis \vec{N}

If the separating axis at time T is \vec{N}, then the intersection must occur on the triangle itself. Dotting Equation (6.6) with \vec{N} yields

$$\sum_{i=0}^{2} x_i \vec{N} \cdot \vec{A}_i = \vec{N} \cdot \vec{D}.$$

Note that $\vec{N} \cdot \vec{D} = \sigma R$ for $|\sigma| = 1$. Thus,

$$\sum_{i=0}^{2} x_i \vec{N} \cdot \vec{A}_i = \sigma R$$

$$\sum_{i=0}^{2} x_i \vec{N} \cdot \vec{A}_i = \sigma \sum_{i=0}^{2} a_i |\vec{N} \cdot \vec{A}_i|$$

$$0 = \sum_{i=0}^{2} |\vec{N} \cdot \vec{A}_i|(a_i - \sigma \, \text{sign}(\vec{N} \cdot \vec{A}_i)x_i). \tag{6.9}$$

Since $|x_i| \le a_i$ and $|\sigma \, \text{sign}(\vec{N} \cdot \vec{A}_i)| \le 1$, it must be that $a_i - \sigma \, \text{sign}(\vec{N} \cdot \vec{A}_i)x_i \ge 0$. If $\vec{N} \cdot \vec{A}_i \ne 0$, then $x_i = \sigma \, \text{sign}(\vec{N} \cdot \vec{A}_i)a_i$ is required to make the sum in Equation (6.9) zero. If any $\vec{N} \cdot \vec{A}_i = 0$, then the sum in Equation (6.9) places no restriction on x_i. For example, this happens when the intersection is edge-to-triangle or face-to-triangle. Any $x_i \in [\min(x_i), \max(x_i)] \cap [-a_i, a_i]$ can be selected for a point of intersection.

Last Separating Axis \vec{A}_i

If the separating axis at time T is \vec{A}_i, then the intersection must occur on one of the two oriented bounding box (OBB) faces perpendicular to \vec{A}_i and $R = a_i$. The formula for x_i from Equation (6.7) has three cases to be considered.

The first case is $p_0 = \min_j(p_j) = a_i$, in which case $\sigma = 1$, or $p_0 = \max_j(p_j) = -a_i$, in which case $\sigma = -1$. Then $\sigma \vec{A}_i \cdot \vec{E}_0 \geq 0$, $\sigma \vec{A}_i \cdot \vec{E}_1 \geq 0$, and $x_i = \sigma a_i + y_0 \vec{A}_i \cdot \vec{E}_0 + y_1 \vec{A}_i \cdot \vec{E}_1$. The intersection occurs on a face of the OBB perpendicular to \vec{A}_i, so it must be that $x_i = \sigma a_i$ and

$$0 = (\sigma \vec{A}_i \cdot \vec{E}_0) y_0 + (\sigma \vec{A}_i \cdot \vec{E}_1) y_1. \tag{6.10}$$

If $\vec{A}_i \cdot \vec{E}_0 \neq 0$ and $\vec{A}_i \cdot \vec{E}_1 \neq 0$, then $y_0 = 0$ and $y_1 = 0$ are required. If $\vec{A}_i \cdot \vec{E}_0 = 0$ and $\vec{A}_i \cdot \vec{E}_1 \neq 0$, Equation (6.10) requires $y_1 = 0$ but does not constrain y_0. In this case $y_0 \in [\min(y_0), \max(y_0)] \cap [0, 1]$, where $\min(y_0)$ and $\max(y_0)$ are defined in Equation (6.8). If $\vec{A}_i \cdot \vec{E}_0 \neq 0$ and $\vec{A}_i \cdot \vec{E}_1 = 0$, Equation (6.10) requires $y_0 = 0$ but does not constrain y_1. In this case $y_1 \in [\min(y_1), \max(y_1)] \cap [0, 1]$, where $\min(y_1)$ and $\max(y_1)$ are defined in Equation (6.8). If $\vec{A}_i \cdot \vec{E}_0 = 0$ and $\vec{A}_i \cdot \vec{E}_1 = 0$, Equation (6.10) constrains neither y_0 nor y_1. The OBB intersects the triangle face-to-face, a case handled by the separating axis test for \vec{N}.

The second case is $p_1 = \min_j(p_j) = a_i$, in which case $\sigma = 1$, or $p_1 = \max_j(p_j) = -a_i$, in which case $\sigma = -1$. Then $-\sigma \vec{A}_i \cdot \vec{E}_0 \geq 0$, $\sigma(\vec{A}_i \cdot \vec{E}_1 - \vec{A}_i \cdot \vec{E}_0) \geq 0$, and $x_i = \sigma a_i - \vec{A}_i \cdot \vec{E}_0 + y_0 \vec{A}_i \cdot \vec{E}_0 + y_1 \vec{A}_i \cdot \vec{E}_1$. Once again, $x_i = \sigma a_i$ and

$$0 = (-\sigma \vec{A}_i \cdot \vec{E}_0)(1 - y_0 - y_1) + [\sigma(\vec{A}_i \cdot \vec{E}_1 - \vec{A}_i \cdot \vec{E}_0)] y_1. \tag{6.11}$$

If $\vec{A}_i \cdot \vec{E}_0 \neq 0$ and $\vec{A}_i \cdot \vec{E}_1 \neq \vec{A}_i \cdot \vec{E}_0$, then $1 - y_0 - y_1 = 0$ and $y_1 = 0$ are required. Therefore, $y_0 = 1$ and $y_1 = 0$. If $\vec{A}_i \cdot \vec{E}_0 = 0$ and $\vec{A}_i \cdot \vec{E}_1 \neq \vec{A}_i \cdot \vec{E}_0$, Equation (6.11) requires $y_1 = 0$ but does not constrain y_0. In this case $y_0 \in [\min(y_0), \max(y_0)] \cap [0, 1]$, where $\min(y_0)$ and $\max(y_0)$ are defined in Equation (6.8). If $\vec{A}_i \cdot \vec{E}_0 \neq 0$ and $\vec{A}_i \cdot \vec{E}_1 = \vec{A}_i \cdot \vec{E}_0$, Equation (6.11) requires $y_0 + y_1 = 1$ but does not constrain y_1. In this case $y_1 \in [\min(y_1), \max(y_1)] \cap [0, 1]$, where $\min(y_1)$ and $\max(y_1)$ are defined in Equation (6.8). Given a choice of y_1, then $y_0 = 1 - y_1$. If $\vec{A}_i \cdot \vec{E}_0 = \vec{A}_i \cdot \vec{E}_1 = 0$, then neither y_0 nor y_1 is constrained. In this event, \vec{N} and \vec{A}_i are parallel, a case handled by the separating axis test for \vec{N}.

The third case is $p_2 = \min_j(p_j) = a_i$, in which case $\sigma = 1$, or $p_2 = \max_j(p_j) = -a_i$, in which case $\sigma = -1$. Then $-\sigma \vec{A}_i \cdot \vec{E}_1 \geq 0$, $\sigma(\vec{A}_i \cdot \vec{E}_0 - \vec{A}_i \cdot \vec{E}_1) \geq 0$, and $x_i = \sigma a_i - \vec{A}_i \cdot \vec{E}_1 + y_0 \vec{A}_i \cdot \vec{E}_0 + y_1 \vec{A}_i \cdot \vec{E}_1$. Once again, $x_i = \sigma a_i$ and

$$0 = [\sigma(\vec{A}_i \cdot \vec{E}_0 - \vec{A}_i \cdot \vec{E}_1)] y_0 + (-\sigma \vec{A}_i \cdot \vec{E}_1)(1 - y_0 - y_1). \tag{6.12}$$

If $\vec{A}_i \cdot \vec{E}_1 \neq 0$ and $\vec{A}_i \cdot \vec{E}_0 \neq \vec{A}_i \cdot \vec{E}_1$, then $1 - y_0 - y_1 = 0$ and $y_0 = 0$ are required. Therefore, $y_0 = 0$ and $y_1 = 1$. If $\vec{A}_i \cdot \vec{E}_1 = 0$ and $\vec{A}_i \cdot \vec{E}_0 \neq \vec{A}_i \cdot \vec{E}_1$, Equation (6.12) requires $y_0 = 0$ but does not constrain y_1. In this case $y_1 \in [\min(y_1), \max(y_1)] \cap [0, 1]$, where $\min(y_1)$ and $\max(y_1)$ are defined in Equation (6.8). Given a choice of y_1, then $y_0 = 1 - y_1$. If $\vec{A}_i \cdot \vec{E}_1 \neq 0$ and $\vec{A}_i \cdot \vec{E}_0 = \vec{A}_i \cdot \vec{E}_1$, Equation (6.12) requires $1 - y_0 - y_1 = 0$ but does not constrain y_0. In this case $y_0 \in [\min(y_0), \max(y_0)] \cap [0, 1]$,

where $\min(y_0)$ and $\max(y_0)$ are defined in Equation (6.8). Given a choice of y_0, then $y_1 = 1 - y_0$. If $\vec{A}_i \cdot \vec{E}_1 = \vec{A}_i \cdot \vec{E}_0 = 0$, then neither y_0 nor y_1 is constrained. In this event, \vec{N} and \vec{A}_i are parallel, a case handled by the separating axis test for \vec{N}.

Last Separating Axis $\vec{A}_i \times \vec{E}_j$

Let (i_0, i_1, i_2) and (j_0, j_1, j_2) be permutations of $(0, 1, 2)$ in the set $\{(0, 1, 2), (1, 0, 2), (2, 1, 0)\}$. Dot Equation (6.6) with $\vec{A}_{i_0} \times \vec{E}_{j_0}$ to obtain

$$(\vec{A}_{i_1} \cdot \vec{A}_{i_0} \times \vec{E}_{j_0})x_{i_1} + (\vec{A}_{i_2} \cdot \vec{A}_{i_0} \times \vec{E}_{j_0})x_{i_2} = \vec{A}_{i_0} \times \vec{E}_{j_0} \cdot \vec{D} + (\vec{E}_0 \cdot \vec{A}_{i_0} \times \vec{E}_{j_0})y_0$$
$$+ (\vec{E}_1 \cdot \vec{A}_{i_0} \times \vec{E}_{j_0})y_1.$$

Using various identities, the equation reduces to

$$(\text{sign}(i_1, i_0)\vec{A}_{i_2} \cdot \vec{E}_{j_0})x_{i_1} + (\text{sign}(i_2, i_0)\vec{A}_{i_1} \cdot \vec{E}_{j_0})x_{i_2} = p_0 - \alpha(j_0)\vec{N} \cdot \vec{A}_{i_0}y_0$$
$$- \gamma(j_0)\vec{N} \cdot \vec{A}_{i_0}y_1, \quad (6.13)$$

where $p_0 = \vec{A}_{i_0} \times \vec{E}_{j_0} \cdot \vec{D}$. The projection of the triangle's vertices leads to (possibly) two distinct p values, $\{p_0, p_0 - \delta(j_0)\vec{N} \cdot \vec{A}_{i_0}\}$. There are two cases to consider depending on which of the p values are minima or maxima. In all cases,

$$R = a_{i_1}|\vec{A}_{i_2} \cdot \vec{E}_{j_0}| + a_{i_2}|\vec{A}_{i_1} \cdot \vec{E}_{j_0}|.$$

The first case is $p_0 = \min_k(p_k) = R$, in which case $\sigma = 1$, or $p_0 = \max_k(p_k) = -R$, in which case $\sigma = -1$. Then $p_0 = \sigma R$ and $-\sigma\delta(j_0)\vec{A}_{i_0} \cdot \vec{N} \geq 0$. Equation (6.13) is equivalent to

$$0 = |\vec{A}_{i_2} \cdot \vec{E}_{j_0}|(a_{i_1} - \sigma \, \text{sign}(i_1, i_0) \, \text{sign}(\vec{A}_{i_2} \cdot \vec{E}_{j_0})x_{i_1}) +$$
$$|\vec{A}_{i_1} \cdot \vec{E}_{j_0}|(a_{i_2} - \sigma \, \text{sign}(i_2, i_0) \, \text{sign}(\vec{A}_{i_1} \cdot \vec{E}_{j_0})x_{i_2}) +$$
$$(-\sigma\delta(j_0)\vec{A}_{i_0} \cdot \vec{N})(\alpha(j_0)y_0 + \beta(j_0)y_1).$$

If $\vec{A}_{i_2} \cdot \vec{E}_{j_0} \neq 0$, then $x_{i_1} = \sigma \, \text{sign}(i_1, i_0) \, \text{sign}(\vec{A}_{i_2} \cdot \vec{E}_{j_0})a_{i_1}$. If $\vec{A}_{i_1} \cdot \vec{E}_{j_0} \neq 0$, then $x_{i_2} = \sigma \, \text{sign}(i_2, i_0) \, \text{sign}(\vec{A}_{i_1} \cdot \vec{E}_{j_0})a_{i_2}$. If $\vec{A}_{i_0} \cdot \vec{N} \neq 0$, then $\alpha(j_0)y_0 + \beta(j_0)y_1 = 0$. These provide three equations in five unknowns. Two additional equations to form an invertible system can be selected from Equation (6.7).

Table 6.9 Coefficients for unique points of triangle-OBB intersection for \vec{N} and \vec{A}_i.

\vec{L}	Coefficients
\vec{N}	$x_i = +\sigma\,\text{sign}(\vec{N} \cdot \vec{A}_i)a_i, \quad i = 0, 1, 2$
\vec{A}_i	$y_0 = 0, \quad y_1 = 0, \quad \sigma p_0 = \min_k(\sigma p_k)$
	$y_0 = 1, \quad y_1 = 0, \quad \sigma p_1 = \min_k(\sigma p_k)$
	$y_0 = 0, \quad y_1 = 1, \quad \sigma p_2 = \min_k(\sigma p_k)$

The second case is $p_0 - \delta(j_0)\vec{N} \cdot \vec{A}_{i_0} = \min_k(p_k) = R$, in which case $\sigma = 1$, or $p_0 - \delta(j_0)\vec{N} \cdot \vec{A}_{i_0} = \max_k(p_k) = -R$, in which case $\sigma = -1$. Then $p_0 = \sigma R + \delta(j_0)\vec{N} \cdot \vec{A}_{i_0}$ and $\sigma\delta(j_0)\vec{A}_{i_0} \cdot \vec{N} \geq 0$. Equation (6.13) is equivalent to

$$0 = |\vec{A}_{i_2} \cdot \vec{E}_{j_0}|(a_{i_1} - \sigma\,\text{sign}(i_1, i_0)\,\text{sign}(\vec{A}_{i_2} \cdot \vec{E}_{j_0})x_{i_1}) +$$

$$|\vec{A}_{i_1} \cdot \vec{E}_{j_0}|(a_{i_2} - \sigma\,\text{sign}(i_2, i_0)\,\text{sign}(\vec{A}_{i_1} \cdot \vec{E}_{j_0})x_{i_2}) +$$

$$(\sigma\delta(j_0)\vec{A}_{i_0} \cdot \vec{N})(1 - \alpha(j_0)y_0 - \beta(j_0)y_1).$$

If $\vec{A}_{i_2} \cdot \vec{E}_{j_0} \neq 0$, then $x_{i_1} = \sigma\,\text{sign}(i_1, i_0)\,\text{sign}(\vec{A}_{i_2} \cdot \vec{E}_{j_0})a_{i_1}$. If $\vec{A}_{i_1} \cdot \vec{E}_{j_0} \neq 0$, then $x_{i_2} = \sigma\,\text{sign}(i_2, i_0)\,\text{sign}(\vec{A}_{i_1} \cdot \vec{E}_{j_0})a_{i_2}$. If $\vec{A}_{i_0} \cdot \vec{N} \neq 0$, then $\alpha(j_0)y_0 + \beta(j_0)y_1 = 1$. These provide three equations in five unknowns. Two additional equations to form an invertible system can be selected from Equation (6.7).

If any of the x_i or y_j are not constrained because their coefficients are zero, a similar construction can be used as before where intervals are obtained on each of the variables and the intersection of those intervals with their natural restrictions produces a point of intersection.

The coefficients needed to produce the unique points of intersection are summarized in Tables 6.9 through 6.12.

6.5.4 TRIANGLES

The method of separating axes still applies for moving triangles. As before there are (up to) six additional axes that must be considered due to the motion. Assuming the first triangle is static and the second triangle is dynamic with velocity \vec{W}, the two triangles appear to be stationary when viewed along the direction of motion. It is possible that the triangles are separated within a plane orthogonal to the motion. The additional axes to test are $\vec{W} \times (\vec{N} \times \vec{E}_i)$ (normals to the edges of the static projected triangle) and $\vec{W} \times (\vec{M} \times \vec{F}_i)$ (normals to the edges of the dynamic projected triangle) for $0 \leq i \leq 2$. Table 6.4 can be extended to add the six new tests.

Table 6.10 Coefficients for unique points of triangle-OBB intersection for $\vec{A}_0 \times \vec{E}_j$.

\vec{L}	Coefficients		
$\vec{A}_0 \times \vec{E}_0$	$x_1 = -\sigma \ \text{sign}(\vec{A}_2 \cdot \vec{E}_0)a_1, \quad x_2 = +\sigma \ \text{sign}(\vec{A}_1 \cdot \vec{E}_0)a_2$		
	$y_1 = \begin{cases} 0, & \sigma p_0 = \min_k(\sigma p_k) \\ 1, & \sigma(p_0 + \vec{N} \cdot \vec{A}_0) = \min_k(\sigma p_k) \end{cases}$		
	$x_0 = \dfrac{\vec{A}_0 \times \vec{E}_0 \cdot (\vec{D} \times \vec{E}_0 - y_1\vec{N} - x_1\vec{A}_1 \times \vec{E}_0 - x_2\vec{A}_2 \times \vec{E}_0)}{	\vec{A}_0 \times \vec{E}_0	^2}$
$\vec{A}_0 \times \vec{E}_1$	$x_1 = -\sigma \ \text{sign}(\vec{A}_2 \cdot \vec{E}_1)a_1, \quad x_2 = +\sigma \ \text{sign}(\vec{A}_1 \cdot \vec{E}_1)a_2$		
	$y_0 = \begin{cases} 0, & \sigma p_0 = \min_k(\sigma p_k) \\ 1, & \sigma(p_0 - \vec{N} \cdot \vec{A}_0) = \min_k(\sigma p_k) \end{cases}$		
	$x_0 = \dfrac{\vec{A}_0 \times \vec{E}_1 \cdot (\vec{D} \times \vec{E}_1 + y_0\vec{N} - x_1\vec{A}_1 \times \vec{E}_1 - x_2\vec{A}_2 \times \vec{E}_1)}{	\vec{A}_0 \times \vec{E}_1	^2}$
$\vec{A}_0 \times \vec{E}_2$	$x_1 = -\sigma \ \text{sign}(\vec{A}_2 \cdot \vec{E}_2)a_1, \quad x_2 = +\sigma \ \text{sign}(\vec{A}_1 \cdot \vec{E}_2)a_2$		
	$y_0 + y_1 = \begin{cases} 0, & \sigma p_0 = \min_k(\sigma p_k) \\ 1, & \sigma(p_0 - \vec{N} \cdot \vec{A}_0) = \min_k(\sigma p_k) \end{cases}$		
	$x_0 = \dfrac{\vec{A}_0 \times \vec{E}_2 \cdot (\vec{D} \times \vec{E}_2 + (y_0 + y_1)\vec{N} - x_1\vec{A}_1 \times \vec{E}_2 - x_2\vec{A}_2 \times \vec{E}_2)}{	\vec{A}_0 \times \vec{E}_2	^2}$

Finding the First Time of Intersection

Given that the two triangles do not intersect at time $t = 0$, but do intersect at some later time, a simple modification of the algorithm for testing for an intersection provides the first time of intersection. The first time is computed as the *maximum* time $T > 0$ for which there is at least one separating axis for any $t \in [0, T)$, but for which no separating axis exists at time T. The idea is to test each potential separating axis and keep track of the time at which the intervals of projection intersect for the first time. The largest such time is the first time at which the triangles intersect. Also, it is important to keep track of which side each of the intervals is relative to the other interval. Finally, knowing the separating axis associated with the maximum time T allows us to reconstruct a point of intersection.

The code for stationary triangles needs to be modified to handle the case of constant velocities. The velocity of the first triangle is subtracted from the velocity of the second triangle so that all calculations are done relative to a stationary first triangle. If the triangle velocities are \vec{V}_0 and \vec{V}_1, define the relative velocity to be $\vec{W} = \vec{V}_1 - \vec{V}_0$. Let the time interval be $[0, t_{\max}]$.

Table 6.11 Coefficients for unique points of triangle-OBB intersection for $\vec{A}_1 \times \vec{E}_j$.

\vec{L}	*Coefficients*		
$\vec{A}_1 \times \vec{E}_0$	$x_0 = +\sigma \ \text{sign}(\vec{A}_2 \cdot \vec{E}_0)a_0, \quad x_2 = -\sigma \ \text{sign}(\vec{A}_0 \cdot \vec{E}_0)a_2$		
	$y_1 = \begin{cases} 0, & \sigma p_0 = \min_k(p_k) \\ 1, & \sigma(p_0 + \vec{N} \cdot \vec{A}_1) = \min_k(\sigma p_k) \end{cases}$		
	$x_1 = \frac{\vec{A}_1 \times \vec{E}_0 \cdot (\vec{D} \times \vec{E}_0 - y_1 \vec{N} - x_0 \vec{A}_0 \times \vec{E}_0 - x_2 \vec{A}_2 \times \vec{E}_0)}{	\vec{A}_1 \times \vec{E}_0	^2}$
$\vec{A}_1 \times \vec{E}_1$	$x_0 = +\sigma \ \text{sign}(\vec{A}_2 \cdot \vec{E}_1)a_0, \quad x_2 = -\sigma \ \text{sign}(\vec{A}_0 \cdot \vec{E}_1)a_2$		
	$y_0 = \begin{cases} 0, & \sigma(p_0 = \min_k(p_k)) \\ 1, & \sigma(p_0 - \vec{N} \cdot \vec{A}_1) = \min_k(\sigma p_k) \end{cases}$		
	$x_1 = \frac{\vec{A}_1 \times \vec{E}_1 \cdot (\vec{D} \times \vec{E}_1 + y_0 \vec{N} - x_0 \vec{A}_0 \times \vec{E}_1 - x_2 \vec{A}_2 \times \vec{E}_1)}{	\vec{A}_1 \times \vec{E}_1	^2}$
$\vec{A}_1 \times \vec{E}_2$	$x_0 = +\sigma \ \text{sign}(\vec{A}_2 \cdot \vec{E}_2)a_0, \quad x_2 = -\sigma \ \text{sign}(\vec{A}_0 \cdot \vec{E}_2)a_2$		
	$y_0 + y_1 = \begin{cases} 0, & \sigma p_0 = \min_k(p_k) \\ 1, & \sigma(p_0 - \vec{N} \cdot \vec{A}_1) = \min_k(\sigma p_k) \end{cases}$		
	$x_1 = \frac{\vec{A}_1 \times \vec{E}_2 \cdot (\vec{D} \times \vec{E}_2 + (y_0 + y_1)\vec{N} - x_0 \vec{A}_0 \times \vec{E}_2 - x_2 \vec{A}_2 \times \vec{E}_2)}{	\vec{A}_1 \times \vec{E}_2	^2}$

Axes \vec{N} or \vec{M}

The problem is to make sure the minimum interval containing $\max(v_0 + t_{\max}w, v_1 + t_{\max}w, v_2 + t_{\max}w)$ does not intersect $\{u\}$. The pseudocode is

```
if ( v0 > u )
{
    if ( v1 >= v0 )
    {
        if ( v2 >= v0 )
        {
            min = v0;
            if ( min + tmax*w > u )
                return no_intersection;
        }
        else
        {
            min = v2;
            if ( min > u and min + tmax*w > u )
                return no_intersection;
```

Table 6.12 Coefficients for unique points of triangle-OBB intersection for $\vec{A}_2 \times \vec{E}_j$.

\vec{L}	Coefficients		
$\vec{A}_2 \times \vec{E}_0$	$x_0 = -\sigma \ \mathrm{sign}(\vec{A}_1 \cdot \vec{E}_0)a_0, \ \ x_1 = +\sigma \ \mathrm{sign}(\vec{A}_0 \cdot \vec{E}_0)a_1$		
	$y_1 = \begin{cases} 0, & \sigma p_0 = \min_k(\sigma p_k) \\ 1, & \sigma(p_0 + \vec{N} \cdot \vec{A}_2) = \min_k(\sigma p_k) \end{cases}$		
	$x_2 = \dfrac{\vec{A}_2 \times \vec{E}_0 \cdot (\vec{D} \times \vec{E}_0 - y_1 \vec{N} - x_0 \vec{A}_0 \times \vec{E}_0 - x_1 \vec{A}_1 \times \vec{E}_0)}{	\vec{A}_2 \times \vec{E}_0	^2}$
$\vec{A}_2 \times \vec{E}_1$	$x_0 = -\sigma \ \mathrm{sign}(\vec{A}_1 \cdot \vec{E}_1)a_0, \ \ x_1 = +\sigma \ \mathrm{sign}(\vec{A}_0 \cdot \vec{E}_1)a_1$		
	$y_0 = \begin{cases} 0, & \sigma p_0 = \min_k(\sigma p_k) \\ 1, & \sigma(p_0 - \vec{N} \cdot \vec{A}_2) = \min_k(\sigma p_k) \end{cases}$		
	$x_2 = \dfrac{\vec{A}_2 \times \vec{E}_1 \cdot (\vec{D} \times \vec{E}_1 + y_0 \vec{N} - x_0 \vec{A}_0 \times \vec{E}_1 - x_1 \vec{A}_1 \times \vec{E}_1)}{	\vec{A}_2 \times \vec{E}_1	^2}$
$\vec{A}_2 \times \vec{E}_2$	$x_0 = -\sigma \ \mathrm{sign}(\vec{A}_1 \cdot \vec{E}_2)a_0, \ \ x_1 = +\sigma \ \mathrm{sign}(\vec{A}_0 \cdot \vec{E}_2)a_1$		
	$y_0 + y_1 = \begin{cases} 0, & \sigma p_0 = \min_k(\sigma p_k) \\ 1, & \sigma(p_0 - \vec{N} \cdot \vec{A}_2) = \min_k(\sigma p_k) \end{cases}$		
	$x_2 = \dfrac{\vec{A}_2 \times \vec{E}_2 \cdot (\vec{D} \times \vec{E}_2 + (y_0 + y_1)\vec{N} - x_0 \vec{A}_0 \times \vec{E}_2 - x_1 \vec{A}_1 \times \vec{E}_2)}{	\vec{A}_2 \times \vec{E}_2	^2}$

```
            }
        }
        else if ( v1 >= v2 )
        {
            min = v2;
            if ( min > u and min + tmax*w > u )
                return no_intersection;
        }
        else
        {
            min = v1;
            if ( min > u and min + tmax*w > u )
                return no_intersection;
        }
    }
    else if ( v0 < u )
    {
        if ( v1 <= v0 )
        {
```

```
                    if ( v2 <= v0 )
                    {
                        max = v0;
                        if ( max + tmax*w < u )
                            return no_intersection;
                    }
                    else
                    {
                        max = v2;
                        if ( max < u and max + tmax*w < u )
                            return no_intersection;
                    }
                }
                else if ( v1 <= v2 )
                {
                    max = v2;
                    if ( max < u and max + tmax*w < u )
                        return no_intersection;
                }
                else
                {
                    max = v1;
                    if ( max < u and max + tmax*w < u )
                        return no_intersection;
                }
            }
        }
```

Axes $\vec{E}_i \times \vec{F}_j$

The problem is to make sure the minimum interval containing $\max(u_0 + t_{\max}w, u_1 + t_{\max}w)$ does not intersect $\{v_0, v_1\}$. The pseudocode is

```
if ( u1 >= u0 )
{
    if ( v0 < u0 )
    {
        if ( v1 <= v0 )
        {
            max = v0;
            if ( max + tmax*w < u0 )
                return no_intersection;
        }
```

```
            else
            {
                max = v1;
                if ( max < 0 and max + tmax*w < 0 )
                    return no_intersection;
            }
        }
        else if ( v0 > u1 )
        {
            if ( v1 >= v0 )
            {
                min = v0;
                if ( min + tmax*w > u1 )
                    return no_intersection;
            }
            else
            {
                min = v1;
                if ( min > u1 and min + tmax*w > u1 )
                    return no_intersection;
            }
        }
    }
    else
    {
        if ( v0 > u0 )
        {
            if ( v1 >= v0 )
            {
                min = v0;
                if ( min + tmax*w > u0 )
                    return no_intersection;
            }
            else
            {
                min = v1;
                if ( min > u0 and min + tmax*w > u0 )
                    return no_intersection;
            }
        }
        else if ( v0 < u1 )
        {
            if ( v1 <= v0 )
```

```
            {
                max = v0;
                if ( max + tmax*w < u1 )
                    return no_intersection;
            }
            else
            {
                max = v1;
                if ( max < u1 and max + tmax*w < u1 )
                    return no_intersection;
            }
        }
    }
```

Finding a Point of Intersection

If T is the first time of intersection, the problem is to find a point in the intersection of the two triangles. Since the triangles are not coplanar, the only possibilities for the set of intersections is a single point or a line segment. The equation to be solved is

$$x_0 \vec{E}_0 + x_1 \vec{E}_1 = \vec{D} + y_0 \vec{F}_0 + y_1 \vec{F}_1, \tag{6.14}$$

where $\vec{D} = (\vec{B}_0 + T\vec{V}_1) - (\vec{A}_0 + T\vec{V}_0)$; for x_i with $0 \le x_0 \le 1, 0 \le x_1 \le 1, x_0 + x_1 \le 1$; and for y_j with $0 \le y_0 \le 1, 0 \le y_1 \le 1, y_0 + y_1 \le 1$.

Equation (6.14) can be solved for each variable individually by crossing and then dotting the equation with the proper vectors. The solutions are

$$x_i = \frac{1-2i}{|\vec{N}|^2} \left(\vec{N} \cdot \vec{D} \times \vec{E}_{1-i} + (\vec{N} \cdot \vec{F}_0 \times \vec{E}_{1-i})y_0 + (\vec{N} \cdot \vec{F}_1 \times \vec{E}_{1-i})y_1 \right)$$

$$y_j = \frac{1-2j}{|\vec{M}|^2} \left(-\vec{M} \cdot \vec{D} \times \vec{F}_1 + (\vec{M} \cdot \vec{E}_0 \times \vec{F}_{1-j})x_0 + (\vec{M} \cdot \vec{E}_1 \times \vec{F}_{1-j})x_1 \right)$$

for $i = 0, 1$ and $j = 0, 1$. Each of these equations defines the left-hand side as a linear function of the variables in the right-hand side. The extreme values occur at the vertices of the triangular domain of the function: $(0, 0)$, $(1, 0)$, and $(0, 1)$. The extreme values of the equations define intervals bounding each variable, $x_i \in [\min(x_i), \max(x_i)]$ and $y_j \in [\min(y_j), \max(y_j)]$. The interval end points are

$$\min(x_i) = \frac{1}{|\vec{N}|^2} \min\left((1 - 2i)\phi_0(i), (1 - 2i)\phi_1(i), (1 - 2i)\phi_2(i)\right)$$

$$\max(x_i) = \frac{1}{|\vec{N}|^2} \max\left((1 - 2i)\phi_0(i), (1 - 2i)\phi_1(i), (1 - 2i)\phi_2(i)\right)$$

$$\min(y_j) = \frac{1}{|\vec{M}|^2} \min\left((1 - 2j)\psi_0(j), (1 - 2j)\psi_1(j), (1 - 2j)\psi_2(j)\right)$$
(6.15)

$$\max(y_j) = \frac{1}{|\vec{M}|^2} \max\left((1 - 2j)\psi_0(j), (1 - 2j)\psi_1(j), (1 - 2j)\psi_2(j)\right),$$

where $\phi_0(i) = \vec{N} \cdot \vec{D} \times \vec{E}_{1-i}$, $\phi_1 = \phi_0(i) + \vec{N} \cdot \vec{F}_0 \times \vec{E}_{1-i}$, $\phi_2(i) = \phi_0(i) + \vec{N} \cdot \vec{F}_1 \times \vec{E}_{1-i}$, $\psi_0(j) = -\vec{M} \cdot \vec{D} \times \vec{F}_{1-j}$, $\psi_1(j) = \psi_0(j) + \vec{M} \cdot \vec{E}_0 \times \vec{F}_{1-j}$, and $\psi_2(j) = \psi_0(j) + \vec{M} \cdot \vec{E}_1 \times \vec{F}_{1-j}$.

In the following constructions of the first point of intersection, if any of the variables is not uniquely constrained by the derived equations, then the variable can be selected from the intervals $[\min(x_i), \max(x_i)]$ or $[\min(y_j), \max(y_j)]$ and subject to triangular domain constraints for that variable.

Last Separating Axis \vec{N}

Dot Equation (6.14) with \vec{N} to obtain

$$0 = \vec{N} \cdot \vec{D} + y_0 \vec{N} \cdot \vec{F}_0 + y_1 \vec{N} \cdot \vec{F}_1.$$

The projection of the first triangle's vertices leads to a single p value of 0. The projection of the second triangle's vertices leads to (possibly) distinct q values, $\{q_0, q_1, q_2\}$. There are three cases to consider.

The first case is $q_0 = \min_i(q_i)$, in which case $\sigma = 1$, or $q_0 = \max_i(q_i)$, in which case $\sigma = -1$. Then $\vec{N} \cdot \vec{D} = 0$, $\sigma \vec{N} \cdot \vec{F}_0 \geq 0$, $\sigma \vec{N} \cdot \vec{F}_1 \geq 0$, and

$$0 = (\sigma \vec{N} \cdot \vec{F}_0) y_0 + (\sigma \vec{N} \cdot \vec{F}_1) y_1.$$
(6.16)

If $\vec{N} \cdot \vec{F}_0 \neq 0$ and $\vec{N} \cdot \vec{F}_1 \neq 0$, then $y_0 = 0$ and $y_1 = 0$ are required. If $\vec{N} \cdot \vec{F}_0 = 0$ and $\vec{N} \cdot \vec{F}_1 \neq 0$, Equation (6.16) requires $y_1 = 0$, but does not constrain y_0. A point of intersection is provided by any $y_0 \in [\min(y_0), \max(y_0)] \cap [0, 1]$, where $\min(y_0)$ and $\max(y_0)$ are defined in Equation (6.15). If $\vec{N} \cdot \vec{F}_0 \neq 0$ and $\vec{N} \cdot \vec{F}_1 = 0$, Equation (6.16) requires $y_0 = 0$, but does not constrain y_1. A point of intersection is provided by any $y_1 \in [\min(y_1), \max(y_1)] \cap [0, 1]$, where $\min(y_1)$ and $\max(y_1)$ are defined in Equation (6.15). If both $\vec{N} \cdot \vec{F}_0 = 0$ and $\vec{N} \cdot \vec{F}_1 = 0$, then \vec{N} and \vec{M} must be parallel and the triangles must be coplanar. While the assumption of this section is that the two vectors are not parallel, numerical error might generate this case.

The second case is $q_1 = \min_i(q_i)$, in which case $\sigma = 1$, or $q_1 = \max_i(q_i)$, in which case $\sigma = -1$. Then $\vec{N} \cdot \vec{D} = -\vec{N} \cdot \vec{F}_0, \sigma \vec{N} \cdot \vec{F}_0 \leq 0, \sigma(\vec{N} \cdot \vec{F}_1 - \vec{N} \cdot \vec{F}_0) \geq 0$, and

$$0 = (-\sigma \vec{N} \cdot \vec{F}_0)(1 - y_0 - y_1) + [\sigma(\vec{N} \cdot \vec{F}_1 - \vec{N} \cdot \vec{F}_0)]y_1. \tag{6.17}$$

If $\vec{N} \cdot \vec{F}_0 \neq 0$ and $\vec{N} \cdot \vec{F}_1 \neq \vec{N} \cdot \vec{F}_0$, then $y_0 + y_1 = 1$ and $y_1 = 0$ are required. Therefore, $y_0 = 1$ and $y_1 = 0$. If $\vec{N} \cdot \vec{F}_0 = 0$ and $\vec{N} \cdot \vec{F}_1 \neq \vec{N} \cdot \vec{F}_0$, Equation (6.17) requires $y_1 = 0$, but does not constrain y_0. In this case $y_0 \in [\min(y_0), \max(y_0)] \cap [0, 1]$, where $\min(y_0)$ and $\max(y_0)$ are defined in Equation (6.15). If $\vec{N} \cdot \vec{F}_0 \neq 0$ and $\vec{N} \cdot \vec{F}_1 = \vec{N} \cdot \vec{F}_0$, Equation (6.17) requires $y_0 + y_1 = 1$, but does not constrain y_1. In this case $y_1 \in [\min(y_1), \max(y_1)] \cap [0, 1]$, where $\min(y_1)$ and $\max(y_1)$ are defined in Equation (6.15). Given a choice for y_1, set $y_0 = 1 - y_1$. If both $\vec{N} \cdot \vec{F}_0 = 0$ and $\vec{N} \cdot \vec{F}_1 = \vec{N} \cdot \vec{F}_0$, then \vec{N} and \vec{M} must be parallel and the triangles must be coplanar.

The third case is $q_2 = \min_i(q_i)$, in which case $\sigma = 1$, or $q_2 = \max_i(q_i)$, in which case $\sigma = -1$. Then $\vec{N} \cdot \vec{D} = -\vec{N} \cdot \vec{F}_1, \sigma(\vec{N} \cdot \vec{F}_0 - \vec{N} \cdot \vec{F}_1) \geq 0, \sigma \vec{N} \cdot \vec{F}_1 \leq 0$, and

$$0 = [\sigma(\vec{N} \cdot \vec{F}_0 - \vec{N} \cdot \vec{F}_1)]y_0 + (-\sigma \vec{N} \cdot \vec{F}_1)(1 - y_0 - y_1). \tag{6.18}$$

If $\vec{N} \cdot \vec{F}_0 \neq \vec{N} \cdot \vec{F}_1$ and $\vec{N} \cdot \vec{F}_1 \neq 0$, then $y_0 = 0$ and $y_0 + y_1 = 1$ are required. Therefore, $y_0 = 0$ and $y_1 = 1$. If $\vec{N} \cdot \vec{F}_0 = \vec{N} \cdot \vec{F}_1$ and $\vec{N} \cdot \vec{F}_1 \neq 0$, Equation (6.18) requires $y_0 + y_1 = 1$, but does not constrain y_0. In this case $y_0 \in [\min(y_0), \max(y_0)] \cap [0, 1]$, where $\min(y_0)$ and $\max(y_0)$ are defined in Equation (6.15). Given a choice for y_0, set $y_1 = 1 - y_0$. If $\vec{N} \cdot \vec{F}_0 \neq \vec{N} \cdot \vec{F}_1$ and $\vec{N} \cdot \vec{F}_1 = 0$, Equation (6.18) requires $y_0 = 0$, but does not constrain y_1. In this case $y_1 \in [\min(y_1), \max(y_1)] \cap [0, 1]$, where $\min(y_1)$ and $\max(y_1)$ are defined in Equation (6.15). If both $\vec{N} \cdot \vec{F}_0 = \vec{N} \cdot \vec{F}_1$ and $\vec{N} \cdot \vec{F}_1 = 0$, then \vec{N} and \vec{M} must be parallel and the triangles must be coplanar.

Last Separating Axis \vec{M}

Dot Equation (6.14) with \vec{M} to obtain

$$x_0 \vec{M} \cdot \vec{E}_0 + x_1 \vec{M} \cdot \vec{E}_1 = \vec{M} \cdot \vec{D}.$$

The projection of the first triangle's vertices leads to (possibly) distinct p values $\{p_0, p_1, p_2\}$. The projection of the second triangle's vertices leads to a single q value, q_0. There are three cases to consider.

The first case is $p_0 = \min_i(p_i)$, in which case $\sigma = -1$, or $p_0 = \max_i(p_i)$, in which case $\sigma = 1$. Then $\vec{M} \cdot \vec{D} = 0, \sigma \vec{M} \cdot \vec{E}_0 \leq 0, \sigma \vec{M} \cdot \vec{E}_1 \leq 0$, and

$$(\sigma \vec{M} \cdot \vec{E}_0)x_0 + (\sigma \vec{M} \cdot \vec{E}_1)x_1 = 0. \tag{6.19}$$

If $\vec{M} \cdot \vec{E}_0 \neq 0$ and $\vec{M} \cdot \vec{E}_1 \neq 0$, then $x_0 = 0$ and $x_1 = 0$ are required. If $\vec{M} \cdot \vec{E}_0 = 0$ and $\vec{M} \cdot \vec{E}_1 \neq 0$, Equation (6.19) requires $x_1 = 0$, but does not constrain x_0. A point

of intersection is provided by any $x_0 \in [\min(x_0), \max(x_0)] \cap [0, 1]$, where $\min(x_0)$ and $\max(x_0)$ are defined in Equation (6.15). If $\vec{M} \cdot \vec{E}_0 \neq 0$ and $\vec{M} \cdot \vec{E}_1 = 0$, Equation (6.19) requires $x_0 = 0$, but does not constrain x_1. A point of intersection is provided by any $x_1 \in [\min(x_1), \max(x_1)] \cap [0, 1]$, where $\min(x_1)$ and $\max(x_1)$ are defined in Equation (6.15). If both $\vec{M} \cdot \vec{E}_0 = 0$ and $\vec{M} \cdot \vec{E}_1 = 0$, then \vec{N} and \vec{M} must be parallel and the triangles must be coplanar. While the assumption of this section is that the two vectors are not parallel, numerical error might generate this case.

The second case is $p_1 = \min_i(p_i)$, in which case $\sigma = -1$, or $p_1 = \max_i(p_i)$, in which case $\sigma = 1$. Then $\vec{M} \cdot \vec{D} = \vec{M} \cdot \vec{E}_0$, $\sigma \vec{M} \cdot \vec{E}_0 \geq 0$, $\sigma(\vec{M} \cdot \vec{E}_1 - \vec{M} \cdot \vec{E}_0) \leq 0$, and

$$0 = (-\sigma \vec{M} \cdot \vec{E}_0)(1 - x_0 - x_1) + [\sigma(\vec{M} \cdot \vec{E}_1 - \vec{M} \cdot \vec{E}_0)]x_1. \tag{6.20}$$

If $\vec{M} \cdot \vec{E}_0 \neq 0$ and $\vec{M} \cdot \vec{E}_1 \neq \vec{M} \cdot \vec{E}_0$, then $x_0 + x_1 = 1$ and $x_1 = 0$ are required. Therefore, $x_0 = 1$ and $x_1 = 0$. If $\vec{M} \cdot \vec{E}_0 = 0$ and $\vec{M} \cdot \vec{E}_1 \neq \vec{M} \cdot \vec{E}_0$, Equation (6.20) requires $x_1 = 0$, but does not constrain x_0. In this case $x_0 \in [\min(x_0), \max(x_0)] \cap [0, 1]$, where $\min(x_0)$ and $\max(x_0)$ are defined in Equation (6.15). If $\vec{M} \cdot \vec{E}_0 \neq 0$ and $\vec{M} \cdot \vec{E}_1 = \vec{M} \cdot \vec{E}_0$, Equation (6.20) requires $x_0 + x_1 = 1$, but does not constrain x_1. In this case $x_1 \in [\min(x_1), \max(x_1)] \cap [0, 1]$, where $\min(x_1)$ and $\max(x_1)$ are defined in Equation (6.15). Given a choice for x_1, set $x_0 = 1 - x_1$. If both $\vec{M} \cdot \vec{E}_0 = 0$ and $\vec{M} \cdot \vec{E}_1 = \vec{M} \cdot \vec{E}_0$, then \vec{N} and \vec{M} must be parallel and the triangles must be coplanar.

The third case is $p_2 = \min_i(p_i)$, in which case $\sigma = -1$, or $p_2 = \max_i(p_i)$, in which case $\sigma = 1$. Then $\vec{M} \cdot \vec{D} = \vec{M} \cdot \vec{E}_1$, $\sigma(\vec{M} \cdot \vec{E}_0 - \vec{M} \cdot \vec{E}_1) \leq 0$, $\sigma \vec{M} \cdot \vec{E}_1 \geq 0$, and

$$0 = [\sigma(\vec{M} \cdot \vec{E}_1 - \vec{M} \cdot \vec{E}_0)]x_0 + (\sigma \vec{M} \cdot \vec{E}_1)(1 - x_0 - x_1). \tag{6.21}$$

If $\vec{M} \cdot \vec{E}_0 \neq \vec{M} \cdot \vec{E}_1$ and $\vec{M} \cdot \vec{E}_1 \neq 0$, then $x_0 = 0$ and $x_0 + x_1 = 1$ are required. Therefore, $x_0 = 0$ and $x_1 = 1$. If $\vec{M} \cdot \vec{E}_0 = \vec{M} \cdot \vec{E}_1$ and $\vec{M} \cdot \vec{E}_1 \neq 0$, Equation (6.20) requires $x_0 + x_1 = 1$, but does not constrain x_0. In this case $x_0 \in [\min(x_0), \max(x_0)] \cap [0, 1]$, where $\min(x_0)$ and $\max(x_0)$ are defined in Equation (6.15). Given a choice for x_0, set $x_1 = 1 - x_0$. If $\vec{M} \cdot \vec{E}_0 \neq \vec{M} \cdot \vec{E}_1$ and $\vec{M} \cdot \vec{E}_1 = 0$, Equation (6.20) requires $x_0 = 0$, but does not constrain x_1. In this case $x_1 \in [\min(x_1), \max(x_1)] \cap [0, 1]$, where $\min(x_1)$ and $\max(x_1)$ are defined in Equation (6.15). If both $\vec{M} \cdot \vec{E}_0 = \vec{M} \cdot \vec{E}_1$ and $\vec{M} \cdot \vec{E}_1 = 0$, then \vec{N} and \vec{M} must be parallel and the triangles must be coplanar.

Last Separating Axis $\vec{E}_i \times \vec{F}_j$

Let (i_0, i_1, i_2) and (j_0, j_1, j_2) be permutations of $(0, 1, 2)$ in the set $\{(0, 1, 2), (1, 0, 2), (2, 1, 0)\}$. The functions α, β, γ, and δ are the same used in Section 6.6.3.

Dot Equation (6.14) with $\vec{E}_{i_0} \times \vec{F}_{j_0}$ to obtain

$$(\vec{E}_0 \cdot \vec{E}_{i_0} \times \vec{F}_{j_0})x_0 + (\vec{E}_1 \cdot \vec{E}_{i_0} \times \vec{F}_{j_0})x_1 = \vec{D} \cdot \vec{E}_{i_0} \times \vec{F}_{j_0} + (\vec{F}_0 \cdot \vec{E}_{i_0} \times \vec{F}_{j_0})y_0$$

$$+ (\vec{F}_1 \cdot \vec{E}_{i_0} \times \vec{F}_{j_0})y_1.$$

Using the various identities mentioned earlier, the equation reduces to

$$\alpha(i_0)(\vec{N} \cdot \vec{F}_{j_0})x_0 + \gamma(i_0)(\vec{N} \cdot F_{j_0})x_1 = \vec{D} \cdot \vec{E}_{i_0} \times \vec{F}_{j_0} - \alpha(j_0)(\vec{M} \cdot \vec{E}_{i_0})y_0$$

$$- \gamma(j_0)(\vec{M} \cdot \vec{E}_{i_0})y_1. \qquad (6.22)$$

The projection of the first triangle's vertices leads to two distinct p values, $p_0 = 0$ and $p_1 = \delta(i_0)\vec{N} \cdot \vec{F}_{j_0}$. The projection of the second triangle's vertices leads to two distinct q values, $q_0 = \vec{D} \cdot \vec{E}_{i_0} \times \vec{F}_{j_0}$ and $q_1 = q_0 - \delta(j_0)\vec{M} \cdot \vec{E}_{i_0}\}$. There are four cases to consider depending on which of the projection values are minima or maxima. In each case the solutions are derived when the intersection point is unique. Nonuniqueness is discussed after the four cases.

The four cases each require two additional constraints on the variables. Dotting Equation (6.14) with \vec{M} and \vec{N} yields equations

$$\vec{M} \cdot \vec{E}_0 x_0 + \vec{M} \cdot \vec{E}_1 x_1 = \vec{M} \cdot \vec{D}$$
$$\vec{N} \cdot \vec{F}_0 y_0 + \vec{N} \cdot \vec{F}_1 y_1 = -\vec{N} \cdot \vec{D}. \qquad (6.23)$$

The first case is $\min(q) = q_0$ and $\max(p) = 0$, in which case $\sigma = 1$, or $\max(q) = q_0$ and $\min(p) = 0$, in which case $\sigma = -1$. Then $q_0 = 0$, $\sigma\delta(i_0)\vec{N} \cdot \vec{F}_{j_0} \leq 0$, and $\sigma\delta(j_0)\vec{M} \cdot \vec{E}_{i_0} \leq 0$. Equation (6.22) is equivalent to

$$0 = [-\sigma\delta(i_0)\vec{N} \cdot \vec{F}_{j_0}][\alpha(i_0)x_0 + \beta(i_0)x_1] + [-\sigma\delta(j_0)\vec{M} \cdot \vec{E}_{i_0}][\alpha(j_0)y_0 + \beta(j_0)y_1].$$

If $\vec{N} \cdot \vec{F}_{j_0} \neq 0$ and $\vec{M} \cdot \vec{E}_{i_0} \neq 0$, then $\alpha(i_0)x_0 + \beta(i_0)x_1 = 0$ and $\alpha(j_0)y_0 + \beta(j_0)y_1 = 0$ are required. These two constraints and Equation (6.23) uniquely determine x_0, x_1, y_0, and y_1.

The second case is $\min(q) = q_0$ and $\max(p) = \delta(i_0)\vec{N} \cdot \vec{F}_{j_0}$, in which case $\sigma = 1$, or $\max(q) = q_0$ and $\min(p) = \delta(i_0)\vec{N} \cdot \vec{F}_{j_0}$, in which case $\sigma = -1$. Then $q_0 = \delta(i_0)\vec{N} \cdot \vec{F}_{j_0}$, $\sigma\delta(i_0)\vec{N} \cdot \vec{F}_{j_0} \geq 0$, and $\sigma\delta(j_0)\vec{M} \cdot \vec{E}_{i_0} \leq 0$. Equation (6.22) is equivalent to

$$0 = [\sigma\delta(i_0)\vec{N} \cdot \vec{F}_{j_0}][1 - \alpha(i_0)x_0 - \beta(i_0)x_1] + [-\sigma\delta(j_0)\vec{M} \cdot \vec{E}_{i_0}][\alpha(j_0)y_0 + \beta(j_0)y_1].$$

If $\vec{N} \cdot \vec{F}_{j_0} \neq 0$ and $\vec{M} \cdot \vec{E}_{i_0} \neq 0$, then $\alpha(i_0)x_0 + \beta(i_0)x_1 = 1$ and $\alpha(j_0)y_0 + \beta(j_0)y_1 = 0$ are required. These two constraints and Equation (6.23) uniquely determine x_0, x_1, y_0, and y_1.

The third case is $\min(q) = q_0 - \delta(j_0)\vec{M} \cdot \vec{E}_{i_0}$ and $\max(p) = 0$, in which case $\sigma = 1$, or $\max(q) = q_0 - \delta(j_0)\vec{M} \cdot \vec{E}_{i_0}$ and $\min(p) = 0$, in which case $\sigma = -1$. Then $q_0 = \delta(j_0)\vec{M} \cdot \vec{E}_{i_0}$, $\sigma\delta(i_0)\vec{N} \cdot \vec{F}_{j_0} \leq 0$, and $\sigma\delta(j_0)\vec{M} \cdot \vec{E}_{i_0} \geq 0$. Equation (6.22) is equivalent to

Table 6.13 Coefficients for unique points of triangle-triangle intersection.

\vec{L}	Coefficients	
\vec{N}	$y_0 = 0,\quad y_1 = 0,$	$\sigma q_0 = \min_k(\sigma q_k)$
	$y_0 = 1,\quad y_1 = 0,$	$\sigma q_1 = \min_k(\sigma q_k)$
	$y_0 = 0,\quad y_1 = 1,$	$\sigma q_2 = \min_k(\sigma q_k)$
\vec{M}	$x_0 = 0,\quad x_1 = 0,$	$\sigma p_0 = \min_k(\sigma p_k)$
	$x_0 = 1,\quad x_1 = 0,$	$\sigma p_1 = \min_k(\sigma p_k)$
	$x_0 = 0,\quad x_1 = 1,$	$\sigma p_2 = \min_k(\sigma p_k)$
$\vec{E}_0 \times \vec{F}_j$	$x_1 = 0,\quad x_0 = \vec{M} \cdot \vec{D} / \vec{M} \cdot \vec{E}_0,$	$0 = \max_k(\sigma p_k)$
	$x_1 = 1,\quad x_0 = 0,$	$0 = \min_k(\sigma p_k)$
$\vec{E}_1 \times \vec{F}_j$	$x_0 = 0,\quad x_1 = \vec{M} \cdot \vec{D} / \vec{M} \cdot \vec{E}_1,$	$0 = \max_k(\sigma p_k)$
	$x_0 = 1,\quad x_1 = 0,$	$0 = \min_k(\sigma p_k)$
$\vec{E}_2 \times \vec{F}_j$	$x_0 = 0,\quad x_1 = 0,$	$0 = \max_k(\sigma p_k)$
	$x_1 = 1,\quad x_0 = (\vec{M} \cdot \vec{E}_1 - \vec{M} \cdot \vec{D}) / \vec{M} \cdot \vec{E}_2,$	$0 = \min_k(\sigma p_k)$

$$0 = [-\sigma \delta(i_0)\vec{N} \cdot \vec{F}_{j_0}][\alpha(i_0)x_0 + \beta(i_0)x_1] + [\sigma \delta(j_0)\vec{M} \cdot \vec{E}_{i_0}][1 - \alpha(j_0)y_0 - \beta(j_0)y_1].$$

If $\vec{N} \cdot \vec{F}_{j_0} \neq 0$ and $\vec{M} \cdot \vec{E}_{i_0} \neq 0$, then $\alpha(i_0)x_0 + \beta(i_0)x_1 = 0$ and $\alpha(j_0)y_0 + \beta(j_0)y_1 = 1$ are required. These two constraints and Equation (6.23) uniquely determine x_0, x_1, y_0, and y_1.

The fourth case is $\min(q) = q_0 - \delta(j_0)\vec{M} \cdot \vec{E}_{i_0}$ and $\max(p) = \delta(i_0)\vec{N} \cdot \vec{F}_{j_0}$, in which case $\sigma = 1$, or $\max(q) = q_0 - \delta(j_0)\vec{M} \cdot \vec{E}_{i_0}$ and $\min(p) = \delta(i_0)\vec{N} \cdot \vec{F}_{j_0}$, in which case $\sigma = -1$. Then $q_0 = \delta(i_0)\vec{N} \cdot \vec{F}_{j_0} + \delta(j_0)\vec{M} \cdot \vec{E}_{i_0}$, $\sigma\delta(i_0)\vec{N} \cdot \vec{F}_{j_0} \geq 0$, and $\sigma\delta(j_0)\vec{M} \cdot \vec{E}_{i_0} \geq 0$. Equation (6.22) is equivalent to

$$0 = [\sigma \delta(i_0)\vec{N} \cdot \vec{F}_{j_0}][1 - \alpha(i_0)x_0 - \beta(i_0)x_1]$$

$$+ [\sigma \delta(j_0)\vec{M} \cdot \vec{E}_{i_0}][1 - \alpha(j_0)y_0 - \beta(j_0)y_1].$$

If $\vec{N} \cdot \vec{F}_{j_0} \neq 0$ and $\vec{M} \cdot \vec{E}_{i_0} \neq 0$, then $\alpha(i_0)x_0 + \beta(i_0)x_1 = 1$ and $\alpha(j_0)y_0 + \beta(j_0)y_1 = 1$ are required. These two constraints and Equation (6.23) uniquely determine x_0, x_1, y_0, and y_1.

The coefficients needed to produce the unique points of intersection are summarized in Table 6.13.

6.6 ORIENTED BOUNDING BOX TREES

In this section, oriented bounding box (OBB) trees are used to provide a hierarchical way of deciding if two objects intersect (Gottschalk, Lin, and Manocha 1996). The computational goal is to minimize the time spent determining if two objects do not intersect. Although the emphasis here is on using boxes as the bounding volumes, the same ideas apply for any type of bounding volume, for example, sphere-swept volumes (see Larsen et al. 1999 and *www.ndl.com*).

SOURCE CODE

LIBRARY

Containment

FILENAME

BoundingVolumeTree
BoxTree
SphereTree
CapsuleTree
LozengeTree

An OBB tree essentially provides a multiscale representation of the object. The root of the tree corresponds to an approximation of the object by a single OBB. The boxes corresponding to the middle levels of the tree represent smaller pieces of the object, thus providing a somewhat better approximation to the object than the root. The leaf nodes of the tree represent the actual geometry of the object. For all practical purposes, the object is a triangular mesh, and each leaf node of the OBB tree corresponds to a single triangle in the mesh.

Although Gottschalk, Lin, and Manocha (1996) formulated their ideas for intersection testing of stationary objects, the construction also applies when the objects are moving. In particular, when each object has a constant velocity during the specified time interval, the extension is mathematically straightforward. When object motion is constrained generally by the system of ordinary differential equations $d\vec{x}/dt = \vec{V}(t, \vec{x})$, where \vec{V} is the velocity vector field that is (possibly) dependent on both current time and current position, a numerical integration of the differential equations can be applied during the specified time interval. The simplest method to apply is Euler's method. For each time step, the object is assumed to have constant velocity during that step. The methods for handling collision of objects with constant velocities can then be applied during that time step. If more positional accuracy is desired, a higher-order numerical integrator can be used to determine various positions during the time interval. The difference between consecutive positions can be used as the constant velocity vector for that time step.

Of particular interest is the case when the objects have constant linear velocities and constant angular velocities. The differential equations are $d\vec{x}/dt = \vec{V} + \vec{W} \times (\vec{x} - \vec{K})$, where \vec{V} is the constant linear velocity, and the axis of rotation is $\vec{K} + t\vec{W}$, where \vec{W} is the constant angular velocity and whose length is the angular speed. The motion is $\vec{x}(t) = \vec{K} + t\vec{V} + R(t, \vec{W})(\vec{x}_0 - \vec{K})$, where $R(t, \vec{W})$ is a rotation matrix about the axis $\vec{K} + t\vec{W}$. While it is possible to perform intersection testing using the closed-form solution for position, it is not recommended. The closed form leads to a test equivalent to showing that the minimum of a function containing sinusoidals and polynomials is positive for the specified time interval. Since minimization algorithms are iterative and since the trigonometric function evaluations are expensive, it is better to numerically solve the differential equation (also iterative) and avoid the trigonometric function calls.

Of additional interest for moving objects is the ability to determine the first time and first point of intersection for the objects during a specified time interval.

These quantities can be determined by processing all the potential separating axes and computing the last time that a separating axis exists. At this time the two objects are just touching (no interpenetration). The various quantities computed for the separation tests provide enough information to reconstruct a first point of intersection (if this point is unique) or to reconstruct one of the points of intersection (if not unique). It is also possible to extract all points of intersection, but this comes with an additional computational cost.

Section 6.9 illustrates one method for automatically generating oriented bounding box trees. The algorithm fits a mesh of triangles with an OBB using either an analysis of a covariance matrix of the vertices and triangles in that mesh or a minimum-volume bounding box fit. Once the OBB is computed, a basic splitting algorithm is used to partition the mesh into two submeshes. The tree generation is recursive in that the algorithm is applied to each of the two submeshes. The result is a binary tree of OBBs. The application has the option of limiting how deep a tree is built by specifying how many triangles are to occur at a leaf node. The default is one triangle. If the leaf nodes have multiple triangles, then only the representing OBB is stored in the tree. The idea is to reduce computation time at the expense of accuracy.

Section 6.10 presents an implementation of a simple dynamic collision detection system. Given two OBB trees, the problem is to traverse them simultaneously and test/find intersections. The application can specify how deep in the tree to traverse, again to reduce computation time at the expense of accuracy. Once an intersection is predicted, the first time and first point of intersection as well as other information is given to the application via callbacks associated with the objects. This scheme makes the collision detection effectively transparent to the application. The application can concentrate solely on the physics of the response, for example, arranging for objects to bounce off walls with the proper angle and angular momentum.

6.7 PROCESSING OF ROTATING AND MOVING OBJECTS

This section shows how to extend the ideas of nonintersection to oriented bounding boxes that have both linear and angular velocities. The algorithm is first presented in a closed-form fashion. Determination of nonintersection is equivalent to showing that at least one function of time (from a set of 15 nonnegative functions) is positive on the specified time interval. The functions contain sine and cosine terms of two different frequencies. Evaluation of these is expensive unless lookup tables are used. Moreover, to show that the function is positive requires a numerical method for constructing the minimum of the function. The iterative schemes can be expensive, too. Alternatively, we may select a fixed number of samples on the specified time interval and evaluate the functions and those samples. Since the trigonometric values are handled by lookup tables, there is an additional problem in that the function values at the samples are all positive, yet the minimum function value is zero.

A better alternative is to formulate the problem in terms of differential equations. In this form no trigonometric function evaluations are required. A numerical method must be used for solving the equations, but it can be as simple as using Euler's method. The same problem exists as in the last paragraph—the numerical method effectively generates a sequence of function values that might all be positive, yet the function minimum is zero. For better accuracy and stability, a Runge-Kutta method can be used (see Appendix B, Section B.7). Regardless of the differential equation solver, the alternative algorithm creates a sequence of oriented bounding boxes for each initial box and uses the linear velocity algorithm to determine the intersection of two boxes between two consecutive elements of the sequence.

6.7.1 EQUATIONS OF MOTION

The high-level abstraction is to have an object that is tagged with a center point \vec{C}, an origin for a frame of reference, and a coordinate frame \vec{U}_0, \vec{U}_1, and \vec{U}_2 (three mutually orthonormal vectors forming a right-handed system). The coordinate axes are represented as the three columns of a rotation matrix $R = [\vec{U}_0\ \vec{U}_1\ \vec{U}_2]$. The object is assigned a linear velocity \vec{V} and an angular velocity \vec{W}. The axis of rotation has origin \vec{C} and direction \vec{W}, and the speed of rotation is $|\vec{W}|$.

The object is associated with an oriented bounding box tree. Each box in the OBB tree is offset from the object center and has a frame that is typically not oriented the same as the object frame. The motion of each box is determined by the motion of the object.

Coordinates of a point \vec{X} can be measured relative to the object coordinate system as $\vec{X} = \vec{C} + R\vec{Y}$. The relative coordinates are represented by \vec{Y}. For-time varying center $\vec{C}(t)$ and frame $R(t)$, the initial point \vec{Y} follows the path

$$\vec{X}(t, \vec{Y}) = \vec{C}(t) + R(t)\vec{Y},$$

where the dependency on \vec{Y} is emphasized by the explicit mention of \vec{Y} in the functional form of \vec{X}. For constant linear and angular velocities, the center and frame are

$$\vec{C}(t) = \vec{C}_0 + t\vec{V}$$

$$R(t) = \exp(\mathrm{skew}(\vec{W})t)R_0,$$

where \vec{C}_0 is the initial center and R_0 is the initial frame. If $\vec{W} = (w_0, w_1, w_2)$, then $[S_{ij}] = \mathrm{skew}(\vec{W})$ is the skew-symmetric matrix whose diagonal entries are $S_{00} = S_{11} = S_{22} = 0$ and whose other entries are $S_{01} = -S_{10} = w_2$, $S_{02} = -S_{20} = -w_1$, and $S_{12} = -S_{21} = w_0$. The matrix $\exp(\mathrm{skew}(\vec{W})t)$ is the rotation matrix that represents the rotation whose axis is in the direction of \vec{W} and whose angle of rotation is $|\vec{W}|t$.

The motion for constant linear and angular velocities is therefore

$$\vec{X}(t, \vec{Y}) = \vec{C}_0 + t\vec{V} + \exp(\text{skew}(\vec{W})t)R_0\vec{Y}$$

for $t \geq 0$. The differential equation governing the motion of the object is

$$\frac{d\vec{X}}{dt} = \vec{V} + \text{skew}(\vec{W})\exp(\text{skew}(\vec{W})t)R_0\vec{Y}$$

$$= \vec{V} + \text{skew}(\vec{W})\left(\vec{X} - (\vec{C}_0 + t\vec{V})\right)$$

$$= \vec{V} + \vec{W} \times \left(\vec{X} - (\vec{C}_0 + t\vec{V})\right).$$

Since the motion is rigid, the OBBs in the OBB tree are governed by the same differential equation. However, the center and frame for an OBB can be derived from basic principles. If \vec{C}_1 is the OBB initial center and R_1 is the OBB initial frame for the oriented bounding box, then in terms of the object coordinate system, $\vec{C}_1 = \vec{C}_0 + R_0\vec{\xi}$ for some relative coordinate vector $\vec{\xi}$. The time-varying path of the OBB center is

$$\vec{K}(t) = \vec{X}(t, \vec{\xi})$$

$$= \vec{C}(t) + R(t)\vec{\xi}$$

$$= \vec{C}_0 + t\vec{V} + [\exp(\text{skew}(\vec{W})t)R_0][R_0^{\text{T}}(\vec{C}_1 - \vec{C}_0)]$$

$$= \vec{C}_0 + t\vec{V} + \exp(\text{skew}(\vec{W})t)(\vec{C}_1 - \vec{C}_0).$$

The time-varying OBB frame is simply the application of the object's relative rotation to the box's frame,

$$P(t) = \exp(\text{skew}(\vec{W})t)R_1.$$

If $\vec{X}(t, \vec{Y}) = \vec{K}(t) + P(t)\vec{Y}$, then

$$\frac{d\vec{X}}{dt} = \frac{d\vec{K}(t)}{dt} + \frac{d\vec{P}(t)}{dt}\vec{Y}$$

$$= \vec{V} + \text{skew}(\vec{W})\exp(\text{skew}(\vec{W})t)(\vec{C}_1 - \vec{C}_0) + \text{skew}(\vec{W})\exp(\text{skew}(\vec{W})t)R_1\vec{Y}$$

$$= \vec{V} + \text{skew}(\vec{W})\left(\vec{X} - (\vec{C}_0 + t\vec{V})\right)$$

$$= \vec{V} + \vec{W} \times \left(\vec{X} - (\vec{C}_0 + t\vec{V})\right).$$

This verifies that in fact the OBB is governed by the equations of motion of the object.

6.7.2 Closed-Form Algorithm

The closed-form approach is illustrated with one of the separating axis tests. The other axes are processed in a similar fashion. For two stationary OBBs (one from each OBB tree for the two interacting objects), the nonintersection test based on the axis with direction \vec{A}_0 is

$$|\vec{A}_0 \cdot \vec{D}| > a_0 + |b_0 c_{00}| + |b_1 c_{01}| + |b_2 c_{02}|,$$

where the c_{ij} are the entries of matrix $C = A^\mathsf{T} B$ with columns of A being the axes of the first box and columns of B being the axes of the second box. The values a_i and b_i are the extents of the boxes. Finally, \vec{D} is the difference between the second and first box centers.

Let $\vec{K}_i(t)$ and $P_i(t)$, $i = 0, 1$ represent the time-varying centers and coordinate frames for the two boxes. Let $\vec{A}_0(t)$ be the first column of $P_0(t)$. The nonintersection test is now time-varying:

$$|\vec{A}_0(t) \cdot (\vec{K}_1(t) - \vec{K}_0(t))| > a_0 + |b_0 c_{00}(t)| + |b_1 c_{01}(t)| + |b_2 c_{02}(t)|,$$

where $C(t) = P_0(t)^\mathsf{T} P_1(t)$.

Each object has (possibly) different angular velocities. Generally, the sinusoidal terms in $P_0(t)$ and $P_1(t)$ have different frequencies. The nonintersection test therefore contains sinusoidals of two frequencies. The centers $\vec{K}_i(t)$ themselves include sinusoidal terms whenever the box centers are not the same as the object centers. Verifying the inequality in the test for all t in a specified interval is not a simple problem. The verification of $\ell(t) > r(t)$ for $t \in [0, T]$ is equivalent to showing that $\delta(t) = \ell(t) - r(t)$ has a positive minimum for $t \in [0, T]$. Although this can be done by applying a numerical minimizer to $\delta(t)$, probably using an inverse parabolic interpolator such as Brent's method, it is expensive because each function evaluation requires computing sinusoidal functions. The cost can be reduced by using table lookups, but the iteration itself might not always converge to an acceptable value in the same number of steps per nonintersection test. Better control of the process would be to select a fixed number of evaluations per test, say, $N > 0$, and compute $\delta_i = \delta(Ti/N)$ for $0 \le i \le N$. The minimum of the δ_i is computed and, if sufficiently larger than zero (the application must select a threshold), the boxes are determined not to intersect.

6.7.3 ALGORITHM BASED ON A NUMERICAL ORDINARY DIFFERENTIAL EQUATION SOLVER

SOURCE CODE

LIBRARY

Intersection

FILENAME

IntrBox3Box3

Rather than evaluating the δ_i per potential separating axis, a better approach is to numerically solve the equations of motion for $t \in [0, T]$. For the first box, solve

$$\frac{d\vec{X}}{dt} = \vec{V} + \vec{W} \times \left(\vec{X} - (\vec{C}_0 + t\vec{V})\right)$$

for $t > 0$ with initial condition $\vec{X}(0) = \vec{K}_0$. The simplest approach is to use Euler's method and iterate N times on the given interval. The time steps are $t_i = Ti/N$ for $0 \le i \le N$. Define \vec{X}_i to be the numerical approximation to $\vec{X}(t_i)$; then $\vec{X}_0 = \vec{K}_0$ and

$$\vec{X}_{i+1} = \vec{X}_i + \frac{T}{N}\left[\vec{V} + \vec{W} \times \left(\vec{X}_i - \vec{C}_0 + t_i\vec{V}\right)\right],$$

where the first object has center \vec{C}_0, linear velocity \vec{V}, and angular velocity \vec{W}. The iteration scheme is evaluated for $0 \le i < N$. This produces a sequence of centers for the first box, \vec{X}_0 through \vec{X}_N. The coordinate frame is also integrated using

$$\frac{dP}{dt} = \text{skew}(\vec{W})P$$

for $t > 0$ with initial condition $P(0) = R_1$. Using Euler's method, the values P_i are approximations to $P(t_i)$ and the iterations are

$$P_{i+1} = P_i + \frac{T}{N}\,\text{skew}(\vec{W})P_i = \left(I + \frac{T}{N}\,\text{skew}(\vec{W})\right)P_i.$$

The numerical scheme does not preserve the orthonormality of the matrix. That is, $P_0 = R_1$ is orthonormal, but P_1 is not necessarily orthonormal. For very small T/N, P_1 is nearly orthonormal and can be used as is. However, it might be desirable to renormalize P_i at each step. This can be done by using Gram-Schmidt orthonormalization on the three columns of P_i.

After the center and frame iterates have been generated, the sequence of centers and frames for the first moving OBB is \vec{X}_i and P_i. The second moving OBB has similar sequences \vec{Y}_i and Q_i. For each i, the linear velocity of the first OBB over the corresponding time subinterval is set to $\vec{V}_0 = \vec{X}_{i+1} - \vec{X}_i$, and the linear velocity of the second OBB is set to $\vec{V}_1 = \vec{Y}_{i+1} = \vec{Y}_i$. On the time subinterval, the two boxes are compared as if they have only linear velocities. The first OBB has center \vec{X}_i, coordinate frame P_i, and velocity \vec{V}_0. The second OBB has center \vec{Y}_i, coordinate frame Q_i, and

velocity \vec{V}_1. The algorithm is applied to each of the N pairs of OBBs. For a given potential separating axis, if the N tests all show nonintersection, then the axis is separating and the two OBBs do not intersect on the given time interval.

6.8 CONSTRUCTING AN OBB TREE

Given a triangular mesh consisting of a collection of vertices and a connectivity list, the basic approach to constructing an OBB tree is recursive. An OBB is computed to contain the initial triangular mesh. The mesh is split ino two submeshes, with the algorithm possibly using information about the OBB to determine how to split the mesh. If a submesh contains at least two triangles, then the process is repeated on that submesh. If a submesh has exactly one triangle, no OBB is constructed, but the triangle is considered to be at a leaf node of the tree.

The OBB nodes themselves must store various information to aid in collision detection. It is assumed that the triangle mesh represents a rigid body. Dynamically morphed objects are problematic in that OBB trees would need to be recomputed during run time, an expensive operation. Although there are many ways to organize the data, the simplest is to require each OBB node to store a pointer to the rigid body object, an OBB pointers to the two child OBB nodes, and an index to a triangle.

The pointer to the object is used to query the object about motion information. For example, if the object velocity is a function of time, an OBB node may need to query the object to determine at a specific time what the velocity is. The pointers to the children are both not null for interior OBB nodes and both null for leaf OBB nodes. The index to a triangle is only used at OBB leaf nodes. This index is used in querying the object to get the actual triangle vertex data that is needed to compute triangle-triangle intersections.

The tree generation algorithm also allows for building less than a full tree. An application can specify a threshold on the number of triangles for an OBB leaf node. The full tree has a single triangle per leaf node. However, if an application specifies at least two triangles per leaf node, the splitting algorithm will be applied during construction of an OBB node only if that node has more than two triangles in its mesh. The number is heuristic: an OBB node with three triangles is allowed to be split. The child with two triangles is no longer subdivided. The other child has a single triangle.

A variety of methods can be used for computing an OBB for a triangular mesh. In real-time applications, these methods are applied in a preprocessing phase, so their execution times are not typically an issue. We will discuss three algorithms: minimum-volume OBB, OBB based on distribution of mesh points, and OBB based on distribution of mesh triangles (described in Gottschalk, Lin, and Manocha 1996). Various bounding algorithms are discussed in Chapter 2 (box from points, box from triangles, minimum-volume box).

Given a triangular mesh with corresponding oriented bounding box, the mesh can be split into two submeshes. The idea is to split the OBB by a plane orthogonal to the

longest axis of the box, then partition the triangles based on which side of the splitting plane their centers lie. There are many heuristics for the location of the splitting plane, but only two are presented here.

The first algorithm uses the splitting plane orthogonal to the longest axis and passing through the center of the OBB. Because of variations in triangle size, this algorithm may not produce a balanced tree. Worse is that it may not provide a subdivision if all the triangle centers occur on the same side of the plane. If the longest axis does not partition the triangles, the next longest axis can be used. If in turn this does not partition the triangles, then the last axis is used. If all three axes fail to partition the triangles, then some other criterion for splitting must be used.

The second algorithm uses the splitting plane orthogonal to the longest axis and passing through that point corresponding to the median value of the projection of the triangle centers onto the longest axis. This guarantees that the tree is balanced, a desirable trait since it keeps the height of the tree small compared to the number of triangles represented by the tree.

6.9 A Simple Dynamic Collision Detection System

There are many choices for testing for collisions between two OBB trees. Here we will present one simple method that implements a dual recursion on the two OBB trees and compares OBB and triangles for collisions. Effectively an OBB of one tree is compared against an OBB of the other tree. If the two OBBs intersect, then the children of the second OBB are compared against the current OBB of the first tree.

The algorithms assume a function `bool HasObb (ObbTree node)` that returns `true` if and only if the node has an associated OBB. It also assumes a function

```
bool HasChildren (ObbTree node, int depth)
{
    return ( Exists(node.Lchild) && Exists(node.Rchild) &&
      depth != 0 );
}
```

Having children is necessary but not sufficient for this function to return `true`. The test on `depth` supports limiting the depth of traversal. The application specifies a positive depth to limit the traversal. To get a full traversal, the application specifies the depth to be a negative number. The depth is decremented for each recursive call of `TestCollisions`, so in the case of an initial positive depth, any visited node for which current depth value is zero is considered a leaf node. For an initial negative depth, the test for children is unaffected by the subsequent depth values. The semantics of `HasChildren` precludes the calls to `HasObb` being replaced by calls to `HasChildren`.

6.9.1 TESTING FOR COLLISION

The method TestIntersection calls the appropriate intersection routine based on whether or not the tree node is interior or leaf. The returned value is true if and only if the corresponding OBB or triangles intersect during the specified time interval. Motion parameters are maintained by the object whose pointer is stored in the OBB nodes and can be accessed within the intersection calls.

```
bool TestIntersection (float dt, ObbTree node0, ObbTree node1)
{
    if ( HasObb(node0) )
    {
        if ( HasObb(node1) )
            return ObbObbIntersect(dt,node0.Obb,node1.Obb);
        else
            return ObbTriIntersect(dt,node0.Obb,node1.Tri);
    }
    else
    {
        if ( HasObb(node1) )
            return TriObbIntersect(dt,node0.Tri,node1.Obb);
        else
            return TriTriIntersect(dt,node0.Tri,node1.Tri);
    }
}
```

The values depth0 and depth1, when passed to the TestCollision for the root nodes of the OBB trees, are the application-specified maximum depths of traversal for the OBB trees. The returned value for TestCollision is true if and only if the two subtrees that are rooted at the input nodes do intersect.

```
bool TestCollision (float dt, ObbTree node0, int depth0, ObbTree node1,
  int depth1)
{
    if ( !TestIntersection(dt,node0,node1) )
        return false;

    if ( HasChildren(node0,depth0) )
    {
        if ( TestCollision(dt,node0.Lchild,depth0-1,node1,depth1) )
            return true;
        if ( TestCollision(dt,node0.Rchild,depth0-1,node1,depth1) )
            return true;
        if ( HasChildren(node1,depth1) )
        {
```

```
            if ( TestCollision(dt,node0,depth0,node1.Lchild,depth1-1) )
                return true;
            if ( TestCollision(dt,node0,depth0,node1.Rchild,depth1-1) )
                return true;
        }
        return false;
    }

    if ( HasChildren(node1,depth1) )
    {
        if ( TestCollision(dt,node0,depth0,node1.Lchild,depth1-1) )
            return true;
        if ( TestCollision(dt,node0,depth0,node1.Rchild,depth1-1) )
            return true;
        return false;
    }

    return true;
}
```

The last line of the function returns true since both node0 and node1 are at the end of the recursive calls and the call to TestIntersection already has shown that the corresponding OBBs or triangles are intersecting. Also note that the semantics of this routine say that if the traversal is limited by an application-specified depth, an intersection between two OBBs or between an OBB and a triangle is counted as a collision, even if the underlying trimesh geometry does not intersect, illustrating once again the trade-off between accuracy and compute time.

6.9.2 Finding Collision Points

The method FindIntersection calls the appropriate intersection routine based on whether the tree node is interior or leaf. A returned value is true if the collision system is to continue searching other collisions. The value does not indicate that there is an intersection point between the OBB, OBB and triangle, or triangles.

Any intersection points found by FindIntersection when applied to OBBs or triangles are passed onto the application via a callback mechanism that is associated with the object whose pointer is stored by the OBB node. Normal vectors are also passed to the callback. A normal for an OBB is computed as if the OBB were an ellipsoid, thus providing a smoothed normal vector field for the box. The return value of the callback is Boolean and indicates whether or not the collision system should continue searching for collisions. This gives the application the opportunity to terminate the search after one or more collisions rather than processing all possible collision points.

```
bool FindIntersection (float dt, ObbTree node0, ObbTree node1)
{
    // first time, location, and normals of intersection
    float time;
    Point3 intersect, normal0, normal1;

    if ( HasObb(node0) )
    {
        if ( HasObb(node1) )
        {
            FindObbObb(dt,node0.Obb,node1.Obb,time,intersect);
            node1.Obb.GetNormal(intersect);
        }
        else
        {
            FindObbTri(dt,node0.Obb,node1.Tri,time,intersect);
            node1.Tri.GetNormal(intersect);
        }

        normal0 = node0.Obb.GetNormal(intersect);
    }
    else
    {
        if ( HasObb(node1) )
        {
            FindTriObb(dt,node0.Tri,node1.Obb,time,intersect);
            node1.Obb.GetNormal(intersect);
        }
        else
        {
            FindTriTri(dt,node0.Tri,node1.Tri,time,intersect);
            node1.Tri.GetNormal(intersect);
        }

        normal0 = node0.Tri.GetNormal(intersect);
    }
}

// provide the application with the collision information
bool bContinue0;
if ( node0.Object.Callback )
{
    bContinue0 = node0.Object.Callback(node1.Object,time,intersect,
        normal0,normal1);
```

```
}
else
{
    bContinue0 = true;
}

bool bContinue1;
if ( node1.Object.Callback )
{
    bContinue1 = node1.Object.Callback(node0.Object,time,intersect,
        normal1,normal0);
}
else
{
    bContinue1 = true;
}

return bContinue0 && bContinue1;
```

The pseudocode for finding a point of intersection is given below. The return value is `true` if and only if the collision system should continue searching for collisions.

```
bool FindCollision (float dt, ObbTree node0, int depth0, ObbTree node1,
  int depth1)
{
    if ( !TestIntersection(dt,node0,node1) )
        return true;

    if ( HasChildren(node0,depth0) )
    {
        if ( !FindCollision(dt,node0.Lchild,depth0-1,node1,depth1) )
            return false;
        if ( !FindCollision(dt,node0.Rchild,depth0-1,node1,depth1) )
            return false;
        if ( HasChildren(node1,depth1) )
        {
            if ( !FindCollision(dt,node0,depth0,node1.Lchild,depth1-1) )
                return false;
            if ( !FindCollision(dt,node0,depth0,node1.Rchild,depth1-1) )
                return false;
        }
        return true;
    }
```

```
    if ( HasChildren(node1,depth1) )
    {
        if ( !FindCollision(dt,node0,depth0,node1.Lchild,depth1-1) )
            return false;
        if ( !FindCollision(dt,node0,depth0,node1.Rchild,depth1-1) )
            return false;
        return true;
    }

    // At this point we know there is an intersection.  Compute the
    // intersection and make this information available to the application
    // via the object callback mechanism.

    return FindIntersection(dt,pkTree1);
}
```

CHAPTER 7

CURVES

At first glance, curves do not appear to be a central topic in building a game engine. Many game engines concentrate on taking polygonal models and processing them for display by the renderer. If objects must change position or orientation during game play, the standard approach has been just to move the objects in a simple fashion, using translation by constant vector offset and rotation by a constant angle— something that requires only vector and matrix algebra (i.e., linear algebra, emphasis on *line*). But curves are actually quite useful when you think about it. For example, if a flight simulator wishes to support realistic flight dynamics, such as the correct banking of a plane as it makes a tight turn, curves can be of assistance. The bank angle is related to how much "bending" there is in the curve that represents the flight path (requiring the concept of "curvature of a curve"). Moreover, if the plane is required to travel at a constant speed along the curved path, the calculations involve knowing something about arc length and the concept of "reparameterization by arc length."

Another popular example is in the construction of a game that requires tunnels. Many developers are interested in specifying the central curve of a tunnel and the width of the tunnel along that curve. From this information the tunnel walls can be built as a polygon mesh. An understanding of the theory of curves is essential in this construction.

257

Finally, curved surfaces have become quite popular, if not essential, for building content in a game that is more realistic looking than the standard polygonal content. The content is typically dynamically tessellated during game play. An understanding of the theory of curves will be quite useful because the same ideas extend to surfaces—the ideas in tessellating curves apply equally well to tessellating surfaces. Understanding curves is a prerequisite to understanding surfaces.

The topic of curves is quite extensive, and only a brief summary is given in this chapter. The basic concepts that are covered in Sections 7.1 and 7.2 are arc length, reparameterization by arc length, curvature, torsion, tangents, normals, and binormals. Special classes of curves are considered in Section 7.3: Bézier curves; natural, clamped, and closed cubic splines; nonparametric B-spline curves; and tension-continuity-bias curves (including Catmull-Rom and Kochanek-Bartels splines). Nonuniform rational B-splines (NURBS) are not discussed here, but more detailed discussions can be found in Farin (1990) and Foley et al. (1990). Topics discussed here that are less frequently found in the standard references are subdivision of a curve by various methods (by uniform sampling in curve parameter, by arc length, by midpoint distance, by variation, and by minimum variation) and fast recursive subdivision for cubic curves, all considered in Section 7.4. Finally, orientation of moving objects along a curved path is discussed in Section 7.5. This is useful for applications such as flight simulators where the orientation must be physically realistic.

7.1 DEFINITIONS

SOURCE CODE

LIBRARY
Curve

FILENAME
Curve
SingleCurve
SingleCurve2
SingleCurve3
MultipleCurve
MultipleCurve2
MultipleCurve3

A *parametric curve* is a function $\vec{x} : [t_{\min}, t_{\max}] \subset \mathbb{R} \to \mathbb{R}^n$. The curve end points are $\vec{x}(t_{\min})$ and $\vec{x}(t_{\max})$. Tangent vectors to the curve are $\vec{x}'(t)$, the derivative with respect to t. The *forward* (*backward*) direction of traversal is that direction implied by increasing (decreasing) t. The *speed* of traversal is $|\vec{x}'(t)|$. A curve $\vec{x}(s)$ is said to be *parameterized by arc length* s if $\vec{T}(s) = \vec{x}'(s)$ is unit length. The relationship between s and t is

$$s(t) = \int_{t_{\min}}^{t} |\vec{x}'(\tau)| \, d\tau.$$

The *length* of the curve is $L = s(t_{\max})$.

A *planar curve* $\vec{x}(t) = (x_0(t), x_1(t))$ has associated with it an orthonormal *coordinate frame* given by the tangent vector $\vec{T}(s)$ and a normal vector $\vec{N}(s)$. The frame relationships are

$$\vec{T}'(s) = \kappa(s)\vec{N}(s)$$

$$\vec{N}'(s) = -\kappa(s)\vec{T}(s).$$

The quantity $\kappa(s)$ is called *curvature*. A curve is uniquely determined (modulo rigid motions) by specifying a curvature function.

If $\vec{T}(s) = (\cos\theta(s), \sin\theta(s))$, then the normal can be chosen as $\vec{N}(s) = (-\sin\theta(s), \cos\theta(s))$. In this case, $\kappa = d\theta/ds$. In terms of the t-components of the curve, curvature is

$$\kappa = \frac{x_0' x_1'' - x_0'' x_1'}{\left((x_0')^2 + (x_1')^2\right)^{3/2}}.$$

A *space curve* $\vec{x}(t) = (x_0(t), x_1(t), x_2(t))$ has associated with it an orthonormal coordinate frame called the *Frenet frame* given by the tangent vector $\vec{T}(s)$, a normal vector $\vec{N}(s)$, and a binormal vector $\vec{B}(s)$. The frame relationships are called the Frenet-Serret equations,

$$\vec{T}'(s) = \kappa(s)\vec{N}(s)$$

$$\vec{N}'(s) = -\kappa(s)\vec{T}(s) + \tau(s)\vec{B}(s)$$

$$\vec{B}'(s) = -\tau(s)\vec{N}(s).$$

The quantity $\kappa(s)$ is the curvature and the quantity $\tau(s)$ is called *torsion*. A curve is uniquely determined (modulo rigid motions) by specifying both a curvature function and a torsion function.

Setting

$$\vec{T} = (\cos\theta\sin\phi, \sin\theta\sin\phi, \cos\phi)$$

$$\vec{u} = (-\sin\theta, \cos\theta, 0) = \frac{1}{\sin\phi}\frac{\partial\vec{T}}{\partial\theta}$$

$$\vec{v} = (\cos\theta\cos\phi, \sin\theta\cos\phi, -\sin\phi) = \frac{\partial\vec{T}}{\partial\phi},$$

it can be shown that $\vec{T} = \vec{v}\times\vec{u}$, $\vec{N} = (\cos\omega)\vec{u} + (\sin\omega)\vec{v}$, and $\vec{B} = (\sin\omega)\vec{u} - (\cos\omega)\vec{v}$ for some angle function $\omega(s)$, and $\vec{B} = \vec{T}\times\vec{N}$. Substituting these in the Frenet-Serret formulas yields

$$\left(\frac{d\theta}{ds}, \frac{d\phi}{ds}, \frac{d\omega}{ds}\right) = \left(\frac{\kappa\cos\omega}{\sin\phi}, \kappa\sin\omega, -\tau + \frac{\kappa\cos\omega\cos\phi}{\sin\phi}\right).$$

In terms of the t-components of the curve, curvature is

$$\kappa = \frac{\pm|\vec{x}' \times \vec{x}''|}{|\vec{x}'|^3},$$

where the choice of sign depends on the orientation of the normal to tangent. The torsion is

$$\tau = \frac{\vec{x}' \cdot (\vec{x}'' \times \vec{x}''')}{|\vec{x}' \times \vec{x}''|^2}.$$

One way to handle the sign problem for normal vector and curvature is the following. Assuming that $\theta(s)$ and $\phi(s)$ are smoothly varying functions, the vectors \vec{T}, \vec{u}, and \vec{v} are smoothly varying. Choose \vec{N} to be the vector that forms an acute angle with \vec{u}. In this way the curvature has a consistent sign related to the normal vector orientation. It can be shown that

$$\vec{N} = \sigma \frac{(\vec{x}' \cdot \vec{x}')\vec{x}'' - (\vec{x}' \cdot \vec{x}'')\vec{x}'}{|\vec{x}'||\vec{x}' \times \vec{x}''|},$$

where $|\sigma| = 1$. A choice for sign is $\sigma = \text{sign}(\vec{u} \cdot \vec{x}'')$. Curvature is then computed as $\kappa = \sigma|\vec{x}' \times \vec{x}''|/|\vec{x}'|^3$.

7.2 REPARAMETERIZATION BY ARC LENGTH

Given a curve $\vec{x}(t)$ for $t \in [t_{\min}, t_{\max}]$, it may be desirable to evaluate curve quantities (position, coordinate frame, curvature, torsion) by specifying an arc length $s \in [0, L]$, where L is the total length of the curve. The algorithm requires computing $t \in [t_{\min}, t_{\max}]$ that corresponds to the specified s. This is accomplished by a numerical inversion of the integral equation relating s to t. Define $\text{Speed}(t) = |\vec{x}'(t)|$ and $\text{Length}(t) = \int_{t_{\min}}^{t} |\vec{x}'(\tau)|\, d\tau$. The problem is now to solve $\text{Length}(t) - s = 0$ for the specifed s, a root-finding task. From the definition of arc length, the root must be unique. An application of Newton's method will suffice (see Appendix B, Section B.5). Evaluation of $\text{Length}(t)$ does require numerical integration. Romberg integration or Gaussian quadrature work fine in this setting (see Appendix B, Section B.6). The pseudocode for the algorithm is

```
Input:  tmin, tmax, L, s in [0,L]
Output:  t in [tmin,tmax] corresponding to s

// Choose an initial guess based on relative location of s
// in [0,L].
ratio = s/L;
```

```
t = (1-ratio)*tmin + ratio*tmax;

for (i = 0; i < IMAX; i++)
{
    diff = Length(t)-s;
    if ( |diff| < EPSILON )
        return t;

    t -= diff/Speed(t);
}

// Newton's method failed to converge.  Return your best guess.
return t;
```

An application must choose the maximum number of iterations `IMAX` and a tolerance `EPSILON` for how close to zero the root is. Reasonable choices appear to be `IMAX = 32` and `EPSILON = 1e-06`.

7.3 SPECIAL CURVES

The following subsections describe various special curves in three dimensions.

7.3.1 BÉZIER CURVES

SOURCE CODE

LIBRARY
Curve

FILENAME
BezierCurve2
BezierCurve3

Bézier curves are popular with game programmers for their mathematical simplicity and ease of use.

Definitions

Given an ordered list of three-dimensional control points \vec{p}_i for $0 \leq i \leq n$, the Bézier curve for the points is

$$\vec{x}(t) = \sum_{i=0}^{n} B_{n,i}(t)\vec{p}_i$$

for $t \in [0, 1]$ and where the coefficients of the control points are the Bernstein polynomials

$$B_{n,i}(t) = C(n; i)t^i (1 - t)^{n-i} \tag{7.1}$$

with combinatorial values $C(n; i) = n!/(i!(n-i)!)$. The barycentric form of the curve is

$$\vec{x}(u, v) = \sum_{i+j=n} C(n; i, j) u^i v^j \vec{q}_{i,j},$$

where $u \in [0, 1]$, $v \in [0, 1]$, $u + v = 1$, $i \geq 0$, $j \geq 0$, and $\vec{q}_{i,j} = \vec{p}_i$. The formula appears to be bivariate, but the condition $v = 1 - u$ shows that it is in fact univariate. The derivative of a Bézier curve is

$$\vec{x}'(t) = n \sum_{i=0}^{n-1} B_{n-1,i}(t)(\vec{p}_{i+1} - \vec{p}_i).$$

Evaluation

In evaluating a Bézier curve, a decision must be made about whether speed or accuracy is more important. For real-time applications, speed is usually the important criterion. Inaccuracies in the computed positions are not noticeable in the sampled curve.

Using the Bernstein form of a Bézier curve, the Bernstein polynomials are evaluated first. The polynomials are computed for the selected t and for all values $0 \leq i \leq n$. The control points are then multiplied by the coefficients and summed. Assuming a fixed degree n and assuming that the combinatorial values $C(n; i)$ are precomputed, the number of multiplications required to compute each polynomial coefficient is n. For small degree n, the number of multiplications can be reduced by computing intermediate products of powers of t and $1 - t$, but this optimization is not considered at the moment in the operation count. Multiplying a polynomial coefficient times control point requires 3 multiplications. Given $n + 1$ terms, the number of required multiplications is $(n + 1)(n + 3)$. There are $n + 1$ three-dimensional terms to sum for a total of $3n$ additions. The total operation count for a single Bézier curve evaluation is $n^2 + 7n + 3$ operations.

Using the barycentric form of a Bézier curve, evaluation is possible by using the de Casteljau algorithm (a good reference on the topic is Farin 1990). Define $\vec{q}_{i,j}^0 = \vec{q}_{i,j}$ to be the original control points. The algorithm is

$$\vec{q}_{i,j}^r(u, v) = u\vec{q}_{i+1,j}^{r-1} + v\vec{q}_{i,j+1}^{r-1}$$

for $1 \leq r \leq n$ and $i + j = n - r$. For each r there are 6 multiplications and 3 additions on the right-hand side of the equation. The number of terms to compute for each r is $n - r$. Total operation count for a single evaluation is $9n(n - 1)/2$ operations. This is quadratic order, just as for the Bernstein evaluation, but the constant is 9 rather than 1. However, the de Casteljau algorithm is numerically stable, whereas the Bernstein form is not, particularly for large n. The amount of numerical error in the Bernstein form is visually insignificant for rendering purposes for small degree $n \leq 4$. The savings in time is clearly worth using Bernstein form.

Degree Elevation

A Bézier curve with $n + 1$ control points is a polynomial of degree n. An equivalent Bézier curve with $n + 2$ control points and that is a polynomial of degree $n + 1$ can be constructed. The process, called *degree elevation,* is useful in smoothly piecing together Bézier curves. The degree-elevated Bézier curve is obtained by multiplying the Bernstein form of the curve by $1 = (t + (1 - t))$. The multiplication by 1 does not intrinsically change the curve, but the polynomial coefficients are changed because of the multiplication by $(t + (1 - t))$. The degree-elevated curve is

$$\vec{x}(t) = \sum_{i=0}^{n+1} B_{n+1,i}(t) \left[\left(1 - \frac{i}{n+1} \right) \vec{p}_i + \frac{i}{n+1} \vec{p}_{i-1} \right].$$

Degree Reduction

If the original Bézier curve is quadratic, the degree-elevated curve is cubic, showing that there are some cubic curves that can be represented by quadratic curves. However, not all cubic curves are representable by quadratic curves. For example, a cubic curve that is *s*-shaped cannot be represented by a quadratic curve. It may be desirable to reduce the degree on a Bézier curve so that the curve evaluations are less expensive to compute. Although it is not always possible to get an exact degree-reduced representation, it is possible to build one that approximately fits the curve. A least-squares fit can be used to obtain the degree-reduced curve. If the original curve has a lot of variation, the least-squares fit may not be as good a fit as is desired. For example, if the original curve is cubic and has control points $(-2, 0, 0)$, $(-1, 1, 0)$, $(1, -1, 0)$, and $(2, 0, 0)$, the curve is *s*-shaped. The least-squares fit will produce a quadratic curve with control points $(-2, 0, 0)$, $(0, 0, 0)$, and $(2, 0, 0)$. This curve is a straight line segment.

Let the original curve be $\vec{x}(t) = \sum_{i=0}^{n} B_{n,i}(t) \vec{p}_i$ and let the degree-reduced curve be $\vec{y}(t) = \sum_{i=0}^{m} B_{m,i}(t) \vec{q}_i$, where $m < n$. The end control points are required to be the same, $\vec{q}_0 = \vec{p}_0$ and $\vec{q}_m = \vec{p}_n$. The remaining control points \vec{q}_i, $1 \le i \le m - 1$, are chosen to minimize the integral of the squared differences of the two curves,

$$E(\vec{q}_1, \ldots, \vec{q}_{m-1}) = \int_0^1 \left| \vec{x}(t) - \vec{y}(t) \right|^2 \, dt.$$

The values of the interior control points are determined by setting all the partial derivatives of E to zero, $\partial E / \partial \vec{q}_j = 0$ for $1 \le j \le m - 1$. This leads to the $m - 1$ equations in the $m - 1$ unknown control points,

$$\sum_{i=0}^{m} \frac{(2m + 1)C(m; i)}{C(2m; i + j)} \vec{q}_i = \sum_{i=0}^{n} \frac{(m + n + 1)C(n; i)}{C(m + n; i + j)} \vec{p}_i.$$

The system always has a solution.

The equations can be solved symbolically for some cases of interest. For $n = 3$ and $m = 2$, the solution is

$$\vec{q}_0 = \vec{p}_0$$

$$\vec{q}_1 = \frac{1}{4}\left(-\vec{p}_0 + 3\vec{p}_1 + 3\vec{p}_2 - \vec{p}_3\right)$$

$$\vec{q}_2 = \vec{p}_3.$$

For $n = 4$ and $m = 3$, the solution is

$$\vec{q}_0 = \vec{p}_0$$

$$\vec{q}_1 = \frac{1}{42}\left(-11\vec{p}_0 + 44\vec{p}_1 + 18\vec{p}_2 - 12\vec{p}_3 + 3\vec{p}_4\right)$$

$$\vec{q}_2 = \frac{1}{42}\left(3\vec{p}_0 - 12\vec{p}_1 + 18\vec{p}_2 + 44\vec{p}_3 - 11\vec{p}_4\right)$$

$$\vec{q}_3 = \vec{p}_4.$$

For $n = 4$ and $m = 2$, the solution is

$$\vec{q}_0 = \vec{p}_0$$

$$\vec{q}_1 = \frac{1}{28}\left(-11\vec{p}_0 + 16\vec{p}_1 + 18\vec{p}_2 + 16\vec{p}_3 - 11\vec{p}_4\right)$$

$$\vec{q}_2 = \vec{p}_4.$$

7.3.2 NATURAL, CLAMPED, AND CLOSED CUBIC SPLINES

SOURCE CODE

LIBRARY

Curve

FILENAME

NaturalSpline2
NaturalSpline3

These curve types have the property of *exact interpolation*—the curves pass through all of the sample points. The motivation is based on interpolation of a univariate function. A good discussion of the topic for natural and clamped splines is Burden and Faires (1985). The closed spline algorithm is not mentioned in Burden and Faires (1985), but can be developed in a similar manner as the natural and clamped versions. A brief discussion is given here.

A list of points (t_i, f_i) for $0 \le i \le n$ is specified. On each interval $[t_i, t_{i+1}]$ with $0 \le i \le n - 1$, a cubic function $S_i(t) = a_i + b_i(t - t_i) + c_i(t - t_i)^2 + d_i(t - t_i)^3$ is required so that the following conditions are met. The first set of conditions are for exact interpolation,

$$S_i(t_i) = f_i, \quad 0 \le i \le n - 1, \quad S_{n-1}(t_n) = f_n, \tag{7.2}$$

for a total of $n + 1$ constraints. The second set requires that the polynomial values at the interior control points must match,

$$S_{i+1}(t_{i+1}) = S_i(t_{i+1}), \quad 0 \leq i \leq n - 2, \tag{7.3}$$

for a total of $n - 1$ constraints. The third set of conditions requires that the first derivatives at the interior control points must match,

$$S'_{i+1}(t_{i+1}) = S'_i(t_{i+1}), \quad 0 \leq i \leq n - 2, \tag{7.4}$$

for a total of $n - 1$ constraints. The fourth set of conditions requires that the second derivatives at the interior control points must match,

$$S''_{i+1}(t_{i+1}) = S''_i(t_{i+1}), \quad 0 \leq i \leq n - 2, \tag{7.5}$$

for a total of $n - 1$ constraints. All conditions together yield $4n - 2$ constraints. The unknown quantities are the coefficients a_i, b_i, c_i, and d_i for $0 \leq i \leq n - 1$. The number of unknowns is $4n$. Two additional constraints must be posed in hopes of obtaining a linear system of $4n$ equations in $4n$ unknowns. The three cases considered here are

- Natural splines: $S''_0(t_0) = 0$ and $S''_{n-1}(t_n) = 0$.
- Clamped splines: $S'_0(t_0)$ and $S'_{n-1}(t_n)$ are specified by the application.
- Closed splines: $S_0(t_0) = S_{n-1}(t_n)$, $S'_0(t_0) = S'_{n-1}(t_n)$, and $S''_0(t_0) = S''_{n-1}(t_n)$, in which case it is necessary that $f_0 = f_n$. Although these appear to be a set of three additional constraints, not two, the requirement that the input data satisfy $f_0 = f_n$ automatically guarantees that $S_0(t_0) = S_{n-1}(t_n)$ whenever the original exact interpolation constraints are satisfied.

Define $h_i = t_{i+1} - t_i$ for $0 \leq i \leq n - 1$. Equation (7.2) implies

$$a_i = f_i, \quad 0 \leq i \leq n - 1$$

$$a_{n-1} + b_{n-1}h_{n-1} + c_{n-1}h_{n-1}^2 + d_{n-1}h_{n-1}^3 = f_n. \tag{7.6}$$

Equation (7.3) implies

$$a_{i+1} = a_i + b_i h_i + c_i h_i^2 + d_i h_i^3, \quad 0 \leq i \leq n - 2. \tag{7.7}$$

Equation (7.4) implies

$$b_{i+1} = b_i + 2c_i h_i + 3d_i h_i^2, \quad 0 \leq i \leq n - 2. \tag{7.8}$$

And Equation (7.5) implies

$$c_{i+1} = c_i + 3d_i h_i, \quad 0 \leq i \leq n - 2. \tag{7.9}$$

Equation (7.9) can be solved for d_i,

$$d_i = \frac{c_{i+1} - c_i}{3h_i}, \quad 0 \le i \le n - 1. \tag{7.10}$$

Replacing Equation (7.10) in Equation (7.7) and solving for b_i yields

$$b_i = \frac{a_{i+1} - a_i}{h_i} - \frac{(2c_i + c_{i+1})h_i}{3}, \quad 0 \le i \le n - 2. \tag{7.11}$$

Replacing Equation (7.11) in Equation (7.8) yields

$$h_{i-1}c_{i-1} + 2(h_i + h_{i-1})c_i + h_i c_{i+1} = \frac{3(a_{i+1} - a_i)}{h_i} - \frac{3(a_i - a_{i-1})}{h_{i-1}}, \tag{7.12}$$

$$1 \le i \le n - 1.$$

Natural Splines

Define $c_n = S''_{n-1}(t_n)/2$. The boundary condition $S''_0(t_0) = 0$ yields

$$c_0 = 0. \tag{7.13}$$

The other condition $S''_{n-1}(t_n) = 0$ yields

$$c_n = 0. \tag{7.14}$$

Equations (7.12), (7.13), and (7.14) form a tridiagonal system of linear equations that can be solved by standard methods in $O(n)$ time.

Clamped Splines

Let the boundary conditions be $S'_0(t_0) = f'_0$ and $S_{n-1}(t_n) = f'_n$, where f'_0 and f'_n are specified by the application. These lead to two equations,

$$2h_0 c_0 + h_0 c_1 = \frac{3(a_1 - a_0)}{h_0} - 3f'_0 \tag{7.15}$$

and

$$h_{n-1}c_{n-1} + 2h_{n-1}c_n = 3f'_n - \frac{3(a_n - a_{n-1})}{h_{n-1}}, \tag{7.16}$$

where we define $a_n = f_n = S_{n-1}(t_n)$. Equations (7.12), (7.15), and (7.16) form a tridiagonal system of linear equations that can be solved by standard methods in $O(n)$ time.

Closed Splines

It is necessary that $f_n = f_0$ to obtain a well-posed system of equations defining the polynomial coefficients. In this case $a_0 = a_n$, where we define $a_n = f_n = S_{n-1}(t_n)$. The boundary condition $S_0''(t_0) = S_{n-1}''(t_n)$ and defined value $c_n = S_{n-1}''(t_n)/2$ imply a constraint

$$c_0 = c_n. \tag{7.17}$$

The boundary condition $S_0'(t_0) = S_{n-1}'(t_n)$ implies

$$b_0 = b_{n-1} + 2c_{n-1}h_{n-1} + 3d_{n-1}h_{n-1}^2.$$

We also know that

$$b_0 = \frac{a_1 - a_0}{h_0} - \frac{(2c_0 + c_1)h_0}{3}$$

$$b_{n-1} = \frac{a_n - a_{n-1}}{h_{n-1}} - \frac{(2c_{n-1} + c_n)h_{n-1}}{3}$$

$$d_{n-1} = \frac{c_n - c_{n-1}}{3h_{n-1}}.$$

Substituting these quantities in the last constraint yields

$$h_{n-1}c_{n-1} + 2(h_{n-1} + h_0)c_0 + h_0 c_1 = 3\left(\frac{a_1 - a_0}{h_0} - \frac{a_0 - a_{n-1}}{h_{n-1}}\right). \tag{7.18}$$

Equations (7.12), (7.17), and (7.18) form a linear system of equations, but it is not tridiagonal and requires a general linear system solver.

The natural, clamped, and closed spline interpolations were defined for fitting a sequence of scalar values, but they can be simply extended to curves by fitting each coordinate component of the curve separately.

7.3.3 NONPARAMETRIC B-SPLINE CURVES

The splines of the previous section are exact interpolating and require solving systems of equations whose size is the number of control points. If one of the control points is changed, the system of equations must be solved again and the entire curve is affected by the change. This might be an expensive operation in an interactive application or when the number of control points is very large. An alternative is to obtain *local control* in exchange for a nonexact interpolation. In this setting, changing a control point affects the curve only locally and any recalculations for the curve are minimal.

One way to obtain local control is to use *B-spline* curves. Generally, a *parameterized* B-spline curve can be built from an ordered list of parameters $\{t_i\}$ and points $\{\vec{p}_i\}$ for $0 \le i \le n$. A detailed discussion of the theory of B-spline curves is found in Farin (1990). The discussion in this section is restricted to *nonparametric* B-spline curves, where the parameter value for each control point is the index of the point, that is, $t_i = i$ for all i.

It is sufficient to understand nonparametric B-spline interpolation of tabulated scalar data. The interpolation for vector data is done per coordinate of the data. Given function values $\{f_i\}_{i=0}^{n}$ where the time parameters are assumed to be $t_i = i$, we want to build a B-spline of degree d that approximates the function values. Let $B(t)$ be the spline function, defined piecewise on intervals of the form $[i, i + 1]$ for $\lfloor(d - 1)/2\rfloor \le i \le \lfloor n - (d - 1)/2 \rfloor$. For each interval, the interpolating polynomial is labeled $B_i(t)$. For example, if $d = 3$ and $n = 4$, then the five control points will be interpolated by two cubic polynomials, $B_1(t)$ for $t \in [1, 2]$ and $B_2(t)$ for $t \in [2, 3]$. To obtain an interpolation for $t \in [0, \lfloor(d - 1)/2\rfloor]$ or $t \in [\lfloor n - (d - 1)/2 \rfloor, n]$ requires specifying additional information at the boundaries of the control points, typically through repetition of the end control points.

For $t \in [i, i + 1]$, the B-spline polynomial is defined as

$$B_i(t) = \sum_{j=0}^{d} \sum_{k=0}^{d} f_{i-\lfloor(d-1)/2\rfloor+j} M_{jk} X_k(t).$$

The polynomial components are $X_k(t) = (t - i)^k$ for $0 \le k \le d$. The $(d + 1) \times (d + 1)$ *blending matrix* $M = [M_{jk}]$ is constructed in the next paragraph. The evaluation of the B-spline for a given t involves nested summation over the appropriate indices. Derivatives of $B(t)$ are evaluated accordingly:

$$\frac{d^p B(x)}{dt^p} = \sum_{j=0}^{d} \sum_{k=0}^{d} f_{i-1+j} M_{jk} \frac{d^p X_k(t)}{dt^p},$$

where $1 \le p \le d$. For $p > d$, the derivatives are identically zero since $B(t)$ is of degree d.

The blending matrix M is now constructed. Given values $\{t_i\}_{i=0}^{n}$, define

$$B_i^{(0)}(t) = \begin{cases} 1, & t \in [t_i, t_{i+1}] \\ 0, & \text{otherwise} \end{cases}.$$

Recursively define

$$B_i^{(d)}(t) = \left(\frac{t - t_i}{t_{i+d} - t_i}\right) B_i^{(d-1)}(t) + \left(\frac{t_{i+d+1} - t}{t_{i+d+1} - t_{i+1}}\right) B_{i+1}^{d-1}(t)$$

for $d \ge 1$. For $t_i = i$, $B_{i+j}^{(d)}(t) = B_i^{(d)}(t - j)$, so there is essentially one B-spline basis function to compute for each d, call it $B_d(t)$. Thus,

$$B_0(t) = \begin{cases} 1, & t \in [0, 1] \\ 0, & \text{otherwise} \end{cases}$$

and

$$B_{d+1}(t) = \frac{t}{d+1} B_d(t) + \frac{d+2-t}{d+1} B_d(t-1),$$

where

$$B_d(t) = \begin{cases} P_d^{(k)}(t), & t \in [k, k+1) \text{ for } 0 \le k \le d \\ 0, & \text{otherwise} \end{cases}$$

and where the $P_d^{(k)}(t)$ are polynomials of degree d to be determined. The recursion implies

$$P_0^{(0)}(t) = 1$$

and

$$P_{d+1}^{(k)}(t) = \frac{t}{d+1} P_d^{(k)}(t) + \frac{d+2-t}{d+1} P_d^{(k-1)}(t-1), \quad 0 \le k \le d+1.$$

Setting

$$P_d^{(k)}(t) = \frac{1}{d!} \sum_{i=0}^{d} a_i^{(k,d)} t^i,$$

we obtain

$$P_d^{(k)}(t-1) = \frac{1}{d!} \sum_{i=0}^{d} a_i^{(k,d)} (t-1)^i$$

$$= \frac{1}{d!} \sum_{i=0}^{d} \left(\sum_{j=i}^{d} (-1)^{j-i} \binom{j}{i} a_j^{(k,d)} \right) t^i$$

$$=: \frac{1}{d!} \sum_{i=0}^{d} b_i^{(k,d)} t^i.$$

The recursion for the polynomials yields

$$a_i^{(k,d+1)} = a_{i-1}^{(k,d)} - b_{i-1}^{(k-1,d)} + (d+2) b_i^{(k-1,d)}$$

for $0 \le i \le d+1$ and $0 \le k \le d+1$. By convention, if an index is out of range, the term containing that index is 0. The initial data is $a_0^{(0,0)} = 1$ (so $b_0^{(0,0)} = 1$).

Define

$$Q_d^{(k)}(t) = P_d^{(k)}(t+k);$$

then

$$Q_d^{(k)}(t) = \frac{1}{d!} \sum_{i=0}^{d} a_i^{(k,d)}(t+k)^i$$

$$= \frac{1}{d!} \sum_{i=0}^{d} \left(\sum_{j=i}^{d} k^{j-i} \binom{j}{i} a_i^{(k,d)} \right) t^i$$

$$=: \frac{1}{d!} \sum_{i=0}^{d} c_i^{(k,d)} t^i.$$

The basis matrix $M = [M_{ij}]$ is therefore

$$M_{ij} = c_i^{(d-j,d)}.$$

Basis matrices for $1 \le d \le 5$ are

$$\begin{bmatrix} 1 & -1 \\ 0 & 1 \end{bmatrix}, \quad \frac{1}{2}\begin{bmatrix} 1 & -2 & 1 \\ 1 & 2 & -2 \\ 0 & 0 & 1 \end{bmatrix}, \quad \frac{1}{6}\begin{bmatrix} 1 & -3 & 3 & -1 \\ 4 & 0 & -6 & 3 \\ 1 & 3 & 3 & -3 \\ 0 & 0 & 0 & 1 \end{bmatrix},$$

$$\frac{1}{24}\begin{bmatrix} 1 & -4 & 6 & -4 & 1 \\ 11 & -12 & -6 & 12 & -4 \\ 11 & 12 & -6 & -12 & 6 \\ 1 & 4 & 6 & 4 & -4 \\ 0 & 0 & 0 & 0 & 1 \end{bmatrix}, \quad \frac{1}{120}\begin{bmatrix} 1 & -5 & 10 & -10 & 5 & 1 \\ 26 & -50 & 20 & 20 & -20 & 5 \\ 66 & 0 & -60 & 0 & 30 & -10 \\ 26 & 50 & 20 & -20 & -20 & 10 \\ 1 & 5 & 10 & 10 & 5 & -5 \\ 0 & 0 & 0 & 0 & 0 & 1 \end{bmatrix}$$

The pseudocode for nonparameteric B-spline evaluation is given below. It is assumed that the blending matrix has already been computed. The quantity $f_{\lfloor t \rfloor - \lfloor (d-1)/2 \rfloor + j} M_{jk}$ is referred to in the code as the *intermediate tensor*.

```
const int D;  // degree D > 0
const int Dp1 = D+1;
const int offset = floor((D-1)/2);
const float M[Dp1][Dp1];  // blending matrix
const int N;  // last data index, N >= D
float f[N+1];  // data to be interpolated
```

```
float t;  // floor((D-1)/2) <= t < floor(N-(D-1)/2)

// determine base index of interval for evaluation
int b = floor(t) - offset;

// compute intermediate tensor (nonpolynomial part of B(t))
float intermediate[Dp1];
for (k = 0; k <= D; k++)
{
    intermediate[k] = 0;
    for (j = 0, i = b; j <= D; j++, i++)
        intermediate[k] += data[i]*M[j][k];
}

// compute polynomial (1,t,t^2,...,t^D)
float X[Dp1];
float dt = t - b;
X[0] = 1;
for (k = 1; k <= D; k++)
    X[k] = X[k-1]*dt;

// compute final result
float result = 0;
for (k = 0; k <= D; k++)
    result += intermediate[k]*X[k];
```

7.3.4 KOCHANEK-BARTELS SPLINES

SOURCE CODE

LIBRARY

Curve

FILENAME

TCBSpline2
TCBSpline3

Given an ordered list of points $\{\vec{p}_i\}_{i=0}^n$, the Kochanek-Bartels splines provide a cubic interpolation between each pair \vec{p}_i and \vec{p}_{i+1} with varying properties specified at the end points (Kochanek and Bartels 1996). These properties are *tension* τ, which controls how sharply the curve bends at a control point; *continuity* γ, which provides a smooth visual variation in the continuity at a control point ($\gamma = 0$ yields derivative continuity, but $\gamma \neq 0$ gives discontinuities); and *bias* β, which controls the direction of the path at a control point by taking a weighted combination of one-sided derivatives at that control point.

Using a Hermite interpolation basis $H_0(t) = 2t^3 - 3t^2 + 1$, $H_1(t) = -2t^3 + 3t^2$, $H_2(t) = t^3 - 2t^2 + t$, and $H_3(t) = t^3 - t^2$, a parametric cubic curve passing through points \vec{p}_i and \vec{p}_{i+1} with tangent vectors \vec{T}_i and \vec{T}_{i+1}, respectively, is

$$\vec{x}_i(t) = H_0(t)\vec{p}_i + H_1(t)\vec{p}_{i+1} + H_2(t)\vec{T}_i + H_3(t)\vec{T}_{i+1}, \tag{7.19}$$

where $0 \leq t \leq 1$. Catmull-Rom interpolation is a special case where $\vec{T}_i = (\vec{p}_{i+1} - \vec{p}_{i-1})/2$, a centered finite difference.

Equation (7.19) may be modified to allow specification of an *outgoing* tangent \vec{T}_i^0 at $t = 0$ and an *incoming* tangent \vec{T}_{i+1}^1 at $t = 1$,

$$\vec{x}_i(t) = H_0(t)\vec{p}_i + H_1(t)\vec{p}_{i+1} + H_2(t)\vec{T}_i^0 + H_3(t)\vec{T}_{i+1}^1. \tag{7.20}$$

Tension $\tau \in [-1, 1]$ can be introduced by using

$$\vec{T}_i^0 = \vec{T}_i^1 = \frac{(1-\tau)}{2}\left((\vec{p}_{i+1} - \vec{p}_i) + (\vec{p}_i - \vec{p}_{i-1})\right).$$

The Catmull-Rom spline occurs when $\tau = 0$. For τ near 1 the curve is *tightened* at the control point; τ near -1 produces *slack* at the control point. Varying τ changes the length of the tangent at the control point; a smaller tangent leads to a tightening, and a larger tangent leads to a slackening.

Continuity $\gamma \in [-1, 1]$ can be introduced by using

$$\vec{T}_i^0 = \left(\frac{1-\gamma}{2}(\vec{p}_{i+1} - \vec{p}_i) + \frac{1+\gamma}{2}(\vec{p}_i - \vec{p}_{i-1})\right)$$

and

$$\vec{T}_i^1 = \left(\frac{1+\gamma}{2}(\vec{p}_{i+1} - \vec{p}_i) + \frac{1-\gamma}{2}(\vec{p}_i - \vec{p}_{i-1})\right).$$

When $\gamma = 0$, the curve has a continuous tangent vector at the control point. As $|\gamma|$ increases, the resulting curve has a *corner* at the control point, the direction of the corner depending on the sign of γ.

Bias $\beta \in [-1, 1]$ can be introduced by using

$$T_n^0 = T_n^1 = \left(\frac{1-\beta}{2}(P_{n+1} - P_n) + \frac{1+\beta}{2}(P_n - P_{n-1})\right).$$

When $\beta = 0$, the left and right one-sided tangents are equally weighted, producing the Catmull-Rom spline. For β near -1, the outgoing tangent dominates the direction of the path of the curve through the control point—an effect referred to as *undershooting*. For β near 1, the incoming tangent dominates—an effect referred to as *overshooting*.

The three effects may be combined into a single set of equations

$$\vec{T}_i^0 = \frac{(1-\tau)(1-\gamma)(1-\beta)}{2}(\vec{p}_{i+1} - \vec{p}_i) + \frac{(1-\tau)(1+\gamma)(1+\beta)}{2}(\vec{p}_i - \vec{p}_{i-1}) \tag{7.21}$$

and

$$\vec{T}_i^1 = \frac{(1-\tau)(1+\gamma)(1-\beta)}{2}(\vec{p}_{i+1} - \vec{p}_i) + \frac{(1-\tau)(1-\gamma)(1+\beta)}{2}(\vec{p}_i - \vec{p}_{i-1}). \tag{7.22}$$

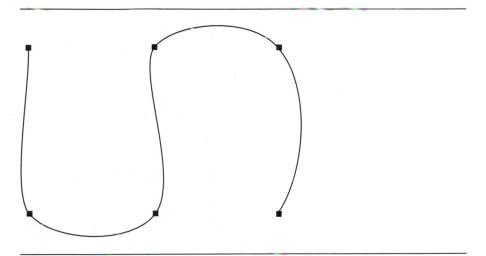

Figure 7.1 Parameters: $\tau = 0, \gamma = 0, \beta = 0$.

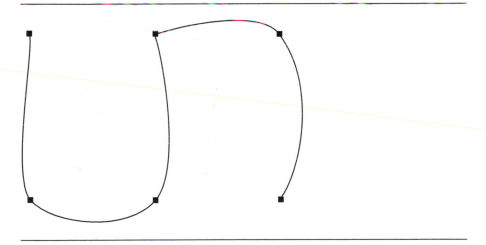

Figure 7.2 Parameters: $\tau = 1, \gamma = 0, \beta = 0$.

These formulas assume a uniform spacing in time of the position samples. An adjustment can be made for nonuniform spacing. For Equation (7.21) the multiplier is $2\Delta_i/(\Delta_{i-1} + \Delta_i)$, and for Equation (7.22) the multiplier is $2\Delta_{i-1}/(\Delta_{i-1} + \Delta_i)$, where $\Delta_i = s_{i+1} - s_i$ and s_i is the sample time for position \vec{p}_i.

Figures 7.1 through 7.7 show a curve with six control points and various choices for tension, continuity, and bias at one of the control points.

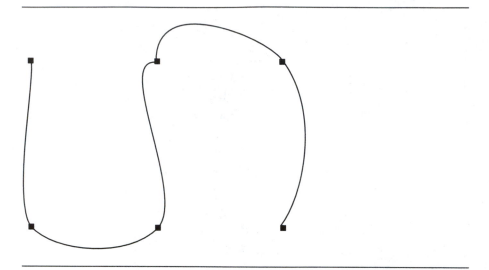

Figure 7.3 Parameters: $\tau = 0, \gamma = 1, \beta = 0$.

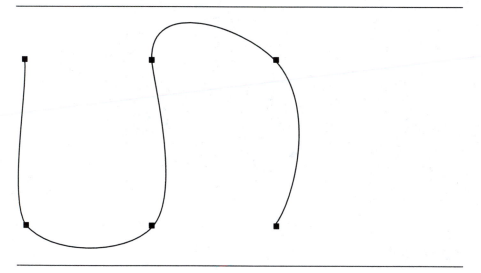

Figure 7.4 Parameters: $\tau = 0, \gamma = 0, \beta = 1$.

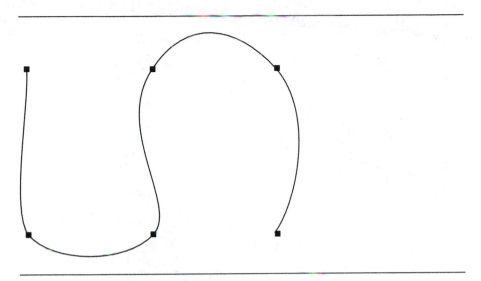

Figure 7.5 Parameters: $\tau = -1, \gamma = 0, \beta = 0$.

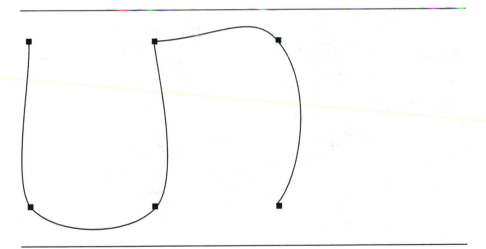

Figure 7.6 Parameters: $\tau = 0, \gamma = -1, \beta = 0$.

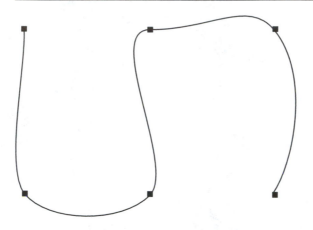

Figure 7.7　Parameters: $\tau = 0$, $\gamma = 0$, $\beta = -1$.

7.4　SUBDIVISION

SOURCE CODE

LIBRARY

Curve

FILENAME

Curve

For drawing purposes, it is sometimes necessary to produce a piecewise linear approximation to a curve with $n + 1$ curve points that will be the line segment end points. If t_i are the selected curve parameters for $0 \le i \le n$, then the set of points $\vec{x}_i = \vec{x}(t_i)$ for $0 \le i \le n$ is referred to as a *subdivision* of the curve. Five methods are discussed.

7.4.1　SUBDIVISION BY UNIFORM SAMPLING

The simplest way to subdivide is to uniformly sample $[t_{\min}, t_{\max}]$ as $t_i = t_{\min} + (t_{\max} - t_{\min})i/n$ for $0 \le i \le n$. Although easy to compute, the resulting polyline is not always a good approximation because places of large variation in the curve might be skipped. Figure 7.8 illustrates a uniform subdivision.

7.4.2　SUBDIVISION BY ARC LENGTH

This subdivision scheme selects a set of points that are equidistant from each other (measured with respect to arc length). Given $s_i = Li/n$, where L is the total curve length and $0 \le i \le n$, the algorithm for reparameterization by arc length can be applied to produce the corresponding t_i value. The subdivision points $\vec{x}(t_i)$ are then calculated. This method has the same problem as uniform sampling, namely, large variations of the curve over a small arc length may not be captured unless n is quite large. Figure 7.9 illustrates a subdivision by arc length.

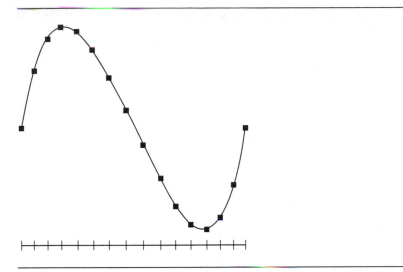

Figure 7.8 Uniform subdivision of a curve.

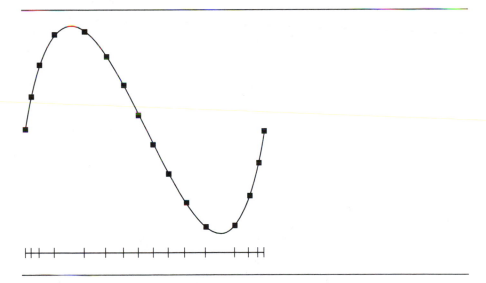

Figure 7.9 Subdivision of a curve by arc length.

7.4.3 SUBDIVISION BY MIDPOINT DISTANCE

This scheme produces a nonuniform sampling by recursively bisecting the parameter space. The bisection is actually performed, and the resulting curve point corresponding to the midpoint parameter is analyzed. If \vec{a} and \vec{b} are the end points of the segment

and if \vec{c} is the computed point in the bisection step, then the distance D_0 from \vec{c} to the segment is computed. If $D_1 = |\vec{b} - \vec{a}|$, then \vec{c} is added to the tessellation if $D_0/D_1 > \varepsilon$ for an application-specified maximum relative error of $\varepsilon > 0$. The pseudocode is given below. Rather than maintaining a doubly linked list to handle the insertion of points on subdivision, the code maintains a singly linked list of ordered points.

```
Input:   Curve x(t) with t in [tmin,tmax]
         m, the maximum level of subdivision
         epsilon, the maximum relative error
         subdivision {}, an empty list
Output: n >= 1 and subdivision {p[0],....,p[n]}

bool Bisect (int level, float t0, Point x0, float t1, Point x1)
{
    if ( level > 0 )
    {
        tm = (t0+t1)/2;
        xm = x(tm);
        d0 = length of segment <x0,x1>
        d1 = distance from xm to segment <x0,x1>;

        if ( d1/d0 > epsilon )
        {
            Bisect(level-1,t0,x0,tm,xm);
            Bisect(level-1,tm,xm,t1,x1);
            return;
        }
    }

    add x1 to end of list;
}

Initial call:
    subdivision = { x(tmin) };
    Bisect(m,tmin,x(tmin),tmax,x(tmax));
```

Figure 7.10 illustrates a subdivision using this method.

7.4.4 SUBDIVISION BY VARIATION

The midpoint distance subdivision used a bisection criterion based on performing the bisection, then deciding on how much the midpoint varies from the original line segment. There are many other criteria to choose from for deciding whether or not to

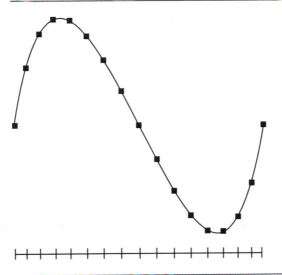

Figure 7.10 Subdivision of a curve by midpoint distance.

bisect. One criterion is to measure on a subinterval the variation between the curve and the line segment connecting the end points of the subinterval. If the subinterval is $[t_i, t_{i+1}]$, then the variation is

$$V = \int_{t_i}^{t_{i+1}} \left| \vec{x}(t) - \vec{\ell}_i(t) \right|^2 \, dt,$$

where $\vec{\ell}(t)_i$ is the line segment connecting the points $\vec{x}(t_i)$ and $\vec{x}(t_{i+1})$,

$$\vec{\ell}_i(t) = \vec{x}(t_i) + \frac{t - t_i}{t_{i+1} - t_i} \left(\vec{x}(t_{i+1}) - \vec{x}(t_i) \right). \tag{7.23}$$

The integration is shown for $i = 0$ to illustrate some optimizations that can be made in computing variation. Define $\vec{x}_j = \vec{x}(t_j)$ for $j = 0, 1$. The integral can be decomposed as

$$V = \int_{t_0}^{t_1} \vec{\ell} \cdot \vec{\ell} \, dt - 2 \int_{t_0}^{t_1} \vec{x} \cdot \vec{x}_0 \, dt - 2 \int_{t_0}^{t_1} \vec{x} \cdot (\vec{x}_1 - \vec{x}_0) \frac{t - t_0}{t_1 - t_0} \, dt$$

$$+ \int_{t_0}^{t_1} \vec{x} \cdot \vec{x} \, dt = V_1 - 2V_2 - 2V_3 + V_4.$$

The first integral is

$$V_1 = \int_{t_0}^{t_1} \vec{x}_0 \cdot \vec{x}_0 + 2\vec{x}_0 \cdot (\vec{x}_1 - \vec{x}_0)\frac{t - t_0}{t_1 - t_0} + (\vec{x}_1 - \vec{x}_0) \cdot (\vec{x}_1 - \vec{x}_0)\left(\frac{t - t_0}{t_1 - t_0}\right)^2 dt$$

$$= (t_1 - t_0)\vec{x}_0 \cdot \vec{x}_0 + (t_1 - t_0)\vec{x}_0 \cdot (\vec{x}_1 - \vec{x}_0) + \frac{t_1 - t_0}{3}(\vec{x}_1 - \vec{x}_0) \cdot (\vec{x}_1 - \vec{x}_0)$$

$$= \frac{t_1 - t_0}{3}\left(\vec{x}_0 \cdot \vec{x}_0 + \vec{x}_0 \cdot \vec{x}_1 + \vec{x}_1 \cdot \vec{x}_1\right).$$

The second integral is

$$V_2 = \int_{t_0}^{t_1} \sum_{i=0}^{n} C(n; i)t^i (1 - t)^{n-i}\vec{p}_i \cdot \vec{x}_0 \, dt = \sum_{i=0}^{n} C(n; i)\vec{p}_i \cdot \vec{x}_0 \int_{t_0}^{t_1} t^i (1 - t)^{n-i} \, dt$$

$$= \sum_{i=0}^{n} C(n; i)\vec{p}_i \cdot \vec{x}_0 I_i,$$

where $I_i = \int_{t_0}^{t_1} t^i (1 - t)^{n-i} \, dt$. An integration by parts with $u = t^i$ and $dv = (1 - t)^{n-i} dt$ leads to the recursion formula

$$I_i = \frac{t_0^i (1 - t_0)^{n-i+1} - t_1^i (1 - t_1)^{n-i+1} + i I_{i-1}}{n - i + 1}$$

for $i \geq 0$ with initial value $I_{-1} = 0$ (any value will suffice).

Similarly, the third integral is

$$V_3 = \sum_{i=0}^{n} C(n; i)\frac{\vec{p}_i \cdot (\vec{x}_1 - \vec{x}_0)}{t_1 - t_0}(J_i - t_0 I_i),$$

where $J_i = \int_{t_0}^{t_1} t^{i+1}(1 - t)^{n-i} \, dt$. Integration by parts leads to the recursion formula

$$J_i = \frac{t_0^{i+1}(1 - t_0)^{n-i+1} - t_1^{i+1}(1 - t_1)^{n-i+1} + (i + 1)J_{i-1}}{n - i + 1}$$

for $i \geq 0$. An initial value for J_{-1} can be computed from the same recursion formula with $i = -1$ (any value for J_{-2} will suffice). An application can precompute $1/(n - i + 1)$ for the appropriate i so that at run time the calculation of variation avoids the expensive divisions.

The fourth integral is somewhat more complicated. Consider

$$V_4 = \int_{t_0}^{t_1} \left(\sum_{j=0}^{n} C(n;j) t^j (1-t)^{n-j} \vec{p}_j \right) \cdot \left(\sum_{k=0}^{n} C(n;k) t^k (1-t)^{n-k} \vec{p}_k \right) \, dt$$

$$= \sum_{j=0}^{n} \sum_{k=0}^{n} C(n;j) C(n;k) \vec{p}_j \cdot \vec{p}_k \int_{t_0}^{t_1} t^{j+k} (1-t)^{2n-j-k} \, dt$$

$$= \sum_{i=0}^{2n} \left(\sum_{j+k=i} S_{jk} \right) K_i,$$

where $S_{jk} = C(n;j) C(n;k) \vec{p}_j \cdot \vec{p}_k$ is symmetric in its indices and the indices are restricted to $0 \le j \le n$ and $0 \le k \le n$. Also, $K_i = \int_{t_0}^{t_1} t^i (1-t)^{2n-i} \, dt$, an integral the same as I_i but with n replaced by $2n$. The recursion formula is

$$K_i = \frac{t_0^i (1-t_0)^{2n-i+1} - t_1^i (1-t_1)^{2n-i+1} + i K_{i-1}}{2n - i + 1}$$

for $i \ge 0$. The summation $\sum_{j+k=i} S_{jk}$ with the noted restrictions on j and k and with $0 \le i \le 2n$ can be viewed as a summation over diagonals of the original $(n+1) \times (n+1)$ lattice of points. The diagonals start at $i = 0$ (1 entry on diagonal), grow in quantity to $i = n$ (n entries on diagonal), then shrink in quantity to $i = 2n$ (1 entry on diagonal). As such, the summation is

$$\sigma_i = \sum_{j+k=i} S_{jk} = \begin{cases} \sum_{\ell=0}^{i} S_{\ell,i-\ell}, & 0 \le i \le n \\ \sum_{\ell=i-n}^{2n} S_{\ell,i-\ell}, & n+1 \le i \le 2n \end{cases} = \sum_{\ell=\max(0,i-n)}^{\min(i,n)} S_{\ell,i-\ell}.$$

Moreover, since S_{jk} is symmetric the summation can be further simplified into

$$\sigma_i = \begin{cases} S_{i/2,i/2} + 2 \sum_{\ell=\max(0,i-n)}^{i/2-1} S_{\ell,i-\ell}, & i \text{ even} \\ 2 \sum_{\ell=\max(0,i-n)}^{(i+1)/2-1} S_{\ell,i-\ell}, & i \text{ odd} \end{cases},$$

so $V_4 = \sum_{i=0}^{2n} \sigma_i K_i$. An application can precompute the σ_i values so that calculation of variation at run time is fast.

An application-specified tolerance $\varepsilon > 0$ is used to compare variations. The subinterval is bisected if and only if $V > \varepsilon$. However, to avoid deep recursions, a limit is placed on the number of recursive subdivisions. The pseudocode below illustrates the algorithm. Rather than maintaining a doubly linked list to handle the insertion of points on subdivision, the code maintains a singly linked list of ordered points.

```
Input:   Curve x(t) with t in [tmin,tmax]
         m, the maximum level of subdivision
         epsilon, the maximum relative error
         subdivision {}, an empty list
Output: n >= 1 and subdivision {p[0],...,p[n]}

void Bisect (int level, float t0, Point x0, float t1, Point x1)
{
    if ( level > 0 )
    {
        if ( Variation(t0,x0,t1,x1) > epsilon )
        {
            tm = (t0+t1)/2;
            compute xmid = x(tm);
            Bisect(level-1,t0,x0,tm,xm);
            Bisect(level-1,tm,xm,t1,x1);
            return;
        }
    }

    add x1 to end of list;
}

Initial call:
    subdivision = { x(tmin) };
    Bisect(m,tmin,x(tmin),tmax,x(tmax));
```

Figure 7.11 illustrates a subdivision using this method.

7.4.5 SUBDIVISION BY MINIMIZING VARIATION

The most desirable subdivision algorithm should allow the application to specify n ahead of time—a sample point budget, so to speak. The samples are selected so that large curvature portions of the curve have assigned to them a larger number of samples than do small curvature portions of the curve. This problem can be solved by using a minimization approach. Set $t_0 = t_{min}$ and $t_{m+1} = t_{max}$. Define $\vec{T} = (t_0, t_1, \ldots, t_{m+1})$ and define the energy function

$$E(\vec{T}) = \sum_{i=0}^{m} \int_{t_i}^{t_{i+1}} \left| \vec{x}(t) - \vec{\ell}_i(t) \right|^2 \, dt,$$

where $\vec{\ell}_i(t)$ is the line segment connecting the points $\vec{x}(t_i)$ and $\vec{x}(t_{i+1})$ and is defined by Equation (7.23). The domain variable \vec{T} lives in the simplex defined by $0 \le t_0 \le$

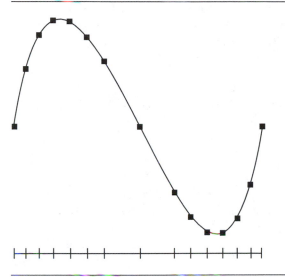

Figure 7.11 Subdivision of a curve by variation.

$t_1 \leq \cdots \leq t_{m+1} \leq 1$. The function E is continuous and its domain is a compact set, so E must attain a global minimum on its domain. The minimum can be computed with standard numerical minimizers (see Appendix B, Section B.4). The minimum value of E can even be used by the application as a measure of how well the polyline fits the curve. If minimum E is sufficiently large, the application might want to increase n to obtain a better fit. Most likely, the end points of the curve are required to be in the subdivision, so $t_0 = 0$ and $t_{m+1} = 1$ are required and the remaining t_i for $1 \leq i \leq m$ are computed by the minimization.

7.4.6 FAST SUBDIVISION FOR CUBIC CURVES

SOURCE CODE

LIBRARY

Curve

FILENAME

CubicPolynomial-
Curve2
CubicPolynomial-
Curve3

Cubic polynomial curves can be subdivided by variation as described earlier. A suggested criterion for subdivision is to measure on a subinterval the variation between the curve and the line segment connecting the end points of the subinterval. This can be an expensive operation in a real-time game engine, but the criterion provides an accurate representation of how flat the curve is on the subinterval. To speed things up, it is possible to use a heuristic that estimates the flatness, but sometimes may be inaccurate depending on the curve data. The method described in this section uses the magnitude of the second-derivative vector of the curve multiplied by the squared length of a subinterval as an estimate of how flat (or curved) the curve is on that subinterval. If the magnitude is smaller than the application-specified tolerance, the subdivision step is not executed. The classic case where the heuristic fails is an s-shaped curve whose point of inflection is the midpoint of the given interval.

The second derivative is zero at the midpoint, so the subdivision step is not executed. However, the curve can have significant variation from the line segment connecting the end points of the interval.

The subdivision-by-variation method is naturally recursive. We take advantage of this fact and use a central differencing scheme to compute the curve points (Watt and Watt 1992).

Let the cubic curve be $\vec{x}(t) = \sum_{i=0}^{3} \vec{c}_i t^i$ for $t \in [t_{\min}, t_{\max}]$. Using a Taylor series to represent the curve, the following equations can be derived:

$$\vec{x}(t \pm \delta) = \vec{x}(t) \pm \delta \vec{x}'(t) + \frac{1}{2}\delta^2 \vec{x}''(t) \pm \frac{1}{6}\delta^3 \vec{x}'''(t).$$

There are no additional terms in the Taylor series since the curve is already a polynomial. Taking the average of the two equations and solving for $\vec{x}(t)$ yields

$$\vec{x}(t) = \frac{1}{2}\left(\vec{x}(t+\delta) + \vec{x}(t-\delta) - \delta^2 \vec{x}''(t)\right). \qquad (7.24)$$

Expanding the second derivative term as a Taylor series, we obtain

$$\vec{x}''(t \pm \delta) = \vec{x}''(t) \pm \delta \vec{x}'''(t).$$

Adding these and solving for $\vec{x}''(t)$ yields

$$\vec{x}''(t) = \frac{1}{2}\left(\vec{x}''(t+\delta) + \vec{x}''(t-\delta)\right). \qquad (7.25)$$

Equation (7.25) allows us to compute the second derivative of the curve at the midpoint t of the interval $[t-\delta, t+\delta]$. This can be substituted in Equation (7.24) to compute the curve at the midpoint.

The pseudocode for the recursive subdivision is

```
Input:   Cubic curve x(t) with t in [tmin,tmax]
         epsilon, the maximum relative error (units of squared
         length)
         subdivision {}, an empty list
Output:  n >= 1 and subdivision {p[0],...,p[n]}

void Subdivide (float t0, float t1, Point x0, Point x1,
      Point sd0, Point sd1)
{
    // x0 and x1 are end points
    // sd0 and sd1 are second derivatives at the end points

    sdmid = 0.5*(sd0+sd1);
```

```
d = t1-t0;
dsqr = d*d;
nonlinearity = dsqr*sdmid;
if ( SquaredLength(nonlinearity) > epsilon )
{
    tmid = 0.5*(t0+t1);
    xmid = 0.5*(x0+x1-nonlinearity);
    insert xmid in subdivision between x0 and x1;
    Subdivide(t0,tmid,x0,xmid,sd0,sdmid);
    Subdivide(tmid,t1,xmid,x1,sdmid,sd1);
}
}

Initial call:
    x0 = x(tmin);
    x1 = x(tmax);
    sd0 = x"(tmin);
    sd1 = x"(tmax);
    subdivision = { x0, x1 };
    Subdivide(tmin,tmax,x0,x1,sd0,sd1);
```

7.5 ORIENTATION OF OBJECTS ON CURVED PATHS

Specifying a path of motion for an object, including the orientation of the object at each point along the path, is called *path controlling*. For example, if a model airplane is given a path to follow, the orientation of the model airplane along the path should be representative of the real thing. If the path takes the airplane to the right, the plane should change orientation and bank to the right.

Let the specified path of the object be a curve $\vec{x}(t)$ for some domain of t values. The orientation can be specified as a rotation matrix $R(t)$, where the columns of R are the coordinate axes at each point on the path. The columns are ordered in the following sense. The first column represents a *direction* vector, but is not required by the theory to be the tangent to the curve. The second column is an *up* vector, and the third column is a *right* vector. There are many ways to specify orientation, but the two most common are to use either the Frenet frame of the curve or a coordinate system with a fixed "up" vector where the upward direction is specific to an application.

7.5.1 ORIENTATION USING THE FRENET FRAME

This method requires that $\vec{x}(t)$ be twice differentiable so that the normal vector is well defined. Recall from the curve definitions that the Frenet frame consists of a tangent vector $\vec{T}(t)$, a normal vector $\vec{N}(t)$, and a binormal vector $\vec{B}(t) = \vec{T} \times \vec{N}$.

The tangent vector is a unit-length vector with direction $\vec{x}'(t)$. The normal vector represents a force parallel to the acceleration of the object. The orientation matrix is $R(t) = [\vec{T}(t) \; \vec{N}(t) \; \vec{B}(t)]$.

7.5.2 ORIENTATION USING A FIXED "UP" VECTOR

This method requires that $\vec{x}(t)$ be once differentiable so that the tangent vector is well defined. An application must specify a vector \vec{U} that points in the upward direction. The tangent vector is $\vec{T}(t)$, the unit-length vector with direction $\vec{x}'(t)$,

$$\vec{T}(t) = \frac{\vec{x}'(t)}{|\vec{x}'(t)|}.$$

The first column of $R(t)$ is chosen to be \vec{T}. The third column of $R(t)$, $\vec{B}(t)$, is computed as the unit-length cross product between \vec{T} and \vec{U},

$$\vec{B}(t) = \frac{\vec{T}(t) \times \vec{U}}{|\vec{T}(t) \times \vec{U}|}.$$

The second column of $R(t)$, $\vec{N}(t)$, is chosen as

$$\vec{N}(t) = \vec{B}(t) \times \vec{T}(t).$$

The only item of concern in using this method for orientation is that $\vec{T}(t)$ should never be parallel to \vec{U}, otherwise $\vec{B}(t) = \vec{0}$ and the coordinate system cannot be constructed. For numerical reasons, it is better to constrain the curve so that the angle between \vec{T} and \vec{U} is larger than a predefined positive minimum angle.

SURFACES

The need for curved surfaces in a game engine is becoming ever more important. Polygonal models have been used in the past for their simplicity in construction and efficiency in rendering, two aspects that surface models tend not to have. However, as personal computers and hardware-accelerated graphics cards increase in processing power, it is less essential to have simple polygonal models and more important for physical realism to have surface-based content. Also consider that the next-generation game consoles (Sega Dreamcast, Sony Playstation2, Nintendo Dolphin, and Microsoft X-Box) are extremely powerful—even more so than the current generation of CPUs— but they are typically limited in memory. For example, Sony Playstation2 has 32 MB of system memory and 4 MB of video memory. Large detailed polygonal models require a lot of memory for storage, so they are not good candidates for the content for consoles. However, curved surfaces have a very compact representation that requires a minimum of memory for storage, but can be dynamically tessellated during game play. The game consoles have the processing power to tessellate very rapidly, so curved surfaces should (and must) be the content of choice for those platforms. In addition, modeling packages will evolve to make surface modeling easier.

The topic of surfaces is even more extensive than that of curves, and again only a brief summary is given in this chapter. Sections 8.1 and 8.2 cover the basics:

tangents, normals, metric and curvature tensors (the analog to arc length and curvature for curves), and methods for constructing the various quantities. Special types of surfaces are discussed in Section 8.3: Bézier rectangle and triangle patches, Bézier cylinder surfaces (formed by linearly interpolating between two Bézier curve boundaries), nonparametric B-spline rectangle patches, quadric surfaces (spheres, ellipsoids, paraboloids, etc.), and tube surfaces (generated from a central curve with width information). Section 8.4 is an in-depth discussion of ways to subdivide the special types of surfaces found in the chapter. In particular, recursive subdivision of bicubic patches provides a rapid way for dynamically tessellating Bézier rectangle meshes. Just as for curves, nonuniform rational B-spline surfaces are not discussed here, but more detailed discussions can be found in Farin (1990) and Foley et al. (1990).

8.1 DEFINITIONS

A *parametric surface patch* is a function $\vec{x} : [u_{\min}, u_{\max}] \times [v_{\min}, v_{\max}] \subset \mathbb{R}^2 \to \mathbb{R}^3$. The surface boundary curves are $\vec{x}(u_{\min}, v)$, $\vec{x}(u_{\max}, v)$, $\vec{x}(u, v_{\min})$, and $\vec{x}(u, v_{\max})$. Tangent vectors to the surface are the partial derivatives $\vec{x}_u = \partial\vec{x}/\partial u$ and $\vec{x}_v = \partial\vec{x}/\partial v$. A normal vector at each point on the surface is the cross product of the partial derivatives, $\vec{N} = \vec{x}_u \times \vec{x}_v$. If unit-length normals are required, the cross product can be normalized. The patch is actually called a *rectangular patch* because the domain is a rectangular set in the parameter space. The standard domain for rectangular patches is $[0, 1]^2$. Another common type of patch is a *triangular patch,* where the domain is a triangular set. The standard domain for a triangular patch is $u \geq 0$, $v \geq 0$, and $u + v \leq 1$. Generally, the parametric domain can be a set $D \subseteq \mathbb{R}^2$. The *surface area* corresponding to subdomain $D_0 \subseteq D$ is

$$A = \int\int_{D_0} |\vec{x}_u \times \vec{x}_v| \; du \, dv.$$

An *implicit surface* is defined by level sets $F(\vec{x}) = c$ for a function $F : \mathbb{R}^3 \to \mathbb{R}$. A normal vector at each point is the gradient, $\vec{N} = \vec{\nabla}F$. If unit-length normals are required, the gradient can be normalized. Two linearly independent tangent vectors \vec{U} and \vec{V} can be constructed from \vec{N}. A reasonable algorithm for constructing the tangents is

```
Point3 N = (x,y,z);  // unit-length normal
Point3 U, V;  // unit-length tangents
if ( |x| >= |y| and |x| >= |z| )
    U = (y,-x,0)/sqrt(x*x+y*y);
```

```
else
    U = (0,y,-z)/sqrt(y*y+z*z);
V = Cross(N,U);
```

A surface that is the *graph* of a function f can be described either parametrically as $(x, y, f(x, y))$ or implicitly as $F(x, y, z) = z - f(x, y) = 0$. In the first case, two tangents are $\vec{U} = (1, 0, \partial f/\partial x)$ and $\vec{V} = (0, 1, \partial f/\partial y)$, and a normal is the cross product $\vec{N} = (-\partial f/\partial x, -\partial f/\partial y, 1) = (-\vec{\nabla} f, 1)$. In the second case, note that $\vec{\nabla} F = \vec{N}$.

8.2 CURVATURE

Curvature at a point \vec{P} on a surface is a generalization of the concept of curvature at a point on a curve. Let \vec{N} be a unit-length normal at \vec{P}, and let \vec{T} be any unit-length tangent vector. The intersection of the surface and the plane passing through point \vec{P} and containing vectors \vec{N} and \vec{T} is a curve (at least in a small neighborhood of \vec{P}). The curvature of that curve at \vec{P} can be computed, call it $\kappa_{\vec{T}}$. Thus, for each tangent \vec{T} at \vec{P}, a curvature can be measured. The minimum and maximum curvatures are called the *principal curvatures*. The corresponding tangent vectors are called the *principal directions* at the point.

The following discussion is a summary of what can be found in standard texts on differential geometry of surfaces (for example, Thorpe 1979).

8.2.1 CURVATURES FOR PARAMETRIC SURFACES

Consider a parametric surface $\vec{x}(u, v)$. Let $\vec{N} = \vec{x}_u \times \vec{x}_v / |\vec{x}_u \times \vec{x}_v|$, a unit-length normal to the surface. The *metric tensor* is the 2×2 matrix

SOURCE CODE

LIBRARY

Surface

FILENAME

ParametricSurface

$$G = \begin{bmatrix} \vec{x}_u \cdot \vec{x}_u & \vec{x}_u \cdot \vec{x}_v \\ \vec{x}_v \cdot \vec{x}_u & \vec{x}_v \cdot \vec{x}_v \end{bmatrix},$$

and the *curvature tensor* is

$$B = \begin{bmatrix} -\vec{N} \cdot \vec{x}_{uu} & -\vec{N} \cdot \vec{x}_{uv} \\ -\vec{N} \cdot \vec{x}_{vu} & -\vec{N} \cdot \vec{x}_{vv} \end{bmatrix}.$$

The principal curvatures $\kappa_{\min}^{\rightarrow}$ and $\kappa_{\max}^{\rightarrow}$ are the generalized eigenvalues of the system of equations $B\vec{w} = \kappa G \vec{w}$. The principal directions are determined by the corresponding 2D generalized eigenvectors. If κ is a principal curvature and

$\vec{w} = (w_0, w_1)$ is a 2D generalized eigenvector, then a corresponding principal direction as a 3D vector is $\vec{T} = w_0 \vec{x}_u + w_1 \vec{x}_v$. The *mean curvature* is the average $\kappa_{\text{mean}} = (\kappa_{\min} + \kappa_{\max})/2$. The *Gaussian curvature* is the product $\kappa_{\text{Gaussian}} = \kappa_{\min} \kappa_{\max}$, which actually has units of squared curvature.

Setting $B = [b_{ij}]$ and $G = [g_{ij}]$, the generalized eigenvalues of $B\vec{w} = \kappa G \vec{w}$ are solutions to the quadratic equation

$$
\begin{aligned}
0 &= \det(B - \kappa G) \\
&= (b_{00} - \kappa g_{00})(b_{11} - \kappa g_{11}) - (b_{01} - \kappa g_{01})(b_{10} - \kappa g_{10}) \\
&= (\det G)\kappa^2 + (b_{01} g_{10} + b_{10} g_{01} - b_{11} g_{00} - b_{00} g_{11})\kappa + (\det B).
\end{aligned}
$$

For each root κ, $\vec{w} \neq \vec{0}$ is constructed by solving $(B - \kappa G)\vec{w} = \vec{0}$. This system is not invertible and has infinitely many solutions.

8.2.2 CURVATURES FOR IMPLICIT SURFACES

Consider an implicit surface $F(x, y, z) = c$. The gradient is the vector of first derivatives,

SOURCE CODE

LIBRARY

Surface

$$
\vec{\nabla} F = \begin{bmatrix} F_x \\ F_y \\ F_z \end{bmatrix}.
$$

FILENAME

ImplicitSurface

The Hessian is the matrix of second derivatives,

$$
D^2 F = \begin{bmatrix} F_{xx} & F_{xy} & F_{xz} \\ F_{yx} & F_{yy} & F_{yz} \\ F_{zx} & F_{zy} & F_{zz} \end{bmatrix}.
$$

The curvature at a point corresponding to unit tangent \vec{T} is

$$
\kappa_{\vec{T}} = -\vec{T}^t \frac{D^2 F}{|\vec{\nabla} F|} \vec{T}. \tag{8.1}
$$

The right-hand side is an example of a restricted quadratic form. The principal curvatures are the minimum and maximum of the form.

Maxima of Quadratic Forms

Let A be an $n \times n$ symmetric matrix. The function $Q : \mathbb{R}^n \to \mathbb{R}$ defined by $Q(\vec{v}) = \vec{v}^t A \vec{v}$ for $|\vec{v}| = 1$ is called a *quadratic form*. Since Q is defined on the unit sphere in \mathbb{R}^n,

a compact set, and since Q is continuous, it must have a maximum and a minimum on this set.

Let $\vec{v} = \sum_{i=1}^{n} c_i \vec{v}_i$, where $A\vec{v}_i = \lambda_i \vec{v}_i$, $\lambda_1 \leq \cdots \leq \lambda_n$, and $\sum_{i=1}^{n} c_i^2 = 1$. That is, the λ_i are the eigenvalues of A, and the \vec{v}_i are the corresponding eigenvectors. Expanding the quadratic yields

$$Q(\vec{v}) = \left(\sum_{i=1}^{n} c_i \vec{v}_i^t \right) A \left(\sum_{j=1}^{n} c_j \vec{v}_j \right) = \sum_{i=1}^{n} \sum_{j=1}^{n} c_i c_j \vec{v}_i^t A \vec{v}_j = \sum_{k=1}^{n} \lambda_k c_k^2.$$

The rightmost summation is a convex combination of the eigenvalues of A, so its maximum is λ_n and occurs when $c_n = 1$ and all other $c_i = 0$. Consequently, $\max Q(\vec{v}) = \lambda_n = Q(\vec{v}_n)$.

Maxima of Restricted Quadratic Forms

In some applications it is desirable to find the maximum of a quadratic form defined on the unit hypersphere S^{n-1}, but restricted to the intersection of this hypersphere with a hyperplane $\vec{N} \cdot \vec{x} = 0$ for some special normal vector \vec{N}. Let A be an $n \times n$ symmetric matrix. Let $\vec{N} \in \mathbb{R}^n$ be a unit-length vector. Let $\{\vec{N}\}^{\perp}$ denote the orthogonal complement of \vec{N}. Define $Q : \{\vec{N}\}^{\perp} \to \mathbb{R}$ by $Q(\vec{v}) = \vec{v}^t A \vec{v}$, where $|\vec{v}| = 1$. Now Q is defined on the unit sphere in the $(n-1)$-dimensional space $\{\vec{N}\}^{\perp}$, so it must have a maximum and a minimum.

Let \vec{v}_1 through \vec{v}_{n-1} be an orthonormal basis for $\{\vec{N}\}^{\perp}$. Let $\vec{v} = \sum_{i=1}^{n-1} c_i \vec{v}_i$, where $\sum_{i=1}^{n} c_i^2 = 1$. Let $A\vec{v}_i = \sum_{j=1}^{n-1} \alpha_{ji} \vec{v}_j + \alpha_{ni} \vec{N}$, where $\alpha_{ji} = \vec{v}_j^t A \vec{v}_i$ for $1 \leq i \leq n-1$ and $1 \leq j \leq n-1$, and where $\alpha_{ni} = \vec{N}^t A \vec{v}_i$ for $1 \leq i \leq n-1$. Expanding the quadratic form yields

$$Q(\vec{v}) = \left(\sum_{i=1}^{n-1} c_i \vec{v}_i^t \right) A \left(\sum_{j=1}^{n-1} c_j \vec{v}_j \right) = \sum_{i=1}^{n-1} \sum_{j=1}^{n-1} c_i c_j \alpha_{ij} = \vec{c}^t \bar{A} \vec{c} =: P(\vec{c}),$$

where quadratic form $P : \mathbb{R}^{n-1} \to \mathbb{R}$ satisfies the conditions for the maximization in the last subsection. Thus, $\max Q(\vec{v}) = \max P(\vec{c})$, which occurs for \vec{c} and λ such that $\bar{A}\vec{c} = \lambda\vec{c}$ and λ is the maximum eigenvalue of \bar{A}. The following calculations lead to a matrix formulation for determining the maximum value:

$$\sum_{j=1}^{n-1} \alpha_{ij} c_j = \lambda c_i$$

$$\sum_{j=1}^{n-1} c_j \vec{v}_i = \lambda c_i \vec{v}_i$$

$$\sum_{i=1}^{n-1} \sum_{j=1}^{n-1} \alpha_{ij} c_j \vec{v}_i = \lambda \sum_{i=1}^{n-1} c_i \vec{v}_i$$

$$\sum_{j=1} \left(\sum_{i=1}^{n-1} \alpha_{ij} \vec{v}_i \right) c_j = \lambda \vec{v}$$

$$\sum_{j=1}^{n-1} \left(A \vec{v}_j - \alpha_{nj} \vec{N} \right) c_j = \lambda \vec{v}$$

$$A \left(\sum_{j=1}^{n-1} c_j \vec{v}_j \right) - \left(\sum_{j=1}^{n-1} \alpha_{nj} c_j \right) \vec{N} = \lambda \vec{v}$$

$$A\vec{v} - \left(\vec{N}^t A \vec{v} \right) \vec{N} = \lambda \vec{v}$$

$$(I - \vec{N} \vec{N}^t) A \vec{v} = \lambda \vec{v}.$$

Therefore, $\max Q(\vec{v}) = \lambda_{n-1} = Q(\vec{v}_{n-1})$, where λ_{n-1} is the maximum eigenvalue corresponding to the eigenvector \vec{v}_{n-1} of $(I - \vec{N} \vec{N}^t) A$. Note that $n-1$ of the eigenvectors are in $\{\vec{N}\}^{\perp}$. The remaining eigenvector is $\vec{v}_n = A^{\text{adj}} \vec{N}$, where $A A^{\text{adj}} = (\det A) I$ and $\lambda_n = 0$.

Application to Finding Principal Curvatures

The right-hand side of Equation (8.1) is a restricted quadratic form. According to the construction in the last subsection, the minimum and maximum values κ_{\min} and κ_{\max} are selected from the eigenvalues of

$$-\left(I - \frac{\vec{\nabla} F}{|\vec{\nabla} F|} \frac{\vec{\nabla} F}{|\vec{\nabla} F|}^{\mathrm{T}} \right) \frac{D^2 F}{|\vec{\nabla} F|} \vec{v} = \kappa \vec{v}$$

that are in $\{\vec{N}\}^{\perp}$.

The mean curvature can be computed as the average of the extreme curvature values, and the Gaussian curvature can be computed as the product. However, these two values can be computed without solving the eigensystem,

$$\kappa_{\text{mean}} = \frac{|\vec{\nabla}F|^2 \text{ trace}\left(D^2 F\right) - \vec{\nabla}F^{\mathrm{T}} D^2 F \vec{\nabla} F}{2|\vec{\nabla}F|^3}$$

and

$$\kappa_{\text{Gaussian}} = \frac{\vec{\nabla}F^{\mathrm{T}}\left(D^2 F\right)^{\text{adj}} \vec{\nabla} F}{|\vec{\nabla}F|^4},$$

where

$$\left(D^2 F\right)^{\text{adj}} = \begin{bmatrix} F_{yy}F_{zz} - F_{yz}F_{yz} & F_{yz}F_{xz} - F_{xy}F_{zz} & F_{xy}F_{yz} - F_{xz}F_{yy} \\ F_{yz}F_{xz} - F_{xy}F_{zz} & F_{xx}F_{zz} - F_{xz}F_{xz} & F_{xy}F_{xz} - F_{xx}F_{yz} \\ F_{xy}F_{yz} - F_{xz}F_{yy} & F_{xy}F_{xz} - F_{xx}F_{yz} & F_{xx}F_{yy} - F_{xy}F_{xy} \end{bmatrix}.$$

8.2.3 CURVATURES FOR GRAPHS

The parametric form for a graph is $(x, y, f(x, y))$. The metric tensor can be shown to be $G = I + \vec{\nabla}f\vec{\nabla}f^{\mathrm{T}}$, where I is the 2×2 identity matrix. The curvature tensor can be shown to be $H = D^2 f / \sqrt{1 + |\vec{\nabla}f|^2}$. The eigensystem that defines the principal curvatures is

$$\frac{D^2 f}{\sqrt{1 + |\nabla f|^2}}\vec{v} = \kappa(I + \nabla f \nabla f^{\mathrm{T}})\vec{v}.$$

This system can be solved just as in Section 8.2.1.

8.3 SPECIAL SURFACES

The following sections describe various special surfaces in three dimensions.

8.3.1 BÉZIER RECTANGLE PATCHES

Bézier rectangle patches are popular with game programmers for their mathematical simplicity and ease of use.

Definitions

Given a rectangular lattice of three-dimensional control points \vec{p}_{i_0,i_1} for $0 \le i_0 \le n_0$ and $0 \le i_1 \le n_1$, the Bézier rectangle patch for the points is

$$\vec{x}(s,t) = \sum_{i_0=0}^{n_0} \sum_{i_1=0}^{n_1} B_{n_0,i_0}(s) B_{n_1,i_1}(t) \, \vec{p}_{i_0,i_1}$$

for $(s,t) \in [0,1]^2$ and where the coefficients are products of the Bernstein polynomials defined in Equation (7.1). The first-order partial derivatives of the patch are

$$\vec{x}_s(s,t) = n_0 \sum_{i_0=0}^{n_0-1} \sum_{i_1=0}^{n_1} B_{n_0-1,i_0}(s) B_{n_1,i_1}(t) \, \left(\vec{p}_{i_0+1,i_1} - \vec{p}_{i_0,i_1}\right)$$

and

$$\vec{x}_t(s,t) = n_1 \sum_{i_0=0}^{n_0} \sum_{i_1=0}^{n_1-1} B_{n_0,i_0}(s) B_{n_1-1,i_1}(t) \, \left(\vec{p}_{i_0,i_1+1} - \vec{p}_{i_0,i_1}\right).$$

Evaluation

As for Bézier curves, the same trade-off of speed versus accuracy must be made for Bézier rectangles. The choice here is for speed. Each Bernstein polynomial is computed, then the product of the polynomials for each term is computed. There are $n_0 + 1$ evaluations of $B_{n_0,i_0}(s)$, $n_1 + 1$ evaluations of $B_{n_1,i_1}(t)$, and $n_0 n_1$ multiplications for pairs of the evaluated polynomials.

The de Casteljau algorithm repeatedly computes convex combinations and is generally more stable, but it uses more floating-point operations. For example, let's compare it to the Bernstein form of evaluation for bilinear interpolation, the case where $n_0 = 1$ and $n_1 = 1$. The Bernstein form for evaluation is

$$(1-s)(1-t)\vec{p}_{0,0} + (1-s)t\,\vec{p}_{0,1} + s(1-t)\vec{p}_{1,0} + st\,\vec{p}_{1,1}$$

and requires 2 subtractions, 9 additions, and 16 multiplications. The de Casteljau form for evaluation is

$$(1-s)\left((1-t)\vec{p}_{0,0} + t\,\vec{p}_{0,1}\right) + s\left((1-t)\vec{p}_{1,0} + t\,\vec{p}_{1,1}\right)$$

and requires 2 subtractions, 9 additions, and 18 multiplications.

Degree Elevation

A Bézier rectangle patch of degree (n_0, n_1) can be written as a patch of degree $(n_0 + 1, n_1)$. The process is similar to that of a Bézier curve where the equation is multiplied by $1 = (1 - s) + s$ and formally expanded. The degree-elevated patch is

$$\vec{x}(s, t) = \sum_{i_0=0}^{n_0+1} \sum_{i_1=0}^{n_1} B_{n_0+1,i_0}(s) B_{n_1,i_1}(t) \left[\left(1 - \frac{i_0}{n_0 + 1} \right) \vec{p}_{i_0,i_1} + \frac{i_0}{n_0 + 1} \vec{p}_{i_0-1,i_1} \right].$$

The patch can be similarly degree-elevated to one of degree $(n_0, n_1 + 1)$,

$$\vec{x}(s, t) = \sum_{i_0=0}^{n_0} \sum_{i_1=0}^{n_1+1} B_{n_0,i_0}(s) B_{n_1+1,i_1}(t) \left[\left(1 - \frac{i_1}{n_1 + 1} \right) \vec{p}_{i_0,i_1} + \frac{i_1}{n_1 + 1} \vec{p}_{i_0,i_1-1} \right].$$

The patch can be degree-elevated in both components to one of degree $(n_0 + 1, n_1 + 1)$,

$$\vec{x}(s, t) = \sum_{i_0=0}^{n_0+1} \sum_{i_1=0}^{n_1+1} B_{n_0,i_0}(s) B_{n_1,i_1}(t) \, \vec{q}_{i_0,i_1},$$

where

$$\vec{q}_{i_0,i_1} = \begin{bmatrix} 1 - \frac{i_0}{n_0+1} & \frac{i_0}{n_0+1} \end{bmatrix} \begin{bmatrix} \vec{p}_{i_0,i_1} & \vec{p}_{i_0,i_1-1} \\ \vec{p}_{i_0-1,i_1} & \vec{p}_{i_0-1,i_1-1} \end{bmatrix} \begin{bmatrix} 1 - \frac{i_1}{n_1+1} \\ \frac{i_1}{n_1+1} \end{bmatrix}.$$

The right-hand side is evaluated symbolically as a product of the three matrices.

Degree Reduction

A Bézier rectangle patch can be reduced in degree with similar constraints as in the Bézier curve case. The reduced patch in almost all cases is an approximation to the original patch. A least-squares fit is used to obtain the reduced patch.

Let the original surface be $\vec{x}(s, t) = \sum_{i_0=0}^{n_0} \sum_{i_1=0}^{n_1} B_{n_0,i_0}(s) B_{n_1,i_1}(t) \, \vec{p}_{i_0,i_1}$, and let the degree-reduced surface be $\vec{y}(s, t) = \sum_{i_0=0}^{m_0} \sum_{i_1=0}^{m_1} B_{m_0,i_0}(s) B_{m_1,i_1}(t) \, \vec{q}_{i_0,i_1}$, where $m_0 \leq n_0$ and $m_1 \leq n_1$. For degree reduction of Bézier curves we imposed the constraint that the end points of the two curves be the same. The extension to rectangle patches is to require that the four corner points match between the two patches. Although it is possible to apply a least-squares fit to construct the remaining control points, a better approach looks ahead to the situations where two patches have a common boundary curve. The reduction scheme when applied to the two adjacent patches should guarantee that the patches match on the common reduced boundary curve.

The algorithm for a single patch should therefore degree-reduce the four boundary curves first, then compute the remaining interior control points using the least-squares fit. The to-be-determined interior points are \vec{q}_{i_0,i_1} for $1 \le i_0 \le m_0 - 1$ and $1 \le i_1 \le m_1 - 1$. These are chosen to minimize the integral of the squared differences of the two surfaces,

$$E(\vec{q}_{1,1}, \ldots, q_{m_0-1,m_1-1}) = \int_0^1 \int_0^1 \left| \vec{x}(s,t) - \vec{y}(s,t) \right| \, ds \, dt.$$

The values of the interior control points are determined by setting all the partial derivatives of E to zero, $\partial E / \partial \vec{q}_{i_0,i_1} = 0$ for $1 \le i_0 \le m_0 - 1$ and $1 \le i_1 \le m_1 - 1$. This leads to $(m_0 - 1)(m_1 - 1)$ equations in the same number of unknown control points,

$$\sum_{i_0=0}^{m_0} \sum_{i_1=0}^{m_1} \frac{(2m_0 + 1)(2m_1 + 1)C(m_0; i_0)C(m_1; i_1)}{C(2m_0; i_0 + j_0)C(2m_1; i_1 + j_1)} \vec{q}_{i_0,i_1} =$$

$$\sum_{i_0=0}^{n_0} \sum_{i_1=0}^{n_1} \frac{(n_0 + m_0 + 1)(n_1 + m_1 + 1)C(n_0; i_0)C(n_1; i_1)}{C(n_0 + m_0; i_0 + j_0)C(n_1 + m_1; i_1 + j_1)} \vec{p}_{i_0,i_1}.$$

The system always has a solution.

For example, solving the equations symbolically for degree reduction of a bicubic patch to a biquadratic patch, $n_0 = n_1 = 3$ and $m_0 = m_1 = 2$:

$$\vec{q}_{0,0} = \vec{p}_{0,0}$$

$$\vec{q}_{0,2} = \vec{p}_{0,3}$$

$$\vec{q}_{2,0} = \vec{p}_{3,0}$$

$$\vec{q}_{2,2} = \vec{p}_{3,3}$$

$$\vec{q}_{0,1} = \frac{1}{4} \left(-\vec{p}_{0,0} + 3\vec{p}_{0,1} + 3\vec{p}_{0,2} - \vec{p}_{0,3} \right)$$

$$\vec{q}_{1,0} = \frac{1}{4} \left(-\vec{p}_{0,0} + 3\vec{p}_{1,0} + 3\vec{p}_{2,0} - \vec{p}_{3,0} \right)$$

$$\vec{q}_{1,2} = \frac{1}{4} \left(-\vec{p}_{0,3} + 3\vec{p}_{1,3} + 3\vec{p}_{2,3} - \vec{p}_{3,3} \right)$$

$$\vec{q}_{2,1} = \frac{1}{4} \left(-\vec{p}_{3,0} + 3\vec{p}_{3,1} + 3\vec{p}_{3,2} - \vec{p}_{3,3} \right)$$

$$\vec{q}_{1,1} = \frac{1}{16} \left(\vec{p}_{0,0} - 3\vec{p}_{0,1} - 3\vec{p}_{0,2} + \vec{p}_{0,3} - 3\vec{p}_{1,0} + 9\vec{p}_{1,1} + 9\vec{p}_{1,2} - 3\vec{p}_{1,3} \right.$$

$$\left. - 3\vec{p}_{2,0} + 9\vec{p}_{2,1} + 9\vec{p}_{2,2} - 3\vec{p}_{2,3} + \vec{p}_{3,0} - 3\vec{p}_{3,1} - 3\vec{p}_{3,2} + \vec{p}_{3,3} \right).$$

v^2		
$2vw$	$2uv$	
w^2	$2uw$	u^2

Coefficients of \vec{x}

0		
$-2v$	$2v$	
$-2w$	$2(-u+w)$	$2u$

Coefficients of \vec{x}_u

$2v$		
$2(-v+w)$	$2u$	
$-2w$	$-2u$	0

Coefficients of \vec{x}_v

Figure 8.1 Polynomial coefficients for $n = 2$.

8.3.2 BÉZIER TRIANGLE PATCHES

SOURCE CODE

Bézier triangle patches are slightly more complicated to use than Bézier rectangle patches, but they are useful for creating models of arbitrary complexity.

LIBRARY

Surface

FILENAME

BezierTriangle
BezierTriangle2
BezierTriangle3

Definitions

Given a triangle lattice of three-dimensional control points \vec{p}_{i_0,i_1,i_2} for $i_0 \geq 0$, $i_1 \geq 0$, $i_2 \geq 0$, and $i_0 + i_1 + i_2 = n$, the Bézier triangle patch for the points is

$$\vec{x}(u, v, w) = \sum_{|I|=n} B_{n,I}(u, v, w)\, \vec{p}_I,$$

where $I = (i_0, i_1, i_2)$, $|I| = i_0 + i_1 + i_2$, $u \geq 0$, $v \geq 0$, $w \geq 0$, and $u + v + w = 1$. The summation involves $(n+1)(n+2)/2$ terms. The Bernstein polynomial coefficients are

$$B_{n,I}(u, v, w) = C(n; i_0, i_1, i_2)u^{i_0}v^{i_1}w^{i_2} = \frac{n!}{i_0!i_1!i_2!}u^{i_0}v^{i_1}w^{i_2}.$$

The first-order partial derivatives \vec{x}_u and \vec{x}_v can be computed with respect to u or v, where $w = 1 - u - v$. While the symbolic formula can be computed from the equation for $\vec{x}(u, v, w)$, it is simpler to visualize the coefficients for \vec{x}, \vec{x}_u, and \vec{x}_v as triangles of terms. The multi-index $I = (i_0, i_1, i_2)$ varies as follows. The index i_0 increases from left to right, the index i_1 varies from bottom to top, and $i_2 = n - i_0 - i_1$. Figure 8.1 shows the coefficient triangles for the case $n = 2$. Figure 8.2 shows the coefficient triangles for the case $n = 3$. Figure 8.3 shows the coefficient triangles for the case $n = 4$.

Evaluation

Evaluation of \vec{x} or its derivatives is a matter of computing the coefficients, illustrated in Figures 8.1 through 8.3, and multiplying them times the control points and summing. In an implementation, the triangle coefficients are stored in a one-dimensional array.

v^3			
$3v^2w$	$3uv^2$		
$3vw^2$	$6uvw$	$3u^2v$	
w^3	$3uw^2$	$3u^2w$	u^3

Coefficients of \vec{x}

0			
$-3v^2$	$3v^2$		
$-6vw$	$6v(-u+w)$	$6uv$	
$-3w^2$	$3w(-2u+w)$	$3u(-u+2w)$	$3u^2$

Coefficients of \vec{x}_u

$3v^2$			
$3v(-v+2w)$	$6uv$		
$3w(-2v+w)$	$6u(-v+w)$	$3u^2$	
$-3w^2$	$-6uw$	$-3u^2$	0

Coefficients of \vec{x}_v

Figure 8.2 Polynomial coefficients for $n = 3$.

The rows of the coefficient tables are stored bottom first ($n + 1$ items, scanned left to right) through top last (1 item). The coefficients themselves are computed to minimize arithmetic operations by saving intermediate products and sums.

Degree Elevation

A Bézier triangle patch of degree n can be written as a patch of degree $n + 1$. The idea is to formally multiply the original patch by $1 = u + v + w$ so that the surface does not change, but the degree does. The degree-elevated patch is defined by

$$\vec{x}(u, v, w) = (u + v + w) \sum_{|I|=n} B_{n,I}(u, v, w)\, \vec{p}_I = \sum_{|I|=n+1} B_{n+1,I}(u, v, w)\, \vec{q}_I,$$

where the degree-elevated control points are

$$\vec{q}_I = \frac{1}{n + 1} \left(i_0 \vec{p}_{i_0-1,i_1,i_2} + i_1 \vec{p}_{i_0,i_1-1,i_2} + i_2 \vec{p}_{i_0,i_1,i_2-1} \right).$$

Degree Reduction

A Bézier triangle patch can be reduced in degree with the same constraints as for Bézier curves. The reduced patch in almost all cases is an approximation to the original patch. A least-squares fit can be used to obtain the reduction.

Let the original surface be $\vec{x}(u, v, w) = \sum_{|I|=n} B_{n,I}(u, v, w)\, \vec{p}_I$, and let the degree-reduced surface be $\vec{y}(u, v, w) = \sum_{|I|=m} B_{m,I}(u, v, w)\, \vec{q}_I$, where $m < n$. For

v^4				
$4v^3w$	$4uv^3$			
$6v^2w^2$	$12uv^2w$	$6u^2v^2$		
$4vw^3$	$12uvw^2$	$12u^2vw$	$4u^3v$	
w^4	$4uw^3$	$6u^2w^2$	$4u^3w$	u^4

Coefficients of \vec{x}

0				
$-4v^3$	$4v^3$			
$-12v^2w$	$12v^2(-u+w)$	$12uv^2$		
$-12vw^2$	$12vw(-2u+w)$	$12uv(-u+2w)$	$12u^2v$	
$-4w^3$	$4w^2(-3u+w)$	$12uw(-u+w)$	$4u^2(-u+3w)$	$4u^3$

Coefficients of \vec{x}_u

$4v^3$				
$4v^2(-v+3w)$	$12uv^2$			
$12vw(-v+w)$	$12uv(-v+2w)$	$12u^2v$		
$4w^2(-3v+w)$	$12uw(-2v+w)$	$12u^2(-v+w)$	$4u^3$	
$-4w^3$	$-12uw^2$	$-12u^2w$	$-4u^2w$	$-4u^3$

Coefficients of \vec{x}_v

Figure 8.3 Polynomial coefficients for $n = 4$.

Bézier curves, we imposed the constraint that the end points of the two curves must match. The extension to triangle patches is to require that the three corner points match between the two patches. Just as with rectangle patches, the boundary curves of the patch are reduced separately, and the interior points of the patch are determined from a surface least-squares fit. This guarantees that applying a reduction in degree across multiple patches with shared boundaries will maintain continuity across those boundaries. The interior points are chosen to minimize the integral of the squared differences of the two patches,

$$E(\cdot) = \int_0^1 \int_0^{1-v} \left| \vec{x}(u, v, 1 - u - v) - \vec{y}(u, v, 1 - u - v) \right|^2 \, du \, dv.$$

The arguments for $E(\cdot)$ are the interior control points for the approximating patch.

The values of the interior control points are determined by setting all the partial derivatives of E to zero, $\partial E/\partial \vec{q}_J$ for those indices $J = (j_0, j_1, j_2)$ with $j_0 j_1 j_2 \neq 0$. This leads to the equations

$$\sum_{|I|=m} a_{JI} \vec{q}_I = \sum_{|I|=n} b_{JI} \vec{p}_I,$$

where

$$a_{JI} = \frac{C(m; J)C(m; I)}{(2m + 2)(2m + 1)C(2m; I + J)}$$

and

$$b_{JI} = \frac{C(m; J)C(n; I)}{(n + m + 2)(n + m + 1)C(n + m; I + J)}.$$

The system always has a solution.

The equations can be solved symbolically for some cases of interest. For $n = 4$ and $m = 3$, the solution is

$$\vec{q}_{300} = \vec{p}_{400}$$

$$\vec{q}_{030} = \vec{p}_{040}$$

$$\vec{q}_{003} = \vec{p}_{004}$$

$$\vec{q}_{012} = \frac{1}{42}\left(-11\vec{p}_{004} + 44\vec{p}_{013} + 18\vec{p}_{022} - 12\vec{p}_{031} + 3\vec{p}_{040}\right)$$

$$\vec{q}_{021} = \frac{1}{42}\left(3\vec{p}_{004} - 12\vec{p}_{013} + 18\vec{p}_{022} + 44\vec{p}_{031} - 11\vec{p}_{040}\right)$$

$$\vec{q}_{102} = \frac{1}{42}\left(-11\vec{p}_{004} + 44\vec{p}_{103} + 18\vec{p}_{202} - 12\vec{p}_{301} + 3\vec{p}_{400}\right)$$

$$\vec{q}_{201} = \frac{1}{42}\left(3\vec{p}_{004} - 12\vec{p}_{103} + 18\vec{p}_{202} + 44\vec{p}_{301} - 11vecp_{400}\right)$$

$$\vec{q}_{210} = \frac{1}{42}\left(-11\vec{p}_{400} + 44\vec{p}_{310} + 18\vec{p}_{220} - 12\vec{p}_{130} + 3\vec{p}_{040}\right)$$

$$\vec{q}_{120} = \frac{1}{42}\left(3\vec{p}_{400} - 12\vec{p}_{310} + 18\vec{p}_{220} + 44\vec{p}_{130} - 11\vec{p}_{040}\right)$$

$$\vec{q}_{111} = \frac{1}{2520}\left(5(\vec{p}_{004} + \vec{p}_{040} + \vec{p}_{400}) + 8(\vec{p}_{103} + \vec{p}_{301} + \vec{p}_{013} + \vec{p}_{310} + \vec{p}_{031} + \vec{p}_{130})\right.$$

$$\left. + 9(\vec{p}_{202} + \vec{p}_{022} + \vec{p}_{220}) + 12(\vec{p}_{112} + \vec{p}_{211} + \vec{p}_{121})\right)$$

$$- \frac{2}{560}\left(\vec{q}_{300} + \vec{q}_{030} + \vec{q}_{003}\right) - \frac{3}{560}\left(\vec{q}_{012} + \vec{q}_{021} + \vec{q}_{102} + \vec{q}_{201} + \vec{q}_{120} + \vec{q}_{210}\right).$$

For $n = 4$ and $m = 2$, the solution is

$$\vec{q}_{200} = \vec{p}_{400}$$

$$\vec{q}_{020} = \vec{p}_{040}$$

$$\vec{q}_{002} = \vec{p}_{004}$$

$$\vec{q}_{101} = \frac{1}{28} \left(-11\vec{p}_{004} + 16\vec{p}_{103} + 18\vec{p}_{202} + 16\vec{p}_{301} - 11\vec{p}_{400} \right)$$

$$\vec{q}_{011} = \frac{1}{28} \left(-11\vec{p}_{004} + 16\vec{p}_{013} + 18\vec{p}_{022} + 16\vec{p}_{031} - 11\vec{p}_{040} \right)$$

$$\vec{q}_{110} = \frac{1}{28} \left(-11\vec{p}_{400} + 16\vec{p}_{310} + 18\vec{p}_{220} + 16\vec{p}_{130} - 11\vec{p}_{040} \right).$$

For $n = 3$ and $m = 2$, the solution is

$$\vec{q}_{200} = \vec{p}_{300}$$

$$\vec{q}_{020} = \vec{p}_{030}$$

$$\vec{q}_{002} = \vec{p}_{003}$$

$$\vec{q}_{101} = \frac{1}{4} \left(-\vec{p}_{003} + 3\vec{p}_{102} + 3\vec{p}_{201} - \vec{p}_{300} \right)$$

$$\vec{q}_{011} = \frac{1}{4} \left(-\vec{p}_{003} + 3\vec{p}_{012} + 3\vec{p}_{021} - \vec{p}_{030} \right)$$

$$\vec{q}_{110} = \frac{1}{4} \left(-\vec{p}_{030} + 3\vec{p}_{210} + 3\vec{p}_{120} - \vec{p}_{030} \right).$$

8.3.3 BÉZIER CYLINDER SURFACES

SOURCE CODE

LIBRARY

Surface

FILENAME

BezierCylinder

Bézier rectangle or triangle patches may provide more curvature variation than is needed for a particular model. For example, a curved archway is curved in one dimension and flat in another. Such surfaces are said to be *developable surfaces* or *cylinder surfaces*. The surface is generated by taking a curve and linearly translating it in a sweeping operation. Equivalently, the surface is generated by taking a line segment and moving it so that one end point is constrained to the originally specified curve. If the Bézier curve is $\vec{y}(u) = \sum_{i=0}^{n} B_{n,I}(u)\, \vec{p}_i$ and if the linear translation is \vec{D}, then the cylinder surface is $\vec{x}(u, v) = (1 - v)\vec{y}(u) + v\vec{D}$ for $(u, v) \in [0, 1]$. The first-order partial derivatives are $\vec{x}_u = (1 - v)\vec{y}_u$ and $\vec{x}_v = \vec{D} - \vec{y}$.

More generally, a *generalized cylinder surface* is one obtained by specifying two Bézier curves with the same number of control points and blending between the two

curves. If \vec{p}_i and \vec{q}_i are the control points for $0 \le i \le n$, then the generalized cylinder surface is

$$\vec{x}(u, v) = (1 - v) \sum_{i=0}^{n} B_{n,i}(u)\, \vec{p}_i + v \sum_{i=0}^{n} B_{n,I}(u)\, \vec{q}_i = \sum_{i=0}^{n} B_{n,I}(u)[(1 - v)\vec{p}_i + v\vec{q}_i].$$

The first-order partial derivatives are

$$\vec{x}_u = n \sum_{i=0}^{n-1} B_{n-1,i}(u)[(1 - v)(\vec{p}_{i+1} - \vec{p}_i) + v(\vec{q}_{i+1} - \vec{q}_i)]$$

and

$$\vec{x}_v = \sum_{i=0}^{n} B_{n,I}(u)\, (\vec{q}_i - \vec{p}_i) .$$

The methods for evaluation, degree elevation, and degree reduction can be applied to the initial curve for cylinder surfaces or to the boundary curves for generalized cylinder surfaces.

8.3.4 Nonparametric B-Spline Rectangle Patches

Source Code

Library

Surface

Filename

BSplineRectangle

Our discussion here parallels that for Section 7.3.3 (nonparametric B-spline curves). Understanding how to interpolate a rectangular lattice of scalars $(i_0, i_1, f_{i_0 i_1})$ for $0 \le i_0 \le n_0$ and $0 \le i_1 \le n_1$ is sufficient. The interpolation for a lattice of control points is performed componentwise.

The blending matrices $M = [M_{jk}]$ computed for B-spline curves apply as well for surfaces. For $(s, t) \in [i_0, i_0 + 1] \times [i_1, i_1 + 1]$, the B-spline polynomial of degree d is defined as

$$B_{i_0 i_1}(s, t) = \sum_{j_0=0}^{d} \sum_{j_1=0}^{d} \sum_{k_0=0}^{d} \sum_{k_1=0}^{d} f_{i_0 - \lfloor (d-1)/2 \rfloor + j_0, i_1 - \lfloor (d-1)/2 \rfloor + j_1} M_{j_0 k_0} M_{j_1 k_1} X_{k_0}(s) X_{k_1}(t).$$

The polynomial components are $X_{k_0}(s) = (s - i_0)^{k_0}$ for $0 \le k_0 \le d$ and $X_{k_1}(t) = (t - i_1)^{k_1}$ for $0 \le k_1 \le d$.

The pseudocode for nonparametric B-spline evaluation is given below. It is assumed that the blending matrix has already been computed. The quantity $f_{i_0 - \lfloor (d-1)/2 \rfloor + j_0, i_1 - \lfloor (d-1)/2 \rfloor + j_1} M_{j_0 k_0} M_{j_1 k_1}$ in the B-spline polynomial formula is referred to as the intermediate tensor.

```
const int D;   // degrees D0 > 0, D1 > 0
const int Dp1 = D+1;
```

```
const int offset = floor((D-1)/2);
const float M[Dp1][Dp1];  // blending matrix
const int N0, N1;  // last data indices, N0 >= D and N1 >= D
float f[N1+1][N0+1];  // data to be interpolated
float s;  // floor((D-1)/2) <= s <= floor(N0-(D-1)/2)
float t;  // floor((D-1)/2) <= t <= floor(N1-(D-1)/2)

// determine base indices of intervals for evaluation
int b0 = floor(s) - offset;
int b1 = floor(t) - offset;

// compute intermediate tensor (nonpolynomial part of B(s,t))
float intermediate[Dp1][Dp1];
for (k1 = 0; k1 <= D; k1++)
for (k0 = 0; k0 <= D; k0++)
{
    intermediate[k1][k0] = 0;
    for (j1 = 0, r1 = b1-1; j1 <= D; j1++, r1++)
    for (j0 = 0, r0 = b0-1; j0 <= D; j0++, r0++)
    {
        intermediate[k1][k0] += f[r1][r0]*M[j0][k0]*M[j1][k1];
    }
}

// compute polynomial (1,s,s^2,...,s^D)
float Xs[Dp1];
float ds = s - b0;
Xs[0] = 1;
for (k = 1; k <= D; k++)
    Xs[k] = Xs[k-1]*ds;

// compute polynomial (1,t,t^2,...,t^D)
float Xt[Dp1];
float dt = t - b0;
Xt[0] = 1;
for (k = 1; k <= D; k++)
    Xt[k] = Xt[k-1]*dt;

// compute final result
float result = 0;
for (k1 = 0; k1 <= D; k1++)
for (k0 = 0; k0 <= D; k0++)
{
    result += intermediate[k1][k0]*Xs[k0]*Xt[k1];
}
```

For applications that must evaluate the B-spline many times in a region for which the base interval $[i_0, i_0 + 1] \times [i_1, i_1 + 1]$ does not change, the intermediate tensor can be cached. The polynomial terms are evaluated each time and the final result is computed. The intermediate tensor itself can be optimized for speed. (See Eberly 1996, Chapter 7.2, for optimizations for nonparametric B-spline evaluation in arbitrary dimensions.)

8.3.5 QUADRIC SURFACES

SOURCE CODE

LIBRARY

Surface

FILENAME

QuadricSurface

The discussion of quadric surfaces in Thomas and Finney (1988) is excellent, but considers all equations in axis-aligned form. The discussion here involves the general quadratic equation and relies on an eigendecomposition of a matrix to characterize the surfaces.

The general quadratic equation is $\vec{x}^T A \vec{x} + \vec{b}^T \vec{x} + c = 0$, where A is a 3×3 nonzero symmetric matrix, \vec{b} is a 3×1 vector, and c is a scalar. The 3×1 vector \vec{x} represents the variable quantities. Since A is symmetric, it can be factored as $A = R^T D R$, where D is a diagonal matrix whose diagonal entries are the eigenvalues of A, and R is a rotational matrix whose rows are corresponding eigenvectors. Setting $\vec{y} = R\vec{x}$ and $\vec{e} = R\vec{b}$, the quadratic equation is $\vec{y}^T D \vec{y} + \vec{e}^T \vec{y} + c = 0$. The quadratic equation can be factored by completing the square on terms. This allows us to characterize the surface type or determine that the solution is degenerate (point, line, plane). Let $D = \text{diag}(d_0, d_1, d_2)$ and $\vec{e} = (e_0, e_1, e_2)$.

Three Nonzero Eigenvalues

The factored equation is

$$d_0 \left(y_0 + \frac{e_0}{2d_0} \right)^2 + d_1 \left(y_1 + \frac{e_1}{2d_1} \right)^2 + d_2 \left(y_2 + \frac{e_2}{2d_2} \right)^2 + c - \frac{e_0^2}{4d_0} - \frac{e_1^2}{4d_1} - \frac{e_2^2}{4d_2} = 0.$$

Define $\gamma_i = -e_i/(2d_i)$ for $i = 0, 1, 2$, and define $f = e_0^2/4d_0 + e_1^2/4d_1 + e_2^2/4d_2 - c$. The equation is $d_0(y_0 - \gamma_0)^2 + d_1(y_1 - \gamma_1)^2 + d_2(y_2 - \gamma_2)^2 = f$.

Suppose $f = 0$. If all eigenvalues are positive or all are negative, then the equation represents a *point* $(\gamma_0, \gamma_1, \gamma_2)$. If at least one eigenvalue is positive and one eigenvalue is negative, reorder the terms and possibly multiply by -1 so that $d_0 > 0$, $d_1 > 0$, and $d_2 < 0$. The equation is $(y_2 - \gamma_2)^2 = (-d_0/d_2)(y_0 - \gamma_0)^2 + (-d_1/d_2)(y_1 - \gamma_1)^2$ and represents an *elliptic cone* (circular cone if $d_0 = d_1$).

Suppose $f > 0$ (if $f < 0$, multiply the equation by -1 so that f is positive). If all eigenvalues are negative, then the equation has no solutions. If all the eigenvalues are positive, the equation represents an *ellipsoid*. The center is $(\gamma_0, \gamma_1, \gamma_2)$, and the

semiaxis lengths are $\sqrt{f/d_i}$ for $i = 0, 1, 2$. If at least one eigenvalue is positive and one eigenvalue is negative, then the equation represents a *hyperboloid* (one or two sheets depending on the number of positive eigenvalues).

Two Nonzero Eigenvalues

Without loss of generality, assume that $d_2 = 0$. The factored equation is

$$d_0 \left(y_0 + \frac{e_0}{2d_0} \right)^2 + d_1 \left(y_1 + \frac{e_1}{2d_1} \right)^2 + e_2 y_2 + c - \frac{e_0^2}{4d_0} - \frac{e_1^2}{4d_1} = 0.$$

Define $\gamma_i = -e_i/(2d_i)$ for $i = 0, 1$, and define $f = e_0^2/4d_0 + e_1^2/4d_1 - c$. The equation is $d_0(y_0 - \gamma_0)^2 + d_1(y_1 - \gamma_1)^2 + e_2 y_2 = f$.

Suppose $e_2 = 0$ and $f = 0$. If d_0 and d_1 are both positive or both negative, then the equation represents a *line* containing $(\gamma_0, \gamma_1, 0)$ and having direction $(0, 0, 1)$. Otherwise, the eigenvalues have opposite signs, and the equation represents the *union of two planes*, $y_1 - \gamma_1 = \pm\sqrt{-d_0/d_1}(y_0 - \gamma_0)$.

Suppose $e_2 = 0$ and $f > 0$ (if $f < 0$, multiply the equation by -1). If d_0 and d_1 are both negative, then the equation has no solution. If both are positive, then the equation represents an *elliptic cylinder* (a circular cylinder if $d_0 = d_1$). Otherwise, d_0 and d_1 have opposite signs, and the equation represents a *hyperbolic cylinder*.

Suppose $e_2 \neq 0$. Define $\gamma_2 = f/e_q$. The equation is $d_0(y_0 - \gamma_0)^2 + d_1(y_1 - \gamma_1)^4 + e_2(y_2 - \gamma_2) = 0$. If d_0 and d_1 have the same sign, the equation represents an *elliptic paraboloid* (circular paraboloid if $d_0 = d_1$). Otherwise, d_0 and d_1 have opposite signs, and the equation represents a *hyperbolic paraboloid*.

One Nonzero Eigenvalue

The factored equation is

$$d_0 \left(y_0 + \frac{e_0}{2d_0} \right)^2 + e_1 y_1 + e_2 y_2 + c - \frac{e_0^2}{4d_0} = 0.$$

If $e_1 = e_2 = 0$, then the equation is degenerate (either no solution or y_0 is constant, in which case the solution is a *plane*). Otherwise, define $L = \sqrt{e_1^2 + e_2^2} \neq 0$ and divide the equation by L. Define $\alpha = d_0/L$, $\beta = (c - e_0^2/(4d_0))/L$, and make the rigid change of variables $z_0 = y_0 + e_0/(2d_0)$, $z_1 = -(e_1 y_1 + e_2 y_2)/L$, and $z_2 = (-e_2 y_1 + e_1 y_2)/L$. The equation in the new coordinate system is $z_1 = \alpha z_0^2 + \beta$, so the surface is a *parabolic cylinder*.

8.3.6 TUBE SURFACES

A *swept surface* is generated by sweeping a region of space by a planar object along a specified central curve $\vec{x}(t)$. The planar object itself may change shape as t varies. The most common shape is a circle whose radius is constant, but more generally is allowed to vary with time, say, $r(t)$. The resulting surface is called a *tube surface*. A special case is a *surface of revolution,* where the central curve is a straight line.

Given an orientation matrix $R(t)$ with columns \vec{T}, \vec{N}, and \vec{B}, a tube surface is parameterized by

$$\vec{S}(t, \theta) = \vec{x}(t) + r(t)\left(\cos\theta\, \vec{N} + \sin\theta\, \vec{B}\right) \tag{8.2}$$

for curve parameter t and for $\theta \in [0, 2\pi)$. The columns of R may be chosen according to the discussion in Section 7.5.

8.4 SUBDIVISION

Subdivision is an important process for converting surface patches to a set of triangles that the game engine can use. This section describes subdivision algorithms for rectangle patches, triangle patches, cylinder patches, and spheres or ellipsoids. Two variations of subdivision are considered—uniform and nonuniform subdivision.

8.4.1 SUBDIVISION OF BÉZIER RECTANGLE PATCHES

The ideas of subdivision are best illustrated when the surface patch is a rectangle patch, whether the subdivision is uniform or nonuniform.

Uniform Subdivision

A rectangle patch can be subdivided by uniformly tessellating the parameter space to a specified level $L \geq 0$. Figure 8.4 illustrates the subdivisions for $L = 0$ and $L = 1$. The vertices occur at (s_i, t_j), where $s_i = i/2^L$ for $0 \leq i \leq 2^L$ and $t_j = j/2^L$ for $0 \leq j \leq 2^L$. The number of vertices in the tessellation is $V = (2^L + 1)^2$, and the number of triangles is $T = 2 \cdot 4^L$.

The obvious way to compute the vertices is iteration of a double loop:

```
L = levels of subdivision;
P = pow(2,L);  // maximum index per row or column
M = pow(2,L)+1;  // number of vertices per row or column
vertex[M][M] = array of vertices;
```

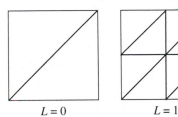

$L = 0$ $L = 1$

Figure 8.4 Subdivisions of parameter space for a rectangle patch.

```
for (i = 0; i < M; i++)
{
    s = i/P;
    for (j = 0; j < M; j++)
    {
        t = j/P;
        vertex[i][j] = X(s,t);   // evaluation of patch
    }
}
```

However, this does not minimize the number of floating-point operations for Bézier rectangle patches of odd degree. Let's consider an example for bicubic patches. Ignoring loop overhead and the divisions for computing s and t (these can be replaced by incrementing by a precomputed delta), the floating-point operations occur in the evaluation of the Bézier patch $\vec{x}(s, t)$. Define

$$\vec{q}_i = \sum_{j=0}^{3} B_{3,j}(t)\vec{p}_{i,j} = \vec{r}_0^{(i)} + t\vec{r}_1^{(i)} + t^2\vec{r}_2^{(i)} + t^3\vec{r}_3^{(i)} = \vec{r}_0^{(i)} + t(\vec{r}_1^{(i)} + t(\vec{r}_2^{(i)} + t\vec{r}_3^{(i)}))$$

for $0 \le i \le 3$. The $\vec{r}_j^{(i)}$ are precomputed. Evaluation of this vector-valued polynomial requires 9 multiplications and 9 additions. Doing so for each i requires 72 operations. The next evaluation is for

$$\vec{x}(s, t) = \sum_{i=0}^{3} B_{3,i}(s)\vec{q}_i = \vec{c}_0 + s\vec{c}_1 + s^2\vec{c}_2 + s^3\vec{c}_3 = \vec{c}_0 + s(\vec{c}_1 + s(\vec{c}_2 + s\vec{c}_3)).$$

This requires an additional 18 operations. The total operation count is $90V = 90(2^L + 1)^2$.

A recursive subdivision using central differences may be used just as was done for Bézier cubic curves. Tensor notation is used to simplify the expressions. Rather

than explicitly writing summation signs, if an expression contains a repeated index, the assumption is that the index is summed over the appropriate range of values. For example, if $A = [A_{ij}]$ is an $n \times n$ matrix and $\vec{x} = [x_j]$ is an $n \times 1$ vector, then the expression $A\vec{x}$ is written as $\sum_{j=0}^{n-1} A_{ij} x_j$ in the standard notation, but as $A_{ij} x_j$ using the summation convention. The index j is repeated, so an implied summation occurs over j. The second part of tensor notation specifies derivatives using indices. If $\vec{x}(\vec{p})$ is an $n \times 1$ vector-valued function of the $m \times 1$ vector \vec{p}, then the derivative of the ith component of \vec{x} with respect to the jth component of \vec{p} is denoted $x_{i,j}$. In tensor notation, indices before the subscripted comma refer to components and indices after the comma refer to derivatives. Second derivatives have two indices after the comma, third derivatives have three, and so on.

For a polynomial curve of degree at most three, the identities equivalent to Equation (7.24) for surfaces are

$$\vec{x}(s, t) = \frac{1}{2} \left(\vec{x}(s + \delta, t) + \vec{x}(s - \delta, t) - \delta^2 \vec{x}_{ss}(s, t) \right)$$

$$\vec{x}(s, t) = \frac{1}{2} \left(\vec{x}(s, t + \delta) + \vec{x}(s, t - \delta) - \delta^2 \vec{x}_{tt}(s, t) \right)$$

$$(8.3)$$

Similarly, the identities equivalent to Equation (7.25) for surfaces are

$$\vec{x}_{ss}(s, t) = \frac{1}{2} \left(\vec{x}_{ss}(s + \delta, t) + \vec{x}_{ss}(s - \delta, t) \right)$$

$$\vec{x}_{tt}(s, t) = \frac{1}{2} \left(\vec{x}_{tt}(s, t + \delta) + \vec{x}_{tt}(s, t - \delta) \right)$$

$$(8.4)$$

Now we will describe the algorithm for the block with parameter values $s \in [s_0, s_1]$ and $t \in [t_0, t_1]$. Define $s_m = (s_0 + s_1)/2$, $t_m = (t_0 + t_1)/2$, and $d = s_m - s_0 = t_m - t_0$. At each of the four corner points it is assumed that the following quantities are precomputed: \vec{x}, \vec{x}_{ss}, \vec{x}_{tt}, and \vec{x}_{sstt}. The subscripts indicate partial derivatives with respect to the listed variables. The formulas shown below are valid because of Equations (8.3) and (8.4).

For midpoints (s_m, \bullet), where \bullet is either t_0 or t_1:

$$\vec{x}_{ss}(s_m, \bullet) = 0.5 \left(\vec{x}_{ss}(s_0, \bullet) + \vec{x}_{ss}(s_1, \bullet) \right)$$

$$\vec{x}_{sstt}(s_m, \bullet) = 0.5 \left(\vec{x}_{sstt}(s_0, \bullet) + \vec{x}_{sstt}(s_1, \bullet) \right)$$

$$\vec{x}_{tt}(s_m, \bullet) = 0.5 \left(\vec{x}_{tt}(s_0, \bullet) + \vec{x}_{tt}(s_1, \bullet) - d^2 \vec{x}_{sstt}(s_m, \bullet) \right)$$

$$\vec{x}(s_m, \bullet) = 0.5 \left(\vec{x}(s_0, \bullet) + \vec{x}(s_1, \bullet) - d^2 \vec{x}_{ss}(s_m, \bullet) \right).$$

For midpoints (\bullet, t_m), where \bullet is either s_0 or s_1:

$$\vec{x}_{tt}(\bullet, t_m) = 0.5 \left(\vec{x}_{tt}(\bullet, t_0) + \vec{x}_{tt}(\bullet, t_1) \right)$$

$$\vec{x}_{sstt}(\bullet, t_m) = 0.5 \left(\vec{x}_{sstt}(\bullet, t_0) + \vec{x}_{sstt}(\bullet, t_1) \right)$$

$$\vec{x}_{ss}(\bullet, t_m) = 0.5 \left(\vec{x}_{ss}(\bullet, t_0) + \vec{x}_{ss}(\bullet, t_1) - d^2 \vec{x}_{sstt}(\bullet, t_m) \right)$$

$$\vec{x}(\bullet, t_m) = 0.5 \left(\vec{x}(\bullet, t_0) + \vec{x}(\bullet, t_1) - d^2 \vec{x}_{tt}(\bullet, t_m) \right).$$

At the center point (s_m, t_m):

$$\vec{x}_{ss}(s_m, t_m) = 0.5 \left(\vec{x}_{ss}(s_0, t_m) + \vec{x}_{ss}(s_1, t_m) \right)$$

$$\vec{x}_{tt}(s_m, t_m) = 0.5 \left(\vec{x}_{tt}(s_m, t_0) + \vec{x}_{tt}(s_m, t_1) \right)$$

$$\vec{x}_{sstt}(s_m, t_m) = 0.5 \left(\vec{x}_{sstt}(s_0, t_m) + \vec{x}_{sstt}(s_1, t_m) \right)$$

$$\vec{x}(s_m, t_m) = 0.5 \left(\vec{x}(s_0, t_m) + \vec{x}(s_1, t_m) - d^2 \vec{x}_{ss}(s_m, t_m) \right).$$

If L full subdivisions are performed, then $M_\ell = 2^\ell (2^{\ell-1} + 1)$ new midpoints and $C_\ell = 4^{\ell-1}$ new centers are generated at subdivision ℓ. The total number of midpoints is

$$M = \sum_{\ell=1}^{L} 2^\ell (2^{\ell-1} + 1) = \frac{2}{3}(4^L - 1) + 2(2^L - 1),$$

and the total number of center points is

$$C = \sum_{\ell=1}^{L} 4^{\ell-1} = \frac{1}{3}(4^L - 1).$$

For L subdivisions, the total number of vertices is $(2^L + 1)^2$. The four initial corners and the additional midpoints and centers yields

$$4 + \frac{2}{3}(4^L - 1) + 2(2^L - 1) + \frac{1}{3}(4^L - 1) = 4 + 4^L - 1 + 2(2^L - 1)$$

$$= 4^L + 2 \cdot 2^L + 1 = (2^L + 1)^2,$$

a verification that the counts on the midpoints and centers are correct.

Calculation of d^2 requires 1 subtraction and 1 multiplication per level and is not counted in the operation count because the number is insignificant compared to the number of subdivision vertices. Calculation of $\vec{x}, \vec{x}_{ss}, \vec{x}_{tt}$, and \vec{F}_{uuvv} at each midpoint takes 4 additions, 2 subtractions, and 6 multiplications per vector component. Add these and multiply by 3 (for the three components) to obtain 36 operations per midpoint. The center calculations take 4 additions, 1 subtraction, and 5 multiplications per vector component, times 3 components, yields 30 operations per center. The total operation count for the full subdivision is

$$36\left(\frac{2}{3}(4^L - 1) + 2(2^L - 1)\right) + 30\left(\frac{1}{3}(4^L - 1)\right) = 34(4^L - 1) + 72(2^L - 1).$$

The high-order term in the loop iteration algorithm is $90 \cdot 4^L$. For the recursive subdivision, it is $34 \cdot 4^L$. Therefore, the recursive algorithm is about 2.64 times faster.

The pseudocode for the algorithm is shown below.

```
void Subdivide (s0, s1, t0, t1, x[2][2], xss[2][2], xtt[2][2],
  xsstt[2][2])
{
    // Parameter block is [s0,s1]x[t0,t1].
    // x[i][j] = x(si,tj)
    // xss[i][j] = x_{ss}(si,tj)
    // xtt[i][j] = x_{tt}(si,tj)
    // xsstt[i][j] = x_{sstt}(si,tj)

    d = s1 - s0;  // = t1 - t0 since blocks are square
    dsqr = d*d;

    xss_m0 = 0.5*(xss[0][0]+xss[1][0]);
    xss_m1 = 0.5*(xss[0][1]+xss[1][1]);
    xsstt_m0 = 0.5*(xsstt[0][0]+xsstt[1][0]);
    xsstt_m1 = 0.5*(xsstt[0][1]+xsstt[1][1]);
    xtt_m0 = 0.5*(xtt[0][0]+xtt[1][0]-dsqr*xsstt_m0);
    xtt_m1 = 0.5*(xtt[0][1]+xtt[1][1]-dsqr*xsstt_m1);
    x_m0 = 0.5*(x[0][0]+x[1][0]-dsqr*xss_m0);
```

```
x_m1 = 0.5*(x[0][1]+x[1][1]-dsqr*xss_m1);
insert x_m0 and x_m1 in subdivision;

xtt_0m = 0.5*(xtt[0][0]+xtt[0][1]);
xtt_1m = 0.5*(xtt[1][0]+xtt[1][1]);
xsstt_0m = 0.5*(xsstt[0][0]+xsstt[0][1]);
xsstt_1m = 0.5*(xsstt[1][0]+xsstt[1][1]);
xss_0m = 0.5*(xss[0][0]+xss[0][1]-dsqr*xsstt_0m);
xss_1m = 0.5*(xss[1][0]+xss[1][1]-dsqr*xsstt_1m);
x_0m = 0.5*(x[0][0]+x[0][1]-dsqr*xtt_0m);
x_1m = 0.5*(x[1][0]+x[1][1]-dsqr*xtt_1m);
insert x_0m and x_1m in subdivision;

xss_mm = 0.5*(xss_0m+xss_1m);
xtt_mm = 0.5*(xtt_m0+xtt_m1);
xsstt_mm = 0.5*(xsstt_0m+xsstt_1m);
x_mm = 0.5*(x_0m+x1m-dsqr*xss_mm);
insert x_mm in subdivision;

sm = 0.5*(s0+s1);
tm = 0.5*(t0+t1);

// subblock [s0,sm]x[t0,tm]
y[0][0] = x[0][0];
y[1][0] = x_m0;
y[0][1] = x_0m;
y[1][1] = x_mm;
yss[0][0] = xss[0][0];
yss[1][0] = xss_m0;
yss[0][1] = xss_0m;
yss[1][1] = xss_mm;
ytt[0][0] = xtt[0][0];
ytt[1][0] = xtt_m0;
ytt[0][1] = xtt_0m;
ytt[1][1] = xtt_mm;
yss[0][0] = xss[0][0];
yss[1][0] = xss_m0;
yss[0][1] = xss_0m;
yss[1][1] = xss_m;
ysstt[0][0] = xsstt[0][0];
ysstt[1][0] = xsstt_m0;
ysstt[0][1] = xsstt_0m;
ysstt[1][1] = xsstt_mm;
Subdivide(s0,sm,t0,tm,y,yss,ytt,ysstt);
```

```
// subblock [s0,sm]x[tm,t1]
y[0][0] = x_0m;
y[1][0] = x_mm;
y[0][1] = x[0][1];
y[1][1] = x_m1;
yss[0][0] = xss_0m;
yss[1][0] = xss_mm;
yss[0][1] = xss[0][1];
yss[1][1] = xss_m1;
ytt[0][0] = xtt_0m;
ytt[1][0] = xtt_mm;
ytt[0][1] = xtt[0][1];
ytt[1][1] = xtt_m1;
ysstt[0][0] = xsstt_0m;
ysstt[1][0] = xsstt_mm;
ysstt[0][1] = xsstt[0][1];
ysstt[1][1] = xsstt_m1;
Subdivide(s0,sm,tm,t1,y,yss,ytt,ysstt);

// subblock [sm,s1]x[t0,tm]
y[0][0] = x_m0;
y[1][0] = x[1][0];
y[0][1] = x_mm;
y[1][1] = x_1m;
yss[0][0] = xss_m0;
yss[1][0] = xss[1][0];
yss[0][1] = xss_mm;
yss[1][1] = xss_1m;
ytt[0][0] = xtt_m0;
ytt[1][0] = xtt[1][0];
ytt[0][1] = xtt_mm;
ytt[1][1] = xtt_1m;
ysstt[0][0] = xsstt_m0;
ysstt[1][0] = xsstt[1][0];
ysstt[0][1] = xsstt_mm;
ysstt[1][1] = xsstt_1m;
Subdivide(sm,s1,t0,tm,y,yss,ytt,ysstt);

// subblock [sm,s1]x[tm,t1]
y[0][0] = x_mm;
y[1][0] = x_1m;
y[0][1] = x_m1;
y[1][1] = x[1][1];
yss[0][0] = xss_mm;
```

```
yss[1][0] = xss_1m;
yss[0][1] = xss_m1;
yss[1][1] = xss[1][1];
ytt[0][0] = xtt_mm;
ytt[1][0] = xtt_1m;
ytt[0][1] = xtt_m1;
ytt[1][1] = xtt[1][1];
ysstt[0][0] = xsstt_mm;
ysstt[1][0] = xsstt_1m;
ysstt[0][1] = xsstt_m1;
ysstt[1][1] = xsstt[1][1];
Subdivide(sm,s1,tm,t1,y,yss,ytt,ysstt);
}
```

Warning: The code does not show how to memoize the various quantities so that terms are not computed multiple times. If the initial block is subdivided into four subblocks, the code as shown will twice compute the quantities at the midpoint of the shared edge $\{s_m\} \times [t_0, t_m]$, once for subblock $[s_0, s_m] \times [t_0, t_m]$ and once for subblock $[s_m, s_1] \times [t_0, t_m]$. One possibility for avoiding the repetitive calculations is to assign responsibility for the various midpoint quantities to specific subblocks and to pass an additional parameter to Subdivide that indicates which of the four subblocks is being recursed on. Block $[s_0, s_m] \times [t_0, t_m]$ is responsible for four midpoints, blocks $[s_0, s_m] \times [t_m, t_1]$ and $[s_m, s_1] \times [t_0, t_m]$ are each responsible for three midpoints, and block $[s_m, s_1] \times [t_m, t_1]$ is responsible for two midpoints.

Plate 1 illustrates subdivision of an object containing rectangle and triangle patches using uniform tessellation in parameter space.

Nonuniform Subdivision

The recursive uniform subdivision ignores two important aspects of rendering surfaces. The first aspect is that the patch may be relatively flat in some subblocks. There is no point in further subdividing those subblocks because no additional variation is to be found in the surface. The second aspect is that the surface might be far away from the eye point. A fixed level of subdivision could produce a suitable number of triangles to accurately represent the surface when near the eye point, but the same level might produce a large number of small triangles that are expensive to render yet do not contribute much to the perceived shape of the patch. A smarter subdivision scheme will handle both aspects appropriately.

The recursive subdivision can be modified to terminate at a block if the measured variation within the block is insignificant. This modification is done much in the same way as the recursive algorithm for curves. If any of the second derivatives at the four midpoints of a block's edges is significantly large, then the block is subdivided. If the second derivatives at the four midpoints are all significantly small, then the block is

not subdivided. For recursive uniform subdivision, the algorithm essentially builds a complete quadtree of the specified level. The modified recursive algorithm builds a partial quadtree.

The term in Equation (8.3) that measures variation from the line segment connecting the end points of the interval is $x_{i,jk}(\vec{p})\delta_j\delta_k$, with the factor of one-half omitted. According to the summation convention, there is a double summation over indices j and k. The remaining index i is a free index, so this quantity is a vector, call it \vec{V}. For a midpoint calculation on a horizontal edge $[s_0, s_1]$, let $\Delta = s_1 - s_0$; then $\vec{\delta} = \Delta(1, 0)$ and $\vec{V} = \Delta^2 \vec{x}_{ss}((s_0 + s_1)/2, t)$. For a midpoint calculation on a vertical edge $[t_0, t_1]$, let $\Delta = t_1 - t_0$; then $\vec{\delta} = \Delta(0, 1)$ and $\vec{V} = \Delta^2 \vec{x}_{tt}(s, (t_0 + t_1)/2)$.

The pseudocode for the unconstrained recursion can be modified to add the tests on the size of \vec{V}.

```
void Subdivide (s0, s1, t0, t1, x[2][2], xss[2][2], xtt[2][2],
  xsstt[2][2])
{
    // Parameter block is [s0,s1]x[t0,t1].
    // x[i][j] = x(si,tj)
    // xss[i][j] = x_{ss}(si,tj)
    // xtt[i][j] = x_{tt}(si,tj)
    // xsstt[i][j] = x_{sstt}(si,tj)

    d = s1 - s0;  // = t1 - t0 since blocks are square
    dsqr = d*d;

    xss_m0 = 0.5*(xss[0][0]+xss[1][0]);
    xss_m1 = 0.5*(xss[0][1]+xss[1][1]);
    xtt_0m = 0.5*(xtt[0][0]+xtt[0][1]);
    xtt_1m = 0.5*(xtt[1][0]+xtt[1][1]);

    vm0 = dsqr*xss_m0;
    vm1 = dsqr*xss_m1;
    v0m = dsqr*xtt_0m;
    v1m = dsqr*xtt_1m;

    if ( SquaredLength(vm0) > epsilon or
         SquaredLength(vm1) > epsilon or
         SquaredLength(v0m) > epsilon or
         SquaredLength(v1m) > epsilon )
    {
        // subdivide the block

        xsstt_m0 = 0.5*(xsstt[0][0]+xsstt[1][0]);
```

```
xsstt_m1 = 0.5*(xsstt[0][1]+xsstt[1][1]);
xtt_m0 = 0.5*(xtt[0][0]+xtt[1][0]-dsqr*xsstt_m0);
xtt_m1 = 0.5*(xtt[0][1]+xtt[1][1]-dsqr*xsstt_m1);
x_m0 = 0.5*(x[0][0]+x[1][0]-dsqr*xss_m0);
x_m1 = 0.5*(x[0][1]+x[1][1]-dsqr*xss_m1);
insert x_m0 and x_m1 in subdivision;

xsstt_0m = 0.5*(xsstt[0][0]+xsstt[0][1]);
xsstt_1m = 0.5*(xsstt[1][0]+xsstt[1][1]);
xss_0m = 0.5*(xss[0][0]+xss[0][1]-dsqr*xsstt_0m);
xss_1m = 0.5*(xss[1][0]+xss[1][1]-dsqr*xsstt_1m);
x_0m = 0.5*(x[0][0]+x[0][1]-dsqr*xtt_0m);
x_1m = 0.5*(x[1][0]+x[1][1]-dsqr*xtt_1m);
insert x_0m and x_1m in subdivision;

xss_mm = 0.5*(xss_0m+xss_1m);
xtt_mm = 0.5*(xtt_m0+xtt_m1);
xsstt_mm = 0.5*(xsstt_0m+xsstt_1m);
x_mm = 0.5*(x_0m+x1m-dsqr*xss_mm);
insert x_mm in subdivision;

sm = 0.5*(s0+s1);
tm = 0.5*(t0+t1);

// The pseudocode from the unconstrained algorithm
// for the four subblocks goes here...
    }
}
```

This pseudocode has the same warning as for the unconstrained case. The various midpoint quantities could be computed twice. Note that assigning responsibility for computing the various midpoint quantities to specific subblocks does not work in this case. The problem is that one subblock decides not to recurse on its children, thereby not calculating some of the midpoint quantities (the ones that occur in the "subdivide the block" chunk of code), but a neighboring subblock relies on these values being computed. A modification that takes care of this is to provide a set of Boolean flags indicating which of the midpoint quantities still requires computation. By using these, we effectively have a classic table of memoized values. Another possibility is to allow the multiple computations to occur. The worst case is that all midpoints are calculated twice. The number of midpoints to compute at level ℓ is $M_\ell = 4^\ell$. The total number of midpoints for L levels of subdivision is $M = \sum_{\ell=1}^{L} M_\ell = 4(4^L - 1)/3$. The total number of center points is $C = (4^L - 1)/3$. The total operation count (see the formula for the unconstrained case) is $36M + 30C = 58(4^L - 1)$. The high-order term for the loop iteration algorithm was $90 \cdot 4^L$, for the unconstrained algorithm was $34 \cdot 4^L$,

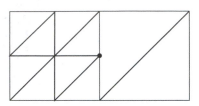

Figure 8.5 Subdivision that contains cracking.

and for the current algorithm is $58 \cdot 4^L$. The approximate speedup over the loop iteration is 1.55—still faster, but not as fast as the algorithm that avoids the repetitious calculations.

Adjustments for the Camera Model

The nonuniform subdivision tests the lengths of the nonlinear terms \vec{V} to decide whether or not to subdivide. For a surface with a lot of variation in it, the subdivisions will occur. In the presence of a camera model and perspective projection, the subdivision is acceptable when the surface is near the eye point. However, if the surface is far away from the eye point, the subdivision may not add much to the visual quality of the rendered surface because each already existent triangle maps only to a handful of pixels on the screen.

One heuristic for the subdivision step is provided in Sharp (1999). The idea is to get an estimate of the length (in pixels) of the projection of \vec{V} into screen space. Sharp (1999) estimates a slice, perpendicular to the camera direction, in the view frustum in which \vec{V} lives, computes the width (in pixels) of that slice, then computes the ratio of the length of \vec{V} to the slice width and compares that ratio to a tolerance. If smaller, the subdivision step is performed.

Another possibility is to compute the midpoint \vec{M} of the line segment connecting the two known end points and compute the length of the projected line segment (in pixels) from \vec{M} to $\vec{M} - \vec{V}/2$, the last point being the actual midpoint if the edge were to be subdivided. This can be done using Equation (3.15). If that distance is larger than an application-specified number of pixels, then the subdivision is performed.

Cracking

The story is not yet finished. Nonuniform subdivision allows for neighboring blocks to be subdivided to different resolutions, which creates cracking in the final mesh. Figure 8.5 shows two adjacent blocks in a subdivision that has cracking. The crack occurs at

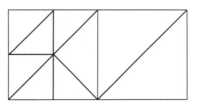

Figure 8.6 Subdivision that has no cracking.

the T-junction marked with a solid dot. The left block wants to be subdivided, but the right block does not. It appears as if one of two choices can be made, and the consequences of either are undesirable. The first choice is to subdivide those blocks that want to be subdivided and force adjacent blocks to follow suit. Applied recursively in the quadtree, this will force a uniform tessellation to the level of the most detailed block. The second choice is to disallow subdivision of blocks that have an adjacent block that does not want to subdivide. This will also force a uniform tessellation, but to the level of the least detailed block. The problem here is subdivision performed strictly as a quadtree process. To accommodate adjacent blocks that do not jointly subdivide (in the quadtree sense), we need to allow for a form of *partial subdivision*. Even with a suitable definition for partial subdivision, the same two choices remain about whether to force the least detailed block to partially subdivide or to prevent the most detailed block from partially subdividing.

A quadtree approach to tessellating a height field surface that uses partial subdivision based on the concept of *vertex dependencies* is discussed in Chapter 11 and is based on Lindstrom et al. (1996). The method is quite sophisticated and takes the stance that a lesser-detailed block must partially subdivide to accommodate a more detailed adjacent block.

An approach that prevents the quadtree subdivision of a more detailed block is mentioned in Sharp (1999). That article illustrates how to resolve the cracking shown in Figure 8.5. The idea is to collapse the midpoint vertex to a corner vertex, as shown in Figure 8.6. The general algorithm can be stated as follows. For each block, if all of the edges are at the same level of detail, then no collapsing is required. Otherwise, collapse the midpoints to the corners at those edges. Recurse on the four subblocks. The nonuniform subdivision requires two passes: one to generate the vertices of the final mesh and one to fix the cracking. While the second pass may not be that expensive, it must handle the type of subdivision shown in Figure 8.7.

Now let's consider a single-pass algorithm that prevents the quadtree subdivision of a more detailed block. The main idea is to do a depth-first traversal of the quadtree, but to use topological information about neighboring blocks to decide if the traversal can continue at the current block. Since neighboring blocks might not have been visited yet, the topological information is obtained by allowing a block to compute

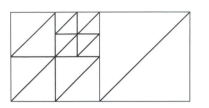

Figure 8.7 Subdivision that contains more complicated cracking.

Figure 8.8 Partial subdivision with three subdividing edges.

quantities that the neighbor would have computed if it had been visited first in the traversal. To avoid recalculating that information, a temporary buffer is used to store computed vertices. The buffer is shared by all patches in the system, so the per-object memory costs are avoided. Consider first the block corresponding to the root of the quadtree. If all four edges want to subdivide, then the block is subdivided into four subblocks and the subdivision process is applied to those subblocks.

Suppose that the right edge of the root block does not want to be subdivided. The partial subdivision is illustrated in Figure 8.8. The upper right and lower right subblocks are no longer considered for subdivision as the tessellation of that part of the parameter space is already determined to be the three triangles that are shown in the figure. The partial subdivision allows the upper-left and lower-left subblocks to continue subdividing, but with constraints. The right edges of those subblocks cannot subdivide because of the final tessellation in the two neighboring subblocks. At best, the topology of the partial subdivision for either subblock can look only like that of the parent block. Figure 8.9 illustrates this for the upper-left subblock. The topological constraints for the subdivision of the child blocks is actually quite natural. The right half of the original block is relatively flat since the right edge did not want to subdivide. The left half of the original block is less flat and wants to subdivide to show off its detail. The constraints lead to a tessellation that conforms to the demands of both halves with a gradual increase in tessellation from right to left.

Figure 8.9 Partial subdivision illustrating the parent's topological constraint.

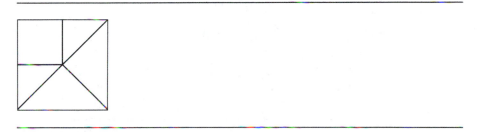

Figure 8.10 Partial subdivision with two adjacent subdividing edges.

Suppose that both the right and bottom edges of the root block do not want to be subdivided. The partial subdivision is illustrated in Figure 8.10. The upper-right, lower-right, and lower-left subblocks are no longer considered for subdivision. The tessellation for that part of the parameter space is determined to be the four triangles shown in the figure. The partial subdivision allows the upper-left subblock to continue subdividing, but again with constraints. The right and bottom edges cannot be subdivided, just as the parent's edges cannot be subdivided. At best, the topology of the partial subdivision can look only like that of the parent block. Figure 8.11 illustrates this for the subblock. The constraint allows a gradual increase in detail from lower right to upper left.

Suppose that both the top and bottom edges of the root block do not want to be subdivided. None of the subblocks are considered for subdivision. However, the left and right triangles in the partial subdivision can be split in half. Figure 8.12 illustrates the partial subdivision with the two additional triangle splits. The surface appears to have saddlelike behavior in the block. No further subdivision is necessary to explore this feature.

Finally, suppose that only the top edge wants to be subdivided. None of the subblocks are considered for subdivision and the top triangle can be split in half. Figure 8.13 illustrates the subdivision with the additional triangle split.

Figure 8.11 Partial subdivision illustrating the parent's topological constraint.

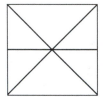

Figure 8.12 Partial subdivision with two opposing subdividing edges.

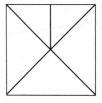

Figure 8.13 Partial subdivision with one subdividing edge.

Figure 8.14 illustrates how a block can subdivide by calculating information in an adjacent block. The left block L is visited first in the quadtree traversal. If L determines that its right edge can be subdivided, then point A is computed. Block R shares that edge and would have agreed to split and compute A also. Because A occurs in the subdivision, point B must occur in the subdivision of R, so L computes it for R. The children of block L are traversed next. The upper-right child might want to subdivide its right edge and compute point C, but this split is only allowed by block R if point D occurs in the subdivision of R. Since R has not yet been visited in the traversal, L can

Figure 8.14 Subdivision based on calculating information in adjacent block.

go ahead and determine if the top edge of R can be split. If so, D is computed and the recursion on the upper-right child of L is allowed. A shared array of subdivision points is used by all patches for temporary storage, and a shared array of Boolean flags is used to indicate whether or not a subdivision point has been computed. Before subdivision of a patch, the Boolean array has all its entries set to `false`.

In an application, typically an object is composed of many surface patches. The crack-free algorithm still applies. The quadtree decomposition for a patch is a convenience for subdividing the parameter space. For cross-patch tessellation, two adjacent patches act like two adjacent blocks. The only information they both need is whether or not to subdivide the common edge. Of course this does assume some continuity between adjacent patches.

One final note: The subdivision algorithm can be made more like the algorithm in Lindstrom et al. (1996)—force lesser-detail blocks to partially subdivide—but requires the concept of vertex dependencies. The challenge is to design a set of data structures that avoids having to store information whose size is of the order of the uniform tessellation at the highest level of detail. If such storage is used in an implementation, then there is no advantage to using a top-down subdivision for surfaces over a bottom-up method such as the one used for terrain tessellation. The top-down method is very desirable for platforms such as game consoles that have large processing power but small memory. For platforms with large memory such as PCs, the choice of algorithm is less important. This particular variation on subdivision will be discussed in the next section.

Plate 2 illustrates subdivision of an object containing rectangle and triangle patches using tessellation based on the continuous level-of-detail algorithm described in this section.

8.4.2 Subdivision of Bézier Triangle Patches

Bézier triangle patches are more difficult to subdivide than Bézier rectangle patches because of the more complicated indexing. However, the concepts are still the same at a high level.

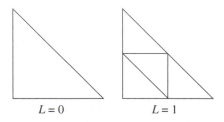

$$L = 0 \qquad\qquad L = 1$$

Figure 8.15 Subdivisions of parameter space for a triangle patch.

Uniform Subdivision

A triangle patch can be subdivided by uniformly tessellating the parameter space to a specified level $L \geq 0$. Figure 8.15 illustrates the subdivisions for $L = 0$ and $L = 1$.

For general level $L > 0$, the number of vertices in the tessellation is $V = (2^L + 1)(2^{L-1} + 1)$, and the number of triangles is $T = 4^L$. The vertices are packed in a one-dimensional array, the bottom row first (containing $2^L + 1$ vertices) through the top row last (containing 1 vertex). The mapping from the integer lattice point (x, y), where x and y are nonnegative integers with $x + y \leq 2^L$, to one-dimensional array index i is

$$i = x + \frac{y(2^{L+1} + 3 - y)}{2}.$$

The straightforward way to compute the vertices is iteration of a double loop. The vertices are stored in a one-dimensional array as mentioned previously. The pseudocode below also shows how to generate an array of indices that represents the triangle connectivity. Each group of three indices corresponds to those vertices that make up a triangle in the tessellation.

```
N = pow(2,L);

// compute the vertices
k = 0;
for (y = 0; y <= N; y++)
{
    v = y/N;
    for (x = 0; x + y <= N; x++)
```

```
        {
            u = x/N;
            vertex[k++] = X(u,v);   // evaluation of triangle patch
        }
    }

// compute the triangle connectivity
t = 0;
ystart = 0;
for (y = 0; y < N; y++)
{
    k0 = ystart;
    k1 = k0 + 1;
    ystart = (y+1)*(2*(N+1)-y)/2;
    k2 = ystart;
    for (x = 0; x + y < N; x++)
    {
        connectivity[t++] = k0;
        connectivity[t++] = k1;
        connectivity[t++] = k2;

        if ( x + y + 1 < N )
        {
            connectivity[t++] = k1;
            connectivity[t++] = k2+1;
            connectivity[t++] = k2;
        }

        k0++;
        k1++;
        k2++;

    }
}
```

 Plate 1 illustrates subdivision of an object containing rectangle and triangle patches using uniform tessellation in parameter space.

Nonuniform Subdivision

Like the algorithm of Lindstrom et al. (1996), the following algorithm uses the equivalent of a symmetric triangulation for quadtree blocks and has a vertex dependency structure.

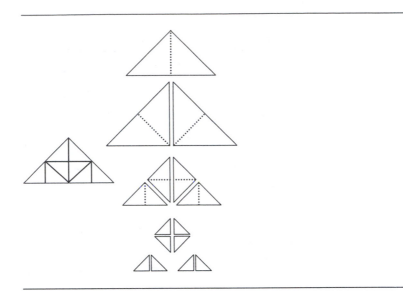

Figure 8.16 Subdivision of a triangle and the corresponding binary tree.

Consider a single triangle whose vertices are labeled as top T, left L, and right R. If the angle at T is a right angle, the edge from L to R is called the *hypotenuse* of the triangle. Taking liberty with the terminology, even if the angle at T is not a right angle, the edge opposite that vertex will be called the "hypotenuse." The subdivision algorithm involves deciding if the hypotenuse of a triangle can be subdivided based on the same heuristic as is used for rectangle patch subdivision. If so, the triangle is split into two triangles. The midpoint of the original hypotenuse becomes the top vertex for the two new triangles. The left and right vertices are labeled so that T, L, and R occur in counterclockwise order. The subdivision process is applied to each of the two new subtriangles. For an unconstrained subdivision of a single triangle, the result is a complete binary tree whose leaf nodes represent the final triangles in the subdivision. Figure 8.16 illustrates the subdivision step applied three times.

The labeling of the subdivided triangles is important in the remainder of this section. The triangle for the root node of the tree is labeled A_0. If A_i is the current triangle to be subdivided and has top vertex T, left vertex L, and right vertex R, and if M is the midpoint of the hypotenuse, then the two children of A_i are A_{2i+1} and A_{2i+2}. The top, left, and right vertices of A_{2i+1} are M, T, and L, respectively. The top, left, and right vertices of A_{2i+2} are M, R, and T. The level in the tree at which A_i occurs is $\ell = \lfloor \log_2(i+1) \rfloor$, where $\lfloor x \rfloor$ is the floor function that computes the largest integer smaller or equal to x.

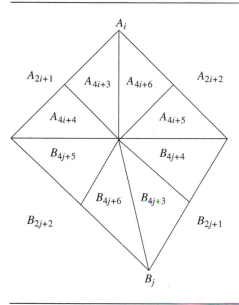

Figure 8.17 H-adjacency for triangles A and B.

The subdivision is more complicated for a triangle mesh. Two adjacent triangles are said to be *H-adjacent* if they share the same hypotenuse. If one of the triangles wants to subdivide its hypotenuse, the other one must also. For a single triangle, this leads to a vertex dependency structure based on the following relationships:

- If A_i and A_{i+1} are siblings, then A_{2i+1} and A_{2i+4} are H-adjacent.

- If A_i and A_j are H-adjacent, then A_{4i+4} and A_{4j+5} are H-adjacent. By symmetry, A_{4i+5} and A_{4j+4} are also H-adjacent.

For two triangles A_0 and B_0 that are H-adjacent, the last relationship is also valid. If A_i and B_j are H-adjacent, then A_{4i+4} and B_{4j+5} are H-adjacent and A_{4i+5} and B_{4j+4} are H-adjacent. Figure 8.17 illustrates the relationships.

The relationships between two triangles that are adjacent on an edge that is not the hypotenuse affects the indexing in the H-adjacency. If A_0 has vertices T, L_0, and R_0, and if C_0 is a triangle that has top vertex T, left vertex L_1, and right vertex L_0, then A_0 and C_0 are not H-adjacent. If M_0 is the midpoint of the edge from L_1 to L_0, then C_2 has top, left, and right vertices M_0, L_0, and T, respectively. If M_1 is the midpoint of the edge from L_0 to R_0, then A_1 has top, left, and right vertices M_1, T, and L_0, respectively. It is the case that A_1 and C_2 are H-adjacent. Generally, if A_{2i+1} and C_{2j+2} are H-adjacent, then so are A_{8i+9} and C_{8j+12} and A_{8i+8} and C_{8j+13}. Figure 8.18 illustrates the relationships. The same constructions apply for an adjacent triangle D_0

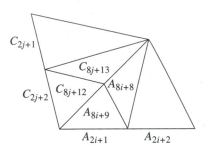

Figure 8.18 H-adjacency for triangles A and C.

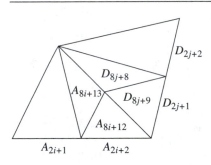

Figure 8.19 H-adjacency for triangles A and D.

whose top, left, and right vertices are T, R_0, and R_1, respectively. The triangles A_2 and D_1 are H-adjacent. Generally, if A_{2i+2} and D_{2j+1} are H-adjacent, then so are A_{8i+13} and D_{8j+8} and A_{8i+12} and D_{8j+9}. Figure 8.19 illustrates the relationships.

For a single triangle to be subdivided, given a maximum level L for subdivision, the storage requirements for vertices are easily computed. Figure 8.20 illustrates the pattern for subdivision for levels $0 \leq L \leq 4$. The number of vertices for maximum subdivision at level L is

$$V = \begin{cases} \sum_{k=1}^{2^{L/2}+1} k, & L \text{ even} \\ \sum_{k=1}^{2^{(L-1)/2}+1} (2k-1), & L \text{ odd} \end{cases} = \begin{cases} \left(2^{L/2}+1\right)\left(2^{L/2-1}+1\right), & L \text{ even} \\ \left(2^{(L-1)/2}+1\right)^2, & L \text{ odd} \end{cases}.$$

The number of triangles for maximum subdivision at level L is $T = 2^L$. Vertex storage is as a regular triangular array with row-major indexing, hypotenuse row first through top vertex last. Indexing will depend on the parity of L.

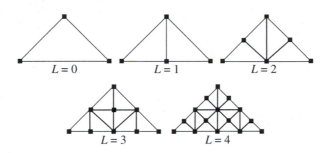

Figure 8.20 Pattern for subdivision of a triangle.

The storage for the worst case can be allocated for a single triangle. Each subdivided triangle uses the same storage and, once subdivided, the renderer must draw the triangles to free the storage for the next triangle to use. This approach leads to some redundant calculations of vertices, those that lie on shared edges of the original mesh triangles. If size of storage is not an issue, then vertex storage can be allocated per triangle, and the vertex dependencies for H-adjacent triangles can be used in support for calculating each subdivision vertex exactly once. If size of storage is an issue, but speed of vertex calculations is not, then each leaf triangle in the binary tree can be drawn when visited with effectively no storage requirements. The binary tree is virtually traversed simply by the recursive function calls:

```
void Subdivide (Point T, Point L, Point R)
{
    M = R - L;
    compute second derivative vector D;
    if ( D is sufficiently large )
    {
        Subdivide(M,T,L);
        Subdivide(M,R,T);
    }
    else
    {
        DrawTriangle(T,L,R);
    }
}
```

Finally, given a triangle mesh it is necessary to select those edges that will be hypotenuses. It appears that this should always be possible with the mesh, but a guaranteed way of doing this that does not require a preprocessing pass is to subdivide each triangle into three triangles by adding the centroid and edges connecting the

centroid to the original vertices. In this way all the edges of the original mesh are the hypotenuses of the tripled mesh. Moreover, if a rectangle mesh is processed in the same way by adding the centroids and connecting to the four corners, the resulting triangle mesh can be subdivided with the algorithm mentioned in this section. This subdivision is the symmetric triangulation discussed in Lindstrom et al. (1996) for terrains.

Plate 2 illustrates subdivision of an object containing rectangle and triangle patches using tessellation based on the continuous level-of-detail algorithm described in this section.

8.4.3 SUBDIVISION OF BÉZIER CYLINDER SURFACES

Bézier cylinder surfaces are easier to subdivide than rectangle or triangle patches because only the curve boundaries need to be subdivided.

SOURCE CODE

LIBRARY

Surface

FILENAME

BezierCylinder
BezierCylinder2
BezierCylinder3

Uniform Subdivision

A cylinder surface can be subdivided by uniformly tessellating the parameter space to specified levels L in the curve direction and M in the extruded direction. The defaults are $L = 0$ and $M = 0$, in which case the tessellation consists of two triangles. The tessellation is similar to that for Bézier rectangle patches with the exception that the number of rows and number of columns of vertices do not have to be the same. The number of vertices in the tessellation is $V = (2^L + 1)(M + 2)$, and the number of triangles is $T = 2^{L+1}(M + 1)$.

Nonuniform Subdivision

For a cylinder surface whose two boundary curves are rigid translations of each other, a nonuniform subdivision of the boundary curve and a uniform subdivision in the extruded direction produce a nonuniform subdivision of the surface. If the two boundary curves are not related by a rigid translation, then the curves can be jointly subdivided. We can choose to subdivide if at least one of the curves wants to subdivide (higher level of tessellation) or not subdivide if at least one of the curves does not want to subdivide (lower level of tessellation). A uniform subdivision is still performed in the extruded direction.

8.4.4 SUBDIVISION OF SPHERES AND ELLIPSOIDS

This section describes how to tessellate a unit radius sphere starting with an inscribed convex triangular mesh. A typical starting mesh is an inscribed octahedron with equilateral triangular faces, but the algorithm applies equally well to any inscribed convex triangular mesh. The choice of initial mesh affects the final distribution of

triangles. Each triangle in the initial mesh is assumed to have its vertices ordered in a counterclockwise fashion as you look at the triangle from the outside of the initial convex mesh.

Each triangle is subdivided into four triangles by computing the midpoints of the triangle edges and connecting them together. The midpoints are not on the unit sphere, but must be moved onto the sphere. Normalizing the points does not necessarily yield a convex polyhedron, especially when the sphere center is not in the initial convex polyhedron. Instead, the centroid of the polyhedron (guaranteed to be inside the polyhedron) is computed, then the edge midpoints are projected onto the sphere along the rays connecting the centroid and midpoints. If an ellipsoid is being tessellated instead, the projection of midpoints onto the ellipsoid is similar to that for the sphere.

Subdividing the polyhedron is simple to implement if all you keep track of is a list of triangles and the three vertex locations per triangle. However, if you need more connectivity relationships among the vertices, edges, and triangles of the mesh, the implementation becomes more difficult. While simple to describe, the difficult problem is maintaining data structures.

Data Structures for the Algorithm

The following data types are used. The implementation uses pointers for efficiency by avoiding full copying of the data members.

```
typedef struct
{
    float x, y, z;
}
Point3;

typedef struct
{
    Point3* point;
    int numEdges;  // number of edges sharing the vertex
    struct Edge** edge;  // array of numEdges edge pointers
}
Vertex;

typedef struct
{
    struct Vertex* vertex[2];  // end points of edge
    struct Triangle* triangle[2];  // t[0] and t[1] share
                                   // the edge
}
Edge;
```

```
typedef struct
{
    struct Vertex* vertex[3];   // vertices of triangle
    struct Edge* edge[3];   // e0 = <v0,v1>, e1 = <v1,v2>,
                            // e2 = <v2,v0>
    struct Triangle* adjacent[3];   // adj[i] shares e[i]
                                    // with triangle
}
Triangle;

typedef struct
{
    int numVertices;
    Vertex* vertex;

    int numEdges;
    Edge* edge;

    int numTriangles;
    Triangle* triangle;

    Point3 centroid;
}
ConvexPolyhedron;
```

Although other variations on the data types may be required for an application, this one suffices in the algorithm for computing the terminator and silhouette of a convex polyhedron. Our goals in the construction are to have no reallocation of memory (avoiding fragmentation of the heap) and to update the data structures in place (efficiently using memory).

Let the initial mesh have v_0 vertices, ϵ_0 edges, and τ_0 triangles. Let v_i, ϵ_i, and τ_i be the number of vertices, edges, and triangles, respectively, after the ith subdivision step. The number of vertices increases by the number of edges. The number of edges is first doubled by the edge splitting, then increased by three times the number of triangles due to connecting the midpoints of the edges. The number of triangles quadruples. The recurrence relations are

$$v_{i+1} = v_i + \epsilon_i, \quad \epsilon_{i+1} = 2\epsilon_i + 3\tau_i, \quad \tau_{i+1} = 4\tau_i, \quad i \geq 0.$$

While these can be solved in closed form, the code just iterates the equations for the desired number of subdivision steps n to compute the total number of vertices, edges, and triangles required for the final convex polyhedron. The required memory for vertices, edges, and triangles can be allocated all at once for the polyhedron.

The other dynamically allocated quantities are the arrays of edge pointers in the `Vertex` structure. The arrays for the initial vertices never change size. For each added vertex, the number of edges is always six. Because of the edge splitting, the actual edge pointers may change during a subdivision step.

Subdivision Algorithm

Initially, and after each subdivision step, the centroid of the convex polyhedron is computed to be used in the midpoint projection phase of the subdivision. This point is computed as the average of the current vertices in the polyhedron. The centroid at step s is

$$\vec{C} = \sum_{j=0}^{v_s} \vec{P}_j,$$

where the vertex locations are \vec{P}_0 through \vec{P}_{v_s-1}.

A new vertex is added per edge by computing the midpoint \vec{M} of the edge, then projecting that point along the ray starting at the centroid \vec{C} and passing through \vec{M}. If edge E has end points \vec{P}_0 and \vec{P}_1, then $\vec{M} = (\vec{P}_0 + \vec{P}_1)/2$. The ray is given parametrically as $\vec{X}(t) = \vec{C} + t(\vec{M} - \vec{C})$, where $t \geq 0$. Since both \vec{C} and \vec{M} are inside the sphere, $\vec{X}(t)$ must be inside the sphere for any $t \in [0, 1]$. The new vertex location occurs where the ray and sphere intersect. If \bar{t} is the parameter value at the intersection, then $\bar{t} > 1$ and the squared length of $\vec{X}(\bar{t})$ is 1. This condition is a quadratic equation

$$1 = \vec{X}(\bar{t}) \cdot \vec{X}(\bar{t})$$

$$= [\vec{C} + \bar{t}(\vec{M} - \vec{C})] \cdot [\vec{C} + \bar{t}(\vec{M} - \vec{C})]$$

$$= \vec{C} \cdot \vec{C} + 2\vec{C} \cdot (\vec{M} - \vec{C})t + (\vec{M} - \vec{C}) \cdot (\vec{M} - \vec{C})t^2.$$

If $\vec{D} = \vec{M} - \vec{C}$, the quadratic equation is $a_2 t^2 + a_1 t + a_0 = 0$, where $a_2 = \vec{D} \cdot \vec{D}$, $a_1 = 2\vec{C} \cdot \vec{D}$, and $a_0 = \vec{C} \cdot \vec{C} - 1$. As argued earlier, the equation has one root larger than 1, namely,

$$\bar{t} = \frac{-a_1 + \sqrt{a_1^2 - 4a_0 a_2}}{2a_2}.$$

The location for the new vertex is therefore $\vec{P} = \vec{C} + \bar{t}\vec{D}$.

The total amount of memory required for the vertex, edge, and triangle arrays in the final polyhedron is computed, and the corresponding memory is allocated. The vertex array has v_n elements, the edge array has ϵ_n elements, and the triangle array has τ_n elements. The initial items are stored at the beginning of each of the arrays. For a

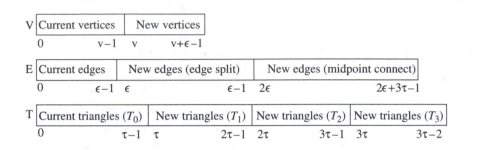

V	Current vertices	New vertices		
0	v−1	v		v+ε−1

E	Current edges	New edges (edge split)		New edges (midpoint connect)	
0	ε−1	ε	ε−1 2ε		2ε+3τ−1

T	Current triangles (T_0)	New triangles (T_1)	New triangles (T_2)	New triangles (T_3)	
0	τ−1	τ 2τ−1	2τ 3τ−1	3τ	3τ−2

Figure 8.21 Working set of vertices, edges, and triangles.

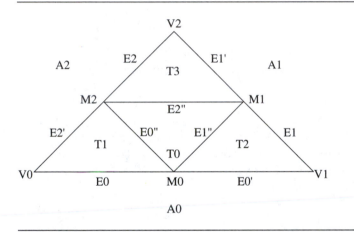

Figure 8.22 Subdivided triangle.

single subdivision step, the working set in memory is shown in Figure 8.21. The values v, ϵ, and τ are the current numbers of vertices, edges, and triangles, respectively. The partitioning of the triangle subarray into four sections corresponds to splitting the triangle into four pieces as shown in Figure 8.22. If the figure represents the triangle stored at the tth location in the array, then the subtriangle T_k is stored at location $t + k\tau$ for $k = 1, 2, 3$. The subtriangle T_0 is stored at the same location as the original triangle. This in-place storage requires careful bookkeeping to avoid overwriting old triangle information with new information before the old information is no longer needed for other parts of the algorithm.

As the data structures are updated, it is important to retain old vertex, edge, or triangle information that is necessary for use at a later stage of the update. In the pseudocode, variables vmax, emax, and tmax correspond to v, ϵ, and τ, the current

number of vertices, edges, and triangles. The variables vertex, edge, and triangle refer to the arrays V, E, and T shown in Figure 8.21. The variable centroid is the centroid of the current polyhedron.

The first two safe operations are to add the new vertex locations and to split the edges.

```
for (e = 0; e < emax; e++)
{
    // generate new vertex M from edge[e]
    E0 located at edge[e];
    P0 = E0.vertex[0].point;
    P1 = E0.vertex[0].point;
    mid = (P0+P1)/2;
    M located at vertex[vmax+e];
    M.point = RaySphereIntersection(centroid,mid);
    M.numberOfEdges = 6;
    M.edge = allocate 6 edge pointers;

    // split edge E0 = <V0,V1> into E0 = <V0,M> and E1 = <V1,M>
    E1 located at edge[emax+e];
    E1.vertex[0] = E0.vertex[1];
    E0.vertex[1] = M;
    E1.vertex[1] = M;
}
```

The edge pointers for the new vertices are set later to point to the subdivided edges. The triangle pointers for the split edges are the old ones and are updated later to point to the subdivided triangles. Once the new vertex locations are known, the centroid of the old and new vertices can be precomputed for the next subdivision pass.

An iteration can now be made over the current triangles to update various fields in the data structures. The function VertexIndex(V) returns the index of vertex V in the array of vertices. Similarly, EdgeIndex(E) returns the index of edge E in the array of edges, and TriangleIndex(T) returns the index of triangle T in the array of triangles.

The code uses four indices into the triangle array: t0 for the current triangles (then later to represent the middle triangle in the subdivision) and t1, t2, and t3 for the other subdivided triangles. Initially,

```
t0 = 0;
t1 = tmax;
t2 = 2*tmax;
t3 = 3*tmax;
```

In the following discussion, each displayed block of code is contained in a loop where t0 varies from 0 to tmax-1. All four counters are incremented each pass of the loop. The first displayed block of code indicates the relationships that are immediately discernable from Figure 8.22.

```
// get triangles to process
Tj located at triangle[tj] for j = 0,1,2,3;
Vi = T0.vertex[i] for i = 0,1,2;  // vertices
Ei = T0.edge[i] for i = 0,1,2;  // original edges
Ei' is other half of original edge formed by split;
Ai = T0.adjacent[i] for i = 0,1,2;  // adjacent triangles
Mi located at vertex[vmax+EdgeIndex(Ei)] for i = 0,1,2;
                                        // midpoints

// edges corresponding to connections of midpoints
Ei" located at edge[2*emax+3*t0+i] for i = 0,1,2;

// set vertices and triangles for edges
E0".vertex[0] = M2;
E0".vertex[1] = M0;
E0".triangle[0] = T0;
E0".triangle[1] = T1;
E1".vertex[0] = M0;
E1".vertex[1] = M1;
E1".triangle[0] = T0;
E1".triangle[1] = T2;
E2".vertex[0] = M1;
E2".vertex[1] = M2;
E2".triangle[0] = T0;
E2".triangle[1] = T3;

// set some members of triangle T1
T1.vertex[0] = V0;
T1.vertex[1] = M0;
T1.vertex[2] = M2;
T1.edge[0] = E0;
T1.edge[1] = E0";
T1.edge[2] = E2';
T1.adjacent[1] = T0;

// set some members of triangle T2
T2.vertex[0] = M0;
T2.vertex[1] = V1;
T2.vertex[2] = M1;
```

```
T2.edge[0] = E0';
T2.edge[1] = E1;
T2.edge[2] = E1";
T2.adjacent[2] = T0;

// set some members of triangle T2
T3.vertex[0] = M2;
T3.vertex[1] = M1;
T3.vertex[2] = V2;
T3.edge[0] = E2";
T3.edge[1] = E1';
T3.edge[2] = E2;
T3.adjacent[0] = T0;
```

The subdivided triangles T1, T2, and T3 have some adjacent triangles that are themselves subdivided triangles of adjacent triangles of the original triangle T0. At this point in the algorithm we know the index of each original adjacent triangle in the triangle array for the polyhedron. We can use this index to locate the triangle array elements for the subdivided triangle of the adjacent triangle. However, there is one complication. Figure 8.22 shows a triangle in a *standard* configuration based on how the vertices and edges were labeled (vertices start at lower-left corner of triangle, others labeled in counterclockwise order). An adjacent triangle can have one of three possible orientations in its relationship to the central triangle. The code must determine which edge of the adjacent triangle is shared with the central triangle. This information allows proper labeling of the adjacency relationship between subdivided triangles and adjacent original triangles.

Figure 8.23 shows the nine cases to consider, three choices for adjacent triangle and three orientations for that triangle. The pseudocode for handling the adjacent triangle A0 is

```
// get the indices for the subdivided triangles of A0
i0 = TriangleIndex(A0);
i1 = i0+tmax;
i2 = i1+tmax;
i3 = i2+tmax;

orient = shared ege of A0 and T0 is A0.edge[orient];
if ( orient == 0 )
{
    T1.adjacent[0] is triangle[i2];
    T2.adjacent[0] is triangle[i1];
    triangle[i2].adjacent[0] is T1;
    triangle[i1].adjacent[0] is T2;
}
```

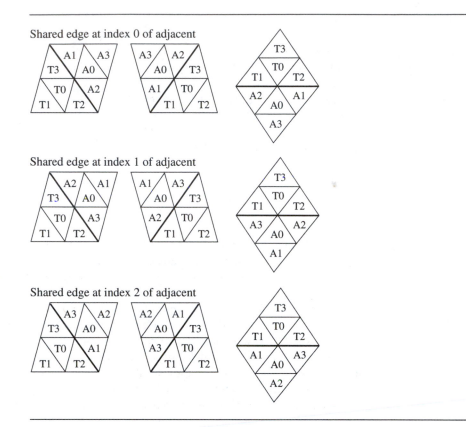

Figure 8.23 Possible orientations of adjacent triangle with central triangle.

```
else if ( orient == 1 )
{
    T1.adjacent[0] is triangle[i3];
    T2.adjacent[0] is triangle[i2];
    triangle[i3].adjacent[1] is T1;
    triangle[i2].adjacent[1] is T2;
}
else
{
    T1.adjacent[0] is triangle[i1];
    T2.adjacent[0] is triangle[i3];
    triangle[i1].adjacent[2] is T1;
    triangle[i3].adjacent[2] is T2;
}
```

Similar blocks of code are in the source file on the CD-ROM for adjacent triangles A1 and A2.

Finally, in this loop, the edge pointers for the new vertices can be set. The real code initializes the number of edges of each new vertex to zero as a flag. The first time a new vertex is encountered, it is processed as a midpoint of an edge of a triangle. At this time four of the edges sharing the vertex are known. At later pass through the loop, the adjacent triangle is encountered that shares the edge whose midpoint generated the new vertex. At this time the remaining two edge pointers can be set. For example:

```
// add edge links to midpoint vertices
if ( M0.numEdges == 0 )
{
    // add four edges (first time edges are added for this vertex)
    M0.numEdges = 4;
    M0.edge[0] is T1.edge[0];
    M0.edge[1] is T1.edge[1];
    M0.edge[2] is T2.edge[2];
    M0.edge[3] is T2.edge[0];
}
else if ( M0.numEdges == 4 )
{
    // add two edges (last time edges are added for this vertex)
    M0.numEdges = 6;
    M0.edge[4] is T1.edge[1];
    M0.edge[5] is T2.edge[2];
}
```

Similar blocks of code are in the source file on the CD-ROM for new vertices M1 and M2.

A second iteration over the current triangles is made. This step requires information produced by the first iteration over all triangles. The following blocks of pseudocode are contained in a loop over the four triangle counters, just as before. The initial values of the counters are

```
t0 = 0;
t1 = tmax;
t2 = 2*tmax;
t3 = 3*tmax;
```

The first part of the loop is

```
// get triangles to process
Tj located at triangle[tj] for j = 0,1,2,3;
Ei = T0.edge[i] for i = 0,1,2;
Mi = vertex[vmax+EdgeIndex(Ei)] for i = 0,1,2;
```

```
// set vertices, edges, adjacencies for middle triangle
T0.vertex[0] is M2;
T0.vertex[1] is M0;
T0.vertex[2] is M1;
T0.edge[0] is T1.edge[1];
T0.edge[1] is T2.edge[2];
T0.edge[2] is T3.edge[0];
T0.adjacent[0] is T1;
T0.adjacent[1] is T2;
T0.adjacent[2] is T3;
```

The subdivided triangle edge pointers can be set at this time. For example, at T1,

```
T1.edge[0].triangle[0] is T1;
T1.edge[0].triangle[1] is T1.adjacent[0];
T1.edge[2].triangle[0] is T1;
T1.edge[2].triangle[1] is T1.adjacent[2];
```

The actual code initializes the triangle pointers to zero and tests before the pointers are set. Otherwise, each triangle pointer is written twice (simply an efficiency gain). Similar blocks of code exist on the CD-ROM for T2 and T3.

The last step is to adjust the edge pointers of the original vertices to account for the edge splitting. The main concern is to select the correct half edge to store a pointer to. This can be determined by comparing the vertex pointer values of the half edges to the testing vertex.

```
for (v = 0; v < vmax; v++)
{
    V is vertex[v];
    for (e = 0; e < V.numEdges; e++)
    {
        E is V.edge[e];
        if ( E.vertex[0] not equal V and E.vertex[1] not equal V )
        {
            // V.edge[e] currently points to wrong half edge,
            // switch it
            V.edge[e] = edge[emax+EdgeIndex(E)];
        }
    }
}
```

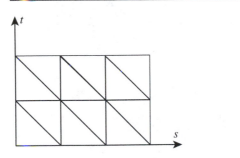

Figure 8.24 Tessellation of parameter space for a tube surface.

8.4.5 SUBDIVISION OF TUBE SURFACES

Tessellation of a tube surface is a straightforward process. The surface is defined parametrically by Equation (8.2). The parameter space is $[t_{\min}, t_{\max}] \times [0, 2\pi)$ and can be uniformly subdivided into triangles as shown in Figure 8.24. Let $t_i = t_{\min} + i(t_{\max} - t_{\min})/n$ for $0 \le i \le n$ and $\theta_j = j(2\pi)/m$ for $0 \le j \le m$. The vertices participating in the tessellation are $\vec{S}_{i,j} = \vec{S}(t_i, \theta_j)$. Since the surface is a tube, $\vec{S}_{i,m} = \vec{S}_{i,0}$ for all i. Additionally, if the tube is required to be closed (that is, $\vec{x}(t)$ is a closed curve), then $\vec{S}_{n,j} = \vec{S}_{0,j}$. The following pseudocode shows the generation of a connectivity list, an array of indices into a vertex array with each set of three consecutive indices corresponding to a triangle. The vertices in the parameter space tessellation are stored in row-major order with the $t = t_{\min}$ row occurring first and are ordered with increasing θ.

```
tmax = maximum index on time T samples;
amax = maximum index on angle A samples;
numVertices = 2*(tmax+1)*(amax+1);
numTriangles = 2*tmax*amax;
triList[3*numTriangles];  // array of vertex indices
for (t = 0, k = 0, start = 0; t < tmax; t++)
{
    j0 = start;
    j1 = j0 + 1;
    start += amax+1;
    j2 = start;
    for (a = 0; a < amax; a++, j0++, j1++, j2++)
    {
        triList[k++] = j0;
        triList[k++] = j2;
```

```
            triList[k++] = j1;
            triList[k++] = j1;
            triList[k++] = j2;
            triList[k++] = j2+1;
        }
    }
```

Additional work is required if relationships must be maintained between vertices, edges, and triangles.

ANIMATION OF
CHARACTERS

In Chapter 4, the concept of *animation* was presented as the process of controlling any time-varying quantity in a scene graph. The classic setting is character animation, where an articulated figure changes position and orientation over time. The quantities to be controlled are just the local transformations at the joints of the figure. Two standard approaches to animating a character are *key frame animation* and *inverse kinematics*.

Key frame animation requires an artist to build a character in various poses; each pose is called a *key frame*. Each key frame changes the local positions and local orientations of the nodes in the hierarchy. When it comes time to animate the character, the poses at the times between key frames are computed using interpolation. A flexible method for interpolating the local translations uses Kochanek-Bartels splines, discussed in Section 7.3.4. The interpolation of local rotations is more complex and is discussed in this chapter. The idea is to represent the rotations as quaternions and then interpolate the quaternions. The smooth interpolation of quaternions is a somewhat technical concept. The focus in this chapter is on the quaternion calculus and interpolation concepts.

341

One potential problem with key frame animation is that the local transformations at the nodes are interpolated in a relatively independent way. Interpolation at one node is performed independently from interpolation at another node, which can lead to artifacts, such as the stretching of character components that normally are considered to be rigid. For example, the local translations of a shoulder node and elbow node are interpolated independently, but the length of the arm from shoulder to elbow should be constant. The interpolations do not guarantee that this constraint will be satisfied.

An alternative method for animation is to use inverse kinematics. Constraints are placed at the various nodes—constraints such as fixed lengths between nodes or rotations restricted to planes and/or with restricted ranges of angles. The only interpolation that needs to occur is at those nodes with any degree of freedom. For example, an elbow node and wrist node have a fixed length between them, and both nodes have rotations restricted to planes with a fixed range of angles. A hand node is attached to the wrist and has three degrees of freedom (the components of local translation). The hand can be moved to some location in space; the wrist and elbow must follow accordingly, but with the mentioned constraints. In this chapter, we will restrict our discussion of inverse kinematics to a tree of nodes.

Animating the nodes corresponding to the joints of a character is one thing, getting the surface of the character to move properly with the joints is another. The last section in this chapter talks about *skinning*—establishing a set of bones connecting the joints and assigning the vertices of the mesh representing skin, clothing, and other quantities to various bones for weighting purposes. As the bones move, the vertices will change according to their weights.

Now a brief mention of what this chapter is *not* about. Nothing is discussed in this chapter about how to actually build physically realistic animations. That topic is quite complex and could fill a large book by itself. Recently, a few companies have ventured into producing *physics engines* to provide for realistic motions and realistic interactions between objects in the world. Although correct physics is a very important topic, this chapter describes only how to process the animation data that was already constructed by an artist through a modeling package, by motion capture, or by other procedural means.

9.1 KEY FRAME ANIMATION

Key frame animation is effectively an interpolation of translational and rotational information over time. Interpolation of translational information is conceptually easy. Interpolation of rotational information is conceptually difficult. This section focuses on interpolation of rotations that are represented as quaternions.

9.1.1 QUATERNION CALCULUS

The only support needed for quaternion interpolation is to differentiate unit quaternion functions raised to a real-valued power. These formulas are identical to those

derived in a standard calculus course, but the order of multiplication must be observed. The ideas in this discussion are taken from Shoemake (1987). The derivative of the function q^t, where q is a constant unit quaternion, is

$$\frac{d}{dt}q^t = q^t \log(q),\qquad(9.1)$$

where \log is the function defined earlier by $\log(\cos\theta + \hat{u}\sin\theta) = \hat{u}\theta$. The power can be a function itself,

$$\frac{d}{dt}q^{f(t)} = f'(t)q^{f(t)}\log(q).\qquad(9.2)$$

9.1.2 SPHERICAL LINEAR INTERPOLATION

Given two distinct points on a unit sphere in three-dimensional space, it is possible to interpolate between them by sampling along a great arc containing the two points. In particular, the idea may be extended to quaternions as points on the unit hypersphere in four-dimensional space.

To construct the formula, let q_0 and q_1 be distinct unit vectors on the hypersphere. An interpolation is required of the form

$$q(t) = c_0(t)q_0 + c_1(t)q_1,\quad 0 \le t \le 1,$$

where $c_0(t)$ and $c_1(t)$ are real-valued functions and where $q(t)$ is always a unit vector. Moreover, $c_0(0) = 1$, $c_1(0) = 0$, $c_0(1) = 0$, and $c_1(1) = 1$. Thus,

$$1 = q(t)\cdot q(t) = c_0(t)^2 + 2c_0(t)c_1(t)(q_0\cdot q_1) + c_1(t)^2$$

$$= [\,c_0\ \ c_1\,]^T \begin{bmatrix} 1 & d \\ d & 1 \end{bmatrix}\begin{bmatrix} c_0 \\ c_1 \end{bmatrix} = c^t M c,$$

where $d = q_0 \cdot q_1 = \cos\theta$ and θ is the angle between the two unit quaternions. The matrix M is positive definite since $|d| < 1$. It can be factored as $M = R^t D R$, where $D = \text{diag}(1 + d, 1 - d)$ and R is orthogonal with first column $(1, -1)/\sqrt{2}$ and second column $(1, 1)/\sqrt{2}$ (see Appendix B, Section B.2). Defining $u = \sqrt{D}Rc$, the previous equation becomes $u^T u = 1$. Therefore, u is a unit-length vector and can be written as $u = (\cos(\omega t)), \sin(\omega t))$. Solving for c_0 yields

$$c_0 = \frac{\cos(\omega t)}{\sqrt{2(1+d)}} - \frac{\sin(\omega t)}{\sqrt{2(1-d)}} = \frac{\sin(\omega t + \psi_0)}{\sqrt{1-d^2}} = \frac{\sin(\omega t + \psi_0)}{\sin\theta}$$

for some phase angle ψ_0. Similarly,

$$c_1 = \frac{\sin(\omega t + \psi_1)}{\sin\theta}$$

for some phase angle ψ_1. The boundary conditions for c_0 are used to obtain $1 = \sin(\psi_0)/\sin\theta$ and $0 = \sin(\omega + \psi_0)/\sin\theta$, which are satisfied when $\psi_0 = \theta$ and $\omega = -\theta$. Thus,

$$c_0(t, \theta) = \frac{\sin((1 - t)\theta)}{\sin\theta}.$$

The boundary conditions for c_1 are used to obtain $0 = \sin(\psi_1)/\sin\theta$, and $1 = \sin(\omega + \psi_1)/\sin\theta$, which are satisfied when $\psi_1 = 0$ and $\omega = \theta$. Thus,

$$c_1(t, \theta) = \frac{\sin(t\theta)}{\sin\theta}.$$

The spherical linear interpolation, abbreviated as *slerp*, is defined by

$$\text{slerp}(t; q_0, q_1) = \frac{q_0 \sin((1 - t)\theta) + q_1 \sin(t\theta)}{\sin\theta} \tag{9.3}$$

for $0 \le t \le 1$.

Although q_1 and $-q_1$ represent the same rotation, the values of $\text{slerp}(t; q_0, q_1)$ and $\text{slerp}(t; q_0, -q_1)$ are not the same. It is customary to choose the sign σ on q_1 so that $q_0 \cdot (\sigma q_1) \ge 0$ (the angle between q_0 and σq_1 is acute). This choice avoids extra spinning caused by the interpolated rotations.

For unit quaternions, slerp can be written as

$$\text{slerp}(t; q_0, q_1) = q_0 \left(q_0^{-1} q_1 \right)^t, \tag{9.4}$$

in which case $\text{slerp}(0; q_0, q_1) = q_0$ and $\text{slerp}(1; q_0, q_1) = q_0(q_0^{-1}q_1) = q_1$. The term $q_0^{-1}q_1 = \cos\theta + \hat{u}\sin\theta$, where θ is the angle between q_0 and q_1. The time parameter can be introduced into the angle so that the adjustment of q_0 varies uniformly with time over the great arc between q_0 and q_1. That is, $q(t) = q_0[\cos(t\theta) + \hat{u}\sin(t\theta)] = q_0[\cos\theta + \hat{u}\sin\theta]^t = q_0(q_0^{-1}q_1)^t$.

The derivative of slerp in the form of Equation (9.4) is a simple application of Equation (9.1):

$$\text{slerp}'(t; q_0, q_1) = q_0(q_0^{-1}q_1)^t \log(q_0^{-1}q_1). \tag{9.5}$$

It is possible to add *extra spins* to the interpolation. Rather than interpolating the shortest great arc between the two quaternions, it is possible to wrap around the great circle n times before stopping at the destination quaternion. The formula in Equation (9.3) requires addition of a phase angle to θ,

$$\text{SlerpExtra}(t; q_0, q_1) = \frac{q_0 \sin((1 - t)(\theta + 2\pi n)) + q_1 \sin(t(\theta + 2\pi n))}{\sin\theta}.$$

9.1.3 SPHERICAL CUBIC INTERPOLATION

SOURCE CODE

LIBRARY

Core

FILENAME

Quaternion

The cubic interpolation of quaternions can be achieved using a method described by Boehm (1982), which has the flavor of bilinear interpolation on a quadrilateral. The evaluation uses an iteration of three slerps and is similar to the de Casteljau algorithm (Farin 1990). Imagine four quaternions p, a, b, and q as the ordered vertices of a quadrilateral lying on the unit hypersphere. Interpolate c along the great circle arc from p to q using slerp. Interpolate d along the great circle arc from a to b. Now interpolate the interpolations c and d to get the final result e. The end result is denoted *squad* and is given by

$$\text{squad}(t; p, a, b, q) = \text{slerp}(2t(1-t); \text{slerp}(t; p, q), \text{slerp}(t; a, b)). \tag{9.6}$$

The derivative of squad in Equation (9.6) is computed as follows. Let $u(t) = c_0(t, \theta)p + c_1(t, \theta)q$, $v(t) = c_0(t, \phi)a + c_1(t, \theta)b$, and $S(t) = \text{squad}(t; p, a, b, q) = c_0(2t(1-t), \psi(t))u(t) + c_1(2t(1-t), \psi(t))$, where $\cos(\theta) = p \cdot q$, $\cos(\psi) = a \cdot b$, and $\cos(\psi(t)) = u(t) \cdot v(t)$. The derivative is

$$S'(t) = c_0(2t(1-t), \psi(t))u'(t) + \frac{dc_0(2t(1-t), \psi(t))}{dt}u(t) +$$

$$c_1(2t(1-t), \psi(t))v'(t) + \frac{dc_1(2t(1-t), \psi(t))}{dt}v(t).$$

Using the chain rule and Equation (9.5), it can be shown that

$$\left.\frac{dc_0(2t(1-t), \psi(t))}{dt}\right|_{t=0} u(0) + \left.\frac{dc_1(2t(1-t), \psi(t))}{dt}\right|_{t=0} v(0) = \text{slerp}'(0; p, a)$$

and

$$\left.\frac{dc_0(2t(1-t), \psi(t))}{dt}\right|_{t=1} u(1) + \left.\frac{dc_1(2t(1-t), \psi(t))}{dt}\right|_{t=1} v(1) = \text{slerp}'(0; q, b).$$

Consequently, $S'(0) = p \log(p^{-1}q) + 2p \log(p^{-1}a)$ and $S'(1) = q \log(p^{-1}q) - 2q \log(q^{-1}b)$. The derivative of squad at the end points are

$$\text{squad}'(0; p, a, b, q) = p[\log(p^{-1}q) + 2 \log(p^{-1}a)]$$

$$\text{squad}'(1; p, a, b, q) = q[\log(p^{-1}q) - 2 \log(q^{-1}b)]. \tag{9.7}$$

9.1.4 SPLINE INTERPOLATION OF QUATERNIONS

Given a sequence of N unit quaternions $\{q_n\}_{n=0}^{N-1}$, a spline is built that interpolates those quaternions subject to the conditions that the spline pass through the control points and that the derivatives are continuous. The idea is to choose intermediate quaternions a_n and b_n to allow control of the derivatives at the end points of the spline segments. More precisely, let $S_n(t) = \text{squad}(t; q_n, a_n, b_{n+1}, q_{n+1})$ be the spline segments. By the definition of squad it is easy to show that

$$S_{n-1}(1) = q_n = S_n(0).$$

To obtain continuous derivatives at the end points, the derivatives of two consecutive spline segments must be matched,

$$S'_{n-1}(1) = S'_n(0).$$

It can be shown from Equation (9.7) that

$$S'_{n-1}(1) = q_n[\log(q_{n-1}^{-1}q_n) - 2\log(q_n^{-1}b_n)]$$

and

$$S'_n(0) = q_n[\log(q_n^{-1}q_{n+1}) + 2\log(q_n^{-1}a_n)].$$

The derivative continuity equation provides one equation in the two unknowns a_n and b_n, so there is one degree of freedom. As suggested in Shoemake (1987), a good choice for the derivative at the control point uses an average T_n of "tangents," so $S'_{n-1}(1) = q_n T_n = S'_n(0)$, where

$$T_n = \frac{\log(q_n^{-1}q_{n+1}) + \log(q_{n-1}^{-1}q_n)}{2}. \tag{9.8}$$

There are now two equations to determine a_n and b_n. Some algebra will show that

$$a_n = b_n = q_n \exp\left(-\frac{\log(q_n^{-1}q_{n+1}) + \log(q_n^{-1}q_{n-1})}{4}\right). \tag{9.9}$$

Thus, $S_n(t) = \text{squad}(t; q_n, a_n, a_{n+1}, q_{n+1})$.

To illustrate the cubic nature of the interpolation, consider a sequence of quaternions whose general term is $q_n = \exp(i\theta_n)$. This is a sequence of complex numbers whose products do commute and for which the usual properties of exponents and logarithms do apply. The intermediate terms are $a_n = \exp(-i(\theta_{n+1} - 6\theta_n + \theta_{n-1})/4)$. Also,

$$\text{slerp}(t, q_n, q_{n+1}) = \exp(i((1-t)\theta_n + t\theta_{n+1}))$$

and

$$\text{slerp}(t, a_n, a_{n+1}) = \exp(-i((1-t)(\theta_{n+1} - 6\theta_n + \theta_{n-1}) + t(\theta_{n+2} - 6\theta_{n+1} + \theta_n))/4).$$

Finally,

$$\text{squad}(t, q_n, a_n, a_{n+1}, q_{n+1}) = \exp([1 - 2t(1-t)][(1-t)\theta_n + t\theta_{n+1}]$$
$$- [2t(1-t)/4][(1-t)(\theta_{n+1} - 6\theta_n + \theta_{n-1})$$
$$+ t(\theta_{n+2} - 6\theta_{n+1} + \theta_n)]).$$

The angular cubic interpolation is

$$\phi(t) = -\frac{1}{2}t^2(1-t)\theta_{n+2} + \frac{1}{2}t(2 + 2(1-t) - 3(1-t)^2)\theta_{n+1}$$
$$+ \frac{1}{2}(1-t)(2 + 2t - 3t^2)\theta_n - \frac{1}{2}t(1-t)^2\theta_{n-1}.$$

It can be shown that $\phi(0) = \theta_n$, $\phi(1) = \theta_{n+1}$, $\phi'(0) = (\theta_{n+1} - \theta_{n-1})/2$, and $\phi'(1) = (\theta_{n+2} - \theta_n)/2$. The derivatives at the end points are centralized differences, the average of left and right derivatives as expected.

9.1.5 UPDATING A KEY FRAME NODE

SOURCE CODE

LIBRARY

Animation

FILENAME

KeyframeController

A node to be used for key framing has a local translation and local rotation, just like any other node in the system. The transformations are procedurally updated using a key frame controller. The controller is a straightforward implementation of linear interpolation or Kochanek-Bartels splines for the translations and slerp or squad for the rotations. A key frame node also stores the sequences of keys. Note that it is not a requirement that the number of position keys and number of orientation keys be the same. Each key frame keeps track of the time at which it is valid. The pseudocode for the key frame controller update is given below. Recall from Chapter 4 the update mechanism for class `Spatial`. A check was made for the existence of a controller that manages transforms. The update method of that controller is called before the calculation of world transforms.

```
void KeyFrameController::Update (float time)
{
    InterpolateTranslation(time,localTranslate);
    InterpolateRotation(time,localRotate);
}
```

Each interpolation routine takes the specified time and finds the two keys whose time bound it. These keys are then interpolated according to the methods mentioned earlier.

9.2 INVERSE KINEMATICS

Kinematics is the study of motion without considerations of mass or forces. We will illustrate the ideas first in two dimensions. Given a planar polyline consisting of a sequence of line segments (or bones, so to speak), with each segment starting at \vec{P}_i, having unit-length direction \vec{U}_i, and length L_i for $0 \le i < n$, and with the last segment terminating at \vec{P}_n, the *forward kinematics* problem is to compute \vec{P}_n in terms of the known direction vectors and lengths. The structure is called a *manipulator*, and the final point is called an *end effector*. Figure 9.1 illustrates the general setting. The final point of each segment is related to its starting point by $\vec{P}_{i+1} = \vec{P}_i + L_i \vec{U}_i$ for $0 \le i < n$. Summing over all i and canceling the common terms leads to the end effector formula

$$\vec{P}_n = \vec{P}_0 + \sum_{i=0}^{n-1} L_i \vec{U}_i.$$

Each direction vector can be viewed as an incremental rotation of the previous direction,

$$\vec{U}_i = \left(\cos\left(\sum_{j=0}^{i} \theta_j\right), \ \sin\left(\sum_{j=0}^{i} \theta_j\right) \right).$$

The angles θ_j are called the *joint angles* of the manipulator. Using notation $\vec{\theta} = (\theta_0, \dots, \theta_{n-1})$, the end effector can be written as a function

$$\vec{P}_n(\vec{\theta}) = \vec{P}_0 + \sum_{i=0}^{n-1} L_i \left(\cos\left(\sum_{j=0}^{i} \theta_j\right), \ \sin\left(\sum_{j=0}^{i} \theta_j\right) \right). \tag{9.10}$$

The *inverse kinematics* problem is to select the position \vec{G} for the end effector and determine joint angles $\vec{\theta}$ so that $\vec{P}_n(\vec{\theta}) = \vec{G}$. The point \vec{G} is called the *goal* and might not always be attainable. This is definitely the case when the distance of the goal to the initial point of the manipulator is larger than the sum of the lengths of the segments. Even if the goal is attainable, there may be multiple solutions. Thus, the inverse problem is generally ill-posed.

Obtaining a closed-form representation of the joint angles in terms of \vec{G}, \vec{P}_0, and the L_i is a hard problem. To show the complexity, consider the case of two segments. The equation to be inverted is $\vec{G} = \vec{P}_0 + L_0 \vec{U}_0 + L_1 \vec{U}_1$, where $\vec{U}_0 = (\cos\theta_0, \sin\theta_0)$ and $\vec{U}_1 = (\cos(\theta_0 + \theta_1), \sin(\theta_0 + \theta_1))$. Define $(a, b)^{\perp} = (-b, a)$. Using the double

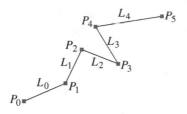

Figure 9.1 A general linearly linked manipulator.

angle identities from trigonometry, $\vec{U}_1 = (\cos \theta_1)\vec{U}_0 + (\sin \theta_1)\vec{U}_0^\perp$. The equation to be solved is therefore

$$\vec{G} = \vec{P}_0 + (L_0 + L_1 \cos \theta_1)\vec{U}_0 + (L_1 \sin \theta_1)\vec{U}_0^\perp = \vec{P}_0 + R_0 \vec{V}_1,$$

where $R_0 = [\vec{U}_0 \mid \vec{U}_0^\perp]$ is a rotation matrix and $\vec{V}_1 = (L_0 + L_1 \cos \theta_1, L_1 \sin \theta_1)$.

Note that $\vec{G} - \vec{P}_0 = R_0 \vec{V}_1$, so the difference between the goal and the initial point is just a rotation of \vec{V}_1. Since rotation preserves length,

$$|\vec{G} - \vec{P}_0|^2 = |\vec{V}_1|^2 = L_0^2 + L_1^2 + 2L_0 L_1 \cos \theta_1,$$

in which case

$$\cos \theta_1 = \frac{|\vec{G} - \vec{P}_0|^2 - L_0^2 - L_1^2}{2L_0 L_1}.$$

There are two possible choices for the sine, $\sin \theta_1 = \pm\sqrt{1 - \cos^2 \theta_1}$. The other angle is determined by

$$|\vec{V}_1|^2 \cos \theta_0 = \vec{V}_1 \cdot R_0 \vec{V}_1 = \vec{V}_1 \cdot (\vec{G} - \vec{P}_0)$$

and

$$|\vec{V}_1|^2 \sin \theta_0 = \vec{V}_1^\perp \cdot R_0 \vec{V}_1 = \vec{V}_1^\perp \cdot (\vec{G} - \vec{P}_0).$$

As long as $|\vec{G} - \vec{P}_0| < L_0 + L_1$ there are two solutions, as indicated by the sign choice for $\sin \theta_1$. This is clear geometrically since one manipulator configuration is obtained from the other by reflection through the line containing the initial point and goal.

The inverse kinematics problem can be complicated even more so by allowing quite a few variations. The example above was two-dimensional. The real problems are three-dimensional. Each joint has six degrees of freedom, three for position and

three for orientation. The degrees of freedom can be additionally constrained within their parameter space. The typical constraints are to restrict rotation about a single axis, in which case the joint is called a *revolute joint*, and/or to restrict translation along the direction of the previous segment, in which case the joint is called a *prismatic joint*. Moreover, within the restrictions the parameters might themselves be constrained. At a revolute joint, the angle of rotation might be limited to a subset of $[0, 2\pi]$. At a prismatic joint, the translation might be constrained to be a small interval $[-\epsilon, \epsilon]$. Finally, manipulators can be trees of segments rather than lists of segments. The leaves of the trees represent the end effectors, so there are multiple goals that can be specified. Some attempt must be made to simultaneously satisfy the goals, or at least to get close to the goals. Yet another variation is to specify goals that are lines or planes. The end effector is considered to be in its best position when the distance from the end effector to the goal is minimized. At any rate, closed-form solutions are usually not possible—or even desirable—because they involve evaluation of trigonometric functions. Numerical methods are a better choice for attempting to find solutions.

One of the best discussions for inverse kinematics is Welman (1993). Landers (1998b) provides a well-written summary of the topic.

9.2.1 NUMERICAL SOLUTION BY JACOBIAN METHODS

Consider a manipulator that is a polyline with a single end effector. Let the end effector be written as $\vec{P} = \vec{F}(\vec{\theta})$, a function of the joint angles $\vec{\theta}$. The derivative of the end effector position with respect to each joint parameter θ_i can be used to determine an incremental step in joint space that will (hopefully) move the end effector closer to the goal. If the position of the end effector is thought of as moving, hence a function of time t, the derivatives are

$$\frac{d\vec{P}}{dt} = D\vec{F}\frac{d\vec{\theta}}{dt},$$

where $D\vec{F}$ is the *Jacobian* of \vec{F}, the matrix of first-order partial derivatives,

$$D\vec{F} = \left[\frac{\partial F_i}{\partial \theta_j}\right],$$

where F_i is the ith component of \vec{F} and θ_j is the jth component of $\vec{\theta}$. The time derivative equation relates the end effector velocity to the joint velocities.

If \vec{G} is the goal and if $d\vec{P}/dt$ is replaced by $\vec{G} - \vec{P} = \vec{G} - \vec{F}(\vec{\theta})$ as an approximation, then the numerical method is to use $\vec{G} - \vec{F}(\vec{\theta}) = D\vec{F}(\vec{\theta})d\vec{\theta}/dt$ to update $\vec{\theta}$ from its current value. The Jacobian matrix is (usually) not square, so its inverse is not defined. However, given a nonsquare matrix M, its pseudoinverse is defined to be

$M^+ = M^{\mathrm{T}}(MM^{\mathrm{T}})^{-1}$, where $M^+M = I$, the identity matrix. Applying the pseudo-inverse of the Jacobian yields

$$\frac{d\vec{\theta}}{dt} = D\vec{F}^+(\vec{\theta})(\vec{G} - \vec{F}(\vec{\theta})).$$

Given a current value of $\vec{\theta}$, this equation allows an update by using a forward difference operator to approximate the time derivative of the joint angles. The scheme is applied iteratively until some stopping criterion is met.

This approach is not always the best one since computing the pseudoinverse is expensive (a square matrix inverse is required). Moreover, sometimes the Jacobian is singular on its domain or is ill-conditioned, so numerical problems arise in the inversion. A different approach is to avoid the inversion and apply the transpose of the Jacobian to obtain

$$\vec{\tau} = D\vec{F}^{\mathrm{T}}\frac{d\vec{P}}{dt} = \left(D\vec{F}^{\mathrm{T}}D\vec{F}\right)\frac{d\vec{\theta}}{dt}.$$

The value $\vec{\tau}$ measures the amount of torque at the joints induced by a force $d\vec{P}/dt$. If the torque is computed for the current joint angles and using $\vec{G} - \vec{F}(\vec{\theta})$ instead of $d\vec{P}/dt$, the unknown vector is $\vec{x} = d\vec{\theta}/dt$. The displayed equation is of the form $A\vec{x} = \vec{b}$ and might not always have a solution. However, minimization methods can be applied to $\vec{e}(\vec{x}) = |A\vec{x} - \vec{b}|^2$ to obtain a solution \vec{x}. Again using a forward difference approximation, this allows an update of the current joint angles. (For more on Jacobian methods, see Das, Slotine, and Sheridan 1988; Novaković and Nemec 1990; Sciavicco and Siciliano 1987.)

9.2.2 NUMERICAL SOLUTION BY NONLINEAR OPTIMIZATION

This is a general approach that can take advantage of already existing algorithms for optimization. The idea is to minimize the squared error $E(\vec{\theta}) = |\vec{G} - \vec{F}(\vec{\theta})|^2$ with respect to θ. While the goal indicator here is a point, the same type of error function applies for goals that are lines or planes. Secondary goals are easily incorporated into the error function. The results using general optimization are generally good, but the algorithm tends to be expensive. (For more on nonlinear optimization methods, see Phillips, Zhao, and Badler 1990; Zhao and Badler 1994.)

9.2.3 NUMERICAL SOLUTION BY CYCLIC COORDINATE DESCENT

The *cyclic coordinate descent* approach was introduced in Wang and Chen (1991). The idea is conceptually simple, and the algorithm is fast. The joints of the manipulator

are optimized one at a time, and several passes are made over the manipulator to (hopefully) arrive at the global minimum of $|\vec{P} - \vec{F}(\vec{\theta})|$. As with most minimization schemes, local minima can attract the iterates. In terms of manipulators, this can happen if the polyline has a kink in it that cannot be undone by successive iterations. For the purposes of animation, secondary goals or restrictions on joint angles can be added to avoid such behavior.

List Manipulator with One End Effector

Consider a list manipulator with initial point \vec{I} and lengths L_i for $0 \leq i < n$. The update at a single joint is discussed for goals that are points, lines, or planes. The joint can be revolute or prismatic.

Rotate to Point

Let the goal be \vec{G}. If the rotation is unconstrained, then the end effector position \vec{E} is chosen so that it lies on the line containing \vec{I} and \vec{G}. The position is $\vec{E} = \vec{I} + t(\vec{G} - \vec{I})$, where $t = (\vec{G} - \vec{I}) \cdot (\vec{E} - \vec{I})/|\vec{G} - \vec{I}|^2$.

If the rotation is constrained to the plane $\vec{N} \cdot (\vec{X} - \vec{I}) = 0$, where \vec{N} is unit length, then the end effector position is chosen so that it lies on the line containing \vec{I} and the projection of \vec{G} onto the plane. The previous case applies using the projection. The projection is $\vec{H} = \vec{G} - [\vec{N} \cdot (\vec{G} - \vec{I})]\vec{N}$.

Rotate to Line

Let the goal be $\vec{G}(s) = \vec{G}_0 + s\vec{G}_1$ for $s \in \mathbb{R}$ and where $|\vec{G}_1| = 1$. If the rotation is unconstrained, there are two cases to consider. The closest point on the line to \vec{I} is

$$\vec{J} = \vec{G}_0 - [\vec{G}_1 \cdot (\vec{G}_0 - \vec{I})]\vec{G}_1$$

and the distance from \vec{I} to the line is $D = |\vec{J} - \vec{I}|$. If $D \geq |\vec{E} - \vec{I}|$, then the end effector is chosen so that it lies on the line containing \vec{I} and \vec{J}. The position is $\vec{E} = \vec{I} + t(\vec{J} - \vec{I})$, where $t = (\vec{J} - \vec{I}) \cdot (\vec{E} - \vec{J})/|\vec{J} - \vec{I}|^2$. If $D < |\vec{E} - \vec{I}|$, then there are two solutions that lie on the line itself, $\vec{J} \pm R\vec{G}_1$. The quantity R is determined from the Pythagorean theorem applied to the right triangle containing vertices \vec{I} and \vec{J} and having hypotenuse $|\vec{E} - \vec{I}|$. Thus, $R^2 = |\vec{E} - \vec{I}|^2 - |\vec{J} - \vec{I}|^2$. In an iterative scheme, the end effector will be updated to the nearest of the two points.

If the rotation is constrained to the plane $\vec{N} \cdot (\vec{X} - \vec{I}) = 0$, where \vec{N} is unit length, then the line is projected onto that plane and the previous case applies using the projected line. The projected line is $\vec{H}_0 + s\vec{H}_1$, where $\vec{H}_0 = \vec{G}_0 - [\vec{N} \cdot (\vec{G}_0 - \vec{I})]\vec{N}$ and $\vec{H}_1 = \vec{G}_1 - (\vec{N} \cdot \vec{G}_1)\vec{N}$.

Rotate to Plane

Let the goal be $\vec{M} \cdot \vec{X} = c$, where \vec{M} is unit length. If the rotation is unconstrained, then there are two cases to consider. The closest point on the plane to \vec{I} is

$$\vec{J} = \vec{I} - (\vec{M} \cdot \vec{I} - c)\vec{M}$$

and the distance from \vec{I} to the plane is $D = |\vec{J} - \vec{I}| = |\vec{M} \cdot \vec{I} - c|$. If $D \geq |\vec{E} - \vec{I}|$, then the end effector is chosen so that it lies on the line containing \vec{I} and \vec{J}. The position is $\vec{E} = \vec{I} + t(\vec{J} - \vec{I})$, where $t = (\vec{J} - \vec{I}) \cdot (\vec{E} - \vec{J})/|\vec{J} - \vec{I}|^2$. If $D < |\vec{E} - \vec{I}|$, then there are infinitely many solutions that lie on a circle in the goal plane that is centered at \vec{J} and has radius R. The radius is determined in a way similar to when the goal is a line, $R^2 = |\vec{E} - \vec{I}|^2 - |\vec{J} - \vec{I}|^2$. In an iterative scheme, the end effector will be updated to the nearest of the circle points. Finding the nearest point on a circle in three dimensions was discussed in Section 2.6.11.

Let the rotation be constrained to the plane $\vec{N} \cdot (\vec{X} - \vec{I}) = 0$, where \vec{N} is unit length. If \vec{N} and \vec{M} are parallel, then the circle of possible end effector positions is parallel to the goal plane, in which case no motion is necessary. If the two plane normals are not parallel, then the circle of positions is $\vec{F}(\theta) = \vec{I} + (\cos \theta)(\vec{E} - \vec{I}) + (\sin \theta)\vec{N} \times (\vec{E} - \vec{I})$, where \vec{E} is the current end effector position. The signed distance from any circle point to the plane is

$$s(\theta) = \vec{M} \cdot \vec{F}(\theta) - c = (\vec{M} \cdot \vec{I} - c) + \mu_0 \cos \theta + \mu_1 \sin \theta,$$

where $\mu_0 = \vec{M} \cdot (\vec{E} - \vec{I})$ and $\mu_1 = \vec{M} \cdot \vec{N} \times (\vec{E} - \vec{I})$. In the case under consideration, the circle is not parallel to the plane, so $\mu_0^2 + \mu_1^2 = |\vec{M} - (\vec{M} \cdot \vec{N})\vec{N}|^2 \neq 0$. The range of $s(\theta)$ is $[s_{\min}, s_{\max}]$, where $s_{\min} = \vec{M} \cdot \vec{I} - c - \sqrt{\mu_0^2 + \mu_1^2}$ and $s_{\max} = \vec{M} \cdot \vec{I} - c + \sqrt{\mu_0^2 + \mu_1^2}$.

If $0 \in [s_{\min}, s_{\max}]$, then the circle intersects the goal plane for two values of θ. Define $\lambda = c - \vec{M} \cdot \vec{I}$, $x_0 = \cos \theta$, $x_1 = \sin \theta$, and set $s(\theta) = 0$ to obtain $\mu_0 x_0 + \mu_1 x_1 = \lambda$ and $x_0^2 + x_1^2 = 1$. These form a polynomial system, one linear and one quadratic equation, that can be solved by resultants (see Appendix B). The resultant is $r(x_0) = (\mu_0^2 + \mu_1^2)x_0^2 - 2\lambda\mu_0 x_0 + \lambda^2 - \mu_1^2 = 0$. The solutions are

$$\cos \theta = \frac{\lambda\mu_0 \pm \mu_1\sqrt{\mu_0^2 + \mu_1^2 - \lambda^2}}{\mu_0^2 + \mu_1^2}.$$

If $0 \notin [s_{\min}, s_{\max}]$, then observe $\mu_0 \cos \theta + \mu_1 \sin \theta = \sqrt{\mu_0^2 + \mu_1^2} \cos(\theta - \phi)$, where $\tan \phi = \mu_1/\mu_0$. If $s_{\min} > 0$, then the closest point occurs when $\theta - \phi = \pi$. If $s_{\max} < 0$, then the closest point occurs when $\theta - \phi = 0$.

Slide to Point

Sliding refers to the linear motion of an end point of a segment in the manipulator. If \vec{I} is the initial point of a segment and the direction of the segment is the unit-length vector \vec{U}, unconstrained motion allows the final point to be $\vec{F} = \vec{I} + t\vec{U}$ for $t \in [0, \infty)$. Constrained motion requires $t \in [t_{min}, t_{max}]$, where the interval is application-specific. The path traveled by the end effector position relative to the sliding motion is $\vec{E} + t\vec{U}$ for t in the appropriate interval.

Let the goal be \vec{G}. The projection onto the ray containing \vec{E} with direction \vec{U} is $\vec{H} = \vec{E} + T\vec{U}$, where $T = \vec{U} \cdot (\vec{G} - \vec{E})$. If the sliding is unconstrained, then the end effector position \vec{E} is updated to $\vec{F} = \vec{E} + \max\{0, T\}\vec{U}$. If the sliding is constrained, then the end effector position is updated to $\vec{F} = \vec{E} + \text{clamp}\{T, t_{min}, t_{max}\}$, where

$$\text{clamp}\{T, t_{min}, t_{max}\} = \begin{cases} t_{max}, & T > t_{max} \\ T, & T \in [t_{min}, t_{max}] \\ t_{min}, & T < t_{min} \end{cases}.$$

Slide to Line

Let the goal be $\vec{G}(s) = \vec{G}_0 + s\vec{G}_1$ for $s \in \mathbb{R}$ and where $|\vec{G}_1| = 1$. If the goal line is parallel to the direction of sliding, $\vec{U} \times \vec{G}_1 = \vec{0}$, then no updating of \vec{E} is necessary. Otherwise, the lines are not parallel and the closest point on the ray containing \vec{E} with direction \vec{U} is $\vec{H} = \vec{E} + T\vec{U}$, where $T \geq 0$ (see Section 2.6.2). The update of \vec{E} in the previous subsection on sliding to a point can now be applied using \vec{H}.

Slide to Plane

Let the goal be $\vec{M} \cdot \vec{X} = c$, where \vec{M} is unit length. If the goal plane is parallel to the direction of sliding, $\vec{M} \cdot \vec{U} = 0$, then no updating of \vec{E} is necessary. Otherwise, let \vec{H} on the ray containing \vec{E} with direction \vec{U} be the closest point to the plane. The update of \vec{E} is the same as for that shown in sliding to a point.

List Manipulator with Multiple End Effectors

Consider the example of a two-segment manipulator whose initial point corresponds to a shoulder, whose midpoint corresponds to an elbow, and whose final point corresponds to a hand. If a point goal is specified for the hand end effector, it is possible that obtaining the goal requires bending the elbow joint in an unnatural way. The algorithm for rotation to a point described earlier could be modified to include a restriction on the angles for the elbow to prevent the unnatural bending. Alternatively, the elbow itself can be tagged as an end effector, and a secondary goal can be specified that affects the elbow location.

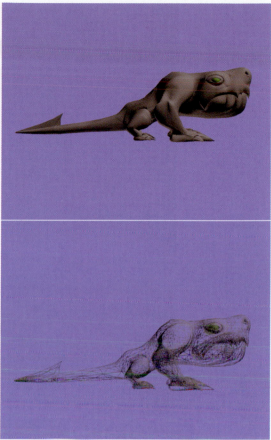

Plate 1 The images are screen shots from the Surface Sample, courtesy of Numerical Design, Ltd. The top image is a rendering of a creature built as a mesh of Bézier triangle and rectangle patches. The tessellation is based on uniform sampling in parameter space. The bottom image is a wireframe view to show that the tessellation is independent of the mesh curvature.

Plate 2 The images are screen shots from the Surface Sample, courtesy of Numerical Design, Ltd. The top image is a rendering of a creature built as a mesh of Bézier triangle and rectangle patches. The tessellation is based on a continuous level of detail algorithm that depends on mesh curvature and view frustum parameters. The bottom image is a wireframe view to show that the tessellation is dependent on the mesh curvature (low tessellation in flat regions, high tessellation in curved regions).

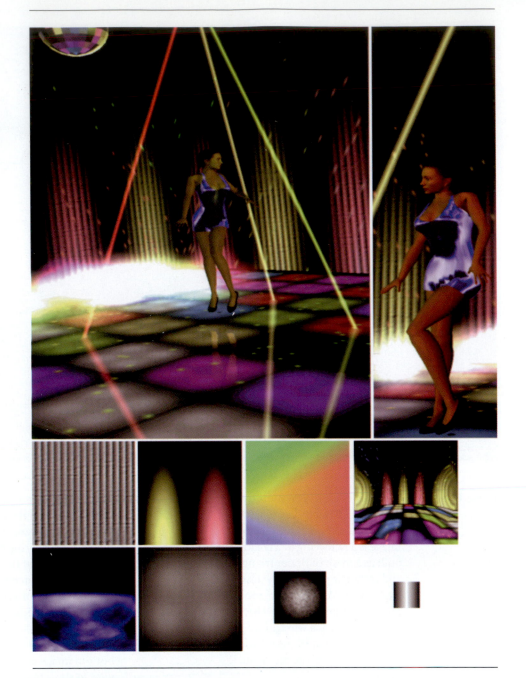

Plate 3 The images are screen shots from the Dancer Demo, courtesy of Numerical Design, Ltd.
 See page 357 for detailed comments.

Plate 4 The images are screen shots from the Eclipse Demo, courtesy of Random Games. See page 358 for detailed comments.

Plate 5 The images are screen shots from the Terrain Flyer Demo, courtesy of Numerical Design, Ltd. See page 392 for detailed comments.

Plate 6 The images are screen shots from the Priority 12 Demo, courtesy of Numerical Design, Ltd. The images are taken at two separate times and show how the direction of the flare changes. The flare was generated by using five alpha-blended grayscale textures.

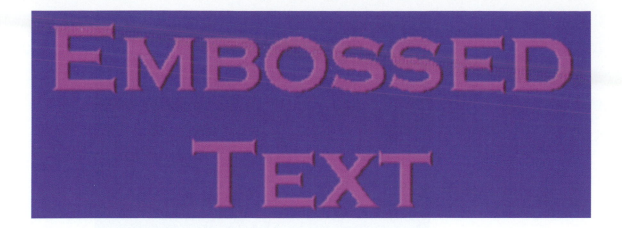

Plate 7 The words "EMBOSSED TEXT" were generated as white letters on a black background. To generate a derivative-style bump map, the directional derivative of the white-on-black image was computed in the direction (2,1) and added back to the original image, a process called *image sharpening*. The values of the sharpened image were used to control the color that was applied to the text.

Plate 8 The image is a screen shot from the Explosion Demo, courtesy of Numerical Design, Ltd. The volumetric fog layer is generated by the intersections of rays from the eye point to terrain vertices with a slab of finite thickness but infinite extent.

Plate 9 The image is a screen shot from the Advanced Multitexture Sample, courtesy of Numerical Design, Ltd. See page 432 for detailed comments.

Plate 10 The image is a screen shot from the Eclipse Demo, courtesy of Random Games. See page 433 for detailed comments.

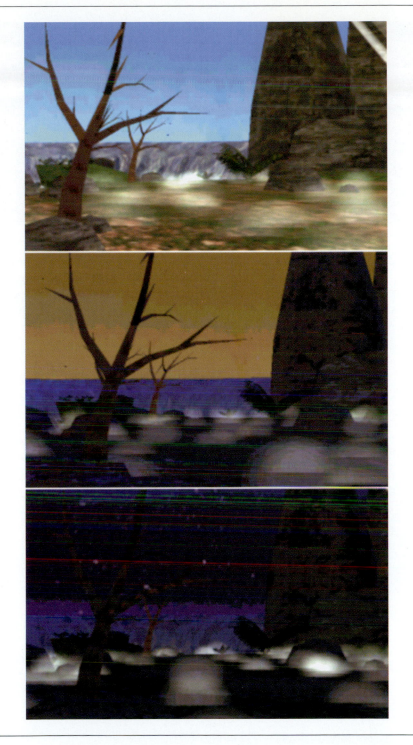

Plate 11 The images are screen shots from the Eclipse Demo, courtesy of Random Games. See
page 433 for detailed comments.

Plate 12 The images show various time samples of a morphed face. The data set consists of five targets, each having 1330 vertices, leading to 1330 sets of five vertices. At a selected time each set of vertices is blended using a set of convex weights to generate an output vertex for that time. Initially, the first few targets have the most weight in the morph. Later, the last few targets have the most weight.

Let \vec{S} be the shoulder location, \vec{E} be the elbow location, and \vec{H} be the hand location. Let \vec{G}_H be the goal for the hand and let \vec{G}_E be the goal for the elbow. Consider adjusting the joint angles at the shoulder. If only the hand goal is required, the rotate to point algorithm minimized the distance from \vec{H} to \vec{G}_H. To handle multiple end effectors, the minimization algorithm applies to a weighted sum of squared distances, $D = w_H|\vec{H} - \vec{G}_H|^2 + w_E|\vec{E} - \vec{G}_E|^2$, where the weights are application-specific. The number of independent parameters for D depends on whether or not the shoulder joint is unconstrained.

To illustrate how the minimization applies, consider a constrained rotation with the plane $\vec{N} \cdot (\vec{X} - \vec{S}) = 0$. The circle spanned by \vec{H} is

$$\vec{h}(\theta) = \vec{S} + (\cos\theta)(\vec{H} - \vec{S}) + (\sin\theta)\vec{N} \times (\vec{H} - \vec{S}),$$

and the circle spanned by \vec{E} is

$$\vec{e}(\theta) = \vec{S} + (\cos\theta)(\vec{E} - \vec{S}) + (\sin\theta)\vec{N} \times (\vec{E} - \vec{S}).$$

The weighted distance as a function of the single joint angle is

$$D(\theta) = w_H|\vec{h}(\theta) - \vec{G}_H|^2 + w_E|\vec{e}(\theta) - \vec{G}_E|^2.$$

The minimum occurs when the derivative is zero,

$$D'(\theta) = w_H(\vec{h}(\theta) - \vec{G}_H) \cdot \vec{h}'(\theta) + w_E(\vec{e}(\theta) - \vec{G}_E) \cdot \vec{e}'(\theta) = 0.$$

If $x_0 = \cos\theta$ and $x_1 = \sin\theta$, the equation $D'(\theta) = 0$ is clearly a quadratic polynomial in x_0 and x_1. Moreover, $x_0^2 + x_1^2 = 1$, another quadratic polynomial. The common solutions can be obtained by computing the resultant polynomial (see Appendix B) in x_0, a quartic polynomial. This can be solved by using closed-form equations or by using iterative polynomial root finders.

Similar algorithms can be developed for line or plane goals and for sliding joints.

Tree Manipulator

The situation can be even more complicated. The manipulator can be a tree of line segments. The leaf nodes are typically end effectors, with each leaf having a primary goal. Interior nodes can also be tagged as end effectors with secondary goals. The method of solution is similar to that of list manipulators with multiple end effectors.

Other Variations

Manipulator joints can have their parameters restricted (limited rotation or sliding). The algorithms mentioned earlier must be modified to support this. A joint can be set

up to be springlike so that it tends to move toward a specified resting point. A joint can be damped to resist motion, either in a constant fashion or in a limiting fashion where the damping increases with the number of iterations of the joint optimizers.

The implementation must also decide on the order of processing joints. A general implementation will allow the application to select the order. For a list the two basic orderings are initial joint to final joint or final joint to initial joint. For a tree the basic orderings are depth-first traversal, breadth-first traversal, or iteration over the leaves and a traversal from each leaf to the root.

Finally, it is possible to specify that a joint cannot change. The initial point of the manipulator always has this property. If an interior joint of a list is tacked down, then the two sublists are in effect separate manipulators, but the first one that connects the two tacked-down joints does not change. Thus, the interior joint acts as the initial point for a smaller manipulator.

9.3 SKINNING

Skinning is the process of attaching a deformable mesh to a skeletal structure for animation purposes. The skeleton consists of a hierarchy of *bones*. The *skin* consists of a mesh of vertices, each vertex assigned to one or more bones so that those bones influence how the vertex is moved whenever the bones are moved. The end result is a deformable mesh that changes in a way natural to the underlying skeleton. (For an easy-to-read article on skinning, see Landers 1998.)

Although these ideas have emerged only recently in games, they have been around for quite some time in graphics and in image analysis. In particular, the idea of a skeletal structure to represent a solid shape is what medial axes (Blum and Nagel 1978) and medial surfaces (Nackman 1982) are about. For a tubular object in three dimensions, the medial axis provides a central curve through the object, and each point on the curve stores a radius to the tube boundary. In effect, the boundary (or skin) is determined by the central curve and radius information, thus providing a compact representation of the object. If the central curve is instead thought of as containing cross-sectional information, then nontubular objects can be generated without a need for medial surfaces. For example, a forearm can be represented as a central curve with cross sections given by ellipses. Skins in a game environment are usually built by artists with some GUI that allows one to create vertices and bones and to attach the vertices to relevant bones with user-selected weights. It might be possible instead to procedurally generate skins using the ideas of medial axes that store cross-sectional information. Such a representation would clearly be useful on a machine with a small amount of memory but a lot of processing power (the next-generation game consoles, for example). The skins themselves could be generated and tessellated on the fly from only the medial axis and its stored information, much like what was shown in Section 8.4.5.

The hierarchical organization suggested in Chapter 4 easily supports a skin-and-bones system. Each node in the scene graph can represent the bone itself, so bones are

objects in the Node class. The vertices of the mesh can be stored as a triangle mesh of type TriMesh that is derived from the Geometry class so that the skin can be attached as a leaf node in the scene graph and rendered when necessary. Each bone maintains a list of vertices that it influences. Moreover, for each vertex the bone stores its local offset to the vertex and the weight of the vertex relative to the bone. Since the vertices of the skin are calculated from the bones, it is essential in the scene graph that the bone tree occur before the skin mesh in the depth-first traversal UpdateGS that was described in Chapter 4. Moreover, the skin and bones must be in the same coordinate system, so it is natural to create a common parent node whose first child is the root of the bone tree and whose second child is the skin mesh. The calculation of the final skin vertex positions can be performed by a controller, SkinController, that keeps a reference to the bone tree and manages the skin mesh.

The natural progression of events is

1. Move the bones by changing their local transforms.

2. Update the scene graph to propagate transforms down the hierarchy. The bones are updated first and have the correct world transforms. The skin mesh is visited next.

3. When the skin mesh is visited in the update, the skin controller attached to the mesh updates the vertex locations. The list of bones are iterated. For each bone the vertices are incrementally updated by the offset from the bone and using the appropriate weight.

4. Pass the updated mesh to the renderer for drawing.

Take note that the values are already in world coordinates. The base class Spatial whose update implicitly called the skin controller's update is already set up, as described in Chapter 4, to ignore computing the world transforms. To support this the controller class Update routine can return a Boolean flag indicating whether or not it calculated the world transforms for the data.

Plate 3 shows an animated character formed from skin and bones. The data itself was obtained by motion capture, and sequences of key frames were generated for the bones. The dancer consists of an animated skin-and-bones system with skin containing 18,000 triangles. The images in the top row show a number of special effects and features.

1. The reflection of the legs is generated by duplicating only the leg geometry of the dancer, reflecting it through the plane of the floor, and drawing both dancer and reflected legs. The floor is necessarily transparent and the background color is black.

2. The wall backdrop consists of planar geometry with the first texture in the second row as the base texture. The second texture in the second row is applied as a dark map in the multitexturing system to get the color tint.

3. The disco ball is a tessellated sphere with base texture given by the third texture in the second row. The fourth texture in the second row is applied as an environment map in the multitexturing system. The environment map was generated by capturing a rendered image of only the dance floor and walls, then distorted so that the application of the environment map is spherical.

4. The disco ball is rotating at a slow rate. The light dots on the walls and floor are generated by a projected light system using parallel projection. The dots themselves rotate at the same rate as the disco ball.

5. The dancer's dress has an environment map applied, the first texture in the third row. The idea is to make it appear as if there are quite a few lights nearby and gives the dress the metallic appearance.

6. The floor consists of tiles with the second texture in the third row. The floor has transparency so that the legs can be reflected. Also, the floor vertices have assigned vertex colors that change over time so that the tiles appear to be floor lights that dynamically change color.

7. The third texture in the third row is used for particles that simulate the smoke on the dance floor. The particles also use vertex colors that correspond to the floor colors, thus giving the smoke a colored tint that dynamically changes.

8. The laser beams are alpha-blended billboards that use the last texture in the last row and use vertex colors. The laser beams are also moving as the dancer moves. The beams are reflected in the floor using the same technique as the dancer's legs—duplicated and reflected geometry.

Plate 4 shows two animal characters, a squirrel and a bird, both of which are skin-and-bones based with key-framed bones. The top image is of the Norlina character (shown on the front cover of the book). The fire is a billboard with a texture sequence to animate the flame. The squirrel is a skin-and-bones animated animal. The trees consist of multiple crossing alpha-blended polygons. The shadows are secondary textures that were prerendered and applied as a decal texture in the multitexturing system. Some of the tree polygons have vertex normals and are dynamically lit to match the flickering of the fire. The middle image shows more trees, a bridge, and a skin-and-bones animated bird. The water appears to be flowing based on animation of texture coordinates. The water is alpha-blended so that you can partly see the riverbed. The bottom image is of the same hut (more recent data set) and has smoke spewing from the chimney. The smoke is moving.

GEOMETRIC LEVEL OF DETAIL

The rendering of a detailed and complex model that consists of thousands of triangles looks quite good when the model is near the eye point. The time it takes to render the large number of triangles is well worth the gain in visual quality. However, when the same model is far from the eye point, the detail provided by thousands of triangles is not that noticeable because the screen space coverage of the rendered model might only be a handful of pixels. In this situation, the trade-off in time versus visual quality is not worth it. If the final rendering covers only a handful of pixels, the number of triangles processed should be proportional. This chapter introduces the concept of *level of detail* (LOD). The amount of work done by the renderer per model per pixel should be as independent as possible of the number of triangles that make up the model.

Although rendering time and potential loss of visual quality factor into decisions about level of detail, geometric level of detail can also be important for nonvisual aspects of the game engine, most notably in collision detection. A character in the game might consist of some 10,000 triangles so that the rendered version is visually

appealing. If that character is to interact with his environment for purposes of collision, it would be quite expensive to process most (or all) of the 10,000 triangles in an intersection test with a wall of a room. An alternative is to provide one or more coarse resolution representations of the character to be used by the collision system. The idea is that the coarse-level representation allows for sufficient accuracy and speed in the collision system but is not detailed enough for visual purposes. The automatic generation of levels of detail in many of the current algorithms allows us to create the coarse resolution representations for collision detection purposes.

The chapter is by no means a detailed description of all the various ideas and algorithms that have been developed over the past few years. It is intended to give you a flavor of the concepts that any game program must handle when incorporating level of detail. The simplest form of level of detail involves two-dimensional representations of three-dimensional objects, called sprites or billboards, and is discussed in Section 10.1. Switching between models of varying degrees of resolution, a process called *discrete level of detail,* is a step up in quality from two-dimensional representations. The switching is usually associated with distance from eye point to object. Section 10.2 covers the basic concepts for this topic. Currently the most popular form of geometric control for visual quality, continuous level of detail, is discussed in Section 10.3. Although a single continuous level-of-detail algorithm is explained in that section, the ideas apply to other continuous level-of-detail algorithms that both researchers and games programmers use. Most notable are the automatic generation of the levels of detail from a single high-resolution model and the automatic switching between levels at run time.

10.1 SPRITES AND BILLBOARDS

SOURCE CODE

LIBRARY
Detail

FILENAME
BillboardNode

The simple form of level of detail uses *sprites*, sometimes called *impostors*. These are prerendered images of three-dimensional objects. The idea is that the time it takes to draw the image as a texture is much less than the time to render the object. In a three-dimensional environment, sprites are useful for software rendering simply because of the reduction in the time to draw. However, sprites are usually easy to spot in a rendering if they represent objects that are close to the eye point or if the eye point moves. The image gives the impression that the object is not changing correctly with eye point location or orientation. The visual anomaly due to closeness to eye point is softened if sprites are only used for distant objects, for example, trees drawn in the distance.

The visual anomaly associated with a moving eye point can be rectified in two ways. The first way is to have a set of prerendered images of the object calculated from a set of predefined eye points and orientations. During application execution, a function is used to select the appropriate image to draw based on the current location of the eye point. The second way is to allow a single prerendered image to change orientation depending on eye point location and orientation. In this setting the sprite is called a *billboard*.

Billboards can change orientation based on a few schemes. All calculations are assumed to be in the model space of the billboard. During application execution, the eye

point and orientation vectors are transformed from world space to the model space of the billboard, and the billboard's new alignment is calculated. The basic billboard consists of a rectangle (two triangles) and a textured image. A coordinate system is assigned to the billboard; the origin is the center point of the rectangle, the edge directions are two coordinate axes, and the normal to the plane of the rectangle is the third coordinate axis. A billboard can be *screen aligned*. The billboard is first rotated so that its normal vector is aligned with the view direction. Within this new plane the billboard is rotated so that its model space up vector is aligned with the view up vector. Screen alignment is good for isotropic textures such as smoke clouds. If the texture is anisotropic, for example, a tree texture, then screen alignment does not make sense in the case when the viewer rotates about the current view direction. The tree should remain upright even though the viewer is tilting his or her head. For these types of billboards, *axial alignment* is used. The billboard is allowed to rotate only about its model space up vector. For a given eye point, the billboard is rotated so its normal vector is aligned with the vector from the eye point to its projection onto the up axis of the billboard.

Note that the alignment of a billboard relative to an eye point requires identifying a coordinate frame for the billboard and changing its coordinate frame with respect to the eye point's coordinate frame. The idea of alignment can therefore be extended to a fully three-dimensional object as long as a coordinate frame is assigned to that object. In this sense, a billboard class can be defined for a special type of node in a scene graph, and the children of that node can be arbitrary objects, not just flat polygons and images.

10.2 DISCRETE LEVEL OF DETAIL

SOURCE CODE

LIBRARY
Detail

FILENAME
SwitchNode
DLODNode

The simplest LOD solution is to construct a sequence of models whose triangle count diminishes over the sequence. The sequence is assigned a center point that is used as a representative of the centers for all the models. The model with the largest number of triangles is drawn when the LOD center for that model is close to the camera. As the center point moves farther away from the camera, at some preselected distance the current model is replaced by the next model in the sequence. To support this, the hierarchical scene graph has a node type designated as a *switch node*. This type node provides an interface that allows the application to select which child of the node should be processed in any recursive traversals of the scene graph. Only one child may be active at a time. The scene graph can then support specialized switch nodes, one of those being an *LOD node*. The children of an LOD node are the models in the sequence. The node itself maintains the center point. During a rendering pass when the LOD node is visited, its prerender function computes the distance from the center point to the eye point and sets the appropriate active child to propagate the rendering call.

The word *discrete* refers to the fact that the number of models is a small finite number. The advantage of discrete level of detail is the simplicity of the implementation. The disadvantage is that an artist must build all those models. Moreover, whenever a

switch occurs during rendering it is usually noticeable and not very natural—the *popping* effect. One approach that has been taken to reduce the popping is to morph between two consecutive models in the LOD sequence. This requires establishing a correspondence between the vertices of the models and is problematic when the number of vertices is different between the two. The morphing is implemented as convex combinations of paired vertices, with the weighting factors dependent on the switching distances for the models. That is, if d_1 is the distance at which model 1 switches to model 2, and if d_2 is the distance at which model 2 switches to model 3, while the LOD center is a distance $d \in [d_1, d_2]$ from the eye point, the weight $(d - d_1)/(d_2 - d_1)$ is applied to vertices in model 1 and the weight $(d_2 - d)/(d_2 - d_1)$ is applied to vertices in model 2. The results might be acceptable, but the price to be paid each frame is the expensive interpolations. However, the results might not be visually appealing since the morphing is not based on preserving geometric information about the models. The quality of the end result depends a lot on the quality and differences in the original models.

10.3 CONTINUOUS LEVEL OF DETAIL

An alternative to discrete level of detail is *continuous level of detail* (CLOD). One major category of CLOD algorithms includes progressive meshes that simplify already existing triangle meshes (Hoppe 1996a, 1996b; Garland and Heckbert 1997, 1998; Cohen et al. 1996; Cohen, Olano, and Manocha 1998; Luebke and Erikson 1997; Lindstrom and Turk 1998). Some of the later papers realized the importance of also simplifying the surface attributes (for example, vertex colors and texture coordinates) in a visually appealing way. The basic concept is one of triangle reduction. The Garland-Heckbert algorithm (Garland and Heckbert 1997) is particularly well suited for a game engine and is discussed in this section. This algorithm effectively builds a large sequence of models from the highest-resolution model, so in a sense it is like discrete LOD, but it does not require an artist to build the additional models. The change in the number of triangles between consecutive models is typically one (or a small number), so popping is not as noticeable, particularly when a screen space error metric is used to control the triangle changes rather than the distance of the model center from the eye point.

Another major category of CLOD algorithms includes the dynamic tessellation of surfaces that are defined functionally. Because there is no theoretical bound on the number or size of triangles that can be created in the tessellation, this type of algorithm provides infinite level of detail. Of course, there is a practical bound based on the number of triangles an engine can process to maintain a high frame rate and the amount of memory available. The benefit, though, is compactness of representation of the model. See Chapter 8 for a discussion of dynamic tessellation.

10.3.1 SIMPLIFICATION USING QUADRIC ERROR METRICS

The Garland-Heckbert algorithm (Garland and Heckbert 1997) creates a sequence of incremental changes to the triangle mesh of the original model by contracting

Figure 10.1 Edge contraction.

pairs of vertices in a way that attempts to preserve geometric information about the model rather than topological information. Other researchers have used methods that typically require manifold topology and do not necessarily handle shape in a reasonable way. Vertex decimation involves removing a vertex and all triangles sharing it, then retriangulating the hole that was produced by removal (Schroeder, Zarge, and Lorensen 1992). Vertex clustering involves placing the mesh in a bounding box, partitioning that box into a lattice of small boxes, collapsing all vertices in each small box into a single vertex, and removing and adjusting the triangles of the original mesh accordingly (Rossignac and Borrel 1993). Iterative edge contraction involves replacing an edge and its two vertices by a single vertex, removing the triangles sharing that edge, and adjusting the connectivity information for the triangles adjacent to the ones removed (Hoppe 1996a).

The current algorithm is based on iterative vertex contraction and is not restricted to a manifold topology. Moreover, two disjoint components of a triangle mesh might very well be joined by this algorithm, so mesh topology is not necessarily preserved. This is not a drawback to the algorithm because a mesh that appears as two distinct objects while close to the eye point might look like a single object while in the distance. Merging of components by the simplification algorithm supports this. The basic contraction involves a vertex pair (\vec{V}_1, \vec{V}_2) that is replaced by a single vertex \vec{V}. The original vertices are in a sense moved to the new vertex, \vec{V}_1 becomes \vec{V}, and \vec{V}_2 is removed. The edges that shared \vec{V}_2 are now connected to \vec{V}, and any edges or faces that become degenerate are removed. Figure 10.1 illustrates the contraction of a pair of vertices. In fact, the contraction process can be applied to an entire set of vertices $\{\vec{V}_i\}_{i=1}^m \rightarrow \vec{V}$ if desired. Simplification amounts to taking the original mesh M_0 and creating a sequence of n vertex contractions to produce a sequence of meshes M_0, M_1, \ldots, M_n.

The algorithm requires identification of those pairs of vertices in the original mesh that can be contracted. A pair (\vec{V}_1, \vec{V}_2) is said to be a *valid pair* for contraction if the two points are end points of the same edge or if $|\vec{V}_1 - \vec{V}_2| < \tau$ for some threshold parameter $\tau > 0$ specified by the application. If $\tau = 0$, then the vertex contraction is really an edge contraction. Positive thresholds allow nonconnected vertices to be paired.

The algorithm also requires taking the set of valid pairs and associating with each pair a metric that is used to prioritize the pairs. The smaller the metric, the more likely the pair should be contracted. This is accomplished by associating with each vertex $\vec{V} = (\vec{X}, 1)$, treated as a homogeneous vector, a symmetric 4×4 matrix $Q(\vec{V})$, and choosing the metric to be the quadratic form

$$E(\vec{X}) = \vec{V}^\mathrm{T} Q \vec{V} = [\ \vec{X}^\mathrm{T}\ |\ 1\] \left[\begin{array}{c|c} A & \vec{b} \\ \hline \vec{b}^\mathrm{T} & c \end{array} \right] \left[\begin{array}{c} \vec{X} \\ 1 \end{array} \right] = \vec{X}^\mathrm{T} A \vec{X} + 2\vec{b}^\mathrm{T} \vec{X} + c,$$

where A is a 3×3 symmetric matrix, \vec{b} is a 3×1 vector, and c is a scalar. Note that $E(\vec{X}) = d$ for a constant d defines a quadric surface. A specific matrix Q is constructed in the next section, but for the purposes of the simplification it could be one of many choices.

Given a valid pair (\vec{V}_1, \vec{V}_2), there are two things to do. The first thing to do is to compute the target \vec{V} of the contraction. While simple choices are \vec{V}_1 or \vec{V}_2 (replacement) or $(\vec{V}_1 + \vec{V}_2)/2$ (averaging), a better choice is to choose \vec{V} so that $E(\vec{X})$ is minimized. This occurs when $\vec{\nabla} E(\vec{X}) = \vec{0}$, which leads to solving $A\vec{X} = -\vec{b}$. If A is invertible, then the solution \vec{X} is used to generate the contracted vertex $\vec{V} = (\vec{X}, 1)$. However, if A is not invertible, then the minimization problem is restricted to the line segment $\vec{X}(t) = \vec{X}_0 + t(\vec{X}_1 - \vec{X}_0)$ for $t \in [0, 1]$. The function to minimize is the quadratic in one variable, $\phi(t) = E(\vec{X}(t))$. The minimum occurs either where $\phi'(t) = 0$ with $t \in [0, 1]$ or at an end point $t = 0$ or $t = 1$. The second thing to do is associate a metric with \vec{V}. A simple choice is $Q = Q_1 + Q_2$, where Q_i is the metric for $\vec{V}_i, i = 1, 2$.

10.3.2 THE ALGORITHM

The model is represented using a vertex-edge-face table to store the connectivity information. Each vertex keeps track of a list of other vertices to which it is adjacent. The algorithm is

1. Compute Q for all vertices.

2. Compute all valid pairs based on a selected $\tau \geq 0$.

3. Compute \vec{V} for each pair (\vec{V}_1, \vec{V}_2), $Q = Q_1 + Q_2$, and $\vec{V}^\mathrm{T} Q \vec{V}$.

4. Place all pairs in a heap whose first element is that pair with minimum $\vec{V}^\mathrm{T} Q \vec{V}$ for the vertex \vec{V} that is contracted from the pair.

5. The first pair in the list is contracted to form the new mesh and is removed from the heap. The valid pairs affected by the removal have their metrics recalculated. The pair with the minimum error term is moved to the front of the heap, and this step is repeated until the heap is empty.

A couple of potential problems need to be dealt with. The first problem is that the algorithm does not handle open boundaries in any special way. For some models (such as terrain) it might be important to tack down the boundary edges of the mesh. One way to do this is to generate a plane through each boundary edge that is perpendicular to the triangle containing that edge. The quadric matrix is calculated, weighted by a large penalty factor, and added into the quadric matrices for the end points of the edge. It is still possible for boundary edge vertices to move, but it is highly unlikely. Another way is never to allow a boundary edge vertex to be moved or replaced in the simplification.

The second problem is that pair contractions might not preserve the orientation of the faces near the contraction, so a folding over of the mesh occurs. A method to prevent this is to compare the normal vector of each neighboring face before and after the contraction. If the normal vector changes too much, the contraction is disallowed.

10.3.3 CONSTRUCTION OF THE ERROR METRIC

A heuristic is chosen for the quadric error metric. Each vertex in the mesh is in the intersection of the planes containing the triangles that share that point. If a plane is represented as $\vec{P}^{\mathrm{T}}\vec{V} = 0$, where $\vec{V} = (\vec{X}, 1)$ and $\vec{P} = (\vec{N}, d)$ with $|\vec{N}| = 1$, define $S(\vec{V})$ to be the set of vectors \vec{P} representing the planes containing the triangles that share \vec{V}. The error of \vec{V} with respect to $S(\vec{V})$ is the sum of squared distances from \vec{V} to its planes,

$$E(\vec{V}) = \sum_{\vec{P}\in S(\vec{V})} (\vec{P}^{\mathrm{T}}\vec{V})^2 = \vec{V}^{\mathrm{T}} \left(\sum_{\vec{P}\in S(\vec{V})} \vec{P}\vec{P}^{\mathrm{T}} \right) \vec{V} =: \vec{V}^{\mathrm{T}} Q(\vec{V})\vec{V},$$

where the last equality defines $Q(\vec{V})$ for a given vertex. The matrix $\vec{P}\vec{P}^{\mathrm{T}}$ is called a fundamental error quadric and, when applied to any point \vec{W}, measures the squared distance from that point to the plane.

The initial vertices have matrix $Q(\vec{V}) \neq 0$, but the initial error estimates are $\vec{V}^{\mathrm{T}} Q(\vec{V})\vec{V} = 0$. On the first iteration of the algorithm, the sum of two quadric error matrices will generate another nonzero quadric error matrix whose quadratic form usually has a positive minimum.

10.3.4 SIMPLIFICATION AT RUN TIME

A class `ClodMesh` can be derived from `Spatial` and added to the collection of geometric-type leaf nodes that can be placed in a scene graph and rendered. A `ClodMesh` object represents the mesh sequence M_0 through M_n, where M_0 is highest resolution. The original mesh is assumed to have manifold topology and the simplification is assumed to do edge contractions. While neither of these is a requirement of the algorithm as published, they do make the implementation a bit more manageable. A consequence of the two assumptions is that two consecutive meshes in the

simplification differ by one or two triangles. Moreover, the sequence is assumed to be precomputed, thereby gaining execution speed at the cost of memory usage.

An automated selection can be made each frame to display mesh M_i for some appropriate index i by using the prerendering virtual function. Although there are many possibilities for selection, a simple one uses screen space coverage by the world bounding volume containing mesh M_0. If A is the screen space area covered by the bounding volume and if τ is an application-specified number of triangles per pixel, then the number of requested triangles in the mesh to be drawn is $A\tau$. This number is clamped to $[T_0, T_n]$, where T_i is the number of triangles in mesh M_i. The index j is chosen so that $T_j = \lfloor A\tau \rfloor$, and the mesh M_j is identified as the one to be drawn in the rendering virtual function.

10.3.5 Selecting Surface Attributes

If the original mesh has surface attributes at the vertices such as normal vectors, texture coordinates, and colors, then new surface attributes must be selected for a contracted vertex. For a single edge contraction, it is reasonable to select texture coordinates and colors based on the values at the vertices of the two triangles sharing that edge. If the two triangles are not coplanar, then the four vertices form a tetrahedron. A simple scheme to compute a new scalar value based on four old ones is to compute the barycentric coordinates of the new vertex with respect to the tetrahedron and use them in a weighted average of the scalar values. Some care must be taken if the new vertex is not inside the tetrahedron so that at least one of the barycentric coordinates is outside the interval $[0, 1]$. To remedy this, any negative barycentric coordinates are clamped to 0 and the coordinates are rescaled to sum to 1. The resulting coordinates are used to compute a convex combination of the four scalar values.

Normal vectors at contracted vertices can be computed using the barycentric coordinate scheme or by computing a weighted average of the normals of the triangles sharing the new vertex. However, weighted averages of normals is not geometrically appealing. An alternative is to view the unit-length normals as points on a sphere. The minimal angle cone containing those points is computed and the axis of the cone is used as the new normal. The axis can be thought of as a median of vectors. The only pathological problem with this method is if the cone angle is larger than π radians. Although the cone axis is still well defined, it is difficult to detect this case in an algorithm. Computation of the minimal cone can be done using an algorithm that is effectively the one used for computing the minimum circle containing a set of points in the plane (Welzl 1991). In that algorithm the test for point-in-circle is replaced by vector-in-cone.

A cone with vertex at the origin, unit-length axis \vec{A}, and angle θ is represented as $\vec{A} \cdot \vec{X} = \cos\theta$. The solid cone is $\vec{A} \cdot \vec{X} \geq \cos\theta$. The essential heart of the algorithm is to compute the minimal cone containing either one point, two points, or three points. For two distinct points, the cone axis is the unit-length bisector of the two points. For three points not all lying on a great circle arc, the cone axis must form the same angle with the three points. Let \vec{U}_i for $0 \leq i \leq 2$ be the three points. Let \vec{A} be the

axis that needs to be determined. The requirement is that $\vec{U}_0 \cdot \vec{A} = \vec{U}_1 \cdot \vec{A} = \vec{U}_2 \cdot \vec{A}$. Let λ represent this common value (to be determined). Represent $\vec{A} = \sum_{i=0}^{2} c_i \vec{U}_i$. Define $d_{ij} = \vec{U}_i \cdot \vec{U}_j$, $D = [d_{ij}]$, a 3×3 matrix, $\vec{c} = (c_0, c_1, c_2)$, and $\vec{1} = (1, 1, 1)$. The system of equations to be solved is $D\vec{c} = \lambda\vec{1}$ with constraint $|\vec{A}| = 1$. Rather than directly use the quadratic constraint on length of \vec{A}, compute $\vec{B} = (\det D)\vec{A}$ and extract $\vec{A} = \vec{B}/|\vec{B}|$. Applying the adjoint matrix of D to the linear system yields $(\det D)\vec{c} = \lambda D^{\text{adj}}\vec{1}$. Therefore,

$$\vec{B} = \sum_{i=0}^{2}(c_i \det D)\vec{U}_i = \sum_{i=0}^{2} \lambda D^{\text{adj}}\vec{1} = \lambda \begin{bmatrix} 1 - d_{01} - d_{02} + d_{12}(d_{01} + d_{02} - d_{12}) \\ 1 - d_{01} - d_{12} + d_{02}(d_{01} + d_{12} - d_{02}) \\ 1 - d_{02} - d_{12} + d_{01}(d_{02} + d_{12} - d_{01}) \end{bmatrix}.$$

The value of λ is irrelevant since \vec{B} is to be normalized.

The pseudocode is given below and assumes that the input points lie in a cone with angle $\theta \in [0, \pi/2)$. This algorithm is essentially the one that is used for computing the minimum-area circle containing a set of points and is related to the algorithm in Section 2.5.1 for computing the minimum-volume sphere containing a set of points. Since in most cases the number of points is not large, the random permutation is not applied. This should not affect the performance of the algorithm.

```
void MinimalCone (int N, Point3 V[])
{
    Cone cone = ExactCone1(P[0]);
    PointSet support = { P[0] };
    i = 1;
    while ( i < N )
    {
        if ( P[i] not in support )
        {
            if ( P[i] not in cone )
            {
                add P[i] to support and (possibly) remove
                                    unnecessary points;
                compute cone from current support;
                i = 0;   // need to start over when support
                         // changes
                continue;
            }
        }
        i++;
    }
}
```

Internally, the algorithm requires computing cones that contain exactly two points or exactly three points. Updating the support can be modularized into a collection of update functions, each depending on the current number of points in the support.

TERRAIN

Many games are based in an outdoor environment. For example, flight simulators test your skills at flying airplanes or jets. The missions are based on accomplishing goals such as destroying other planes or bombing various targets. During each mission your plane is flying over terrain, whether land or sea, and it is important that the terrain look realistic. Another example is a massively multiplayer networked game where the world is necessarily large and might even grow as new players enter the game and add their own environments for other players to wander through. In either case the extent of the world can be quite large and requires a significant amount of modeling. Moreover, at run time this data needs to be efficiently managed. A *terrain system* has the job of supporting both the modeling process and run-time management.

Terrain data is typically represented as height values sampled on either a rectangular lattice or a network of triangles. In either case the data sets tend to be quite large and make it difficult to render at real-time rates for two reasons. First, the terrain data cannot fit entirely in memory, so it needs to be loaded from disk. Second, the renderer must process a large number of small triangles corresponding to distant terrain.

A standard approach to triangle reduction is to construct multiresolution models representing the terrain. One possibility is to use *discrete level of detail:* the entire current resolution model is switched to a different resolution model based on the

distance from the eye point, but the switching is very noticeable. is better to reduce triangles in a way to minimize visual impact. This is done by *continuous level of detail*: the model is changed by a small number of triangles at a time. Moreover, the change in the number of triangles is based on error measurements in screen space. The idea is that two triangles are reduced to one triangle if the height variation between the two triangles is smaller than an application-specified number of pixels. Michael Garland and Paul Heckbert (1997) developed one such algorithm for triangulated manifold meshes, but it is view independent. Peter Lindstrom et al. (1996) developed a view-dependent algorithm for square lattices with symmetric triangulation.

The algorithm by Lindstrom et al. (1996) is the one discussed in this chapter. It consists of three phases: a coarse-level simplification based on square blocks of the terrain, a fine-level simplification at the vertices within each block, and a rendering of each block. The original paper makes a *distant terrain assumption:* the camera does a flyover of the terrain so that the distance from the eye point to any terrain vertex is significantly large, which allows some approximations that simplify the mathematics in computing screen space errors. However, the assumption is invalid when the camera corresponds to a character walking about the terrain. Also discussed in this chapter is the *close terrain assumption,* where the approximations are made based on the camera being close to terrain vertices. A different mathematical approximation is made for computing screen space errors. Finally, similar analysis is applied when no assumption is made about the camera and the exact screen space error metric is used. Some variations from the original paper are included: simpler dependency handling is used to reduce memory usage (parent dependencies are maintained but not child dependencies), visibility testing for block culling is done before simplification (blocks are not simplified if they are not in the view frustum), and a connectivity array is constructed for the full mesh in preparation for rendering (rather than rendering each triangle as it is known).

11.1 TERRAIN TOPOLOGY

The height field is a 2D square array of size $2^N + 1$ for $N \geq 1$. Each entry is a point of the form $(i, j, H(i, j))$, where $0 \leq i \leq 2^N$, $0 \leq j \leq 2^N$, and $H(i, j)$ is the height value. In the implementation, the height values are stored as `unsigned short` rather than `float` to reduce memory usage. The range for `unsigned short` allows for enough variation in typical terrain data sets. The height field can be viewed as a $2^{N-1} \times 2^{N-1}$ array of *primitive blocks;* each block is a 3×3 array of points that are immediately adjacent in the field.

The height field can also be viewed as a quadtree of *blocks*, each block representing a 3×3 array of points that are uniformly spaced by a *stride* that depends on where the block occurs in the quadtree. The leaf nodes of the quadtree are primitive blocks with a stride of 1. If the corner of a leaf block is located in the plane at (i, j), then the other

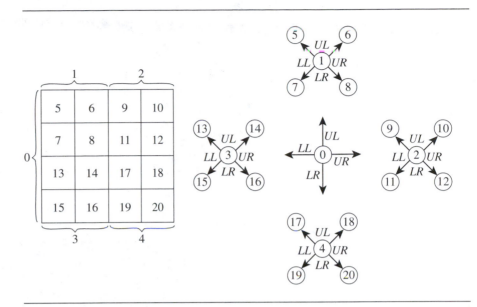

Figure 11.1 A 5 × 5 height field and quadtree representation.

eight points represented by the block are $(i + 1, j), (i + 2, j), (i, j + 1), (i + 1, j + 1),$ $(i + 2, j + 1), (i, j + 2), (i + 1, j + 2),$ and $(i + 2, j + 2).$ The root node of the quadtree is a block with stride $2^{N-1}.$ The nine points represented by the root block are located in the plane at $(0, 0), (0, 2^{N-1}), (0, 2^N), (2^{N-1}, 0), (2^{N-1}, 2^{N-1}), (2^{N-1}, 2^N),$ $(2^N, 0), (2^N, 2^{N-1}),$ and $(2^N, 2^N).$ If a block has stride S and a corner value of $(i, j),$ then the four children of the block have a stride of $S/2$ and corner points $(i, j),$ $(i + S, j), (i, j + S),$ and $(i + S, j + S).$ The total number of levels in the quadtree is $N,$ and the total number of blocks is $(4^N - 1)/3.$ Figure 11.1 shows the planar points of a 5 × 5 height field, points occurring at the intersections of the various lines, and shows the corresponding quadtree. Since the quadtree is a complete tree, the nodes can be indexed so that the root node has index 0. Given parent index $P,$ the upper-left child index is $C_{UL} = 4P + 1,$ the upper-right child index is $C_{UR} = 4P + 2,$ the lower-left child index is $C_{LL} = 4P + 3,$ and the lower-right child index is $C_{LR} = 4P + 4.$ Given a child index $C,$ the parent index is $P = \lfloor (C - 1)/4 \rfloor,$ where $\lfloor n \rfloor$ is the *floor* function that returns the largest integer less than or equal to $n.$

A block represents 8 triangles (9 vertices, 16 edges), all sharing the center point of the block. Figure 11.2 shows the topology of a block. The primitive blocks contain totally $(2^N + 1)$ vertices, $(2^N + 1)[3(2^N + 1) - 1]$ edges, and $2[(2^N + 1) - 1]$ triangles. The *simplification* of the vertices in a block refers to reducing the number of triangles

Figure 11.2 The topology for a single block.

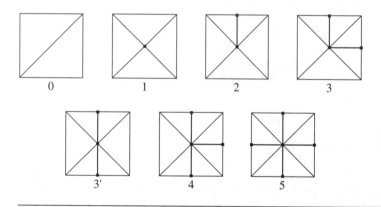

Figure 11.3 The seven distinct triangle configurations.

in the block by removing vertices that are deemed unnecessary based on measurements of screen space heights. The maximum number of triangles in a block is 8; the minimum number is 2. The candidate vertices to be removed are the midpoints of the edges of the block and the center of the block. The distinct triangle configurations (modulo rotations) are shown in Figure 11.3. The numbers refer to how many of the 5 candidate vertices occur in the final mesh. Configuration 0 has two orientations. The one shown is labeled as *even*, the other is *odd*. The simplification of a block to configuration 0 depends on where the block occurs in the quadtree. The root block is an even block. The parity of any other block depends on which child it is. Child blocks C_{UL} and C_{LR} are even blocks, and child blocks C_{UR} and C_{LL} are odd blocks. Figure 11.4 shows the highest resolution and the smallest set of triangles to which four sibling blocks can be simplified.

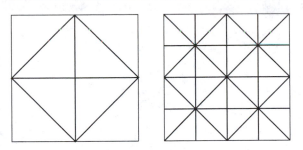

Figure 11.4 The smallest simplification and highest resolution for four sibling blocks.

11.2 VERTEX-BASED SIMPLIFICATION

Consider a single (even) block in the quadtree as illustrated in Figure 11.5. The block is conveniently shown in rendered form in screen space. The midpoint of edge $\langle \vec{V}_{02}, \vec{V}_{22} \rangle$ is $\vec{M}_{12} = (\vec{V}_{02} + \vec{V}_{22})/2$. The segment $\langle \vec{M}_{12}, \vec{V}_{12} \rangle$ is vertical in world space and has world height $L_w = |\vec{M}_{12} - \vec{V}_{12}|$. Let L_s denote the length of the corresponding segment in screen space. This length is determined by Equation (3.16). If L_s is sufficiently small (as determined by the application), then the vertex \vec{V} may as well be removed from the tessellation of the block and the two triangles $\langle \vec{V}_{22}, \vec{V}_{12}, \vec{V}_{11} \rangle$ and $\langle \vec{V}_{02}, \vec{V}_{12}, \vec{V}_{11} \rangle$ collapsed into a single triangle $\langle \vec{V}_{22}, \vec{V}_{11}, \vec{V}_{02} \rangle$. The same analysis can be applied to the screen space lengths at the other edge points \vec{V}_{01}, \vec{V}_{10}, and \vec{V}_{21}. For an even block, the vertex \vec{V}_{11} is considered for removal by analyzing the screen space height of the vertical segment $\langle \vec{V}_{11}, (\vec{V}_{20} + \vec{V}_{02})/2 \rangle$. For an odd block, \vec{V}_{11} is considered for removal by analyzing the screen space height of the vertical segment $\langle \vec{V}_{11}, (\vec{V}_{00} + \vec{V}_{22})/2 \rangle$.

The specification of how small L_s should be for collapsing is left to the application. If no visual artifacts are desired, then $L_s \leq 1$ pixel is sufficient. This prevents popping of the triangles as the camera is moved closer to or farther from the terrain. However, some popping might be allowed by an application that wishes to maintain a constant frame rate. The threshold on L_s can vary over time to maintain the desired rate.

11.2.1 DISTANT TERRAIN ASSUMPTION

Although Equation (3.16) can be evaluated directly for candidate vertices, the cost may be significant enough to warrant approximations. The same approximations are used when doing block-based simplification, a topic discussed later.

The assumption made in Lindstrom et al. (1996) is that the eye point is far away from the terrain. This is a valid assumption when doing a flyover of the terrain,

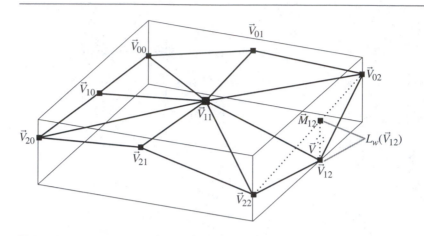

Figure 11.5 A single block with nine vertices labeled and all eight triangles drawn. The candidate vertex is \vec{V}_{12} and the candidate vertical line segment is $\langle \vec{M}_{12}, \vec{V}_{12}\rangle$. The midpoint of the segment is \vec{V} and the world height is $L_w(\vec{V})$. The corresponding screen space height is $L_s(\vec{V})$.

but if an application allows the camera to get close to ground level, the approximation is not a good one. The distant terrain assumption has three consequences. The first is that the view direction \vec{D} is approximately the unit-length vector $\vec{\Delta}/|\vec{\Delta}|$, where $\vec{\Delta} = (\Delta_x, \Delta_y, \Delta_z) = \vec{V} - \vec{E}$, \vec{E} is the eye point, and \vec{V} is any vertex in the terrain. The second is that the world space height L_w of each \vec{V} is much smaller than the distance $|\vec{\Delta}|$ from the eye point to that vertex. The third is that the actual vertex may be used in computing $\vec{\Delta}$ rather than the midpoint of the line segment. In Figure 11.5 this amounts to using \vec{V}_{12} instead of \vec{V} in the screen space distance formula. The mathematical approximations in Equation (3.16) are $\vec{D} = \vec{\Delta}/|\vec{\Delta}|$ and $L_w/|\vec{\Delta}| = 0$, do $L_w^2 D_z^2/4 = L_w^2 (\Delta_z)^2/|\vec{\Delta}|^2 = 0$. Replacing these in Equation (3.15) yields $L_s^2 = \lambda^2 n^2 L_w^2 (\Delta_x^2 + \Delta_y^2)/(\Delta_x^2 + \Delta_y^2 + \Delta_z^2)^2$. If the screen space distance threshold is selected to be τ, then a vertex is removed from the mesh as long as $L_s^2 \le \tau^2$. The simplification constraint is

$$\frac{\lambda^2 n^2 L_w^2 (\Delta_x^2 + \Delta_y^2)}{(\Delta_x^2 + \Delta_y^2 + \Delta_z^2)^2} \le \tau^2. \tag{11.1}$$

11.2.2 CLOSE TERRAIN ASSUMPTION

The assumption is that the camera is oriented so that its direction vector \vec{D} is approximately horizontal. This is typical for third-person views where a character is

moving along the terrain and the camera follows closely. Assuming height is measured in the z-direction, the mathematical approximation is $D_z = 0$. Replacing this in Equation (3.16) and canceling the common factors in numerator and denominator yields the simplification constraint

$$\frac{\lambda^2 n^2 L_w^2}{(D_x \Delta_x + D_y \Delta_y)^2} \le \tau^2. \tag{11.2}$$

11.2.3 NO ASSUMPTION

There is no approximation made in this case. The screen space distance is used as specified in Equation (3.16). Given a screen space distance threshold of τ, a vertex is removed from the mesh when its world space height L_w satisfies the simplification constraint

$$\frac{\lambda^2 n^2 L_w^2 [D_z^2(\Delta_x^2 + \Delta_y^2) + (D_x \Delta_x + D_y \Delta_y)^2]}{[(D_x \Delta_x + D_y \Delta_y + D_z \Delta_z)^2 - L_w^2 D_z^2 / 4]^2} \le \tau^2. \tag{11.3}$$

The value \vec{V} in computing $\vec{\Delta}$ is the midpoint of the line segment connecting the height field vertex and the midpoint of the line segment connecting the neighboring two vertices. For example, in Figure 11.5 if the candidate vertex is \vec{V}_{12}, then $\vec{V} = (\vec{V}_{02} + 2\vec{V}_{12} + \vec{V}_{22})/4$.

11.3 BLOCK-BASED SIMPLIFICATION

Typical terrain data sets have a large number of vertices. Performing vertex simplification on all vertices each frame is very expensive and will prevent real-time frame rates. Instead, groups of vertices can be simplified at once by analyzing the screen space heights of the bounding boxes of blocks that contain those vertices. Block-based simplification allows you to quickly get to approximately the correct resolution for the entire terrain. The blocks that are selected to be included in the mesh are called *active blocks*. Vertex-based simplification can then be performed on the five candidate vertices of each active block treated as a collection of nine vertices to get the final refinement.

Each block in the quadtree covers an area containing numerous vertices. An axis-aligned bounding box B can be computed for each block. If the vertices represented by the block are organized in a spatial array as $\hat{B} = \{\vec{V}_{ij} : i_0 \le i \le i_1, \ j_0 \le j \le j_1\}$, then $B = [x_{min}, x_{max}] \times [y_{min}, y_{max}] \times [z_{min}, z_{max}]$, where (x_{min}, y_{min}) is the spatial coordinate of $\vec{V}_{i_0 j_0}$, (x_{max}, y_{max}) is the spatial coordinate of $\vec{V}_{i_1 j_1}$, z_{min} is the minimum z-value of the \vec{V}_{ij}, and z_{max} is the maximum z-value of the \vec{V}_{ij}. Note that $\hat{B} \subset B$.

Define $\delta_{\max} = \max_{\vec{V} \in \hat{B}} L_w(\vec{V})$ to be the largest world space height of the vertical segment centered at \vec{V}, where \vec{V} is determined as illustrated in Figure 11.5. If δ_{\max} is sufficiently small as determined by the screen space threshold τ, then all vertices in the block meet the threshold condition and the block can be simplified into two triangles, its lowest resolution. Moreover, if the three siblings of the block also have sufficiently small δ_{\max} values, then the four blocks together can be simplified by replacing them by their common parent.

Similarly, define $\delta_{\min} = \min_{\vec{V} \in \hat{B}} L_w(\vec{V})$. If δ_{\min} is sufficiently large as determined by τ, then all vertices in the block fail the threshold condition, and the block must be triangulated to its highest resolution of eight triangles. While this test does not help to simplify blocks, it is used in vertex simplification.

The terms "sufficiently small" and "sufficiently large" need to be made more precise. Abstractly, there is an interval $I_u = [\delta_0, \delta_1] \subset [0, \infty)$ such that (1) if $\delta_{\max} \leq \delta_0$, then the block is tessellated to its lowest resolution, and (2) if $\delta_{\min} \geq \delta_1$, then the block is tessellated to its highest resolution. If neither condition holds, then the vertices in the block must be analyzed individually for simplification. For this reason the interval I_u is called the *interval of uncertainty* for the block. The block-based simplification algorithm amounts to making a slice through the quadtree of blocks so that the blocks in the slice are all uncertain about how their vertices should be simplified.

11.3.1 DISTANT TERRAIN ASSUMPTION

In Inequality (11.1), define $F(\vec{V} - \vec{E}) = F(\vec{\Delta}) = \sqrt{\Delta_x^2 + \Delta_y^2}/(\Delta_x^2 + \Delta_y^2 + \Delta_z^2)$. The inequality is rewritten as $L_s(\vec{V}) = \lambda n L_w(\vec{V}) F(\vec{V} - \vec{E}) \leq \tau$ for $\vec{V} \in \hat{B}$. Observe that

$$\max_{\vec{V} \in \hat{B}} L_s(\vec{V}) = \max_{\vec{V} \in \hat{B}} \left(\lambda n L_w(\vec{V}) F(\vec{V} - \vec{E}) \right)$$

$$= \lambda n L_w(\vec{V}_0) F(\vec{V}_0 - \vec{E}) \quad \text{for some } \vec{V}_0 \in \hat{B}$$

$$\leq \lambda n \left(\max_{\vec{V} \in B} L_w(\vec{V}) \right) \left(\max_{\vec{V} \in B} F(\vec{V} - \vec{E}) \right)$$

$$= \lambda n \delta_{\max} F_{\max}(\vec{E}),$$

where $F_{\max}(\vec{E}) = \max_{\vec{V} \in B} F(\vec{V} - \vec{E})$. A conservative estimate can be made to constrain L_s for the block by requiring $\lambda n \delta_{\max} F_{\max}(\vec{E}) \leq \tau$. The condition for δ_{\max} being "sufficiently small" is

$$\delta_{\max} \leq \frac{\tau}{\lambda n F_{\max}(\vec{E})} =: \delta_0(\vec{E}). \tag{11.4}$$

Similarly,

$$\min_{\vec{V} \in \hat{B}} L_s(\vec{V}) = \min_{\vec{V} \in \hat{B}} \left(\lambda n L_w^2(\vec{V}) F(\vec{V} - \vec{E}) \right)$$

$$= \lambda n L_w(\vec{V}_1) F(\vec{V}_1 - \vec{E}) \quad \text{for some } \vec{V}_1 \in \hat{B}$$

$$\geq \lambda n \min_{\vec{V} \in B} L_w(\vec{V}) \min_{\vec{V} \in B} F(\vec{V} - \vec{E})$$

$$= \lambda n \delta_{\min} F_{\min}(\vec{E}),$$

where $F_{\min}(\vec{E}) = \min_{\vec{V} \in B} F(\vec{V} - \vec{E})$. A conservative estimate can also be made to constrain L_s for the block by requiring $\lambda n \delta_{\min} F_{\min}(\vec{E}) \geq \tau$. The condition for δ_{\min} being "sufficiently large" is

$$\delta_{\min} \geq \frac{\tau}{\lambda n F_{\min}(\vec{E})} =: \delta_1(\vec{E}). \tag{11.5}$$

The remaining problem is to compute $F_{\min}(\vec{E})$ and $F_{\max}(\vec{E})$. To make $F(\vec{\Delta})$ as large as possible, it is clear that for a given (Δ_x, Δ_y), Δ_z^2 should be made as small as possible. Given the bounding box $B = [x_{\min}, x_{\max}] \times [y_{\min}, y_{\max}] \times [z_{\min}, z_{\max}]$ and $\vec{E} = (E_x, E_y, E_z)$, we have

$$\Delta_z^2 = \begin{cases} (z_{\min} - E_z)^2 & \text{if } E_z < z_{\min} & \text{(eye below box)} \\ 0 & \text{if } z_{\min} \leq E_z \leq z_{\max} & \text{(eye at box level)} \\ (z_{\max} - E_z)^2 & \text{if } z_{\max} < E_z & \text{(eye above box)} \end{cases} .$$

Now F may be treated as a function of $r = \sqrt{\Delta_x^2 + \Delta_y^2}$, $F(r) = r/(r^2 + h_{\min}^2)$, where h_{\min} is the fixed value of Δ_z given in the previous displayed equation. The minimum and maximum distances from (E_x, E_y) to the solid box $[x_{\min}, x_{\max}] \times [y_{\min}, y_{\max}]$ are computed as r_{\min} and r_{\max}. The global maximum of $F(r)$ occurs at $r' = h_{\min}$ and is $F(r') = 1/(2h_{\min})$. Therefore,

$$F_{\max}(\vec{E}) = \begin{cases} \frac{1}{2h_{\min}} & h_{\min} \in [r_{\min}, r_{\max}] \\ \frac{r_{\min}}{r_{\min}^2 + h_{\min}^2} & r_{\min} > h_{\min} \\ \frac{r_{\max}}{r_{\max}^2 + h_{\min}^2} & r_{\max} < h_{\min} \end{cases} .$$

If the eye point is inside the box, then the box should be fully simplified, so set $F_{\max}(\vec{E}) = 0$ and $\delta_0(\vec{E}) = \infty$.

Table 11.1 Values for r_{min} and r_{max} based on eye point location.

Region	r_{min}^2	r_{max}^2
$E_x \le x_{min} \wedge y_{max} \le E_y$	$dx_0^2 + dy_1^2$	$dx_1^2 + dy_0^2$
$E_x \le x_{min} \wedge y_{min} \le E_y \le y_{max}$	dx_0^2	$dx_1^2 + \max\{dy_0^2, dy_1^2\}$
$E_x \le x_{min} \wedge E_y \le y_{min}$	$dx_0^2 + dy_0^2$	$dx_1^2 + dy_1^2$
$x_{min} \le E_x \le x_{max} \wedge y_{max} \le E_y$	dy_1^2	$\max\{dx_0^2, dx_1^2\} + dy_0^2$
$x_{min} \le E_x \le x_{max} \wedge y_{min} \le E_y \le y_{max}$	0	$\max\{dx_0, dx_1\}^2 + \max\{dy_0, dy_1\}^2$
$x_{min} \le E_x \le x_{max} \wedge E_y \le y_{min}$	dy_0^2	$\max\{dx_0, dx_1\}^2 + dy_1^2$
$x_{max} \le E_x \wedge y_{max} \le E_y$	$dx_1^2 + dy_1^2$	$dx_0^2 + dy_0^2$
$x_{max} \le E_x \wedge y_{min} \le E_y \le y_{max}$	dx_1^2	$dx_0^2 + \max\{dy_0^2, dy_1^2\}$
$x_{max} \le E_x \wedge E_y \le y_{min}$	$dx_1^2 + dy_0^2$	$dx_0^2 + dy_1^2$

To make $F(\vec{\Delta})$ as small as possible, it is clear that for a given (Δ_x, Δ_y), Δ_z^2 should be made as large as possible:

$$\Delta_z^2 = \max\{(z_{min} - E_z)^2, (z_{max} - E_z)^2\}.$$

As before, F is treated as a function of r, $F(r) = r/(r^2 + h_{max}^2)$, where h_{max} is the fixed value of Δ_z given in the displayed equation. The minimum of F on $[r_{min}, r_{max}]$ is

$$F_{min}(\vec{E}) = \min\left\{ \frac{r_{min}}{r_{min}^2 + h_{max}^2}, \frac{r_{max}}{r_{max}^2 + h_{max}^2} \right\}.$$

Finally, r_{min}^2 and r_{max}^2 are computed in the following way. Let $dx_0 = |x_{min} - E_x|$, $dx_1 = |x_{max} - E_x|$, $dy_0 = |y_{min} - E_y|$, and $dy_1 = |y_{max} - E_y|^2$. The values are specified in Table 11.1.

11.3.2 CLOSE TERRAIN ASSUMPTION

In Inequality (11.2), define $F(\vec{V} - \vec{E})$ by $F(\vec{V} - \vec{E}) = F(\vec{\Delta}) = 1/|D_x\Delta_x + D_y\Delta_y|$. The inequality is rewritten as $L_s(\vec{V}) = \lambda n L_w(\vec{V})F(\vec{V} - \vec{E}) \le \tau$ for $\vec{V} \in \hat{B}$. The same construction that was used for the distant terrain assumption can be applied here, but

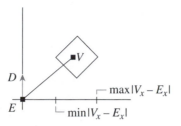

Figure 11.6 Special case for optimization when $(D_x, D_y) = (1, 0)$.

for the current function F. The conditions in Equations (11.4) and (11.5) apply. The problem now is to compute $F_{min}(\vec{E})$ and $F_{max}(\vec{E})$. Note that

$$F_{min}(\vec{E}) = \min_{\vec{V} \in B} \frac{1}{|D_x(V_x - E_x) + D_y(V_y - E_y)|} = \max_{\vec{V} \in B} |D_x(V_x - E_x) + D_y(V_y - E_y)|$$

and

$$F_{max}(\vec{E}) = \max_{\vec{V} \in B} \frac{1}{|D_x(V_x - E_x) + D_y(V_y - E_y)|} = \min_{\vec{V} \in B} |D_x(V_x - E_x) + D_y(V_y - E_y)|.$$

The z-components of the vectors do not matter in the optimization, so the problem is two-dimensional. Figure 11.6 illustrates the case when $(D_x, D_y) = (1, 0)$. In this special setting, the optimum values to compute are those of $|V_x - E_x|$. Clearly, these occur at the extreme values of the two-dimensional box in the x-direction, and the occurrences are at two of the corners of the box. For general (D_x, D_y), the optimization process consists of computing $|D_x(V_x - E_x) + D_y(V_y - E_y)|$ at the four xy-corners of box B and selecting the minimum and maximum values.

11.3.3 No Assumption

In Inequality (11.3), define

$$G(L_w, \vec{\Delta}) = \frac{L_w \sqrt{D_z^2(\Delta_x^2 + \Delta_y^2) + (D_x\Delta_x + D_y\Delta_y)^2}}{(D_x\Delta_x + D_y\Delta_y + D_z\Delta_z)^2 - L_w^2 D_z^2/4}.$$

For a fixed $\vec{\Delta}$, define $g(\xi) = G(\xi, \vec{\Delta})$. In short format, $g(\xi) = a\xi/(b - c\xi^2)$ for positive constants a, b, and c. The derivative is $g'(\xi) = a(b + c\xi^2)/(b - c\xi^2)^2 > 0$. Thus, g is an increasing function. Consequently, $G(L_w, \vec{\Delta}) \leq G(\delta_{max}, \vec{\Delta})$, where

$\delta_{\max} = \max_{\vec{V} \in B} L_w(\vec{V})$, and $G(L_w, \vec{\Delta}) \geq G(\delta_{\min}, \vec{\Delta})$, where $\delta_{\min} = \min_{\vec{V} \in B} L_w(\vec{V})$. The extreme values for L_s over the set \hat{B} are

$$\max_{\vec{V} \in \hat{B}} L_s(\vec{V}) \leq \lambda n \max_{\vec{V} in B} G(\delta_{\max}, \vec{V} - \vec{E})$$

and

$$\min_{\vec{V} \in \hat{B}} L_s(\vec{V}) \geq \lambda n \min_{\vec{V} in B} G(\delta_{\min}, \vec{V} - \vec{E}).$$

Let \vec{V}_{\max} and \vec{V}_{\min} be those vectors in B that optimize the G function. The constraints on δ_{\min} and δ_{\max} that are equivalent to those in Equations (11.4) and (11.5) are

$$\lambda n G(\delta_{\max}, \vec{V}_{\max} - \vec{E}) \leq \tau \qquad (11.6)$$

and

$$\lambda n G(\delta_{\min}, \vec{V}_{\min} - \vec{E}) \geq \tau. \qquad (11.7)$$

Both equations are implicit constraints, but they are quadratic. Using the short format $G(\delta_{\max}, \vec{V}_{\max} - \vec{E}) = a\delta_{\max}/(b - c\delta_{\max}^2)$, the implicit maximum constraint is

$$\frac{\lambda n a \delta_{\max}}{b - c\delta_{\max}^2} \leq \tau.$$

The denominator of the fraction is positive, so multiplying by it and collecting terms on the left-hand side yields

$$Q(\delta_{\max}) := c\tau\delta_{\max}^2 + \lambda n a \delta_{\max} - b\tau.$$

Note that $Q(0) < 0$ and $Q'(0) = \lambda n a > 0$, so the unique positive value δ_0 for which $Q(\delta_0) = 0$ provides the upper bound test, $\delta_{\max} \leq \delta_0$. Computing the root for Q is expensive and is in fact not necessary. The quadratic inequality itself may be evaluated in the implementation. Similarly, a quadratic function can be established for δ_{\min}, and the threshold test is $\delta_{\min} \geq \delta_1$, where δ_1 is the unique positive root of the quadratic function.

The problem now is to compute \vec{V}_{\max} and \vec{V}_{\min} so that the coefficients in the quadratic inequality constraints can be evaluated. As in the distant terrain assumption, G is a decreasing function of Δ_z. The vector \vec{V}_{\max} must occur at a point for which $\Delta_z = z_{\min}$, the minimum z-value for the box. Similarly, \vec{V}_{\min} must occur at a point for which $\Delta_z = z_{\max}$. This limits the search for the optimum points to eight edges of the box. On one such edge where Δ_y is fixed, G is a rational function in Δ_x whose numerator is quadratic and whose denominator is quartic. The minimum

and maximum of the rational function must be computed. The derivative is also a rational function whose numerator is a cubic polynomial and whose denominator is positive. The search for extreme points along the edge amounts to computing the roots of the cubic polynomial, evaluating the rational function at those points, and comparing among themselves and the rational function at the end points (up to five points to test). This is done for all eight edges to find the global minimum and maximum. The construction also yields the points \vec{V}_{max} and \vec{V}_{min} at which the extrema occur.

11.4 Vertex Dependencies

After block-based simplification, the five candidate vertices of each block are analyzed for simplification. At this stage adjacent blocks may have cracks that need to be removed. The problem is that one higher-resolution block contains a vertex in its mesh and the adjacent lower-resolution block does not contain the same vertex. The vertex forms a T-junction, and a crack occurs in the mesh. The cracks are removed by keeping track of vertex dependencies. If a vertex is determined to be in the final mesh, then any dependent vertices must also be in the final mesh. For a block treated as a 3×3 array of vertices, the dependencies are shown in Figure 11.7. The four corners of each active block must occur in the mesh.

As an example, consider a 5×5 height field. The corresponding quadtree has three levels: 1 root block, 4 interior blocks, and 16 leaf blocks. Figure 11.8 illustrates there was enough variation in the screen space vertex heights for the vertices represented by the root block that its four children needed to be analyzed for further simplification. The figure also illustrates that the lower-left child block itself needed to be analyzed for further simplification. There are 7 active blocks. The minimal triangulation for each active block is shown. If only the triangles shown are drawn, there are two cracks in the mesh, one between the upper-left and lower-left children of the root block and one between the lower-right and lower-left children of the root block.

The left half of Figure 11.9 illustrates the vertex dependencies (large solid dots) generated by the midpoint (small solid dot) of the edge shared by the lower-left and lower-right children of the root block. The right half of Figure 11.9 shows the additional vertices (large solid dots), edges (bold lines), and triangles that are generated because of the vertex dependencies of the two midpoints (small solid dots).

Finally, suppose that a vertex in the lower-right child of the lower-left child of the root block was added to the mesh because its screen space height was large enough. The presence of the vertex and its dependencies force the mesh to be further refined. The upper-left part of Figure 11.10 shows the added vertex (small solid dot) and the dependencies (large solid dots) generated by its left dependent. The upper-right part of Figure 11.10 shows the dependencies generated by the right dependent. The lower part of Figure 11.10 shows the additional edges and triangles that are generated by the

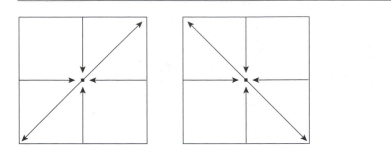

Figure 11.7 Vertex dependencies for an even block (left) and an odd block (right).

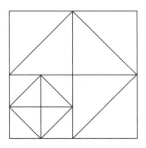

Figure 11.8 Minimal triangulation after block-based simplification.

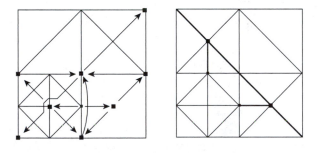

Figure 11.9 Triangulation after vertex dependencies are satisfied.

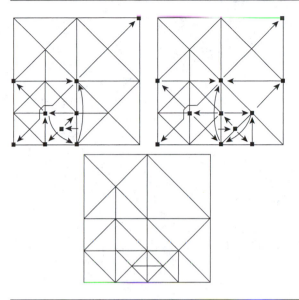

Figure 11.10 The upper-left block shows one set of dependents for the added vertex. The upper-right block shows the other set of dependents. The lower block is the triangulation based on all dependents.

full set of dependencies. The dependencies for a vertex form a binary tree since each vertex has two immediate dependents. However, the nodes of the binary tree are not necessarily distinct, as is clear from Figure 11.10.

11.5 BLOCK RENDERING

After simplification, the triangles in each active block must be rendered. Computing the triangles is straightforward because the triangles form a binary tree that can be recursively traversed. For example, consider the lower-right child of the root block shown in Figure 11.10. After block simplification, the block consisted of two triangles. After vertex simplification, the block was subdivided into smaller triangles. Figure 11.11 shows the original configuration and the subdivided configuration.

Figure 11.12 shows the corresponding binary tree for the block. The root node of the binary tree corresponds to the block itself and is not a triangle. All other nodes represent isosceles right triangles. The dotted lines indicate where a parent node is split to form the two child nodes. The triangle of a node is split only when the midpoint of its hypotenuse is a vertex that is required to be in the final mesh, as determined by

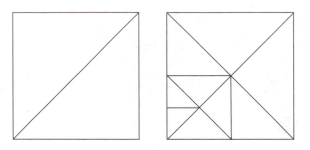

Figure 11.11 The left block is the configuration after block simplification. The right block is the configuration after vertex simplification.

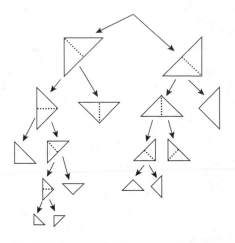

Figure 11.12 Binary tree for the right block in Figure 11.11.

the screen space height calculations during vertex simplification. Thus, a leaf node of the binary tree is one whose triangles cannot be split because either the hypotenuse does not contain an enabled vertex from simplification or is a triangle in the highest-resolution mesh for the height field, in which case the length of a leg of the triangle is the spacing between consecutive samples in the height field.

The binary tree is traversed in depth-first order. When a leaf node is encountered, either the corresponding triangle can be rendered immediately or information about it can be saved for deferred rendering. The choice depends on how the renderer itself is structured.

11.6 THE FULL ALGORITHM

This section provides a detailed description of an algorithm for the simplification and rendering of a height field. The height field itself is characterized by a *size* of $2^N + 1$ for $N \geq 1$ and a two-dimensional array of height values, H_{ij} for $0 \leq i \leq 2^N$ and $0 \leq j \leq 2^N$. In an implementation, a height value is usually stored as a 1-byte or 2-byte unsigned integer type to minimize memory usage. The application must then also supply parameters to relate the height array to world coordinates. In particular, the following parameters should be specified: minimum elevation z_{min} and maximum elevation z_{max} (corresponding to zero and the maximum representable value M of the unsigned integer type), the spacing between spatial samples σ (assumed to be uniform in both spatial dimensions), and the spatial location (x_{min}, y_{min}) of the point with height H_{00}. The world coordinates of the sample corresponding to height H_{ij} are $(x_i, y_j, z_{ij}) = (x_{min} + i\sigma, y_{min} + j\sigma, z_{min} + ((z_{max} - z_{min})/M)H_{ij})$ for $0 \leq i \leq 2^N$ and $0 \leq j \leq 2^N$.

A quadtree of blocks is maintained. For a size of $2^N + 1$, the quadtree has $(4^N - 1)/3$ nodes. Since the quadtree is complete, it can be stored in memory as an array of structures, each structure containing information relative to a block. The array is assumed to have zero-based indexing. Given a parent node with index p, the four child nodes have indices $c = 4p + i$ for $1 \leq i \leq 4$. Given a child node with index c, the parent node has index $p = \lfloor (c - 1)/4 \rfloor$.

A queue of blocks is maintained to keep track of the current blocks that are at the correct level of detail (based on the block simplification algorithm) and are potentially in the view frustum. Theoretically, the queue must be large enough to hold the entire set of blocks from the quadtree, so an implementation needs to provide enough space for this case, however improbable.

Finally, a two-dimensional array of vertex information is maintained, one vertex per height sample. Each item has a Boolean flag storing whether or not the vertex is currently in the mesh that is to be rendered (based on the vertex simplification algorithm). The item also stores information about who are its two dependent vertices.

The choice of data structures is of course dependent on implementation. The usual space-time trade-offs come into play, and each implementor has to decide what is the best trade-off for his application. The vertex information structure is the simplest one. It contains two pointers to its dependent vertices and a Boolean flag indicating whether or not the vertex is currently in the mesh to be rendered.

The block structure contains information to index into various arrays, such as the height array or related surface attribute arrays including normals and vertex colors. Minimally, it contains an index into the global arrays, the index corresponding to the origin point of the block. This is typically the upper-left point when viewing the block in row-major order with row indices increasing from top to bottom. The block must also contain the stride information so that it can be manipulated as an entity representing a 3×3 array of points. To distinguish between even and odd blocks, the block stores a Boolean flag. Since the vertex simplification occurs more often than

most other processes in the system, it is too expensive to constantly be calculating the world space heights of the line segments corresponding to the five candidate vertices. Therefore, the block structure saves the world space heights for those five points. The calculations of the heights are done during program initialization. The maximum of the five heights is also saved at leaf blocks. At interior blocks, the maximum of the five heights and of the maximum heights for the four child blocks is saved. The minimum and maximum heights δ_0 and δ_1 that change with eye point are computed and stored whenever necessary. Finally, the block stores the axis-aligned bounding box that contains all the highest-resolution vertices covered by the spatial extent of the block.

The queue is implemented in bounded memory as a circular queue. The queue items contain the block indices and two flags, one to indicate whether or not the block has already been processed during the current simplification phase and one to indicate whether or not the block is potentially visible. It is possible to implement the flags using the two high-order bits of the block indices as long as the total number of blocks is representable by an integer with two less bits than the total number of bits for the integer type of the index.

The processing of the height field is in three stages: initialization of the blocks, vertices, and queue; simplification based on current eye point; and rendering of the active blocks. The camera represents both the eye point and view frustum.

```
InitBV();
InitQ();
for (each frame) do
{
    if (camera.eye point has changed since last frame) then
    {
        ResetBlocks();
        SimplifyBlocks(camera);
        SimplifyVertices(camera);
    }
    RenderBlocks();
}
```

Block initialization involves a recursive traversal of the quadtree. The interval values for all blocks are initialized to $\delta_0 = 0$ and $\delta_1 = \infty$. The origin indices for the root block are $(0, 0)$, the upper-left corner of the height field, and the stride is 2^{N-1}. The root block is an even block, and its quadtree index is 0. Generally, if a block has quadtree index q, origin indices (x, y), stride s, and Boolean e indicating whether or not the block is even, then `InitBV(block,q,x,y,s,e)`, shown below, provides a recursive initialization of all blocks. The initial call is `InitBV(rootBlock,0,0,0,2^{N-1},true)`.

```
InitBV (block,q,x,y,s,e)
{
    block.xOrigin = x;
    block.yOrigin = y;
    block.stride = s;
    block.even = e;
    block.delta0 = 0;
    block.delta1 = infinity;

    // delta values for five candidate vertices
    block.delta[0] = (P(x,y).z + P(x+2s,y))/2 - P(x+s,y);
    block.delta[1] = (P(x+2s,y).z + P(x+2s,y+2s))/2 - P(x+2s,y+s);
    block.delta[2] = (P(x,y+2s).z + P(x+2s,y+2s))/2 - P(x+s,y+2s);
    block.delta[3] = (P(x,y).z + P(x,y+2s))/2 - P(x,y+s);
    if ( block.even )
        block.delta[4] = (P(x,y+2s).z + P(x+2s,y).z)/2 - P(x+s,y+s);
    else
        block.delta[4] = (P(x,y).z + P(x+2s,y+2s).z)/2 - P(x+s,y+s);

    block.deltaMax = maximum of block.delta[i];

    // vertex dependencies
    V(x+s,y).dependent0 = V(x+s,y+s);
    V(x,y+s).dependent1 = V(x+s,y+s);
    V(x+2s,y+s).dependent0 = V(x+s,y+s);
    V(x+s,y+2s).dependent1 = V(x+s,y+s);
    if ( block.even )
    {
        V(x+s,y+s).dependent0 = V(x,y+2s);
        V(x+s,y+s).dependent1 = V(x+2s,y);
    }
    else
    {
        V(x+s,y+s).dependent0 = V(x,y);
        V(x+s,y+s).dependent1 = V(x+2s,y+2s);
    }

    // recursively handle remaining blocks
    if ( block is interior )
    {
        InitBV(block.childUL,4*quadIndex+1,x,y,s/2,even);
        InitBV(block.childUR,4*quadIndex+2,x+s,y,s/2,!even);
        InitBV(block.childLL,4*quadIndex+3,x,y+s,s/2,!even);
```

```
        InitBV(block.childLR,4*quadIndex+4,x+s,y+s,s/2,even);

        block.min = minimum of block.childIJ.min;
        block.max = maximum of block.childIJ.max;
        block.deltaMax = max(block.deltaMax,block.childIJ.deltaMax);
    }
    else
    {
        // leaf block, stride = 1
        block.min = minimum of nine world vertices with indices (i,j)
            with x <= i <= x+2, y <= j <= y+2;
        block.max = maximum of nine world vertices with indices (i,j)
            with x <= i <= x+2, y <= j <= y+2;

    }

}
```

The function InitQ() creates a circular queue stored as an array of unsigned short indices. The queue represents those currently active blocks for which vertex simplification must occur. The number of elements is the number of leaf nodes in the quadtree, the maximum possible number of active blocks at any one time. The queue is initially empty.

After each frame the vertices of an active block are tagged as either enabled or disabled for the final tessellation. Function ResetBlocks iterates over the active blocks and resets the vertices to be disabled. If a vertex is currently enabled and must be disabled, the dependents of that vertex must be informed to disable themselves, too. Thus, a call to ResetBlocks requires traversing the vertex dependency trees, an operation that typically is not inexpensive. A more complicated scheme for updating vertex dependencies by Lindstrom et al. (1996) attempts to maintain the correct current state for each vertex.

Function SimplifyBlocks does the block simplification as described earlier. The blocks in the queue are considered to be *unprocessed* and may need to be replaced by four child blocks (need more detail) or, together with its three siblings, may need to be replaced by a parent block (need less detail).

```
while ( queue.ExistUnprocessedBlocks() )
{
    block = queue.GetFrontAndRemove();
    if ( not block.Processed() )
    {
        queue.DecrementUnprocessedCount();

        if ( block.IsFirstChild() )
        {
            // test if block and siblings need to be replaced by parent
```

```
        if ( queue.ContainsSiblings(block) )
        {
            for ( each child of block )
                child.ComputeDeltaInterval(eyepoint,tolerance);

            if ( child.deltaMax <= child.delta0 for all children )
            {
                // need to replace by parent, first remove children
                // blocks
                for ( each child of block )
                {
                    queue.RemoveFront();
                    if ( not child.Processed() )
                        queue.DecrementUnprocessedCount();
                }

                // add parent (may need further reductions later)
                parent = block.GetParent();
                parent.SetProcessed(false);
                queue.AddRear(parent);
                queue.IncrementUnprocessedCount();
                continue with while loop;
            }
        }
    }

    if ( not block.VisibilityTested() )
        block.TestForIntersectionWithFrustum();

    if ( block.IsInteriorNode() )
    {
        // subdivide only if block intersects view frustum
        if ( block.IsVisible() )
        {
            for ( each child of block )
                child.ComputeDeltaInterval(eyepoint,tolerance);

            if ( child.deltaMax > child.delta0 for some child )
            {
                // subdivide if at least one child requires it
                for ( each child of block )
                {
                    // add child (may need further processing)
                    child.SetProcessed(false);
```

```
                    queue.AddRear(child);
                    queue.IncrementUnprocessedCount();
                }

                continue with while loop;
            }
        }
    }

    block.SetProcessed(true);
}

// place processed blocks at rear of queue
queue.AddRear(block);
}
```

The function ComputeDeltaInterval implements the simplification constraint based on which type of constraint is desired: distant terrain assumption, close terrain assumption, or no assumptions.

Function SimplifyVertices does the vertex simplification as described earlier. The pseudocode is

```
for ( each block in queue )
{
    if ( block.IsVisible() )
        block.SimplifyVertices();
}
```

Each visible block attempts to simplify its five noncorner vertices and automatically enables two of its four corner points depending on the parity of the block. The pseudocode is

```
for ( each noncorner vertex )
{
    if ( vertex.IsEnabled() )
    {
        if ( block.delta0 <= vertex.delta0 )
        {
            if ( vertex.delta0 <= block.delta1 )
            {
                // not sure vertex is needed, test
                // simplification constraint
                if ( not vertex.SatisfiesConstraint(tolerance) )
                    vertex.SetEnabled(true);
            }
```

```
            else
            {
                // absolutely certain vertex is needed in
                // tessellation
                vertex.SetEnabled(true);
            }
        }
    }
}

if ( block.IsEvenParity() )
{
    vertex[lowerLeft].Enable(true);
    vertex[upperRight].Enable(true);
}
else
{
    vertex[upperLeft].Enable(true);
    vertex[lowerRight].Enable(true);
}
```

Finally, the function RenderBlocks traverses the binary tree of triangles for the block, as illustrated in Figure 11.12. Let the corner vertices be \vec{V}_{ij} for $0 \leq i \leq 1$ and $0 \leq j \leq 1$. The pseudocode is

```
if ( block.IsEven() )
{
    RenderTriangle(V00,V10,V01);
    RenderTriangle(V11,V01,V10);
}
else
{
    RenderTriangle(V10,V11,V00);
    RenderTriangle(V01,V00,V11);
}
```

The function RenderTriangle does the recursive traversal of the binary tree. The pseudocode is

```
void RenderTriangle (T,L,R)
{
    // T = top vertex, L = left vertex, R = right vertex
    if ( triangle is interior node of tree )
    {
```

```
    // compute midpoint, recurse only if it is enabled
    M = (L+R)/2;
    if ( M.IsEnabled() )
    {
        // split the triangle and recurse
        RenderTriangle(M,T,L);
        RenderTriangle(M,R,T);
        return;
    }
}

// Code for adding triangle <T,L,R> to tessellation goes
// here. Alternatively, the triangle can be sent directly
// to the rendering engine to be drawn now.
}
```

An implementation must have structures that keep track of the vertices and their state (enabled/disabled). Rather than passing vertex locations, it is possible to pass indices into vertex arrays and perform arithmetic on them to do the splitting and state lookup.

Plate 5 illustrates subdivision of a height field terrain using tessellation based on the continuous level-of-detail algorithm described in this chapter. The terrain system is an implementation of a continuous level-of-detail algorithm. The top-left image is the rendering at a particular level of detail for a small screen space error tolerance. The bottom-left image is a wireframe view of that image. The top-right image is the rendering at a level of detail with a larger screen space error tolerance. The bottom-right image is a wireframe view of that image. While the top two images look the same, the wireframe images show the difference in tessellation. In the demo, there is some noticeable popping of triangles as you move about the terrain with the larger error tolerance.

11.7 Other Issues

Although the tessellation algorithm itself is the core of the terrain system, other issues must be handled in a real game environment. This section describes the most important of these: paging and memory management, use and construction of vertex colors and normals, and height calculations.

11.7.1 Terrain Pages and Memory Management

The terrain algorithm was described for a single-height $(2^N + 1) \times (2^N + 1)$ height field. To keep the memory usage at a minimum (unsigned short for heights and queue indices), the restriction is $N \leq 7$. A height field of size 129×129 is not really

large enough to represent an expansive terrain in a game. Thus, a rectangular lattice of height fields can be used, with each height field in the lattice called a *terrain page*. There are two problems with this. The first problem is that if two adjacent pages are dynamically tessellated independently, each page has no cracking, but the common boundary will. The second problem is that the memory usage is still a concern for a single page, especially if additional per-vertex information needs to be stored, such as texture coordinates, vertex colors, or vertex normals.

The first problem is straightforward to handle. Recall in the pseudocode for block initialization the lines of code where the vertex dependencies are established. For a single page this code only initializes one of the two dependents for any vertex on the boundary of the page. In an implementation using pointers to dependents, the uninitialized pointer will be set to null, and any vertex dependency tree traversing will test to make sure that a dependent pointer is not null before traversing a branch of the tree. If two terrain pages are adjacent, then in fact the null dependent pointers of one page can be set to point to vertices in the other page by a *stitching* process. If an adjacent page is unloaded from memory, then the dependent pointers for the page remaining in memory must be reset to null by an *unstitching* process. The pseudocode for stitching is given below. The vertex information is assumed to be stored as a two-dimensional array in row-major order. The dependents are indexed by 0 and 1, just as in the block initialization pseudocode, and are consistently named to work with that code.

```
// for two pages that are adjacent on a left-right edge

void StitchLeftRight (TerrainPage pageL, TerrainPage pageR)
{
    for (row = 1; row < 2^N; row++)
    {
        pageR.vertex[row][0].dependent0 = pageL.vertex[row][2^N];
        pageL.vertex[row][2^N].dependent1 = pageR.vertex[row][0];
    }
}

void UnstitchLeftRight (TerrainPage pageL, TerrainPage pageR)
{
    for (row = 1; row < 2^N; row++)
    {
        pageR.vertex[row][0].dependent0 = null;
        pageL.vertex[row][2^N].dependent1 = null;
    }
}

// for two pages that are adjacent on a top-bottom edge

void StitchTopBottom (TerrainPage pageT, TerrainPage pageB)
{
```

```
    for (col = 1; col < 2^N; col++)
    {
        pageT.vertex[2^N][col].dependent0 = pageB.vertex[0][col];
        pageB.vertex[0][col].dependent1 = pageT.vertex[2^N][col];
    }
}

void UnstitchTopBottom (TerrainPage pageT, TerrainPage pageB)
{
    for (col = 1; col < 2^N; col++)
    {
        pageT.vertex[2^N][col].dependent0 = null;
        pageB.vertex[0][col].dependent1 = null;
    }
}
```

The memory usage problem is a more complicated one. Given a set of terrain pages that are required to be coexistent in memory, one way to minimize the use of memory is to share as much as possible between pages. While the height information is typically unique to each page, it can be shared if the application wishes to repeat height fields, much like texture coordinates are allowed to repeat to conserve texture memory usage. The texture images themselves can be shared between pages, but at the cost of having some parts of the world looking the same as other parts. Some of this effect can be lessened by applying small, yet different, secondary textures that contain noise or light maps to the terrain pages. If the tessellation of a page is stored in memory so that the renderer can be fed all the triangles at once, as compared to sending one triangle at a time when it is known it will be in the tessellation, the storage used by the tessellation algorithm can be shared among all pages. While this does keep memory usage to a minimum, the tessellation data is not persistent. If a picking operation is initiated for a set of terrain pages, the pages have to be retessellated for that operation rather than having the tessellation available from the previous rendering pass. However an application decides to share memory, there are always trade-offs like these to consider.

Given an expansive terrain, not all pages can fit into memory at once, even with an optimum amount of sharing. This requires what is effectively a virtual memory manager whose job it is to load and unload terrain pages on demand or based on a predictive system. If the terrain pages are organized as a rectangular lattice, a subset of the pages called the *working set* (the same concept found in operating systems) is maintained in memory. As the camera moves about the world, pages must be unloaded and new pages must be loaded. Before unloading an old page, the unstitching process is applied to all its adjacent pages. After loading the new page, the stitching process is applied to all its adjacent pages. The loading process will be affected by any design choices, such as which pages will share a single texture. In such a case, the texture image will not be reloaded when the new height field is streamed in.

A recommended system for predictive loading is to use a multiresolution approach. Suppose the working set is a $(2P + 1) \times (2P + 1)$ lattice of pages. The center

page, and possibly some set of immediate neighbors, is stored in memory in its highest resolution. That is, the height field and texture image are fully loaded in memory. However, pages more distant from the center can be only partially loaded in memory. Consider that even if a distant page were fully loaded in memory, it is sufficiently far from the camera that the tessellation algorithm would produce a small number of large triangles. The active blocks in the quadtree are nearer to the root of the tree than they are to the leaf nodes of the tree. The quadtree is effectively truncated and represents a height field of smaller resolution than the original. Thus, it is sufficient to load only a small portion of the height field to support a coarse tessellation. As the camera gets closer to that page, more height field data is loaded to allow a finer tessellation. If the camera moves farther from the page, then the coarse-level data can be unloaded to make room for data in pages that the camera is getting closer to. This scheme requires that the height field *not* be stored as an array in row-major order. The height data must be arranged to support the coarse-to-fine requirements. The coarsest level of detail corresponds to the root block and uses the four corner points, the midpoints of the edges, and the center point, a 3×3 array of values. The next level of detail fills in the heights to form a 5×5 array, and so on. The implementation of a working set manager includes tagging each entry in the $(2P + 1) \times (2P + 1)$ lattice with the desired level of detail that must occur for the height fields that are stored there. Each time the camera moves, the system must decide to load/unload the height field data at the specified levels.

11.7.2 VERTEX ATTRIBUTES

A terrain has to look good to be effective in a game. That means an application will require textures, multitexture, and lighting (prelit with vertex colors or dynamically lit using vertex normals). Each of these increases the memory usage for the terrain system. Whether prelighting or dynamic lighting is used, the lighting requires knowing or computing normals at the vertices of the height field. From a modeling point of view, it is better to automatically generate normals rather than require an artist to generate them. The normals can be computed using central differences. If $(x_i, y_j, z_{i,j})$ is a height sample at an interior point ($0 < i < 2^N$ and $0 < j < 2^N$), then an estimate of the normal vector is obtained by using the fact that $(-\partial H/\partial x, -\partial H/\partial y, 1)$ is a (not necessarily unit-length) normal to the graph of $z = H(x, y)$,

$$\vec{N}_{i,j} = \left(\frac{z_{i-1,j} - z_{i+1,j}}{2\delta_x}, \frac{z_{i,j-1} - z_{i,j+1}}{2\delta_y}, 1 \right),$$

where δ_x and δ_y are the sample spacings in world coordinates. The height samples z_{ij} are also measured in world units. If the heights are stored as `unsigned short`, then a conversion to world coordinates is necessary, so each page must store such conversion factors. The normal vector in the previous equation is then normalized, a requirement by the lighting system.

Normals at points on edges or corner points of the height field must be calculated differently. If an edge is shared between two adjacent terrain pages, then central differences again can be used for normal vector estimates. In this case both pages contribute to that estimate. For example, if a point $(x_i, y_0, z_{i,0})$ is on the top edge of a page, but not a corner $(0 < i < 2^N)$, and there is an adjacent page, then a normal is

$$\vec{N}_{i,0} = \left(\frac{z_{i-1,0}^{(C)} - z_{i+1,0}^{(C)}}{2\delta_x}, \frac{z_{i,2^N-1}^{(T)} - z_{i,1}^{(C)}}{2\delta_y}, 1 \right),$$

where the superscript (C) indicates height data from the current page and (T) indicates height data from the adjacent top page. The normal is also then normalized. Similar formulas can be derived for edge points on left, right, or bottom edges when there are adjacent pages. At a corner point, information is required from two adjacent pages, the ones adjacent to the edges forming the corner. For example, consider the point $(x_0, y_0, z_{0,0})$. A normal is

$$\vec{N}_{0,0} = \left(\frac{z_{-1,0}^{(L)} - z_{1,0}^{(C)}}{2\delta_x}, \frac{z_{0,2^N-1}^{(T)} - z_{0,1}^{(C)}}{2\delta_y}, 1 \right),$$

where the superscript (C) indicates height data from the current page, (T) indicates height data from the top page, and (L) indicates height data from the left page. Similar formulas can be derived for the other corner points when the adjacent pages exist.

At edges or corners when adjacent pages do not exist, the application can assign a zero vector to the normals since typically such a page will not occur in the view frustum (unless fogging is used to hide the end of the world). Another possibility is to use one-sided differences for derivative estimation. For example, at $(x_i, y_0, z_{i,0})$ on the top edge of a page, but not a corner, a normal that uses only the current page data is

$$\vec{N}_{i,0} = \left(\frac{z_{i-1,0} - z_{i+1,0}}{2\delta_x}, \frac{z_{i,0} - z_{i,1}}{\delta_y}, 1 \right).$$

The x-derivative estimate is centralized, whereas the y-derivative estimate is one-sided. The one-sided estimates are not recommended on an edge shared by two pages. The problem is that a triangle is computed, one per page, and the triangle shares an edge along the common page boundary. Because the two pages might duplicate vertices along the shared edge (if that is how the pages are implemented), the one-sided estimates will produce different normal vectors for the duplicated vertices, so a discontinuity in lighting will most likely occur.

The normals as calculated here can be used for prelighting to generate vertex colors. In a terrain-based game that has the concept of long-term time (that is, the sun may vary its position in the sky during game play), dynamic lighting may be too expensive since it is calculated each frame even when the position of the sun has not changed. A better choice would be to use vertex colors that are recalculated only when the position of the sun has changed.

11.7.3 HEIGHT CALCULATIONS

The height field provides information at points on a lattice. However, if the game requires sublattice calculations to support picking, collision detection, or simply to have smooth motion of a vehicle over the terrain, then there is a need to calculate heights at points other than those of the lattice. A simple method for continuous height is to use linear interpolation. If (x, y) is the world spatial location at which an estimate is required for height z, it is necessary to find the three bounding samples in the height field. The column index is $c = \lfloor x/\delta_x \rfloor$, and the row index is $r = \lfloor y/\delta_y \rfloor$, where δ_x and δ_y are the world values for the sample spacing. The row and column indices determine the square that contains the test sample. A further check must be made to determine in which of two triangles forming the block the point lives. The pseudocode for the height estimate is given below.

```
float Height (float world_x, float world_y)
{
    // world_delta_x is world spacing in x-direction;
    // world_delta_y is world spacing in y-direction;
    c = floor(world_x/world_delta_x);
    r = floor(world_y/world_delta_y);
    dx = world_x - c;
    dy = world_y - r;

    if ( parity(c) == parity(r) )
    {
        if ( dx > dy )
            z = (1-dx)*H[r][c]+(dx-dy)*H[r+1][c]+dy*H[r+1][c+1];
        else
            z = (1-dy)*H[r][c]+(dy-dx)*H[r][c+1]+dx*fH[r+1][c+1];
    }
    else
    {
        if ( dx + dy <= 1 )
            z = (1-dx-dy)*H[r][c]+dx*H[r+1][c]+dy*H[r][c+1];
        else
            z = (dx+dy-1)*H[r+1][c+1]+(1-dy)*H[r+1][c]+(1-dx)
                *H[r][c+1];
    }

    return z;
}
```

For a smoother interpolation, it is also possible to use bilinear interpolation or some higher-order scheme.

11.8 HEIGHT FIELDS FROM POINT SETS OR TRIANGLE MESHES

Although it is easy enough to model the terrain for a game by building the height fields directly on a rectangular lattice, it is also possible to construct the fields from unordered point sets or from already constructed triangle meshes. In the case of point sets, each element must be of the form $(x, y, f(x, y))$. The spatial locations (x, y) can be triangulated, typically with a Delaunay triangulation (see O'Rourke 1994; Watson 1981). This reduces the problem of generating height fields from triangle meshes, a process that can be done using interpolation.

11.8.1 LINEAR INTERPOLATION

SOURCE CODE

LIBRARY

Terrain

FILENAME

TriangleNetwork
LinearNetwork

Given a triangular mesh $\{(x_i, y_i, z_i)\}$ that represents the graph of a function, an axis-aligned bounding rectangle can be constructed to contain the spatial locations of the vertices: $x_{\min} = \min_i x_i$, $x_{\max} = \max_i x_i$, $y_{\min} = \min_i y_i$, $y_{\max} = \max_i y_i$, and $z_{\min} = \min_i z_i$, $z_{\max} = \max_i z_i$. It is assumed that outside the planar extent of the mesh the heights are provided procedurally, the simplest method being the assignment of zero to the heights. The bounding rectangle can be partitioned into an $R \times C$ array of terrain pages, where each page is to be sampled as a $(2^N + 1) \times (2^N + 1)$ array of vertices. Adjacent pages overlap by one row or one column.

If (x, y) is the spatial location for one of the vertices in a page, a corresponding height z must be computed for it. Simply locate a triangle in the original mesh that contains (x, y). This is accomplished by using barycentric coordinates. If the three vertices of a triangle are (x_j, y_j, z_j) for $0 \le j \le 2$, then any point $\vec{P} = (x, y)$ can be written as a barycentric combination of the $\vec{V}_j = (x_j, y_j)$,

$$\vec{P} = c_0 \vec{V}_0 + c_1 \vec{V}_1 + c_2 \vec{V}_2,$$

where $c_0 + c_1 + c_2 = 1$. If $c_j \in [0, 1]$ for all j, then \vec{P} is contained by the triangle, either at an interior point (all $c_j \in (0, 1)$), at an edge ($c_j = 0$ for exactly one j), or at a vertex ($c_j = 0$ for exactly two j values). Using $c_0 = 1 - c_0 - c_2$,

$$\vec{P} = \vec{V}_0 + c_1(\vec{V}_1 - \vec{V}_0) + c_2(\vec{V}_2 - \vec{V}_0) = \vec{V}_0 + c_1 \vec{E}_1 + c_2 \vec{E}_2.$$

The coefficients c_1 and c_2 can be computed by solving a linear system,

$$\begin{bmatrix} \vec{E}_1 \cdot \vec{E}_1 & \vec{E}_1 \cdot \vec{E}_2 \\ \vec{E}_2 \cdot \vec{E}_1 & \vec{E}_2 \cdot \vec{E}_2 \end{bmatrix} \begin{bmatrix} c_1 \\ c_2 \end{bmatrix} = \begin{bmatrix} \vec{P} \cdot \vec{E}_1 \\ \vec{P} \cdot \vec{E}_2 \end{bmatrix}.$$

Defining $e_{ij} = \vec{E}_i \cdot \vec{E}_j$, $\delta = e_{11}e_{22} - e_{12}^2$, and $p_i = \vec{P} \cdot \vec{E}_i$, the solution is $c_1 = (e_{22}p_1 - e_{12}p_2)/\delta$, $c_2 = (e_{11}p_2 - e_{12}p_1)/\delta$, and $c_0 = 1 - c_1 - c_2$.

If the solution satisfies the conditions $c_j \in [0, 1]$ for all j, then \vec{P} is contained by the projected triangle in the plane. The barycentric coefficients are used to compute the z-value of \vec{P} so that \vec{P} is in the plane of the unprojected triangle, $z = c_0 z_0 + c_1 z_1 + c_2 z_2$.

11.8.2 QUADRATIC INTERPOLATION

SOURCE CODE

LIBRARY

Terrain

FILENAME

TriangleNetwork
QuadraticNetwork

The height fields generated by linear resampling of the triangle mesh are piecewise planar. Such a mesh is not visually appealing. Instead, it is possible to create a smooth mesh by local quadratic interpolation (Cendes and Wong 1987). This method requires specifying first-order partial derivatives at the original samples. These can be estimated from the original mesh itself. Let's look closer at the algorithm.

The input points are of the form $(x_i, y_i, f(x_i, y_i), f_x(x_i, y_i), f_y(x_i, y_i))$, and a triangulation of the spatial locations is assumed. The algorithm consists of two parts:

- *Subdivison.* Each triangle is subdivided into six triangles. The subdivision requires knowledge of the inscribed centers of the triangle and its three adjacent triangles.

- *Bézier net construction.* Each subtriangle is further partitioned into four triangles. This subdivision is affine, and the partition is used to build a quadratic function (via the Bézier triangle method described in Chapter 18 of Farin 1990).

The quadratics are of course C^1 functions, but additionally the interpolation is C^1 at any interface with other triangles, whether they are part of the current subdivision or part of the subdivision of an adjacent triangle. Thus, the interpolation is globally C^1. Moreover, the interpolation has *local control*. If the function or derivative values are modified at a single data point, then the affine subdivision of the triangles sharing the data point does not change, but the function values at the additional control points must be recalculated. If the spatial component of a single data point is modified, then the affine subdivisions of the triangles sharing the data point change. These changes are propagated to any immediately adjacent triangles of those that share the data point, but no further.

Barycentric Coefficients as Areas

The algorithm makes use of barycentric coordinates, as described in the last section. The coefficients have a geometric interpretation,

$$c_0 = \frac{\text{Area}(\vec{P}, \vec{V}_1, \vec{V}_2)}{\text{Area}(\vec{V}_0, \vec{V}_1, \vec{V}_2)}, \quad c_1 = \frac{\text{Area}(\vec{V}_0, \vec{P}, \vec{V}_2)}{\text{Area}(\vec{V}_0, \vec{V}_1, \vec{V}_2)}, \quad c_2 = \frac{\text{Area}(\vec{V}_0, \vec{V}_1, \vec{P})}{\text{Area}(\vec{V}_0, \vec{V}_1, \vec{V}_2)}.$$

The center of the inscribed circle for the triangle can be written in barycentric form. The triangle formed by \vec{P}, \vec{V}_1, and \vec{V}_2 has base length $|\vec{V}_1 - \vec{V}_2|$ and height given by the radius r of the inscribed circle. Thus, $\text{Area}(\vec{P}, \vec{V}_1, \vec{V}_2) = |\vec{V}_1 - \vec{V}_2| r/2$. Similarly,

$\mathrm{Area}(\vec{V}_0, \vec{P}, \vec{V}_2) = |\vec{V}_0 - \vec{V}_2|r/2$ and $\mathrm{Area}(\vec{V}_0, \vec{V}_1, \vec{P}) = |\vec{V}_0 - \vec{V}_1|r/2$. The total area is the sum of these three values,

$$A = \frac{r}{2}\left(|\vec{V}_1 - \vec{V}_2| + |\vec{V}_0 - \vec{V}_2| + |\vec{V}_0 - \vec{V}_1|\right).$$

The barycentric coordinates of the inscribed center are therefore

$$c_0 = \frac{|\vec{V}_1 - \vec{V}_2|}{|\vec{V}_1 - \vec{V}_2| + |\vec{V}_0 - \vec{V}_2| + |\vec{V}_0 - \vec{V}_1|}, \quad c_1 = \frac{|\vec{V}_0 - \vec{V}_2|}{|\vec{V}_1 - \vec{V}_2| + |\vec{V}_0 - \vec{V}_2| + |\vec{V}_0 - \vec{V}_1|},$$

$$c_2 = \frac{|\vec{V}_0 - \vec{V}_1|}{|\vec{V}_1 - \vec{V}_2| + |\vec{V}_0 - \vec{V}_2| + |\vec{V}_0 - \vec{V}_1|}.$$

These are just ratios of the lengths of the triangle sides to the triangle perimeter.

Inscribed Circles

One of the properties of the inscribed center is that each line from a vertex to the center bisects the angle corresponding to that vertex. This property may be used to prove the following result, which is needed in the subdivision algorithm: The line segment connecting the inscribed centers of two adjacent triangles must intersect the common edge of the triangles at an interior point.

If two adjacent triangles form a convex quadrilateral, then clearly the line segment connecting the inscribed centers has the desired property. If the triangles do not form a convex quadrilateral, as is shown in Figure 11.13, some work must be done to prove the result. The inscribed centers are \vec{K}_0 and \vec{K}_1. Set up the intersection equations as

$$(1 - s)\vec{K}_0 + s\vec{K}_1 = (1 - t)\vec{c} + t\vec{b}.$$

Note that \vec{K}_0 and \vec{K}_1 lie on different sides of the common edge $\langle \vec{b}, \vec{c} \rangle$, so the line segment connecting the centers must intersect the line containing the common edge, implying $0 < s < 1$. The geometry of the setting also implies that the intersection must occur on the \vec{c} side of \vec{b}, which implies $t < 1$. If it can additionally be shown that $t > 0$, then the line segment connecting the inscribed centers must intersect the interior of the common triangle edge.

Subtracting \vec{c}, rearranging terms, and dotting with $\vec{b} - \vec{c}$ yields

$$t|\vec{b} - \vec{c}|^2 = (1 - s)[(\vec{K}_0 - \vec{c}) \cdot (\vec{b} - \vec{c})] + s[(\vec{K}_1 - \vec{c}) \cdot (\vec{b} - \vec{c})]$$

$$= (1 - s)[|\vec{K}_0 - \vec{c}||\vec{b} - \vec{c}| \cos(\theta_0/2) + s[|\vec{K}_1 - \vec{c}||\vec{b} - \vec{c}| \cos(\theta_1/2),$$

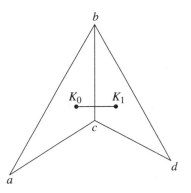

Figure 11.13 Adjacent triangles forming a nonconvex quadrilateral.

where θ_0 is the angle formed by edges $\vec{a} - \vec{c}$ and $\vec{b} - \vec{c}$, and θ_1 is the angle formed by edges $\vec{d} - \vec{c}$ and $\vec{b} - \vec{c}$. The half-angles in the formula occur because of the bisection property mentioned earlier. Since $0 < \theta_i < \pi$ for interior angles in a triangle, it follows that $0 < \theta_i/2 < \pi/2$ and $\cos(\theta_i/2) > 0$. The convex combination in the above formula is therefore positive, which implies that $t > 0$.

Bézier Triangles

Define a *multi-index on three indices* as $I = (i_0, i_1, i_2)$, where $0 \leq i_j \leq |I|$ and $|I| = i_0 + i_1 + i_2$. Define $E_0 = (1, 0, 0)$, $E_1 = (0, 1, 0)$, and $E_2 = (0, 0, 1)$. Given a triangular array of points $\vec{b}_I \in \mathbb{R}^3$, where $|I| = n$, and given a barycentric coordinate $\vec{u} = (u_0, u_1, u_2)$, recursively define

$$\vec{b}_I^0(\vec{u}) = \vec{b}_I$$

and

$$\vec{b}_J^r(\vec{u}) = \sum_{k=0}^{2} u_k \vec{b}_{J+E_k}^{r-1}(\vec{u}),$$

where $1 \leq r \leq n$ and $|J| = n - r$. The point $\vec{b}^n(\vec{u}) := \vec{b}_0^n(\vec{u})$ is a point on the *Bézier triangle* determined by the original array. The iterative algorithm is called the *de Casteljau algorithm*.

When $n = 1$, this states that the point on the Bézier triangle is just the barycentric combination of the three vertices $\vec{b}_{(n,0,0)}$, $\vec{b}_{(0,n,0)}$, and $\vec{b}_{(0,0,n)}$. The interpolation

algorithm is concerned with the case $n = 2$. The triangle array is organized as

$$\vec{b}_{(0,0,2)}$$
$$\vec{b}_{(1,0,1)} \quad \vec{b}_{(0,1,1)}$$
$$\vec{b}_{(2,0,0)} \quad \vec{b}_{(1,1,0)} \quad \vec{b}_{(0,2,0)}$$

The barycentric coordinates are listed as (u, v, w). For $r = 1$,

$$\vec{b}^1_{(1,0,0)} = u\vec{b}_{(2,0,0)} + v\vec{b}_{(1,1,0)} + w\vec{b}_{(1,0,1)}$$

$$\vec{b}^1_{(0,1,0)} = u\vec{b}_{(1,1,0)} + v\vec{b}_{(0,2,0)} + w\vec{b}_{(0,1,1)}$$

$$\vec{b}^1_{(0,0,1)} = u\vec{b}_{(1,0,1)} + v\vec{b}_{(0,1,1)} + w\vec{b}_{(0,0,2)}.$$

For $r = 2$,

$$\vec{b}^2_{(0,0,0)} = u\vec{b}^1_{(1,0,0)} + v\vec{b}^1_{(0,1,0)} + w\vec{b}^1_{(0,0,1)}$$

$$= [\,u \quad v \quad w\,] \begin{bmatrix} \vec{b}_{(2,0,0)} & \vec{b}_{(1,1,0)} & \vec{b}_{(1,0,1)} \\ \vec{b}_{(1,1,0)} & \vec{b}_{(0,2,0)} & \vec{b}_{(0,1,1)} \\ \vec{b}_{(1,0,1)} & \vec{b}_{(0,1,1)} & \vec{b}_{(0,0,2)} \end{bmatrix} \begin{bmatrix} u \\ v \\ w \end{bmatrix},$$

so the triangular Bézier patch is a quadratic function. This formula is a nice generalization of tensor products for rectangular grids.

Derivatives

Given a surface vector $\vec{x}(\vec{u})$, where $\vec{u} = (u_0, u_1, u_2)$ are barycentric coordinates ($u_0 + u_1 + u_2 = 1$), and a barycentric direction $\vec{d} = (d_0, d_1, d_2)$ with $d_0 + d_1 + d_2 = 0$, the derivative in the given direction is the tangent vector

$$D_{\vec{d}}\, \vec{x}(\vec{u}) = \sum_{i=0}^{2} d_i \vec{x}_{u_i},$$

where \vec{x}_{u_i} denotes the partial derivative of \vec{x} with respect to barycentric component u_i. The second-order directional derivative is

$$D_{\vec{d}}^2\, \vec{x}(\vec{u}) = [\,d_0 \quad d_1 \quad d_2\,] \begin{bmatrix} \vec{x}_{u_0 u_0} & \vec{x}_{u_0 u_1} & \vec{x}_{u_0 u_2} \\ \vec{x}_{u_1 u_0} & \vec{x}_{u_1 u_1} & \vec{x}_{u_1 u_2} \\ \vec{x}_{u_2 u_0} & \vec{x}_{u_2 u_1} & \vec{x}_{u_2 u_2} \end{bmatrix} \begin{bmatrix} d_0 \\ d_1 \\ d_2 \end{bmatrix}.$$

A general formulation can be made by using Bernstein polynomials,

$$B_{(i,j,k)}^n(\vec{u}) = \frac{n!}{i!\,j!\,k!} u^i v^j w^k,$$

where $i + j + k = n$. The rth-order directional derivative is

$$D_{\vec{d}}^r \vec{x}(\vec{u}) = \sum_{|I|=r} \partial^I \vec{x}(\vec{u}) B_I^r(\vec{d}),$$

where $I = (i_0, i_1, i_2)$ and $\partial^I \vec{x} = \partial^{|I|} \vec{x} / \partial u_0^{i_0} \partial u_1^{i_1} \partial u_2^{i_2}$. For a Bézier triangle, the rth-order directional derivative is given in terms of de Casteljau iterates and Bernstein polynomials:

$$D_{\vec{d}}^r \vec{b}^n(\vec{u}) = \frac{n!}{(n-r)!} \sum_{|I|=r} \vec{b}_I^{n-r}(\vec{u}) B_I^r(\vec{d}).$$

For the quadratic case $n = 2$, the first and second directional derivatives of $b^2(u, v, w)$ are

$$D_{(d,e,f)}^1 \vec{b}^2(u, v, w) = 2 \begin{bmatrix} u & v & w \end{bmatrix} \begin{bmatrix} \vec{b}_{(2,0,0)} & \vec{b}_{(1,1,0)} & \vec{b}_{(1,0,1)} \\ \vec{b}_{(1,1,0)} & \vec{b}_{(0,2,0)} & \vec{b}_{(0,1,1)} \\ \vec{b}_{(1,0,1)} & \vec{b}_{(0,1,1)} & \vec{b}_{(0,0,2)} \end{bmatrix} \begin{bmatrix} d \\ e \\ f \end{bmatrix}$$

and

$$D_{(d,e,f)}^2 \vec{b}^2(u, v, w) = 2 \begin{bmatrix} d & e & f \end{bmatrix} \begin{bmatrix} \vec{b}_{(2,0,0)} & \vec{b}_{(1,1,0)} & \vec{b}_{(1,0,1)} \\ \vec{b}_{(1,1,0)} & \vec{b}_{(0,2,0)} & \vec{b}_{(0,1,1)} \\ \vec{b}_{(1,0,1)} & \vec{b}_{(0,1,1)} & \vec{b}_{(0,0,2)} \end{bmatrix} \begin{bmatrix} d \\ e \\ f \end{bmatrix}.$$

Note that the second derivative is constant with respect to u, v, and w, as expected for a quadratic function.

Derivative Continuity

Farin (1990) provides a comprehensive development of derivative continuity on the common boundary between two adjacent triangular patches. The main result is that derivatives up through order s of \vec{b}^n depend only on the $s + 1$ rows of control points "parallel" to the boundary in question. The cases discussed are those relevant to the quadratic interpolation, $s = 0$ and $s = 1$. Figure 11.14 illustrates two adjacent triangular patches ($n = 2$). The patches define two functions $\vec{b}^2(u, v, w)$ and $\vec{c}^2(u, v, w)$.

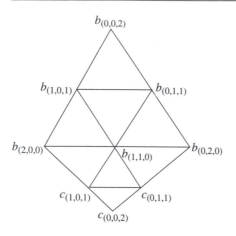

Figure 11.14 Adjacent Bézier triangle patches.

Continuity of the functions is guaranteed if

$$\vec{b}_{(2,0,0)} = \vec{c}_{(2,0,0)}, \quad \vec{b}_{(1,1,0)} = \vec{c}_{(1,1,0)}, \quad \vec{b}_{(0,2,0)} = \vec{c}_{(0,2,0)}.$$

Continuity of the derivatives is guaranteed if

$$\vec{c}_{(1,0,1)} = u\vec{b}_{(1,0,1)} + v\vec{b}_{(2,0,0)} + w\vec{b}_{(1,1,0)}$$

$$\vec{c}_{(0,1,1)} = u\vec{b}_{(0,1,1)} + v\vec{b}_{(1,1,0)} + w\vec{b}_{(0,2,0)}.$$

Each pair of shaded triangles in the figure is coplanar. Moreover, the two pairs have the same barycentric coordinates. The two continuity conditions are referred to as *coplanarity* and *coaffinity*. Note that coaffinity implies coplanarity.

The Algorithm

In this section we will describe the Cendes-Wong algorithm. The input is a set of points of the form $(x_i, y_i, f(x_i, y_i), f_x(x_i, y_i), f_y(x_i, y_i))$ for $0 \le i < N$. The input also includes a triangle mesh of the spatial locations of the samples. The output is a globally C^1 quadratic interpolating function that takes as input spatial points (x, y) and produces as output function values $f(x, y)$ and derivatives $f_x(x, y)$ and $f_y(x, y)$.

The idea is to subdivide the triangles and fit the subtriangles as quadratic Bézier triangles so that derivative continuity is achieved on each shared triangle edge. The Cendes-Wong paper (Cendes and Wong 1987) provides a construction that stresses the coplanarity condition for derivative continuity. The coaffinity condition is a consequence of the affine subdivision of the planar triangles. Consider one of the triangles

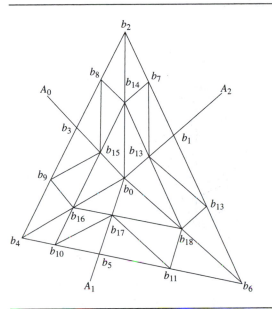

Figure 11.15 Control points in triangle subdivision.

shown in Figure 11.15. The points \vec{b}_2, \vec{b}_4, and \vec{b}_6 are the vertices of the triangle (spatial components in the xy-plane). The point \vec{b}_0 is the inscribed center. The points \vec{A}_i are the inscribed centers for the adjacent triangles. The points \vec{b}_1, \vec{b}_3, and \vec{b}_5 are the intersections of the triangle edges with the line segments connecting the inscribed center with those of its adjacent triangles. In the case that the triangle does not have an adjacent triangle for one of its edges (the edge is on the boundary of the mesh), then the midpoint of the edge is used in lieu of an intersection. The spatial relationships for the subdivision points are as follows:

$$\vec{b}_0 = \delta_0 \vec{b}_2 + \delta_1 \vec{b}_4 + \delta_2 \vec{b}_6, \ \delta_0 + \delta_1 + \delta_2 = 1, \quad \vec{b}_3 = \alpha_0 \vec{b}_2 + \alpha_1 \vec{b}_4, \ \alpha_0 + \alpha_1 = 1,$$

$$\vec{b}_5 = \beta_1 \vec{b}_4 + \beta_2 \vec{b}_6, \ \beta_1 + \beta_2 = 1, \quad\quad\quad \vec{b}_1 = \gamma_0 \vec{V}_2 + \gamma_2 \vec{V}_6, \ \gamma_0 + \gamma_2 = 1,$$

$$\vec{b}_8 = (\vec{b}_2 + \vec{b}_3)/2, \quad\quad\quad\quad\quad\quad\quad\quad \vec{b}_9 = (\vec{b}_4 + \vec{b}_3)/2,$$

$$\vec{b}_{10} = (\vec{b}_4 + \vec{b}_5)/2, \quad\quad\quad\quad\quad\quad\quad \vec{b}_{11} = (\vec{b}_6 + \vec{b}_5)/2,$$

$$\vec{b}_7 = (\vec{b}_2 + \vec{b}_1)/2, \quad\quad\quad\quad\quad\quad\quad\ \vec{b}_{12} = (\vec{b}_6 + \vec{b}_1)/2,$$

$$\vec{b}_{14} = (\vec{b}_2 + \vec{b}_0)/2, \quad\quad\quad\quad\quad\quad\quad \vec{b}_{16} = (\vec{b}_4 + \vec{b}_0)/2,$$

$$\vec{b}_{18} = (\vec{b}_6 + \vec{b}_0)/2, \quad\quad\quad\quad\quad\quad\quad \vec{b}_{15} = \alpha_0 \vec{b}_{14} + \alpha_1 \vec{b}_{16},$$

$$\vec{b}_{17} = \beta_1 \vec{b}_{16} + \beta_2 \vec{b}_{18}, \quad\quad\quad\quad\quad\quad\ \vec{b}_{13} = \gamma_0 \vec{b}_{14} + \gamma_2 \vec{b}_{18}.$$

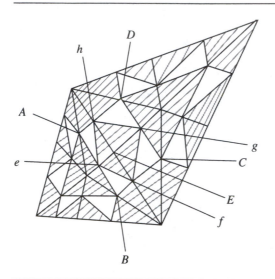

Figure 11.16 The required coaffine subtriangles are shaded in gray.

The 3D mesh points are denoted (\vec{b}_i, ϕ_i). The indices are convenient for identifying the six Bézier control points for each of the six subdivision triangles. If i is the index for a triangle, $1 \le i \le 6$, then the indices of the control points for that triangle are 0, $12 + i$, $13 + i \bmod 6$, i, $6 + i$, and $1 + i \bmod 6$.

The goal now is to specify functions and derivatives at the three vertices and to choose function values at the remaining 16 so that the coplanarity and coaffinity conditions are satisfied in the Bézier triangle constuction. Figures 11.16 and 11.17 are from Cendes and Wong (1987). The shaded regions must be coplanar for derivative continuity to occur. The shaded quadrilateral straddling the interface of two triangles must be planar. To see this let A, B, C, and D be any four points in \mathbb{R}^3. Let e, f, g, and h be points along the line segments AB, BC, CD, and DA, respectively. If

$$\frac{\text{length } Ae}{\text{length } AB} = \frac{\text{length } Dg}{\text{length } DC} = \rho_1 \quad \text{and} \quad \frac{\text{length } Bf}{\text{length } BC} = \frac{\text{length } Ah}{\text{length } AD} = \rho_2,$$

then the four points e, f, g, and h are coplanar.

The proof involves showing $eg = (\rho_1/\rho_2)ef + ((1 - \rho_1)/\rho_2)eh$, in which case eg, ef, and eh are linearly dependent vectors and must be coplanar. The quadrilateral $ABCD$ is constructed so that the desired length ratios hold and the result applies.

Now for the construction of the function values at the control points. Let ϕ_i denote the function values at the 19 control points, $0 \le i \le 18$. The vertex values ϕ_2, ϕ_4, and

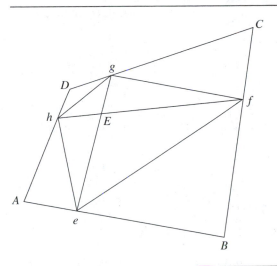

Figure 11.17 Illustration for geometric relationships between the vertices.

ϕ_6 are already specified. The derivative values at the vertices are also specified, call them $\nabla \phi_i$, $i = 2, 4, 6$.

To satisfy coplanarity at vertex \vec{V}_0:

$$\phi_7 = \phi_2 + \nabla \phi_2 \cdot (\vec{b}_7 - \vec{b}_2)$$

$$\phi_8 = \phi_2 + \nabla \phi_2 \cdot (\vec{b}_8 - \vec{b}_2)$$

$$\phi_{14} = \phi_2 + \nabla \phi_2 \cdot (\vec{b}_{14} - \vec{b}_2).$$

To satisfy coplanarity at vertex \vec{V}_1:

$$\phi_9 = \phi_4 + \nabla \phi_4 \cdot (\vec{b}_9 - \vec{b}_4)$$

$$\phi_{10} = \phi_4 + \nabla \phi_4 \cdot (\vec{b}_{10} - \vec{b}_4)$$

$$\phi_{16} = \phi_4 + \nabla \phi_4 \cdot (\vec{b}_{16} - \vec{b}_4).$$

To satisfy coplanarity at vertex \vec{V}_2:

$$\phi_{11} = \phi_6 + \nabla \phi_6 \cdot (\vec{b}_{11} - \vec{b}_6)$$

$$\phi_{12} = \phi_6 + \nabla \phi_6 \cdot (\vec{b}_{12} - \vec{b}_6)$$

$$\phi_{18} = \phi_6 + \nabla \phi_6 \cdot (\vec{b}_{18} - \vec{b}_6).$$

To satisfy coplanarity of the quadrilaterals containing \vec{E}_0, \vec{E}_1, and \vec{E}_2:

$$\phi_3 = \alpha_0\phi_2 + \alpha_1\phi_4$$

$$\phi_5 = \beta_1\phi_4 + \beta_2\phi_6$$

$$\phi_1 = \gamma_0\phi_2 + \gamma_2\phi_6.$$

To satisfy coplanarity of the large triangle containing \vec{C}:

$$\phi_{15} = \alpha_0\phi_{14} + \alpha_1\phi_{16}$$

$$\phi_{17} = \beta_1\phi_{16} + \beta_2\phi_{18}$$

$$\phi_{13} = \gamma_0\phi_{14} + \gamma_2\phi_{18}$$

$$\phi_0 = \delta_0\phi_{14} + \delta_1\phi_{16} + \delta_2\phi_{18}.$$

Verifying coaffinity in the spatial components is straightforward. The triangle vertices are related by $\vec{a}_0 = u\vec{b}_0 + v\vec{b}_3 + w\vec{b}_5$. The midpoints are $\vec{b}_1 = (\vec{b}_0 + \vec{b}_3)/2$, $\vec{b}_2 = (\vec{b}_0 + \vec{b}_5)/2$, $\vec{b}_4 = (\vec{b}_3 + \vec{b}_5)/2$, $\vec{a}_1 = (\vec{a}_0 + \vec{b}_3)/2$, and $\vec{a}_2 = (\vec{a}_0 + \vec{b}_5)/2$. Consider

$$\vec{a}_1 = (\vec{a}_0 + \vec{b}_3)/2$$

$$= (u/2)\vec{b}_0 + ((v + 1)/2)\vec{b}_3 + (w/2)\vec{b}_5$$

$$= (u/2)\vec{b}_0 + ((v + u + v + w)/2)\vec{b}_3 + (w/2)\vec{b}_5$$

$$= u(\vec{b}_0 + \vec{b}_3)/2 + v\vec{b}_3 + w(\vec{b}_3 + \vec{b}_5)/2$$

$$= u\vec{b}_1 + v\vec{b}_3 + w\vec{b}_4.$$

Similarly,

$$\vec{a}_2 = (\vec{a}_0 + \vec{b}_5)/2$$

$$= (u/2)\vec{b}_0 + (v/2)\vec{b}_3 + ((w + 1)/2)\vec{b}_5$$

$$= (u/2)\vec{b}_0 + (v/2)\vec{b}_3 + ((w + u + v + w)/2)\vec{b}_5$$

$$= u(\vec{b}_0 + \vec{b}_5)/2 + v(\vec{b}_3 + \vec{b}_5)/2 + w\vec{b}_5$$

$$= u\vec{b}_2 + v\vec{b}_4 + w\vec{b}_5.$$

Therefore, the midpoint subdivision satisfies the coaffinity conditions. It must be verified that the function values assigned to the control points also satisfy the coaffinity conditions. This turns out to be a consequence of the midpoint subdivision and the coplanarity of certain triangles in the Bézier net.

For example, let $\vec{b}_1 = u\vec{b}_3 + v\vec{b}_0 + w\vec{b}_2$ for some barycentric coordinates (u, v, w). The midpoint subdivision guarantees that $\vec{b}_7 = u\vec{b}_8 + v\vec{b}_{14} + w\vec{b}_2$. The plane at the vertex \vec{b}_2 is of the form $\phi = K + \vec{N} \cdot \vec{b}$. Therefore,

$$\phi_7 - u\phi_8 - v\phi_{14} - w\phi_2 = (K + \vec{N} \cdot \vec{b}_7) - u(K + \vec{N} \cdot \vec{b}_8) - v(K + \vec{N} \cdot \vec{b}_{14})$$

$$- w(K + \vec{N} \cdot \vec{b}_2)$$

$$= K(1 - u - v - w) + \vec{N} \cdot (\vec{b}_7 - u\vec{b}_8 - v\vec{b}_{14} - w\vec{b}_2)$$

$$= K(0) + \vec{N} \cdot \vec{0}$$

$$= 0,$$

so $\phi_7 = u\phi_8 + v\phi_{14} + w\phi_2$. The midpoint subdivision also guarantees that $\vec{b}_{13} = u\vec{b}_{15} + v\vec{b}_0 + w\vec{b}_{14}$. The plane containing control points \vec{b}_i for $i = 0$ and $13 \le i \le 18$ is also of the form $\phi = K + \vec{N} \cdot \vec{b}$. A similar argument shows that $\phi_{13} = u\phi_{15} + v\phi_0 + w\phi_{14}$. Thus, the two subtriangles satisfy the coaffinity condition. The same argument holds for any pair of subtriangles, both within a single triangle and across a triangle boundary.

SPATIAL SORTING

The process of rendering a hierarchically structured scene is discussed in Chapter 4. The objects in the scene are drawn in the order determined by the depth-first traversal of the scene. In almost all cases the rendered scene will be incorrectly drawn using this approach. For example, if two disjoint objects along the line of sight of the eye point are to be drawn, the object that is most distant should be drawn first. If that object occurs after the closest object in a depth-first traversal, the scene will be incorrectly drawn. Therefore, correct drawing of a scene can only be accomplished through *sorting*. The example just given illustrates why sorting is needed. In a real game it might be possible to simply sort the objects as they are modeled, for example, in a cityscape that contains a lot of buildings. The actual sorting mechanism might need to be more complex, especially if the objects are not disjoint and are intertwined to some degree. In fact, if a scene contains transparent objects, the correct order for drawing can be difficult to determine and might even require splitting the objects. This is definitely the case for outdoor environments containing trees that are each modeled by two intersecting alpha-blended polygons.

The basic idea behind spatial sorting is to avoid drawing a pixel on the screen multiple times. The term *depth complexity* refers to how many times a pixel is written.

411

Since the entire screen is drawn each frame, the desired depth complexity is 1; that is, each pixel is drawn once. The higher the depth complexity, the slower the frame rate.

The typical sorting method used is depth buffering, as discussed in Chapter 3. This method is on a per-pixel basis. The depth, measured between near and far planes, is stored in a *z-buffer*. The color of each pixel is stored in the *frame buffer*. Assuming the z-buffer is enabled for both testing and writing, a pixel is drawn in the frame buffer only if its depth indicates it is in front of the pixel previously drawn. This is a slow process for a software renderer, but with hardware-accelerated support, z-buffers are a good general solution for sorting by depth.

Depth buffering requires a triangle to be processed, even if most or all of the enclosed pixels are not drawn. It would be better to avoid sending triangles to the renderer at all if they are not going to be drawn. Determination of this information is on a per-object rather than a per-pixel basis. The methods discussed in this chapter are for higher-level sorting. Section 12.1 is a summary of *quadtrees* and *octrees,* two tree-based structures that provide a regular decomposition of the world. A quadtree is used for subdivision of a planar rectangle, and an octree is used for subdivision of a rectangular solid. However, many game environments require sorting that is naturally related to the world data. For an indoor environment, a natural sorting method relies on the use of portals, the topic of Section 12.2. For outdoor environments and for correct drawing of scenes that contain alpha-blended polygons, binary space partitioning trees are quite useful. Section 12.3 gives a description of such trees, including how to construct them and how they are used for hidden surface removal, visibility determination, and picking or collision detection.

12.1 Quadtrees and Octrees

The scene graph provides a basic mechanism for culling objects. A comparison of the bounding volume of a node to the view frustum can eliminate many objects from being sent to the renderers. If the bounding volume does intersect the frustum, then the subtree rooted at that node is further processed, but the processing is done based solely on bounding volume information. The application may have higher-level information about the structure of the world that can be exploited. For example, in a terrain-based system it is possible to build a visibility graph to help eliminate entire terrain pages that cannot be seen from the current camera location. Specifically, if one terrain page has high mountains that hide the terrain behind them, then the hidden pages do not have to be processed, even if their bounding boxes intersect the view frustum.

Quadtrees or octrees can be used to partition the world into cells. The visibility graph is also cell based. Since the camera is situated in one cell, a list of potentially visible cells can be made that relate to that cell. At best this is a crude way of handling visibility, but it can be quite effective if the world environment is carefully designed to support it.

Construction of a scene graph to support cell-based visibility can be based either on planar locations, in which case the plane can be decomposed into a quadtree, or on full spatial locations, in which case space can be decomposed into an octree. The scene graph nodes represent the particular quadtree blocks or octree blocks. If a node represents a quadtree block, then it has four child nodes. If it represents an octree block, then it has eight child nodes. Additional child nodes are used to represent the actual objects that live in those cells. If the objects move about over time, the scene graph needs to be reconfigured on the fly by attaching and detaching the additional children. However, the basic quadtree or octree structure remains constant over the application lifetime.

The pseudocode for the processing of a quadtree or octree scene graph is given below. The visible list for a quadtree block stores pointers to all the nodes whose blocks are potentially visible from the current block.

```
cameraBlock = GetBlockOf(renderer.camera);
visibleList = GetVisibleCellsFrom(cameraBlock);
for ( each node in visibleList )
    renderer.Draw(node);
```

As mentioned in Chapter 4, the Draw call recursively traverses the specified subtree and attempts to cull based on bounding volumes before drawing. It is quite possible that portions of the subtree corresponding to the quadtree structure are culled away based on the bounding volume comparisons.

Of course the difficult part of the process is establishing the visibility lists. An excellent reference for visibility determination is the doctoral dissertation by Seth Teller (1992). The two-volume set by Hanan Samet (1989, 1990) provides everything you ever wanted to know about quadtrees and octrees.

12.2 PORTALS

The quadtree and octree sorting attempts to set up a visibility graph based on meta-knowledge that the application has about the structure of the world and the objects in it. The game writers have the responsibility for setting up the visibility graph by hand or by some automatic method. An approach that requires less interaction is a portal-based system. In this system, rather than using an explicitly built visibility graph, the game writers can specify additional planes that trim down the view frustum into smaller pieces. The classic situation is where the camera is positioned outside a room, but looking into it. The doorway is a *portal* that allows you to see inside the room, but the walls surrounding the doorway occlude the view of much of the room's contents. When drawing the room, objects hidden by the walls about the doorway can be culled. Moreover, if objects are partially hidden, the planes formed by the frame of the doorway and the camera location can be used to establish planes that can be used for clipping in addition to culling. Portals are particularly useful for indoor-style

Figure 12.1 Illustration of visibility through a portal.

games because there are many walls and other objects that obstruct the view enough so that a sufficient amount of culling can be performed. However, the use of portals is not restricted to an indoor environment. For example, a character visible to the camera might walk behind a building. Assuming the building is tall enough, it is known that the top of the character will never be visible above the rooftops. The plane formed by the camera location and the edge of the side of the building that the character passes by before disappearing from view can be used in a portal system. Once the character is completely behind the building (that is, the character is on the invisible side of the plane), it can be culled completely and not sent to the renderer for processing.

Figure 12.1 illustrates the classic situation for a portal. The gray area in the diagram on the left shows what the renderer attempts to process in the standard view frustum. The gray area in the diagram on the right shows how the portal planes restrict what must be considered. Support for additional planes for culling is trivial using the hierarchical scheme mentioned in Chapter 4. The culling mechanism kept track of a flag of six bits, with each bit indicating whether or not the object is culled against the corresponding frustum plane. The flag can be extended to have any number of bits, and the camera can store additional planes for culling purposes. The same planes can be used for clipping, but in a hardware-accelerated system APIs such as OpenGL and Direct3D tend to allow only a small number of additional clipping planes. A portal system wanting to take advantage of the API must restrict its number of additional planes accordingly.

An indoor level for which portals are used must be partitioned into convex regions. By doing so, the order in which the components of the region are rendered is unimportant. The portals themselves are convex polygons that live in a plane separating two convex regions. The portal provides a connection between the regions through which one region can be seen from the other. In this sense a portal is bidirectional, although for interesting effects, it is not necessary to be so. It is possible to construct two adjacent regions such that one region is viewed from the other, but once in the other region, the first is not visible. In fact, the second region may not even have a portal connecting it to the first. This represents the notion of one-way teleportation. In this chapter, we will assume that portals are unidirectional. If two adjacent regions

are to be viewable through a common geometric portal, then both regions must have a portal associated with them, and the two portals coexist in space in identical locations.

The regions and portals together can form an arbitrarily complex scene. For example, it is possible to stand in one region, look through a portal into an adjacent region, and see another portal from that region into yet another region. The rendering algorithm must draw the regions in a back-to-front order to guarantee the correct visual results. This is accomplished by constructing an abstract directed graph for which the regions are the graph nodes and the portals are directed graph edges. This graph is not the parent-child scene graph, but represents relationships about adjacency of the regions. Each region is represented as a scene graph node that contains enough state information to support traversal of the adjacency graph. The portals are represented by scene graph nodes but are not drawable objects. Moreover, the portal nodes are attached as children to the region nodes to allow culling of portals. If a region is currently being visited by the adjacency graph traversal, it is possible that not all portals of that region are in the view frustum (or part of the current set defined by the intersection of the frustum and additional portal planes). The continued traversal of the adjacency graph can ignore such portals, effectively producing yet another type of culling. Finally, the region nodes can have additional child nodes that represent the bounding planes of the regions (the walls, so to speak, if the region is a room) and the objects that are in the regions and that need to be drawn if visible. The pseudocode for rendering a convex region in the portal system is given below. The object planeSet is the current set of planes that the renderer uses for culling and (possibly) clipping. The planes maintained by the portal are those formed by the edges of the convex polygon of the portal and the current camera location.

```
void Render (Region region)
{
    if ( not region.beingVisited )
    {
        region.beingVisited = true;
        for ( each portal in region )
        {
            if ( portal.IsVisibleWithRespectTo(planeSet) )
            {
                planeSet.Add(portal.planes);
                Render(portal.adjacentRegion);
                planeSet.Remove(portal.planes);
            }
        }
        Render(region.boundingPlanes);
        Render(region.containedObjects);
        region.beingVisited = false;
    }
}
```

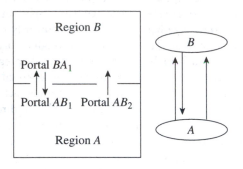

Figure 12.2 Simple portal example.

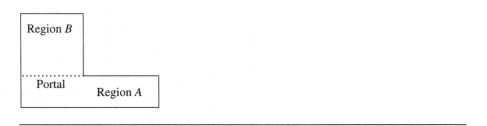

Figure 12.3 *L*-shaped region in a portal system.

The visitation flag is required in case a region has a bidirectional portal into an adjacent region or if the region has a unidirectional portal into, and a unidirectional portal out of, an adjacent room. This avoids traversing cycles in the abstract graph. Figure 12.2 shows a simple set of convex regions, portals, and the corresponding adjacency graph.

Although the regions must be convex, a nonconvex region can be processed in a portal system by decomposing it as a union of convex regions with portals acting as "invisible walls." This use of a portal deviates from the classic setting whereby the portal represents a cutout (door, window) in a wall. Figure 12.3 shows how an *L*-shaped region can be represented in the portal system.

As mentioned earlier, the portal planes can be used for both culling and clipping; however, the renderer performance must be considered. If a scene has a lot of portals, there is the potential for having a large number of additional planes active at one time. The time spent culling and clipping can quite possibly be large enough that a better alternative is to just allow the renderer to use a few planes to reduce its clipping load and rely on its depth buffer.

The same problem can occur if a single portal is a many-sided convex polygon that forces the addition of a lot of planes to the system. Two alternatives come to mind. One is to just use the planes for culling. The second is to approximate a complex portal by constructing a bounding convex polygon with fewer edges and use the approximation instead. If an object is culled by the approximating portal, then it would have been culled by the original portal. However, there is the chance that an object is not culled by the approximating portal when in fact the original portal would have culled it. The trade-off is the time spent culling against a large number of planes versus the time spent culling against a smaller number and drawing an object (with the aid of the depth buffer) that is mostly occluded.

12.3 BINARY SPACE PARTITIONING

An extremely popular sorting method is *binary space partitioning*, in which *n*-dimensional space is recursively partitioned into convex subsets by hyperplanes. For $n = 2$ the partitioning structure is a line, and for $n = 3$ the partitioning structure is a plane. A *binary space partitioning tree*, or *BSP tree*, is the data structure used to represent the partitioning. For $n = 3$, the root node represents all of space and contains the partitioning plane that divides space into two subsets. The first child, or *front child*, represents the subset corresponding to that portion of space on the positive side of the plane. That is, if the partitioning plane is $\vec{N} \cdot \vec{X} - d = 0$, then the left child represents those points for which $\vec{N} \cdot \vec{X} - d > 0$. The use of the term *front* is relevant when sorting for reasons of visibility. If the partitioning plane is generated by a face of an object, and if the eye point is on the positive side of the plane, then the face is visible and is called front facing. The second child, or *back child*, represents the subset corresponding to the negative side of the plane. Either of the subsets can be further subdivided by other planes, in which case those nodes store the partitioning plane and their children represent yet smaller convex subsets of space. The leaf nodes represent the final convex sets in the partition. These sets can be bounded or unbounded. Figure 12.4 illustrates a BSP tree in two dimensions. The square is intended to represent all of \mathbb{R}^2. The interior nodes indicate which planes they represent, and the leaf nodes indicate which convex regions of space they represent.

BSP trees are more general than quadtrees and octrees because there is no constraint on the orientation of the planes. Moreover, quadtrees and octrees can be implemented as BSP trees. Given a parent node and four sibling nodes in a quadtree, a new parent node is added for the first two siblings, making the old parent a grandparent. A new parent node is similarly added to the other two parents. The new parent of the first two siblings represents the left half of the quad, and the siblings represent a partitioning of that half into quarters. The same idea applies to an octree, where a parent and eight siblings are replaced by a tree that makes the old parent a great-grandparent and adds two grandparents and four parents.

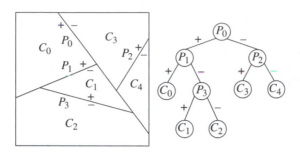

Figure 12.4 BSP tree partitioning \mathbb{R}^2.

The first formal papers on this topic were Fuchs, Kedem, and Naylor (1979, 1980). The BSP FAQ (*reality.sgi.com/bspfaq/*) provides a good summary of the topic and has links to Web sites containing other information or source code.

12.3.1 BSP Tree Construction

Although a BSP tree is a partitioning of space, it may also be used to partition objects in space. If an object is on the positive side of a partition plane, then that object is associated with the front child of the node representing the plane. Similarly, if an object is on the negative side of the plane, it is associated with the back child. The difficulty in classification occurs when the object straddles the plane. In this case the object can be split into two subobjects, each associated with a child node. If the objects are polytopes, then the subobjects are also polytopes that share a common face on the partition plane. An implementation of BSP trees that treats the objects in the world as a polygon soup may store the common face with the node of the partition plane. Because of the potential to do a lot of splitting, this saves memory since the common face data is stored once and shared by the polytopes. The pseudocode for construction is given below. A precondition is that the initial polygon list is not empty.

```
void ConstructTree (BspTree tree, PolygonList list)
{
    PolygonList posList, negList;
    EdgeList sharedList;

    tree.plane = SelectPartitionPlane(list);    // Dot(N,X)-c = 0
    for (each polygon in list) do
    {
        type = Classify(polygon,tree.plane);
        if (type == POSITIVE) then
```

```
    {
        // Dot(N,X)-c >= 0 for all vertices with at least
        // one positive
        posList.Add(polygon);
    }
    else if (type == NEGATIVE) then
    {
        // Dot(N,X)-c <= 0 for all vertices with at least
        // one negative
        negList.Add(polygon);
    }
    else if (type == TRANSVERSE) then
    {
        // Dot(N,X)-c is positive for at least one vertex
        // and negative for at least one vertex.
        Polygon posPoly, negPoly;
        Edge sharedEdge;
        Split(polygon,tree.plane,posPoly,negPoly,
                                        sharedEdge);
        positiveList.Add(posPoly);
        negativeList.Add(negPoly);
        sharedList.Add(sharedEdge);
    }
    else  // type == COINCIDENT
    {
        // Dot(N,X)-c = 0 for all vertices
        tree.coincident.Add(polygon);
    }
}

if ( sharedList is not empty )
{
    // Find all disjoint polygons in the intersection of
    // partition plane with polygon list.
    PolygonList component;
    ComputeConnectedComponents(sharedList,component);
    tree.coincident.Append(component);
}

if ( posList is not empty )
{
    tree.positive = new BspTree;
    ConstructTree(tree.positive,posList);
}
```

```
    if ( negList is not empty )
    {
        tree.negative = new BspTree;
        ConstructTree(tree.negative,negList);
    }
}
```

The function `SelectPartitionPlane` chooses a partition plane based on what the application wants. The input is the polygon list because typically a plane containing one of the polygons is used, but it is possible to select other planes based on the list data. For example, the ideas in building oriented bounding box trees (see Chapter 2) may be applied. An oriented bounding box can be fit to the polygons in the list, and the selected partition plane is the one whose normal vector corresponds to the axis with greatest extent. This latter choice is an attempt to create a balanced BSP tree. Other choices can be designed to meet a criterion such as minimizing the number of polygon splits.

The function `Split` for triangle lists is essentially the first clipping algorithm mentioned in Chapter 3. More generally, the loop over the polygon list represents the general Boolean operation of splitting a polygonal object by a plane. This allows a BSP tree to be used for computational solid geometry operations. The pseudocode is structured to indicate that the positive and negative polygons in a split share vertices. The shared edges are processed later to compute the polygons of intersection in the partition plane. For many applications, having access to these polygons is not necessary, so the shared edge code can be safely removed.

Finally, note that the recursive call of `ConstructTree` terminates when the corresponding tree node contains only coincident polygons. Other criteria for stopping can be used, such as termination (1) when the number of polygons in a positive or negative list is smaller than an application-specified threshold or (2) when the tree reaches a maximum depth. Both of these criteria were mentioned in oriented bounding box tree construction.

12.3.2 HIDDEN SURFACE REMOVAL

BSP trees provide an efficient method for sorting polygons by way of a depth-first traversal of the tree. The price for sorting is that polygons have to be split in the process. For static geometry, the trees can be built as a preprocessing step, so the expense of sorting is not incurred at run time.

Back-to-Front Drawing

Drawing objects farthest from the eye point first, followed by drawing those closer to the eye point, is the essence of the painter's algorithm. The objects are drawn in an

Figure 12.5 Two polygons that cannot be sorted.

order much like a painter draws on canvas, background first and foreground last. The condition for this method to be correct is that any two visible polygons in the scene must be separated by a plane. Figure 12.5 shows a situation where the separation is not possible. However, the BSP tree construction will partition the overlapping polygons into disjoint subpolygons. The polygons represented by the leaf nodes of the tree are correctly ordered to be drawn back-to-front. The pseudocode for the traversal is shown below and assumes the BSP tree construction does not use the shared list scheme mentioned earlier. The test against view direction eliminates portions of space that are approximately behind the view frustum and are not visible.

```
void DrawBackToFront (BspTree tree, Camera camera)
{
    // compute signed distance from eye point E to plane
    // Dot(N,X)-c = 0
    float sd = Dot(tree.plane.N,camera.E) - tree.plane.c;
    if ( sd > 0 )
    {
        if ( -Dot(tree.plane.N,camera.D) >= camera.cos(A) )
        {
            if ( tree.negative is not empty )
                DrawBackToFront(tree.negative,camera.E);

            DrawPolygons(tree.coincident);
        }

        if ( tree.positive is not empty )
            DrawBackToFront(tree.positive,camera.E);
    }
    else if ( sd < 0 )
    {
        if ( Dot(tree.plane.N,camera.D) >= camera.cos(A) )
        {
```

```
                  if ( tree.positive is not empty )
                      DrawBackToFront(tree.positive,camera.E);

                  DrawPolygons(tree.coincident);
              }

          if ( tree.negative is not empty )
              DrawBackToFront(tree.negative,camera.E);
      }
      else
      {
          if ( Dot(tree.plane.N,camera.D) >= 0 )
          {
              if ( -Dot(tree.plane.N,camera.D) >= camera.cos(A) )
              {
                  if ( tree.negative is not empty )
                      DrawBackToFront(tree.negative,camera.E);

                  DrawPolygons(tree.coincident);
              }

              if ( tree.positive is not empty )
                  DrawBackToFront(tree.positive,camera.E);
          }
          else
          {
              if ( Dot(tree.plane.N,camera.D) >= camera.cos(A) )
              {
                  if ( tree.positive is not empty )
                      DrawBackToFront(tree.positive,camera.E);

                  DrawPolygons(tree.coincident);
              }

              if ( tree.negative is not empty )
                  DrawBackToFront(tree.negative,camera.E);
          }
      }
}
```

The view direction of the camera is \vec{D} and the field of view for the frustum is angle $2A$. The cosine of A is precomputed and stored in the camera object for culling purposes. When sd < 0, the comparison of dot products is used to determine if \vec{N} is in the cone of the view frustum. If it is, then the partition plane is oriented in a way that it

possibly intersects the view frustum, and the subtree must be processed. If it is not, then the negative side of the plane does not intersect the frustum and is invisible, so it is not drawn. A more accurate culling could be implemented by testing for separation between view frustum and partition plane. In this case the sign of the dot product between plane normal and view direction is important, not the field of view of the frustum.

Front-to-Back Drawing

Back-to-front drawing with BSP tree support accurately draws the scene, but pixel overdraw can be significant. The depth complexity is sufficient that such an algorithm is not fast enough for real-time rendering. It is better to first draw the polygons closest to the eye point. Now once a pixel is written, it should not be overwritten by any other polygon because of the correctness of the sorting. This requires some type of pixel mask that indicates whether or not a pixel has been drawn. Note that the mask is not the same as a depth buffer. The depth buffer is used when it is not known what order the polygons are in. Depth values are compared before an attempt to write a pixel. Moreover, a pixel can be written more than once using a depth buffer approach.

Scan Line Masks

There are a couple of ways that BSP trees can be used to assist in maintaining the pixel mask. One way is to keep track of each scan line separately. When a triangle is rasterized, each scan line that intersects the triangle has an interval of pixels that are written (interval length is one or larger). A one-dimensional BSP tree can be used to keep track of the written intervals. Each node represents an interval $[x_0, x_1)$, where the left end point is included and the right end point is not. The half-open interval supports the idea that each triangle is responsible for its left and vertical edges, thereby guaranteeing that shared edges and shared vertices of triangles do not have their pixels drawn more than once. Initially, an empty scan line is represented by a single-node BSP tree. If the screen width is W pixels, then the interval for the node is $[0, W)$. Now if a triangle is rasterized on that scan line in the interval $[x_0, x_1)$, the value x_0 causes a split into $[0, x_0)$ and $[x_0, W)$. The left interval is associated with the left child of the root node and the right interval is associated with the right child. The value x_1 causes a split of the node for $[x_0, W)$ into a left child representing $[x_0, x_1)$ and a right child representing $[x_1, W)$. Figure 12.6 illustrates the BSP tree representing rasterization of a single interval of points. The figure shows the split intervals and the x-value that caused the split. Consider a new interval $[x_2, x_3)$ to be rasterized on that scan line. For the sake of argument, suppose that $0 \le x_0 < x_2 < x_1 < x_3 \le W$. Value x_2 is processed first. Comparing it against x_0 at the root node, x_2 is larger so the right child is the next node to visit. Comparing x_2 against x_1 shows it is smaller. Since the left child is an interval of drawn pixels, no splitting occurs. Value x_3 is now processed. The tree is traversed and the comparisons cause the leaf node for $[x_1, W)$ to be reached. That

Figure 12.6 One-dimensional BSP tree representing drawn pixels on a scan line.

interval has undrawn pixels, so a split occurs into $[x_1, x_3)$ and $[x_3, W)$. The left interval is tagged as drawn and the right interval is tagged as undrawn.

This method of masking is very well suited for software renderers that need to conserve as many cycles as possible. Keep in mind that the triangle edge setup for interpolation of vertex attributes must still be performed. Moreover, if a prepared interval is additionally clipped by the scan line BSP tree, the vertex attributes for the end points of the clipped interval must also be interpolated.

Region Masks

The scan line mask concepts can be extended to two dimensions. A BSP tree represents the current drawn state of pixels on the screen. When a triangle is to be rasterized, each line containing a triangle edge is processed by the tree. The line normal is chosen to point to the triangle side, the side on which pixels will be drawn. After the three lines are processed, the BSP tree has at most seven leaf nodes, with one of them corresponding to the triangle to be rasterized. The next triangle to be rasterized has its edges processed by the BSP tree, but overlap is possible. The technical challenge is tagging the nodes appropriately so that the leaf nodes are correctly tagged as drawn or undrawn. In effect the region mask algorithm produces a BSP tree whose drawn leaf nodes form a disjoint union of all pixels that will be drawn on the screen for the given frame.

12.3.3 Visibility Determination

Given the eye point, *visibility determination* refers to the process of deciding what parts of the world are visible from that location. In a world populated with polygonal objects, knowing what is visible helps to minimize the data that is sent to the renderer. The concept of *occlusion* is related. Objects that are occluded in the scene do not have to be processed by the renderer. Visibility information can be used for *occlusion culling*, the process of determining those objects that are not visible from the current eye point. For a static scene where the eye point cannot move, the visibility information can be computed as a preprocessing step. However, if the eye point can move, what is

visible changes over time. Determining exactly what is visible dynamically is usually an expensive process. Most systems attempt to get an approximation and minimize the number of objects that are sent to the renderer but are unknowingly invisible.

The portal system described earlier is a reasonable way to deal with dynamic visibility as long as the number of portals is small. BSP trees can also be used for visibility determination. Two methods are described here, one that works in view space (3D) and one that works in screen space (2D). In both cases, a BSP tree already exists that represents the partitioned world and is used for front-to-back sorting. Call this tree the *world tree*. A second BSP tree is used to store the visibility information. Call this the *visibility tree*.

View Space Method

The visibility tree lives in three dimensions and initially represents the view frustum. The partitioning planes in the tree are the six forming the frustum. Given the current eye point, the world tree is traversed. Each polygon encountered in the traversal is processed by the visibility tree and factored into subpolygons, each of which is totally visible or totally invisible. Each visible subpolygon is used to define a new set of partitioning planes that are formed by the eye point and the edges of the subpolygon (compare with portal systems). The eye point and corresponding planes form a pyramid. Any portions of the world in the pyramid but behind the subpolygon are invisible to the eye. The visibility tree now stores that pyramid and uses it for further clipping of polygons that are visited in the world tree traversal.

Screen Space Method

The visibility tree lives in two dimensions and initially represents the rectangle corresponding to the drawable pixels on the screen. Given the current eye point, the world tree is traversed. Each polygon encountered in the traversal is projected to screen space, then is processed by the visibility tree and factored into subpolygons, each of which is totally visible or totally invisible. Because the world tree sorts the polygons from front to back, any visible subpolygon obtained in the clipping will remain visible throughout the visibility tree calculations. These subpolygons can be stored in a list for whatever purposes the application requires.

12.3.4 Picking and Collision Detection

Given a BSP tree representing the world, a picking operation involves determining if a linear component (line, ray, or segment) intersects any objects in the world. The idea is to traverse the BSP tree and recursively split the linear component. If any linear subcomponent exists once a leaf node representing a world polygon is reached, then

the original linear component does intersect an object in the world. The exact point of intersection can be computed when the intersected leaf node is reached in the traversal.

Collision detection between two polygonal objects is a more complicated problem to solve. If two BSP trees are used to represent the objects, and if the objects are not moving, the BSP trees can be used to compute the intersection of the objects. If the intersection is not empty, then the objects are currently in a colliding state. Although Boolean operations between BSP trees can be implemented to provide general support for computational solid geometry, they can be somewhat expensive because they involve splitting each polygonal face in one tree against all the polygonal faces of the other tree. Moreover, if the objects are moving but not changing shape, the BSP trees represent model space information, and the partitioning planes must be transformed into world space coordinates each time the objects move. The intersection testing is much more complicated by the motion, and Boolean operations between the trees are generally very expensive. The methods for bounding volume trees are much cheaper to use since they are based on separating axis testing or distance calculations that take advantage of geometric information about the bounding volumes to localize polygon-polygon intersection testing rather than doing an exhaustive comparison of pairs of triangles.

SPECIAL EFFECTS

This chapter describes some special effects that can be used to provide a more realistic rendering of a scene. So far this book has discussed only the mechanisms that a game engine provides for drawing whatever content the game designers can dream up. But generating the content for special effects and combining them in just the right way is essentially an art. In this chapter we will give only a high-level summary of the ideas, with examples presented in the color plates that accompany the book. For a more detailed description of special effects and references, see Möller and Haines (1999) and many of the articles that appear in *Game Developer Magazine*.

13.1 LENS FLARE

Lens flare occurs when the lens of a camera is pointed near a bright light source. The flare typically consists of a set of annular regions of brightness that occur approximately along a line and a set of various length line segments emanating from the light source. The effects are due to refraction of light in the lens and to variation of density of material in the lens. Adding lens flare to a rendered scene is quite popular. The basic method is to create textures for the flare components, then place them in the scene

427

along a ray emanating from the light source with direction dependent on the view direction. The textures are placed as billboards that are required to be screen aligned. The starlike texture can also be animated as the eye point moves to give a more realistic effect. Plate 6 provides an illustration of the concept.

13.2 ENVIRONMENT MAPPING

Environment mapping is a method that allows surfaces to be drawn with a reflection of the environment in which the surface lives. Blinn and Newell (1976) introduced the concept. A ray is drawn from the eye point to each point on the surface and reflected through the outward pointing unit-length normal at that point. The direction of the reflection vector is used as a lookup into a texture map that represents the surrounding environment. Figure 13.1 illustrates the idea. If \vec{E} is the eye point and \vec{P} is the surface point with normal \vec{N}, the unit-length view vector is $\vec{V} = (\vec{P} - \vec{E})/|\vec{P} - \vec{E}|$. The unit-length reflection vector \vec{R} must be computed. Observe that the projections of \vec{V} and \vec{R} onto the tangent plane must be the same vector; therefore, $\vec{R} - (\vec{N} \cdot \vec{R})\vec{N} = \vec{V} - (\vec{N} \cdot \vec{V})\vec{N}$. The angle between \vec{N} and \vec{R} and the angle between \vec{N} and $-\vec{V}$ are the same, in which case $\vec{N} \cdot \vec{R} = -\vec{N} \cdot \vec{V}$. The reflection vector is therefore $\vec{R} = \vec{V} - 2(\vec{N} \cdot \vec{V})\vec{N}$. In spherical coordinates it is

$$\vec{R} = (R_x, R_y, R_z) = (\cos\theta \, \sin\phi, \sin\theta \, \sin\phi, \cos\phi),$$

where $\theta \in [0, 2\pi]$ and $\phi \in [0, \pi]$. The texture coordinates are chosen as $u = \theta/(2\pi)$ and $v = \phi/\pi$, so

$$u = \begin{cases} \frac{1}{2\pi}\,\mathrm{atan2}(R_y, R_x), & R_x \geq 0 \\ 1 + \frac{1}{2\pi}\,\mathrm{atan2}(R_y, R_x), & R_x < 0 \end{cases} \quad \text{and} \quad v = \frac{1}{\pi}\,\mathrm{acos}(R_z).$$

Applying environment mapping on a per-pixel basis is an expensive operation because it requires calculating an inverse square root (to create unit vector \vec{V}), an inverse tangent, and an inverse cosine for each point \vec{P} on the surface. The cost can be significantly reduced in three ways by using approximations. First, in a real-time system the objects are polygonal models or dynamically tessellated surfaces that result in polygonal models. Assuming each vertex in the model has been assigned a surface normal, only the vertices need to be assigned texture coordinates using the reflection vector. The texture coordinates for other points in the polygons are computed via interpolation by the rasterizer. This reduces the number of points for which (u, v) must be computed. Second, if the object is approximately convex and the eye point somewhat distant from the object, a central point \vec{C} can be selected to represent the object. For example, the central point can be chosen as the average of the model vertices or as the center of a bounding sphere for the object. The view direction is computed to be $\vec{V} = (\vec{C} - \vec{E})/|\vec{C} - \vec{E}|$ and is used for all model vertices. Thus, the inverse

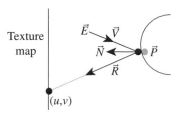

Figure 13.1 Illustration of environment mapping.

square root that was required per vertex is replaced by a single inverse square root. Third, the inverse trigonometric functions can be approximated by linear functions $v = (1 + R_z)/2$ and $u = (1 + R_z)/4$ for $R_x \geq 0$ or $u = (3 - R_z)/4$ for $R_x < 0$.

The function from $(u, v) \to \vec{R}$ is a map from the unit square onto the sphere. One problem with such a mapping is that if the texture is not cylindrical in u, then the seam is visible in the environment mapping. A more serious problem is that the metrics of the plane and the sphere are not the same, so there must be distortion near the poles of the sphere. This problem is mathematically unavoidable. Other methods have been developed to circumvent the problem: *cubic environment mapping,* where the target surface is a cube rather than a sphere (Greene 1986); *sphere mapping,* where the texture image itself is defined on a sphere and the environment mapping does not lead to distortion (Williams 1978); and *parabolic mapping,* where two parabolic halves are used instead of a sphere and two textures are reflected off the halves (Heidrich and Seidel 1998). Plate 3 provides an illustration of environment mapping in the character's dress.

13.3 BUMP MAPPING

Bump mapping is a method for changing the visual appearance of a surface by using a different set of normals for lighting than the surface normals (Blinn 1978). The classical method is to vary the normal per pixel, but this is not suitable for real-time graphics. An approach involving derivatives of the texture image requires multiple rendering passes to an offscreen buffer and the ability to do multitexturing. The effect in this method is to provide an embossed surface. The original texture is a gray-scale image. The triangle mesh is rendered to an offscreen buffer with this texture and with diffuse lighting. The texture coordinates at the vertices are then offset by a differential vector (u, v) whose length is small (on the order of a pixel or two), and the mesh is rendered to a second offscreen buffer. The difference of the values in the two offscreen buffers produces an image with an embossed effect. The mesh is rendered to the screen in the usual way, and the difference texture is combined as a secondary texture. Other

more sophisticated methods have been proposed for bump mapping, but a standard across current hardware-accelerated cards is not yet agreed upon. A good survey of the various techniques is found in Möller and Haines (1999). Plate 7 provides an illustration of derivative-based bump mapping.

13.4 Volumetric Fogging

Depth-based fogging was described in Chapter 3. The general use of such fogging is to hide clipping artifacts at the far plane when new objects enter the view frustum at that plane. The fog also helps add to the perception of depth of faraway objects. Depth-based fogging cannot help an application generate dense fog that occurs close to the eye point. Instead, the method of *volumetric fogging* can be used. The idea is to select a region of space that is to contain fog. For each visible vertex in the scene, calculate the length of intersection with the region and the segment from the eye point to the vertex. A fog value proportional to the length of intersection and in the range $[0, 1]$ is assigned to the vertex as an attribute that will be interpolated during rasterization. This provides fog values for the other points of the triangles sharing that vertex. Color combination is the same as for depth-based fogging, $\vec{c}_{\text{final}} = (1 - f)\vec{c}_{\text{vertex}} + f\vec{c}_{\text{fog}}$.

One example is to create a layer of fog over a terrain. The fog region is chosen as the region of space between two parallel planes. If \vec{E} is the eye point, \vec{V} is the vertex, and $\vec{N} \cdot \vec{X} = c_i$ are the planes for $i = 0, 1$, then the segment is $\vec{E} + t(\vec{V} - \vec{E})$ for $t \in [0, 1]$, and the intersection of the line of the segment and the planes occurs when at $t_i = (c_i - \vec{N} \cdot \vec{E})/\vec{N} \cdot (\vec{V} - \vec{E})$. Let $[\tau_0, \tau_1] = [0, 1] \cap [t_0, t_1]$. The length of the intersection is

$$L(\vec{V}) = |(\vec{E} + \tau_1(\vec{V} - \vec{E})) - (\vec{E} + \tau_0(\vec{V} - \vec{E}))| = (\tau_1 - \tau_0)|\vec{V} - \vec{E}|.$$

Assuming that the fog range is $[0, 1]$, the values $L(\vec{V}) \in [0, \infty)$ must be mapped to the range. There are many choices, but a simple one is to use a rational function $f(L) = cL/(L + 1)$ for constant $c > 0$. The choice of c allows control over how large L must be before $f(L)$ is sufficiently close to 1. Plate 8 provides an illustration of volumetric fogging.

13.5 Projected Lights

Projected lighting is a dynamic multitexturing technique that can be used to create a wide variety of interesting special effects. The idea is to select a location in space that corresponds to the *projector*, a *projection frustum* that is much like the view frustum but allows for skewing (the pyramid is not necessarily orthogonal), a texture to project into the environment, and a set of triangles in the environment that are to receive that image as a secondary texture. A classic example is to set up a projected light that casts light through a stained glass window. While there is technically no light source present,

the stained glass texture is projected onto the walls and floor of the room that contains the window. Moreover, the projector can be moved over time so that the projected texture itself moves, thus giving the appearance that the sun is slowly moving across the sky. Other examples include creating the effects of a vehicle's headlamps shining onto a road, a flashlight shining onto portions of a room, or even projecting cloud shadow textures onto the ground.

The secondary texture coordinates of the triangles that are to receive the projected texture must be computed on the fly. For each triangle vertex, a ray is cast from the projector location to that vertex. The intersection of the ray with the near plane of the projection frustum generates a relative coordinate $(x, y) \in [0, 1]^2$ that is used as a lookup into the projected texture image. Thus, the projection is as if a light shines onto a texture that is coincident with the near plane of the frustum, with the corresponding color projected onto the receiving triangle. Once the secondary texture coordinates are known for the triangle, the projected image is combined with the base texture of the triangle just as in the multitexturing system. The application has the choice of how to combine the textures, whether as an additive process (brightening effect), a multiplicative process (darkening effect), or some other combination mode that is supported by the system.

While the projection process is much like that of the camera and view frustum, there are some differences that must be considered. First, the projection frustum should not usually have a far plane since that might abruptly terminate the light effect in an unnatural way. The other planes can be used for clipping the receiving triangles, but depending on the application that might also cause strange artifacts. If only one or two vertices of a triangle are influenced by the projector, the third can be assigned some texture coordinate so that the entire triangle is multitextured in a way to cause some type of gradual attenuation of the projected texture. Finally, back facing triangles do not have to receive the projected texture. If back facing triangles are omitted, there can be noticeable artifacts along the *terminator*, the polyline that separates the front facing triangles from the back facing ones. An alternative to eliminate the artifact is to use culling based on vertex normals rather than triangle normals. The triangles that share the terminator will have some front facing and some back facing normals. An interpolation can split the triangle into two halves, one half that receives the projection and one half that does not. For a tessellated sphere, this method will project the texture onto exactly the front facing hemisphere. Plate 3 provides an illustration of projected light in the disco ball dots.

13.6 PROJECTED SHADOWS

Projected shadows are very much related to projected lights. Rather than projecting a texture onto the environment, a projected shadow system consists of a projector that corresponds to a *dark source* rather than a light source. The system has a set of objects that are used to occlude the projector as a light source or enhance the projector as a dark source. The occluding objects will cast shadows on a receiving set of triangles.

The associated projected texture is actually generated on the fly rather than selected a priori as for projected lights. The idea is to treat the projector as another camera and render the occluding objects to an offscreen texture. This is necessary since the occluding objects can be arbitrarily complex, such as a moving character in the scene. The background color of the rendering is white, and the triangles of the occluders are rendered with only black vertex colors. The resulting texture appears as a shadow with hard edges. Support by some hardware cards for this process uses a block of memory called a *stencil buffer*. Blending the shadow texture as a secondary texture is done with any of the usual combination modes in the multitexturing system.

For an occluder that is a convex triangular mesh, the general rendering of the mesh is not necessary to obtain the shadow edge. The terminator of the mesh can be computed very rapidly. The idea is to treat the triangle mesh as an abstract graph whose nodes correspond to the triangles and whose arcs connect nodes corresponding to adjacent triangles. Each node has an associated value that is the signed distance of the projector location to the plane of the triangle (with outward facing normal). The arcs that connect two nodes with opposite signs correspond to the edges on the terminator. Starting with a single triangle, a linear walk of the graph is started to find an arc connecting opposite-signed nodes. Once found we have an edge of the terminator. A second linear walk occurs along the remaining edges of the terminator. This requires a vertex-edge-triangle data structure for which the vertices store all adjacent edges. Abstractly, the determination of all node pairs with opposite-signed distances is similar to a zero contour extraction of a planar image. The graph nodes are the pixels, and the signed distances are the pixel values. However, the image is defined on a closed surface rather than on a plane. The terminator extraction for a convex mesh can be extended to general meshes using the analogy to zero contour extraction in an image. The terminator now consists of a union of polylines, each polyline representing a connected component of the zero contour of signed distances.

Once the terminator is computed for the convex occluder, it can be projected onto the offscreen buffer. The projection of the terminator is a convex polygon in the projection plane, so it can be fanned into a set of triangles and processed by the rasterizer. Or the convex polygon itself can be rasterized without the partitioning into triangles as long as the rendering system has support for it. Plate 9 provides an illustration of projected shadows. The harlequin is an animated skin-and-bones character that performs a tumble roll into a kneeling position. The image shows the first part of the sequence. A projected shadow system is used to render the harlequin with a second camera and renderer to an offscreen texture that is black at a pixel whenever that pixel is occluded by the harlequin. That texture is rendered as a secondary texture by the multitexturing system.

13.7 PARTICLE SYSTEMS

In its simplest form, a *particle system* consists of a set of points, each having an associated color. The point locations are time-dependent and can change based on

just about any algorithm the user can think of. Usually, a physically based model is applied. For example, the particles might represent smoke and move randomly to simulate Brownian motion. Another example is to use particles to represent water droplets spewing from a fountain. The path of each particle is parabolic and depends on the initial velocity of the particle and the acceleration due to gravity. Although such particle systems are easy to render, they can be limited in visual effect.

An extension is to allow the elements of the particle system to be short line segments with vertex colors assigned to the end points. These can be used to simulate effects such as sparks shooting from a fire. The leading point of the spark is colored red or orange and the trailing point is a darker hue. The vertex colors themselves change over time to represent that the spark is cooling. Although line segments allow more significant effects than points, they can also be limiting in visual effect.

One of the best ways to represent a particle is as a square with center point \vec{C} and half-width r. The square is always screen aligned, and the four corners are $\vec{C} \pm r\vec{U} \pm r\vec{R}$, where \vec{U} is the view frustum up vector and \vec{R} is the view frustum right vector. Moreover, the particle has assigned to it a color, a normal vector, and a textured image. In this sense the particle is rendered as a two-triangle square with the same surface attributes that any rendered triangle mesh can have. The textured image is mapped fully onto the square and in almost all cases has an alpha channel. The idea is that a spherical particle can be drawn with a textured image that contains a sphere in its center and is fully transparent outside that part of the image. Because the particle now has a size, the distance from the eye point makes a difference in the rendering. The color and normal vector can be used for modulation of the texture, usually via dynamic lighting. One nice use of particles in this form is as leaves of a tree. The particle can represent a single leaf or a collection of leaves. Multiple systems can be used, each system having its own leaf texture, so that some variation of leaves occurs in the final rendering. Plates 10 and 11 provide illustrations of particle systems. In Plate 10, the pond has fireflies swarming over it, generated as a particle system. The light shafts are alpha-blended polygons with an additive effect to produce the brightness. The view is taken with the observer just slightly under a downed tree trunk with moss hanging from it.

In Plate 11, the renderings are from the same part of the data set, but with lighting that conforms to day, dusk, and night (top to bottom images). There is a wind blowing from top left to bottom right in the images and the trees are animated to display the effect of the wind. The dust clouds are also moving and are built as a particle system. The waterfall is built with static geometry, but animated texture coordinates to give the effect of flow.

13.8 MORPHING

Morphing is the process of deforming an object over time. In a graphics setting only the surface of the object is deformed. In particular, the vertices of a mesh are allowed to change with time, and in many applications the topology of the mesh is preserved,

although this constraint is not essential. Because morphing involves time-varying quantities, it can be implemented as a controller, as discussed in Chapter 4.

While there are infinitely many ways to control a morph, two standard ones are useful in a real-time setting. The first way is to control the individual vertices while preserving the mesh topology. A vertex location can be controlled through user interaction with some input device. For example, a vertex can be selected with the mouse (by a three-dimensional picking operation) and dragged. In this sense the vertex location is a function of time, but is indeterminate. Vertex locations can also be controlled procedurally, in which case the locations are determinate functions of time. For example, a pool of water might have a triangle mesh representing the surface of the water. The mesh is rigidly attached to the pool walls, but the interior vertices are allowed to move. To give the impression that the surface is slightly moving, each interior vertex can be slightly perturbed in the normal direction to the plane of the original mesh and perturbed with a somewhat greater amplitude within the plane of the original mesh.

The second way for defining a morph is to blend between two objects. This is what most people tend to think of as morphing. A correspondence must be defined between the surfaces of the two objects, and a blending function is selected that uses the correspondence. The simplest morph for two triangular meshes with the same number of vertices involves choosing a one-to-one correspondence between vertices and applying a linear blend. If \vec{V}_0 is a vertex in the first mesh and \vec{V}_1 is its corresponding vertex in the second mesh, then the morph is $\vec{V}(t) = (1 - t)\vec{V}_0 + t\vec{V}_1$ for a normalized time $t \in [0, 1]$. If the two objects are not significantly different in shape, the objects obtained by blending will have a natural look about them. Attempts to linearly blend two somewhat different-shaped objects will produce in-between objects that usually are not what you expect. It is more difficult to establish a reasonable correspondence between vertices if the two meshes have different topologies. It is even more difficult to control the blending so that the in-between objects look reasonable. Morphing based on shape information is possible, but gets heavily into differential geometric concepts and is not covered in this book.

Morphing can be implemented using the controller system described in Chapter 4. Modeling packages that allow morphing by providing the pairing between two sets of vertices can have their data exported as objects in a class `MorphController`. The update routine of this controller performs the linear interpolation for the specified time between the paired vertices. Plate 12 provides an illustration of morphing.

OBJECT-ORIENTED INFRASTRUCTURE

SOURCE CODE

LIBRARY
Engine

FILENAME
Object
RTTI
SmartPointer
Stream
TArray
TMap
TClassArray
TClassMap

A game engine is a large and complicated software system. The principles of object-oriented software engineering and large library design apply just as they would to any other large system. This appendix presents a review of some basic issues of object-oriented infrastructure. In addition, specific issues related directly to implementation of object-oriented support in the game engine are also addressed, including naming conventions and namespaces, run-time type information, single and multiple inheritance, templates (parameterized data types), shared objects and reference counting, streaming, and startup and shutdown mechanisms.

A.1 OBJECT-ORIENTED SOFTWARE CONSTRUCTION

A good reference on object-oriented software engineering is Meyer (1988). Extensive in-depth coverage of abstract data types including stacks, lists, strings, queues, maps, sets, trees, and graphs can be found in Booch (1987).

A.1.1 SOFTWARE QUALITY

The goal of software engineering is to help produce quality software, both from the point of view of the end users and of the software writers. The desired qualities in software fall into two categories:

- External: Software is fast, reliable, and easy to use. The end users care about these qualities. End users also include team members who will use the code, so ease of use is important.

- Internal: Software is readable, modular, and structured. The programmers care about these qualities.

The external qualities are the more important since the goal of software construction is building what a client wants. However, the internal qualities are key to attaining the external qualities. Object-oriented design is intended to deal with the internal, but the end result should be to satisfy the following external qualities:

- Correctness: the ability of software to exactly perform tasks, as defined by the requirements and specification

- Robustness: the ability of software to function even in abnormal conditions

- Extendability: the ease with which software may be adapted to changes of specifications

- Reusability: the ability of software to be reused, in whole or in part, from new applications

- Compatibility: the ease with which software products may be combined with others

- Efficiency: the good use of hardware resources such as processor, memory, and storage, both in space and time

- Portability: the ease with which software may be transferred to various hardware and software platforms

- Verifiability: the ease of preparing test data and procedures for detecting and locating failures of the software

- Integrity: the ability of software systems to protect their various components against unauthorized access and modification, whether or not the access or modification is intentional

- Ease of use: the ease of learning how to use software, including executing the programs, preparing input data, interpreting output data, and recovering from exceptions

Software maintenance is the process of modifying already existing code either to correct deficiencies, enhance efficiency, or extend the code to handle new or modi-

fied specifications. The following is a representative breakdown of maintenance time (Meyer 1988):

- Changes in user requirements (41.8%). Inevitable, but is the large percentage due to a lack of extendability?

- Changes in data formats (17.4%). Also inevitable since initial design may have lacked insight into how data might evolve.

- Emergency fixes (12.4%).

- Routine debugging (9.0%). For example, fixes need to be made, but the software can still run without them.

- Hardware changes (6.2%). Also inevitable, but isolation of hardware-dependent code can minimize these changes by encapsulation of the dependent code into device drivers.

- Documentation (5.5%). All of us are taught to do this as code is developed, but the reality is the client always wants the code yesterday.

- Efficiency improvements (4.0%).

A.1.2 MODULARITY

Modules are autonomous, coherent, robust, and organized packages. Not that this really defines what a module is, but all of us have an idea of what a module should be. The following criteria should help in deciding what it means for a software construction method to be modular:

- Decomposability. The design method helps decompose a problem into several subproblems whose solution may be pursued separately.
 - Example: Top-down design.
 - Counterexample: Initialization modules.
- Composability. The design method supports production of software elements that may be freely combined to produce new systems.
 - Example: Math libraries.
 - Counterexample: Combined GUI and database libraries.
- Understandability. The design method helps produce modules that can be separately understood by a human reader or can be understood together with a few other modules.
 - Example: A math library with exported functions clearly specified and for which no other libraries are required for linking.
 - Counterexample: Sequentially dependent modules, module A depends on module B, module B depends on module C, and so on.

- Continuity. A small change in the problem specification results in a change of just one (or a few) modules. Changes should not affect the architecture of the system.

 - Examples: Symbolic constants (do not hard-code numbers), the Principle of Uniform Reference (services of a module should be available through a uniform notation; in C++ this becomes a design question about public versus private members).
 - Counterexample: Failing to hide the data representation from the user when that representation may change later.

- Protection. The design method yields an architecture in which the effect of abnormal conditions at run time in a module remains confined to that module (or a few modules).

 - Example: Validation of input and output at their sources. This is the notion of preconditions and postconditions in abstract data types.
 - Counterexample: Undisciplined exceptions. An exception is a signal that is raised by one code block and handled in another, possibly remote part of the system. This separates algorithms for normal cases from error processing in abnormal cases, but the mechanism violates the criterion of confining the abnormal conditions to the module. This also violates the continuity criterion.

The five criteria lead to five principles that should be followed to ensure modularity. The criteria that lead to each principle are listed in parentheses.

- Linguistic modular units. Modules must correspond to syntactic units in the language used. (decomposability, composability, protection)

- Few interfaces. Every module should communicate with as few others as possible. (continuity, protection)

- Small interfaces. If two modules must communicate, they should exchange as little information as possible. This is termed *weak coupling*. (continuity, protection)

- Explicit interfaces. Whenever two modules communicate, this must be obvious from the text of the modules. This is termed *direct coupling*. (decomposability, composability, continuity, understandability)

- Information hiding. All information about the module should be private unless it is declared public. (continuity, not necessarily protection)

The Open-Closed Principle

This is one final requirement for a good modular decomposition. It states that a module must be both *open* and *closed*.

- Open module: The module is still available for extension. For example, it is still possible to add fields to data structures or to add new functions that operate on the structures.

- Closed module: The module is available for use by other modules. This assumes that the module has a well-defined, stable interface, with the emphasis being on "stable." For example, such a module would be compiled into a library.

At first glance, being both open and closed appears to be contradictory. If the public interface to a module remains constant, but the internal implementations are changed, the module may be considered open and closed (it has been modified, but dependent code does not need to be changed or recompiled). However, most modifications of modules are to add new functionality. The concept of *inheritance* allows for open-closed modules.

A.1.3 REUSABILITY

Reusability is a basic issue in software engineering. Why spend time designing and coding an algorithm when it probably already exists elsewhere? But this question does not have a simple answer. It is easy to find already-written code for searching and sorting lists, handling stacks, and other basic data structure manipulations. However, other factors may compound the issue. Some companies provide libraries that have capabilities you need, but to use the libraries you need to purchase a license and possibly pay royalties. If the acquired components have bugs in them, you must rely on the provider to fix them, and that will probably not occur in the time frame in which you need the repairs.

At least in your local environment, you can attempt to maximize reuse of your own components. Here are some issues for module structures that must be resolved to yield reusable components:

- Variation in types. The module should be applicable to structures of different types. Templates or parameterized data types can help here.

- Variation in data structures and algorithms. The actions performed during an algorithm might depend on the underlying structure of the data. The module should allow for handling variations of the underlying structures. Overloading can help here.

- Related routines. The module must have access to routines for manipulating the underlying data structure.

- Representation independence. The module should allow a user to specify an operation without knowing how it is implemented or what underlying data structures have been used. For example,

```
x_is_in_table_t = search(x,t);
```

is a call to search for item x in a table t and return the (Boolean) result. If many types of tables are to be searched (lists, trees, files, etc.), it is desirable not to have massive control structures such as

```
if ( t is of type A )
    apply search algorithm A
else if ( t is of type B )
    apply search algorithm B
else if ...
```

whether it be in the module code or in the client code. Overloading and polymorphism can help here.

- Commonality within subgroups. Extract commonality, extract commonality, extract commonality! Avoid the repetition of similar blocks of code because if a change is required in one block, it is probably also required in the other similar blocks, which will require a lot of time spent on maintenance. Build an abstract interface that doesn't expose the underlying data structures.

A.1.4 FUNCTIONS AND DATA

Which comes first, functions or data? The key element in answering this question is the problem of extendability, and in particular, the principle of continuity. During the full life cycle, functions tend to change quite a bit since requirements on the system also tend to change regularly. However, the data on which the functions operate tend to be persistent and change very little. The object-oriented approach is to concentrate on building modules based on objects.

A classical design method is the top-down functional approach—specifying the system's abstract function, then applying stepwise refinement to smaller, more manageable functions. The approach is logical, well-organized, and encourages orderly development. The drawbacks are as follows:

- The method ignores the evolutionary nature of software systems. The problem is continuity. The top-down approach yields short-term convenience, but as the system changes, there will be constant redesigning, with a large potential for long-term disaster.

- The notion of a system being characterized by one function is questionable. An operating system is the classic case of a system not characterized by a single "main" function. *Real systems have no top.*

- The method does not promote reusability. The designers tend to decompose the functions based on current specifications. The subroutines are reflections of the initial design. As the system evolves, the subroutines may no longer be relevant to the new requirements.

A.1.5 OBJECT ORIENTATION

Object-oriented design leads to software architectures based on the objects every system or subsystem manipulates rather than "the function" it is meant to ensure. Issues are

- How to find the objects. A well-organized software system may be viewed as an *operational model* of some aspect of the world. The software objects will simply reflect the real-world objects.

- How to describe the objects. The standard approach to describing objects is through *abstract data types*. Specification for an abstract data type involves *types* (type becomes a parameter of the abstraction), *functions* (what operations are applied), *preconditions* (these must be satisfied before operations are applied), *postconditions* (these must be satisfied after operations are applied), and *axioms* (how compositions of the functions behave).

Object-oriented design is also the construction of software systems as structured collections of abstract data type implementations. Issues are

- Object-based modular structure. Systems are modularized on the basis of their data structures.

- Data abstraction. Objects should be described as implementations of abstract data types.

- Automatic memory management. Unused objects should be deallocated by the underlying language system, without programmer intervention.

- Classes. Every nonsimple type is a module, and every high-level module is a type. This is implemented as the *one-class-per-module* paradigm.

- Inheritance. A class may be defined as an extension or restriction of another.

- Polymorphism and dynamic binding. Program entities should be permitted to refer to objects of more than one class, and operations should be permitted to have different realizations in different classes.

- Multiple and repeated inheritance. It should be possible to declare a class as heir to more than one class, and more than once to the same class.

Whether or not a language can support all the various features mentioned in this section is questionable. Certainly, SmallTalk and Ada make claims that they are fully featured. However, fully featured languages come at a price in performance. The object-oriented code that accompanies this book is written in C++. While not a "pure" object-oriented language, C++ supports the paradigm fairly well, yet allows flexibility in dealing with situations where performance is important. One of the common fallacies about C++ is that its performance is unacceptable compared to that

of C. Keep in mind that a compiler is a large software system itself and is susceptible, just as any other large system, to being poorly implemented. Current-generation C++ compilers produce code that is quite compact and fast. (For a reference book on C++, see Ellis and Stroustrup (1994). For an extensive set of examples illustrating the features of C++, see Lippman (1991).)

A.2 STYLE, NAMING CONVENTIONS, AND NAMESPACES

One of the software engineering goals mentioned previously is that code should be readable. In an environment with many programmers developing small pieces of a system, each programmer tends to have his or her own style, including choice of identifier names, use of white space, alignment and indentation of code, placement of matching braces, and internal comments. If a team of programmers develops code that will be read both internally (by other team members) and externally (by paying clients), ideally the code should have as consistent a style as possible purely from the point of view of readability. Inconsistent style distracts from the client's main purpose—to understand and use the code for his or her own applications. A management-imposed style certainly is a possibility, but beware of the potential religious wars. Many of today's C++ programmers learned C first and learned their programming style at that time. Although a lot of the conventions in that language are not consistent with an object-oriented philosophy, the programmers are set in their ways and will still use what they originally learned.

Naming conventions are particularly important so that a reader of the code knows what to expect across multiple files that were written by multiple programmers. One of the most useful naming conventions used in the code on the CD-ROM that accompanies this book allows the reader to distinguish between class members, local variables, and global variables, including whether they are nonstatic or static. This makes it easy to determine where to look for definitions of variables and to understand their scope. Moreover, the identifier names have type information encoded in them. The embedded information is not as verbose as Microsoft's Hungarian notation, but it is sufficient for purposes of readability and understandability of the code.

Because a game engine, like any other large library, will most likely be integrated with software libraries produced by other teams, whether internal or external, there is the possibility of clashes of class names and other global symbols. Chances are that you have named your matrix class `Matrix` and so has someone else who has produced header files and libraries for your use. Someone has to make a name change to avoid the clash. C++ provides the concept of `namespace` to support avoiding the clashes, but a method that is popular among many library producers is to use a prefix on class names and global symbols in hopes that the prefix is unique among all packages that will be integrated into the final product. The namespace construct implicitly mangles the class names, whereas the manual selection of prefix makes the mangling explicit.

The conventions used for the accompanying code are the following. The class names and global symbols are prefixed by `Mgc`. Function names are capitalized; if multiple words make up the name, each distinct word is capitalized. For example, given a class that represents a string, a class member function to access the length of the string would be named `GetLength`. Identifier names are capitalized in the same way that function names are, but with prefixes. Nonstatic class data members are prefixed with `m_`, and static class data members are prefixed with `ms_`. The *m* refers to "member" and the *s* indicates "static." A static local variable is prefixed with `s_`. A global variable is prefixed with `g_`, and a static global variable is prefixed with `gs_`. The type of the variable is encoded and is a prefix to the identifier name, but follows the underscore (if any) for member or global variables. Table A.1 lists the various encoding rules. Identifier names do not use underscores, except for the prefixes as described earlier. Class constants are capitalized and may include underscores for readability. Combinations of the encodings are also allowed, for example,

```
unsigned int* auiArray = new int[16];
void ReallocArray (int iQuantity, unsigned int*& rauiArray)
{
    delete[] rauiArray;
    rauiArray = new unsigned int[iQuantity];
}

short sValue;
short& rsValue = sValue;
short* psValue = &sValue;

class MgcSomeClass
{
public:
    MgcSomeClass ();
    MgcSomeClass (const MgcSomeClass& rkObject);

protected:
    enum { NOTHING, SOMETHING, SOMETHING_ELSE };
    unsigned int m_eSomeFlag;

    typedef enum { ZERO, ONE, TWO } Counter;
    Counter m_eCounter;
};
```

The rules of style in the code are not listed here and can be inferred from reading any of the source files.

Table A.1 Encoding for the various types to be used in identifier names.

Type	Encoding	Type	Encoding
char	c	unsigned char	uc
short	s	unsigned short	us
int	i	unsigned int	ui
long	l	unsigned long	ul
float	f	double	d
pointer	p	smart pointer	sp
reference	r	array	a
enumerated type	e	class variable	k
template	t	function pointer	o
void	v		

A.3 RUN-TIME TYPE INFORMATION

Polymorphism provides abstraction of functionality. A polymorphic function call can be made regardless of the true type of the calling object. But there are times when you need to know the type of the polymorphic object, or you need to determine if the object's type is derived from a specified type—for example, to safely typecase a base class pointer to a derived class one, a process called *dynamic typecasting*. *Run-time type information* (RTTI) provides a way to determine this information while the program is executing.

A.3.1 SINGLE-INHERITANCE SYSTEMS

A single-inheritance object-oriented system consists of a collection of directed trees where the vertices represent classes and the edges represent inheritance. Suppose vertex V_0 represents class C_0 and vertex V_1 represents class C_1. If C_1 inherits from C_0, then the directed edge from V_1 to V_0 represents the inheritance relationship between C_1 and C_0. The directed edges indicate an *is-a* relationshiop. Figure A.1 shows a simple single-inheritance hierarchy.

The root of the tree is Polygon. Rectangle is a Polygon, and Square is a Rectangle. Moreover, Square is a Polygon indirectly. Triangle is a Polygon, EquilateralTriangle is a Triangle, and RightTriangle is a triangle. However, Square is not a Triangle, and RightTriangle is not an EquilateralTriangle.

An RTTI system is a realization of the directed trees. The basic RTTI data type stores any class-specific information an application might require at run time. It also

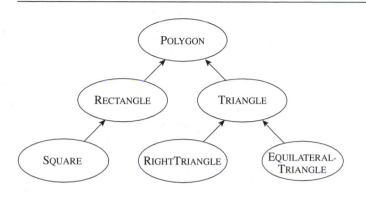

Figure A.1 Single-inheritance hierarchy.

stores a link to the base class (if any) to allow an application to determine if a class is inherited from another class. The simplest representation stores no class information and only the link to the base class. However, it is useful to store a string encoding the name of the class. In particular, the string will be used in the streaming system that is described later. The string may also be useful for debugging purposes in quickly identifying the class type.

```
class MgcRTTI
{
public:
    MgcRTTI (const char* acName, const MgcRTTI* pkBaseRTTI) :
        m_kName(acName)
    {
        m_pkBaseRTTI = pkBaseRTTI;
    }

    const MgcRTTI* GetBaseRTTI () const
    {
        return m_pkBaseRTTI;
    }

    const MgcString& GetName () const
    {
        return m_kName;
    }
```

```
private:
    const MgcRTTI* m_pkBaseRTTI;
    const MgcString& m_kName;
};
```

The root class `MgcObject` in an inheritance tree must contain basic support for the RTTI system. Minimally, the class is structured as

```
class MgcObject
{
public:
    static const MgcRTTI ms_kRTTI;

    virtual const MgcRTTI* GetRTTI () const
    {
        return &ms_kRTTI;
    }

    bool IsExactlyClass (const MgcRTTI* pkQueryRTTI) const
    {
        return ( GetRTTI() == pkQueryRTTI );
    }

    bool IsDerivedFromClass (const MgcRTTI* pkQueryRTTI) const
    {
        const MgcRtti* pkRTTI = GetRTTI();
        while ( pkRTTI )
        {
            if ( pkRTTI == pkQueryRTTI )
                return true;
            pkRTTI = pkRTTI->GetBaseRTTI();
        }
        return false;
    }

    void* DynamicCast (const MgcRTTI* pkQueryRTTI)
    {
        return ( IsDerivedFromClass(pkQueryRTTI) ? this : 0 );
    }
};
```

Each derived class in the inheritance tree has a static MgcRTTI and must minimally be structured as

```
class MgcDerivedClass : public MgcBaseClass
{
public:
    static const MgcRTTI ms_kRTTI;

    virtual const MgcRTTI* GetRTTI () const
    {
        return &ms_kRTTI;
    }
};
```

where MgcBaseClass is, or is derived from, MgcObject. Note that the unique identification is possible since the static MgcRTTI members all have distinct addresses in memory at run time. The source file for the derived class must contain

```
const MgcRTTI MgcDerivedClass::ms_kRTTI("MgcDerivedClass",
        &MgcBaseClass::ms_kRTTI);
```

A.3.2 MULTIPLE-INHERITANCE SYSTEMS

A multiple-inheritance object-oriented system consists of a collection of directed acyclic graphs where the vertices represent classes and the edges represent inheritance. Suppose vertices V_i represent classes C_i for $i = 0, 1, 2$. If C_2 inherits from both C_0 and C_1, then V_2 has directed edges to both V_0 and V_1 that represent the multiple inheritance. Figure A.2 shows a multiple-inheritance hierarchy. An RTTI system in the context of multiple inheritance is a realization of the directed acyclic graphs. While the RTTI data type for a singly inherited system has a single link to a base class, the RTTI data type for a multiply inherited system requires a list of links to the base classes (if any). The simplest representation stores no class information and only the links to the base classes. To support a to-be-determined number of base classes, the C-style ellipses are used in the constructor, thus requiring standard argument support. For most compilers, including stdarg.h gives access to the macros for parameter parsing.

```
class MgcRTTI
{
public:
    MgcRTTI (const char* acName, unsigned int uiNumBaseClasses,...) :
        m_kName(acName)
```

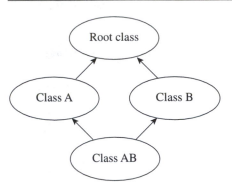

Figure A.2 Multiple-inheritance hierarchy. Class AB inherits from both class A and class B and indirectly inherits from the root class.

```
    {
        if ( uiNumBaseClasses == 0 )
        {
            m_uiNumBaseClasses = 0;
            m_apkBaseRTTI = 0;
        }
        else
        {
            m_uiNumBaseClasses = uiNumBaseClasses;
            m_apkBaseRTTI = new const MgcRTTI*[uiNumBaseClasses];

            va_list list;
            va_start(list,uiNumBaseClasses);
            for (unsigned int i = 0; i < uiNumBaseClasses; i++)
                m_apkBaseRTTI[i] = va_arg(list, const MgcRTTI*);
            va_end(list);
        }
    }

    ~MgcRTTI ()
    {
        delete[] m_apkBaseRTTI;
    }

    unsigned int GetNumBaseClasses () const
    {
```

```
            return m_uiNumBaseClasses;
        }

        const MgcRTTI* GetBaseRTTI (unsigned int uiIndex) const
        {
            return m_apkBaseRTTI[uiIndex];
        }

private:
    unsigned int m_uiNumBaseClasses;
    const MgcRTTI** m_apkBaseRTTI;
    const MgcString m_kName;
};
```

The root class in a single-inheritance tree provided the member functions for searching the directed tree to determine if one class is the same or derived from another class. A technical problem with a multiple-inheritance directed graph is that there may be more than one vertex with no edges; that is, the hierarchy may have multiple root classes. To avoid this situation, always provide a single root class whose sole job is to provide an interface for any systems used by the entire inheritance graph.

The root class in the multiple-inheritance graph is structured exactly as in the single-inheritance tree, except that the implementation of member function IsDerivedFromClass must handle the list of base class RTTI pointers.

```
bool MgcObject::IsDerivedFromClass (const MgcRTTI* pkQueryRTTI) const
{
    const MgcRTTI* pkRTTI = GetRTTI();
    if ( pkRTTI == pkQueryRTTI )
        return true;

    for (unsigned int i = 0; i < pkRTTI->GetNumBaseClasses(); i++)
    {
        if ( IsDerivedFromClass(pkRTTI->GetBaseRTTI(i)) )
            return true;
    }

    return false;
}
```

The derived classes still provide the same static RTTI member and a virtual function to access its address. For example, consider

```
        class MgcDerived : public MgcBase0, MgcBase1
        {
```

```
        public:
            static const MgcRTTI ms_kRTTI;

            virtual const MgcRTTI* GetRTTI () const
            {
                return &ms_kRTTI;
            }
        };
```

where both `MgcBase0` and `MgcBase1` are either `MgcObject` or are derived from `MgcObject`. The source file for this derived class must contain

```
        const MgcRtti MgcDerived::ms_kRTTI("MgcDerived",2,
                    &MgcBase0::ms_kRTTI,&MgcBase1::ms_kRTTI);
```

A.3.3 MACRO SUPPORT

Macros can be used to simplify use by an application and to hide the verbosity of the code. The following macros apply to both single-inheritance and multiple-inheritance systems:

```
// macros in MgcRTTI.h

#define MgcDeclareRTTI \
    public: \
        static const MgcRTTI ms_kRTTI; \
        virtual const MgcRTTI* GetRTTI () const { return &ms_kRTTI; }

#define MgcImplementRootRTTI(rootclassname) \
    const MgcRTTI rootclassname::ms_kRTTI(#rootclassname,0)

// macros in MgcObject.h and MgcObjectM.h

#define MgcIsExactlyClass(classname,pObject) \
    ( pObject ? pObject->IsExactlyClass(&classname::ms_kRTTI) : false )

#define MgcIsDerivedFromClass(classname,pObject) \
    ( pObject ? pObject->IsDerivedFromClass(&classname::ms_kRTTI) : false )

#define MgcStaticCast(classname,pObject) \
    ((classname*)pObject)

#define MgcDynamicCast(classname,pObject) \
    ( pObject ? (classname*)pObject->DynamicCast(&classname::ms_kRTTI) : 0 )
```

The macro `MgcDeclareRTTI` is placed in the class declaration in the header file. Note that the scope is `public`, so any other class declarations following the macro call will need to declare other scopes if needed.

The following macro applies to the single-inheritance case:

```
#define MgcImplementRTTI(classname,baseclassname) \
    const MgcRTTI classname::ms_kRTTI(#classname,&baseclassname::ms_kRTTI);
```

and should be called in the source file for the class definition. A similar macro for multiple-inheritance systems is not possible because C-style macros do not allow for a variable number of arguments.

A.4 TEMPLATES

Templates, sometimes called *parameterized data types*, are used to share code among classes that all require the same structure. The classic example is a stack of objects. The operations for a bounded stack are `Push`, `Pop`, `IsEmpty`, `IsFull`, and `GetTop` (read top element without popping the stack). The operations are independent of the type of object stored on the stack. A stack could be implemented for both `int` and `float`, each using array storage for the stack elements. The only difference between the two implementations is that the integer stack code uses an array of `int` and the float stack code uses an array of `float`. A template can be used instead so that the compiler generates object code for each type requested by an application.

```
template <class T> class Stack
{
public:
    Stack (int iStackSize)
    {
        m_iStackSize = iStackSize;
        m_iTop = -1;
        m_akStack = new T[iStackSize];
    }

    ~Stack () { delete[] m_akStack; }

    bool Push (const T& rkElement)
    {
        if ( m_iTop < m_iStackSize )
        {
            m_akStack[++m_iTop] = rkElement;
            return true;
        }
        return false;
    }
```

```
    bool Pop (T& rkElement)
    {
        if ( m_iTop >= 0 )
        {
            rkElement = m_akStack[m_iTop--];
            return true;
        }
        return false;
    }

    bool GetTop (T& rkElement) const
    {
        if ( m_iTop >= 0 )
        {
            rkElement = m_akStack[m_iTop];
            return true;
        }
        return false;
    }

    bool IsEmpty () const { return m_iTop == -1; }
    bool IsFull () const { return m_iTop == m_iStackSize-1; }

protected:
    int m_iStackSize;
    int m_iTop;
    T* m_akStack;
};
```

Macros could be used to generate code for different types, but the macros are not typesafe and are susceptible to side effects. Although it is possible to implement the stack code for both int and float, this poses a problem for code maintenance. If one file changes, the other must be changed accordingly. The maintenance issue is magnified even more so when there are a large number of types sharing the same code. Templates provide a way of localizing those changes to a single file.

Templates are a good choice for container classes for various data structures such as stacks, arrays, lists, and so on. Standard template libraries are available that can be integrated into a game engine. One problem to be aware of when dealing with a container of objects (in this case, objects of type MgcObject) is that certain side effects of the class are necessary, especially in construction and destruction. If a standard template library container class has a need to resize itself, it might do so by creating an array of the new size, placing a memory copy of the old array into the new array, then deleting the old array. This scheme has the implicit assumption that the underlying data is native. If the data consists of class objects where the constructor allocates

memory and the destructor deallocates memory, the memory copy causes memory leaks and misses side effects that occur because of object construction or destruction. This will definitely be the case for shared objects and reference counting, the topic of the next section. If the standard template library does not support side effects, the game engine code will need to implement its own template container classes.

A.5 SHARED OBJECTS AND REFERENCE COUNTING

Sharing of objects is natural in a game engine. Models that contain a lot of data might be shared to minimize memory use. Renderer state can also be shared, particularly when texture images are shared among objects. It is unlikely that a game engine can be implemented in a way to *manually* manage shared objects without losing some along the way (object leaking) or destroying some while still in use by other objects (premature destruction). Therefore, a more automated system is required to assist in the bookkeeping of sharing. The most popular system is to add a reference counter to the root class object. Each time an object is shared (referenced) by another object, the reference counter is incremented. Each time an object is finished sharing with another, the reference counter is decremented. Once the reference counter decreases to zero, the object is no longer referenced within the system, and it is deleted.

The details of reference counting can be exposed so that the application is responsible for adjusting the reference counter, but this mechanism places great faith in the programmer to properly manage the objects. Another possibility is to implement a *smart pointer* system that adjusts the reference counter internally while still allowing the application to intervene in cases that require special handling. Thus, the burden of proper management of shared objects is mostly taken from the programmer.

In addition to run-time type information, the root class MgcObject now includes the following code to support reference counting:

```
public:
    MgcObject () { m_uiReferences = 0; ms_uiTotalObjects++; }
    ~MgcObject () { ms_uiTotalObjects--; }
    void IncrementReferences () { m_uiReferences++; }
    void DecrementReferences () { if ( --m_uiReferences == 0 ) delete this;
}
    unsigned int GetReferences () { return m_uiReferences; }
    static unsigned int GetTotalObjects () { return ms_uiTotalObjects; }
private:
    unsigned int m_uiReferences;
    static unsigned int ms_uiTotalObjects;
```

The static counter keeps track of the total number of objects currently in the system. The initial value at program execution time is zero.

The smart pointer system is now built on top of this and uses templates:

```cpp
template <class T> class MgcPointer
{
public:
    // construction and destruction
    MgcPointer (T* pkObject = 0)
    {
        m_pkObject = pkObject;
        if ( m_pkObject )
            m_pkObject->IncrementReferences();
    }

    MgcPointer (const MgcPointer& rkPointer)
    {
        m_pkObject = rkPointer.m_pkObject;
        if ( m_pkObject )
            m_pkObject->IncrementReferences();
    }

    ~MgcPointer ()
    {
        if ( m_pkObject )
            m_pkObject->DecrementReferences();
    }

    // implicit conversions
    operator T* () const { return m_pkObject; }
    T& operator* () const { return *m_pkObject; }
    T* operator-> () const { return m_pkObject; }

    // assignment
    MgcPointer& operator= (const MgcPointer& rkPointer)
    {
        if ( m_pkObject != rkPointer.m_pkObject )
        {
            if ( m_pkObject )
                m_pkObject->DecrementReferences();
            m_pkObject = rkPointer.m_pkObject;
            if ( m_pkObject )
                m_pkObject->IncrementReferences();
        }
        return *this;
    }
```

```
    MgcPointer& operator= (T* pkObject)
    {
        if ( m_pkObject != pkObject )
        {
            if ( m_pkObject )
                m_pkObject->DecrementReferences();
            m_pkObject = pkObject;
            if ( m_pkObject )
                m_pkObject->IncrementReferences();
        }
        return *this;
    }

    // comparisons
    bool operator== (T* pkObject) const { return m_pkObject ==
                                                    pkObject; }
    bool operator!= (T* pkObject) const { return m_pkObject !=
                                                    pkObject; }
    bool operator== (const MgcPointer& rkPointer) const
    {
        return m_pkObject == rkPointer.m_pkObject;
    }
    bool operator!= (const MgcPointer& rkPointer) const
    {
        return m_pkObject != rkPointer.m_pkObject;
    }

private:
    // the shared object
    T* m_pkObject;
};
```

The assignment operator must compare the pointer values first before adjusting reference counting to guard against assignments:

```
MgcPointer<MgcObject> spPointer = new MgcObject;
spPointer = spPointer;
```

The constructor for MgcObject sets the references to zero. The constructor for MgcPointer increments the references to one. If the initial comparison were not present in the assignment operator, the call to DecrementReferences would decrement the references to zero, then destroy the object. Consequently, the pointer rkPointer.m_pkObject points to a memory block no longer owned by the application, and the pointer m_pkObject, the target of the assignment, will point to the same

invalid block. The call to IncrementReferences will write to the invalid block—an error. Although such a statement is unlikely in a program, the situation might arise unexpectedly due to pointer aliasing.

For convenience, MgcObject or any class derived from it can use a type definition to avoid the verbosity of the template notation. Macro support to declare smart pointer types is

```
#define MgcSmartPointer(classname) \
    class classname; \
    typedef MgcPointer<classname> classname##Ptr
```

Each class can place the declaration in its header file for the convenience of client code. For example, file MgcObject.h will contain the class definition for MgcObject and the statement

```
MgcSmartPointer(MgcObject);
```

This defines the type MgcObjectPtr. The forward declaration of the class name in the macro supports providing a forward declaration of a smart pointer type.

There might be a need to typecast a smart pointer to a pointer or smart pointer. For example, class MgcNode, the internal node representation for scene graphs, is derived from MgcSpatial, the leaf node representation for scene graphs. Polymorphism allows the assignment

```
MgcNode* pkNode = <some node in scene graph>;
MgcSpatial* pkObject = pkNode;
```

Abstractly, a smart pointer of type MgcNodePtr is derived from MgcSpatialPtr, but the language does not support this. The use of implicit operator conversions in the smart pointer class guarantees a side effect that makes it appear as if the derivation really does occur. For example,

```
// This code is valid.
MgcNodePtr spNode = <some node in scene graph>;
MgcSpatialPtr spObject = spNode;

// This code is not valid when class A is not derived from
// class B.
MgcAPtr spAObject = new A;
MgcBPtr spBObject = spAObject;
```

The implicit conversions also support comparison of smart pointers to null, just like regular pointers:

```
MgcNodePtr spNode = <some node in scene graph>;
MgcSpatialPtr spChild = spNode->GetChildAt(2);
if ( spChild )
{
    <do something with spChild>;
}
```

A simple example illustrating the use and cleanup of smart pointers is the following. The class `MgcNode` stores an array of smart pointers for its children.

```
MgcNodePtr spNode = <some node in scene graph>;
MgcNode* pkNode = new MgcNode;      // pkNode references = 0
MgcNodePtr spChild = new MgcNode;   // pkNode references = 1
spNode->AttachChild(spChild);       // pkNode references = 2
spNode->DetachChild(spChild);       // pkNode references = 1
spChild = 0;                        // pkNode references = 0,
                                    // destroy it
```

This illustrates how to properly terminate use of a smart pointer. In this code the call `delete spChild` would work just fine. However, if the object that `spChild` points to has a positive reference count, explicitly calling the destructor forces the deletion, and the other objects that were pointing to the same object now have dangling pointers. If instead the smart pointer is assigned 0, the reference count is decremented and the object pointed to is not destroyed if there are other objects referencing it. Thus, code like the following is safe:

```
MgcNodePtr spNode = <some node in scene graph>;
MgcNode* pkNode = new MgcNode;      // pkNode references = 0
MgcNodePtr spChild = new MgcNode;   // pkNode references = 1
spNode->AttachChild(spChild);       // pkNode references = 2
spChild = 0;                        // pkNode references = 1,
                                    // no destruction
```

Also note that if the assignment of 0 to the smart pointer is omitted in this code, the destructor for the smart pointer is called and the reference count for `pkNode` still is decremented to one.

Some other guidelines that must be adhered to when using smart pointers are the following. Smart pointers apply only to dynamically allocated objects, not to objects on the stack. For example,

```
void MyFunction ()
{
    MgcNode kNode;                      // kNode references = 0
    MgcNodePtr spNode = &kNode;         // kNode references = 1
    spNode = 0;                         // kNode references = 0,
                                        // kNode is deleted
}
```

is doomed to failure. Since kNode is on the stack, the deletion implied in the last statement will attempt to deallocate stack memory, not heap memory.

Using smart pointers as function parameters or returning them as the result of a function call also has its pitfalls. The following example illustrates the dangers:

```
void MyFunction (MgcNodePtr spNode)
{
    <do nothing>;
}

MgcNode* pkNode = new MgcNode;
MyFunction(pkNode);
// pkNode now points to invalid memory
```

On allocation pkNode has zero references. The call to MyFunction creates an instance of an MgcNodePtr on the stack via the copy constructor for that class. That call increments the reference count of pkNode to one. On return from the function, the instance of MgcNodePtr is destroyed, and in the process, pkNode has zero references and it too is destroyed. However, the following code is safe:

```
MgcNode* pkNode = new MgcNode;  // pkNode references = 0
MgcNodePtr spNode = pkNode;     // pkNode references = 1;
MyFunction(spNode);  // pkNode references increase to 2,
                     // then decrease to 1
// pkNode references = 1 at this point
```

A related problem is the following:

```
MgcNodePtr MyFunction ()
{
    MgcNode* pkReturnNode = new MgcNode;  // references = 0;
    return pkReturnNode;
}

MgcNode* pkNode = MyFunction();
// pkNode now points to invalid memory
```

A temporary instance of an MgcNodePtr is implicitly generated by the compiler for the return value of the function. The copy constructor is called to generate that instance, so the reference count of pkNode is one. The temporary instance is no longer needed and is implicitly destroyed, and in the process, pkNode has zero references and it too is destroyed. The following code is safe:

```
MgcNodePtr spNode = MyFunction();
// spNode.m_pkObject has one reference
```

The temporary instance increases the reference count of `pkReturnNode` to one. The copy constructor is used to create `spNode`, so the reference count increases to two. The temporary instance is destroyed, and the reference count decreases to one.

A.6 STREAMING

Persistence of storage is a requirement for a game engine. Game content is typically generated by a modeling tool and must be exported to a format that the game application can import. The game application itself might have a need to save its data so that it can be reloaded at a later time. *Streaming* of data refers to the process of mapping data between two media, typically disk storage and memory. In this section, we will discuss transfers between disk and memory, but the ideas directly apply to transfers between memory blocks (which support transfers across a network). A class that exists to manage the streaming process is `MgcStream`.

A.6.1 SAVING DATA

The usual object that is to be saved to disk is a scene graph. Although it is possible to traverse a scene graph and save each object when visited, there are two complications. The first complication is that objects can be shared in a scene graph. In this case an object might be saved to disk twice. The second complication is that objects tend to contain pointers to other objects. The primary occurrence is in the parent-child relationships of the nodes in the scene graph. At some point a saved scene graph must be reloaded into memory, and all the various relationships between the objects should be readily available in the file.

The abstract view of the problem is that a scene graph is an abstract directed graph of objects (of type `MgcObject`). The nodes of the graph are the objects, and the arcs of the graph are pointers between objects. Each object has nonobject members, in particular, any members of native data type (integer, float, string, etc.). The abstract graph must be saved to disk so that it can be re-created later, which means that both the graph nodes and graph arcs must be saved in some reasonable form. Moreover, each graph node should be saved exactly once. The process of saving a scene graph to disk is therefore equivalent to creating a list of the unique objects in the graph, saving them to disk, and in the process saving any connections between them. If the graph has multiple connected components, then each component must be traversed and saved. Support for saving multiple abstract objects is easy to implement. The class `MgcStream` provides the ability to assemble a list of *top-level* objects to save. Typically, these are the roots of scene graphs, but they can be other objects whose state needs to be saved. To support loading the file and obtaining the same list of top-level objects, an identifying piece of information must be written to disk before each abstract graph corresponding to a top-level object. A simple choice is to write a string to disk.

Identifying the unique objects amounts to traversing the graph and inserting each unvisited object into a list of visited objects. An ideal data structure for this is a hash table for an $O(1)$ lookup for speed. After the graph is traversed and the hash table built, the hash table can be traversed as if it were a list, and each object's data is saved to disk. To support loading, the run-time type information of the object is written first. To support fast loading of file chunks, the number of bytes to be stored is written next. Any native data is written with standard C++ streaming operators, although not all data must be written. Object members that are not native data and not of type `MgcObject` have their own streaming operators and can write themselves to disk. Some data members are *derivable* from other data members, thereby implying a graph of dependencies between the members. Only the root items in this graph need to be written. Once reloaded, the dependent members are constructed appropriately.

Data members that are pointers to objects can be saved as unsigned integer memory addresses since a memory address serves as a unique identifier for each arc in the abstract graph. However, when the saved file is loaded later, the pointer values on disk are no longer valid memory addresses. The method for handling this is discussed in the next subsection.

A.6.2 LOADING DATA

Loading is a more complicated process than saving. Since the pointer values on disk are invalid, each object must be created in memory first, then filled in with data loaded from disk. Links between objects such as parent-child relationships must be established later. Despite the invalidity of the disk pointer values, they do store information about the abstract graph that is being loaded. The address of each object in memory is associated with a disk pointer value, so the same hash table that was used for storing the unique objects for saving can be reused for tracking the correspondence between the disk pointer values, called *link IDs*, and the actual memory address of the object. Once all objects are in memory and the hash table is complete with the correspondences, the table is iterated as if it were a list, and the link IDs in each object are replaced by the actual memory addresses. This is exactly the concept of resolving addresses that a linker uses when combining object files created by a compiler.

The steps in loading an object from the stream are the following. The run-time type information is read first so that the object type is known. The chunk size is read and that quantity of bytes is read. All the information to create the object is now known. An appropriate constructor call and any set methods must occur to reproduce the object that has been loaded. Switching on the run-time type information to determine which constructor to call is inefficient. Instead, a static factory function must be provided by each class, and the `MgcStream` object maintains a hash table of factories; the hash key is the run-time type information. The factory acts as a constructor, takes the already-loaded memory block corresponding to the object, and creates an object of the correct type and initializes it according to the information in the memory block.

A.6.3 STREAMING SUPPORT

At a high level the MgcStream class supports the following interface:

```
class MgcStream
{
    // construction and destruction
    MgcStream ();
    ~MgcStream ();

    // The objects to process, each object representing an entry
    // into a connected component of the abstract graph.
    void Insert (MgcObject* pkObject);
    void Remove (MgcObject* pkObject);
    void RemoveAllObjects ();
    unsigned int GetObjectCount () const;
    MgcObject* GetObjectAt (unsigned int uiIndex) const;

    // file loads and saves
    bool Load (const char* acFilename);
    bool Save (const char* acFilename);

    // memory loads and saves
    bool Load (char* acBuffer, int iSize);
    bool Save (char*& racBuffer, int& riSize);

    // linking support
    class Link
    {
    public:
        MgcTStorage<MgcObject*> m_tObject;
    }
};
```

MgcTStorage represents a templated resizeable array storage class. In an application, saving a file to disk requires

```
MgcStream kStream;
for ( each pkObject worth saving )
    kStream.Insert(pkObject);
kStream.Save("myfile.mff");
kStream.RemoveAllObjects();
```

In an application, loading a file to memory requires

```
MgcStream kStream;
kStream.Load("myfile.mff");
for (unsigned int uiIndex = 0; uiIndex < kStream.GetObjectCount(); uiIndex++)
{
    MgcObject* pkObject = kStream.GetObjectAt(uiIndex);
    <application-specific handling of the object goes here>;
}
kStream.RemoveAllObjects();
```

The calls to RemoveAllObjects free up the stream to be ready to save or load at a later time.

The base class MgcObject provides the fundamental support for an object to stream itself.

```
public:
    // support for loading
    static MgcObject* Factory (MgcStream& rkStream);
    virtual void Load (MgcStream& rkStream, MgcStream::Link* pkLink);
    virtual void Link (MgcStream& rkStream, MgcStream::Link* pkLink);

    // support for saving
    virtual bool Register (MgcStream& rkStream);
    virtual void Save (MgcStream& rkStream);
```

The stream's Save method iterates over the top-level objects and calls each object's Register method. This routine starts the traversal of the abstract graph and adds all the unique objects to the hash table maintained by the stream. After traversal, the stream object iterates over the hash table and calls each object's Save method.

The stream's Load method reads the file and loads one object at a time by reading the run-time type information and chunk size. The static factory function is looked up and called. The factory then creates an object and calls its Load function. The object pointer and its link IDs are inserted in the stream object's hash table. After all objects are loaded, the stream iterates over the hash table and calls each object's Link function to replace the link IDs by memory addresses. Any top-level objects encountered during loading are placed in the stream object's list of such objects so that the application has access to them.

One complication to deal with is the persistence of link IDs between the time they are loaded and the time an object is linked. At first glance it appears that the link IDs can be stored in the object's MgcObject pointer members as is, but this approach will not work in the presence of sharing and smart pointers. If an object has a smart pointer member, an assignment of a link ID to it will implicitly force calls to the reference count accessors. Since the link ID is not a valid memory address, any calls to member functions are incorrect and will fail. For this reason, link IDs must be stored separately

as regular pointers. The MgcStream class defines a nested class to support an array of MgcObject links with an index to keep track of the current object being processed. When the factory function is called for an object, an array of type MgcStream::Link is created and passed to the load function. Any link IDs are stored in this array. When the base class load function is reached, the link ID array is associated with the object in the stream's hash table. When the link phase takes place, the link ID array is passed to all the link calls and used as a lookup for replacement of the link IDs by the actual memory addresses.

The pseudocode to illustrate the streaming support function is given below. The assumption is that MgcDerived is derived directly from MgcBase.

```
MgcObject* MgcDerived::Factory (MgcStream& rkStream)
{
    MgcDerived* pkDerived = new MgcDerived;
    MgcStream::Link* pLink = new MgcStream::Link;
    pkDerived->Load(rkStream,pLink);
    return pkDerived;
}

void MgcDerived::Load (MgcStream& rkStream, MgcStream::Link* pkLink)
{
    MgcBase::Load(rkStream,pkLink);

    // Load the member data for 'this' here.  Any MgcObject* members
    // are loaded into pkLink.m_tObject for use as link IDs.
}

void MgcDerived::Link (MgcStream& rkStream, MgcStream::Link* pkLink)
{
    MgcBase::Link(rkStream,pkLink);

    // Link the MgcObject* members for 'this' here.  This is
    // generally the complicated part of the process since link
    // resolution could require calling member functions of
    // 'this' to establish the connections between the loaded
    // objects and 'this'.
}

bool MgcDerived::Register (MgcStream& rkStream)
{
    if ( !MgcBase::Register(rkStream) )
    {
        // 'this' is shared and was already registered by another
        // owner
        return false;
    }
```

```
      for each MgcObject pointer 'member' of 'this' do
          member.Register(rkStream);
}

void MgcDerived::Save (MgcStream& rkStream)
{
    MgcBase::Save(rkStream);

    // Save the member data for 'this' here.  Any MgcObject* members
    // have their pointer values written.  The values are used as
    // link IDs when the file is loaded at a later date.
}
```

A.7 STARTUP AND SHUTDOWN

Many of the classes in the system have requirements for initialization before the application main function starts and for termination after the application main function ends. For example, a matrix class might store a constant static member that represents the identity matrix. The following code will guarantee that the static data member is created pre-main.

```
// in matrix.h
class Matrix
{
public:
    Matrix (float fM00, float fM01, float fM02,
            float fM10, float fM11, float fM12,
            float fM20, float fM21, float fM22)
    {
        // initialization of m_aafM[][] goes here
    }

    static const Matrix IDENTITY;
protected:
    float m_aafM[3][3];
};

// in matrix.cpp
#include "matrix.h"
const Matrix Matrix::IDENTITY(1,0,0,0,1,0,0,0,1);
```

A compiler will generate code that executes the constructor for the matrix class before the application main starts, thereby guaranteeing that the identity matrix is

ready for use in the application. If there is a need to initialize dynamic memory pre-main, then the allocated memory should be freed post-main. An automatic way of doing this in C++ is illustrated. This mechanism may also be used to initialize any static data.

```cpp
// in point.h
class Point
{
public:
    Point (float fX, float fY, float fZ);
    {
        m_fX = fX;  m_fY = fY;  m_fZ = fZ;
    }

    static void Initialize ()
    {
        ms_uiQuantity = DEFAULT_QUANTITY;
        ms_akHandyBuffer = new Point[ms_uiQuantity];
        ZERO.m_fX = 0;
        ZERO.m_fY = 0;
        ZERO.m_fZ = 0;
    }

    static void Terminate ()
    {
        delete[] ms_akHandyBuffer;
    }

    static const Point ZERO;
protected:
    float m_fX, m_fY, m_fZ;

    enum { DEFAULT_QUANTITY = 32 };
    static unsigned int ms_uiQuantity;
    static Point* ms_akHandyBuffer;

    friend class _PointInitTerm;
};

// in point.cpp
#include "point.h"
const Point Point::ZERO;  // just declare storage,
                          // no initialization
class _PointInitTerm
```

466 Appendix A *Object-Oriented Infrastructure*

```
{
public:
    _PointInitTerm () { Point::Initialize(); }
    ~_PointInitTerm () { Point::Terminate(); }
};
static _PointInitTerm _forceInitTerm;
```

The compiler generates a constructor call for `_forceInitTerm` that occurs pre-main and a destructor call that occurs post-main.

While the startup and shutdown mechanism is automatic, there is the problem of dependencies between objects that require such assistance. For example, suppose class A has a static member that is initialized pre-main, and class B has a static member that must be initialized to the value from class A. The initialization code is contained in the source file for that class. The compiler and linker process both source files, but the generated pre-main calls are not guaranteed to be in any particular order.

```
// in A.h
class A
{
public:
    static void Initialize () { <initialize OBJECT here>; }
    static void Terminate () { <any cleanup goes here>; }
    static A OBJECT;
private:
    friend class _AInitTerm;
};
```

```
// in A.cpp
#include "A.h"
A A::OBJECT;
class _AInitTerm
{
public:
    _AInitTerm () { A::Initialize(); }
    ~_AInitTerm () { A::Terminate(); }
};
static _AInitTerm _forceInitTerm;
```

```
// in B.h
#include "A.h"
class B
{
public:
    static void Initialize () { DEPENDENT_OBJECT = A::OBJECT; }
    static void Terminate () { <any cleanup goes here>; }
```

```
    static A DEPENDENT_OBJECT;
private:
    friend class _BInitTerm;
};

// in B.cpp
#include "B.h"
A B::DEPENDENT_OBJECT;
class _BInitTerm
{
public:
    _BInitTerm () { B::Initialize(); }
    ~_BInitTerm () { B::Terminate(); }
};
static _BInitTerm _forceInitTerm;
```

If the pre-main initialization of A::OBJECT occurs before the pre-main call initialization of B::DEPENDENT_OBJECT, then all is well. However, if the calls are in reverse order, B::DEPENDENT_OBJECT will use whatever is currently stored in memory for A::OBJECT and should be zeroed memory since the object is static.

Dependencies can be handled in a localized way by requiring each pre-main initializer to call the pre-main initializers for any classes that it depends on for proper setup, but this approach leads to yet another problem: a pre-main initializer for a class should only be called once. The solution is to include a static Boolean flag that indicates whether or not the initialization has already occurred. When the initialization function is called the second (or later) time, the flag is checked and the function returns immediately. The previous example is now

```
// in A.h
class A
{
public:
    static void Initialize ()
    {
        static s_bInitialized = false;
        if ( s_bInitialized ) return;
        s_bInitialized = true;
        <initialize OBJECT here>;
    }
    static void Terminate () { <any cleanup goes here>; }
    static A OBJECT;
private:
    friend class _AInitTerm;
};
```

```
// in A.cpp
#include "A.h"
A A::OBJECT;
class _AInitTerm
{
public:
    _AInitTerm () { A::Initialize(); }
    ~_AInitTerm () { A::Terminate(); }
};
static _AInitTerm _forceInitTerm;

// in B.h
#include "A.h"
class B
{
public:
    static void Initialize ()
    {
        static s_bInitialized = false;
        if ( s_bInitialized ) return;
        s_bInitialized = true;
        A::Initialize();
        DEPENDENT_OBJECT = A::OBJECT;
    }
    static void Terminate () { <any cleanup goes here>; }
    static A DEPENDENT_OBJECT;
private:
    friend class _BInitTerm;
};

// in B.cpp
#include "B.h"
A B::DEPENDENT_OBJECT;
class _BInitTerm
{
public:
    _BInitTerm () { B::Initialize(); }
    ~_BInitTerm () { B::Terminate(); }
};
static _BInitTerm _forceInitTerm;
```

NUMERICAL METHODS

This appendix describes various numerical methods that are generally useful in computer graphics. Many of these are specifically useful in real-time game engines.

B.1 SYSTEMS OF EQUATIONS

The two types of systems that arise often in graphics applications are linear systems and polynomial systems. Linear systems are written in the form $A\vec{X} = \vec{b}$ for $n \times n$ matrix A and $n \times 1$ vectors \vec{X} and \vec{b}. Both A and \vec{b} are known. The unknowns are the components of \vec{X}. Polynomial systems are written in the form $p_i(\vec{X}) = 0$ for $0 \le i < n$ for $n \times 1$ vector \vec{X} and where p_i is a polynomial function.

B.1.1 LINEAR SYSTEMS

The standard approach to solving linear systems is Gaussian elimination with some type of pivoting. Standard numerical methods textbooks cover this topic in detail

(Burden and Faires 1985). *Numerical Recipes in C* (Press et al. 1988) also has good coverage. For more advanced topics on matrix systems, see *Matrix Computations* (Golub and Van Loan 1993).

For a 3×3 system, one symbolic method that is typically taught for solving the system uses the method of cofactors to invert A. If A is invertible, then $A^{-1} = A^{\mathrm{adj}}/det(A)$, where A^{adj} is the adjoint matrix, the transpose of the matrix of cofactors for A. The solution to the system is

$$\begin{bmatrix} x_0 \\ x_1 \\ x_2 \end{bmatrix} = \frac{1}{det(A)} \begin{bmatrix} a_{11}a_{22} - a_{12}a_{21} & a_{02}a_{21} - a_{01}a_{22} & a_{01}a_{12} - a_{02}a_{11} \\ a_{12}a_{20} - a_{10}a_{22} & a_{00}a_{22} - a_{02}a_{20} & a_{02}a_{10} - a_{00}a_{12} \\ a_{10}a_{21} - a_{11}a_{20} & a_{01}a_{20} - a_{00}a_{21} & a_{00}a_{11} - a_{01}a_{10} \end{bmatrix} \begin{bmatrix} b_0 \\ b_1 \\ b_2 \end{bmatrix},$$

where

$$det(A) = a_{00}(a_{11}a_{22} - a_{12}a_{21}) + a_{01}(a_{12}a_{20} - a_{10}a_{22}) + a_{02}(a_{10}a_{21} - a_{11}a_{20}).$$

For $n \times n$ systems, the method of cofactors to invert A is $O(n!)$. Gaussian elimination is $O(n^3)$, so it is not difficult to see that Gaussian elimination is faster as n gets large. Moreover, the numerical stability of elimination algorithms is greatly desired. However, for $n = 3$, the asymptotic analysis is not particularly relevant. On most platforms, inversion of a 3×3 matrix is faster using cofactors than Gaussian elimination because a generic Gaussian elimination package requires some overhead, in particular loop iterations, which costs cycles. The speedup by using cofactors can be quite significant.

B.1.2 POLYNOMIAL SYSTEMS

Consider first the example of determining where two circles intersect in the plane. The equations for the circles are $(x - x_0)^2 + (y - y_0)^2 = r_0^2$ and $(x - x_1)^2 + (y - y_1)^2 = r_1^2$. The intersections (if any) are those (x, y) that solve both equations simultaneously. From the geometry there is either no solution (circles are disjoint), one solution (circles are tangent to each other), two solutions (circles interpenetrate), or infinitely many solutions (the circles are identical). If the circles are concentric, $x_0 = x_1$ and $y_0 = y_1$, then there is no intersection when $r_0 \neq r_1$ or infinitely many intersections when $r_0 = r_1$. Otherwise, suppose that either $x_0 \neq x_1$ or $y_0 \neq y_1$. The two quadratic equations can be solved by eliminating one of the variables. The second equation is subtracted from the first to obtain the linear equation

$$2(x_1 - x_0)x + x_0^2 - x_1^2 + 2(y_1 - y_0)y + y_0^2 - y_1^2 = r_0^2 - r_1^2.$$

If $|y_1 - y_0| \geq |x_1 - x_0|$, solve for

$$y - y_0 = \frac{r_0^2 - r_1^2 + (x_1 - x_0)^2 + (y_0 - y_1)^2 - 2(x_1 - x_0)(x - x_0)}{2(y_1 - y_0)} = \frac{a(x - x_0) + b}{2(y_0 - y_1)}.$$

Replace this in the first equation to obtain

$$(4(y_1 - y_0)^2 + a^2)(x - x_0)^2 + 2ab(x - x_0) + b^2 - 4(y_1 - y_0)^2 r_0^2 = 0.$$

This is a quadratic equation in the single variable x and can be solved accordingly for up to two real-valued solutions. For each solution, the corresponding value of y is computed. The final pairs (x, y) must be tested for validity since extraneous solutions might have been generated because of handling both signs on the square root in the quadratic formula.

The general problem of solving two quadratic equations in two unknowns is presented here. Given $P_0(x, y) = a_0 x^2 + b_0 xy + c_0 y^2 + d_0 x + e_0 y + f_0$ and $P_1(x, y) = a_1 x^2 + b_1 xy + c_1 y^2 + d_1 x + e_1 y + f_1$, find all solutions to $P_0(x, y) = 0$ and $P_1(x, y) = 0$. The solutions to $P_0(x, y) = 0$ and $P_1(x, y) = 0$ are found by elimination.

The two polynomials $f(x) = \alpha_0 + \alpha_1 x + \alpha_2 x^2$ and $g(x) = \beta_0 + \beta_1 x + \beta_2 x^2$ have a common root if and only if the *Bézout determinant* is zero,

$$(\alpha_2 \beta_1 - \alpha_1 \beta_2)(\alpha_1 \beta_0 - \alpha_0 \beta_1) - (\alpha_2 \beta_0 - \alpha_0 \beta_2)^2 = 0,$$

and in which case the common root is

$$\bar{x} = (\alpha_2 \beta_0 - \alpha_0 \beta_2)/(\alpha_1 \beta_2 - \alpha_2 \beta_1).$$

The common root to $f(x) = 0$ and $g(x) = 0$ is obtained from the linear equation $\beta_2 f(x) - \alpha_2 g(x) = 0$. If the coefficient of x is zero, then f and g either have no common root or are the same polynomial (modulo a constant multiplier). Replacing the common root into $f(x) = 0$ yields the Bézout determinant.

The simultaneous quadratic equations are $P_i(x, y) = (a_i)x^2 + (b_i y + d_i)x + (c_i y^2 + e_i y + f_i)$ for $i = 0, 1$. The Bézout determinant is a quartic polynomial

$$R(y) = u_0 + u_1 y + u_2 y^2 + u_3 y^3 + u_4 y^4,$$

where

$$u_0 = v_2 v_{10} - v_4^2$$

$$u_1 = v_0 v_{10} + v_2(v_7 + v_9) - 2v_3 v_4$$

$$u_2 = v_0(v_7 + v_9) + v_2(v_6 - v_8) - v_3^2 - 2v_1 v_4$$

$$u_3 = v_0(v_6 - v_8) + v_2 v_5 - 2v_1 v_3$$

$$u_4 = v_0 v_5 - v_1^2$$

with $v_0 = a_0 b_1 - a_1 b_0$, $v_1 = a_0 c_1 - a_1 c_0$, $v_2 = a_0 d_1 - a_1 d_0$, $v_3 = a_0 e_1 - a_1 e_0$, $v_4 = a_0 f_1 - a_1 f_0$, $v_5 = b_0 c_1 - b_1 c_0$, $v_6 = b_0 e_1 - b_1 e_0$, $v_7 = b_0 f_1 - b_1 f_0$, $v_8 = c_0 d_1 - c_1 d_0$, $v_9 = d_0 e_1 - d_1 e_0$, and $v_{10} = d_0 f_1 - d_1 f_0$. For each \bar{y} solving $R(\bar{y}) = 0$, solve $P_0(x, \bar{y}) = 0$ for up to two values \bar{x}. Eliminate any extraneous solution (\bar{x}, \bar{y}) by verifying that $P_i(\bar{x}, \bar{y}) = 0$ for $i = 0, 1$.

Wee and Goldman (1995a, 1995b) discuss the general handling of polynomial systems using elimination and resultants in detail. For three or more variables, the constructions can be quite complex.

B.2 EIGENSYSTEMS

SOURCE CODE

LIBRARY

Numerics

FILENAME

Eigen

Given an $n \times n$ matrix A, an *eigensystem* is of the form $A\vec{X} = \lambda\vec{X}$ or $(A - \lambda I)\vec{X} = \vec{0}$. It is required that there be solutions $\vec{X} \neq \vec{0}$. For this to happen, the matrix $A - \lambda I$ must be noninvertible. This is the case when $\det(A - \lambda I) = 0$, a polynomial in λ of degree n called the *characteristic polynomial* for A. For each root λ, the matrix $A - \lambda I$ is computed, and the system $(A - \lambda I)\vec{X} = \vec{0}$ is solved for nonzero solutions. Although standard linear algebra textbooks show numerous examples for doing this symbolically, most applications require a robust numerical method for doing so. In particular, if $n \geq 5$, there are no closed formulas for roots to polynomials, so numerical methods must be applied. A good reference on solving eigensystems is Press et al. (1988). An excellent reference for numerical methods relating to matrices is Golub and Van Loan (1993). An excellent reference for matrix analysis is Horn and Johnson (1985).

Most of the applications in graphics that require eigensystems have symmetric matrices. The numerical methods are quite good for these since a full basis of eigenvectors is guaranteed. The standard approach is to apply orthogonal transformations, called *Householder transformations,* to reduce A to a tridiagonal matrix. The QR algorithm is applied iteratively to reduce the tridiagonal matrix to a diagonal one. Press et al. (1988) advise using a QL algorithm with implicit shifting to be as robust as possible.

For $n = 3$, the problem can be solved by simply computing the roots of $\det(A - \lambda I) = 0$. Often the numerical issues can be avoided since the end result is some visual presentation of data where the numerical error is not as important as for applications that require high precision.

B.3 LEAST-SQUARES FITTING

Least-squares fitting is the process of selecting a parameterized equation that represents a discrete set of points in a continuous manner. The parameters are estimated by minimizing a nonnegative function of the parameters. This section discusses fitting by lines, planes, quadratic curves, and quadric surfaces.

B.3.1 LINEAR FITTING OF POINTS $(x, f(x))$

This is the usual introduction to least squares fit by a line when the data represents measurements where the y-component is assumed to be functionally dependent on the x-component. Given a set of samples $\{(x_i, y_i)\}_{i=1}^{m}$, determine A and B so that

the line $y = Ax + B$ best fits the samples in the sense that the sum of the squared errors between the y_i and the line values $Ax_i + B$ is minimized. Note that the error is measured only in the y-direction.

Define $E(A, B) = \sum_{i=1}^{m}[(Ax_i + B) - y_i]^2$. This function is nonnegative, and its graph is a paraboloid whose vertex occurs when the gradient satisfies $\nabla E = (0, 0)$. This leads to a system of two linear equations in A and B that can be easily solved:

$$(0, 0) = \nabla E = 2 \sum_{i=1}^{m}[(Ax_i + B) - y_i](x_i, 1)$$

and so

$$\begin{bmatrix} \sum_{i=1}^{m} x_i^2 & \sum_{i=1}^{m} x_i \\ \sum_{i=1}^{m} x_i & \sum_{i=1}^{m} 1 \end{bmatrix} \begin{bmatrix} A \\ B \end{bmatrix} = \begin{bmatrix} \sum_{i=1}^{m} x_i y_i \\ \sum_{i=1}^{m} y_i \end{bmatrix}.$$

The solution provides the least-squares solution $y = Ax + B$.

B.3.2 LINEAR FITTING OF POINTS USING ORTHOGONAL REGRESSION

SOURCE CODE

LIBRARY

Approximation

FILENAME

LineFit

It is also possible to fit a line using least squares where the errors are measured *orthogonally* to the proposed line rather than measured vertically. The following argument holds for sample points and lines in n dimensions. Let the line be $\vec{L}(t) = t\vec{D} + \vec{A}$, where \vec{D} is unit length. Define \vec{X}_i to be the sample points; then

$$\vec{X}_i = \vec{A} + d_i \vec{D} + p_i \vec{D}_i^{\perp},$$

where $d_i = \vec{D} \cdot (\vec{X}_i - \vec{A})$ and \vec{D}_i^{\perp} is some unit-length vector perpendicular to \vec{D} with appropriate coefficient p_i. Define $\vec{Y}_i = \vec{X}_i - \vec{A}$. The vector from \vec{X}_i to its projection onto the line is

$$\vec{Y}_i - d_i \vec{D} = p_i \vec{D}_i^{\perp}.$$

The squared length of this vector is $p_i^2 = (\vec{Y}_i - d_i \vec{D})^2$. The energy function for the least-squares minimization is $E(\vec{A}, \vec{D}) = \sum_{i=1}^{m} p_i^2$. Two alternative forms for this function are

$$E(\vec{A}, \vec{D}) = \sum_{i=1}^{m} \left(\vec{Y}_i^t \left[I - \vec{D}\vec{D}^t \right] \vec{Y}_i \right)$$

and

$$E(\vec{A}, \vec{D}) = \vec{D}^t \left(\sum_{i=1}^{m} \left[(\vec{Y}_i \cdot \vec{Y}_i)I - \vec{Y}_i \vec{Y}_i^t \right] \right) \vec{D} = \vec{D}^t M(A) \vec{D}.$$

Using the first form of E in the previous equation, take the derivative with respect to A to get

$$\frac{\partial E}{\partial A} = -2 \left[I - \vec{D}\vec{D}^t \right] \sum_{i=1}^{m} \vec{Y}_i.$$

This partial derivative is zero whenever $\sum_{i=1}^{m} \vec{Y}_i = 0$, in which case $\vec{A} = (1/m) \sum_{i=1}^{m} \vec{X}_i$, the average of the sample points.

Given \vec{A}, the matrix $M(A)$ is determined in the second form of the energy function. The quantity $\vec{D}^t M(A)\vec{D}$ is a quadratic form whose minimum is the smallest eigenvalue of $M(A)$. This can be found by standard eigensystem solvers. A corresponding unit-length eigenvector \vec{D} completes our construction of the least-squares line.

For $n = 2$, if $\vec{A} = (a, b)$, then matrix $M(A)$ is given by

$$M(A) = \left(\sum_{i=1}^{m} (x_i - a)^2 + \sum_{i=1}^{n} (y_i - b)^2 \right) \begin{bmatrix} 1 & 0 \\ 0 & 1 \end{bmatrix}$$

$$- \begin{bmatrix} \sum_{i=1}^{m} (x_i - a)^2 & \sum_{i=1}^{m} (x_i - a)(y_i - b) \\ \sum_{i=1}^{m} (x_i - a)(y_i - b) & \sum_{i=1}^{m} (y_i - b)^2 \end{bmatrix}.$$

For $n = 3$, if $\vec{A} = (a, b, c)$, then matrix $M(A)$ is given by

$$M(A) = \delta \begin{bmatrix} 1 & 0 & 0 \\ 0 & 1 & 0 \\ 0 & 0 & 1 \end{bmatrix}$$

$$- \begin{bmatrix} \sum_{i=1}^{m} (x_i - a)^2 & \sum_{i=1}^{m} (x_i - a)(y_i - b) & \sum_{i=1}^{m} (x_i - a)(z_i - c) \\ \sum_{i=1}^{m} (x_i - a)(y_i - b) & \sum_{i=1}^{m} (y_i - b)^2 & \sum_{i=1}^{m} (y_i - b)(z_i - c) \\ \sum_{i=1}^{m} (x_i - a)(z_i - c) & \sum_{i=1}^{m} (y_i - b)(z_i - c) & \sum_{i=1}^{m} (z_i - c)^2 \end{bmatrix},$$

where

$$\delta = \sum_{i=1}^{m} (x_i - a)^2 + \sum_{i=1}^{m} (y_i - b)^2 + \sum_{i=1}^{m} (z_i - c)^2.$$

B.3.3 PLANAR FITTING OF POINTS $(x, y, f(x, y))$

Here we assume that the z-component of the data is functionally dependent on the x- and y-components. Given a set of samples $\{(x_i, y_i, z_i)\}_{i=1}^{m}$, determine A, B, and C

so that the plane $z = Ax + By + C$ best fits the samples in the sense that the sum of the squared errors between the z_i and the plane values $Ax_i + By_i + C$ is minimized. Note that the error is measured only in the z-direction.

Define $E(A, B, C) = \sum_{i=1}^{m}[(Ax_i + By_i + C) - z_i]^2$. This function is nonnegative, and its graph is a hyperparaboloid whose vertex occurs when the gradient satisfies $\nabla E = (0, 0, 0)$. This leads to a system of three linear equations in A, B, and C that can be easily solved:

$$(0, 0, 0) = \nabla E = 2 \sum_{i=1}^{m}[(Ax_i + By_i + C) - z_i](x_i, y_i, 1)$$

and so

$$\begin{bmatrix} \sum_{i=1}^{m} x_i^2 & \sum_{i=1}^{m} x_i y_i & \sum_{i=1}^{m} x_i \\ \sum_{i=1}^{m} x_i y_i & \sum_{i=1}^{m} y_i^2 & \sum_{i=1}^{m} y_i \\ \sum_{i=1}^{m} x_i & \sum_{i=1}^{m} y_i & \sum_{i=1}^{m} 1 \end{bmatrix} \begin{bmatrix} A \\ B \\ C \end{bmatrix} = \begin{bmatrix} \sum_{i=1}^{m} x_i z_i \\ \sum_{i=1}^{m} y_i z_i \\ \sum_{i=1}^{m} z_i \end{bmatrix}.$$

The solution provides the least-squares solution $z = Ax + By + C$.

B.3.4 HYPERPLANAR FITTING OF POINTS USING ORTHOGONAL REGRESSION

SOURCE CODE

LIBRARY

Approximation

FILENAME

PlaneFit

It is also possible to fit a plane using least squares where the errors are measured *orthogonally* to the proposed plane rather than measured vertically. The following argument holds for sample points and hyperplanes in n dimensions. Let the hyperplane be $\vec{N} \cdot (\vec{X} - \vec{A}) = 0$, where \vec{N} is a unit-length normal to the hyperplane and \vec{A} is a point on the hyperplane. Define \vec{X}_i to be the sample points; then

$$\vec{X}_i = \vec{A} + \lambda_i \vec{N} + p_i \vec{N}_i^{\perp},$$

where $\lambda_i = \vec{N} \cdot (\vec{X}_i - \vec{A})$ and \vec{N}_i^{\perp} is some unit-length vector perpendicular to \vec{N} with appropriate coefficient p_i. Define $\vec{Y}_i = \vec{X}_i - \vec{A}$. The vector from \vec{X}_i to its projection onto the hyperplane is $\lambda_i \vec{N}$. The squared length of this vector is $\lambda_i^2 = (\vec{N} \cdot \vec{Y}_i)^2$. The energy function for the least-squares minimization is $E(\vec{A}, \vec{N}) = \sum_{i=1}^{m} \lambda_i^2$. Two alternative forms for this function are

$$E(\vec{A}, \vec{N}) = \sum_{i=1}^{m} \left(\vec{Y}_i^t \left[\vec{N} \vec{N}^t \right] \vec{Y}_i \right)$$

and

$$E(\vec{A}, \vec{N}) = \vec{N}^t \left(\sum_{i=1}^{m} \vec{Y}_i \vec{Y}_i^t \right) \vec{N} = \vec{N}^t M(A) \vec{N}.$$

Using the first form of E in the previous equation, take the derivative with respect to A to get

$$\frac{\partial E}{\partial A} = -2 \left[\vec{N} \vec{N}^t \right] \sum_{i=1}^{m} \vec{Y}_i.$$

This partial derivative is zero whenever $\sum_{i=1}^{m} \vec{Y}_i = 0$, in which case $\vec{A} = (1/m) \sum_{i=1}^{m} \vec{X}_i$ (the average of the sample points).

Given \vec{A}, the matrix $M(A)$ is determined in the second form of the energy function. The quantity $\vec{N}^t M(A) \vec{N}$ is a quadratic form whose minimum is the smallest eigenvalue of $M(A)$. This can be found by standard eigensystem solvers. A corresponding unit-length eigenvector \vec{N} completes our construction of the least-squares hyperplane.

For $n = 3$, if $\vec{A} = (a, b, c)$, then matrix $M(A)$ is given by

$$M(A) = \begin{bmatrix} \sum_{i=1}^{m}(x_i - a)^2 & \sum_{i=1}^{m}(x_i - a)(y_i - b) & \sum_{i=1}^{m}(x_i - a)(z_i - c) \\ \sum_{i=1}^{m}(x_i - a)(y_i - b) & \sum_{i=1}^{m}(y_i - b)^2 & \sum_{i=1}^{m}(y_i - b)(z_i - c) \\ \sum_{i=1}^{m}(x_i - a)(z_i - c) & \sum_{i=1}^{m}(y_i - b)(z_i - c) & \sum_{i=1}^{m}(z_i - c)^2 \end{bmatrix}.$$

B.3.5 FITTING A CIRCLE TO 2D POINTS

Given a set of points $\{(x_i, y_i)\}_{i=1}^{m}$, $m \geq 3$, fit them with a circle $(x - a)^2 + (y - b)^2 = r^2$, where (a, b) is the circle center and r is the circle radius. An assumption of this algorithm is that not all the points are collinear. The energy function to be minimized is

SOURCE CODE

LIBRARY

Approximation

$$E(a, b, r) = \sum_{i=1}^{m}(L_i - r)^2,$$

FILENAME

CircleFit

where $L_i = \sqrt{(x_i - a)^2 + (y_i - b)^2}$. Take the partial derivative with respect to r to obtain

$$\frac{\partial E}{\partial r} = -2 \sum_{i=1}^{m}(L_i - r).$$

Setting equal to zero yields

$$r = \frac{1}{m} \sum_{i=1}^{m} L_i.$$

Take the partial derivative with respect to a to obtain

$$\frac{\partial E}{\partial a} = -2 \sum_{i=1}^{m} (L_i - r) \frac{\partial L_i}{\partial a} = 2 \sum_{i=1}^{m} \left((x_i - a) + r \frac{\partial L_i}{\partial a} \right)$$

and take the partial derivative with respect to b to obtain

$$\frac{\partial E}{\partial b} = -2 \sum_{i=1}^{m} (L_i - r) \frac{\partial L_i}{\partial b} = 2 \sum_{i=1}^{m} \left((y_i - b) + r \frac{\partial L_i}{\partial b} \right).$$

Setting these two derivatives equal to zero yields

$$a = \frac{1}{m} \sum_{i=1}^{m} x_i + r \frac{1}{m} \sum_{i=1}^{m} \frac{\partial L_i}{\partial a}$$

and

$$b = \frac{1}{m} \sum_{i=1}^{m} y_i + r \frac{1}{m} \sum_{i=1}^{m} \frac{\partial L_i}{\partial b}.$$

Replacing r by its equivalent from $\partial E/\partial r = 0$ and using $\partial L_i/\partial a = (a - x_i)/L_i$ and $\partial L_i/\partial b = (b - y_i)/L_i$ leads to two nonlinear equations in a and b:

$$a = \bar{x} + \bar{L}\bar{L}_a =: F(a, b)$$
$$b = \bar{y} + \bar{L}\bar{L}_b =: G(a, b),$$

where

$$\bar{x} = \frac{1}{m} \sum_{i=1}^{m} x_i$$

$$\bar{y} = \frac{1}{m} \sum_{i=1}^{m} y_i$$

$$\bar{L} = \frac{1}{m} \sum_{i=1}^{m} L_i$$

$$\bar{L}_a = \frac{1}{m} \sum_{i=1}^{m} \frac{a - x_i}{L_i}$$

$$\bar{L}_b = \frac{1}{m} \sum_{i=1}^{m} \frac{b - y_i}{L_i}.$$

Fixed-point iteration can be applied to solving these equations: $a_0 = \bar{x}$, $b_0 = \bar{y}$, and $a_{i+1} = F(a_i, b_i)$ and $b_{i+1} = G(a_i, b_i)$ for $i \geq 0$.

B.3.6 FITTING A SPHERE TO 3D POINTS

Given a set of points $\{(x_i, y_i, z_i)\}_{i=1}^{m}$, $m \geq 4$, fit them with a sphere $(x - a)^2 + (y - b)^2 + (z - c)^2 = r^2$, where (a, b, c) is the sphere center and r is the sphere radius. An assumption of this algorithm is that not all the points are coplanar. The energy function to be minimized is

SOURCE CODE

LIBRARY

Approximation

$$E(a, b, c, r) = \sum_{i=1}^{m} (L_i - r)^2,$$

FILENAME

SphereFit

where $L_i = \sqrt{(x_i - a)^2 + (y_i - b)^2 + (z_i - c)}$. Take the partial derivative with respect to r to obtain

$$\frac{\partial E}{\partial r} = -2 \sum_{i=1}^{m} (L_i - r).$$

Setting equal to zero yields

$$r = \frac{1}{m} \sum_{i=1}^{m} L_i.$$

Take the partial derivative with respect to a to obtain

$$\frac{\partial E}{\partial a} = -2 \sum_{i=1}^{m} (L_i - r) \frac{\partial L_i}{\partial a} = 2 \sum_{i=1}^{m} \left((x_i - a) + r \frac{\partial L_i}{\partial a} \right),$$

take the partial derivative with respect to b to obtain

$$\frac{\partial E}{\partial b} = -2 \sum_{i=1}^{m} (L_i - r) \frac{\partial L_i}{\partial b} = 2 \sum_{i=1}^{m} \left((y_i - b) + r \frac{\partial L_i}{\partial b} \right),$$

and take the partial derivative with respect to c to obtain

$$\frac{\partial E}{\partial c} = -2 \sum_{i=1}^{m} (L_i - r) \frac{\partial L_i}{\partial c} = 2 \sum_{i=1}^{m} \left((z_i - c) + r \frac{\partial L_i}{\partial c} \right).$$

Setting these three derivatives equal to zero yields

$$a = \frac{1}{m} \sum_{i=1}^{m} x_i + r \frac{1}{m} \sum_{i=1}^{m} \frac{\partial L_i}{\partial a}$$

and

$$b = \frac{1}{m} \sum_{i=1}^{m} y_i + r \frac{1}{m} \sum_{i=1}^{m} \frac{\partial L_i}{\partial b}$$

and

$$c = \frac{1}{m} \sum_{i=1}^{m} z_i + r \frac{1}{m} \sum_{i=1}^{m} \frac{\partial L_i}{\partial c}.$$

Replacing r by its equivalent from $\partial E / \partial r = 0$ and using $\partial L_i / \partial a = (a - x_i)/L_i$, $\partial L_i / \partial b = (b - y_i)/L_i$, and $\partial L_i / \partial c = (c - z_i)/L_i$ leads to three nonlinear equations in a, b, and c:

$$a = \bar{x} + \bar{L} \bar{L}_a =: F(a, b, c)$$

$$b = \bar{y} + \bar{L} \bar{L}_b =: G(a, b, c)$$

$$c = \bar{z} + \bar{L} \bar{L}_c =: H(a, b, c),$$

where

$$\bar{x} = \frac{1}{m} \sum_{i=1}^{m} x_i$$

$$\bar{y} = \frac{1}{m} \sum_{i=1}^{m} y_i$$

$$\bar{z} = \frac{1}{m} \sum_{i=1}^{m} z_i$$

$$\bar{L} = \frac{1}{m} \sum_{i=1}^{m} L_i$$

$$\bar{L}_a = \frac{1}{m} \sum_{i=1}^{m} \frac{a - x_i}{L_i}$$

$$\bar{L}_b = \frac{1}{m} \sum_{i=1}^{m} \frac{b - y_i}{L_i}$$

$$\bar{L}_c = \frac{1}{m} \sum_{i=1}^{m} \frac{c - z_i}{L_i}.$$

Fixed-point iteration can be applied to solving these equations: $a_0 = \bar{x}$, $b_0 = \bar{y}$, $c_0 = \bar{z}$, and $a_{i+1} = F(a_i, b_i, c_i)$, $b_{i+1} = G(a_i, b_i, c_i)$, and $c_{i+1} = H(a_i, b_i, c_i)$ for $i \geq 0$.

B.3.7 FITTING A QUADRATIC CURVE TO 2D POINTS

SOURCE CODE

LIBRARY

Approximation

FILENAME

QuadraticFit2

EllipseFit

Given a set of points $\{(x_i, y_i)\}_{i=0}^{n}$, a quadratic curve of the form $Q(x, y) = c_0 + c_1 x + c_2 y + c_3 x^2 + c_4 y^2 + c_5 xy = 0$ is sought to fit the points. Given values c_i that provide the fit, any scalar multiple provides the same fit. To eliminate this degree of freedom, require that $\vec{C} = (c_0, \ldots, c_5)$ have unit length. Define the vector variable $\vec{V} = (1, x, y, x^2, y^2, xy)$. The quadratic equation is restated as $Q(\vec{V}) = \vec{C} \cdot \vec{V} = 0$ and is a linear equation in the space of \vec{V}. Define $\vec{V}_i = (1, x_i, y_i, x_i^2, y_i^2, x_i y_i)$ for the ith data point. While generally $Q(\vec{V}_i)$ is not zero, the idea is to minimize the sum of squares

$$E(\vec{C}) = \left(\sum_{i=0}^{n} \vec{C} \cdot \vec{V}_i \right)^2 = \vec{C}^{\mathrm{T}} M \vec{C},$$

where $M = \sum_{i=0}^{n} \vec{V}_i \vec{V}_i^{\mathrm{T}}$ and subject to the constraint $|\vec{C}| = 1$. Now the problem is in the standard format for minimizing a quadratic form (see Section 8.2.2). The minimum value is the smallest eigenvalue of M, and \vec{C} is a corresponding unit-length eigenvector. The minimum itself can be used as a measure of how good the fit is (0 means the fit is exact).

If there is reason to believe the input points are nearly circular, a minor modification can be used in the construction. The circle is of the form $Q(x, y) = c_0 + c_1 x + c_2 y + c_3(x^2 + y^2) = 0$. The same construction can be applied where $\vec{V} = (1, x, y, x^2 + y^2)$ and $E(\vec{C}) = \vec{C}^{\mathrm{T}} M \vec{C}$ subject to $|\vec{C}| = 1$.

B.3.8 Fitting a Quadric Surface to 3D Points

SOURCE CODE

LIBRARY

Approximation

FILENAME

QuadraticFit3
EllipsoidFit
ParaboloidFit

Given a set of points $\{(x_i, y_i, z_i)\}_{i=0}^{n}$, a quadric surface of the form $Q(x, y, z) = c_0 + c_1 x + c_2 y + c_3 z + c_4 x^2 + c_5 y^2 + c_6 z^2 + c_7 xy + c_8 xz + c_9 yz = 0$ is sought to fit the points. Just like in the previous section, $\vec{C} = (c_i)$ is required to be unit length and $\vec{V} = (1, x, y, z, x^2, y^2, z^2, xy, xz, yz)$. The quadratic form to minimize is $E(\vec{C}) = \vec{C}^{\mathrm{T}} M \vec{C}$, where $M = \sum_{i=0}^{2} \vec{V}_i \vec{V}_i^{\mathrm{T}}$. The minimum value is the smallest eigenvalue of M, and \vec{C} is a corresponding unit-length eigenvector. The minimum itself can be used as a measure of how good the fit is (0 means the fit is exact).

If there is reason to believe the input points are nearly spherical, a minor modification can be used in the construction. The sphere is of the form $Q(x, y, z) = c_0 + c_1 x + c_2 y + c_3 z + c_4(x^2 + y^2 + z^2) = 0$. The same construction can be applied where $\vec{V} = (1, x, y, z, x^2 + y^2 + z^2)$ and $E(\vec{C}) = \vec{C}^{\mathrm{T}} M \vec{C}$ subject to $|\vec{C}| = 1$.

B.4 Minimization

The generic problem is to find a global minimum for a function $f : D \subset \mathbb{R}^n \to \mathbb{R}$. The function is constrained to be at least continuous, and D is assumed to be a compact set. If the function is continuously differentiable, this fact can help in locating a minimum, but there are methods that do not require derivatives in finding one.

B.4.1 Methods in One Dimension

SOURCE CODE

LIBRARY

Numerics

FILENAME

Minimize1D

Consider $f : [t_{\min}, t_{\max}] \to \mathbb{R}$. If f is differentiable, then the global minimum must occur either at a point where $f' = 0$ or at one of the end points. This standard approach is the one used to compute the distance between a point and a line segment (see Section 2.6). The squared-distance function is quadratic and is defined on a compact interval. The minimum of that function occurs at an interior point of the interval, in which case the closest point is interior to the line segment or at an end point. Solving the problem $f'(t) = 0$ may be complicated in itself. (This root-finding problem is described in Section B.5.1.)

Brent's Method

Continuous functions that are not necessarily differentiable must attain a minimum on a compact interval. A method to find the minimum that does not require derivatives or determining where the derivative is zero when the function is differentiable is very desirable. One such method, *Brent's method,* uses inverse parabolic interpolation in an iterative fashion.

The idea is to *bracket* the minimum by three points $(t_0, f(t_0))$, $(t_m, f(t_m))$, and $(t_1, f(t_1))$ for $t_{min} \leq t_0 < t_m < t_1 \leq t_{max}$, where $f(t_m) < f(t_0)$ and $f(t_m) < f(t_1)$. This means the function must decrease for some values of $t \in [t_0, t_m]$ and must increase for some values of $t \in [t_m, t_1]$, which guarantees that f has a local minimum somewhere in $[t_0, t_1]$. Brent's method attempts to narrow in on the local minimum, much like the bisection method narrows in on the root of a function (see Section B.5).

The following is a variation of the description of Brent's method by Press et al. (1988). The three bracketing points are fit with a parabola, $p(t)$. The vertex of the parabola is guaranteed to lie within (t_0, t_1). Let $f_0 = f(t_0)$, $f_m = f(t_m)$, and $f_1 = f(t_1)$. The vertex of the parabola occurs at $t_v \in (t_0, t_1)$ and can be shown to be

$$t_v = t_m - \frac{1}{2} \frac{(t_1 - t_0)^2(f_0 - f_m) - (t_0 - t_m)^2(f_1 - f_m)}{(t_1 - t_m)(f_0 - f_m) - (t_0 - t_m)(f_1 - f_m)}.$$

The function is evaluated there, $f_v = f(t_v)$. If $t_v < t_m$, then the new bracket is (t_0, f_0), (t_v, f_v), and (t_m, f_m). If $t_v > t_m$, then the new bracket is (t_m, f_m), (t_v, f_v), and (t_1, f_1). If $t_v = t_m$, the bracket cannot be updated in a simple way. Moreover, it is not sufficient to terminate the iteration here because it is simple to construct an example where the three samples form an isosceles triangle whose vertex on the axis of symmetry is the parabola vertex, but the global minimum is far away from that vertex. One simple heuristic is to use the midpoint of one of the half-intervals, say, $t_b = (t_0 + t_m)/2$, evaluate $f_b = f(t_b)$, and compare to f_m. If $f_b > f_m$, then the new bracket is (t_b, f_b), (t_m, f_m), and (t_1, f_1). If $f_b < f_m$, then the new bracket is (t_0, f_0), (t_b, f_b), and (t_m, f_m). If $f_b = f_m$, the other half-interval can be bisected and the same tests repeated. If that also produces the pathological equality case, try a random sample from $[t_0, t_1]$. Once the new bracket is known, the method can be repeated until some stopping criterion is met.

Brent's method can also be modified to support derivative information (Press et al. 1988).

B.4.2 METHODS IN MANY DIMENSIONS

Consider $f : D \subset \mathbb{R}^n \to \mathbb{R}$, where D is a compact set. Typically in graphics applications, D is a polyhedron or even a Cartesian product of intervals. If f is differentiable, then the global minimum must occur either at a point where $\vec{\nabla} f = \vec{0}$ or on the boundary of D. In the latter case if D is a polyhedron, then the restriction of f to each face of D produces the same type of minimization problem, but in one less dimension.

For example, this happens for many of the distance methods described in Chapter 2. Solving $\vec{\nabla} f = \vec{0}$ is a root-finding problem and itself may be a difficult problem to solve.

Steepest Descent Search

Steepest descent search is a simple approach to searching for a minimum of a differentiable function. From calculus it is known that the direction in which f has its greatest rate of decrease is $-\vec{\nabla} f$. Given an initial guess \vec{X} for the minimum point, the function $\phi(t) = f(\vec{X} - t\vec{\nabla} f(\vec{X}))$ is minimized using a one-dimensional algorithm. If t' is the parameter at which the minimum occurs, then $\vec{X} \leftarrow \vec{X} - t'\vec{\nabla} f(\vec{X})$, and the algorithm is repeated until a stopping condition is met. The condition is typically a measure of how different the last starting position is from the newly computed position.

The problem with this method is that it can be very slow. The pathological case is the minimization of a paraboloid $f(x, y) = (x/a)^2 + y^2$, where a is a very large number. The level sets are ellipses that are very elongated in the x-direction. For points not on the x-axis, the negative of the gradient vector tends to be nearly parallel to the y-axis. The search path will zig-zag back and forth across the x-axis, taking its time getting to the origin, where the global minimum occurs. A better approach is not to use the gradient vector, but to use something called the *conjugate direction*. For the paraboloid, no matter where the initial guess is, only two iterations using conjugate directions will always end up at the origin. These directions in a sense encode shape information about the level curves of the function.

Conjugate Gradient Search

This method attempts to choose a better set of directions than steepest descent for a minimization search. Only a brief summary is given here (for more details, see Press et al. 1988). Two sequences of directions are built, a sequence of gradient directions \vec{g}_i and a sequence of conjugate directions \vec{h}_i. The one-dimensional minimizations are along lines corresponding to the conjugate directions. The following pseudocode uses the Polak and Ribiere formulation as mentioned in Press et al. (1988). The function to be minimized is $E(\vec{X})$. The function MinimizeOn minimizes the function along the line using a one-dimensional minimizer. It returns the location x of the minimum and the function value fval at that minimum.

```
x = initial guess;
g = -gradient(E)(x);
h = g;
while ( not done )
{
    line.origin = x;
    line.direction = h;
```

```
    MinimizeOn(line,x,fval);
    if ( stopping condition met )
        return <x,fval>;

    gNext = -gradient(E)(x);
    c = Dot(gNext-g,gNext)/Dot(g,g);
    g = gNext;
    h = g + c*h;
}
```

The stopping condition can be based on consecutive values of fval and/or on consecutive values of x. The condition in Press et al. (1988) is based on consecutive function values, f_0 and f_1, and a small tolerance value $\tau > 0$,

$$2|f_1 - f_0| \leq \tau(|f_0| + |f_1| + \epsilon),$$

for a small value $\epsilon > 0$ that supports the case when the function minimum is zero.

Powell's Direction Set Method

SOURCE CODE

LIBRARY

Numerics

FILENAME

MinimizeND

If f is continuous but not differentiable, then it attains a minimum on D. The search for the minimum simply cannot use derivative information. A method to find a minimum that does not require derivatives is *Powell's direction set method*. This method solves minimization problems along linear paths in the domain. The current candidate for the point at which the minimum occurs is updated to the minimum point on the current line under consideration. The next line is chosen to contain the current point and has a direction selected from a maintained set of direction vectors. Once all the directions have been processed, a new set of directions is computed. This is typically all but one of the previous set, but with the first direction removed and a new direction set to the current position minus the old position before the line minimizations were processed. The minimizations along the lines use something such as Brent's method since f restricted to the line is a one-dimensional function. The fact that D is compact guarantees that the intersection of a line with D is a compact set. Moreover, if D is convex (which in most applications it is), then the intersection is a connected interval so that Brent's method can be applied to that interval (rather than applying it to each connected component of the intersection of a line with D). The pseudocode for Powell's method is

```
// F(x) is the function to be minimized
n = dimension of domain;
directionSet = {d[0],...., d[n-1]}; // usually the standard axis
                                    // directions
x = xInitial = initial guess for minimum point;
```

```
while ( not done )
{
    for ( each direction d )
    {
        line.origin = x;
        line.direction = d;
        MinimizeOn(line,x,fval);
    }

    conjugateDirection = x - xInitial;
    if ( Length(conjugateDirection) is small )
        return <x,fval>;   // minimum found

    for (i = 0; i <= n-2; i++)
        d[i] = d[i+1];
    d[n-1] = conjugateDirection;
}
```

The function `MinimizeOn` is the same one mentioned in the previous subsection on the conjugate gradient search.

B.5 ROOT FINDING

Given a continuous function $\vec{F} : D \subset \mathbb{R}^n \to \mathbb{R}^n$, the problem is to find an \vec{X} (or find a set of points) for which $\vec{F}(\vec{X}) = 0$.

B.5.1 METHODS IN ONE DIMENSION

Given a continuous function $f : [a, b] \to \mathbb{R}$, the first question is whether or not $f(r) = 0$ for some $r \in [a, b]$. If $f(a)f(b) < 0$, then there is at least one root. However, there may be multiple roots. If a root r is computed, other analyses are required to locate others. For example, if f is a polynomial and r is a root, the function can be factored as $f(t) = (t - r)^p g(t)$, where $p \geq 1$ and g is a polynomial with degree$(g) = $ degree$(f) - p$. The root-finding process is now continued with function g on $[a, b]$.

If $f(a)f(b) > 0$, there is no guarantee that f has a root on $[a, b]$. For problems of this type, a root-bounding preprocessing step can be used. The interval is partitioned into $t_i = a + i(b - a)/n$ for $0 \leq i \leq n$. If $f(t_i)f(t_{i+1}) < 0$ for some i, then that subinterval is bisected to locate a root. A reasonable choice of n will be related to what information the application knows about its function f.

Finally, it might be necessary to find roots of $f : \mathbb{R} \to \mathbb{R}$, where the domain of f is not a bounded interval. In this case, roots of f can be sought in the interval

$[-1, 1]$. For $|t| \geq 1$, the function $g(t) = f(1/t)$ is defined for $t \in [-1, 1]$. Roots for g are sought on $[-1, 1]$. If $g(r) = 0$, then $f(1/r) = 0$.

Bisection

SOURCE CODE

LIBRARY

Numerics

FILENAME

Bisect1

Bisection is the process of finding a root to a continuous function $f : [a, b] \to \mathbb{R}$ by bracketing a root with an interval, then successively bisecting the interval to narrow in on the root. Suppose that initially $f(a)f(b) < 0$. Since f is continuous, there must be a root $r \in (a, b)$. The midpoint of the interval is $m = (a + b)/2$. The function value $f(m)$ is computed and compared to the function values at the end points. If $f(a)f(m) < 0$, then the subinterval (a, m) brackets a root and the bisection process is repeated on that subinterval. If $f(m)f(b) < 0$, the subinterval (m, b) brackets a root and the bisection process is repeated instead on that subinterval. If $f(m) = 0$ or is zero within a specified tolerance, the process terminates. A stopping condition might also be based on the length of the current subinterval—that is, if the length becomes small enough, terminate the algorithm. If a root exists on $[a, b]$, bisection is guaranteed to find it. However, the rate of convergence is slow.

Newton's Method

Given a differentiable function $f : \mathbb{R} \to \mathbb{R}$, an initial guess is chosen about where f is zero, $(x_0, f(x_0))$. The tangent line to the graph at this point is used to update the estimate to a (hopefully) better one. The tangent line is $y - f(x_0) = f'(x_0)(x - x_0)$ and intersects the x-axis at $(0, x_1)$, so $-f(x_0) = f'(x_0)(x_1 - x_0)$. Assuming $f'(x_0) \neq 0$, solving for x_1 yields

$$x_1 = x_0 - \frac{f(x_0)}{f'(x_0)}.$$

The next point in the iteration is $(x_1, f(x_1))$ and the process is repeated until a stopping condition is met, typically one based on closeness of the function value to zero. Unlike bisection, the iterations are not guaranteed to converge, but if there is convergence, it is at a faster rate. Success depends a lot on the initial guess for x_0.

Polynomial Roots

SOURCE CODE

LIBRARY

Core

FILENAME

Polynomial

A polynomial of degree n is $f(t) = \sum_{i=0}^{n} a_i t^n$, where $a_n \neq 0$. While standard root finders may be applied to polynomials, a better approach takes advantage of the nature of such functions. For $2 \leq n \leq 4$, there are closed-form equations for the roots of the polynomial. Direct application of the formulas is possible, but numerical problems tend to occur, particularly when the polynomial has a root of multiplicity larger than 1. For example, the roots of a quadratic $f(t) = at^2 + b^t + c$

are $t = (-b \pm \sqrt{b^2 - 4ac})/(2a)$. If $b^2 - 4ac = 0$, the quadratic has a double root $t = -b/(2a)$. However, numerical round-off errors might cause $b^2 - 4ac = -\epsilon < 0$ for very small ϵ. Another condition that leads to numerical problems is if a is nearly zero. If so, it is possible to solve $g(t) = t^2 f(1/t) = ct^2 + bt + a = 0$ and get $t = (-b \pm \sqrt{b^2 - 4ac})/(2c)$. But the problem still exists if c is also nearly zero. Similar problems occur with the formulas for cubic and quartic polynomials.

An approach based on iteration schemes is to attempt to bracket the roots in a way that each bracketing interval contains exactly one root. For each such interval, bisection can be applied to find the root. A hybrid scheme is also possible that mixes bisection steps with Newton steps; the bisection step is used only when the Newton step generates an iterate outside the current bracketing interval. The hope is that the Newton iterates converge quickly to the root, but if they appear not to, bisection attempts to generate better initial guesses for the Newton iteration.

Bounding Roots by Derivative Sequences

A simple approach to the bracketing problem is to partition \mathbb{R} into intervals, with the polynomial $f(t)$ monotone on each interval. If it can be determined where the derivative of the polynomial is zero, this set provides the partition. If d_i and d_{i+1} are consecutive values for which $f'(d_i) = f'(d_{i+1}) = 0$, then either $f'(t) > 0$ on (d_i, d_{i+1}) or $f'(t) < 0$ on (d_i, d_{i+1}). In either case, f can have at most one root on the interval. The existence of this root is guaranteed by the condition $f(d_i) f(d_{i+1}) < 0$ or $f(d_i) = 0$ or $f(d_{i+1}) = 0$.

Solving $f'(t) = 0$ requires the same techniques as solving $f(t) = 0$. The difference is that degree(f') = degree(f) $- 1$. A recursive implementation is warranted for this problem; the base case is the constant polynomial that is either never zero or identically zero on the real line.

If $f'(t) \neq 0$ for $t \in (-\infty, d_0)$, it is possible that f has a root on the semi-infinite interval $(-\infty, d_0]$. Bisection does not help locate a root because the interval is unbounded. However, it is possible to determine the largest bounded interval that contains the roots of a polynomial. The construction relies on the concepts of *spectral radius* and *norm of a matrix* (Horn and Johnson 1985). Given a square matrix A, the spectral radius, denoted $\rho(A)$, is the maximum of the absolute values of the eigenvalues for the matrix. A matrix norm of A, denoted $\|A\|$, is a scalar-valued function that must satisfy the five conditions: $\|A\| \geq 0$, $\|A\| = 0$ if and only if $A = 0$, $\|cA\| = |c|\|A\|$ for any scalar c, $\|A + B\| \leq \|A\| + \|B\|$, and $\|AB\| \leq \|A\|\|B\|$. The relationship between the spectral radius and any matrix norm is $\rho(A) \leq \|A\|$. Given $f(t) = \sum_{i=0}^{n} a_i t^i$, where $a_n = 1$, the *companion matrix* is

$$
A = \begin{bmatrix}
-a_{n-1} & -a_{n-2} & \cdots & -a_1 & -a_0 \\
1 & 0 & \cdots & 0 & 0 \\
0 & 1 & \cdots & 0 & 0 \\
\vdots & \vdots & \ddots & \vdots & \vdots \\
0 & 0 & \cdots & 1 & 0
\end{bmatrix}.
$$

The characteristic polynomial is $f(t) = \det(A - tI)$, so the roots of f are the eigenvalues of A. The spectral norm therefore provides a bound for the roots. Since there are lots of matrix norms to choose from, there are many possible bounds. One such bound is Cauchy's bound,

$$|t| \le \max\{|a_0|, 1 + |a_1|, \ldots, 1 + |a_{n-1}|\} = 1 + \max\{|a_0|, \ldots, |a_{n-1}|\}.$$

Another bound that can be obtained is the Carmichael and Mason bound,

$$|t| \le \sqrt{1 + \sum_{i=0}^{n-1} |a_i|^2}.$$

If $a_0 \ne 0$, then $f(0) \ne 0$, so the roots of f are bounded away from zero. It is possible to construct lower bounds by using $g(t) = [t^n f(1/t)]/a_0$. The roots of $g(t)$ are the reciprocal roots of $f(t)$. Cauchy's bound applied to $g(t)$, then taking reciprocals is

$$|t| \ge \frac{|a_0|}{1 + \max\{1, |a_1|, \ldots, |a_{n-1}|\}}.$$

The Carmichael and Mason bound is

$$|t| \ge \frac{|a_0|}{\sqrt{1 + \sum_{i=0}^{n-1} |a_i|^2}}.$$

These bounds are used in the recursive call to determine where $f(t)$ is monotone. The polynomial can be factored $f(t) = t^p g(t)$, where $p \ge 0$ and g is a polynomial for which $g(0) \ne 0$. If $p = 0$, then $f = g$, and f is processed for $0 < a \le |t| \le b$, where a and b are bounds computed from the previously mentioned inequalities. If $p > 0$, then g is processed on the intervals obtained by using the bounds from the same inequalities.

Bounding Roots by Sturm Sequences

Consider a polynomial $f(t)$ defined on interval $[a, b]$. A Sturm sequence for f is a set of polynomials $f_i(t)$, $0 \le i \le m$, such that degree$(f_{i+1}) >$ degree(f_i) and the number of distinct real roots for f in $[a, b]$ is $N = s(a) - s(b)$, where $s(a)$ is the number of sign changes of $f_0(a), \ldots, f_m(a)$ and $s(b)$ is the number of sign changes of $f_1(b), \ldots, f_m(b)$. The total number of real-valued roots of f on \mathbb{R} is $s(-\infty) - s(\infty)$. It is not always the case that $m =$ degree(f).

The classic Sturm sequence is $f_0(t) = f(t)$, $f_1(t) = f'(t)$, and $f_i(t) = -$ remainder(f_{i-2}/f_{i-1}) for $i \ge 2$. The polynomials are generated by this method until the remainder term is a constant. An instructive example from the article by D.G. Hook and P.R. McAree in *Graphics Gems I* (Glassner 1990) is $f(t) = t^3 + 3t^2 - 1$.

Table B.1 Signs of the Sturm polynomials for $t^3 + 3t^2 - 1$ at various t values.

t	Sign $f_0(t)$	Sign $f_1(t)$	Sign $f_2(t)$	Sign $f_3(t)$	Sign changes
$-\infty$	$-$	$+$	$-$	$+$	3
-3	$-$	$+$	$-$	$+$	3
-2	$+$	0	$-$	$+$	2
-1	$+$	$-$	$-$	$+$	2
0	$-$	0	$+$	$+$	1
$+1$	$+$	$+$	$+$	$+$	0
$+\infty$	$+$	$+$	$+$	$+$	0

Table B.2 Signs of the Sturm polynomials for $(t - 1)^3$ at various t values.

t	Sign $f_0(t)$	Sign $f_1(t)$	Sign $f_2(t)$	Sign changes
$-\infty$	$-$	$+$	0	1
0	$-$	$+$	0	1
$+\infty$	$+$	$+$	0	0

The Sturm sequence is $f_0(t) = t^3 + 3t^2 - 1$, $f_1(t) = 3t^2 + 6t$, $f_2(t) = 2t + 1$, and $f_3 = 9/4$. Table B.1 lists the signs of the Sturm polynomials for various t values. Letting $N(a, b)$ denote the number of real-valued roots on the interval (a, b), the table shows that $N(-\infty, -3) = 0$, $N(-3, -2) = 1$, $N(-2, -1) = 0$, $N(-1, 0) = 1$, $N(0, 1) = 1$, and $N(1, \infty) = 0$. Moreover, the number of negative real roots is $N(-\infty, 0) = 2$, the number of positive real roots is $N(0, \infty) = 1$, and the total number of real roots is $N(-\infty, \infty) = 3$.

The next example shows that the number of polynomials in the Sturm sequence is not necessarily the degree(f) + 1. The function $f(t) = (t - 1)^3$ has a Sturm sequence $f_0(t) = (t - 1)^3$, $f_1(t) = 3(t - 1)^2$, and $f_2(t) \equiv 0$ since f_1 exactly divides f_0 with no remainder. Table B.2 lists sign changes for f at various t values. The total number of real roots is $N(-\infty, \infty) = 1$.

B.5.2 METHODS IN MANY DIMENSIONS

Root finding in many dimensions is a more difficult problem than it is in one dimension. Two simple algorithms are summarized here: bisection and Newton's method.

Bisection

The bisection method for one dimension can be extended to multiple dimensions. Let $(f, g) : [a, b] \times [c, d] \to \mathbb{R}^2$. The problem is to find a point $(x, y) \in [a, b] \times [c, d]$ for which $(f(x, y), g(x, y)) = (0, 0)$. A quadtree decomposition of $[a, b] \times [c, d]$ can be used for the root search. Starting with the initial rectangle, f and g are evaluated at the four vertices:

- If either f or g has the same sign at the four vertices, the algorithm stops processing that region.

- If both f and g have a sign change at the vertices, they are evaluated at the center point of the region. If the values at the center are close enough to zero, that point is returned as a root and the search is terminated in that region.

- If the center value is not close enough to zero, the region is subdivided into four subregions by using the original four vertices, the midpoints of the four edges, and the center point. The algorithm is recursively applied to those four subregions.

It is possible that when a region is not processed further because f or g has the same sign at all four vertices, the region really does contain a root. The issue is the same as for one dimension—the initial rectangle needs to be partitioned to locate subrectangles on which a root is bound. The bisection method can be applied to each subrectangle that contains at least one root.

For three dimensions, an octree decomposition is applied in a similar way. For n dimensions, a 2^n-tree decomposition is used.

Newton's Method

Given differentiable $\vec{F} : \mathbb{R}^n \to \mathbb{R}^n$, the equation $\vec{F}(\vec{X}) = \vec{0}$ can be solved by the extension of Newton's method in one dimension. The iteration scheme that directly generalizes the method is to select an initial guess $(\vec{X}_0, \vec{F}(\vec{X}_0))$ and generate the next iterate by

$$\vec{X}_1 = \vec{X}_0 - (DF(\vec{X}_0))^{-1} F(\vec{X}_0).$$

The quantity $DF(\vec{X})$ is the matrix of partial derivatives of \vec{F}, called the *Jacobian matrix*, and has entries $\partial F_i / \partial x_j$, where F_i is the ith component of \vec{F} and x_j is the jth component of \vec{X}. Each iterate requires a matrix inversion. Although the obvious extension, it is not always the best to use. There are variations on the method that work much better in practice, some of which use *splitting methods* that avoid having to invert a matrix and usually have better convergence behavior.

B.6 INTEGRATION

Two standard methods are presented here for numerical integration, Romberg integration and Gaussian quadrature (Burden and Faires 1985). Either one is useful for graphics applications, for example, in computing the inverse arc length integral when reparameterizing by arc length.

B.6.1 ROMBERG INTEGRATION

SOURCE CODE

LIBRARY

Numerics

FILENAME

Integrate

Romberg integration is an excellent choice for numerical integration that is based on extrapolation methods and the trapezoid rule.

Richardson Extrapolation

The Richardson extrapolation method is very powerful. The key idea is to get high-order accuracy by using low-order formulas. Not only is it used in Romberg integration, but it is also used in the adaptive Runge-Kutta differential equation solvers.

Let Q be an unknown quantity approximated by $A(h)$ with approximation error of order $O(h^2)$. That is,

$$Q = A(h) + C_1 h^2 + O(h^4) = A(h) + O(h^2) \tag{B.1}$$

for some constant C_1. This formula can be used to produce a (possibly) more accurate approximation. Replacing h by $h/2$ in the formula yields

$$Q = A\left(\frac{h}{2}\right) + \frac{C_1}{2}h^2 + O(h^4). \tag{B.2}$$

Taking four times Equation (B.2) and subtracting Equation (B.1), then dividing by three yields

$$Q = \frac{4A\left(\frac{h}{2}\right) - A(h)}{3} + O(h^4). \tag{B.3}$$

The goal is for the $O(h^4)$ terms in Equations (B.1) and (B.3) to be about the same size. If so, Equation (B.3) is more accurate since it does not have the h^2 term in it.

Define $A_1(h) = A(h)$ and $A_2(h) = (4A_1(h/2) - A_1(h))/3$. Other approximations can be written in an extrapolation table:

$A_1(h)$

$A_1\left(\dfrac{h}{2}\right)$ $A_2(h)$

$A_1\left(\dfrac{h}{4}\right)$ $A_2\left(\dfrac{h}{2}\right)$

$A_1\left(\dfrac{h}{8}\right)$ $A_2\left(\dfrac{h}{4}\right)$

\vdots \vdots

$A_1\left(\dfrac{h}{2^n}\right) A_2\left(\dfrac{h}{2^{n-1}}\right)$

The approximation $A_1(h/2^k)$ is order $O(h^2)$, and the approximation $A_2(h/2^k)$ is order $O(h^4)$.

If the original approximation is written as

$$Q = A(h) + C_1 h^2 + C_2 h^4 + O(h^6),$$

then the extrapolation table has an additional column:

$A_1(h)$

$A_1\left(\dfrac{h}{2}\right)$ $A_2(h)$

$A_1\left(\dfrac{h}{4}\right)$ $A_2\left(\dfrac{h}{2}\right)$ $A_3(h)$

$A_1\left(\dfrac{h}{8}\right)$ $A_2\left(\dfrac{h}{4}\right)$ $A_3\left(\dfrac{h}{2}\right)$

\vdots \vdots

$A_1\left(\dfrac{h}{2^n}\right) A_2\left(\dfrac{h}{2^{n-1}}\right)$ $A_3\left(\dfrac{h}{2^{n-2}}\right)$

where

$$A_3(h) = \frac{16A_2\left(\frac{h}{2}\right) - A_2(h)}{15}.$$

The approximation $A_3(h/2^k)$ is order $O(h^6)$.

In general, the extrapolation table is an $n \times m$ lower triangular matrix $T = [T_{rc}]$, where

$$T_{rc} = A_c\left(\frac{h}{2^{r-1}}\right)$$

and

$$A_c(h) = \frac{4^{c-1}A_{c-1}\left(\frac{h}{2}\right) - A_{c-1}(h)}{4^{c-1} - 1}.$$

Trapezoid Rule

An approximation for $\int_a^b f(x)\, dx$ can be computed by first approximating $f(x)$ by the linear function

$$L(x) = \frac{x-b}{a-b}f(a) + \frac{x-a}{b-a}f(b)$$

and using $h[f(b) + f(a)]/2 = \int_a^b L(x)\, dx \doteq \int_a^b f(x)\, dx$. Some calculus shows that

$$\int_a^b f(x)\, dx = \frac{f(b) + f(a)}{2}h + O(h^3).$$

When $f(x) > 0$, the approximation is the area of a trapezoid with vertices at $(a, 0)$, $(a, f(a))$, $(b, 0)$, and $(b, f(b))$.

The integration interval $[a, b]$ can be divided into N subintervals over which the integration can be composited. Define $h = (b-a)/N$ and $x_j = a + jh$ for $0 \le j \le N$. It can be shown that

$$\int_a^b f(x)\, dx = \frac{h}{2}\left[f(a) + 2\sum_{j=1}^{N-1} f(x_j) + f(b)\right] + O(h^2).$$

Note that the order of the approximation decreases by a power of one.

The Integration Method

Romberg integration uses the trapezoid rule to obtain preliminary approximations to the integral followed by Richardson extrapolation to obtain improvements.

Define $h_k = (b - a)/2^{k-1}$ for $k \geq 1$. The trapezoidal approximations corresponding to the interval partitions are

$$T_{k,1} = \frac{h_k}{2} \left[f(a) + 2 \left(\sum_{j=1}^{2^{k-1}-1} f(a + jh_k) \right) + f(b) \right],$$

and so

$$\int_a^b f(x)\,dx = T_{k,1} + O(h_k^2)$$

for all $k \geq 1$. The following recursion formula can be shown to hold:

$$2T_{k,1} = T_{k-1,1} + h_{k-1} \sum_{j=1}^{2^{k-2}} f(a + (j - 0.5)h_{k-1}) \tag{B.4}$$

for $k \geq 2$.

Richardson extrapolation can be applied; that is, generate the table

$$T_{i,j} = \frac{4^{j-1} T_{i,j-1} - T_{i-1,j-1}}{4^{j-1} - 1}$$

for $2 \leq j \leq i$. It can be shown that

$$\lim_{k \to \infty} T_{k,1} = \int_a^b f(x)\,dx \quad \text{if and only if} \quad \lim_{k \to \infty} T_{k,k} = \int_a^b f(x)\,dx.$$

The second limit typically converges much faster than the first. The idea now is to choose a value n and use $T_{n,n}$ as an approximation to the integral. The code is

```
float RombergIntegral (float a, float b, float (*F)(float))
{
    const int order = 5;

    float rom[2][order];
    float h = b-a;

    // initialize T_{1,1} entry
    rom[0][0] = h*(F(a)+F(b))/2;
```

```
    for (int i = 2, ipower = 1; i <= order; i++, ipower *= 2,
                                                 h /= 2)
    {
        // calculate summation in recursion formula for T_{k,1}
        float sum = 0;
        for (int j = 1; j <= ipower; j++)
            sum += F(a+h*(j-0.5));

        // trapezoidal approximations
        rom[1][0] = (rom[0][0]+h*sum)/2;

        // Richardson extrapolation
        for (int k = 1, kpower = 4; k < i; k++, kpower *= 4)
            rom[1][k] = (kpower*rom[1][k-1]
                         - rom[0][k-1])/(kpower-1);

        // save extrapolated values for next pass
        for (j = 0; j < i; j++)
            rom[0][j] = rom[1][j];
    }

    return rom[0][order-1];
}
```

The value order is arbitrarily chosen to be 5. Increasing the order will generally give better estimates, but at increased execution time. The values of $T_{i,j}$ are stored in rom[2][order]. Note that not all the values must be saved to build the next ones (so the first dimension of rom does not have to be order). This follows from the recursion given in Equation (B.4).

B.6.2 GAUSSIAN QUADRATURE

Gaussian quadrature approximates a definite integral,

$$\int_a^b f(x)\,dx \doteq \sum_{i=1}^n c_i f(x_i),$$

for some choice of constants c_i and values $x_i \in [a, b]$ regardless of what f is. If $a = -1$ and $b = 1$, the optimal choices for c_i and x_i are related to the Legendre polynomial of degree n. The x_i are the roots of that polynomial on $(-1, 1)$, and the c_i are given by

$$c_i = \int_{-1}^1 \prod_{j=1,j\neq i}^n \frac{x - x_j}{x_i - x_j}\,dx.$$

The original problem can be transformed so that the quadrature formula applies. Let $t = (2x - a - b)/(b - a)$, then

$$\int_a^b f(x)\, dx = \int_{-1}^1 f\left(\frac{(b-a)t + b + a}{2}\right) \frac{b-a}{2}\, dt = \frac{b-a}{2} \int_{-1}^1 g(t)\, dt.$$

The implementation of Gaussian quadrature amounts to selecting n, storing the tabulated values for c_i and x_i statically, and simply evaluating $((b-a)/2) \sum_{i=1}^n c_i g(t_i)$.

B.7 DIFFERENTIAL EQUATIONS

Differential equations are used to model physical systems that depend on rates of change of various quantities in the system. Ordinary differential equations have a single independent variable, usually time. Partial differential equations have multiple independent variables, usually including time and spatial variables. This section gives a brief overview of each type of equation.

B.7.1 ORDINARY DIFFERENTIAL EQUATIONS

A *first-order system of ordinary differential equations* is of the form

SOURCE CODE

LIBRARY

Numerics

FILENAME

ODE
Euler
Midpoint
RK4
RK4Adapt

$$\frac{d\vec{X}(t)}{dt} = \vec{F}(t, \vec{X}(t)),$$

where $\vec{F} : \mathbb{R} \times \mathbb{R}^n \to \mathbb{R}$. The system is said to be *autonomous* if \vec{F} does not depend explicitly on t, $\vec{F} = \vec{F}(\vec{X})$. An *initial value problem* supplies an initial condition $\vec{X}(t_0) = \vec{X}_0$ and time interval $t \geq t_0$. Under reasonable conditions on \vec{F}, the initial value problem has a unique solution for some range of t values near the initial time t_0. The system of equations is *explicit* in that the first-derivative term occurs explicitly in the equation (the left-hand side). An *implicit* equation is of the form $\vec{G}(t, \vec{X}, \vec{X}') = \vec{0}$.

A *second-order system of ordinary differential equations* is of the form

$$\frac{d^2\vec{X}(t)}{dt^2} = \vec{F}(t, \vec{X}(t), d\vec{X}(t)/dt).$$

An *initial value problem* supplies the initial conditions $\vec{X}(t_0) = \vec{X}_0$ and $d\vec{X}(t_0)/dt = \vec{D}_0$ and a time interval $t \geq t_0$. A *two-point boundary value problem* supplies an initial condition and final condition, $\vec{X}(t_0) = \vec{X}_0$ and $\vec{X}(t_1) = \vec{X}_1$ for $t \in [t_0, t_1]$. The system of equations is explicit in that the second-derivative term occurs explicitly in the equation. An implicit equation is of the form $\vec{G}(t, \vec{X}, \vec{X}', \vec{X}'') = \vec{0}$. It is possible to reduce a second-order system to a first-order system that has more variables. Setting

$\vec{Y} = \vec{X}'$, the explicit system with n equations, the number of components of \vec{X}, is converted to a system with $2n$ equations, the number of components of the vector $\vec{Z} = (\vec{X}, \vec{Y})$,

$$\frac{d\vec{Z}}{dt} = \frac{d(\vec{X}, \vec{Y})}{dt} = \left(\frac{d\vec{X}}{dt}, \frac{d\vec{Y}}{dt}\right) = (\vec{Y}, \vec{F}(t, \vec{X}, \vec{Y})) = \vec{G}(t, \vec{Z}).$$

The solution $\vec{Z}(t)$ has $2n$ components, but only the first n matter for the original problem. The last n just list the derivatives of the first n.

Second-order equations arise in physics problems, a topic that is gaining a lot of popularity in games. Realistic collision response will require solving second-order initial value differential equations, so it is necessary to understand what these equations are and how to solve them. The rest of this section presents a few standard methods for solving initial value systems. A problem such as minimum weight path finding, for example, the shortest distance between two points on a surface, requires solving second-order boundary value differential equations. This is a more difficult problem to solve and requires either *shooting methods* or *relaxation methods*, which are not discussed here (see Burden and Faires 1985).

Euler's Method

The easiest differential equation solver is Euler's method. The initial value is (t_0, \vec{X}_0). Successive approximations (t_i, \vec{X}_i) for $i > 0$ are generated by using a first-order forward difference to approximate the first derivative,

$$\vec{x}_{i+1} = \vec{X}_i + h\vec{F}(t_i, \vec{X}_i)$$

$$t_{i+1} = t_i + h,$$

where $h > 0$ is a sufficiently small step size.

Midpoint Method

The midpoint method is a second-order Runge-Kutta algorithm. The initial value is (t_0, \vec{X}_0). Successive approximations (t_i, \vec{X}_i) for $i > 0$ are generated by

$$\vec{A}_1 = \vec{F}(t_i, \vec{X}_i)$$

$$\vec{A}_2 = \vec{F}(t_i + h/2, \vec{X}_i + h\vec{A}_1/2)$$

$$\vec{X}_{i+1} = \vec{X}_i + h\vec{A}_2$$

$$t_{i+1} = t_i + h.$$

Runge-Kutta Fourth-Order Method

The Runge-Kutta fourth-order method has good accuracy. The initial value is (t_0, \vec{X}_0). Successive approximations (t_i, \vec{X}_i) for $i > 0$ are generated by

$$\vec{A}_1 = \vec{F}(t_i, \vec{X}_i)$$

$$\vec{A}_2 = \vec{F}(t_i + h/2, \vec{X}_i + h\vec{A}_1/2)$$

$$\vec{A}_3 = \vec{F}(t_i + h/2, \vec{X}_i + h\vec{A}_2/2)$$

$$\vec{A}_4 = \vec{F}(t_i + h, \vec{X}_i + h\vec{A}_3)$$

$$\vec{X}_{i+1} = \vec{X}_i + \frac{h}{6}(\vec{A}_1 + 2\vec{A}_2 + 2\vec{A}_3 + \vec{A}_4)$$

$$t_{i+1} = t_i + h.$$

Runge-Kutta with Adaptive Step

For some data sets, it is possible to dynamically adjust the step size h to reduce the total number of steps to get to a desired final time. The following algorithm is fifth order and adjusts the step size accordingly:

1. Take two half-steps:

$$\vec{A}_1 = \vec{F}(t_i, \vec{X}_i)$$

$$\vec{A}_2 = \vec{F}(t_i + h/4, \vec{X}_i + h\vec{A}_1/4)$$

$$\vec{A}_3 = \vec{F}(t_i + h/4, \vec{X}_i + h\vec{A}_2/4)$$

$$\vec{A}_4 = \vec{F}(t_i + h/2, \vec{X}_i + h\vec{A}_3/2)$$

$$\vec{X}_{inter} = \vec{X}_i + \frac{h}{12}(\vec{A}_1 + 2\vec{A}_2 + 2\vec{A}_3 + \vec{A}_4)$$

and

$$\vec{B}_1 = \vec{F}(t_i + h/2, \vec{X}_{inter})$$

$$\vec{B}_2 = \vec{F}(t_i + 3h/4, \vec{X}_{inter} + h\vec{B}_1/4)$$

$$\vec{B}_3 = \vec{F}(t_i + 3h/4, \vec{X}_{inter} + h\vec{B}_2/4)$$

$$\vec{B}_4 = \vec{F}(t_i + h, \vec{X}_{inter} + h\vec{B}_3/2)$$

$$\vec{X}_{half} = \vec{X}_{inter} + \frac{h}{12}(\vec{B}_1 + 2\vec{B}_2 + 2\vec{B}_3 + \vec{B}_4).$$

2. Take a full step:

$$\vec{C}_1 = \vec{F}(t_i, \vec{X}_n)$$

$$\vec{C}_2 = \vec{F}(t_i + h/2, \vec{X}_i + h\vec{C}_1/2)$$

$$\vec{C}_3 = \vec{F}(t_i + h/2, \vec{X}_i + h\vec{C}_2/2)$$

$$\vec{C}_4 = \vec{F}(t_i + h, \vec{X}_i + h\vec{C}_3)$$

$$\vec{X}_{\text{full}} = \vec{X}_i + \frac{h}{6}(\vec{C}_1 + 2\vec{C}_2 + 2\vec{C}_3 + \vec{C}_4).$$

3. Compute the fractional error term Δ, where $\varepsilon > 0$ is a constant specified by the user:

$$\Delta = \frac{1}{\varepsilon} \max_i \left| \frac{(x_{\text{half}})_i - (x_{\text{full}})_i}{h F_i(t_n, x_n) + \epsilon_0} \right|,$$

where ϵ_0 is a very small positive number that protects against the case $F_i(t_n, x_n) = 0$, in which case Δ becomes a very large positive number. The choice of ε is crucial. Its value can be selected by experimentation in a specific application.

4. If $\Delta \leq 1$, then the iteration is successful. The step size h is used and the next iterates are

$$\vec{X}_{i+1} = \vec{X}_{\text{half}} + \frac{1}{15} \left(\vec{X}_{\text{half}} - \vec{X}_{\text{full}} \right)$$

$$t_{i+1} = t_i + h.$$

The successful iteration suggests trying a larger step size for the next iteration. The step size is adjusted as follows. Let $S < 1$ be a number close to 1 (typical is $S = 0.9$). If $\Delta > (S/4)^5$, then a conservative increase is made: $h \leftarrow Sh\Delta^{-1/5}$. If $\Delta \leq (S/4)^5$, a more aggressive increase is made: $h \leftarrow 4h$.

5. If $\Delta > 1$, then the iteration fails. The step size must be reduced and the iteration is repeated starting with the initial iterate x_n. The adjustment is $h \leftarrow Sh\Delta^{-1/4}$. Repeat step 1 with this new step size. A check must be made for the low-probability case where $h \to 0$.

B.7.2 Partial Differential Equations

Ordinary differential equations involve specifying changes to a function of one independent variable, $\vec{X}(t)$. Partial differential equations are a natural extension to handle functions of many independent variables. Although this topic is immense, it is relevant to games because second-order linear partial differential equations arise naturally in modeling physical phenomena. On a hardware platform with a lot of processing

power, it is possible to procedurally morph geometric data based on the physics. For example, the flapping of a flag in the wind can be modeled as a wavelike behavior. A partial differential equation can be used to model the motion, and a numerical solution can be computed at run time.

The second-order partial differential equations are characterized as parabolic, hyperbolic, or elliptic. Let $x \in \mathbb{R}$, $t \geq 0$, and $u = u(x, t) \in \mathbb{R}$ in the following examples.

Parabolic: Heat Transfer, Population Dynamics

Diffusion of heat $u(x, t)$ in a rod of length L and with heat source $f(x)$ is modeled by

$$u_t(x, t) = u_{xx}(x, t) + f(x), \qquad x \in (0, L),\ t > 0 \qquad \text{(from conservation laws)}$$

$$u(x, 0) = g(x), \qquad x \in [0, L] \qquad \text{(initial heat distribution)}$$

$$u(0, t) = a(t),\ u(L, t) = b(t), \qquad t \geq 0 \qquad \text{(temperature known at boundaries)}$$

or

$$u_x(0, t) = u_x(L, t) = 0, \qquad t \geq 0 \qquad \text{(insulated boundaries)}.$$

Numerical solution for the case of no heat source, $f = 0$, and insulated boundaries uses finite differences to approximate the partial derivatives. Select $m + 1$ spatial locations uniformly sampled as $x_i = i \Delta x$ for $0 \leq i \leq m$ with $\Delta x = L/m$. Select temporal samples as $t_j = j \Delta t$ for $j \geq 0$ with $\Delta t > 0$. The estimates of temperature are $u_i^{(j)} \doteq u(x_i, t_j)$ for $0 \leq i \leq m$ and $j \geq 0$. The sampled initial temperature is $g_i = g(x_i)$ for $0 \leq i \leq m$. Approximate the time derivative by a forward difference,

$$u_t(x, t) \doteq \frac{u(x, t + \Delta t) - u(x, t)}{\Delta t},$$

and approximate the spatial derivatives by central differences,

$$u_{xx}(x, t) \doteq \frac{u(x + \Delta x, t) - 2u(x, t) + u(x - \Delta x, t)}{(\Delta x)^2}.$$

Replace these in the heat equation to obtain

$$\frac{u_i^{(j+1)} - u_i^{(j)}}{\Delta t} = \frac{u_{i+1}^{(j)} - 2u_i^{(j)} + u_{i-1}^{(j)}}{(\Delta x)^2}.$$

The boundary conditions are $u_0^{(j)} = u_m^{(j)} = 0$ for $j \geq 0$. The numerical algorithm is implemented as

$$u_i^{(0)} = g_i, \qquad\qquad\qquad\qquad\qquad\qquad 0 \leq i \leq m$$

$$u_0^{(j)} = u_m^{(j)} = 0, \qquad\qquad\qquad\qquad\qquad j \geq 0$$

$$u_i^{(j+1)} = u_i^{(j)} + \frac{\Delta t}{(\Delta x)^2}\left(u_{i+1}^{(j)} - 2u_i^{(j)} + u_{i-1}^{(j)}\right), \qquad 1 \leq i \leq m-1, \quad j \geq 0.$$

For this to be numerically stable, $\Delta t < (\Delta x)^2/2$ is required. An alternative scheme is the Crank-Nicholson method:

$$u_i^{(j+1)} = u_i^{(j)} + \frac{\Delta t}{(\Delta x)^2}\left(\frac{u_{i+1}^{(j)} - 2u_i^{(j)} + u_{i-1}^{(j)}}{2} + \frac{u_{i+1}^{(j+1)} - 2u_i^{(j+1)} + u_{i-1}^{(j+1)}}{2}\right).$$

This method is stable for all $\Delta t > 0$, but is harder to solve since $u_i^{(j+1)}$ is implicitly defined.

Hyperbolic: Wave and Shock Phenomena

Displacement $u(x, t)$ of an elastic string is modeled by

$$u_{tt}(x, t) = u_{xx}(x, t), \qquad\qquad x \in (0, L), \ t > 0 \quad \text{(from conservation laws)}$$

$$u(x, 0) = f(x), \ u_t(x, 0) = g(x), \qquad x \in [0, L] \quad \text{(initial displacement and speed)}$$

$$u(0, t) = a(t), \quad u(L, t) = b(t), \qquad t \geq 0 \qquad\qquad \text{(location of string ends).}$$

Numerical solution for the case of clamped ends, $a = 0$ and $b = 0$, uses finite differences to approximate the partial derivatives. Centralized differences are used for both the time and spatial derivatives,

$$u_i^{(0)} = f_i, \qquad\qquad\qquad\qquad\qquad\qquad 0 \leq i \leq m$$

$$u_i^{(1)} = u_i^{(0)} + (\Delta t)g_i, \qquad\qquad\qquad\qquad 0 \leq i \leq m$$

$$u_0^{(j)} = u_m^{(j)} = 0, \qquad\qquad\qquad\qquad\qquad j \geq 0$$

$$\frac{u_i^{(j+1)} - 2u_i^{(j)} + u_i^{(j-1)}}{(\Delta t)^2} = \frac{u_{i+1}^{(j)} - 2u_i^{(j)} + u_{i-1}^{(j)}}{(\Delta x)^2}, \qquad 1 \leq i \leq m-1, \quad j \geq 1.$$

The method is stable when $\Delta t < \Delta h$. If the right-hand side is modified as in the Crank-Nicholson method for the heat equation, then the method is stable for all $\Delta t > 0$.

Elliptic: Steady-State Heat Flow, Potential Theory

Steady-state distribution of heat $u(x)$ in a bar of length L with heat source $f(x)$ is modeled by

$$u_{xx}(x) = -f(x), \quad x \in (0, L) \qquad (t \to \infty \text{ in the heat equation})$$

$$u(0) = A, \quad u(L) = B \qquad\qquad (\text{boundary conditions}).$$

The numerical method for the constant temperature boundary, $A = B = 0$, is

$$u_0 = 0, \ u_m = 0$$

$$\frac{u_{i+1} - 2u_i + u_{i-1}}{(\Delta x)^2} = -f_i, \quad 1 \le i \le m - 1.$$

Define the $(m-1) \times 1$ vectors $\vec{u} = [u_i]$, where $1 \le i \le m - 1$ and $\vec{b} = [-(\Delta x)^2 f_i]$. This vector is the unknown in a linear system $A\vec{u} = \vec{b}$, where A is tridiagonal with main diagonal -2 and sub- and superdiagonals 1. Such systems are solved robustly in $O(m)$ time.

Extension to Higher Dimensions

Consider $u(x, y, t)$ for two-dimensional problems. The heat equation is $u_t = u_{xx} + u_{yy}$, the wave equation is $u_{tt} = u_{xx} + u_{yy}$, and the potential equation is $u_{xx} + u_{yy} = f(x, y)$. If the domain for (x, y) is a rectangle, then finite difference methods such as the ones used in the one-dimensional problems extend fairly easily. If the domain is not rectangular, then *finite elements* must be used—approximating the boundary of the domain by a polygon, then decomposing the polygon into triangles. A good method for the decomposition is by Narkhede and Manocha (Paeth 1995).

For example, consider $u_{xx} + u_{yy} = 0$, where domain R is not rectangular. Let $u(x, y)$ be specified on the boundary of R. Decompose region R into triangles. On each triangle approximate the true solution $u(x, y)$ by a linear function $v(x, y)$ that interpolates the triangle vertices. If the vertices are $\vec{P}_i = (x_i, y_i, v_i)$ for $0 \le i \le 2$ and where the v_i estimate $u(x_i, y_i)$, then a triangle normal is $\vec{N} = (\vec{P}_1 - \vec{P}_0) \times (\vec{P}_2 - \vec{P}_0)$, and $v(x, y)$ is the linear function determined by $\vec{N} \cdot ((x, y, v(x, y)) - \vec{V}_0) = 0$. The boundary v_i are known, but the interior v_i must be determined.

Solving the potential equation on R is equivalent to finding a function u that minimizes the integral

$$I = \int \int_R u_x^2 + u_y^2 \, dx \, dy$$

subject to the boundary conditions. Define \tilde{I} to be the approximate integral where $u(x, y)$ is replaced by $v(x, y)$. For triangle T, let the linear approximation for u on that triangle be denoted $v_T(x, y) = \alpha_T x + \beta_T y + \gamma_T$; then the approximating integral to I is

$$\tilde{I} = \sum_T \left(\alpha_T^2 + \beta_T^2 \right) \text{area}(T).$$

Since α_T and β_T are linear functions of the interior values v_i, \tilde{I} is quadratic in v_i. Minimizing a quadratic function can be done by solving a linear system (set derivatives equal to zero) or by the conjugate gradient method (equivalent to solving the linear system, but uses root-finding techniques).

B.8 FAST FUNCTION EVALUATION

SOURCE CODE

LIBRARY

Numerics

FILENAME

FastFunction

A handful of functions that are typically expensive to compute occur frequently in computer graphics and games applications: computing the length of a vector requires a square root, resizing a vector to be unit length requires a reciprocal square root, computing angles from spatial information requires inverse tangent (or another inverse trigonometric function), and computing sine or cosine. Even division by a floating-point number is somewhat expensive compared to additions and multiplications. Current-generation CPUs are adding fast hardware support for many of these operations, most notably inverse square root and fast (but less accurate) division.

The algorithms described in this section are designed for fast evaluation of various functions. Some of them can be implemented in hardware, but they can be implemented easily in software and might provide an alternative to the operations provided by a floating-point coprocessor whose function calls still take a significant amount of cycles.

A wonderful source for tricks and techniques for mathematical functions is the *Handbook of Mathematical Functions* (Abramowitz and Stegun 1965). In particular, there are lots of formulas for approximating functions by polynomials of small degree. The formulas are always accompanied by a domain on which the approximation is intended and a global error estimate for that domain.

B.8.1 SQUARE ROOT AND INVERSE SQUARE ROOT

Many of the fast square root methods provide a low-accuracy result, but for many graphics applications, this is an acceptable trade-off. *Graphics Gems I* (Glassner 1990) has a number of articles on these methods.

A method by Paul Lalonde and Robert Dawson represents a nonnegative floating-point number as $x = n \cdot 2^{2p}$, where p is an integer and $m \in [1, 4)$ is the mantissa. Thus,

$\sqrt{x} = \sqrt{m \cdot 2^{2p}} = \sqrt{m} \cdot 2^p$, where $\sqrt{m} \in [1, 2)$. Using an n-bit mantissa, a table of values for \sqrt{m} can be computed and stored for lookup. The pseudocode is

```
float SquareRoot (float x)
{
    SplitFloat(x,p,m);   // p = power, m = mantissa
    p = p/2;
    m = Lookup[m];
    return MakeFloat(p,m);
}
```

Steve Hill in *Graphics Gems II* (Arvo 1991) provides code to implement this using IEEE double-precision floating-point numbers. At the expense of one division, this routine can be used to compute inverse square root of y by $1/\sqrt{y} = \sqrt{1/y} = \sqrt{x}$, where $x = 1/y$.

Graphics Gems V (Paeth 1995) has an algorithm by Ken Turkowski that uses Newton's method for computing the inverse square root. Only a few iterations are used, and an initial point is provided by table lookup just as in the method for square root calculation. If $y = 1/\sqrt{x}$, then $1/y^2 - x = 0$. Define $f(y) = 1/y^2 - x$ for the selected x. A positive root \bar{y} to $f(y) = 0$ will be the inverse square root of x. The equation can be solved by Newton iteration. An initial guess $y_0 > 0$ is selected. The iterates are generated by

$$y_{i+1} = y_i - \frac{f(y_i)}{f'(y_i)} = \frac{y_i(3 - xy_i^2)}{2}.$$

The initial guess is chosen just as for the square root algorithm mentioned earlier. The mantissa is used to index into a table of inverse square root quantities. The value looked up is polished further by the iteration mentioned above. The smaller the lookup table, the larger the number of iterations to get to the desired accuracy. Once the inverse square root $r = 1/\sqrt{x}$ is computed, the square root may be obtained by an extra multiplication, $\sqrt{x} = x * r$.

B.8.2 Sine, Cosine, and Tangent

Because sine and cosine are bounded functions with not much variation, the simplest method for fast evaluation of sine and cosine is to use range reduction followed by a table lookup. Both tables store values in the range $[0, \pi/2]$.

Polynomial approximations can also be used (Abramowitz and Stegun 1965). Approximations to sine on the interval $[0, \pi/2]$ are

$$\sin(x) = \sum_{i=0}^{2} a_i x^{2i+1} + \epsilon(x),$$

where $a_0 = 1$, $a_1 = -1.6605e - 01$, $a_2 = 7.61e - 03$, and $|\epsilon(x)| \leq 1.6415e - 04$; and

$$\sin(x) = \sum_{i=0}^{5} a_i x^{2i+1} + \epsilon(x),$$

where $a_0 = 1$, $a_1 = -1.666666664e - 01$, $a_2 = 8.3333315e - 03$, $a_3 = -1.984090e - 04$, $a_4 = 2.7526e - 06$, $a_5 = -2.39e - 08$, and $|\epsilon(x)| \leq 2.3279e - 09$.

Approximations to cosine on the interval $[0, \pi/2]$ are

$$\cos(x) = \sum_{i=0}^{2} a_i x^{2i} + \epsilon(x),$$

where $a_0 = 1$, $a_1 = -4.9670e - 01$, $a_2 = 3.705e - 02$, and $|\epsilon(x)| \leq 1.188e - 03$; and

$$\cos(x) = \sum_{i=0}^{5} a_i x^{2i} + \epsilon(x),$$

where $a_0 = 1$, $a_1 = -4.999999963e - 01$, $a_2 = 4.16666418e - 02$, $a_3 = -1.3888397e - 03$, $a_4 = 2.47609e - 05$, $a_5 = -2.605e - 07$, and $|\epsilon(x) \leq 2.3082e - 09$.

Approximations to tangent on the interval $[0, \pi/4]$ are

$$\tan(x) = \sum_{i=0}^{2} a_i x^{2i+1} + \epsilon(x),$$

where $a_0 = 1$, $a_1 = 3.1755e - 01$, $a_2 = 2.0330e - 01$, and $|\epsilon(x) \leq 8.0613e - 04$; and

$$\tan(x) = \sum_{i=0}^{6} a_i x^{2i+1} + \epsilon(x),$$

where $a_0 = 1$, $a_1 = 3.333314036e - 01$, $a_2 = 1.333923995e - 01$, $a_3 = 5.33740603e - 02$, $a_4 = 2.45650893e - 02$, $a_5 = 2.9005250e - 03$, $a_6 = 9.5168091e - 03$, and $|\epsilon(x)| \leq 1.8897e - 08$.

B.8.3 INVERSE TANGENT

A family of polynomials that approximate the inverse tangent function can be built using a least-squares algorithm based on integrals (as compared to the summations that occur in Section B.3). The approximations are computed to $\text{Tan}^{-1}(z)$ for $z \in [-1, 1]$. For $z > 1$, the trigonometric identity $\text{Tan}^{-1}(z) = \pi/2 - \text{Tan}^{-1}(1/z)$ reduces the problem to evaluating the inverse tangent for $u = 1/z \in (-1, 1)$. Similarly, for $z < -1$, $\text{Tan}^{-1}(z) = -pi/2 - \text{Tan}^{-1}(1/z)$.

Table B.3 Coefficients for polynomial approximations to $\mathrm{Tan}^{-1}(z)$.

n	Coefficients			Maximum error
2	$a_0 = +0.995987$	$a_1 = -0.292298$	$a_2 = +0.0830353$	$1.32603e - 03$
3	$a_0 = +0.999337$	$a_1 = -0.322456$	$a_2 = +0.149384$	$2.05811e - 04$
	$a_3 = -0.0410731$			
4	$a_0 = +1.000000$	$a_1 = -0.332244$	$a_2 = +0.187557$	$6.53509e - 05$
	$a_3 = -0.0956074$	$a_4 = +0.0257527$		
5	$a_0 = +1.000700$	$a_1 = -0.347418$	$a_2 = +0.278742$	$1.95831e - 04$
	$a_3 = -0.317300$	$a_4 = +0.259954$	$a_5 = -0.0894795$	

The function $\mathrm{Tan}^{-1}(z)$ is an odd function on $[-1, 1]$. An approximating polynomial $p(z) = \sum_{i=0}^{n} a_i z^{2i+1}$ is desired; this is also an odd function. Ideally, n can be chosen to be a small number so that only a few polynomial terms have to be computed using additions and multiplications. The size of n, of course, will depend on how much error an application can tolerate. The idea is to select the coefficients $\vec{a} = [a_i]$ to minimize the squared integral error

$$E(\vec{a}) = \int_{-1}^{1} [p(z; \vec{a}) - \mathrm{Tan}^{-1}(z)]^2 \, dz.$$

The minimum must occur when $\vec{\nabla} E = \vec{0}$. The ith derivative is

$$\frac{\partial E}{\partial a_i} = \int_{-1}^{1} 2z^{2i+1} [p(z; \vec{a} - \mathrm{Tan}^{-1}(z)] \, dz$$

$$= 2 \int_{-1}^{1} z^{2i+1} p(z; \vec{a}) \, dz - 2 \int_{-1}^{2} z^{2i+1} \, \mathrm{Tan}^{-1}(z) \, dz$$

$$= 4 \sum_{j=0}^{n} \frac{a_j}{2i + 2j + 3} - \frac{2}{i + 1} \left(\frac{\pi}{4} (1 + (-1)^i) - \sum_{j=0}^{i} \frac{(-1)^j}{2i + 1 - 2j} \right).$$

The $n + 1$ equations obtained from $\vec{\nabla} E = \vec{0}$ provide a linear system in the $n + 1$ unknowns, the components of \vec{a}. This system can be solved by standard solvers. It is also possible to obtain global error bounds from the theory of Taylor series (estimating error when a series is truncated). The coefficients and global error bounds are summarized for $2 \le n \le 5$ in Table B.3.

Table B.4 Various parameters for the CORDIC scheme.

	$\delta_k = \begin{cases} 1, & z_k \geq 0 \\ -1, & z_k < 0 \end{cases}$	$\delta_k = \begin{cases} 1, & y_k < 0 \\ -1, & y_k \geq 0 \end{cases}$
$m = 0$	x_0 given, $y_0 = 0$, z_0 given	x_0 given, y_0 given, $z_0 = 0$
$\epsilon_k = 2^{-k}$	$y_{n+1} \doteq x_0 z_0$	$z_{n+1} \doteq y_0 / x_0$
$m = 1$	$x_0 = K$, $y_0 = 0$, $z_0 = \theta$	x_0 given, y_0 given, $z_0 = 0$
$\epsilon_k = \mathrm{Tan}^{-1}(2^{-k})$ $K = \prod_{j=0}^{n} \cos(\epsilon_j)$	$x_{n+1} \doteq \cos(\theta)$, $y_{n+1} \doteq \sin(\theta)$	$z_{n+1} \doteq \mathrm{Tan}^{-1}(y_0/x_0)$, $x_{n+1} \doteq K\sqrt{x_0^2 + y_0^2}$
$m = -1$	$x_0 = K'$, $y_0 = 0$, $z_0 = \theta$	x_0 given, y_0 given, $z_0 = 0$
$\epsilon_k = \mathrm{Tanh}^{-1}(2^{-k})$ $K' = \prod_{j=0}^{n} \cosh(\epsilon_j)$	$x_{n+1} \doteq \cosh(\theta)$, $y_{n+1} \doteq \sinh(\theta)$	$z_{n+1} \doteq \mathrm{Tanh}^{-1}(y_0/x_0)$, $x_{n+1} \doteq K'\sqrt{x_0^2 - y_0^2}$ or $x_0 = w + 1$, $y_0 = w - 1$ $z_{n+1} \doteq 0.5 \log w$ or $x_0 = w + 0.25$, $y_0 = w - 0.25$ $x_{n+1} \doteq K'\sqrt{w}$.

B.8.4 CORDIC METHODS

CORDIC (coordinate rotation digital computer) methods were first used in 1959 to solve trigonometric relationships that arose in navigation problems (Volder 1959). In the early 1980s, the methods were used by Hewlett-Packard for trigonometric function evaluation on the HP-35 calculator. Schelin (1983) provides a good discussion of the topic.

The functions that can be evaluated using CORDIC methods are sine, cosine, tangent, inverse tangent, hyperbolic sine, hyperbolic cosine, hyperbolic tangent, inverse hyperbolic tangent, natural logarithm, natural exponential, square root, multiplication, and division. In binary form the scheme consists of the iterative equations

$$x_{k+1} = x_k - m\delta_k y_k 2^{-k}$$

$$y_{k+1} = y_k + \delta_k x_k 2^{-k}$$

$$z_{k+1} = z_k - \delta_k \epsilon_k,$$

where $m \in \{-1, 0, 1\}$ is a mode indicator, $\{\epsilon_k\}_{k=0}^{n}$ is a sequence of precomputed constants depending on m, and $\delta_k \in \{-1, 1\}$ are appropriately chosen. The initial values x_0, y_0, and z_0 must also be appropriately chosen. Table B.4 provides the necessary values to obtain the aforementioned functions.

GLOSSARY

ALIASING The visual artifacts generated by drawing on a discrete raster. Aliased lines on the screen are affectionately known to have "jaggies." **Antialiasing** is the process of drawing objects with some amount of blurring to hide the "jaggies."

ALPHA BLENDING The process of blending colors already in the frame buffer with a new set of colors; used for transparency effects.

ALPHA CHANNEL An opacity value that is assigned to a color. An alpha value of 1 corresponds to a completely opaque value. An alpha value of 0 corresponds to a completely transparent value.

ANIMATION As used in this book, the fact that a quantity in the scene graph can be time varying. In the more classic sense, animation refers to geometric values that are time varying. **Key frame animation** refers to the transformations in a hierarchical scene being time varying. **Morphing** refers to the model points themselves being time varying. However, quantities such as render state can also vary with time.

ANTIALIASING See Aliasing.

ASPECT RATIO The ratio of rectangle width and height. The term is typically used in reference to screen dimensions (4/3 for standard monitors, 16/9 for high-definition monitors).

AXIS-ALIGNED BOX A box whose axes are parallel to the standard coordinate axes. A standard acronym for such a box is AABB (axis-aligned bounding box).

BACK BUFFER The block of memory to which the application writes the pixels for the currently rendered scene. A typical rendering system will write to the back buffer and then copy it into the **frame buffer** once the scene is completely rendered.

BACK FACE CULLING See Culling.

BARYCENTRIC COORDINATES Given a triangle with vertices \vec{V}_0, \vec{V}_1, and \vec{V}_2, the barycentric coordinates of a point \vec{X} with respect to the triangle are (c_0, c_1, c_2), where $\vec{X} = c_0\vec{V}_0 + c_1\vec{V}_1 + c_2\vec{V}_2$ with $c_0 + c_1 + c_2 = 1$.

BÉZOUT DETERMINANT A construct that is useful in solving systems of polynomial equations.

BILLBOARD One of the simplest forms used for level of detail consisting of a prerendered image of a three-dimensional object that is applied to a two-dimensional geometric mesh, usually a rectangle. The orientation of the mesh is chosen to be related to the orientation of the camera.

509

BOUNDING VOLUME A regularly shaped object that encloses a region of space and is used for purposes of culling and collision detection. Typical bounding volumes are boxes, capsules, cylinders, ellipsoids, lozenges, and spheres.

BSP TREE A binary tree structure that is used to partition space using planar splitting. The acronym BSP means *binary space partition*. The root node represents all of space and has assigned to it some plane (relevant to the application). The two children of the root node represent the two half-spaces that share the specified plane. Each child node itself can split the space it represents using yet another plane. The standard uses for BSP trees have been for sorting algorithms.

BUMP MAPPING A special effect that gives the appearance of small-scale geometric variation by using a texture map rather than actually perturbing the geometry.

CAMERA MODEL A system consisting of an eye point (location of the camera), a set of coordinate axes, and a view volume. For perspective projections, the view volume is a frustum that is delimited by six planes: the near plane, far plane, left plane, right plane, bottom plane, and top plane. The system also has a viewing plane on which the projections occur. For perspective projections this is usually selected as the near plane. Within the viewing plane the region that contains all the possible projected points is called a **view port**.

CAPSULE An object that consists of all points that are equidistant from a line segment. Algorithms for culling and intersection testing are simpler for a capsule than a cylinder because of the equidistance condition.

CARTESIAN PRODUCT OF SETS Given two sets A and B, the Cartesian product is the set $A \times B$ consisting of pairs (a, b) where $a \in A$ and $b \in B$.

CLIPPING Computing the intersection of objects with the view frustum planes. The portion of the object inside the frustum is drawn by the rasterizer. The portion outside the frustum is not drawn.

COLLISION DETECTION The process of determining if two stationary objects are intersecting is called **static collision detection**. If either or both of the objects are moving, **dynamic collision detection** refers to predicting if, when, and where the two objects will intersect.

COLLISION RESPONSE Given that two objects will intersect, how the objects will behave after the intersection has occurred. Such behavior is determined by the application and usually handled by a general component called the **physics engine**.

COMPACT SET A set is compact if it is bounded and closed. The concept of interval on the real axis provides the motivation. The interval $[a, b]$ is bounded and closed (both a and b are in the set), so it is compact. The intervals $[a, b)$ and $(a, b]$ are bounded, but not closed since each interval does not contain an end point; therefore they are not compact. The interval $[0, \infty)$ is closed, but not bounded, so it is not compact.

CONTINUOUS LEVEL OF DETAIL See **Level of detail**.

CONVEX SET A set is convex if, given two points in the set, the line segment connecting them is also in the set. The **convex hull** of a set of points is the smallest convex set containing the points.

COORDINATES The algebraic abstraction for locating points in space as tuples of numbers. The numbers are measurements relative to a set of axes called coordinate axes. The axes themselves form either a right-handed system or a left-handed system, the conversion from one system to the other involving a single transposition of two components of the tuple. **Model coordinates** refer to the 3-tuples that are used in constructing an object, say, with a modeling package. **World coordinates** refer to the 3-tuples that represent the object in the global coordinate system of the application (see **Transformation**). **View coordinates** refer to the coordinates of a point using the camera model. The origin of the model is the eye point and the coordinate axis directions are specified by the application. **Screen coordinates** refer to the 2-tuples that represent the object after it has been sent through the geometric pipeline of the renderer (transformations followed by perspective projection).

CRACKING Gaps that occur between two rasterized triangles. This usually happens in one of two cases. The first case is when the adjacent triangles share the same edge, but the integer-based edge setup traverses the edge in two different orders and produces different sets of pixels for the edge. The second case is when one triangle is adjacent to two or more triangles, but the edge of the first triangle does not match the combined edges of the other triangles.

CULLING The process by which an object is determined not to be visible and therefore does not have to be drawn by the renderer. The standard culling methods compare bounding volumes of objects to the view frustum. However, **portal culling** allows for additional view-dependent tests based on occlusion by various planar objects in the scene. **Back face culling** allows triangles within a single object to be discarded from rendering when those triangles are not visible to the current eye point.

CYLINDER An object that consists of all points that are equidistant from a line, but truncated by two planes perpendicular to the line. Algorithms for culling and intersection testing are more complicated for a cylinder than a capsule because of the need to handle a cylinder as a volume determined by three conditions (equidistance from line, truncation by two planes).

DEPTH-BASED FOGGING See **Fogging**.

DEPTH BUFFER The block of memory that keeps track of screen depth for written pixels. It is used for sorted drawing on a per-pixel basis.

DEPTH COMPLEXITY How many times a pixel is written to during rendering of the scene for one frame. Given that the entire screen is to be written, the desired depth complexity is 1. As the depth complexity increases, the frame rate tends to decrease.

DETERMINANT A scalar quantity derived from a square matrix M. If M is a 2×2 matrix, M transforms the unit cube into a parallelogram or line segment. The determinant of M is the signed area of that parallelogram, zero in the degenerate case

of a line segment. The idea that a determinant represents area generalizes to higher dimensions, in which case the determinant represents a signed volume.

DISCRETE LEVEL OF DETAIL See **Level of detail**.

EIGENVALUES, EIGENVECTORS, EIGENSOLVERS, AND EIGENDECOMPO-SITIONS Given a square matrix A, a nonzero vector \vec{X}, and a scalar λ, \vec{X} is said to be an *eigenvector* of A corresponding to *eigenvalue* λ if $A\vec{X} = \lambda\vec{X}$. An algorithm that computes the eigenvalues and eigenvectors is called an *eigensolver*. If A is a symmetric matrix, then the eigenvectors can be stored as the columns of an orthonormal matrix R and the eigenvalues can be stored as the diagonal entries of a diagonal matrix D. An *eigendecomposition* of the matrix is $A = RDR^{\mathrm{T}}$. Eigenvalues and eigenvectors are useful in conjuction with Gaussian distributions for determining approximations to, or containment of, point sets.

ENVIRONMENT MAPPING A special effect that allows surfaces to be drawn with a reflection of the environment in which the surface lives. This is useful for mirror effects or for giving the effect of multiple light sources when no real light sources exist in a scene.

EYE POINT The location of the observer in a camera model for a renderer.

FLAT SHADING See **Shading**.

FOGGING **Depth-based fogging** is a mechanism to help hide clipping artifacts at the far plane. A fogging color is blended with vertex colors such that the final color of pixels close to the far plane are nearly the fogging color. Pixels in the foreground have almost no contribution from the fogging color. **Volumetric fogging** is a mechanism to add fog that is not based on depth. This type of fogging is useful for special effects rather than hiding deficiencies in a frustum-based viewing system.

FORWARD KINEMATICS See **Kinematics**.

FRAME BUFFER The block of memory that keeps track of the current color for written pixels. Usually the block resides in video memory for hardware acceleration, but it can reside in system memory for a software renderer. A typical rendering system will write to a **back buffer** that is copied into the frame buffer once the scene is completely rendered.

GAUSSIAN DISTRIBUTION A probability distribution of the form $A \exp((\vec{X} - \vec{U})^{T} C^{-1}(\vec{X} - \vec{U}))$ where A is an appropriate scaling factor, \vec{U} is the *mean*, and C is the *covariance matrix*. The distribution is *isotropic* if C is a multiple of the identity matrix, but *anisotropic* otherwise. This distribution is useful for constructing approximations to point sets by lines or planes and for constructing bounding volumes of points. The algorithms involve constructing \vec{U} and C from the point sets and using the eigenvectors of C in various ways.

GAUSSIAN ELIMINATION The standard method for solving systems of linear equations. The algorithm is discussed in all standard texts on linear algebra.

GOURAUD SHADING See **Shading**.

GRADIENT VECTOR Given a function that maps n-tuples to real numbers, the gradient is the vector whose components are the first-order partial derivatives of the function with respect to the components of the n-tuple.

GRAM-SCHMIDT ORTHONORMALIZATION The process that takes three linearly independent vectors and creates three unit-length vectors that are mutually orthogonal. This is a useful way to adjust matrices that are obtained as products of rotations, but numerical errors are propagated in the products. At periodic intervals the columns of the current matrix can be orthonormalized to correct for numerical errors.

HARDWARE RENDERER See **Renderer**.

HARDWARE TRANSFORM AND LIGHTING Sometimes referred to as *hardware T & L*. Some of the current generation graphics processing units handle the entire geometric pipeline, including transforming, lighting, culling, clipping, and rasterizing. The application need only provide model space data, the camera model, and model-to-world transforms to the hardware API.

HIDDEN SURFACE REMOVAL An **occlusion culling** method to identify portions of the scene that are invisible because they are behind other opaque objects in the scene.

HOMOGENEOUS COORDINATES AND TRANSFORMS Homogeneous coordinates are of the form (x, y, z, w) with $w \neq 0$ and are used in the camera model for perspective projection. Any homogeneous point of the given form is considered to be equivalent to $(x/w, y/w, z/w, 1)$ and is naturally related to perspective projection. Homogeneous transforms are operations applied to homogeneous coordinates to obtain other such coordinates. The use of homogeneous coordinates and transforms is a mathematical convenience for motivating the transformation pipeline in a renderer, but unless there is hardware support for 4×4 matrices and 4×1 vectors, an implementation of the transformation pipeline does not need to handle these quantities and can work with 3×3 matrices and 3×1 vectors instead.

IMPOSTOR See **Billboard**.

INVERSE KINEMATICS See **Kinematics**.

KEY FRAME ANIMATION See **Animation**.

KINEMATICS The study of motion without consideration of mass or forces. The simplest structures to study are objects that are linked in a linear chain. **Forward kinematics** refers to specifying the transforms for the objects and computing the new positions and orientations of each object, one at a time, starting with the first in the chain. **Inverse kinematics** refers to specifying the (desired) position and orientation of the last object in the chain and determining the positions and orientations of the other objects in the chain.

LAGRANGE MULTIPLIERS A method of calculus that allows the calculation of an extreme value of a function when there are additional equality constraints. The

method introduces new variables to formulate the optimization in higher dimensions in a way that can be solved by the standard techniques that determine where the gradient vector is zero.

LEAST-SQUARES FIT The process of estimating the parameters of a parameterized object that is used to approximate a discrete point set. The estimates are based on minimizing the sum of the squared errors between the discrete points and the parameterized object. The least-squares algorithms involve fitting a line or plane to point sets.

LENS FLARE A special effect that attempts to reproduce the visual effects of interaction between a light source and the lens of a camera.

LEVEL OF DETAIL The concept of providing to the renderer a representation of an object, with the complexity of the representation being dependent on various parameters in the system including geometry of the object and camera model information. The essential idea is to draw a high-resolution representation when the object is close to the eye point and to draw lower-resolution representations as the object is moved away from the eye point. An acronym used for this term is LOD. The term **discrete level of detail** is used when there is a small number of representations for the object and the selection of representation is based on a simple criterion such as distance from eye point. The term **continuous level of detail** (CLOD) is used when the number of representations is potentially quite large and the selection itself can be a complex process.

LIGHT A representation in a graphics system of a real light source. For computational efficiency in a real-time system, light sources are assumed to be ambient, directional, point, or spot lights. An ambient light affects all objects in the same way in that all vertices receive the same contribution from the light. A directional light is assumed to be located infinitely far from the objects, but the light rays all have the same direction. Contributions to the vertex values depend on normal vectors defined at the vertices. A point light has a specified location and emits light in all directions. Contributions to the vertices also depend on normal vectors defined at the vertices. A spot light has a specified location, but light is emitted only with a specified cone. Once again, contributions to the vertices depend on normal vectors defined at the vertices.

LIGHTING The process of computing the final color at each vertex in the scene. Calculations depend on the light sources, and contributions are classified as ambient, diffuse, specular, or emissive. The light sources can be attenuated in that the final contribution depends on the distance from light source to object. **Static lighting** refers to calculating the final contributions of stationary light sources to stationary geometry. These calculations can be done off-line, and the vertices can simply store the final colors for use by the renderer. **Dynamic lighting** refers to calculating the final contributions of light sources to the vertices at run time. In this case, vertex normals must be stored since calculations involving directional, point, or spot lights require this information.

LINEAR COMPONENT A general term that refers to lines, rays, or line segments.

LOZENGE An object that consists of all points that are equidistant from a rectangle.

MATERIALS An object in a scene can have materials associated with it. The material attributes are used in conjunction with lighting to obtain a more realistic appearance of the object.

MATRIX An $R \times C$ table of values with a specified number of rows R and columns C. In graphics typically the matrices are 3×3 or 4×4. Various operations can be applied to matrices including transpose, inverse, adjoint, and computation of determinant. The definitions for these can be found in standard texts on matrix algebra.

MIPMAPPING Interpolation of images in a multiresolution pyramid. See **Textures**.

MORPHING The process of animating an object by either procedurally changing its vertices or by blending between two objects over time.

MULTITEXTURING Many special effects can be implemented by using two or more textures on an object. **Static multitexturing** refers to the two textures and texture coordinates being known before the program run. The texture interpolation is done by the rasterizer and the colors are combined in the usual way. For example, a decal can be applied as a secondary texture. **Dynamic multitexturing** refers to a secondary texture or secondary texture coordinates being calculated on the fly. For example, projected shadows are computed dynamically.

NEWTON'S ITERATION METHOD FOR ROOT FINDING Given a function $f(x)$, roots of the function are those values x for which $f(x) = 0$. A simple iterative method for constructing the roots is to choose an initial guess x_0 and compute $x_{n+1} = x_n - f(x_n)/f'(x_n)$ for $n \geq 0$.

OCCLUSION CULLING Objects in the view frustum can still be invisible if they are completely hidden by other objects. Occlusion culling refers to a class of methods whose goal is to rapidly determine such hidden objects so that the renderer does not have to process them.

OCTREE A data structure that represents a node in a tree that has eight children. An octree is usually used for partitioning space. It is a special case of a **BSP tree**.

ORIENTED BOX A box whose axes can occur in any orientation, not just in the orientation of the standard coordinate axes. A standard acronym for such a box is OBB (oriented bounding box).

PARTICLE SYSTEM A collection of small objects, usually points (zero area) or rectangles (positive area), that can be colored in the usual way that vertices in a triangle mesh are colored (vertex colors, textures). Various special effects can be simulated such as smoke, fog, or water fountains. The rectangular particles are usually treated as billboards so that they always face the camera. Moreover, they usually have alpha-blended textures to give the rectangles the appearance of arbitrarily shaped geometry. The behavior of particles can be governed by any physics imaginable.

PERSPECTIVE PROJECTION The operation of mapping 3D objects onto a 2D plane using an eye point not located on the plane. All points along a ray from the eye point whose direction is not perpendicular to the plane are mapped to the same point on the plane.

PHONG SHADING See **Shading**.

PHYSICS ENGINE See **Collision response**.

PICKING The classic definition refers to using an input device such as a mouse to select a 3D object or point on the 2D computer screen. This process requires constructing a ray in world coordinates whose origin is the eye point and whose direction is determined from the camera model and the selected screen pixel. That ray is then tested for intersection with the objects in the scene. In this book, picking refers to the more general process of computing the intersection of a linear component with an object.

POLYTOPE AND POLYHEDRON Three-dimensional objects that are made up of planar facets.

POPPING Noticeable changes in a triangle mesh during a change in level of detail. For discrete level of detail the noticeable changes have to do with switching the entire object resolution. For continuous level of detail the noticeable changes have to do with two triangles collapsing into one or one triangle expanding into two.

PORTAL Visibility determination in an indoor environment can be done using portals. The typical example occurs when an observer is outside a room and looking into the room through a doorway (the portal). The observer only sees what is visible through the doorway. The wall of the doorway occludes everything else. A portal system will construct culling/clipping planes formed by the eye point and each edge of the doorway, assuming the doorway is a convex polygon.

PORTAL CULLING See **Culling**.

POWELL'S DIRECTION SET METHOD A method for computing the minimum of a multivariate function by solving for minima along various lines in the domain of the function. The method is iterative and avoids derivative calculations, so it is useful when the derivative is unknown or expensive to compute numerically.

PROJECTED LIGHT An example of dynamic multitexturing where a light source is chosen and a texture map is associated with it. Triangles that are to receive the texture map require their texture coordinates to be computed on the fly if the light position or direction change.

PROJECTED SHADOW An example of dynamic multitexturing where a light source is chosen and a texture map representing a shadow affected by the light is constructed on the fly. The triangles that are to receive the texture map require their texture coordinates to be computed on the fly if the light position or direction changes.

QUADTREE A data structure that represents a node in a tree that has four children. A quadtree is usually used for partitioning the plane. It is a special case of a **BSP tree**.

QUATERNIONS A set of 4-tuples that form an algebraic system in which multiplication is not a commutative operation. The unit-length quaternions are used as a compact representation of rotations. This representation is also convenient for use in key frame animation.

RASTERIZER As used in this book, the component of the computer graphics system that has the responsibility for calculating and drawing the screen pixels corresponding to each triangle that it is given by the renderer.

RENDERER As used in this book, the component of the computer graphics system that has the responsibility for drawing the triangles of a model using the current drawing state information, called **render state**. A **software renderer** is an implementation that uses only the central processing unit for computations. A **hardware renderer** is an implementation that relies on a graphics processing unit to handle the computations.

SCENE GRAPH The data structure that represents all the data in a scene. The geometric relationships are represented as a tree where the leaf nodes contain the drawable data. Sharing of data leads to additional linking that requires a graph data structure.

SCENE GRAPH MANAGEMENT The process of maintaining a scene graph. This includes various systems such as hierarchical culling and transformations, accumulation and updating of geometric and renderer state, automatic selection of level of detail, picking and collision detection, and so on.

SCREEN SPACE The coordinate system for the computer screen or raster image.

SEPARATING AXIS A line such that the projection of two objects onto that line are disjoint. In this case the two objects cannot intersect since there exists a plane perpendicular to the line such that the two objects are separated by the plane.

SHADING The process of computing pixel colors. **Flat shading** uses the same color for all pixels in a renderer triangle. **Gouraud shading** applies the lighting equations to the vertices of the triangle to get the final vertex colors and then interpolates them to obtain the remaining pixel colors. **Phong shading** interpolates the vertex normals at each pixel and applies the lighting equations per pixel. This method is expensive and is not typically used in a real-time system.

SIMPLIFICATION The process of dynamically calculating the new triangle mesh in a continuous level-of-detail algorithm. See also **Tessellation**.

SKIN AND BONES A skeletal system for which the bones are represented as nodes in a scene graph and the skin is a triangle mesh whose vertex positions are determined by predefined relationships between each vertex and various bones. The typical representation assigns to each vertex a list of bones and a list of weights corresponding to those bones.

SOFTWARE RENDERER See Renderer.

SPRITE See Billboard.

STREAMING The process of converting one form of data to another where the two data sets reside on different media. One example is reading data from disk into memory or writing data from memory to disk. Another example is sending data from one computer to another, which typically involves repackaging the data for the transfer.

SUBDIVISION The process of taking a curve or surface and computing a set of points that are in some sense representative of the original object. See also **Tessellation**.

TESSELLATION The process by which an object in whatever form is approximated by triangles. For example, for the purpose of drawing, a sphere can be approximated by a collection of triangles. The sphere is said to be tessellated by the triangles. **Static tessellation** refers to the construction of triangles being performed once on an object, with that representation used for the lifetime of a program run. **Dynamic tessellation** refers to the construction being performed on an as-needed basis, for example, in schemes involving continuous level of detail.

TEXTURES Images applied to the models in a scene to provide realism. The images can be generated by an artist or obtained from digital photographs. Each pixel of the image together with its color value is called a texture element or **texel**. In order for a rasterizer to draw a model with texture, the vertices of the triangles need to be assigned **texture coordinates** that represent pixel locations in the image. During interpolation the coordinates can be **clamped** or **wrapped**. When wrapped, the texture image is usually **cylindrical** (image is periodic in one direction) or **toroidal** (image is periodic in both directions). Also during interpolation the pixel locations might not exactly be a texel location and the resulting rasterized triangle is aliased. The texel selection is called **nearest neighbor filtering**. Other types of filtering can be applied to remove the aliasing. Examples are **bilinear filtering** and **trilinear filtering**. The latter involves calculation of a pyramid of textures from the initial one. The construction is called **mipmapping**. Interpolation can occur both within and across images in the pyramid.

TOPOLOGY OF A MESH In computer graphics, the characteristics of a mesh relating to its boundaries and how many holes are in the mesh. For example, the triangle meshes that tessellate a cube and a sphere have the same topology in that neither has a boundary polyline and neither has holes. A triangle mesh that tessellates a torus does not have the same topology as a sphere mesh since it has no boundary yet has one hole. A triangle mesh that tessellates a planar square does not have the same topology as a sphere mesh since it has a boundary and no holes.

TRANSFORMATION An operation that converts points in one coordinate system into points in another coordinate system. In a hierarchical system, **local transforms** are used to represent the positioning of objects relative to a parent coordinate system. **World transforms** are used to represent the positioning of objects in a global coordinate system that is natural to the application.

TREE A data structure that represents a hierarchical relationship among nodes. Each node has at most one predecessor (a parent node) and any number of successors (child nodes). A **binary tree** is a tree for which each node has at most two children.

A **quadtree** is a tree for which each node has exactly four children and is used for partitioning a plane. An **octree** is a tree for which each node has exactly eight children and is used for partitioning space.

TRIANGLE FAN The tessellation of a convex polygon where one vertex is common to all triangles. If the vertices are ordered as \vec{V}_0 through \vec{V}_n, then the triangles in the tessellation are $\langle \vec{V}_0, \vec{V}_1, \vec{V}_2 \rangle, \langle \vec{V}_0, \vec{V}_2, \vec{V}_3 \rangle, \ldots, \langle \vec{V}_0, \vec{V}_{n-1}, \vec{V}_n \rangle$.

TRIANGLE MESH A collection of triangles that share a set of vertices but whose connectivity must also be specified. A **manifold triangle mesh** is one such that an edge is shared by at most two triangles. A **nonmanifold triangle mesh** can have an arbitrary number of triangles sharing an edge.

TRIANGLE STRIP A list of triangles, each triangle sharing two vertices from the previous triangle. This data structure is useful when there is hardware support: once the vertices of the first triangle are transformed, each additional triangle requires only one more vertex transformation. If the vertices are ordered as \vec{V}_0 through \vec{V}_n, then the triangles in the tessellation are $\langle \vec{V}_0, \vec{V}_2, \vec{V}_1 \rangle, \langle \vec{V}_1, \vec{V}_2, \vec{V}_3 \rangle, \langle \vec{V}_2, \vec{V}_4, \vec{V}_3 \rangle, \langle \vec{V}_3, \vec{V}_4, \vec{V}_5 \rangle$, and so on.

VECTOR An $R \times 1$ table of values with a specified number of rows R and 1 column. In graphics typically the vectors are 3×1 or 4×1. Various operations can be applied to vectors including dot product, cross product, and normalization. The definitions for these can be found in standard texts on vector algebra.

VERTEX A vector that is associated with a triangle mesh that represents an object in the graphics system. A vertex can have various attributes, called **vertex attributes**, associated with it such as texture coordinates, color, or normal vector. These attributes are used to calculate final vertex colors that are used by the rasterizer for interpolation and drawing of a triangle. The interpolated attributes are called **surface attributes**.

VIEW FRUSTUM That portion of view space that is considered to be visibile to the eye point. It is formed by six **view planes** called the near, far, left, right, top, and bottom planes.

VIEW PORT See **Camera model**.

VIEW SPACE The coordinate system of the camera model for a renderer. The origin is the eye point, and the directions of the coordinate axes correspond to the direction, up, and left vectors of the camera.

VISIBILITY Which objects are visible from the current eye point. Knowing what objects are visible (or potentially visible) is helpful because only those objects need to be processed by the renderer. The topic is related to occlusion culling.

VOLUMETRIC FOGGING See **Fogging**.

Z-BUFFER See **Depth buffer**.

BIBLIOGRAPHY

Abramowitz, M., and I.A. Stegun. 1965. *Handbook of Mathematical Functions with Formulas, Graphs, and Mathematical Tables.* Dover, New York.

Andres, E. 1994. Discrete circles, rings and spheres. *Computer and Graphics,* vol. 18, no. 5, pp. 695–706.

Andres, E., and M.A. Jacob. 1997. The discrete analytical hyperspheres. *IEEE Transactions on Visualization and Computer Graphics,* vol. 3, no. 1.

Arvo, J., ed. 1991. *Graphics Gems II.* Academic Press, San Diego, CA.

Blinn, J.F. 1978. Simulation of wrinkled surfaces. *Proceedings of SIGGRAPH 1978,* pp. 192–198.

Blinn, J.F. 1996. *Jim Blinn's Corner: A Trip Down the Graphics Pipeline,* Morgan Kaufmann, San Francisco, CA.

Blinn, J.F., and M.E. Newell. 1976. Texture and reflection in computer generated images. *Communications of the ACM,* vol. 19, no. 10, pp. 542–547.

Blum, H., and R.N. Nagel. Shape description using weighted symmetric axis features. *Pattern Recognition,* vol. 10, pp. 167–180.

Boehm, W. 1982. On cubics: a survey. *Computer Graphics and Image Processing,* vol. 19, pp. 201–226.

Booch, G. 1987. *Software Components with Ada: Structures, Tools, and Subsystems.* Benjamin/Cummings, Menlo Park, CA.

Bresenham, J.E. 1965. Algorithm for computer control of a digital plotter. *IBM Systems Journal,* vol. 4, no. 1, pp. 25–30.

Burden, R.L., and J.D. Faires. 1985. *Numerical Analysis,* 3rd edition. Prindle, Weber & Schmidt, Boston.

Cameron, S. 1996. A comparison of two fast algorithms for computing the distance between convex polyhedra. *IEEE Transactions on Robotics and Automation,* vol. 13, no. 6, pp. 915–920.

Cendes, Z.J., and S.H. Wong. 1987. C^1 quadratic interpolation over arbitrary point sets. *IEEE Computer Graphics and Applications,* pp. 8–16.

Cohen, J.D., M. Olano, and D. Manocha. 1998. Appearance-preserving simplifications. *Proceedings of SIGGRAPH 1998,* pp. 115–122.

Cohen, J.D., A. Varshney, D. Manocha, G. Turk, H. Weber, P. Agarwal, F. Brooks, and W. Wright. 1996. Simplification envelopes. *Proceedings of SIGGRAPH 1996,* pp. 119–128.

Das, H., J.-J.E. Slotine, and T.B. Sheridan. 1988. Inverse kinematic algorithms for redundant systems. *IEEE International Conference on Robotics and Automation,* pp. 43–48.

Eberly, D. 1996. *Ridges in Image and Data Analysis.* Series on Computational Imaging and Vision, Max A. Viergever, ed. Kluwer, Dordrecht, Netherlands.

Ellis, M.A., and B. Stroustrup. 1994. *The Annotated C++ Reference Manual,* Addison-Wesley, Reading, MA.

Farin, G. 1990. *Curves and Surfaces for Computer Aided Geometric Design.* Academic Press, San Diego, CA.

Foley, J.D., A. van Dam, S.K. Feiner, and J.F. Hughes. 1990. *Computer Graphics: Principles and Practice,* 2nd edition. Addison-Wesley, Reading, MA.

Fuchs, H., Z. Kedem, and B. Naylor. 1979. Predetermining visibility priority in 3-D scenes. *Proceedings of SIGGRAPH 1979,* pp. 175–181.

Fuchs, H., Z. Kedem, and B. Naylor. 1980. On visible surface generation by *a priori* tree structures. *Proceedings of SIGGRAPH 1980,* pp. 124–133.

Garland, M., and P. Heckbert. 1997. Surface simplification using quadric error metrics. *Proceedings of SIGGRAPH 1997,* pp. 209–216.

Garland, M., and P. Heckbert. 1998. Simplifying surfaces with color and texture using quadric error metrics. *IEEE Visualization 1998,* pp. 263–269.

Gilbert, E.G., D.W. Johnson, and S.S. Keerthi. 1988. A fast procedure for computing the distance between objects in three-dimensional space. *IEEE J. Robotics and Automation,* vol. RA-4, pp. 193–203.

Glassner, A.S., ed. 1990. *Graphics Gems I.* Academic Press, San Diego, CA.

Golub, G.H., and C.F. Van Loan. 1993. *Matrix Computations,* 2nd edition. Johns Hopkins University Press, Baltimore, MD.

Gottschalk, S., M. Lin, and D. Manocha. 1996. OBBTree: A hierarchical structure for rapid interference detection. *Proceedings of SIGGRAPH 1996,* pp. 171–180.

Greene, N. 1986. Environment mapping and other applications of world projections. *IEEE Computer Graphics and Applications,* vol. 6, no. 11, pp. 21–29.

Gregory, A., M. Lin, S. Gottschalk, and R. Taylor. 1998. A framework for fast and accurate collision detection for haptic interaction. Technical Report TR98-032, Department of Computer Science, University of North Carolina at Chapel Hill.

Heckbert, P., ed. 1994. *Graphics Gems IV.* Academic Press, San Diego, CA.

Hecker, C. 1995a. Perspective texture mapping, part I: Foundations. *Game Developer Magazine,* Miller Freeman, pp. 16–25, April/May.

Hecker, C. 1995b. Perspective texture mapping, part II: Rasterization. *Game Developer Magazine,* Miller Freeman, pp. 18–26, June/July.

Hecker, C. 1995c. Perspective texture mapping, part III: Endpoints and mapping. *Game Developer Magazine,* Miller Freeman, pp. 17–24, August/September.

Hecker, C. 1995d. Perspective texture mapping, part IV: Approximations. *Game Developer Magazine*, Miller Freeman, pp. 19–25, December/January.

Hecker, C. 1996. Perspective texture mapping, part V: It's about time. *Game Developer Magazine*, Miller Freeman, pp. 25–33, April/May.

Heidrich, W., and H.-P. Seidel. 1998. View-independent environment maps. *Proceedings of the 1998 Eurographics/SIGGRAPH Workshop on Graphics Hardware*, pp. 39–45.

Held, M. 1997. A collection of efficient and reliable intersection tests. *Journal of Graphics Tools*, vol. 2, no. 4, pp. 25–44, A.K. Peters Ltd., Natick, MA.

Hoppe, H. 1996a. Progressive meshes. *Proceedings of SIGGRAPH 1996*, pp. 99–108.

Hoppe, H. 1996b. View-dependent refinement of progressive meshes. *Proceedings of SIGGRAPH 1996*, pp. 189–198.

Horn, R.A., and C.R. Johnson. 1985. *Matrix Analysis*. Cambridge University Press, Cambridge, England.

Kirk, D., ed. 1992. *Graphics Gems III*. Academic Press, San Diego, CA.

Kochanek, D.H.U., and R.H. Bartels. 1986. Interpolating splines with local tension, continuity, and bias control. *ACM SIGGRAPH 1986*, Course Notes 22, Advanced Computer Animation.

Landers, J. 1998a. Skin them bones: Game programming for the Web generation. *Game Developer Magazine*, Miller Freeman, pp. 11–16, May.

Landers, J. 1998b. Oh my God, I inverted kine. *Game Developer Magazine*, Miller Freeman, pp. 9–14, September.

Larsen, E., S. Gottschalk, M.C. Lin, and D. Manocha. 1999. Fast proximity queries with sphere-swept volumes. Technical Report TR99-018, Department of Computer Science, University of North Carolina at Chapel Hill.

Liang, Y.-D., and B.A. Barsky. 1984. A new concept and method for line clipping. *ACM Transactions on Graphics*, vol. 3, no. 1, pp. 1–22.

Lindstrom, P., D. Koller, W. Ribarsky, L.F. Hodges, N. Faust, and G.A. Turner. 1996. Real-time, continuous level of detail rendering of height fields. *Proceedings of SIGGRAPH 1996*, pp. 109–118.

Lindstrom, P., and G. Turk. 1998. Fast and memory efficient polygonal simplification. *IEEE Visualization 1998*, pp. 279–286.

Lippman, S.B. 1991. *C++ Primer*, 2nd edition. Addison-Wesley, Reading, MA.

Luebke, D., and C. Erikson. 1997. View-dependent simplification of arbitrary polygonal environments. *Proceedings of SIGGRAPH 1997*, pp. 199–208.

McReynolds, T., D. Blythe, B. Grantham, and S. Nelson. 1998. Programming with OpenGL: Advanced techniques. *ACM SIGGRAPH 1998*, Course Notes 17.

Meyer, B. 1988. *Object-Oriented Software Construction*. International Series in Computer Science, C.A.R. Hoare, ed. Prentice Hall, New York.

Möller, T. 1997. A fast triangle-triangle intersection test. *Journal of Graphics Tools*, vol. 2, no. 2, pp. 25–30, A.K. Peters Ltd., Natick, MA.

Möller, T., and E. Haines. 1999. *Real-Time Rendering*, A.K. Peters Ltd., Natick, MA.

Möller, T., and B. Trumbore. 1997. Fast, minimum storage ray-triangle intersection. *Journal of Graphics Tools*, vol. 2, no. 1, pp. 21–28, A.K. Peters Ltd., Natick, MA.

Nackman, L. 1982. Three-dimensional shape description using the symmetric axis transform. Ph.D. Thesis, Department of Computer Science, University of North Carolina at Chapel Hill.

Novaković, Z.R., and B. Nemec. 1990. A solution of the inverse kinematics problem using the sliding mode. *IEEE Transactions on Robotics and Automation*, vol. 6, no. 2, pp. 247–252.

O'Rourke, J. 1994. *Computational Geometry in C*. Cambridge University Press, Cambridge, England.

Paeth, A., ed. 1995. *Graphic Gems V*. Academic Press, San Diego, CA.

Phillips, C., J. Zhao, and N. Badler. 1990. Interactive real-time articulated figure manipulation using multiple kinematic constraints. *SIGGRAPH I3D Symposium*, vol. 24, no. 2, pp. 245–250.

Press, W.H., B.P. Flannery, S.A. Teukolsky, and W.T. Vetterling. 1988. *Numerical Recipes in C: The Art of Scientific Computing*. Cambridge University Press, Cambridge, England.

Rossignac, J., and P. Borrel. 1993. Multiresolution 3D approximations for rendering complex scenes. In *Modeling in Computer Graphics: Methods and Applications*, B. Falcidieno and T. Kunii, eds., pp. 455–463.

Samet, H. 1989. *The Design and Analysis of Spatial Data Structures*. Addison-Wesley, Reading, MA.

Samet, H. 1990. *Applications of Spatial Data Structures*. Addison-Wesley, Reading, MA.

Schelin, C.W. 1983. Calculator function approximation. *AMS Monthly*, pp. 317–325, May.

Schroeder, W.J., J.A. Zarge, and W.E. Lorensen. 1992. Decimation of triangle meshes. *Proceedings of SIGGRAPH 1992*, pp. 65–70.

Sciavicco, L., and B. Siciliano. 1987. A dynamic solution to the inverse kinematic problem for redundant manipulators. *IEEE International Conference on Robotics and Automation*, pp. 1081–1086.

Sharp, B. 1999. Optimizing curved surface geometry. *Game Developer Magazine*, pp. 40–48, Miller Freeman, July.

Shoemake, K. 1987. Animating rotation with quaternion calculus. *ACM SIGGRAPH 1987*, Course Notes 10, Computer Animation: 3-D Motion, Specification, and Control.

Teller, S. 1992. Visibility computations in densely occluded polyhedral environments. Doctoral Dissertation in Computer Science, University of California, Berkeley.

Thomas, G., and R. Finney. 1988. *Calculus and Analytic Geometry,* 7th edition. Addison-Wesley, Reading, MA.

Thorpe, J.A. 1979. *Elementary Topics in Differential Geometry,* Undergraduate Texts in Mathematics. Springer-Verlag, New York.

van den Bergen, G. 1999. Solid 2.0 Collision Library. *www.win.tue.nl/cs/tt/gino/solid.*

Volder, J. 1959. The CORDIC computing technique. *IRE Transactions on Computers,* vol. EC-8, pp. 330–334.

Wang, L.-C., and C.C. Chen. 1991. A combined optimization method for solving the inverse kinematics problem of mechanical manipulators. *IEEE Transactions on Robotics and Applications,* vol. 7, no. 4, pp. 489–499.

Watson, D.F. 1981. Computing the n-dimensional Delaunay tessellation with application to Voronoi polytopes. *Computer Journal,* vol. 24, no. 2, pp. 167–172.

Watt, A., and M. Watt. 1992. *Animation and Rendering Techniques: Theory and Practice.* ACM Press, New York.

Wee, C.E., and R.N. Goldman. 1995a. Elimination and resultants part 1: Elimination and bivariate resultants. *IEEE Computer Graphics and Applications,* pp. 69–77, January.

Wee, C.E., and R.N. Goldman. 1995b. Elimination and resultants part 2: Multivariate resultants. *IEEE Computer Graphics and Applications,* pp. 60–69, March.

Welman, C. 1993. Inverse kinematics and geometric constraints for articulated figures. Master's Thesis, Simon Frasier University. *fas.sfu.ca/pub/cs/theses/1993/ChrisWelmanMSc.ps.gz.*

Welzl, E. 1991. Smallest enclosing disks (balls and ellipsoids). *Lecture Notes in Computer Science, New Results and New Trends in Computer Science.* H. Maurer, ed., vol. 555, pp. 359–370. Springer-Verlag, New York.

Williams, L. 1978. Casting curved shadows on curved surfaces. *Proceedings of SIGGRAPH 1978,* pp. 270–274.

Williams, L. 1983. Pyramidial parametrics. *Computer Graphics,* vol. 7, no. 3, pp. 1–11.

Zhao, J., and N.I. Badler. 1994. Inverse kinematics positioning using nonlinear programming for highly articulated figures. *ACM Transactions on Graphics,* vol. 13, no. 4, pp. 313–336.

INDEX

About the Author

David Eberly is the President of Magic Software, Inc. *(www.magic-software.com)*, a company known for its Web site that offers free source code and documentation for computer graphics, image analysis, and numerical methods. Previously he was the Director of Engineering at Numerical Design Limited, the company responsible for the real-time 3D game engine, NetImmerse. His background includes a B.A. degree in mathematics from Bloomsburg University, M.S. and Ph.D. degrees in mathematics from the University of Colorado at Boulder, and M.S. and Ph.D. degrees in computer science from the University of North Carolina at Chapel Hill. He is co-author with Philip Schneider of the forthcoming *Geometry Tools for Computer Graphics*, to be published by Morgan Kaufmann.

As a mathematician, Dave did research in the mathematics of combustion, signal and image processing, and length-biased distributions in statistics. He was a research associate professor at the University of Texas at San Antonio with an adjunct appointment in radiology at the U.T. Health Science Center at San Antonio. In 1991 he gave up his tenured position to retrain in computer science at the University of North Carolina. During his stay at U.N.C., MAGIC (My Alternate Graphics and Image Code) was born as an attempt to provide an easy-to-use set of libraries for image analysis. Since its beginnings in 1991, MAGIC has continually evolved into the "net library" that it currently is, now managed by the company Magic Software, Inc. After graduating in 1994, he remained for one year as a research associate professor in computer science with a joint appointment in the Department of Neurosurgery working in medical image analysis. His next stop was the SAS Institute working for a year on SAS/Insight, a statistical graphics package. Finally, deciding that computer graphics and geometry were his real calling, Dave went to work for Numerical Design Limited, then later to Magic Software, Inc. Dave's participation in the newsgroup *comp.graphics.algorithms* and his desire to make 3D graphics technology available to all are what has led to the creation of this book. The evolution of Magic will continue and the technology transfer is not yet over.

ABOUT THE CD-ROM

Contents of the CD-ROM

The accompanying CD-ROM contains source code that illustrates the ideas in the book. A partial listing of the directory structure is

```
/Wild Magic 0.4
    LinuxReadMe.txt
    WindowsReadMe.txt
    /Linux
        /WildMagic
            /Applications
            /Include
            /Library
            /Licenses
            /Object
            /SourceFree
            /SourceGameEngine
    /Windows
        /WildMagic
            /Applications
            /Include
            /Library
            /Licenses
            /SourceFree
            /SourceGameEngine
            /Tools
```

The read-me files contain the installation instructions and other notes. The path `Windows/WildMagic` contains the distribution for use on a computer whose operating system is one of Windows 95, Windows 98, Windows NT, or Windows 2000. The path `Linux/WildMagic` contains the distribution for use on a computer whose operating system is Linux. Compiled source code is already on the CD-ROM. The application directories, located in `Applications`, contain compiled executables that are ready to run.

The distributions are nearly identical. The Windows text files have lines that are terminated by carriage return and line feed pairs whereas the Linux text files are terminated by line feeds. The Windows distribution contains an OpenGL renderer and a Win32 application layer, both dependent on the operating system. The Windows distribution also has a rudimentary software renderer and it has a tool for converting bitmap (*.bmp) files to Magic image files (*.mif). Both the Windows and Linux distributions contain an OpenGL renderer and an application layer that is dependent on GLUT. The Windows code is supplied with Microsoft Developer Studio Projects

(*.dsp) and Microsoft Developer Studio Workspaces (*.dsw). The Linux code is supplied with make files. The other portions of the distributions are the same.

License Agreements

Each source file has a preamble stating which of two license agreements governs the use of that file. The license agreements are located in the directory `Licenses`. The source code in the path `SourceGameEngine` is governed by the license agreement `Licenses/3DGameEngine.pdf`. The remaining source code is governed by the license agreement `Licenses/free.pdf`. All source code may be used for commercial or noncommercial purposes subject to the constraints given in the license agreements.

Installation on a Windows Sytem

These directions assume that the CD-ROM drive is drive `D` and the disk drive to which the contents are to be copied is drive `C`. Of course you will need to substitute the drive letters that your system is using. Copy the CD-ROM subtree `D:\Wild Magic 0.4\Windows\WildMagic` to `C:\SomePath\WildMagic`. Since the files are copied as read-only, execute the following two commands, in order, from a command window: `cd C:\SomePath\WildMagic` and `attrib -r *.* /s`. The distribution comes precompiled, but if you want to rebuild it, open the workspace `C:\SomePath\WildMagic\BuildAll.dsw` and select the `BuildAll` project (the default one that shows up in the project list box is `BezierSurface`). Build both the `Debug` and `Release` configurations. This builds the `SourceFree`, `SourceGameEngine`, and `Application` source trees, in that order. Each of the directories `SourceFree`, `SourceGameEngine`, and `Applications` has a top level workspace to build only those pieces.

Installation on a Linux System

Mount the CD-ROM drive by: `mount -t iso9660 /dev/cdrom /mnt`. If your desired top level directory is `/HomeDirectory/SomePath` (substitute the actual path to your home directory), and if your current working directory is `/HomeDirectory/SomePath` then use `cp "/mnt/Wild Magic 0.4/Linux/WildMagic" -r .` to generate the source tree `/HomeDirectory/SomePath/WildMagic`. Note that "." is the last argument of "cp". Since the files are copied as read-only, execute the following two commands, in order, (assumes your current working directory is still `/HomeDirectory/SomePath`): `cd WildMagic` and `chmod a+rw -R *`. The distribution comes precompiled, but if you want to rebuild it, run `make` on the makefile in the `WildMagic` subdirectory. Build the `Debug` configuration by `make CONFIG=Debug` and the Release configuration by `make CONFIG=Release`. Each of the directories `SourceFree`, `SourceGameEngine`, and `Applications` has a top-level makefile to build only those pieces.

You need some form of OpenGL and GLUT on your machine. I downloaded Mesa packages from the Red Hat site, `Mesa-3.2-2.i686.rpm`, `Mesa-devel-3.202.i686.rpm`, and `Mesa-glut-3.1-1.i686.rpm`, and used the Gnome RPM tool to install them. I told the tool to ignore the fact that GLUT is 3.1 and Mesa is 3.2. The installation puts the libraries in `/usr/X11R6/lib` and the headers in `/usr/X11R6/include`. The makefiles for applications use the libraries `libGL.la`, `libGLU.la`, and `libglut.la`.

TRADEMARKS

The following trademarks, mentioned in this book and the accompanying CD-ROM, are the property of the following organizations.

- K6 is a trademark of Advanced Micro Devices, Inc.
- Macintosh is a trademark of Apple Corporation.
- Myst is a trademark of Cyan, Inc.
- Pentium II, Pentium III, and VTune are trademarks of Intel Corporation.
- DirectX, Direct3D, Visual C++, Windows, and X-Box are trademarks of Microsoft Corporation.
- Prince of Persia 3D is a trademark of Brøderbund Software, Inc.
- Dolphin is a trademark of Nintendo Corporation.
- BoundsChecker is a trademark of NuMega Technologies, Inc.
- NetImmerse is a trademark of Numerical Design, Ltd.
- GeForce, TNT, and TNT2 are trademarks of nVidia Corporation.
- Eclipse is a trademark of Random Games.
- Dreamcast is a trademark of Sega Enterprise, Ltd.
- OpenGL is a trademark of Silicon Graphics, Inc.
- Playstation2 is a trademark of Sony Computer Entertainment, Inc.
- Glide is a trademark of 3Dfx Interactive, Inc.

All other product names are trademarks or registered trademarks of their respective companies. Where trademarks appear in this book and Morgan Kaufmann Publishers was aware of a trademark claim, the trademarks have been printed in initial caps or all caps.

LIBRARIES ON THE CD-ROM
(alphabetical order, related chapters and sections)

Animation (9): Key frame animation, inverse kinematics, skin and bones.

Application: Application layer that hides the underlying operating system, command line parsing, binding of keyboard to changing a transformation.

Approximation (15.3): Fitting of point sets with circles, ellipses, ellipsoids, Gaussian distributions, lines, planes, paraboloids, quadratic curves, quadratic surfaces, spheres.

Containment (2.4, 6.7): Bounding volume trees (box, capsule, lozenge, sphere), containment by circles, boxes, capsules, cylinders, ellipsoids, lozenges, spheres.

Core (2.1, 2.2, 2.3, 2.4): Geometric objects (box, capsule, circle, cylinder, disk, ellipse, ellipsoid, line, lozenge, parallelogram, plane, ray, rectangle, segment, sphere), vector and matrix algebra, quaternions, polynomials, colors, strings, template container classes.

Curve (7): Abstract curve class (position, derivatives, tangents, speed, arc length, reparameterization by arc length, subdivision algorithms), 2D curves (curvature, normals), 3D curves (curvature, torsion, normals, binormals), polynomial curves, Bézier curves, B-spline curves, cubic spline curves, tension-bias-continuity curves.

Detail (10): Discrete level of detail, continuous level of detail.

Distance (2.5): Distance between pairs of objects of type point, segment, ray, line, triangle, rectangle, parallelogram, ellipse, ellipsoid, quadratic curve, quadratic surface.

Engine (3.1, 3.2, 3.3, 3.4.1, 4, Appendix A): Scene graph management (tree structures, internal nodes, abstract leaf node, abstract geometric leaf node, point primitives [particles], line primitives [polylines], triangle primitives [meshes], bounding spheres), render state (alpha blending, dithering, fog, lighting, material, shading, texturing, multitexturing, wireframe, z-buffering), abstract renderer layer, camera and view frustum, object-oriented infrastructure (abstract object base class, run-time type information, streaming, smart pointers for reference counting, cloning for mixed shallow-deep copying of objects, controllers for time-varying quantities).

Intersection (4.3, 5, 6): Picking (segment, ray, line versus box, capsule, cylinder, ellipsoid, lozenge, sphere, triangle), culling (plane versus box, capsule, cylinder, ellipsoid, lozenge, plane, sphere), collision (box, capsule, lozenge, sphere, triangle).

Numerics (Appendix B): root finding via bisection, eigensolver for symmetric matrices, fast function evaluation, integration, linear system solving, systems of ordinary differential equations (Euler, midpoint, Runge-Kutta), minimization without derivative calculations, special functions.

OglRenderer (3): OpenGL-based renderer (supports hardware acceleration).

SoftRenderer (3): Software renderer.

Sorting (12): Portals, BSP trees.

Surface (8): Abstract surface class (metric tensor, curvature tensor, principal curvatures and directions), parametric surfaces (position, derivatives, tangents, normals), implicit surfaces, polynomial surfaces.

Terrain (11): Continuous level of detail for height fields.

LIBRARY DEPENDENCIES